HISTORY OF ART

FIFTH EDITION REVISED
VOLUME I

HISTORY OF ART

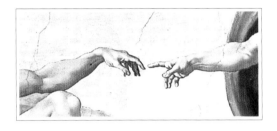

FIFTH EDITION REVISED
VOLUME I

H. W. JANSON ANTHONY F. JANSON

PRENTICE HALL, INC., AND HARRY N. ABRAMS, INC., PUBLISHERS

Project director: JULIA MOORE

Editor: JOANNE GREENSPUN

Assistant editor: MONICA MEHTA

Picture editor: JENNIFER BRIGHT

Art director: LYDIA GERSHEY

Designers:
LYDIA GERSHEY with YONAH SCHURINK
OF COMMUNIGRAPH

The Library of Congress has cataloged the trade edition of this book as follows:

Janson, H. W. (Horst Woldemar), 1913–
 History of art / H.W. Janson.—5th ed. revised Anthony F.
Janson.
 p. cm.
 Includes bibliographical references and index.
 ISBN–0–8109–3442–6
 1. Art—History. I. Janson, Anthony F. II. Title.
 N5300.J3 1997
 709—dc21 96–49963

Prentice Hall ISBN for this book is 0–13–849225–5

Prentice Hall, Inc.
Simon & Schuster/A Viacom Company
Send inquiries to:
 Marketing Manager
 Humanities & Social Sciences, Prentice Hall, Inc.
 One Lake Street
 Upper Saddle River, N.J. 07458
 http://www.prenhall.com

Copyright © 1991, 1995, 1997 Harry N. Abrams, Inc.
Published in 1997 by Harry N. Abrams, Incorporated, New York

Printed and bound in Japan

Note on the picture captions:
Each illustration is placed as close as possible to its first discussion in the text.
Measurements are given throughout, except for objects that are inherently large:
architecture, architectural sculpture, interiors, and wall paintings. Height precedes
width. A probable measuring error of more than one percent is indicated by
"approx." Titles of works are those designated by the institutions owning the works,
where applicable, or by custom. Dates are based on documentary evidence, unless
preceded by "c."

First Edition 1962, revised and enlarged, 1969
Second Edition 1977
Third Edition 1986
Fourth Edition 1991
Fifth Edition 1995, revised 1997

Front cover: *Peaches and Glass Jar*. Roman wall painting, from Herculaneum, near Naples. c. 50 A.D.
Museo Archeologica Nazionale, Naples. Detail of figure 291

CONTENTS

PART TWO
THE MIDDLE AGES *224*
Map *228*

PREFACE AND ACKNOWLEDGMENTS
TO THE FIRST EDITION

The title of this book has a dual meaning: it refers both to the events that *make* the history of art, and to the scholarly discipline that deals with these events. Perhaps it is just as well that the record and its interpretation are thus designated by the same term. For the two cannot be separated, try as we may. There are no "plain facts" in the history of art—or in the history of anything else for that matter, only degrees of plausibility. Every statement, no matter how fully documented, is subject to doubt and remains a "fact" only so long as nobody questions it. To doubt what has been taken for granted, and to find a more plausible interpretation of the evidence, is every scholar's task. Nevertheless, there is always a large body of "facts" in any field of study; they are the sleeping dogs whose very inertness makes them landmarks on the scholarly terrain. Fortunately, only a minority of them can be aroused at the same time, otherwise we should lose our bearings; yet all are kept under surveillance to see which ones might be stirred into wakefulness and locomotion. It is these "facts" that fascinate the scholar. I believe they will also interest the general reader. In a survey such as this, the sleeping dogs are indispensable, but I have tried to emphasize that their condition is temporary, and to give the reader a fairly close look at some of the wakeful ones.

I am under no illusion that my account is adequate in every respect. The history of art is too vast a field for anyone to encompass all of it with equal competence. If the shortcomings of my book remain within tolerable limits, this is due to the many friends and colleagues who have permitted me to tax their kindness with inquiries, requests for favors, or discussions of doubtful points. I am particularly indebted to Bernard Bothmer, Richard Ettinghausen, M. S. İpşiroğlu, Richard Krautheimer, Max Loehr, Wolfgang Lotz, Alexander Marshack, and Meyer Schapiro, who reviewed various aspects of the book and generously helped in securing photographic material. I must also record my gratitude to the American Academy in Rome, which made it possible for me, as art historian in residence during the spring of 1960, to write the chapters on ancient art under ideal conditions, and to the Academy's indefatigable librarian, Nina Langobardi. Irene Gordon, Celia Butler, and Patricia Egan have improved the book in countless ways. Patricia Egan also deserves the chief credit for the reading list. I should like, finally, to acknowledge the admirable skill and patience of Philip Grushkin, who is responsible for the design and layout of the volume; my thanks go to him and to Adrienne Onderdonk, his assistant.

H. W. J.
1962

PREFACE AND ACKNOWLEDGMENTS
TO THE FIFTH EDITION REVISED

The Fifth Edition Revised of H. W. Janson's *History of Art* continues the process of broad change that was inaugurated in the previous edition. Whereas the changes to the Fifth Edition concentrated on art from Mannerism through the art of the twentieth century, this time the focus is on art before 1520. The differences are less sweeping, but readers familiar with earlier editions will note some significant changes in emphasis. I have brought the scholarship on ancient art up to date. In this regard I had the benefit of numerous suggestions made by Professor Andrew Stewart and Dr. Mary Ellen Soles. In several instances, however, I have followed an independent approach to ongoing controversies. Some of them are relatively minor (for example, Which battle does the *Nike of Samothrace* commemorate?). The most important, however, is the vexing question of the debt of Roman painting to Greek art, to which I devoted a year's study before siding with those specialists who see it as essentially Roman in character. I have also rethought a good deal of medieval art. I am indebted to the helpful comments of Professor Dale Kinney, who served as reader. Thus, I examined afresh the contribution of Abbot Suger in the formation of Gothic architecture, which has been undergoing a major re-evaluation of late, although again I have taken a different stand on the issue from many other writers. I have also emphasized what I regard as the critical role of Byzantium in preserving the heritage of Early Christian art and transmitting it to the Latin world, where it provided the foundation for the revolution in Gothic painting and sculpture. Finally, I have reorganized the historical background in the Introduction to Part Two and included additional information within each chapter.

So far as the Renaissance is concerned, I have added more iconography than before, such as the inspiration of Poliziano in Botticelli's *Birth of Venus* and Raphael's *Galatea,* and the symbolism of Giorgione's *The Tempest.* The presentation of High Renaissance art has been altered, particularly in the case of Michelangelo, and more subtly where Leonardo and Raphael are considered.

This addition also completes the process of transforming the book into purely a history of Western art. It has been done with some regret, and I was especially reluctant to relinquish Islamic art. When that chapter was written, it represented the state of the art, and although our understanding has increased greatly in recent years, it would not have been difficult to bring the scholarship up to date. Nevertheless, I have decided to give it up in order to accommodate changes I felt were imperative to strengthen the treatment of other areas.

Perhaps the biggest change to the book has been the incorporation of new sections on the history of music and theater. They are frankly experimental, for although books on other disciplines have often included material on art, art-history surveys have avoided reciprocating the honor. I confess to misgivings about such an interdisciplinary approach, which is perhaps better suited to the expert than to the beginner, and about the risk of committing a naïveté often shown by colleagues in other fields when they have ventured into art. I have nonetheless decided to add them so as to suggest the larger cultural context in which the visual arts have existed. I have

done so out of a deeply felt love for music and drama. However, my account is necessarily slanted to those aspects that illuminate the main content of this book. As this is by no means intended to be a general humanities book, I have placed less emphasis on the history of literature and philosophy, which are vast subjects in themselves, except insofar as they are directly relevant to the discussion.

I must also admit that I have tried to act as an advocate of modern music and theater because I appreciate the resistance that most people feel toward them, just as they do to modern art. I, too, have felt that resistance to modern culture, and I am more than sympathetic to the plight of many readers. From my own experience, I can attest that the only way to come to terms with these demanding art forms is to immerse oneself in them fully, however forbidding that may seem. The rewards are more than worth the effort.

In addition to the new sections on music and theater, the reader will also find a number of other boxed texts that appear throughout the book as supplements to the main text. These deal with such subjects as classical and Christian iconography, the religious orders, the guilds, and printmaking techniques. The Greek chapter, for example, includes discussions of the Greek gods and goddesses and the hero in Greek legend. In the chapter on Early Christian and Byzantine art, there are texts on the liturgy of the Mass, the various versions of the Bible, the life of Jesus, and biblical, church, and celestial beings. Monasticism is explored in the Romanesque art chapter, and the various printmaking techniques are explained in the chapters on fifteenth- and nineteenth-century art.

Putting this book together is a mammoth undertaking. I can honestly say that this time around was by far the smoothest, thanks to the experienced and amicable "dream team" at Abrams, which has worked so well together on previous editions of this and other Janson volumes. Julia Moore served as project manager and developmental respondent and Joanne Greenspun as editor, with the assistance of project editor Monica Mehta and photo editor Jennifer Bright. Lydia Gershey and Yonah Schurink of Communigraph are responsible for the excellent design and prepress, and Shun Yamamoto oversaw the production process. Paul Gottlieb, Abrams' great publisher and editor-in-chief, was unfailingly supportive.

I would like to dedicate this edition to the memory of my father, who wrote the original survey of art history 35 years ago. I am keenly aware of the very broad changes I have introduced over the past several editions. He would undoubtedly be as surprised as I am by how extensive they are. They reflect changes in scholarship, as well as the inevitable differences in taste and outlook between two authors, no matter how closely related they may be. Yet my goal has always been to maintain the identity and integrity of the book as he originally conceived it. It is my hope that he would recognize the book as his. Fortunately, my mother is still alive, and since she played an integral role in its inception (not to mention mine), this edition is happily dedicated to her as well.

A. F. J.
1997

PRELUDE

The art-historical approach of this book is often labeled formalistic insofar as it is concerned with the evolution of style, yet this use of the label should not be taken to mean only the visual analysis of aesthetic qualities. It also draws on iconography, that is, the meaning of a work of art, and what Erwin Panofsky called iconology, its cultural context. Thus, it embodies what might be called the classical approach to art history as defined by three generations of mainly German-born scholars, including H. W. Janson, who was himself a student of Panofsky. It is well suited to introducing beginners to art history by providing the framework for how to look at and respond to art in museums and galleries—something both authors have themselves greatly enjoyed throughout their lifetimes.

Nonetheless, readers should be aware that there are other approaches that have benefited art history and are worthy of attention. The oldest is Marxism, which examines art in terms of the social and political conditions determined by the prevailing economic system. It has been especially useful in treating art since the Industrial Revolution, which created the historical circumstances analyzed so tellingly by Karl Marx in the middle of the nineteenth century. It remains to be seen what will become of Marxist art history in the wake of the collapse of communist governments in Russia and Eastern Europe.

Psychology, too, has added many insights to the private meaning that works of art have held for their creators, particularly when that meaning has been hidden even to the artists themselves. Although the more extreme attempts at psychoanalyzing Leonardo and Michelangelo, for instance, have caused some scholars to distrust this method, works such as Fuseli's *The Nightmare* (whose meaning was analyzed by H. W. Janson in a pioneering article) are incomprehensible without it. Another case in point: at my editor's suggestion, I have traced the theme of a woman holding a mirror from the sixteenth century to modern times as a "textbook" example of iconography, using works by Hans Baldung Grien, Simon Vouet, François Boucher, Pablo Picasso, Erich Heckel, and Cindy Sherman as examples. But the meaning of this fasci-

nating image is vastly enriched by knowing that it is a classic representation of the anima, one of the psychological archetypes defined by Freud's former disciple Carl Jung, which personifies the feminine tendencies in the male psyche and acts as a guide to the inner realm. This discovery opens up a field of analysis that I invite readers to explore on their own.

Three new approaches—feminism, multiculturalism, and deconstruction—are perhaps the most radical of all. Feminism reexamines art history from the point of view of gender. Depictions of the woman with a mirror virtually call for a feminist treatment, which yields a very different understanding of their covert significance, as readers may readily ascertain by questioning these works themselves. Because it is embedded in current gender politics in Western society, there is risk that a major shift in social outlook might call some of its conclusions into question. In principle, however, feminist theory is applicable to the full scope of art history. It has certainly forced everyone to reconsider what is "good" art. After all, when this book first appeared, not a single woman artist was included—nor, I hasten to add, was one to be found in any other art-history survey. Today, such omissions seem nothing short of incredible.

Feminism in turn may be seen as part of the larger shift to multiculturalism, which itself addresses a very real gap in our understanding of the art of traditional and non-Western cultures. The representation of some African-American artists, for example, reflects the inclusion of artists who embody very different sensibilities from that of the European and American mainstreams. In these selections, I have taken a stand about what art I think is most significant, and not all readers will agree with it, since it favors universality over ethnocentricity. This position reflects in part my own sensitivities about the stereotyping that the latter fosters on both sides of the racial fence. In my opinion, it forces a cultural dead end, although I do not deny that art with a racial "edge" has a legitimate place. Feminism and multiculturalism have both attacked the "canon" of masterpieces in this and similar books as embodying a traditional chauvinism and colonialist

attitudes. I leave readers to judge the issue for themselves.

Because they are so central to Postmodernist thought, I have attempted to summarize semiotics and deconstruction toward the end of this book, knowing full well that their followers will never be satisfied, partly because each treatment is necessarily brief and partly because I am not a convert to either cause. I took on the task in order to help the reader gain a little better understanding of the world of ideas we live in. I have to say that I enjoyed drinking from the cup of Postmodernism, even though it is ultimately not to my taste. It provided a brisk, refreshing tonic, hardly the poisonous brew that I might have expected. Rather than emerging gloomy from the experience, I find myself surprisingly optimistic as we fly headlong into the new millennium.

Let me add that I am fundamentally sympathetic to semiotics, which became an interest of mine more than 20 years ago, though I ultimately find Noam Chomsky's theory of linguistics to be more satisfying. Deconstruction has likewise made art historians reconsider meaning in new ways that have breathed fresh life into the field. Nevertheless, I know from classroom experience that semiotics is nearly impossible for the art-history novice to comprehend. Deconstruction, which has taken scholarship by storm in recent years, is even more taxing. What began as an internecine feud between two schools of French semiologists has spread to art history, where it pits older, mostly German-trained scholars against a younger generation using deconstruction as a way of finding their place in the sun. And that is perhaps the point. People are constantly recasting art history in their image. But if art history reflects our time, the reader may well wonder how it can have any claim to objectivity and, hence, validity. In actual fact, people's understanding of history has always changed with the times. How could it be otherwise? Indeed, it seems almost necessary for each generation to reinvent history to understand both the past and the present. The danger is that the intrusion of ideology, regardless of noble intent, will undermine the search for Truth, no matter how relative it may be. Such a thing happened during the 1930s, when scholarship was made to serve the political ends of dictatorships—and which led Panofsky and Janson to leave Germany.

Neither author of the present volume is an ideologue. Both are humanists who believe that the study of the humane letters is an enjoyable and enriching experience. Such a view carries with it the implicit charge (admittedly not always honored in the observance) that scholarly discourse be temperate, though it is rarely dispassionate. I would encourage the reader to examine all forms of art history with an open mind. One cannot view something so rich and complex from a single perspective any more than it is possible to see a diamond from one angle. Each approach has something to contribute to our understanding. To be sure, a plea for tolerance may seem an anachronism at a time when art history, like all fields, has become so contentious. In this regard, scholarship is simply the mirror of the rapid political change, social unrest, ideological intolerance, and religious fanaticism that characterize postindustrial society and the new world order that is emerging in its wake.

Let me end these rather personal remarks with a surprising admission. For nearly 40 years, both authors have given a great deal of thought to this book, which is written in the authoritative tones that intellectuals habitually adopt as their public voice. It is difficult, of course, to resist the temptation to pontificate—to hand down the "canon" as if it were immutable law. Yet, if the truth be told, the experience of surveying such a broad field as art history provides a lesson in humility. One becomes only too aware of the painful omissions and how little one knows about any given subject in this age of increasing specialization. If it requires the egotism of the gods to undertake such a project in the first place, in the end one sees it clearly for what it is: an act of hubris. It also requires a faith in the power of reason to produce such a synthesis, something that is in short supply in this skeptical era.

A. F. J.

INTRODUCTION

ART AND THE ARTIST

"What is art?" Few questions provoke such heated debate and provide so few satisfactory answers. If definitive conclusions are impossible, there is still a good deal that can be said. Art is first of all a *word*, which itself acknowledges both the idea and the fact of art. Without a word, one might well ask whether art exists in the first place. The term, after all, is not found in every society. Yet art is *made* everywhere. Art, therefore, is also an object, but it is not just any kind of object. Art is an *aesthetic object*. It is meant to be looked at and appreciated for its intrinsic value. Its special qualities set art apart, so that it is often placed away from everyday life—in museums, caves, or churches.

What does *aesthetic* mean? By definition, aesthetic is "that which concerns the beautiful." Of course, not all art is beautiful to each person's eyes, but it is art nonetheless. No matter how unsatisfactory, the term will have to do for lack of a better one. Aesthetics is, strictly speaking, a branch of philosophy which has occupied thinkers from Plato to the present day. Like all matters philosophical, it is subject to debate. During the last hundred years, aesthetics has also become a field of psychology, a field which has come to equally little agreement. Why should this be so? On the one hand, people the world over make much the same fundamental judgments. Our brains and nervous systems are the same because, according to recent theory, everyone is descended from one woman who lived in Africa a quarter-million years ago. On the other hand, taste is conditioned solely by culture, which is so varied that it is impossible to reduce art to any one set of precepts. It would seem, therefore, that absolute qualities in art must elude us, that we cannot escape viewing works of art in the context of time and circumstance, whether past or present. How indeed could it be otherwise, so long as art is still being created all around us, opening our eyes almost daily to new experiences and forcing us to readjust our understanding?

Imagination

We all dream. That is imagination at work. To imagine means simply to make an image—a picture—in our minds. Human beings are not the only creatures who have imagination. Even animals dream. However, there is a profound difference between human and animal imagination. Humans are the only creatures who can tell one another about imagination in words or pictures. No other animal has ever been observed to draw a recognizable image spontaneously in the wild. In fact, their only images have been produced under carefully controlled laboratory conditions that tell us more about the experimenter than they do about art. There can be little doubt, on the other hand, that people possess an artistic faculty. By the age of five every normal child has drawn a moon pie-face. The ability to make art is one of our most distinctive features; it separates us from all other creatures across an evolutionary gap that is unbridgeable.

Just as an embryo retraces much of the human evolutionary past, so budding artists reinvent the first stages of art. Soon, however, they complete that process and begin to respond to the culture around them. Thus even children's art is subject to the taste and outlook of the society that shapes his or her personality. In fact, children's art is generally judged according to the same criteria as adult art, only in appropriately simpler terms, and with good reason. The youngster must develop all the skills that go into adult art: coordination, intellect, personality, imagination, creativity, and aesthetic judgment. Seen this way, the making of a youthful artist is a process as fragile as growing up itself, and one that can be stunted at any step by the vicissitudes of life. No wonder that so few continue their creative aspirations into adulthood.

The imagination is one of our most mysterious facets. It can be regarded as the connector between the conscious and the subconscious, where most of our brain activity takes place. It is the very glue that holds our personality, intellect, and

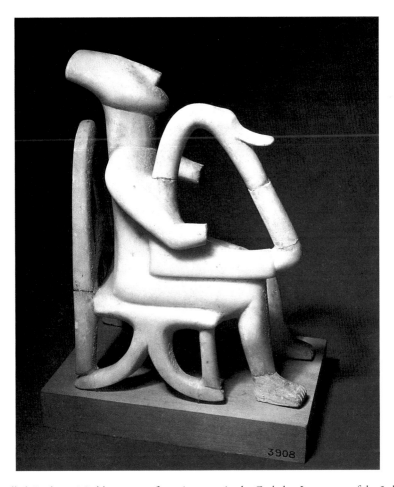

1. *Harpist*, so-called Orpheus. Marble statuette from Amorgos in the Cyclades. Latter part of the 3rd millennium B.C. Height 8¹/₂" (21.5 cm). National Archaeological Museum, Athens

spirituality together. Because the imagination responds to all three, it acts in lawful, if unpredictable, ways that are determined by the psyche and the mind. Even the most private artistic statements can be understood on some level, if only an intuitive one. The imagination is important, as it allows us to conceive of all kinds of possibilities in the future and to understand the past in a way that has real survival value. It is an essential part of our makeup. The ability to make art, in contrast, must have been acquired relatively recently in the course of evolution. The record of the earliest art is lost. Human beings have been walking the earth for nearly 4.5 million years, although our own species (*homo sapiens*) is much younger than that. By comparison, the oldest known prehistoric art was made only about 35,000 years ago, but it was undoubtedly the culmination of a long development no longer traceable. Even the art found today in the simplest traditional culture represents a late stage of development within in a stable society.

Who were the first artists? In all likelihood, they were shamans. Like the legendary Greek poet Orpheus, who sang his words while playing the lyre, they were magicians who were believed to have divine powers of inspiration and to be able to enter the underworld of the subconscious in a death-like trance, but, unlike ordinary mortals, they were then able

to return to the realm of the living. Just such a figure seems to be represented by *Harpist* (fig. 1) from nearly 5,000 years ago. A work of unprecedented complexity for its time, it was carved by a remarkably gifted artist who makes the beholder feel the visionary rapture of a bard as he sings his legend. With this unique ability to penetrate the unknown and rare talent for expressing it through art, the artist-shaman gained control over the forces hidden in human beings and nature. Even today the artist remains a magician whose work can mystify and move us—an embarrassing fact to civilized people, who do not readily relinquish their veneer of rational control.

In a larger sense art, like science and religion, fulfills humanity's innate urge to comprehend itself and the universe. This function makes art especially significant and, hence, worthy of our attention. Art has the power to penetrate to the core of our being, which recognizes itself in the creative act. For that reason, art represents its creator's deepest understanding and highest aspirations. At the same time, artists often play an important role as the articulators of our shared beliefs and values, which they express through an ongoing tradition to their audience.

Given the many factors that feed into it, art must play a very special role in the artist's personality. Sigmund Freud, the founder of modern psychiatry, conceived of art primarily in

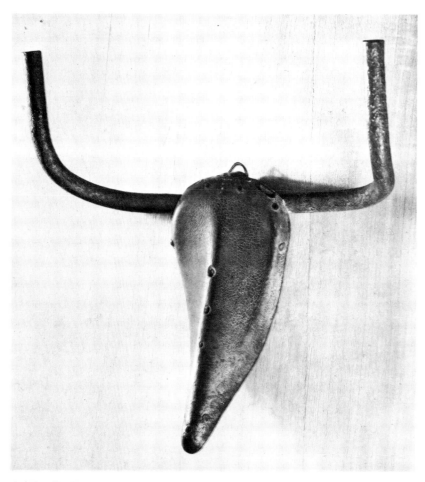

2. Pablo Picasso. *Bull's Head*. 1943. Bronze cast bicycle parts,
height 16 1/8" (41 cm). Musée Picasso, Paris

terms of sublimation outside of consciousness. Such a view hardly does justice to artistic creativity, since art is not simply a negative force at the mercy of our neuroses but a positive expression that integrates diverse aspects of personality. Indeed, when we look at the art of someone who is mentally ill, we may be struck by its vividness; but we instinctively sense that something is wrong, because the expression is incomplete. Artists may sometimes be tortured by the burden of their genius, but they can never be fully creative under the thrall of psychosis.

Creativity

What is meant by making art? At the very least, a work of art must be a tangible thing shaped by human hands. (This definition eliminates the confusion of treating as works of art such natural phenomena as flowers, seashells, or sunsets, which are raised to their status as art when they are depicted in still lifes and landscapes.) It is a far from sufficient definition, to be sure, since human beings make countless things other than works of art. Still, it will serve as a starting point. Now let us look at the striking *Bull's Head* by Picasso (fig. 2), which seems to consist of nothing but the seat and handlebars of an old bicycle. How meaningful is our formula here? Of course the materials used by Picasso are fabricated, but it would be absurd to insist that

Picasso must share the credit with the manufacturer, since the seat and handlebars in themselves are not works of art.

While we feel a certain jolt when we first recognize the ingredients of this visual pun, we also sense that it was a stroke of genius to put them together in this unique way, and we cannot very well deny that it is a work of art. Yet the handiwork— the mounting of the seat on the handlebars—is ridiculously simple. What is far from simple is the leap of the imagination by which Picasso recognized a bull's head in these unlikely objects. That is something only he could have done. Clearly, then, the making of a work of art should not be confused with manual skill or craftsmanship. Some works of art may demand a great deal of technical discipline; others do not. And even the most painstaking piece of craft does not deserve to be called a work of art unless it involves a leap of the imagination.

But if this is true, did not the real making of the *Bull's Head* take place in the artist's mind? No, that is not so, either. Suppose that, instead of actually putting the two pieces together and showing them to us, Picasso merely said, "You know, today I saw a bicycle seat and handlebars that looked just like a bull's head to me." Then there would be no work of art and his remark would not even strike us as an interesting bit of conversation. Moreover, Picasso himself would not have felt the satisfaction of having created something on the basis of

his leap of the imagination alone. Once he had conceived his visual pun, he could never be sure that it would really work unless he put it into effect.

Thus the artist's hands, however modest the task they may have to perform, play an essential part in the creative process. Picasso's *Bull's Head* is, of course, an ideally simple case, involving only one leap of the imagination and a manual act in response to it: once the seat had been properly placed on the handlebars (and then cast in bronze), the job was done. The leap of the imagination is sometimes experienced as a flash of inspiration, but only rarely does a new idea emerge full-blown like the Greek goddess Athena from the head of her father, Zeus. Instead, it is usually preceded by a long gestation period in which all the hard work is done without finding the key to the solution to the problem. At the critical point, the imagination makes connections between seemingly unrelated parts and recombines them.

Ordinarily, artists do not work with ready-made parts but with materials that have little or no shape of their own. The creative process consists of a long series of leaps of the imagination and the artist's attempts to give them form by shaping the material. In painting, for example, the hand tries to carry out the commands of the imagination and puts down a brushstroke, but the result may not be quite what had been expected, partly because all matter resists the human will, partly because the image in the artist's mind is constantly shifting and changing, so that the commands of the imagination cannot be very precise. In fact, the mental image begins to come into focus only as the artist "draws the line somewhere." That line then becomes part—the only fixed part—of the image. The rest of the image, as yet unborn, remains fluid. Each time the artist adds another line, a new leap of the imagination is needed to incorporate that line into the ever-growing mental image. If the line cannot be incorporated, it is discarded and a new one put down.

In this way, by a constant flow of impulses back and forth between the mind and the partly shaped material, the artist gradually defines more and more of the image, until at last all of it has been given visible form. Needless to say, artistic creation is too subtle and intimate an experience to permit an exact step-by-step description. Only artists can observe it fully, but they are so absorbed by it that they have great difficulty explaining it to us. The metaphor of birth comes closer to the truth than would a description of the process in terms of a transfer or projection of the image from the artist's mind, for the making of a work of art is both joyous and painful, replete with surprises, and in no sense mechanical. There is, moreover, ample testimony that artists themselves tend to look upon their creation as living things. Perhaps that is why creativity was once a concept reserved for god, as only he could give material form to an idea. Indeed, the artist's labors are much like the Creation told in the Bible; but this divine ability was not fully realized until Michelangelo described the anguish and glory of the creative experience when he spoke of "liberating the figure from the marble that imprisons it." Evidently he started the process of carving a statue by trying to visualize a figure in the rough, rectilinear block as it came to him from the quarry. (At times he may even have done so while picking out his material on the spot.)

At first Michelangelo did not see the figure any more clearly than one can see an unborn child inside the womb, but he may have believed that he could see isolated "signs of life" within the marble—a knee or an elbow pressing against the surface. To get a firmer grip on this dimly felt, fluid image, he was in the habit of making numerous drawings, and sometimes small models in wax or clay, before he dared to assault the "marble prison" itself. For that, he knew, was the final contest between himself and his material. Once he started carving, every stroke of the chisel would commit him more and more to a specific conception of the figure hidden in the block, and the marble would permit him to free the figure whole only if his guess as to its shape was correct.

Sometimes he did not guess well enough. The stone refused to give up some essential part of its prisoner, and Michelangelo, defeated, left the work unfinished, as he did with his *Awakening Slave* (fig. 3), whose very gesture seems to record the vain struggle for liberation. Looking at the block, we may get some inkling of Michelangelo's difficulties here. But could he not have finished the statue in *some* fashion? Surely there is enough material left for that. Well, he probably could have, but perhaps not in the way he wanted, and so he abandoned the sculpture.

Clearly, then, the making of a work of art has little in common with what is ordinarily meant by "making." It is a strange and risky business in which the makers never quite know what they are making until they have actually made it. Or, to put it another way, it is a game of find-and-seek in which the seekers are not sure what they are looking for until they have found it. In the case of the *Bull's Head* it is the bold "finding" that impresses us most; in the *Awakening Slave*, the strenuous "seeking." To the non-artist, it seems hard to believe that this uncertainty, this need to take a chance, should be the essence of the artist's work. We all tend to think of "making" in terms of artisans or manufacturers who know exactly what they want to produce from the very outset, pick the tools best suited to the task, and are sure of what they are doing at every step. Such "making" is a two-phase affair: first, artisans make a plan, then they act on it. And because they—or their customers—have made all the important decisions in advance, they have to worry only about the means, rather than the ends, while carrying out this plan. There is thus comparatively little risk in their endeavors, which as a consequence tend to become routine. It may even be replaced by the mechanical labor of a machine.

No machine, on the other hand, can replace the artist. In art, conception and execution go hand in hand and are so completely interdependent that they cannot be separated from each other. Whereas artisans generally attempt what they know to be possible, artists are driven to attempt the impossible—or at least the improbable or seemingly unimaginable. Who, after all, would have conceived that a bull's head was hidden in the seat and handlebars of a bicycle until Picasso discovered it? Did he not, almost literally, "make a silk purse out of a sow's ear"? No wonder the artist's way of working is so resistant to any set rules, while the artisan's tends to encourage standardization and regularity. The difference is that the artist *creates* instead of merely *makes* something, although the word has been done to death by overuse, and every child and fashion designer is labeled "creative."

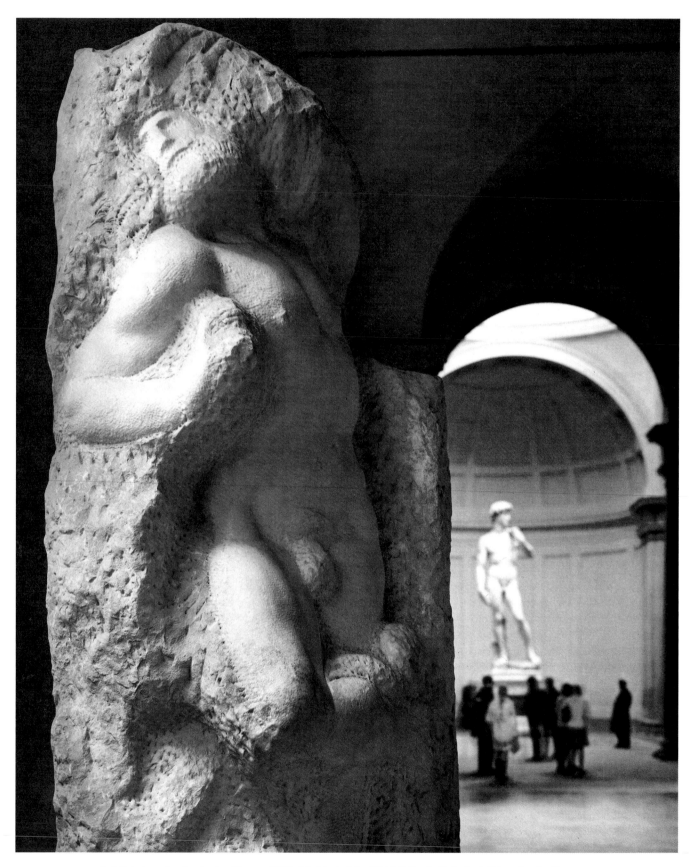

3. Michelangelo. *Awakening Slave.* c. 1525. Marble, height 8'11" (2.7 m). Galleria dell'Accademia, Florence

Needless to say, there have always been many more artisans than artists, since people's need for the familiar and expected far exceeds their capacity to absorb the original but often deeply unsettling experiences they get from works of art. The urge to penetrate unknown realms, to achieve something original, may be felt by every one of us now and then. To that extent, we can all fancy ourselves potential artists—mute, inglorious Miltons as it were. What sets the real artist apart is not so much the desire to *seek*, but that mysterious ability to *find*, which is called talent. It is often called a "gift," implying that it is a sort of present from some higher power; or as "genius," a term which originally meant that a higher power—a kind of "good demon"—inhabits and acts through the artist.

Talent must not be confused with aptitude. Aptitude is what the artisan needs. It means a better-than-average knack for doing something. An aptitude is fairly constant and specific. It can be measured with some success by means of tests that permit us to predict future performance. Creative talent, on the other hand, seems utterly unpredictable. It can be spotted only on the basis of *past* performance. Even past performance is not enough to ensure that a given artist will continue to produce on the same level. Some artists reach a creative peak quite early in their careers and then "go dry," while others, after a slow and unpromising start, may achieve astonishingly original work in middle age or even later.

Originality

Originality is what ultimately distinguishes art from craft. It is the yardstick of artistic greatness or importance. Unfortunately, it is also very hard to define. The usual synonyms—uniqueness, novelty, freshness—do not help us very much, and the dictionaries tell us only that an original work must not be a copy. If we want to rate works of art on an "originality scale," the problem does not lie in deciding whether or not a given work is original (the obvious copies and reproductions are for the most part easy enough to eliminate) but in establishing exactly *how* original it is.

Straightforward copies can usually be recognized as such on internal evidence alone. If the copyists are merely conscientious, they produce works of craft. The execution strikes us as pedestrian and out of tune with the conception of the work. There are also likely to be small slipups that can be spotted in much the same way as misprints in a text. But what happens when great artists copy each other? In such cases, they do not simply produce copies in the accepted sense of the word, since they do not try to achieve the effect of a duplicate. Rather, they do so purely for their own instruction, transcribing their models accurately, yet with their own inimitable rhythm, and are not the least constrained or intimidated by the other work of art. In other words, they "represent" (they do not copy) their models.

Ordinarily, though, the link is not immediately obvious. Édouard Manet's famous painting *Luncheon on the Grass* (*Le Déjeuner sur l'herbe;* fig. 4, page 22) seemed so revolutionary a work when first exhibited more than 130 years ago that it caused a scandal; the artist had dared to show an undressed young woman next to two men in fashionable contemporary dress. People assumed that Manet had intended to represent an actual event. Not until many years later did an art historian discover the source of these figures: a group of classical deities from an engraving by Marcantonio Raimondi after a design supplied to him by Raphael (fig. 5). The relationship, so striking once it has been pointed out to us, had escaped attention, for Manet did not *copy* or *represent* the Raphael composition. He merely *borrowed* its main outlines while translating the figures into modern terms.

Had his contemporaries known of this, the *Luncheon* would have seemed a rather less disreputable kind of outing to them, since then the hallowed shade of Raphael could be seen to hover nearby as a sort of chaperon. For us, the main effect of the comparison is to make the cool, formal quality of Manet's figures even more conspicuous. But does it decrease our respect for his originality? True, he is "indebted" to Raphael; yet his way of bringing the forgotten old composition back to life is in itself so original and creative that he may be said to have more than repaid his debt. As a matter of fact, Raphael's figures are just as "derivative" as Manet's. They stem from still older sources which lead us back to ancient Roman art and beyond (compare the relief of *River Gods*, fig. 6).

Thus Manet, Raphael, and the Roman river-gods form three links in a chain of relationships that arises out of the distant past and continues into the future—for the *Luncheon* on *the Grass* has in turn served as a source of more recent works of art. Nor is this an exceptional case. All works of art anywhere—yes, even such works as Picasso's *Bull's Head*—are part of similar chains that link them to their predecessors. If it is true that "no man is an island," the same can be said of works of art. The sum total of these chains makes a web in which every work of art occupies its own specific place. This is known as *tradition*. Without tradition—the word means "that which has been handed down to us"—no originality would be possible. It is clear that Manet took tradition as his starting point and intended to link his painting to the past through well-hidden quotations in his "scandalous" group, as well as in the figure of the woman bathing and the landscape. Tradition provides, as it were, the firm platform from which artists make their leap of the imagination. The place where they land will then become part of the web and serve as a point of departure for further leaps.

And for us, too, the web of tradition is equally essential. Whether we are aware of it or not, tradition is the framework within which we inevitably form our opinions of works of art and assess their degree of originality. A masterpiece is a work that contributes to our vision of life and leaves us profoundly moved. Yet, it can also bear the closest scrutiny and withstand the test of time. Let us not forget, however, that such assessments should always remain subject to revision. In fact, tastes have varied greatly over time. Works that were once regarded as cornerstones of tradition have been discarded, while others that were ignored or even despised appear to be important works in their own right. Thus the "canon," or core body, of Western art is constantly shifting, rather than being static and immutable. One reason for this change is overexposure, which has reduced the greatest masterpieces to commodities through mass-merchandising in popular culture. Leonardo's *Mona Lisa*, Rodin's *The Thinker*, and Munch's *The Scream* are found everywhere in advertisements, humorous cards, and the like, so that they have become victims of their fame.

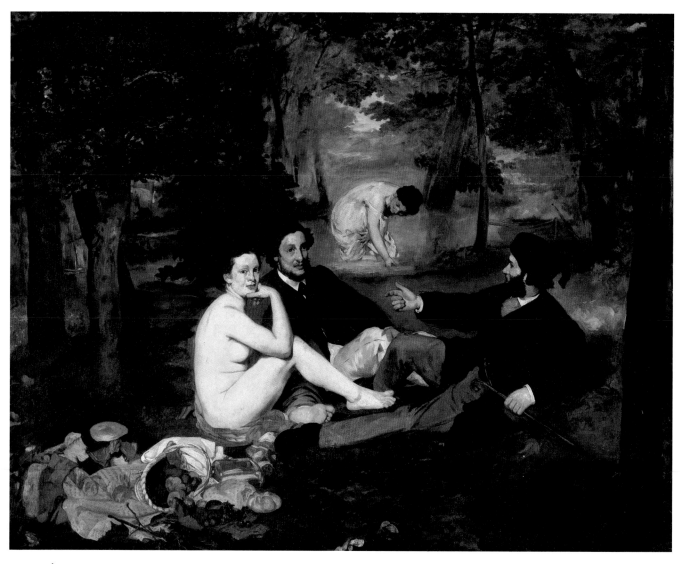

4. Édouard Manet. *Luncheon on the Grass (Le Déjeuner sur l'herbe)*. 1863. Oil on canvas, 7' x 8'10" (2.1 x 2.6 m). Musée d'Orsay, Paris

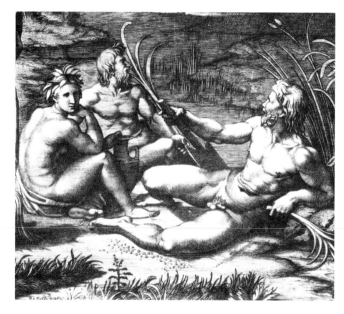

6. *River Gods.* Detail of Roman sarcophagus. 3rd century A.D.
Villa Medici, Rome

5. Marcantonio Raimondi, after Raphael.
The Judgment of Paris (detail). c. 1520. Engraving.
The Metropolitan Museum of Art, New York

Rogers Fund, 1919

If originality distinguishes art from craft, tradition serves as the common meeting ground of the two. Most beginning artists start out on the level of craft by imitating other works of art. In this way, they gradually absorb the artistic tradition of their time and place until they have gained a firm footing in it. But only the truly gifted ever leave that stage of conventional competence and become creators in their own right. No one, after all, can be taught how to create—only how to go through the motions of creating. The aspiring artist of talent will eventually achieve the real thing. What the apprentice or art student learns are skills and techniques: established ways of drawing, painting, carving, designing—established ways of *seeing*.

Nevertheless, one of the attributes that distinguishes great artists is their consummate technical command. This superior talent is recognized by other artists, who admire their work and seek to emulate it. This is not to say that facility alone is sufficient. Far from it! The academic painters and sculptors of the nineteenth century were as a group among the most proficient artists in history—as well as the dullest. Still, complete technical command is a requisite of masterpieces, which are distinguished by their superior execution.

When would-be artists sense that their talents are not great enough to succeed in the fine arts as painters, sculptors, or architects, many of them take up one of the special fields known collectively as "the applied arts," for which they can be rewarded in less artistically risky work: illustration, typographic design, industrial design, and interior design, for example. The applied arts are more deeply enmeshed in our everyday lives and thus cater to a far wider public than do painting and sculpture. Their purpose, as the name suggests, is to beautify the useful—an important and valued end. They provide some scope for originality to their more ambitious practitioners, but the flow of creative endeavor is cramped by such factors as the cost and availability of materials or manufacturing processes, as well as accepted notions of what is useful, fitting, or desirable.

Nevertheless, it is often difficult to maintain the distinction between fine and applied art. Medieval painting, for instance, is to a large extent "applied," in the sense that it embellishes surfaces which serve other, practical purposes as well—walls, book pages, windows, furniture. The same may be said of much ancient and medieval sculpture. Greek vases, although functional pottery, were sometimes decorated by artists of very impressive talent. Indeed, the history of applied art is filled with artists of considerable stature. How can this be so, if art and the crafts are so separate? The reason is that what defines art is not any difference in materials or techniques from the applied arts but the willingness to take risks in the quest for bold, new ideas. In architecture the distinction between art and applied art breaks down altogether, since the design of every building, from country cottage to cathedral, reflects external limitations imposed upon it by the practical purpose of the structure, by the site, by cost factors, materials, and technology. (The only "pure" architecture is imaginary, unbuilt architecture.) Thus architecture is, almost by definition, an applied art, but it is also a major art (as against the other applied arts, which are often called the "minor arts").

The graphic arts, which comprise the pictorial arts outside painting, especially those that rely on line rather than color, form a special case of their own. Drawings are original works of art; that is, they are entirely by the artist's own hand. With prints, however, the relationship between artist and image is more complex. Prints are not unique images but multiple impressions of images made by mechanical means on paper or other suitable material. Perhaps the distinction between original and copy is not so critical in printmaking after all. Printmakers must usually copy onto the plate a composition that was first worked out in a drawing, whether their own or someone else's. From the beginning, many prints have been made, at least in part, by artisans whose technical skill is necessary to ensure the outcome. Woodcuts and engraving in particular were traditionally dependent on craftsmanship, which may explain why so few creative geniuses have made them and have generally been content to let others produce prints from their designs. Although it does not require the artist's intervention at every step of the way, printmaking usually involves the artist's supervision and even active participation, so that the process can be thought of as a collaborative effort. *The Judgment of Paris* in figure 5 is an example of this type of work. Raphael had such admiration for Marcantonio's sensitive interpretations of his paintings that he began to make drawings for him to translate into engravings—a privilege enjoyed by no other printmaker. Because the design was conceived expressly with him in mind, Marcantonio's contribution was just as essential as, and hence no less original than, Raphael's.

Meaning and Style

Why do people create art? Surely one reason is an irresistible urge to adorn themselves and decorate the world around them. Both are part of a larger desire, not to remake the world in their image but to recast themselves and their environment in ideal form. Art is, however, much more than decoration. It is laden with meaning, even if that content is sometimes slender or obscure. What do we mean by content? The word encompasses not only the subject matter and literal meaning (its iconography) but its appearance as well, for the visual elements are themselves filled with significance. Art enables us to communicate our understanding in ways that cannot be expressed otherwise. In art, as in language, human beings are above all inventors of symbols that convey complex thoughts in new ways. We must think of art not in terms of everyday prose but of poetry, which is free to rearrange conventional vocabulary and syntax in order to convey new, often multiple, meanings and moods. A work of art likewise suggests much more than it states. It communicates partly by implying meanings through pose, facial expression, allegory, and the like. And like a poem, the value of art lies equally in what it says and how it says it.

But what is art trying to say? Artists often provide no clear explanation, since the work is the statement itself. If they could say what they mean in words, they would surely be writers instead. Fortunately, certain visual symbols and responses occur so regularly over time and place that they can be regarded as virtually universal. Nevertheless, their exact meaning is specific to each particular culture, giving rise to art's incredible diversity.

The meaning, or content, of art is inseparable from its formal qualities, its style. The word *style* is derived from *stilus*, the

writing instrument of the ancient Romans. Originally, it referred to distinctive ways of writing—the shape of the letters as well as the choice of words. Now, style is used loosely to mean the distinctive way a thing is done in any field of human endeavor. It is a term of praise in most cases: "to have style" means to have distinction, to stand out. A thing that has style also has inner coherence, or unity.

In the visual arts, style means the particular way in which the forms that make up any given work of art are chosen and fitted together. To art historians the study of styles is of great importance. It not only enables them to find out, by means of careful analysis and comparison, when, where, and by whom something was produced, but it also leads them to understand the artist's intention as expressed through the work's style, the way it looks. This intention depends on both the artist's personality and the context of time and place. Accordingly, art historians speak of "period styles" if they are concerned with those features which distinguish, let us say, Egyptian art as a whole from Greek art. Within these broad period styles they in turn distinguish the styles of particular phases, such as the Egyptian Old Kingdom. And wherever it seems appropriate, they differentiate national or local styles within a period, until they arrive at the personal styles of individual artists. Even these may need to be subdivided further into the various phases of an artist's development. The extent to which they are able to categorize effectively depends on the degree of internal coherence, and on how much of a sense of continuity there is in the body of material they are dealing with. Thus art, like language, requires that we learn the style and outlook of a country, period, and artist if it is to be understood properly.

Style needs only be appropriate to the *intent* of the work. This idea is not always easy to accept. Westerners are accustomed to a tradition of naturalism, in which art imitates nature as closely as possible. But the accurate reproduction of visual phenomena, called illusionism, is just one vehicle for expressing an artist's understanding of reality. Truth, it seems, is indeed relative, for it is a matter not simply of what our eyes tell us but also of the concepts through which our perceptions are filtered. There is, then, no reason to place a premium on realism (a term that is sometimes taken to mean truth to life, in contradistinction to naturalism, though most people use them interchangeably). The advantage of realism at face value is that it *seems* easier to understand. The disadvantage is that representational art, like prose, is always bound to the literal meaning and appearance of the everyday world, at least to some extent. Actually, realism is exceptional in the history of art and is not even necessary to its purposes. Any image is a separate and self-contained reality which has its own ends and responds to its own imperatives as determined by the artist's creativity. Even the most convincing illusion is the product of the artist's imagination and understanding, so that we must always ask why this subject was chosen and made in this way rather than in some other way.

Self-Expression and Audience

The birth of a work of art is an intensely private experience, so much so that many artists can work only when completely alone and refuse to show their unfinished pieces to anyone. Yet it must, as a final step, be shared by the public in order for the birth to be successful. Artists do not create merely for their own satisfaction, but want their work validated by others. In fact, the creative process is not completed until the work has found an audience. In the end, works of art exist in order to be liked rather than to be debated.

This seeming paradox can be resolved once we understand what artists mean by "public." They are concerned not with *the* public as a statistical entity but with their particular public, their audience; quality rather than wide approval is what matters to them. At a minimum, this audience needs to consist of only one or two people whose opinions they value. Ordinarily, artists also need patrons among their audience who will purchase their work, thus combining moral and financial support. In contrast to customers of applied art, for example, who know from previous experience what they will get when they buy the products of craftsmanship, the "audience" for art merits such adjectives as critical, fickle, receptive, engaged. It is uncommitted, free to accept or reject, so that anything placed before it is on trial—nobody knows in advance how it will receive the work. Hence, there is a tension between artist and audience that has no counterpart in the relationship of artisan and customer.

The audience whose approval looms so large in artists' minds is a limited and special one. Its members may be other artists as well as patrons, friends, critics, and interested viewers. The one quality they all have in common is an informed love of works of art—an attitude at once discriminating and enthusiastic that lends particular weight to their judgments. They are, in a word, experts, people whose authority rests on experience and knowledge. In reality, there is no sharp break, no difference in kind, between the expert and the layperson, only a difference in degree.

Tastes

Deciding what is art and rating a work of art are two separate problems. If there were an absolute method for distinguishing art from non-art, it would not necessarily help in measuring quality. People tend to compound the two problems into one. Often when they ask, "Why is that art?" they mean, "Why is that *good* art?" How often have we heard this question asked before a strange, disquieting work in a museum or art exhibition? There usually is an undertone of exasperation, for the question implies that the viewer doesn't think he or she is looking at a work of art, but that the experts—the critics, museum curators, art historians—must suppose it to be one, or why else would they put it on public display? Clearly, their standards are very different from others. People wish for a few simple, clear-cut rules to go by. Then maybe they would learn to like what they see—they would know "why it is art." But the experts do not post exact rules, and the lay person is apt to fall back upon a final line of defense: "Well, I don't know anything about art, but I know what I like."

It is a formidable roadblock, this stock phrase, in the path of understanding between expert and lay audience. Until not so very long ago, there was no great need for the two parties to communicate with each other. The general public had little voice in matters of art and therefore could not challenge the

judgment of the expert few. Today both sides are aware of the barrier between them and the need to level it. Let us examine the roadblock and the various unspoken assumptions that buttress it.

The fact that art is a complex and in many ways mysterious human activity about which even the experts can hope to offer only tentative and partial conclusions can be taken as confirming the belief that "I don't know anything about art." But are there really people who know nothing about art? The answer must be no for nearly all adults, who cannot help knowing *something* about it, just as everybody knows something about politics and economics, no matter how indifferent one may be to the issues of the day. Art is so much a part of the fabric of daily life that it is encountered all the time, even if the contacts are limited to magazine covers, advertising posters, war memorials, television, and the buildings where we live, work, and worship. Much of this art, to be sure, is pretty shoddy—art at third- and fourth-hand, worn out by endless repetition, representing the common denominator of popular taste. Still, it is art of a sort, and since it is the only art most people experience, it molds their ideas on art in general. When they say, "I know what I like," they may really mean, "I like what I know (and I am uncomfortable with whatever fails to match the things I am familiar with)." Such likes are not in truth so much theirs as those imposed by habit and culture without any personal choice. To like what we know and to distrust what we do not know is an age-old human trait. The past tends to be "the good old days," while the future seems fraught with danger.

But why should so many people cherish the notion of making personal choices in art when in fact they do not? There is another unspoken assumption at work here that goes something like this. "Since art is such an 'unruly' subject that even the experts keep disagreeing with each other, my opinion is as good as theirs. It's all a matter of subjective preference. In fact, my opinion may be better than theirs, because as a lay person I react to art in a direct, straightforward fashion, without having my view obstructed by a lot of complicated facts and theories. There must be something wrong with a work of art if it takes an expert to appreciate it." On the contrary, experts appreciate art more than other people precisely because of their greater knowledge. Expertise requires only an open mind and a capacity to absorb new experiences. So as their understanding grows, most people find themselves liking a great many more things than they had thought possible at the start. They gradually acquire the courage of their own convictions, until they are able to say, with some justice, that they know what they like.

LOOKING AT ART

The Visual Elements

We live in a sea of images conveying the culture and learning of modern civilization. Fostered by an unprecedented media explosion, this "visual background noise" has become so much a part of our daily lives that we take it for granted. In the process, we have become desensitized to art as well. Anyone can buy cheap paintings and reproductions to decorate a room, where they often hang virtually unnoticed, perhaps

deservedly so. It is small wonder that we look at the art in museums with equal casualness. We pass rapidly from one object to another, sampling them like dishes in a cafeteria line. We may pause briefly before a famous masterpiece that we have been told we are supposed to admire, then ignore the gallery full of equally beautiful and important works around it. We will have seen the art but not really looked at it. Looking at great art is not such an easy task, for art rarely reveals its secrets readily. While the experience of a work can be immediately electrifying, we sometimes do not realize its impact until it has had time to filter through the recesses of our imaginations. It even happens that something that at first repelled or confounded us emerges only many years later as one of the most important artistic events of our lives. Because so much goes into art, it makes much the same demands on our faculties as it did on the person who created it. For that reason, we must be able to respond to it on many levels. If we are going to get the most out of art, we will have to learn how to look and think for ourselves in an intelligent way, which is perhaps the hardest task of all. After all, we will not always have someone at our side to help us. In the end, the confrontation of viewer and art remains a solitary act.

Understanding a work of art begins with a sensitive appreciation of its appearance. Art can be approached and appreciated for its purely visual elements: line, color, light, composition, form, and space. These may be present in any work of art. Their effects, however, vary widely according to medium (the physical materials of which the artwork is made) and technique, which together help to determine the possibilities and limitations of what the artist can achieve. For that reason, our discussion is merged with an introduction to four major arts: graphic arts, painting, sculpture, and architecture. (The technical aspects of the major mediums are treated in sections within the main body of the text and in the glossary toward the end of the book.) Just because line is discussed with drawing, however, does not mean that it is not equally important in painting and sculpture. And although form is introduced with sculpture, it is just as essential to painting, drawing, and architecture.

Visual analysis can help us to appreciate the beauty of a masterpiece, but we must be careful not to use a formulaic approach that would trivialize it. Every aesthetic "law" advanced so far has proven of dubious value, and usually gets in the way of our understanding. Even if a valid "law" were to be found—and none has yet been discovered—it would probably be so elementary as to prove useless in the face of art's complexity. We must also bear in mind that art appreciation is more than enjoyment of aesthetics. It is learning to understand the meaning of a work of art. And finally, let us remember that no work can be understood outside its historical context.

LINE. Line may be regarded as the most basic visual element. A majority of art is initially conceived in terms of contour line. Its presence is often implied even when it is not actually used to describe form. And because children start out by scribbling, line is generally considered the most rudimentary component of art—although as anyone knows who has watched a youngster struggle to make a stick figure with pencil or crayon, drawing is by no means as easy as it seems. Line

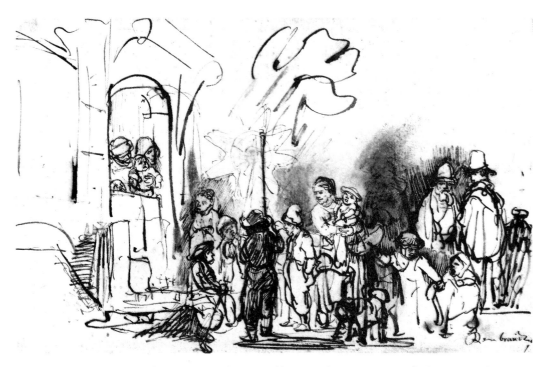

7. Rembrandt. *The Star of the Kings*. c. 1642. Pen and bistre, wash on paper, 8 x 12³/4" (20.3 x 32.4 cm).
The British Museum, London

has traditionally been admired for its descriptive value, so that its expressive potential is easily overlooked. Yet line is capable of creating a broad range of effects.

Drawings represent line in its purest form. The appreciation of drawings as works of art dates from the Renaissance, when the artist's creative genius first came to be valued and paper began to be made in quantity. Drawing style can be as personal as handwriting. In fact, the term *graphic art*, which designates drawings and prints, comes from the Greek word for writing, *graphos*. Collectors treasure drawings because they seem to reveal the artist's inspiration with unmatched freshness. Their role as records of artistic thought also makes drawings uniquely valuable to the art historian, for they help in documenting the evolution of a work from its inception to the finished piece.

Artists themselves commonly treat drawings as a form of note-taking. Some of these notes are discarded as fruitless, while others are tucked away to form a storehouse of motifs and studies for later use. Rembrandt was a prolific draftsman who was constantly jotting down observations of daily life and other ideas for further development. His use of line was highly expressive. Many of his sketches were done in pen and ink, a medium that captured his most intimate thoughts with admirable directness. In *The Star of the Kings* (fig. 7), one of his most elaborate sheets, Rembrandt rendered the essence of each pose and expression with remarkable succinctness—the dog, for example, consists of no more than a few strokes of the pen—yet every figure emerges as an individual character. Rembrandt's draftsmanship is so forceful that it allows us to

mentally trace the movements of the master's hand with astonishing vividness.

Once a basic idea is established, an artist may develop it into a more complete study. Michelangelo's studies (fig. 8) of the Libyan Sibyl for the Sistine Chapel ceiling is a drawing of great beauty. For this sheet, he chose the softer medium of red chalk over the scratchy line of pen and ink that he used in rough sketches. His chalk approximates the texture of flesh and captures the play of light and dark over the nude forms, giving the figure a greater sensuousness. The emphatic outline that defines each part of the form is so fundamental to the conceptual genesis and design process in all of Michelangelo's paintings and drawings that ever since his time line has been closely associated with the "intellectual" side of art.

In accordance with the practice of the day, it was Michelangelo's habit to base his female figures on male nudes drawn from life. To him, moreover, only the heroic male nude possessed the physical monumentality necessary to express the awesome power of figures such as this mythical prophetess. In common with other sheets like this by him, Michelangelo's focus here is on the torso. He studied the musculature at length before turning his attention to details like the hand and toes. Since there is no sign of hesitation in the pose, we can be sure that the artist already had the conception firmly in mind. (Probably it had been established in a preliminary drawing.) Why did he go to so much trouble when the finished sibyl is mostly clothed and must be viewed from a considerable distance below? Evidently Michelangelo believed that only by describing the anatomy completely

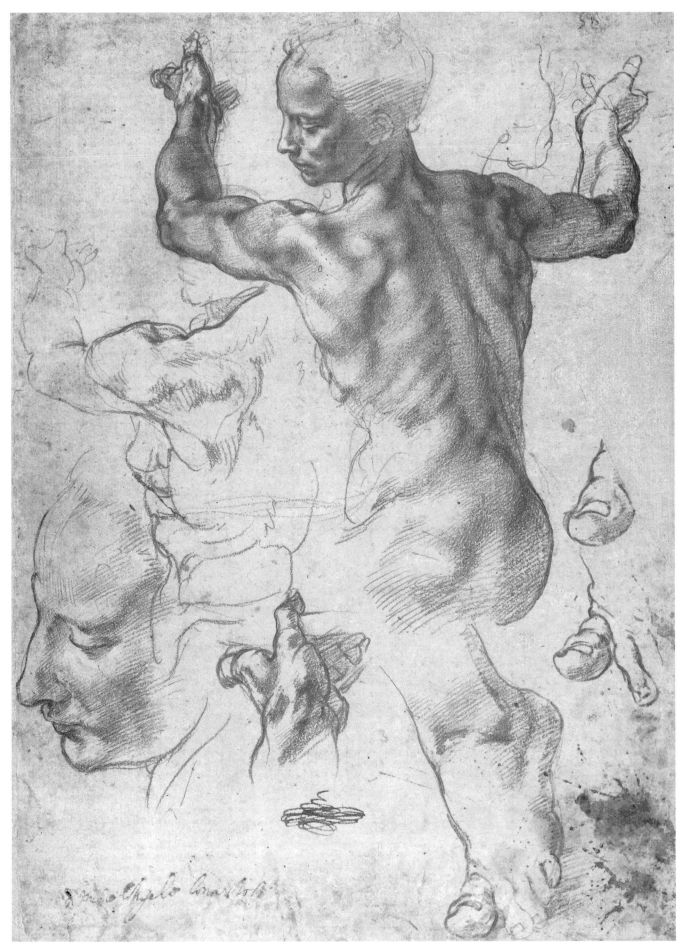

8. Michelangelo. *Studies for the Libyan Sibyl.* c. 1511. Red chalk on paper, 11³/8 x 8³/8" (28 x 21.3 cm). The Metropolitan Museum of Art, New York

Purchase, Joseph Pulitzer Bequest, 1924

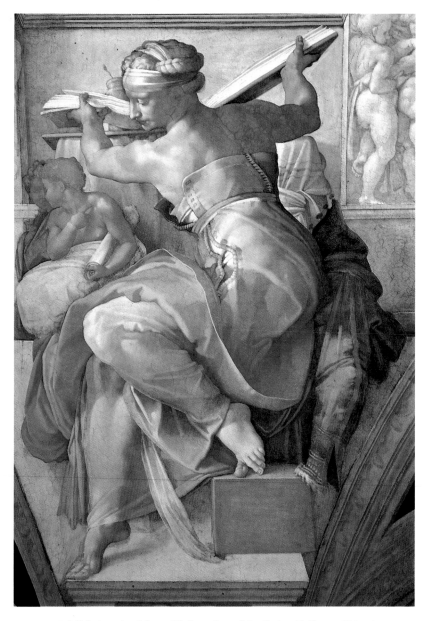

9. Michelangelo. *Libyan Sibyl,* portion of the Sistine Ceiling. 1508–12.
Fresco. Sistine Chapel, The Vatican, Rome

could he be certain that the figure would be convincing. In the final painting (fig. 9) she communicates a superhuman strength, lifting her massive book of prophecies with the utmost ease.

COLOR. The world is alive with color, and because color is an adjunct element to graphics and sometimes sculpture, it is indispensable to virtually all forms of painting. This is true even of tonalism, which emphasizes dark, neutral hues like gray and brown. Of all the visual elements, color is undoubtedly the most expressive—as well as the most intractable. Perhaps for that reason, it has attracted the wide attention of researchers and theorists since the mid-nineteenth century. Along with the Post-Impressionists and, more recently, Op artists, color theorists have tried to set down their understanding of colors as perceptual and artistic laws equivalent to those of optical physics. Both Van Gogh and Seurat developed elaborate color systems, one entirely personal in its meaning, the other claiming to be "scientific." We often read that red seems to advance, while blue recedes; or that the former is a violent or passionate color, the latter a sad one. Like a recalcitrant child, however, color in art refuses to be governed by any rules. They work only when the painter consciously applies them.

Notwithstanding this large body of theory, the role of color in art rests primarily on its sensuous and emotive appeal, in contrast to the more cerebral quality generally associated with line. The merits of line versus color have been the subject of a debate that first arose between partisans of Michelangelo and Titian, Michelangelo's great contemporary in Venice. Titian himself was a fine draftsman and absorbed the influence of Michelangelo. He nevertheless stands at the head of the coloristic tradition that descends through Rubens and Van Gogh to the Abstract Expressionists of the twentieth century. In fact, *Danäe* (fig. 10), painted in the middle of Titian's long career during a sojourn in Rome, shows the

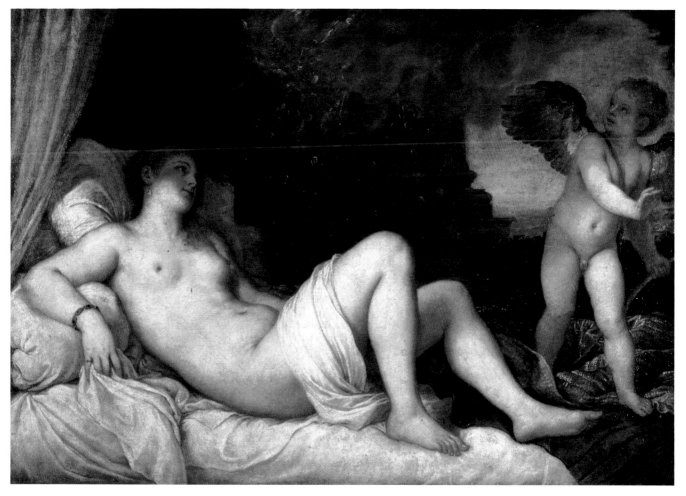

10. Titian. *Danaë*. c. 1544–46. Oil on canvas, 47 1/4 x 67 3/4" (120 x 172 cm). Museo e Gallerie Nazionale di Capodimonte, Naples

impact of Michelangelo's figure of Night on the Tomb of Giuliano de' Medici (fig. 616). After seeing it, Michelangelo is said to have praised Titian's coloring and style but criticized his sense of design. We can readily understand Michelangelo's discomfort, for Titian has rephrased his sculpture in utterly sensuous terms through the painterly application of sonorous color that is characteristic of his work.

Though Titian no doubt worked out the essential features of the composition in preliminary drawings, none have survived. Nor evidently did he transfer the design onto the canvas but worked directly on the surface, making subtle adjustments as he went along. By varying the consistency of his pigments, the artist was able to capture the texture of Danäe's flesh with uncanny accuracy, while distinguishing it clearly from bed sheets and covers. To convey these tactile qualities, Titian built up his surface in thin coats, known as glazes. The interaction between these layers produces unrivaled richness and complexity of color; yet the medium is so filmy as to become nearly translucent as the cloud, in which guise Jupiter appears to the mortal young woman, trails off into the gossamer sky.

Color is so potent that it does not need a system to work its magic in art. From the heavy outlines, it is apparent that Picasso must have originally conceived *Girl Before a Mirror* (fig. 11) in terms of form; yet the picture makes no sense in black and white. He has treated his shapes much like the

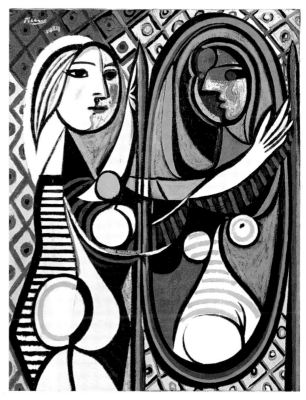

11. Pablo Picasso. *Girl Before a Mirror*. March 1932.
Oil on canvas, 64 x 51 1/4" (162.3 x 130.2 cm).
The Museum of Modern Art, New York

Gift of Mrs. Simon Guggenheim

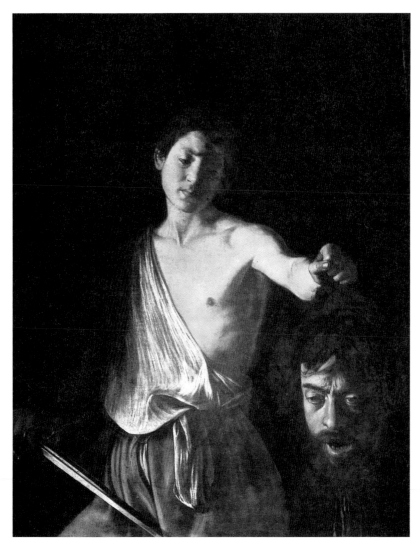

12. Caravaggio. *David with the Head of Goliath.* 1607 or 1609/10. Oil on canvas, 49¼ x 39³/8" (125.1 x 100.1 cm). Galleria Borghese, Rome

enclosed, flat panes of a stained-glass window to create a lively decorative pattern. The motif of a young woman contemplating her beauty goes all the way back to antiquity, but rarely has it been depicted with such disturbing overtones. Picasso's girl is anything but serene. On the contrary, her face is divided into two parts, one with a somber expression, the other with a masklike appearance whose color nevertheless betrays passionate feeling. She reaches out to touch the image in the mirror with a gesture of longing and apprehension.

Now we all feel a jolt when we unexpectedly see ourselves in a mirror, which often gives back a reflection that upsets our self-conception. Picasso here suggests this visionary truth in several ways. Much as a real mirror introduces changes of its own and does not reflect the simple truth, so this one alters the way the girl looks, revealing a deeper reality. She appears not so much to be examining her physical appearance as to be exploring her sexuality. The mirror is a sea of conflicting emotions signified above all by the color scheme of her reflection. Framed by strong blue, purple, and green hues, her features stare back at her with fiery intensity. Clearly discernible is a tear on her cheek. But it is the masterstroke of the green spot, shining like a beacon in the middle of her forehead, that con-

veys the anguish of the girl's confrontation with her inner self. Picasso was probably aware of the theory that red and green are complementary colors which intensify each other. However, this "law" can hardly have dictated his choice of green to stand for the girl's psyche. That was surely determined as a matter of pictorial and expressive necessity.

LIGHT. For the most part, art is concerned with reflected light effects rather than with radiant light. (Among the few exceptions are modern light installations such as laser displays.) Artists have several ways of representing radiant light. Divine light, for example, is sometimes indicated by golden rays, at other times by a halo or aura. A candle or torch may be depicted as the source of light in a dark interior or night scene. The most common method is not to show radiant light directly but to suggest its presence through a change in the value of reflected light from dark to light. Sharp contrast (known as *chiaroscuro*, the Italian word for light-dark) is identified with the Baroque artist Caravaggio, who made it the cornerstone of his style. In *David with the Head of Goliath* (fig. 12), he employed it to heighten the drama. An intense raking light from an unseen source at the left is used to model

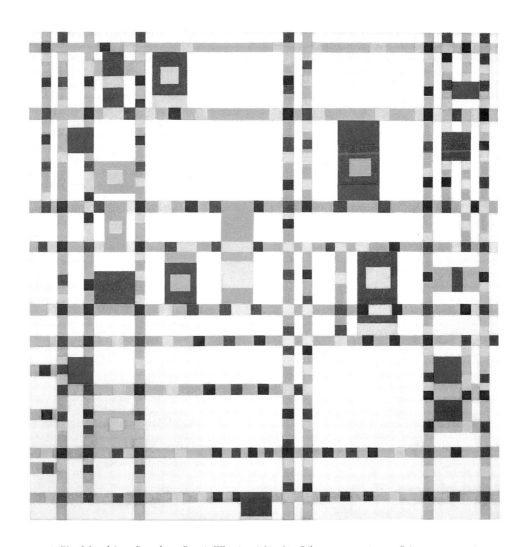

13. Piet Mondrian. *Broadway Boogie Woogie.* 1942–43. Oil on canvas, 50 x 50" (127 x 127 cm). The Museum of Modern Art, New York

Given anonymously

forms and create textures. The selective highlighting endows the lifesize figure of David and the gruesome head with a startling presence. Light here serves as a device to create the convincing illusion that David is standing before us. With its indeterminate depth, the pictorial space, which extends beyond the picture plane, becomes continuous with ours, despite the fact that the frame cuts off the figure. Thus the foreshortened arm with Goliath's head seems to extend out to the viewer from the dark background. For all its obvious theatricality, the painting is surprisingly muted: David seems to contemplate Goliath with a mixture of sadness and pity. The severed head is a self-portrait, and the disturbing image communicates a tragic personal vision that was soon fulfilled. Not long after the *David* was painted, Caravaggio killed another man in a duel, which forced him to spend the rest of his short life on the run.

Light can also be implied through color. Piet Mondrian uses white and the three primary colors—red, yellow, and blue—to signify radiant light in *Broadway Boogie Woogie* (fig. 13), a painting that immortalizes his fascination with the culture he found in America after emigrating from his native Holland during World War II. The play of color evokes with striking success the jaunty rhythms of light and music found in New York's nightclub district during the jazz age. *Broadway Boogie Woogie* is as flat as the canvas it is painted on. Mondrian has laid out his colored "tiles" along a grid system that appropriately resembles a city map. As in a medieval manuscript decoration (fig. 352), the composition relies entirely on surface pattern.

COMPOSITION. Composition is the organization of forms in art. It is of fundamental importance, because all art requires order. Otherwise its message would emerge as visually garbled. To accomplish this, the artist must control space within the framework of a unified composition. Moreover, pictorial space must work across the picture plane, as well as behind it. Since the Early Renaissance, we have become accustomed to experiencing paintings as windows onto separate illusionistic realities. The Renaissance invention of one-point perspective— also called linear or scientific perspective—provided a geometric system for the convincing representation of architectural and open-air settings. By having the orthogonals (shown as diagonal lines) converge at a vanishing point on the horizon, it enabled the artist to gain command over every aspect of his

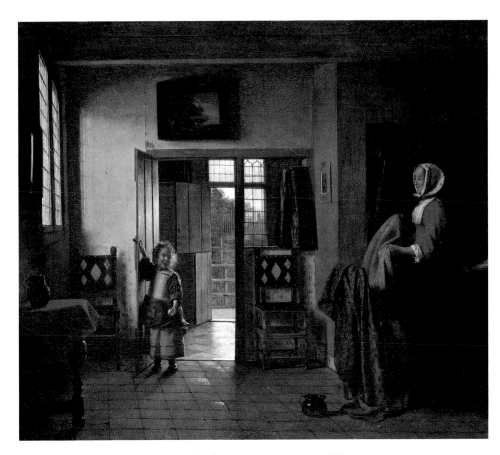

14. Pieter de Hooch. *The Bedroom.* c. 1658–60. Oil on canvas,
20 x 23¹/₂" (51 x 60 cm). National Gallery of Art, Washington, D.C.

Widener Collection

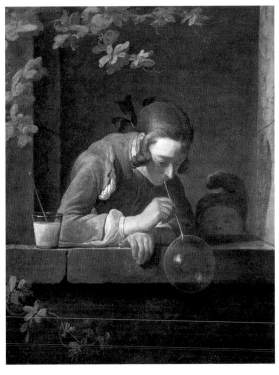

15. Jean-Baptiste-Siméon Chardin. *Soap Bubbles.* c. 1733–34. Oil on canvas,
36⁵/₈ x 29³/₈" (93 x 74.6 cm). National Gallery of Art, Washington, D.C.

Gift of Mrs. John Simpson

16. *A Pond in a Garden.* Fragment of a wall painting, from the Tomb of Ramose, Thebes.
c. 1400 B.C. The British Museum, London

composition, including the rate of recession and placement of figures. Pieter de Hooch, the Dutch Baroque artist, used one-point perspective in organizing *The Bedroom* (fig. 14). Nevertheless, the problems he faced in composing the three-dimensional space of his work were not so very different from those later confronted by Mondrian. (The surface geometry of De Hooch's painting is basically similar in design to *Broadway Boogie Woogie.*) Each part of the house is treated as a separate pocket of space and as a design element that is integrated into the scene as a whole.

Artists will usually dispense with aids like perspective and rely on their own eyes. This does not mean that they merely transcribe optical reality. *Soap Bubbles* by the French painter Jean-Baptiste-Siméon Chardin (fig. 15) depends in good measure on a satisfying composition for its success. The motif had been a popular one in earlier Dutch genre scenes, where bubbles symbolized life's brevity and, hence, the vanity of all earthly things. No such meaning can be attached to Chardin's picture, which is disarming in its simplicity. The interest lies solely in the seemingly insignificant subject and in the sense of enchantment imparted by the children's rapt attention to the moment. We know from a contemporary source that Chardin painted the youth "carefully from life and . . . tried hard to give him an ingenuous air." The results are anything but artless, however. The triangular shape of the boy leaning on the ledge gives stability to the painting, which helps to suspend the fleet-

ing instant in time. To fill out the composition, the artist includes the toddler peering intently over the ledge at the bubble, which is about the same size as his head. Chardin has carefully thought out every aspect of his arrangement. The honeysuckle in the upper left-hand corner, for example, echoes the contour of the adolescent's back, while the two straws are virtually parallel to each other. Even the crack in the stone ledge has a purpose: to draw attention to the glass of soap by setting it slightly apart.

Often artists paint not what they see but what they imagine. A wall painting from Thebes (fig. 16) presents a flattened view of a delightful garden in which everything is shown in profile except for the pond, which is seen from above. In order to provide the clearest, most complete idea of the scene, the Egyptian artist treated each element as an entity unto itself. Instead of using standard devices such as scale and overlapping, space is treated vertically, so that we read the trees at the bottom as being "closer" to us than those at the top, even though they are the same size. Despite the multiple vantage points and implausible bird's-eye view, the image works because it constitutes a self-contained reality. The picture, moreover, has an aesthetically satisfying decorative unity. The geometry underlying the composition reminds us once more of *Broadway Boogie Woogie.* At the same time, the presentation has such clarity that we feel as if we were seeing nature with open eyes for the first time.

17. El Greco. *The Agony in the Garden.* 1597–1600. Oil on canvas, 40¼ x 44¾" (102.2 x 113.6 cm). The Toledo Museum of Art, Toledo, Ohio
Gift of Edward Drummond Libbey

Pictorial space need not conform to either conceptual or visual reality. El Greco's *The Agony in the Garden* (fig. 17) uses contradictory, irrational space to help conjure up a mystical vision that instead represents a spiritual reality. Jesus, isolated against a large rock that echoes his shape, is comforted by the angel bearing a golden cup, symbol of the Passion (the suffering of Jesus in his last days). The angel appears to kneel on a mysterious oval cloud, which envelops the sleeping disciples. In the distance to the right we see Judas and the soldiers coming to arrest the Lord. The composition is balanced by two giant clouds on either side. The entire landscape resounds with Jesus' agitation, represented by the sweep of supernatural forces. The elongated forms, eerie moonlight, and expressive colors—all hallmarks of El Greco's style—help to heighten our sense of identification with Jesus' suffering.

FORM. Line creates shape. Every shape that we encounter in art is a counterpart to form. The only difference between them is that shape is flat, whereas form has volume, though it also has a characteristic shape defined by its contour. There is a vast difference between drawing or painting forms and sculpting them. The one transcribes, the other brings them to life, as it were. They require fundamentally different talents and atti-

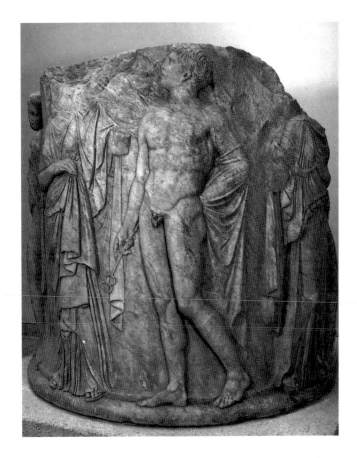

18. *Alkestis Leaving Hades.* Lower column from the Temple of Artemis, Ephesus. c. 340 B.C. Marble, height 71" (180.3 cm). The British Museum, London

19. Praxiteles (attr.). *Standing Youth,* found in the sea off Marathon. c. 350–325 B.C. Bronze, height 51" (129.5 cm). National Archaeological Museum, Athens

20. Gianlorenzo Bernini. *Apollo and Daphne.* 1622–24. Marble, height 8' (2.43 m). Galleria Borghese, Rome

tudes toward material as well as subject matter. Although a number of artists have been competent in both painting and sculpture, only a handful managed to bridge the gap between them with complete success.

Sculpture is categorized according to whether it is carved or modeled and whether it is a relief or a free-standing statue. Relief remains tied to the background, from which it only partially emerges, in contrast to free-standing sculpture, which is fully liberated from it. A further distinction is made between low (*bas*) relief and high (*alto*) relief, depending on how much the carving projects. However, since scale as well as depth must be taken into account, there is no single guideline, so that a third category, middle (*mezzo*) relief, is sometimes added.

Low reliefs often share characteristics with painting. In Egypt, where low-relief carving attained unsurpassed subtlety, many reliefs were originally painted and included elaborate settings. High reliefs largely preclude this kind of pictorialism. The figures on a column from a Greek temple (fig. 18) have become so detached from the background that the addition of landscape or architecture elements would be both unnecessary and unconvincing. The neutral setting, moreover, is in keep-

ing with the mythological subject, which takes place in an indeterminate time and place. In compensation, the sculptor has treated the limited free space atmospherically, yet the figures remain imprisoned in stone.

Free-standing sculpture—that is, sculpture that is carved or modeled fully in the round—is made by either of two methods. One is modeling, an additive process using soft materials such as plaster, clay, or wax. Since these materials are not very durable, they are usually cast in a more lasting medium: anything that can be poured, including molten metal, cement, even plastic. Modeling encourages "open" forms with the aid of metal armatures to support their extension into space. This in conjunction with the development of lightweight hollow-bronze casting enabled the Greeks to experiment with daring poses in monumental sculpture before attempting them in marble. In contrast to the figure of Hades on the column, the bronze youth in figure 19 is free to move about, lending him a lifelike presence that is further enhanced by his dancing pose. His inlaid eyes and soft patina, accentuated by oxidation and corrosion (he was found in the Aegean Sea off the coast of Greece, near Marathon), make him even more credible in a way that marble statues, with their

21. Frank Lloyd Wright. Solomon R. Guggenheim Museum, New York. 1956–59

seemingly cold and smooth finish, rarely equal, despite their more natural color (compare fig. 20).

Carving is the very opposite of modeling. It is a subtractive process that starts with a solid block, usually stone, which is highly resistant to the sculptor's chisel. The brittleness of stone and the difficulty of cutting it tend to result in the compact, "closed" forms seen in Michelangelo's *Awakening Slave* (fig. 3). One of the most daring attempts at overcoming the tyranny of mass over space is *Apollo and Daphne* by the Baroque sculptor Gianlorenzo Bernini (fig. 20). The dancelike pose of Apollo and graceful torsion of Daphne create the impression that they are moving in a carefully choreographed ballet. Time and motion have almost, but not quite, come to a standstill as the nymph begins to change into a tree rather than succumb to the god's amorous advances. The sculpture is an amazing technical achievement. Bernini is completely successful in distinguishing between the soft flesh of Daphne and the rough texture of the bark and leaves. The illusion of change is so convincing that we share Apollo's shock at the metamorphosis.

Like most monumental sculpture, *Apollo and Daphne* was intended for a specific location. It was originally placed along the wall to the left of the doorway, rather than in the middle of the room as now. Thus despite the fact that it is fully carved, the back side was never meant to be seen and provides little additional visual information. The statue demands our direct participation in order to experience the drama. The action unfolds gradually as we walk around the sculpture (our illustration shows the most characteristic view), reaching its climax almost directly in front of Daphne, where her transformation has its greatest "shock effect." Bernini's ingenuity in creating this theatrical display is fully characteristic of the Baroque.

SPACE. In our discussions of pictorial and sculptural space, we have repeatedly referred to architecture, for it is the principal means of organizing space. Of all the arts, it is also the most practical. Architecture's parameters are defined by utilitarian function and structural system, but there is almost always an aesthetic component as well, even when it consists of nothing more than a decorative veneer. A building proclaims the architect's concerns by the way in which it weaves these elements into a coherent program.

Architecture becomes memorable only when it expresses a transcendent vision, whether personal, social, or spiritual. Such buildings are almost always important public places that require the marshaling of significant resources and serve the

22. Interior of the Solomon R. Guggenheim Museum

purpose of bringing people together to share common goals, pursuits, and values. An extreme case is the Solomon R. Guggenheim Museum in New York by the architect Frank Lloyd Wright. Scorned when it was first erected in the late 1950s, it is a brilliant, if idiosyncratic, creation by one of the most original architectural minds of the century. The sculptural exterior (fig. 21) announces that this can only be a museum, for it is self-consciously a work of art in its own right. As a piece of design, the Guggenheim Museum is remarkably willful. In shape it is as defiantly individual as the architect himself and refuses to conform to the boxlike apartments around it. From the outside, the structure looks like a gigantic snail, reflecting Wright's interest in organic shapes. The office area forming the "head" to the left is connected by a narrow passageway to the "shell" containing the main body of the museum.

The outside gives us some idea of what to expect inside (fig. 22), yet nothing quite prepares us for the extraordinary sensation of light and air in the main hall after being ushered through the unassuming entrance. The radical design makes it clear that Wright had completely rethought the purpose of an art museum. The exhibition area is a kind of inverted dome with a huge glass-covered eye at the top. The vast, fluid space

creates an atmosphere of quiet harmony while actively shaping our experience by determining how art shall be displayed. After taking an elevator to the top of the building, the visitor begins a leisurely descent down the gently sloping ramp. The continuous spiral provides for uninterrupted viewing, conducive to studying art. At the same time, the narrow confines of the galleries prevent us from becoming passive observers by forcing us into a direct confrontation with the works themselves. Sculpture takes on a heightened physical presence which demands that we look at it. Even paintings acquire a new prominence by protruding slightly from the curved walls, instead of receding into them. Viewing exhibitions at the Guggenheim is like being conducted through a predetermined stream of consciousness, where everything merges into a total unity. Whether one agrees with this approach or not, the building testifies to the strength of Wright's vision by precluding any other way of seeing the art.

Meaning in Context

Art has been called a visual dialogue, for though the object itself is mute, it expresses its creator's intention just as surely as if it were speaking to us. For there to be a dialogue, however,

our active participation is required. If we cannot literally talk to a work of art, we can learn how to respond to it and question it in order to fathom its meaning. Finding the right answers usually involves asking the right questions. Even if we are not sure which question to ask, we can always start with, "What would happen if the artist had done it another way?" And when we are through, we must question our explanation according to the same test of adequate proof that applies to any investigation: have we taken into account *all* the available evidence, and arranged it in a logical and coherent way? There is, alas, no step-by-step method to guide us, but this does not mean that the process is entirely mysterious. We can illustrate it by looking at some examples together; the demonstration will help us gain courage to try the same analysis the next time we enter a museum.

The great Dutch painter Jan Vermeer has been called the Sphinx of Delft, for all his paintings have a degree of mystery. In *Woman Holding a Balance* (fig. 23), a young woman, richly dressed in at-home wear of the day, is contemplating a balance in her hand, with strings of pearls and gold coins spread out on the table before her. The canvas is painted entirely in gradations of cool, neutral tones, except for a bit of the red dress visible beneath her jacket. The soft light from the partly open window is concentrated on her face and the cap framing it. Other beads of light reflect from the pearls and her right hand. The serene atmosphere is sustained throughout the stable composition. Vermeer places us at an intimate distance within the relatively shallow space, which has been molded around the figure. The underlying grid of horizontals and verticals is modulated by the gentle curves of the woman's form and the heap of blue drapery in the foreground, as well as by the oblique angles of the mirror. The design is so perfect that we cannot move a single element without upsetting the delicate balance.

The composition is controlled in part by perspective. The vanishing point of the diagonals formed by the top of the mirror and the right side of the table lies at the juncture of the woman's little finger and the picture frame. If we look carefully at the bottom of the frame, we see that it is actually lower on the right than on the left, where it lies just below her hand. The effect is so carefully calculated that the artist must have wanted to guide our eye to the painting in the background. Though difficult to read at first, it depicts Christ at the Last Judgment, when every soul is weighed. The parallel of this subject to the woman's activity tells us that, contrary to our initial impression, this cannot be simply a scene of everyday life. The painting, then, is testimony to the artist's faith, for he was a Catholic living in Protestant Holland, where his religion was officially banned, although worship in private houses was tolerated.

The meaning is nevertheless far from clear. Because Vermeer treated forms as beads of light, it was assumed until recently that the balance holds items of jewelry and that the woman is weighing the worthlessness of earthly possessions in the face of death; hence, the painting was generally called *The Pearl Weigher* or *The Gold Weigher*. However, we can see that the pans actually contain nothing. This is confirmed by infrared photography, which also reveals that Vermeer changed the position of the balance: to make the picture more harmonious, he placed them parallel to the picture plane instead of allow-

ing them to recede into space. What, then, is she doing? If she is weighing temporal against spiritual values, it can be only in a symbolic sense, because nothing about the figure or the setting betrays a sense of conflict. What accounts for this inner peace? Perhaps it is self-knowledge, symbolized here by the mirror. It may also be the promise of salvation through her faith. In *Woman Holding a Balance*, as in Caravaggio's *The Calling of St. Matthew* (fig. 726), light might therefore serve not only to illuminate the scene but also to represent religious revelation. In the end, we cannot be sure, because Vermeer's approach to his subject proves as subtle as his pictorial treatment. He avoids any anecdote or symbolism that might limit us to a single interpretation. There can be no doubt, however, about his fascination with light. Vermeer's mastery of light's expressive qualities elevates his concern for the reality of appearance to the level of poetry, and subsumes its visual and symbolic possibilities. Here, then, we have found the real "meaning" of Vermeer's art.

The ambiguity in *Woman Holding a Balance* serves to heighten our interest and pleasure, while the carefully organized composition expresses the artist's underlying concept with singular clarity. But what are we to do when a work deliberately seems devoid of apparent meaning? Modern artists can pose a gap between their intention and the viewer's understanding. The gap is, however, often more apparent than real, for the meaning is usually intelligible to the imagination at some level. Still, we feel we must comprehend intellectually what we perceive intuitively. We can partially solve the personal code in Jasper Johns' *Target with Four Faces* (fig. 24) by treating it somewhat like a rebus. Where did he begin? Surely with the target, which stands alone as an object, unlike the long box at the top, particularly when its hinged door is closed. Why a target in the first place? The size, texture, and colors inform us that this is not to be interpreted as a real target. The design is nevertheless attractive in its own right, and Johns must have chosen it for that reason. When the wooden door is up, the assemblage is transformed from a neutral into a loaded image, bringing out the nascent connotations of the target. Johns has used the same plaster cast four times, which lends the faces a curious anonymity. Then he cut them off at the eyes, "the windows of the soul," rendering them even more enigmatic. Finally, he crammed them into their compartments, so that they seem to press urgently out toward us. The results are disquieting, aesthetically as well as expressively.

Something so disturbing cannot be without significance— but what? We may be reminded of prisoners trying to look out from small cell windows, or perhaps "blindfolded" targets of execution. Whatever our impression, the claustrophobic image radiates an aura of menacing danger. Unlike Picasso's joining of a bicycle seat and handlebars to form a bull's head, *Target with Four Faces* combines two disparate components in an open conflict that we cannot reconcile, no matter how hard we try. The intrusion of this ominous meaning creates an extraordinary tension with the dispassionate investigation of the target's formal qualities. It is, then, this disparity between form and content that must have been Johns' goal.

How do we know we are right? After all, this is merely our "personal" interpretation, so we turn to the critics for help. We find them divided about the meaning of this work, although

23. Jan Vermeer. *Woman Holding a Balance.* c. 1664. Oil on canvas,
16³/4 x 15" (42.5 x 38.1 cm). National Gallery of Art, Washington, D.C.
Widener Collection, 1942

24. Jasper Johns. *Target with Four Faces*. 1955. Assemblage: encaustic and collage on canvas with objects, 26 x 26" (66 x 66 cm) surmounted by four tinted plaster faces in wood box with hinged front. Box, closed 3^3/4 x 26 x 3^1/2" (9.5 x 66 x 8.9 cm); overall dimensions with box open, 33^5/8 x 26 x 3" (85.3 x 66 x 7.6 cm). The Museum of Modern Art, New York

Gift of Mr. and Mrs. Robert C. Scull

25. John Singleton Copley. *Paul Revere*. c. 1768–70.
Oil on canvas, 35 x 28¹/₂" (88.9 x 72.3 cm). Museum of Fine Arts, Boston
Gift of Joseph W., William B., and Edward H. R. Revere

they agree it must have one. Johns, on the other hand, has insisted that there is none! Whom are we to believe, the critics or the artist himself? The more we think about it, the more likely it seems that both sides may be right. The artist is not always aware why he has made a work. That does not mean that there were no reasons, only that they were unconscious ones. Under these circumstances, the critic may well know the artist's mind better than he does and explain his creation more clearly. We can now understand that to Johns the leap of his imagination in *Target with Four Faces* remains as mysterious as it first seemed to us. Our account reconciles the artist's aesthetic concerns and the critics' search for meaning, and while we realize that no ultimate solution is possible, we have arrived at a satisfactory explanation by looking and thinking for ourselves.

It is all too easy to overlook the obvious, and this is especially true in looking at portraits. Those of famous people have a special appeal, for they seem to bridge a gap of time and place and to establish a personal link. In their faces we read a thousand insights about character which no amount of historical data can satisfy nearly as well. Our interest arises no doubt from the remnant of a primitive belief that an image captures not merely the likeness but also the soul of a sitter. In the age of photography, we have come to see portraits as mere likenesses, and we readily forget that they call on all our skill to grasp their meaning. *Paul Revere*, painted by the American

artist John Singleton Copley around 1770 (fig. 25), gives rise to questions we cannot solve with on-the-spot observations, so we must look elsewhere to answer them. The fruit of our investigation must agree with our observations; otherwise we cannot be sure that we are right.

Silversmith, printmaker, businessman, and patriot, Revere has acquired legendary status thanks to Henry Wadsworth Longfellow's long poem about his midnight ride, and Copley's painting has become virtually an American icon. It has generally been treated as a workingman's portrait, so to speak. By all rights, however, such a portrait ought to be much more straightforward than this and, hence, less memorable. Revere has a penetrating glance and thoughtful pose which are heightened by the sharp light, lending him an unusually forceful presence. He looks out at us with astonishing directness, as if he were reading us with the same intensity that we bring to bear on his strongly modeled features. Clearly, Revere is a thinker possessing an active intelligence, and we will recognize the pose of hand on chin as an old device used since antiquity to represent philosophers. This is certainly no ordinary craftsman here, and we may also wonder whether this is really his working outfit. Surely no silversmith would have carried out his craft in what are probably Revere's best business clothes. Simply by looking at the picture we have raised enough doubts to challenge the traditional view of this famous painting.

26. John Singleton Copley. *Nathaniel Hurd.* c. 1765.
Oil on canvas, 30 x 25¹/2" (76.2 x 64.8 cm). The Cleveland Museum of Art
Gift of the John Huntington Art and Polytechnic Trust

At this point, our questioning of the picture's surface comes to an end, for the portrait fails to yield up further clues. Once we have posed the problem of this "artisan's" portrayal, we feel compelled to investigate it further. The more we pursue the matter, the more fascinating it becomes. Copley, we discover, had painted only a few years earlier a portrait of another Boston silversmith, Nathaniel Hurd (fig. 26). Yet this one is so different that we would never guess the sitter's trade. Hurd is wearing a casual robe and turban, and before him are two books, one of them devoted to heraldry from which he culled the coats of arms he needed for his work. Why, then, did Copley show Revere at a workbench with his engraving tools spread out before him, holding a teapot as the object of his contemplation and offering it to us for our inspection? In light of Hurd's portrait, Revere's work as a silversmith hardly explains these attributes and actions, natural as they seem. Oddly enough, the question has never been raised; yet surely the differences between the two paintings cannot be accidental.

Perhaps we can find the answer in the antecedents for each. Hurd's image can be traced back to informal portraits that originated in France in the early eighteenth century and soon became popular as well in England, where there was a rage for portraits of well-known men and women. This type of portrait was customarily reserved for artists, writers, and the like. In turn, the type gave rise to a distinctive offshoot that showed a sculptor at work in his studio with his tools prominently displayed (fig. 27). Sometimes an engraver is seen instead. There is another possible precedent: moralizing portraits, the descendants of pictures of St. Jerome, that show their subjects holding or pointing to skulls, much as Revere has the teapot in his hand. Copley was surely familiar with all of these kinds of images from the portrait engravings that we know he collected, but his exact sources for the Revere painting remain a mystery and may never be discovered. For after 1765 Copley freely adapted and combined motifs from different prints in his paintings, often disguising their origins so completely that we cannot be certain which they were. It is

27. Francis Xavier Vispré (attr.). *Portrait of Louis-François Roubiliac.*
c. 1750. Pastel on paper laid on canvas, 24$\frac{1}{2}$ x 21$\frac{1}{2}$" (62.2 x 54.6 cm).
Yale Center for British Art, New Haven, Connecticut
Paul Mellon Collection

likely that he conflated two or three in Revere's portrait. In any case, it is apparent that Copley has transformed Revere from a craftsman into an artist-philosopher.

Let us now look at this portrait in its larger historical and cultural context. In Europe, the artisan's inferior position to the artist had been asserted since the Renaissance, except in England, where the newly founded Royal Academy first drew the distinction in 1768, about when Copley painted Hurd's portrait. But in the Colonies there was, as Copley himself complained, no distinction between the trades of artist and artisan. Indeed, except for portraiture, it can be argued that the decorative arts *were* the fine arts of America.

It is significant that Copley's portrait probably dates from around the time of Revere's first efforts at making engravings, a form of art that arose, interestingly enough, out of silver- and goldsmith decorating during the late Middle Ages. Revere was then already involved with libertarianism, a cause which Copley himself did not share. This difference in their points of view did not prevent Copley from endowing Revere's portrait

with an ingenious significance and penetrating characterization. The painter and the silversmith must have known each other well. (Copley ordered various pieces of silver, and even false teeth, from Revere.) The portrait stands as Copley's compelling tribute to a fellow artist—and as an invaluable statement about the culture of the Colonial era.

Obviously, not everyone is in a position to undertake this kind of research. Only the art historian and the most interested lay person do. But this does not mean that "there must be something wrong with a work of art if it takes an expert to appreciate it." On the contrary, research serves only to affirm the portrait of Paul Revere as a masterpiece. Reacting to the portrait in "a direct, straightforward fashion," without the benefit of additional knowledge, precludes the understanding necessary for full appreciation. Critics, scholars, and curators are not the public's adversaries. In sharing their expertise and knowledge of art's broader contexts, they expand our general capacity for appreciating art, and provide a model for our own seek-and-find experiences.

PART ONE

THE ANCIENT WORLD

Art history is more than a stream of art objects created over time. It is intimately related to history itself, that is, the recorded evidence of human events. For that reason, we must consider the *concept* of history, which, we are often told, begins with the invention of writing some 5,000 years ago. And, indeed, the invention of writing was an early accomplishment of the "historic" civilizations of Mesopotamia and Egypt. Without writing, the growth we have known would have been impossible. We do not know the earliest phases of its development, but writing seems to have been several hundred years in the making—between 3300 and 3000 B.C., roughly speaking, with Mesopotamia in the lead—after the new societies were already past their first stage. Thus "history" was well under way by the time writing could be used to record events.

The invention of writing makes a convenient landmark, for the absence of written records is surely one of the key differences between prehistoric and historic societies. But as soon as we ask why this is so, we face some intriguing problems. First of all, how valid is the distinction between "prehistoric" and "historic"? Does it merely reflect a difference in our *knowledge* of the past? (Thanks to the invention of writing, we know a great deal more about history than about prehistory.) Or was there a genuine change in the way things happened, and of the kinds of things that happened, after "history" began? Obviously, prehistory was far from uneventful. Yet changes in the human condition that mark this road, decisive though they are, seem incredibly slow-paced and gradual when measured against the events of the last 5,000 years. The beginning of "history," then, means a sudden increase in the speed of events, a shifting from low gear to high gear, as it were. It also means a change in the *kind* of events. Historic societies quite literally make history. They not only bring forth "great individuals and great deeds" (one traditional definition of history) by demanding human effort on a large scale, but they make these achievements *memorable*. And for an event to be memorable, it must be more than "worth remembering." It must also be accomplished quickly enough to be grasped by human memory, and not spread over countless centuries. Collectively, memorable events have caused the ever-quickening pace of change during the past five millenniums, which begin with what we call the ancient world.

This period was preceded by a vast prehistoric era of which we know practically nothing until the last Ice Age in Europe, which lasted from about 40,000 to 8000 B.C. (There had been at least three previous ice ages, alternating with periods of

subtropical warmth, at intervals of about 25,000 years.) At that time, the climate between the Alps and Scandinavia resembled that of present-day Siberia or Alaska. Huge herds of reindeer and other large herbivores roamed the plains and valleys, preyed upon by the ferocious ancestors of today's lions and tigers, as well as by our own ancestors. These people liked to live in caves or in the shelter of overhanging rocks wherever they could find them. Many such sites have been discovered, mostly in Spain and in southern France. This phase of prehistory is known as the Old Stone Age, or Paleolithic era, because tools were exclusively made from stone. Adapted almost perfectly to the special conditions of the receding Ice Age, it was a way of life that could not survive beyond then.

What brought the Old Stone Age to a close has been termed the Neolithic Revolution, which ushered in the New Stone Age. And a revolution it was indeed, although its course extended over several thousand years. It first occurred in the Near East— an area encompassing the modern countries of Turkey, Iraq, Iran, Jordan, Israel, Lebanon, and Syria—sometime about 8000 B.C., with the first successful attempts to domesticate animals and food grains. The cultivation of regular food sources was one of the truly epoch-making achievements of human history. People in Paleolithic societies had led the unsettled life of the hunter and food gatherer, reaping where nature sowed and thus at the mercy of forces that they could neither understand nor control. But having learned how to assure a food supply by their own efforts, they now settled down in permanent village communities. A new discipline and order also entered their lives. There is, then, a very basic difference between the Neolithic and the Paleolithic, despite the fact that both still depended on stone as the material of their main tools and weapons. The new mode of life brought forth a number of important new crafts and inventions long before the earliest appearance of metals: pottery, weaving and spinning, as well as basic methods of architectural construction in wood, brick, and stone. It must also have been accompanied by profound changes in the people's view of themselves and the world.

The Neolithic Revolution placed us on a level at which we might well have remained indefinitely. The forces of nature would never again challenge men and women as they had Paleolithic peoples. In a few places, however, the Neolithic balance between humans and nature was upset by a new threat posed not by nature but by people themselves. The earliest monument to that threat is seen in the earliest Neolithic fortifications, constructed almost 9,000 years ago in the Near East. What

was the source of the human conflict that made these defenses necessary? Competition for grazing land among groups of herders or for arable soil among farming communities? The basic cause, we suspect, was that the Neolithic Revolution had been too successful in this area, permitting population groups to grow beyond the available food supply. This situation might have been resolved in a number of ways. Constant warfare could have reduced the population. Or the people could have united in larger and more disciplined social units for the sake of ambitious group efforts that no loosely organized society would have been able to achieve. Fortifications are an enterprise of this kind, requiring sustained and specialized labor over a long period.

We do not know the outcome of the struggle in the region (future excavations may tell us how far the urbanizing process extended) but about 3,000 years later, similar conflicts, on a larger scale, arose in the Nile Valley and again in the plains of the Tigris and Euphrates rivers. The pressures that forced the inhabitants of both regions to abandon the pattern of Neolithic village life may well have been the same. These conflicts generated enough pressure to produce a new kind of society, organized into much larger units of cities and city-states that were far more complex and efficient than had ever existed before. (The word "civilization" derives from the Latin term for city, *civilis*.) First in Mesopotamia and Egypt, somewhat later in neighboring areas, and in the Indus Valley and along the Yellow River in China, people were to live in a more dynamic world, where their capacity to survive was challenged not by the forces of nature but by human forces—by tensions and conflicts arising either within society or as the result of competition between societies. These efforts to cope with human environment have proved a far greater challenge than the earlier struggle with nature. The problems and pressures faced by historic societies are thus very different from those that confronted peoples in the Paleolithic or Neolithic eras.

They also spurred the development of new technologies in what we designate the Bronze Age and the Iron Age. Like the Neolithic, the Bronze and Iron ages are not distinct eras, but stages. People first began to cast bronze, an alloy of copper and tin, in the Middle East around 3500 B.C., at the same time that the earliest cities arose in Egypt and Mesopotamia. And the smelting and forging of iron were invented about 2000–1500 B.C. by the Hittites, an Indo-European–speaking people who settled in Cappadocia (today's east central Turkey), a high plateau with abundant copper and iron ore. Indeed, it was the competition for mineral resources that helped create the conflicts that beset civilizations everywhere.

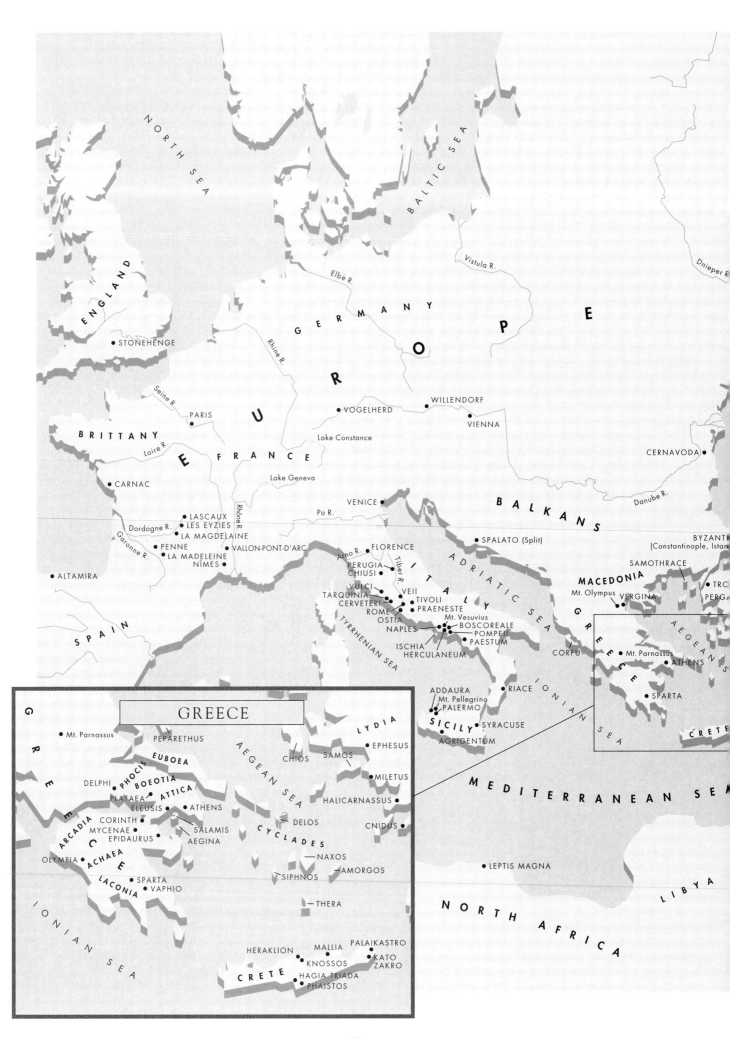

NORTH SEA

BALTIC SEA

Vistula R.

Dnieper R.

ENGLAND

• STONEHENGE

GERMANY

E U R O P E

Rhine R.

Elbe R.

Seine R.

PARIS

VOGELHERD •

WILLENDORF

VIENNA

BRITTANY

F R A N C E

Lake Constance

Loire R.

CERNAVODA •

• CARNAC

Lake Geneva

Dordogne R.

LASCAUX
LES EYZIES
LA MAGDELAINE

VENICE •

Po R.

BALKANS

Danube R.

Rhône R.

SPALATO (Split) •

BYZANT
(Constantinople, Istan

• PENNE
LA MADELEINE
NÎMES

Arno R.

FLORENCE •

PERUGIA
CHIUSI

I T A L Y

A D R I A T I C S E A

SAMOTHRACE •

MACEDONIA

TRC

Garonne R.

VALLON-PONT-D'ARC

Tiber R.

Mt. Olympus

VERGINA

PERG

• ALTAMIRA

VULCI
TARQUINIA
CERVETERI
ROME

VEII

TIVOLI
PRAENESTE

G R E E C E

S P A I N

OSTIA
NAPLES

Mt. Vesuvius
BOSCOREALE
POMPEII
PAESTUM

CORFU

Mt. Parnassus •

• ATHENS

T Y R R H E N I A N S E A

ISCHIA
HERCULANEUM

A E G E A N S E A

ADDAURA
Mt. Pellegrino
PALERMO

RIACE •

I O N I A N S E A

SPARTA •

CRETE

SICILY

SYRACUSE

AGRIGENTUM

M E D I T E R R A N E A N S E A

LEPTIS MAGNA •

N O R T H A F R I C A

LIBYA

GREECE

G R E E C E

• Mt. Parnassus

PEPARETHUS

LYDIA

EUBOEA

A E G E A N S E A

CHIOS

SAMOS

EPHESUS •

DELPHI •

PHOCIS

BOEOTIA

PLATAEA •

ATTICA

MILETUS •

ELEUSIS •

• ATHENS

HALICARNASSUS •

ARCADIA

CORINTH •
MYCENAE •
EPIDAURUS •

SALAMIS
AEGINA

DELOS •

CNIDUS •

C Y C L A D E S

OLYMPIA •

ACHAEA

NAXOS

C
R
E
E
C
E

LACONIA

SPARTA •
VAPHIO •

SIPHNOS

AMORGOS

I O N I A N S E A

THERA

PALAIKASTRO •

HERAKLION •

MALLIA •

KATO
ZAKRO •

KNOSSOS •

CRETE

HAGIA TRIADA •
PHAISTOS •

THE ANCIENT WORLD

STROMSKAYA

ARAL SEA

Don R.

Volga R.

SCYTHIA

CASPIAN SEA

PARTHIA

BACTRIA

BLACK SEA

• TEHERAN

PERSIA

Hoyls R.

Tigris R.

• BOGAZKÖY

DUR SHARRUKIN

NINEVEH • NIMRUD

ASSYRIA

• ASSUR

LURISTAN

• PERSEPOLIS

ANATOLIA

MESOPOTAMIA

ELAM

• NAKSH-I-RUSTAM

EAR EAST

Euphrates R.

BAGHDAD • • TELL ASMAR

• SUSA

• ÇATAL HÜYÜK ISSUS

AKKAD • CTESIPHON

• ANTIOCH

BABYLON • ISIN • LAGASH

LLES

SUMER • LARSA

• LARISSA

SYRIA

BABYLONIA UR

URUK

ODES

PERSIAN GULF

• BAALBEK

PHOENICIA

MIDDLE EAST AKKAD

Jordan R.

JORDAN

JERUSALEM • • JERICHO

• BETHLEHEM

PALESTINE

— Dead Sea

ARABIA

ALEXANDRIA •

• CAIRO

GIZA • SAQQARA

THE FAIYUM

LOWER EGYPT

• BENI HASAN

• TELL EL 'AMARNA

Nile R.

RED SEA

• DEIR EL-BAHARI

THEBES

• LUXOR

• HERAKLION

N

0 MILES 300

0 KM 300

• ASSUAN

UPPER EGYPT

49

PREHISTORIC
ART

28. *Horses.* Cave painting. c. 28,000 B.C. Chauvet cave,
Vallon-pont-d'Arc, Ardèche gorge, France

29. *Wounded Bison.* Cave painting. c. 15,000–10,000 B.C.
Altamira, Spain

THE OLD STONE AGE

When did human beings start creating works of art? What prompted them to do so? What did these earliest works of art look like? Every history of art must begin with these questions—and with the admission that we cannot answer them. Our earliest-known ancestors began to walk on two feet about four million years ago, but how they were using their hands remains unknown to us. Not until more than two million years later do we meet the earliest evidence of toolmaking. Humans must have been using tools all along, however. After all, apes will pick up a stick to knock down a banana or a stone to throw at an enemy. The making of tools is a more complex matter. It demands first of all the ability to think of sticks or stones as "fruit knockers" or "bone crackers," not only when they are needed for such purposes but at other times as well.

Once humans were able to do this, they gradually discovered that some sticks or stones had a handier shape than oth-

30. Axial Gallery, Lascaux (Montignac, Dordogne), France

ers, and they put them aside for future use. They selected and "appointed" certain sticks or stones as tools because they had begun to connect form and function. The sticks, of course, have not survived, but a few of the stones have. They are large pebbles or chunks of rock that show the marks of repeated use for the same operation, whatever that may have been. The next step was to try chipping away at these tools-by-appointment in order to improve their shape. This is the first craft of which we have evidence, and with it we enter a phase of human development known as the Paleolithic, or Old Stone Age, which lasted from about 40,000 to 10,000 B.C.

Cave Art

CHAUVET. The most striking works of Paleolithic art are the images of animals incised, painted, or sculptured on the rock surfaces of caves. In the recently discovered Chauvet cave in southeastern France, we meet the earliest paintings known to us, dating from more than 30,000 years ago. Ferocious lions, panthers, rhinoceroses, bears, reindeer, and mammoths are depicted with extraordinary vividness, along with bulls, horses, birds, and occasionally humans. These paintings already show an assurance and refinement far removed from any humble beginnings. What a vivid, lifelike image is the depiction of horses seen in figure 28! We are amazed not only by the keen observation and the assured, vigorous outlines, but even more perhaps by the power and expressiveness of these creatures. Unless we are to believe that images such as this came into being in a single, sudden burst, we must assume that they were preceded by thousands of years of development about which we know nothing at all.

ALTAMIRA AND LASCAUX. On the basis of differences among the tools and other remains found there, scholars have divided up later "cavemen" into several groups, each named after a characteristic site. Of these it is the so-called Aurignacians and Magdalenians who stand out for the gifted artists they produced and for the important role art must have played in their lives. Besides Chauvet, the major sites are at Altamira, in northern Spain (fig. 29), and Lascaux, in the Dordogne

31. Cave paintings. 15,000–10,000 B.C. Lascaux

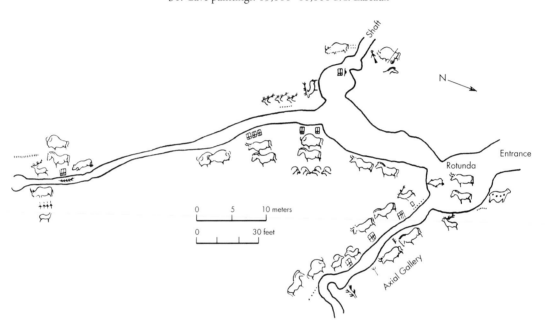

32. Schematic plan of Lascaux

region of France (figs. 30 and 31). At Lascaux, as at Chauvet, bison, deer, horses, and cattle race across walls and ceiling in wild profusion. Some of them are simply outlined in black, others filled in with bright earth colors, but all show the same uncanny sense of life. No less important, the style remains essentially the same between the two caves, despite the gap of thousands of years—testimony to the remarkable stability of Paleolithic culture. Gone, however, are the fiercest of beasts.

How did this extraordinary art happen to survive intact over so many thousands of years? The question can be answered easily enough. The pictures never occur near the mouth of a cave, where they would be open to easy view and destruction, but only in the darkest recesses, as far from the entrance as possible (fig. 32). Some can be reached only by crawling on hands and knees, and the path is so intricate that one would soon be lost without an expert guide. In fact, the cave at Lascaux was discovered purely by chance in 1940 by some neighborhood boys whose dog had fallen into a hole that led to the underground chamber.

What purpose did these images serve? Hidden away as they are in the bowels of the earth, to protect them from the casual intruder, they must have been considered far more serious than decoration. There can be little doubt that they were produced as part of a magic ritual. But of what kind? The traditional explanation is that their origin lies in hunting magic. According to this theory, in "killing" the image of an animal, people of the Old Stone Age thought they had killed its vital spirit; this later evolved into fertility magic, practiced deep within the bowels of the earth. But how are we to account for the presence at Chauvet of lions and other dangerous creatures that we know were not hunted? Perhaps initially cavemen assumed the identity of lions and bears to aid in the hunt. Although it cannot be disproved, this proposal is not completely satisfying. In addition to being highly speculative, it fails to explain many curious features of cave art.

There is a growing consensus that cave paintings must incorporate a very early form of religion. If so, the creatures found in them embody a spiritual meaning that makes of them the distant ancestors of the animal divinities and their half-human, half-animal cousins we shall meet throughout the

33. *Ritual Dance (?).* Rock engraving. c. 10,000 B.C.
Height of figures approx. 10" (25.4 cm). Cave of Addaura,
Monte Pellegrino (Palermo), Sicily

34. *Horse,* from Vogelherd cave. c. 28,000 B.C. Mammoth ivory,
length 2 1/2" (6.4 cm). Private collection

Near East and the Aegean. Indeed, how else are we to account for their existence? Moreover, such a hypothesis accords as well with the belief that nature is filled with spirits. This belief was found the world over in the ethnographic societies that survived intact until recently.

The existence of cave rituals relating to both human and animal fertility would seem to be confirmed by a unique group of Paleolithic drawings found in the 1950s on the walls of the cave of Addaura, near Palermo in Sicily (fig. 33). These images, incised into the rock with quick and sure lines, show human figures in dancelike movements, along with some animals; and, as at Lascaux, we again find several layers of images superimposed on one another. Here, then, we seem to be on the verge of that fusion of human and animal identity that distinguishes the earliest historical religions of Egypt and Mesopotamia.

POSSIBLE ORIGINS. Some of the cave pictures may even provide a clue to the origin of this tradition of fertility magic. In a good many instances, the shape of the animal seems to have been suggested by the natural formation of the rock, so that its body coincides with a bump, or its contour follows a vein or crack as far as possible. We all know how our imagination sometimes makes us see many sorts of images in chance formations such as clouds or blots. Perhaps at first the Stone Age artist merely reinforced the outlines of such images with a charred stick from the fire. It is tempting to think that those

who proved particularly good at finding such images were given a special status as artist-magicians so that they could perfect their image-hunting, until finally they learned how to make images with little or no help from chance formations, though they continued to welcome such aid.

Carved and Painted Objects

Apart from large-scale cave art, the people of the Upper Paleolithic also produced small, hand-sized drawings and carvings in bone, horn, or stone, skillfully cut by means of flint tools. The earliest of these found so far are small figures of mammoth ivory from a cave in southwestern Germany, made 30,000 years ago. Even they, however, are already so accomplished that they too must be the fruit of an artistic tradition many thousands of years old. The graceful, harmonious curves of a running horse (fig. 34) could hardly be improved upon by a more recent sculptor. Many years of handling have worn down some details of the tiny animal. (The two converging lines on the shoulder, indicating a dart or wound, were not part of the original design.)

Some of these carvings suggest that the objects may have originated with the recognition and elaboration of some chance resemblance. Earlier Stone Age people were content to collect pebbles in whose natural shape they saw something that apparently rendered them "magic." Echoes of this approach can sometimes be felt in later, more fully worked

35. *"Venus" of Willendorf.* c. 25,000–20,000 B.C.
Limestone, height 4³/8" (111 cm); shown actual size.
Naturhistorisches Museum, Vienna

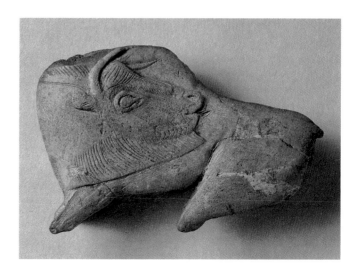

36. *Bison,* from La Madeleine near Les Eyzies (Dordogne).
c. 15,000–10,000 B.C. Reindeer horn, length 4" (10.1 cm).
Musée des Antiquités Nationales, St.-Germain-en-Laye, France

pieces. The so-called *"Venus" of Willendorf* (fig. 35), one of many such female figurines, has a bulbous roundness of form that recalls an egg-shaped "sacred pebble." Her navel, the central point of the design, is a natural cavity in the stone. She and like carvings are often considered fertility figures, based on the spiritual beliefs of "preliterate" societies of modern times. Although the idea is tempting, we cannot be certain that such parallels existed in the Old Stone Age. Likewise, the masterful *Bison* (fig. 36) of reindeer horn owes its compact, expressive outline in part to the contours of the palm-shaped piece of antler from which it was carved. It is a worthy companion to the splendid beasts at Altamira, Lascaux, and Chauvet.

THE NEW STONE AGE

The art of the Old Stone Age in Europe as we know it today marks the highest achievements of a way of life that began to decline soon afterward. Adapted almost perfectly to the special conditions of the receding Ice Age, that way of life could not survive beyond then.

Unfortunately, the tangible remains of Neolithic settlements tell us very little, as a rule, of the spiritual condition of Neolithic culture. Uncovered by excavation, they include stone implements of ever greater technical refinement and beauty of shape, and an infinite variety of clay vessels covered with abstract ornamental patterns, but hardly anything comparable to the painting and sculpture of the Paleolithic. The changeover from hunting to husbandry must nonetheless have been accompanied by profound changes in the people's view of themselves and the world, and it seems impossible to believe that these did not find expression in art. There may be a vast chapter in the development of art here that is largely lost to us simply because Neolithic artists worked in wood or other impermanent materials. Perhaps excavations in the future will help to fill the gap.

JERICHO. Prehistoric Jericho (now in the West Bank territory), the most extensively excavated site thus far, has yielded tantalizing discoveries, which include a group of impressive sculptured heads dating from about 7000 B.C. (fig. 37). They are actual human skulls whose faces have been "reconstituted" in tinted plaster, with pieces of seashell for the eyes. The subtlety and precision of the modeling, the fine gradation of planes and ridges, and the feeling for the relationship of flesh and bone would be remarkable enough in themselves, quite apart from the early date. The features, moreover, do not conform to a single type, for each has a strongly individual cast. Mysterious as they are, those Neolithic heads clearly point forward to Mesopotamian art (compare fig. 88). They are the first harbingers of a phenomenon of portraiture that will continue unbroken until the collapse of the Roman Empire.

Unlike Paleolithic art, which had grown from the perception of chance images, the Jericho heads are not intended to "create" life but to perpetuate it beyond death by replacing the transient flesh with a more enduring substance. From the circumstances in which these heads were found, we gather that they were displayed above ground while the rest of the body was buried beneath the floor of the house. Presumably they belonged to venerated ancestors whose beneficent presence was thus assured. Paleolithic societies, too, had buried their dead, but we do not know what ideas they associated with the grave. Was death merely a return to the womb of mother earth, or did they have some conception of the beyond?

37. Neolithic plastered skull, from Jericho. c. 7000 B.C. Lifesize. Archaeological Museum, Amman, Jordan

38. Early Neolithic wall and tower, Jericho, Jordan. c. 7000 B.C.

The Jericho heads suggest that some peoples of the Neolithic era believed in a spirit or soul, located in the head, that could survive the death of the body. Thus, it could assert its power over the fortunes of later generations and had to be appeased or controlled. The preserved heads apparently were

39. Houses and shrines in terraces. Çatal Hüyük, Turkey (schematic reconstruction of Level VI after Mellaart). c. 6000 B.C.

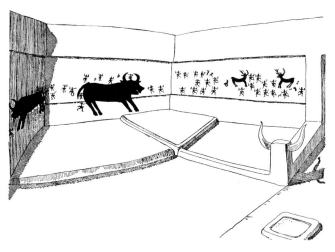

40. *Animal Hunt.* Restoration of Main Room, Shrine A.III.1, Çatal Hüyük (after Mellaart). c. 6000 B.C. 27 x 65" (68.5 x 165 cm)

"spirit traps" designed to keep the spirit in its original dwelling place. They express in visible form the sense of tradition, of family or clan continuity, that sets off the settled life of husbandry from the roving existence of the hunter. And Neolithic Jericho was a settled community of the most emphatic sort: the people who treasured the skulls of their forebears lived in stone houses with neat plaster floors, within a fortified town protected by walls and towers of rough but strong masonry construction (fig. 38). Amazingly enough, they had no pottery. The technique of baking clay in a kiln, it seems, was not invented until later.

ÇATAL HÜYÜK. Excavations at Çatal Hüyük in Anatolia (modern Turkey) brought to light another Neolithic town, roughly a thousand years younger than Jericho. Its inhabitants lived in houses built of mud bricks and timber, clustered around open courtyards (fig. 39). There were no streets, since the houses had no doors; people apparently entered through the roof. The settlement included a number of religious shrines, the earliest found so far, and on their plaster-covered walls we encounter the earliest paintings on a man-made surface. Animal hunts, with small running figures surrounding huge bulls or stags (fig. 40), evoke echoes of cave paintings.

41. *Fertility Goddess,* from Shrine A.II.1, Çatal Hüyük. c. 6000 B.C.
Baked clay, height 8" (20.3 cm).
Archaeological Museum, Ankara, Turkey

42. *View of Town and Volcano.* Wall painting, Shrine VII.14, Çatal Hüyük. c. 6000 B.C.

This is an indication that the Neolithic Revolution must have been a recent event at the time, but the balance has already shifted: these hunts have the character of rituals honoring the deity to whom the bull and stag were sacred, rather than of an everyday activity necessary for survival. They therefore continue the transformation of animals into gods that began in the Old Stone Age.

Compared to the animals of the cave paintings, those at Çatal Hüyük are simplified and immobile. Here it is the hunters who are in energetic motion. Animals associated with female deities display an even more rigid discipline. A pair of leopards forms the sides of the throne of a fertility goddess (fig. 41). Among the wall paintings at Çatal Hüyük, the most surprising one is a view of the town itself, with the twin cones of an erupting volcano above it (fig. 42). The densely packed rectangles of the houses are seen from above, while the mountain is shown in profile, its slope covered with dots representing blobs of lava. Such a volcano is still visible today from Çatal Hüyük. Its eruption must have been a terrifying event for the inhabitants. How could they have viewed it as any-

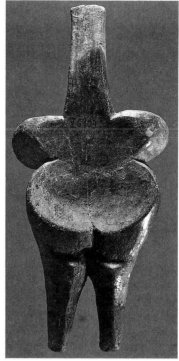

43, 44. *Fertility Goddess* (front and back), from Cernavoda, Romania.
c. 5000 B.C. Baked clay, height 6 ¼" (16 cm). National Museum, Bucharest.

thing except a manifestation of a deity's power? Nothing less could have brought forth this image, halfway between a map and a landscape.

Neolithic Europe

The Near East became the cradle of civilization: to be civilized, after all, means to live as a citizen, a town dweller. Meanwhile, the Neolithic Revolution progressed at a very much slower pace in Europe. About 5000 B.C., Near Eastern influences began to spread to the northern shore of the Mediterranean. Baked clay figurines of fertility goddesses found in the Balkans, such as the striking one from Cernavoda (figs. 43 and 44), have their closest relatives in Asia Minor. What makes the Cernavoda *Fertility Goddess* so memorable is the sculptor's ability to simplify the shapes of a woman's body and yet retain its salient features (which, to him, did not include the face). The smoothly concave back sets off the ballooning convexity of thighs, belly, arms, and breasts on the front.

DOLMENS AND CROMLECHS. North of the Alps, Near Eastern influence cannot be detected until a much later time. In Central and Northern Europe, a sparse population continued to lead the simple tribal life of small village communities even after the introduction of bronze and iron, until a few hundred years before the birth of Christ. Thus Neolithic Europe never reached the level of social organization that produced the masonry architecture of Jericho or the dense urban community of Çatal Hüyük. Instead we find there monumental stone structures of a different kind, called megalithic because

45. Dolmen, Carnac (Brittany), France. c. 1500 B.C.

they consist of huge blocks or boulders placed upon each other without mortar. Their purpose was religious, rather than civic or utilitarian. Apparently, the sustained and coordinated effort they required could be compelled only by the authority of religious faith—a faith that almost literally demanded the moving of mountains. Even today these megalithic monuments have an awe-inspiring, superhuman air about them, as if they were the work of a forgotten race of giants.

Some, known as dolmens, are tombs resembling "houses of the dead," with upright stones for walls and a single giant slab for a roof (fig. 45). Others, the so-called cromlechs, form

46. Stonehenge (aerial view), Salisbury Plain (Wiltshire), England. c. 2000 B.C. Diameter of circle 97' (29.6 m)

47. Stonehenge at sunset

the setting of religious observances. The most famous of these, Stonehenge in southern England (figs. 46 and 47), has a great outer circle of evenly spaced uprights (posts) supporting horizontal slabs (lintels) and two inner circles similarly marked, with an altarlike stone at the center (fig. 48). The entire structure is oriented toward the exact point at which the sun rises on the day of the summer solstice. As our illustration suggests, it probably served a sun-worshiping ritual.

Whether a monument such as this should be termed architecture is a matter of definition. Nowadays, we tend to think of architecture in terms of enclosed interiors, but we also have landscape architects, who design gardens, parks, and playgrounds. Nor would we want to deny the status of architecture to open-air theaters or sports stadiums. To the ancient Greeks, who coined the term, "archi-tecture" meant something higher than ordinary "tecture" (that is, "construction" or "building"), much as an archbishop ranks above a bishop. Thus it is a structure distinguished from the practical, everyday kind by its scale, order, permanence, or solemnity of purpose. A Greek would certainly have acknowledged Stonehenge as architecture. We, too, shall have no difficulty in doing so once we understand that it is not necessary to enclose space in order to

48. Diagram of original arrangement of stones at Stonehenge (after F. Hoyle)

49. Great Serpent Mound, Adams County, Ohio. c. 1070 A.D. Length 1,400' (426.7 m)

define or articulate it. If architecture is "the art of shaping space to human needs and aspirations," then Stonehenge more than meets the test.

Neolithic America

The "earth art" of the prehistoric Indians of North America, the so-called Mound Builders, is comparable to the megalithic monuments of Europe in terms of the effort involved. The term is misleading, since these mounds vary greatly in shape and purpose as well as in date, ranging from about 2000 B.C. to the time of the Europeans' arrival in the late fifteenth century. Of particular interest are the "effigy mounds" in the shape of animals, presumably the totems of the tribes that produced them. The most spectacular is the Great Serpent Mound (fig. 49), a snake some 1,400 feet long that slithers along the crest of a ridge by a small river in southern Ohio. The huge head, its center marked by a heap of stones that may once have been an altar, occupies the highest point. Evidently it was the natural formation of the terrain that inspired this extraordinary work of landscape architecture, as mysterious and moving in its way as Stonehenge.

CHAPTER TWO

EGYPTIAN ART

Egyptian civilization has long been regarded as the most rigid and conservative ever. Plato said that Egyptian art had not changed in 10,000 years. Perhaps "enduring" and "continuous" are better terms for it, although at first glance all Egyptian art between 3000 and 500 B.C. does tend to have a certain sameness. There is a kernel of truth in this: the basic pattern of Egyptian institutions, beliefs, and artistic ideas was formed during the first few centuries of that vast span of time and kept reasserting itself until the very end. We shall see, however, that over the years this basic pattern went through ever more severe crises that challenged its ability to survive. Had it been as inflexible as supposed, it would have succumbed long before it finally did. Egyptian art alternates between conservatism and innovation, but is never static. Some of its great achievements had a decisive influence on Greek and Roman art, and thus we can still feel ourselves linked to the Egypt of 5,000 years ago by a continuous, living tradition.

THE OLD KINGDOM

DYNASTIES. The history of Egypt is divided into dynasties of rulers, in accordance with ancient Egyptian practice, beginning with the First Dynasty shortly after 3000 B.C. (The dates of the earliest rulers are difficult to translate exactly into our calendar; the dating system used in this book is that of French Egyptologist Nicolas Grimal.) The transition from prehistory to the First Dynasty is referred to as the predynastic period.

The next major period, known as the Old Kingdom, lasted from about 2700 B.C. until about 2190 B.C., with the end of the Sixth Dynasty. This method of counting historic time by dynasties conveys at once the strong Egyptian sense of continuity and the overwhelming importance of the pharaoh (king), who was not only the supreme ruler but also a god. The pharaoh transcended all people, for his kingship was not a duty or privilege derived from a superhuman source, but was absolute, divine. This belief remained the key feature of Egyptian civilization and largely determined the character of Egyptian art. We do not know exactly the steps by which the early pharaohs established their claim to divinity, but we know their historic achievements: molding the Nile Valley from the first cataract at Assuan to the Delta into a single, effective state, and increasing its fertility by regulating the river waters through dams and canals.

TOMBS AND RELIGION. Of these vast public works nothing remains today, and very little has survived of ancient Egyptian palaces and cities. Our knowledge of Egyptian civilization rests almost entirely on the tombs and their contents. This is no accident, since these tombs were built to last forever, yet we must not make the mistake of concluding that the Egyptians viewed life on this earth mainly as a road to the grave. Their preoccupation with the cult of the dead is a link with the Neolithic past, but the meaning they gave it was new and different: the dark fear of the spirits of the dead which dominates primitive ancestor cults seems entirely absent.

50. *People, Boats, and Animals.* Reconstruction drawing of wall painting in predynastic tomb. c. 3200 B.C. Hierakonpolis, Egypt

Instead, the Egyptian attitude was that each person must provide for his or her own happy afterlife. [See Primary Sources, no. 1, page 212.] The ancient Egyptians would equip their tombs as a kind of shadowy replica of their daily environment for their spirits (*ka*) to enjoy. They would make sure that the *ka* had a body to dwell in (their own mummified corpse or, if that should become destroyed, a statue of themselves).

There is a curious blurring of the sharp line between life and death here, and perhaps that was the essential impulse behind these mock households. People who knew that after death their *ka*s would enjoy the same pleasures they did, and who had provided these pleasures in advance by their own efforts, could look forward to active and happy lives without being haunted by fear of the great unknown. In a sense, then, the Egyptian tomb was a kind of life insurance, an investment in peace of mind. Such, at least, is the impression one gains of Old Kingdom tombs. Later on, the serenity of this concept of death was disturbed by a tendency to subdivide the spirit or soul into two or more separate identities and by the introduction of a sort of judgment, a weighing of souls. Only then do we also find expressions of the fear of death.

HIERAKONPOLIS. An early stage in the development of Egyptian funerary customs, and of Egyptian art, can be seen in the fragment of a wall painting from Hierakonpolis of about 3200 B.C. (fig. 50). The design is still decidedly primitive in its character—an even scattering of forms over the entire surface. It is instructive to note, however, that the human and animal figures tend to become standardized, abbreviated "signs," almost as if they were on the verge of turning into hieroglyphics (such as we see in fig. 83). The large white shapes are boats. Their significance here seems to be that of funeral barges, or "vehicles of the soul," since that is their role in later tombs. The black-and-white figures above the topmost boat are mourning women, their arms spread out in a gesture of grief. For the rest, the picture does not appear to have any coherence as a scene or any symbolic import. At first glance, it seems simply an early attempt at those typical scenes of daily life that we meet several centuries later in Old Kingdom tombs (compare figs. 68 and 69). However, the figure flanked by a pair of heraldic lions at the bottom center of our illustration is such a striking anticipation of the mythical hero on a Mesopotamian lyre 600 years later (see fig. 92) that the scene may well have a meaning we have yet to decipher.

Egyptian Style and the Palette of King Narmer

At the time of the Hierakonpolis mural, Egypt was in the process of learning the use of bronze tools. The country, we may assume, was ruled by a number of local sovereigns not too far removed from the status of tribal chiefs. The fight scenes between black-bodied and white-bodied men in the painting probably reflect local wars or raids. Out of these emerged two rival kingdoms, Upper and Lower Egypt. The struggle between them ended when the Upper Egyptian kings conquered Lower Egypt and combined the two realms.

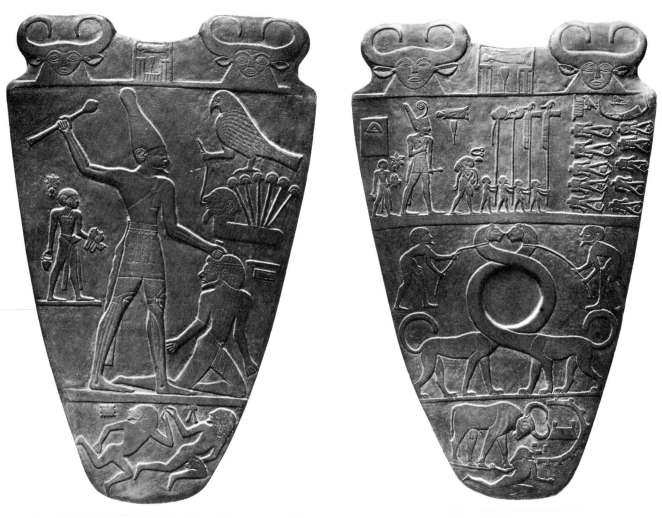

51, 52. *Palette of King Narmer* (both sides), from Hierakonpolis. c. 3150–3125 B.C. Slate, height 25" (63.5 cm). Egyptian Museum, Cairo

One of these was King Menes (Narmer), who appears on the impressive object in figures 51 and 52, a ceremonial slate palette probably celebrating a victory over Lower Egypt, though the precise meaning is under dispute. (Note the different crowns worn by the king.) It, too, comes from Hierakonpolis, but otherwise has little in common with the wall painting. In many ways, the Narmer palette can claim to be the oldest historic work of art we know. Not only is it the earliest surviving image of a historic personage identified by name, but its character is clearly no longer primitive. In fact, it already shows most of the features of late Egyptian art. If only we had enough preserved material to trace step-by-step the evolution that led from the wall painting to this palette!

Let us first "read" the scenes on both sides. The fact that we are able to do so is another indication that we have left prehistoric art behind. The meaning of these reliefs is made clear and explicit not only by means of hieroglyphic labels, but also through the use of a broad range of visual symbols conveying precise messages to the beholder and—most important of all—through the disciplined, rational orderliness of the design. In figure 51 Narmer has seized a fallen enemy by the hair and is about to slay him with his mace. Two more defeated enemies are placed in the bottom compartment. (The small rectangular shape next to the man on the left stands for a fortified town or citadel.) Facing the king in the upper right we see a complex bit of picture writing: a falcon standing above a clump of papyrus plants holds a tether attached to a human

head that "grows" from the same soil as the plants. This composite image actually repeats the main scene on a symbolic level. The head and papyrus plant stand for Lower Egypt, while the victorious falcon is Horus, the local god of Upper Egypt. The parallel is plain. Horus and Narmer are the same; a god triumphs over human foes. Hence, Narmer's gesture must not be taken as representing a real fight. The enemy is helpless from the very start, and the slaying is a ritual rather than a physical effort. We gather the ritual import from the fact that Narmer has taken off his sandals (the court official behind him carries them in his right hand), an indication that he is standing on holy ground.

On the other side of the palette (fig. 52), the king again appears barefoot, followed by the sandal carrier, as he walks in solemn procession behind a group of standard-bearers to inspect the decapitated bodies of prisoners. (The same notion recurs in the Old Testament, apparently as the result of Egyptian influence, when the Lord commands Moses to remove his shoes before he appears to him in the burning bush.) The bottom compartment reenacts the victory once again on a symbolic level, with the pharaoh represented as a strong bull trampling an enemy and knocking down a citadel. (A bull's tail hanging down from his belt is shown in both images of Narmer; it was to remain a part of pharaonic ceremonial garb for the next 3,000 years.) Only the center section fails to convey an explicit meaning. The intertwined snake-necked lions and their two attendants have no identifying attributes. How-

ever, similar beasts are found in protoliterate Mesopotamian art of about 3300–3200 B.C. (see Chapter Three). There they combine the lioness attribute of the mother goddess with the copulating snakes signifying the god of fecundity to form a fertility symbol that unites the female and male principles in nature. Do they perhaps contain another reference to the union of Upper and Lower Egypt? Whatever their meaning on Narmer's palette, their presence provides evidence of the extensive contact between the two emerging civilizations at an early and critical stage of their development. In any event, they do not reappear in Egyptian art.

LOGIC OF EGYPTIAN STYLE. The new inner logic of the Narmer palette's style becomes readily apparent in contrast to the predynastic wall painting. What strikes us first is its strong sense of order. The surface of the palette has been divided into horizontal bands, or registers, and each figure stands on a line or strip denoting the ground. The only exceptions are the attendants of the long-necked beasts, whose role seems mainly ornamental; the hieroglyphic signs, which belong to a different level of reality; and the dead enemies. The latter are seen from above, whereas the standing figures are seen from the side. Obviously, the modern notion of representing a scene as it would appear to a single observer at a single moment is as alien to Egyptian artists as it had been to their Neolithic predecessors. They strive for clarity, not illusion, and therefore pick the most telling view in each case.

But they impose a strict rule on themselves. When the angle of vision changes, it must be by 90 degrees, as if sighting along the edges of a cube. As a consequence, only three views are possible: full face, strict profile, and vertically from above. Any intermediate position is embarrassing. (Note the oddly rubberlike figures of the fallen enemies at the bottom of figure 51.) Moreover, the standing human figure does not have a single main profile but two competing profiles, so that, for the sake of clarity, these views must be combined. The method of doing this (which was to survive unchanged for 2,500 years) is clearly shown in the large figure of Narmer in figure 51: eye and shoulders in frontal view, head and legs in profile. Apparently this formula was worked out so as to show the pharaoh (and all persons of significance who move in the aura of his divinity) in the most complete way possible. And since the scenes depict solemn and, as it were, timeless rituals, our artist did not have to concern himself with the fact that this method of representing the human body made almost any kind of movement or action practically impossible. In fact, the frozen quality of the image would seem especially suited to the divine nature of the pharaoh. Ordinary mortals act; he simply is.

Whenever physical activity demanding any sort of effort or strain must be depicted, the Egyptian artist does not hesitate to abandon the composite view if necessary, for such activity is always performed by underlings whose dignity does not have to be preserved. Thus in our palette the two animal trainers and the four men carrying standards are shown in strict profile, except for the eyes. The Egyptian style of representing the human figure, then, seems to have been created specifically for the purpose of conveying in visual form the majesty of the divine king. It must have originated among the artists working for the

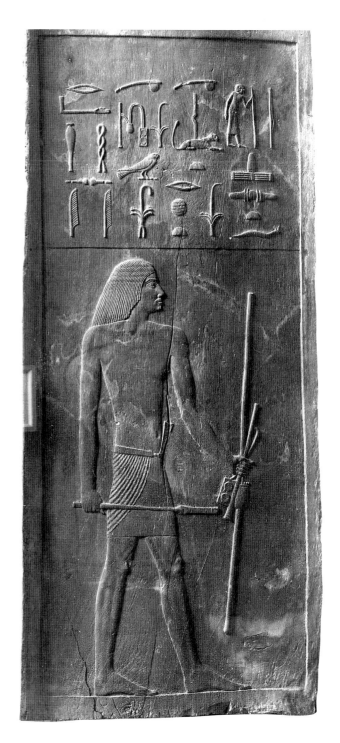

53. *Portrait Panel of Hesy-ra,* from Saqqara. c. 2660 B.C. Wood, height 45" (114.3 cm). Egyptian Museum, Cairo

royal court. It never lost its ceremonial, sacred flavor, even when, in later times, it had to serve other purposes as well.

Third Dynasty

The beauty of the style which we saw in the Narmer palette did not develop fully until about five centuries later, during the Third Dynasty, and especially under the reign of King Djoser, its greatest figure. From the Tomb of Hesy-ra, one of Djoser's high officials, comes the masterly wooden relief (fig. 53) showing

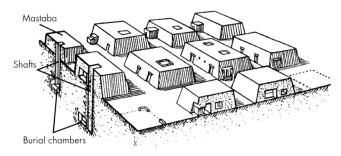

54. Group of mastabas (after A. Badawy). 4th Dynasty

the deceased with the emblems of his rank. These include writing materials, since the position of scribe was a highly honored one. The view of the figure corresponds exactly to that of Narmer on the palette, but the proportions are far more balanced and harmonious, and the carving of the physical details shows keen observation as well as great delicacy of touch.

TOMBS. When we speak of the Egyptians' attitude toward death and afterlife as expressed in their tombs, we must be careful to make it clear that we do not mean the attitude of the average Egyptian but only that of the small aristocratic caste clustered around the royal court. The tombs of the members of this class of high officials, who were often relatives of the royal family, are usually found in the immediate neighborhood of the pharaohs' tombs. Their shape and contents reflect, or are related to, the funerary monuments of the divine kings. We still have a great deal to learn about the origin and significance of Egyptian tombs, but there is reason to believe that the concept of afterlife we find in the so-called private tombs did not apply to ordinary mortals but only to the privileged few because of their association with the immortal pharaohs. [See Primary Sources, no. 2, page 212.]

MASTABAS. The standard form of these tombs was the mastaba, a squarish mound faced with brick or stone, above the burial chamber, which was deep underground and linked to the mound by a shaft (figs. 54 and 55). Inside the mastaba is a chapel for offerings to the *ka* and a secret cubicle for the statue of the deceased. Royal mastabas grew to conspicuous size as early as the First Dynasty, and their exteriors could be elaborated to resemble a royal palace. During the Third Dynasty, they developed into step pyramids. The best known (and probably the first) is that of King Djoser (fig. 56), built over a traditional mastaba (see figs. 55 and 57). The pyramid itself, unlike later examples, is a completely solid structure whose only purpose seems to have been memorial.

FUNERARY DISTRICTS. The modern imagination, enamored of "the silence of the pyramids," is apt to create a false picture of these monuments. They were not erected as isolated structures in the middle of the desert, but were part of vast funerary districts, with temples and other buildings that were the scene of great religious celebrations during the pharaoh's lifetime as well as after. The most elaborate of these is the funerary district around the Step Pyramid of Djoser (fig. 57). Enough of its architecture has survived to enable us to understand why its creator, Imhotep, came to be deified in later Egyptian tradition. He is the first artist whose name has been recorded in history, and deservedly so. His achievement remains impressive not only for its scale but also for its unity, which embodies the concept of the pharaoh to perfection. Imhotep must have possessed remarkable intellect and outstanding ability. In this he set an important precedent for all the great architects who followed in his footsteps. Even architects today address the important ideas and issues of their time.

COLUMNS. Egyptian architecture had begun with structures made of mud bricks, wood, reeds, and other light materials. Imhotep used cut-stone masonry, but his repertory of architectural forms still reflected shapes or devices developed for less enduring materials. Thus we find columns of several kinds—always engaged (set into the wall) rather than free-

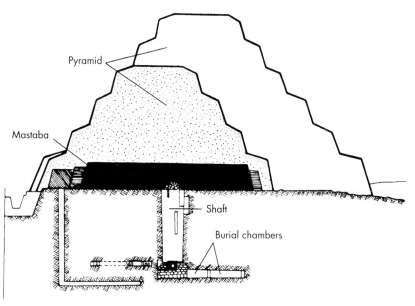

55. Transverse section of the Step Pyramid of King Djoser, Saqqara

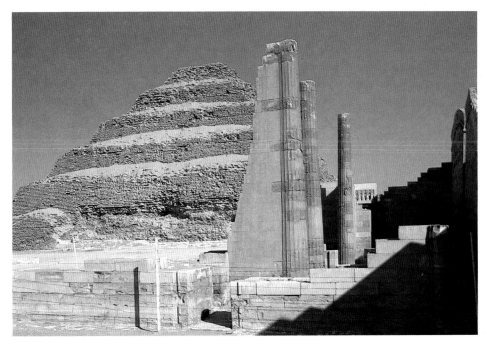

56. Imhotep. Step Pyramid of King Djoser, Saqqara. 3rd Dynasty. c. 2681–2662 B.C.

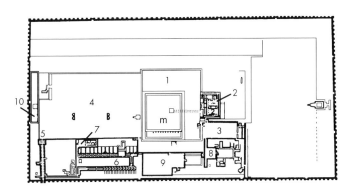

57. Plan of the funerary district of King Djoser, Saqqara (M. Hirmer after J. P. Lauer). 1) pyramid (m=mastaba); 2) funerary temple; 3, 4, 6) courts; 5) entrance hall; 7) small temple; 8) court of North Palace; 9) court of South Palace; 10) southern tomb

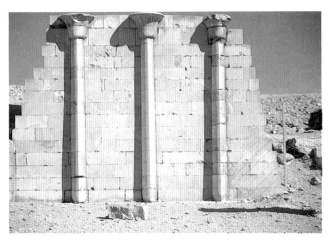

58. Papyrus half-columns, North Palace, Funerary district of King Djoser, Saqqara

standing—which echo the bundles of reeds or the wooden supports that used to be set into mud-brick walls in order to strengthen them. But the very fact that these members no longer had their original functional purpose made it possible for Imhotep and his fellow architects to redesign them so as to make them serve a new, expressive purpose. The notion that architectural forms can express anything may seem difficult to grasp at first. Today we tend to assume that unless these forms have a clear-cut structural service to perform, such as supporting or enclosing, they are mere surface decoration. But let us look at the slender, tapering, fluted columns in figure 56, or the papyrus-shaped half-columns in figure 58. These do not simply decorate the walls to which they are attached, but interpret them and give them life. Their proportions, the feeling of strength or resilience they convey, their spacing, the degree to which they project—all share in this task.

We shall learn more about their expressive role when we discuss Greek architecture, which took over the Egyptian stone column and developed it further. For the time being, let us note one additional factor that may enter into the design and use of such columns: announcing the symbolic purpose of the building. The papyrus half-columns in figure 58 are linked with Lower Egypt (compare the papyrus plants in fig. 51); hence they appear in the North Palace of Djoser's funerary district. The South Palace has columns of different shape to evoke its association with Upper Egypt.

Fourth Dynasty

PYRAMIDS OF GIZA. Djoser's successors soon adapted the step pyramid to the familiar smooth-sided shape. The development of the pyramid reaches its climax during the Fourth

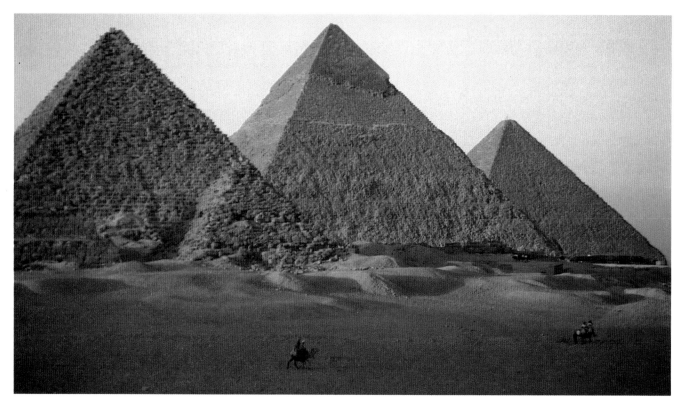

59. The Pyramids of Menkaure (c. 2533–2515 B.C.), Khafre (c. 2570–2544 B.C.), and Khufu (c. 2601–2528 B.C.), Giza

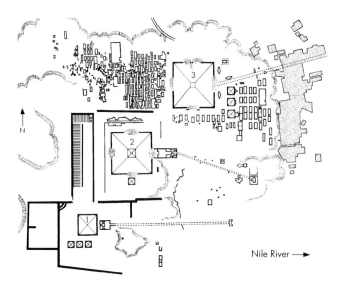

60. Plan of the pyramids at Giza. 1) Menkaure; 2) Khafre; 3) Khufu

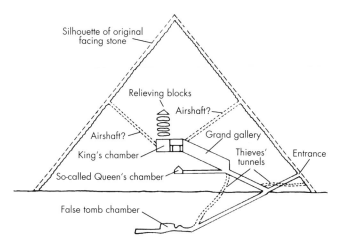

61. North-south section of Pyramid of Khufu (after L. Borchardt)

Dynasty in the famous triad of great pyramids at Giza (figs. 59 and 60). They originally had an outer casing of carefully dressed stone, which has disappeared except near the top of the Pyramid of Khafre. Each of the three differs slightly from the others in details of design and construction, but the essential features are shown in the section of the earliest and largest, that of Khufu (fig. 61). The burial chamber is now near the center of the structure rather than below ground, as in the Step Pyramid of Djoser. This placement of the chamber was a vain attempt to safeguard it from robbers.

According to recent theory, the three pyramids are arranged in the same configuration as the stars in the constellation Orion, which was identified with the god Osiris, the mythical founder of Egypt. One of the mysterious "airshafts" in the king's chamber of the Pyramid of Khufu pointed to the permanently visible polar stars in the north; the other lined up in

ancient times with Orion when it was visible in the southern sky after an absence of some two months, so that it acted as a kind of spiritual "escape hatch" which enabled the pharaoh to ascend and assume his place as a star in the cosmos. Another hidden shaft in the queen's chamber was aligned with the star of Isis (today's Sirius), Osiris' consort, and was evidently used in the ritual of fertilization and rebirth described in the Egyptian *Book of the Dead*. The hypothesis, though controversial, is tantalizing, for it helps to explain many puzzling features of the pyramids in light of the *Pyramid Texts* of the two dynasties that followed. [See Primary Sources, no. 1, page 212.]

Clustered about the three great pyramids are several smaller ones and a large number of mastabas for members of the royal family and high officials, but the unified funerary district of Djoser has given way to a simpler arrangement. Adjoining each of the great pyramids to the east is a funerary temple,

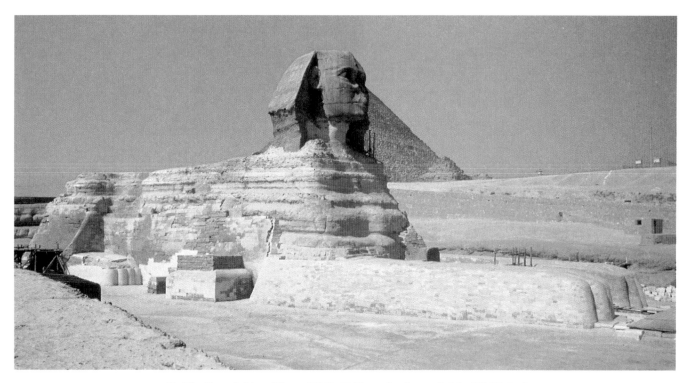

62. The Great Sphinx, Giza. c. 2570–2544 B.C. Sandstone, height 65' (19.8 m)

from which a processional causeway leads to a second temple at a lower level, in the Nile Valley, at a distance of about a third of a mile. This new arrangement represents the decisive final step in the evolution of kingship in Egypt. It links the pharaoh to the eternal cosmic order by connecting him physically and ritually to the Nile River, whose annual cycles give life and dictate its rhythm in Egypt to this very day.

THE GREAT SPHINX. Next to the valley temple of the Pyramid of Khafre stands the Great Sphinx carved from the live rock (fig. 62). It is, if anything, an even more impressive embodiment of divine kingship than the pyramids themselves. The royal head rising from the body of a lion towers to a height of 65 feet and once bore, in all probability, the features of Khafre. (Damage inflicted upon it during Islamic times has obscured the details of the face.) Its awesome majesty is such that a thousand years later it could be regarded as an image of the sun-god.

Enterprises of this huge scale mark the high point of pharaonic power. After the end of the Fourth Dynasty, less than two centuries later, they were never attempted again, although much more modest pyramids continued to be built. The world has always marveled at the sheer size of the great pyramids as well as at the technical accomplishment they represent. They have also come to be regarded as symbols of slave labor, with thousands of men forced by cruel masters to serve the aggrandizement of absolute rulers. Such a picture may well be unjust. Certain records indicate that the labor was paid for, so that we are probably nearer the truth if we regard these monuments as vast public works providing economic security for a good part of the population.

PORTRAITURE. Apart from its architectural achievements, the chief glories of Egyptian art during the Old Kingdom and later are the portrait statues recovered from funerary temples and tombs. One of the finest is that of Khafre, from the valley temple of his pyramid (fig. 63). Carved of diorite, a stone of

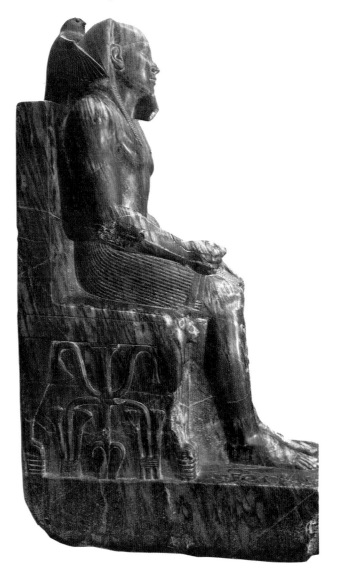

63. *Khafre,* from Giza. c. 2500 B.C. Diorite, height 66" (167.7 cm). Egyptian Museum, Cairo

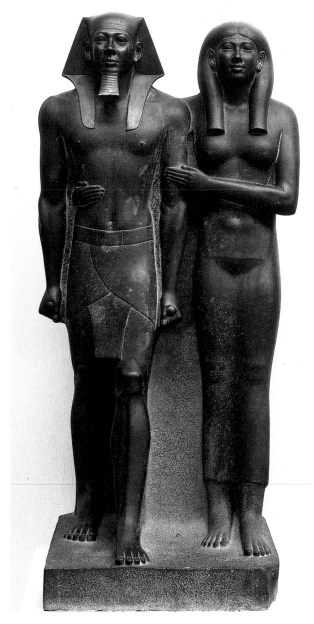

64. *Menkaure and His Wife, Queen Khamerernebty,* from Giza.
c. 2515 B.C. Slate, height 54½" (138.4 cm). Museum of Fine Arts,
Boston. Harvard–Museum of Fine Arts Expedition

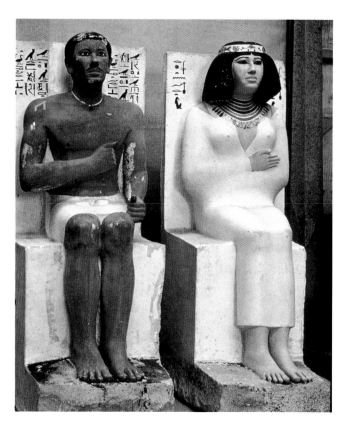

65. *Prince Rahotep and His Wife Nofret.* c. 2580 B.C. Painted
limestone, height 47¼" (120 cm). Egyptian Museum, Cairo

extreme hardness, it shows the king enthroned, with the falcon of the god Horus enfolding the back of the head with its wings. (The pharaoh was equated with Horus as the son of Osiris and Isis; we encountered the association, in different form, in the Narmer palette; fig. 51.)

Here the Egyptian sculptor's "cubic" view of the human form appears in full force. After marking the faces of the rectangular block with a grid, the artist drew the front, top, and side views of the statue, then worked inward until these views met. This approach also encouraged the development of systematic proportions. The result is a figure almost overpowering in its three-dimensional firmness and immobility. Truly it is a magnificent vessel for the spirit! The body, at once idealized and powerfully built, is completely impersonal. Only the face suggests some individual traits, as will be seen if we compare it with that of Menkaure (fig. 64),

Khafre's successor and the builder of the third and smallest pyramid at Giza.

Menkaure, accompanied by his queen, Khamerernebty, is standing. Both have the left foot placed forward, yet there is no hint of a forward movement. These are idealized portraits: a similar group, showing Menkaure between two goddesses, hardly differs in appearance. Since both figures are almost of the same height, they afford an interesting comparison of male and female beauty as interpreted by one of the finest of Old Kingdom sculptors, who knew not only how to contrast the structure of the two bodies but also how to emphasize the soft, swelling forms of the queen through her light, close-fitting gown.

The sculptor who carved the statues of Prince Rahotep and his wife Nofret (fig. 65) was less subtle in this respect. They owe their strikingly lifelike appearance to their vivid coloring, which they must have shared with other such statues but which has survived completely intact only in a few instances. The darker body color of the prince has no individual significance; it is the standard masculine complexion in Egyptian art. The eyes have been inlaid with shining quartz to make them look as alive as possible, and the portrait character of the faces is very pronounced.

Standing and seated figures comprise the basic repertory of Egyptian large-scale sculpture in the round. At the end of the Fourth Dynasty, a third pose was added, as symmetrical and immobile as the first two: that of the scribe sitting cross-legged on the ground. The finest of these scribes dates from the beginning of the Fifth Dynasty (fig. 66). The name of the sitter (in whose tomb at Saqqara the statue was found) is unknown, but we must not think of him as a secretary waiting

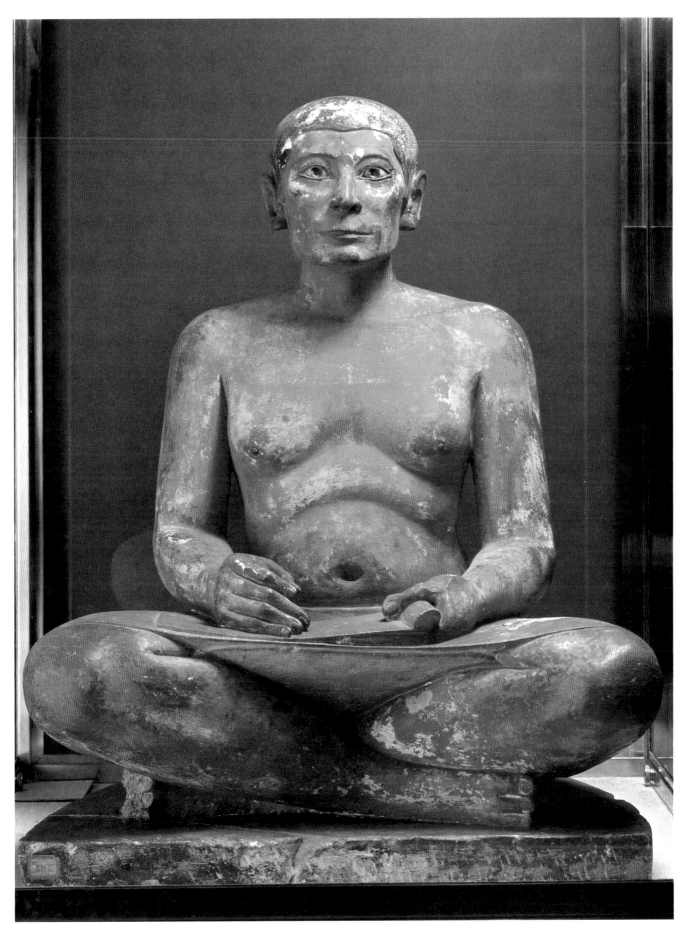

66. *Seated Scribe,* from Saqqara. c. 2400 B.C. Limestone, height 21" (53.3 cm). Musée du Louvre, Paris

67. *Bust of Vizier Ankh-haf,* from Giza. c. 2520 B.C. Limestone, partially molded in plaster, height 21" (53.3 cm). Museum of Fine Arts, Boston. Harvard–Museum of Fine Arts Expedition

68. *Ti Watching a Hippopotamus Hunt.* c. 2510–2460 B.C. Painted limestone relief, height approx. 45" (114.3 cm). Tomb of Ti, Saqqara

to take dictation. Rather, the figure represents a high court official, a "master of sacred—and secret—letters." The solid, incisive treatment of form bespeaks the dignity of his station, which in the beginning seems to have been restricted to the sons of pharaohs. Our example stands out for the vividly alert expression of the face and for the individual handling of the torso, which records the somewhat flabby body of a man past middle age.

Another invention of Old Kingdom art was the portrait bust, a species of sculpture so familiar that we tend to take it for granted; yet its origin is puzzling. Was it simply an abbreviated statue, a cheaper substitute for a full-length figure? Or did it have a distinct purpose of its own, perhaps as a remote echo of the Neolithic custom of keeping the head of the deceased separate from the rest of his body (see pages 54–55)? Be that as it may, the earliest of these busts (fig. 67) is also the finest. Indeed, it is one of the great portraits of all time. In this noble head, we find a memorable image of the sitter's individual character as well as a most subtle differentiation between the solid, immutable shape of the skull and its soft, flexible covering of flesh, abetted by the well-preserved color.

TOMB DECORATION. Before we leave the Old Kingdom, let us look briefly at some of the scenes of daily life from the offering chambers of nonroyal tombs, such as that of the architectural overseer Ti at Saqqara. The hippopotamus hunt in figure 68 is of special interest to us because of its landscape setting. The background of the relief is formed by a papyrus thicket. The stems of the plants make a regular, rippling pattern that erupts in the top zone into an agitated scene of nesting birds menaced by small predators. The water in the bottom zone, marked by a zigzag pattern, is equally crowded with struggling hippopotamuses and fish. All these, as well as the hunters in the first boat, are acutely observed and full of action. Only Ti himself, standing in the second boat, is immobile, as if he belonged to a different world. His pose is that of the funerary portrait reliefs and statues (compare fig. 53), and he towers above the other men, since he is more important than they.

His size also lifts him out of the context of the hunt. He neither directs nor supervises it, but simply observes. His passive role is characteristic of the representations of the deceased in all such scenes from the Old Kingdom. It seems to be a subtle way of conveying the fact that the body is dead but the spirit is alive and aware of the pleasures of this world, though the man can no longer participate in them directly. We should also note that these scenes of daily life do not represent the dead man's favorite pastimes. If they did, he would be looking back, and such nostalgia is quite alien to the spirit of Old Kingdom tombs. It has been shown, in fact, that these scenes form a seasonal cycle, a sort of perpetual calendar of recurrent human activities for the spirit of the deceased to watch year in and year out. For the artist, on the other hand, these scenes, which partake of both sculpture and painting, offered a welcome oppor-

69. *Cattle Fording a River.* Detail of a painted limestone relief. c. 2510–2460 B.C. Tomb of Ti, Saqqara

tunity to widen his powers of observation, so that in details we often find astounding bits of realism.

Another relief from the Tomb of Ti shows some cattle fording a river (fig. 69). One of the herders carries a newborn calf on his back to keep it from drowning, and the frightened animal turns its head to look back at its mother, who answers with an equally anxious glance. Such sympathetic portrayal of an emotional relationship is as delightful as it is unexpected in Old Kingdom art. It will be some time before we encounter anything similar in the human realm. But eventually we shall even see the deceased abandoning his passive, timeless stance to participate in scenes of daily life.

THE MIDDLE KINGDOM

After the collapse of centralized pharaonic power at the end of the Sixth Dynasty, Egypt entered a period of political disturbances and ill fortune that was to last almost 700 years. During most of this time, effective authority lay in the hands of local or regional overlords, who revived the old rivalry of Upper and Lower Egypt. Many dynasties followed one another in rapid succession, but only two, the Eleventh and Twelfth, are worthy of note. The latter constitute the Middle Kingdom (2040–1674 B.C.), when a series of able rulers managed to reassert themselves against the provincial nobility. However, the spell of divine kingship, having once been broken, never regained its old effectiveness, and the authority of the Middle Kingdom pharaohs tended to be personal rather than institutional. Soon after the close of the Twelfth Dynasty, the weakened country was invaded by the Hyksos, a western Asiatic people of somewhat mysterious origin, who seized the Delta area and ruled it for 150 years until their expulsion by the princes of Thebes about 1552 B.C.

70. *Portrait of Sesostris III* (fragment). c. 1850 B.C. Quartzite, height 6 1/2" (16.5 cm). The Metropolitan Museum of Art, New York.
Carnarvon Collection, Gift of Edward S. Harkness, 1926

PORTRAITURE. The unquiet spirit of the times is well reflected in Middle Kingdom art. We find it especially in the new type of royal portrait that marks the Twelfth Dynasty, such as the one in figure 70. There is a real sense of shock on first encountering this strangely modern face. The serene

assurance of the Old Kingdom has given way to a brooding, troubled expression that bespeaks a new level of self-awareness. Lacking its royal trappings, our fragment displays so uncompromising a realism, physical as well as psychological, that at first glance the link with the sculptural tradition of the past seems broken entirely. Here is another enduring achievement of Egyptian art, destined to live on in Roman portraiture and in the portraiture of the Renaissance.

PAINTING AND RELIEF. A loosening of established rules also makes itself felt in Middle Kingdom painting and relief, where it leads to all sorts of interesting departures from convention. They occur most conspicuously in the decoration of the tombs of local princes at Beni Hasan, which have survived destruction better than most Middle Kingdom monuments because they are carved into the living rock. The mural *Feeding the Oryxes* (fig. 71) comes from one of these rock-cut tombs, that of Khnum-hotep. (As the emblem of the prince's domain, the oryx antelope seems to have been a sort of honored pet in his household.) According to the standards of Old Kingdom art, all the figures ought to share the same ground-line, or the second oryx and its attendant ought to be placed above the first. Instead, the painter has introduced a secondary ground-line only slightly higher than the primary one, and as a result the two groups are related in a way that closely approximates normal appearances. His interest in exploring spatial effects can also be seen in the awkward but quite bold foreshortening of the shoulders of the two attendants. If we cover up the hieroglyphic signs, which emphasize the flatness of the wall, we can "read" the forms in depth with surprising ease.

THE NEW KINGDOM

The 500 years following the expulsion of the Hyksos, and comprising the Eighteenth, Nineteenth, and Twentieth dynasties, represent the third and final flowering of Egypt. The country, once more united under strong and efficient kings, extended its frontiers far to the east, into Palestine and Syria; hence this period is also known as the Empire. During the climactic period of power and prosperity, between about 1500 B.C. and the end of the reign of Ramesses III in 1145 B.C., tremendous architectural projects were carried out, centering on the region of the new capital, Thebes, while the royal tombs reached unequaled material splendor.

The divine kingship of the pharaohs was now asserted in a new way: by association with the god Amun, whose identity had been fused with that of the sun-god Ra, and who became the supreme deity, ruling the lesser gods much as the pharaoh towered above the provincial nobility. This very development produced an unexpected threat to royal authority: the priests of Amun grew into a caste of such wealth and power that the pharaoh could maintain his position only with their consent. Amenhotep IV, the most remarkable figure of the Eighteenth Dynasty, tried to defeat them by proclaiming his faith in a single god, the sun disk Aten. He changed his name to Akhenaten, closed the Amun temples, and moved the capital to central Egypt, near the modern Tell el'Amarna. His attempt to place himself at the head of a new monotheistic faith, however, did not outlast his reign (1348–1336/5 B.C.), and under his suc-

71. *Feeding the Oryxes.* c. 1928–1895 B.C. Detail of a wall painting. Tomb of Khnum-hotep, Beni Hasan

cessors orthodoxy was speedily restored. During the long decline that began about 1000 B.C., the country became increasingly priest-ridden, until, under Greek and Roman rule, Egyptian civilization ended in a welter of esoteric religious doctrines.

New Kingdom art covers a wide range of styles and quality, from rigid conservatism to brilliant inventiveness, from oppressively massive ostentation to the most delicate refinement. As with the art of Imperial Rome 1,500 years later, it is almost impossible to summarize in terms of a representative sampling. Different strands are interwoven into a fabric so complex that any choice of monuments is bound to seem arbitrary. All we can hope is to convey some of the flavor of its variety.

Architecture

TEMPLE OF HATSHEPSUT. Among the architectural enterprises that have survived from the early years of the New Kingdom, the outstanding one is the Funerary Temple of Queen Hatshepsut, built by her *vizier* (overseer) Senenmut about 1478–1458 B.C. against the rocky cliffs of Deir el-Bahari (figs. 72 and 73) and dedicated to Amun and several other deities. The worshiper is led toward the holy of holies—a small chamber driven deep into the rock—through three large courts on ascending levels, linked by ramps among long colonnades. They form a processional road reminiscent of those at Giza, but with the mountain instead of a pyramid at the end. It is this magnificent union of architecture and nature (note how ramps and colonnades echo the shape of the cliff) that makes Hatshepsut's temple the rival of any of the Old Kingdom monuments.

TEMPLE AT LUXOR. The later rulers of the New Kingdom continued to build funerary temples, but an ever greater share of their architectural energies was devoted to huge imperial temples of Amun, the supreme god whom the reigning monarch traditionally claimed as his father. The temple complex at Luxor, on the Nile at the site of ancient Thebes, dedicated to Amun, his wife Mut, and their son Khonsu, was begun about 1350 B.C. by Amenhotep III but was extended and completed more than a century later. Its plan is characteristic of the general pattern of later Egyptian temples. The facade consists of two massive walls, with sloping sides, that flank the entrance. This unit, which is known as the gateway or pylon (fig. 74, far

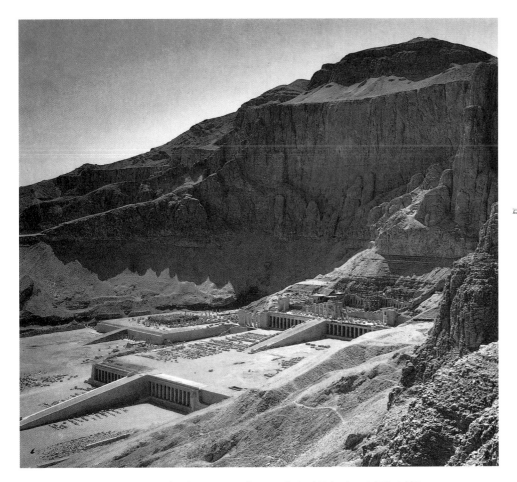

72. Funerary Temple of Queen Hatshepsut, Deir el-Bahari. c. 1478–1458 B.C.

73. Plan of Funerary Temple of Queen Hatshepsut (after Lange)

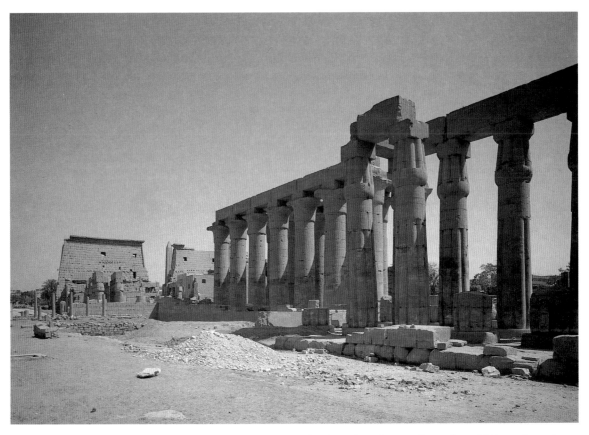

74. Court and pylon of Ramesses II (c. 1279–1212 B.C.) and colonnade and court of Amenhotep III (c. 1350 B.C.), Temple complex of Amun-Mut-Khonsu, Luxor

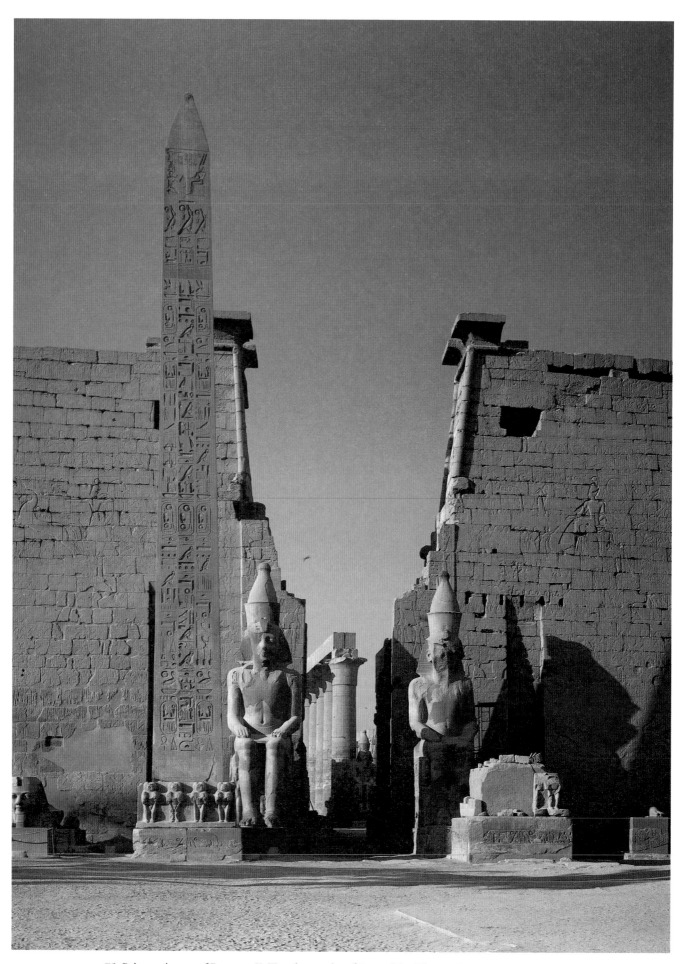

75. Pylon and court of Ramesses II, Temple complex of Amun-Mut-Khonsu, Luxor. c. 1279–1212 B.C.

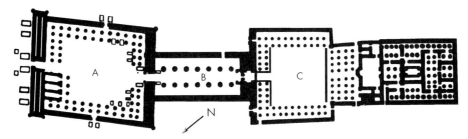

76. Plan of the Temple of Amun, Luxor (after N. de Garis Davies)

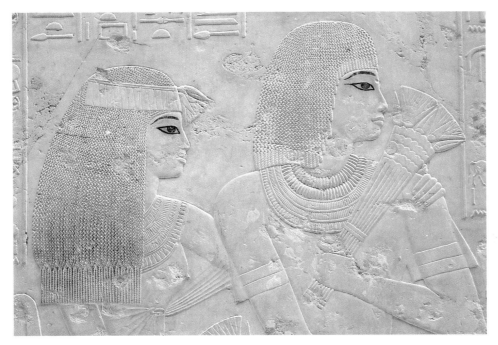

77. *Mai and His Wife Urel.* Detail of a limestone relief. c. 1375 B.C. Tomb of Ramose, Thebes

left, and fig. 75), leads to the court (fig. 76, A). The court, in this case, is a parallelogram, because Ramesses II, who added it to the temple that had been planned under Amenhotep III, changed the axis of his court slightly so as to conform with the direction of the Nile. We then enter a pillared hall, which brings us to the second court (fig. 76, B and C; fig. 74, center and right). On its far side we find another pillared hall. Beyond it, the temple proper begins: a series of symmetrically arranged halls and chapels shielding the holy of holies, a square room with four columns (fig. 76, extreme right).

The entire sequence of courts, halls, and temple was enclosed by high walls that shut off the outside world. Except for the monumental pylon (fig. 75), such a structure is designed to be experienced from within. Ordinary worshipers were confined to the courts and could but marvel at the forest of columns that screened the dark recesses of the sanctuary. The columns had to be closely spaced, for they supported the stone lintels of the ceiling, and these had to be short to keep them from breaking under their own weight. Yet the architect has consciously exploited this condition by making the columns far heavier than they need be. As a result, the beholder feels almost crushed by their sheer mass. The effect is certainly impressive, but also rather coarse when measured against the earlier masterpieces of Egyptian architecture. We need only compare the papyrus columns of the colonnade of Amenhotep III with their remote ancestors in Djoser's North Palace (fig. 58) in order to

realize how little of the genius of Imhotep has survived at Luxor.

Akhenaten

Of the great projects built by Akhenaten hardly anything remains above ground. He must have been a revolutionary not only in his religious beliefs but in his artistic tastes as well, consciously fostering a new style and a new ideal of beauty in his choice of masters. The contrast with the past becomes strikingly evident if we compare a head in low relief from the Tomb of Ramose, done at the end of the reign of Amenhotep III (fig. 77, following page), with a low-relief portrait of Akhenaten that is some 30 to 40 years later in date (fig. 78, following page). Figure 77 shows the traditional style at its best. The wonderful subtlety of the carving and the precision and refinement of its lines make the head of Akhenaten seem at first glance like a brutal caricature. And the latter work is indeed an extreme statement of the new ideal, with its oddly haggard features and overemphatic, undulating outlines. Still, we can perceive its kinship with the justly famous bust of Akhenaten's queen, Nefertiti (fig. 79), one of the masterpieces of the "Akhenaten style."

What distinguishes this style is not greater realism so much as a new sense of form that seeks to unfreeze the traditional immobility of Egyptian art. Not only the contours but the plastic shapes, too, seem more pliable and relaxed, antigeometric. We find these qualities again in the delightful fragment

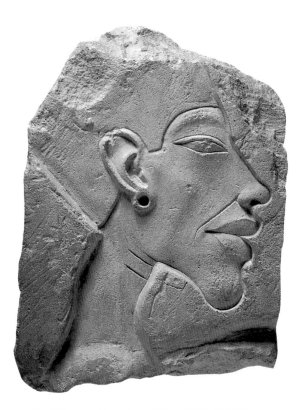

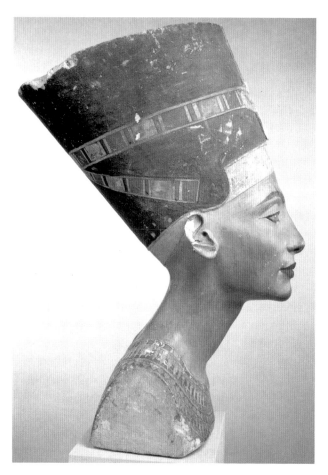

78. *Akhenaten (Amenhotep IV)*. c. 1348–1336/5 B.C.
Limestone, height 3⅛" (7.9 cm). Staatliche Museen zu Berlin,
Preussischer Kulturbesitz, Ägyptisches Museum

79. *Queen Nefertiti*. c. 1348–1336/5 B.C. Limestone, height 19"
(48.3 cm). Staatliche Museen zu Berlin,
Preussischer Kulturbesitz, Ägyptisches Museum

of a wall painting showing the daughters of Akhenaten
(fig. 80). Their playful gestures and informal poses seem in
defiance of all rules of pharaonic dignity.

The old religious tradition was quickly restored after Akhe-
naten's death, but the artistic innovations he encouraged could
be felt in Egyptian art for some time to come. The scene of
workmen struggling with a heavy beam (fig. 81), from the
Tomb of Horemheb at Saqqara, shows a freedom and expres-

siveness that would have been unthinkable in earlier times.

Tutankhamen

Even the face of Akhenaten's successor, Tutankhamen, as it
appears on his gold coffin cover, betrays an echo of the Akhe-
naten style (fig. 82). Tutankhamen, who died at the age of 18,
owes his fame entirely to the accident that his is the only

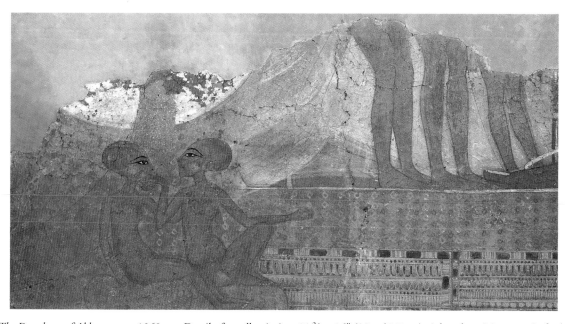

80. *The Daughters of Akhenaten*. c. 1360 B.C. Detail of a wall painting. 11¾ x 16" (30 x 40.7 cm). Ashmolean Museum, Oxford, England

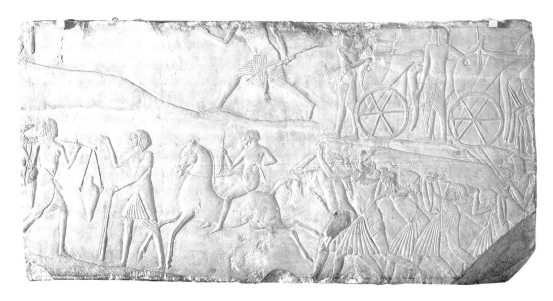

81. *Workmen Carrying a Beam.* Detail of a relief, from the Tomb of Horemheb, Saqqara. c. 1325 B.C. Museo Civico, Bologna

82. Cover of the coffin of Tutankhamen. c. 1327 B.C.
Gold inlaid with enamel and semiprecious stones,
height of whole 6' 7/8" (1.85 m). Egyptian Museum, Cairo

83. *Tutankhamen Hunting.* Detail from a painted chest
found in the king's tomb, Thebes. c. 1336/5–1327 B.C.
Length of scene approx. 20" (50.7 cm). Egyptian Museum, Cairo

pharaonic tomb discovered in our times with most of its contents undisturbed. The sheer material value of the tomb (Tutankhamen's gold coffin alone weighs 250 pounds) makes it understandable that grave robbing has been practiced in Egypt ever since the Old Kingdom. To us, the exquisite workmanship of the coffin cover, with the rich play of colored inlays against the polished gold surfaces, is even more impressive.

As unique in its way as the gold coffin is a painted chest from the same tomb, showing the youthful king in battle and hunting scenes (fig. 83). These subjects, which were intended to glorify Tutankhamen (hunting was of primarily ritual significance), had been traditional since the late years of the Old Kingdom, but here they are done with astonishing freshness, at least so far as the animals are concerned. While the king and his horse-drawn chariot remain frozen against the usual blank background filled with hieroglyphs, the same background in the right-hand half of the scene suddenly turns into a desert. The surface is covered with stippled dots to suggest sand, desert plants are strewn across it in considerable variety, and the animals stampede over it helter-skelter, without any ground-lines to impede their flight.

Here is an aspect of Egyptian painting that we rarely see on the walls of tombs. Perhaps this lively scattering of forms against a landscape background existed only on the miniature scale of the scenes on Tutankhamen's chest, and even there it became possible only as a result of the Akhenaten style. How these animals-in-landscape endured in later Egyptian painting we do not know, but they must have survived somehow, for their resemblance to Islamic miniatures done more than 2,000 years later is far too striking to be ignored.

CHAPTER THREE

ANCIENT NEAR EASTERN ART

SUMERIAN ART

It is an astonishing fact that human civilization should have emerged into the light of history in two separate places at just about the same time. Between 3500 and 3000 B.C., when Egypt was being united under pharaonic rule, another great civilization arose in Mesopotamia, the "land between the rivers." And for close to 3,000 years, the two centers retained their distinct characters, even though they had contact with each other from their earliest beginnings and their destinies were interwoven in many ways. The pressures that forced the inhabitants of both regions to abandon the pattern of Neolithic village life may well have been the same (see fig. 38). But the valley of the Tigris and Euphrates rivers, unlike that of the Nile, is not a narrow fertile strip protected by deserts on either side. It resembles a wide, shallow trough with few natural defenses, crisscrossed by two great rivers and their tributaries, and easily encroached upon from any direction.

Thus the facts of geography tended to discourage the idea of uniting the entire area under a single head. Rulers who had this ambition did not appear, so far as we know, until about a thousand years after the beginnings of Mesopotamian civilization, and they succeeded in carrying it out only for brief periods and at the cost of almost continuous warfare. As a consequence, the political history of ancient Mesopotamia has no underlying theme of the sort that divine kingship provides for Egypt. Local rivalries, foreign incursions, the sudden upsurge and equally sudden collapse of military power—these are its substance. Against such a disturbed background, the continuity of cultural and artistic traditions seems all the more remarkable. This common heritage is very largely the creation of the founders of Mesopotamian civilization, whom we call Sumerians after the region of Sumer, which they inhabited, near the confluence of the Tigris and Euphrates rivers.

The origin of the Sumerians remains obscure. Their language is unrelated to any other known tongue. Sometime

before 4000 B.C., they came to southern Mesopotamia from Persia, and there, within the next thousand years, they founded a number of city-states and developed their distinctive form of writing in cuneiform (wedge-shaped) characters on clay tablets. This transitional phase, corresponding to the predynastic period in Egypt, is called "protoliterate"; it leads to the early dynastic period, from about 3000 to 2340 B.C.

ARCHAEOLOGICAL CONDITIONS. The first evidence of Bronze Age culture is seen in Sumer about 4000 B.C. Unfortunately, the tangible remains of Sumerian civilization are extremely scanty compared to those of ancient Egypt. Building stone being unavailable in Mesopotamia, the Sumerians used mud brick and wood, so that almost nothing is left of their architecture except the foundations. Nor did they share the Egyptians' concern with the hereafter, although some richly endowed tombs in the shape of vaulted chambers below ground from the early dynastic period have been found in the city of Ur. Our knowledge of Sumerian civilization thus depends very largely on chance fragments brought to light by excavation, including vast numbers of inscribed clay tablets. Yet we have learned enough to form a general picture of the achievements of this vigorous, inventive, and disciplined people.

RELIGION. Each Sumerian city-state had its own local god, who was regarded as its "king" and owner. It also had a human ruler, the steward of the divine sovereign, who led the people in serving the deity. The local gods, in return, were expected to plead the cause of their subjects among the other deities who controlled the forces of nature, such as wind and weather, water, fertility, and the heavenly bodies. Nor was the idea of divine ownership treated as a mere pious fiction. The god was quite literally believed to own not only the territory of the

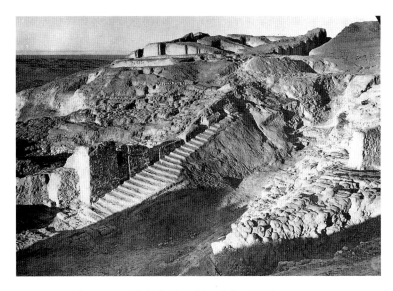

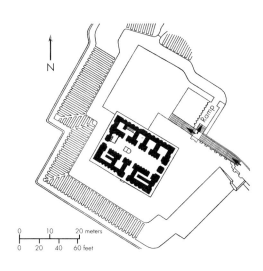

84. Remains of the "White Temple" on its ziggurat, Uruk (Warka), Iraq. c. 3500–3000 B.C.

85. Plan of the "White Temple" on its ziggurat (after H. Frankfort)

city-state but also the labor power of the population and its products. All these were subject to his commands, transmitted to the people by his human steward. The result was an economic system that has been dubbed "theocratic socialism," a planned society whose administrative center was the temple. The temple controlled the pooling of labor and resources for communal enterprises, such as the building of dikes or irrigation ditches, and it collected and distributed a considerable part of the harvest. All this required the keeping of detailed written records. Hence we need not be surprised to find that the texts of early Sumerian inscriptions deal very largely with economic and administrative rather than religious matters, although writing was a priestly privilege.

ARCHITECTURE. The dominant role of the temple as the center of both spiritual and physical existence is strikingly conveyed by the layout of Sumerian cities. The houses were clustered about a sacred area that was a vast architectural complex embracing not only shrines but workshops, storehouses, and scribes' quarters as well. In their midst, on a raised platform, stood the temple of the local god. These platforms soon reached the height of true mountains, comparable to the pyramids of Egypt in the immensity of effort required and in their effect as great landmarks that tower above the featureless plain. They are known as ziggurats.

The most famous of them, the biblical Tower of Babel, has been completely destroyed, but a much earlier example, built shortly before 3000 B.C. and thus several centuries older than the first of the pyramids, survives at Warka, the site of the Sumerian city of Uruk (called Erech in the Bible). The mound, its sloping sides reinforced by solid brick masonry, rises to a height of 40 feet. Stairs and ramps lead up to the platform on which stands the sanctuary, called the "White Temple" because of its whitewashed brick exterior (figs. 84 and

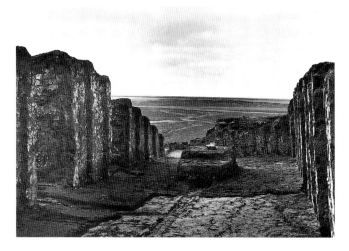

86. Interior of the cella, "White Temple"

85). Its heavy walls, articulated by regularly spaced projections and recesses, are sufficiently well preserved to suggest something of the original appearance of the structure. The main room, or cella (fig. 86), where sacrifices were offered before the statue of the god, is a narrow hall that runs the entire length of the temple and is flanked by a series of smaller chambers. But the main entrance to the cella is on the southwest side, rather than on the side facing the stairs or on one of the narrow sides of the temple, as one might expect. In order to understand the reason for this, we must view the ziggurat and temple as a whole. The entire complex is planned in such a way that the worshiper, starting at the bottom of the stairs on the east side, is forced to go around as many corners as possible before reaching the cella. The processional path, in other words, resembles a sort of angular spiral.

This "bent-axis approach" is a fundamental characteristic of Mesopotamian religious architecture, in contrast to the straight, single axis of Egyptian temples (see fig. 76). During the following 2,500 years, it was elaborated into ever taller and more towerlike ziggurats rising in multiple stages. The one built by King Urnammu at Ur about 2100 B.C. and dedicated

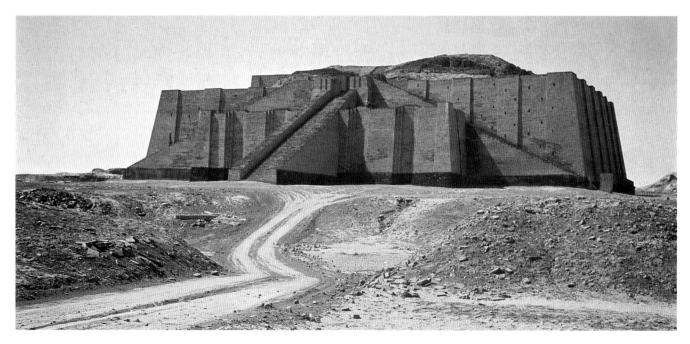

87. Ziggurat of King Urnammu, Ur (El Muqeiyar), Iraq. c. 2100 B.C.

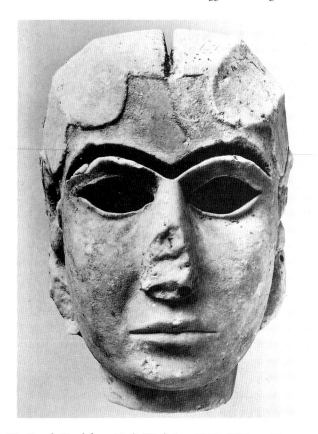

88. *Female Head,* from Uruk (Warka). c. 3500–3000 B.C. Limestone, height 8" (20.3 cm). Iraq Museum, Baghdad

to the moon-god Nanna had three levels (fig. 87). Little is left of the upper two stages, but the bottom one, some 50 feet high, has survived fairly well, and its facing of brick has been restored. What was the impulse behind these structures? Certainly not the kind of pride attributed to the builders of the Tower of Babel in the Old Testament. They reflect, rather, the widespread belief that mountaintops are the dwelling places of the gods. (We need only think of the Mount Olympus of the Greeks.) The Sumerians felt they could provide a fit residence for a deity only by creating their own artificial mountains.

STONE SCULPTURE. The image of the god to whom the "White Temple" was dedicated is lost—it was probably Anu, the god of the sky—but a splendid female head from the same period at Uruk (Warka) may well have belonged to another cult statue (fig. 88). It is carved from limestone, and the hair, eyes, and eyebrows were originally inlaid with colored materials. The rest of the figure, which must have been close to lifesize, was probably of wood. As an artistic achievement, this head is on a par with the finest works of Egyptian Old Kingdom sculpture. The softly swelling cheeks, the delicate curves of the lips, combined with the steady gaze of the huge eyes, create a balance of sensuousness and severity that seems worthy of any goddess.

It was the geometric and expressive aspects of the Uruk head, rather than the realistic ones, that survived in the stone sculpture of the early dynastic period, as seen in a group of figures from Tell Asmar (fig. 89) carved about five centuries later than the head. Although the two tallest figures have traditionally been thought to represent Abu, the god of vegetation, and a mother goddess, it is likely that all are votive statues of priests and worshipers. Despite the disparity in size, each has the same pose of humble worship, save for the kneeling figure to the lower right. The enormous eyes of all the figures communicate a sense of awe entirely appropriate before the often-terrifying deities they worshiped. Their insistent stare is emphasized by colored inlays, which are still in place. The entire group must have stood in the cella of the Abu temple, the priests and worshipers communicating with the god through their eyes.

"Representation" here had a very direct meaning: the gods were believed to be present in their images, and the statues of the worshipers served as stand-ins for the persons they portrayed, offering prayers or transmitting messages to the deity in their stead. Yet none of them indicates any attempt to achieve a real likeness. The bodies as well as the faces are rigorously simplified and schematic, in order to avoid distracting attention from the eyes, "the windows of the soul." If the Egyptian sculptor's sense of form was essentially cubic, that of the Sumerian was based on the cone and cylinder. Arms and legs have the roundness of pipes, and the long skirts worn by

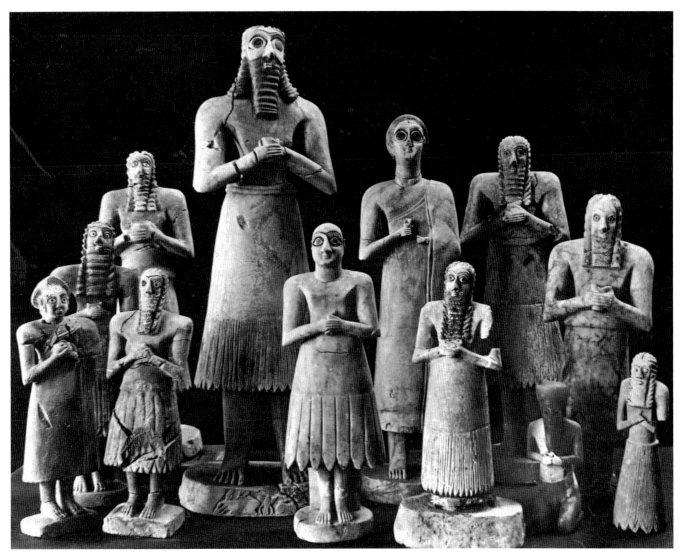

89. Statues, from the Abu Temple, Tell Asmar, Iraq. c. 2700–2500 B.C. Limestone, alabaster, and gypsum, height of tallest figure approx. 30" (76.3 cm). Iraq Museum, Baghdad, and The Oriental Institute Museum of The University of Chicago

all these figures are as smoothly curved as if they had been turned on a lathe. This preference for curvilinear forms may initially have been determined in part by the shape of the blocks supplied from afar, but even in later times, when Mesopotamian sculpture had acquired a far richer repertory of shapes, the same quality asserted itself again and again.

BRONZE OR ASSEMBLED SCULPTURE. The conic-cylindrical simplification of the Tell Asmar statues is characteristic of the carver, who works by cutting forms out of a solid block. A far more flexible and realistic style prevails among the Sumerian sculpture that was made by addition rather than subtraction (that is, either modeled in soft materials for casting in bronze or put together by combining such varied substances as wood, gold leaf, and lapis lazuli). Some pieces of the latter kind, roughly contemporary with the Tell Asmar figures, have been found in the tombs at Ur which we mentioned earlier. They include the fascinating object shown in figure 90, an offering stand in the shape of a ram rearing up

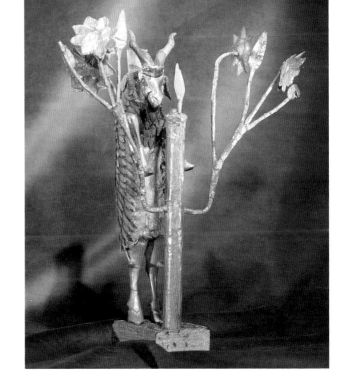

90. *Ram and Tree.* Offering stand from Ur. c. 2600 B.C. Wood, gold, and lapis lazuli, height 20" (50.7 cm).
University of Pennsylvania Museum, Philadelphia

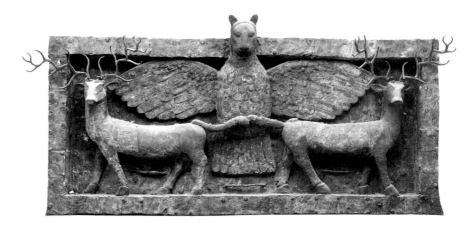

91. *Imdugud and Two Stags.* c. 2500 B.C. Copper over wood, 3' 6 1/8" x 7' 10" (1 x 2.3 m). The British Museum, London

against a flowering tree. The animal, marvelously alive and energetic, has an almost demonic power of expression as it gazes at us from between the branches of the symbolic tree. And well it might, for it is sacred to the god Tammuz and thus embodies the male principle in nature. Even more astonishing is the copper relief of the storm god Imdugud in the guise of a lion-headed eagle between two heraldically arranged stags (fig. 91), which probably came from a lintel over a doorway. Here the awesome power of Mesopotamian gods and goddesses becomes terrifyingly clear.

Such an association of animals with deities is a carry-over from prehistoric times (see pages 52–53). We find it not only in Mesopotamia but in Egypt as well (see the falcon of Horus in fig. 51). What distinguishes the sacred animals of the Sumerians is the active part they play in mythology. Much of this lore, unfortunately, has not come down to us in written form, but tantalizing glimpses of it can be caught in pictorial representations such as those on an inlaid panel from a harp (fig. 92) that was recovered together with the offering stand at Ur. The hero embracing two human-headed bulls in the top compartment was so popular a subject that its design has become a rigidly symmetrical, decorative formula. The other sections, however, show animals performing a variety of human tasks in surprisingly lively and precise fashion. The wolf and the lion carry food and drink to an unseen banquet, while the ass, bear, and deer provide musical entertainment. (The bull-headed harp is the same type as the instrument to which the inlaid panel was attached.) At the bottom, a scorpion-man and a goat carry some objects they have taken from a large vessel.

The skillful artist who created these scenes was far less constrained by rules than the Egyptian. Even though the figures, too, are placed on ground-lines, there is no fear of overlapping forms or foreshortened shoulders. However, we must be careful not to misinterpret the intent. What strikes the modern eye as delightfully humorous was probably meant to be viewed with perfect seriousness. If we only knew the context in which these actors play their roles! The animals, which probably descend from tribal totems or worshipers wearing masks, presumably represent deities engaged in familiar

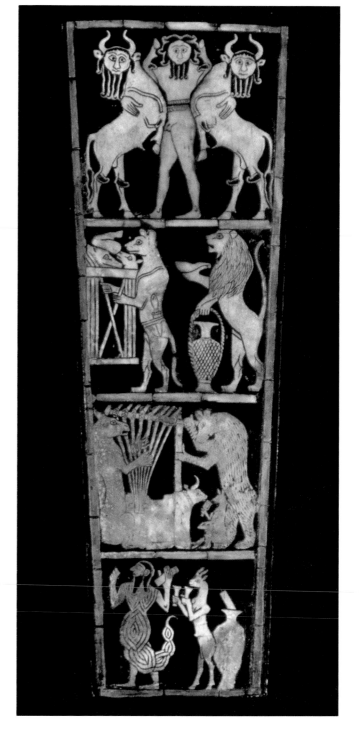

92. Inlay panel from the soundbox of a lyre, from Ur.
c. 2600 B.C. Shell and bitumen, 12 1/4 x 4 1/2" (31.1 x 11.3 cm).
University of Pennsylvania Museum, Philadelphia

93. *Standard of Ur*, front and back sides. c. 2600 B.C. Wood inlaid with shell, limestone, and lapis lazuli, height 8" (20.3 cm). The British Museum, London

human activities. Nevertheless, we are entitled to regard them as the earliest known ancestors of the animal fable that flourished in the West from Aesop to La Fontaine. The ass with the harp and the hero between two animals survived as fixed images, and we encounter them almost 4,000 years later in medieval sculpture.

The royal *Standard of Ur*, which celebrates an important military victory, attests to the Sumerian artist's sophistication at inlaywork (fig. 93). The side depicting "war" records the conquest itself in fascinating detail, including costume elements and a row of chariots pulled by wild asses known as onagers, with a driver and spearman in each chariot; the "peace" side shows officials in celebration as animals are shepherded in for the feast, while onagers and other booty are being brought back on the bottom register. The triangular end panels of the standard also had animal scenes. The figures have the same squat proportions and rounded forms as the statues from

Tell Asmar. Here the artist observes the combination of profile and frontal views familiar to us from Egyptian art, which became the convention in Mesopotamia as well.

Akkadian

Toward the end of the early dynastic period, the theocratic socialism of the Sumerian city-states began to decay. The local "stewards of the god" had in practice become reigning monarchs, and the more ambitious among them attempted to enlarge their domain by conquering their neighbors. At the same time, the Semitic-speaking inhabitants of northern Mesopotamia drifted south in ever larger waves, until they outnumbered the Sumerian peoples in many places. These newer arrivals had adopted many features of Sumerian civilization but were less bound to the tradition of the city-state. So it is perhaps not surprising that Sargon of Akkad (his name

94. *Head of an Akkadian Ruler,* from Nineveh (Kuyunjik), Iraq.
c. 2300–2200 B.C. Bronze, height 12" (30.7 cm).
Iraq Museum, Baghdad

means "true king") and his successors (2340–2180 B.C.) were the first Mesopotamian rulers who openly called themselves kings and proclaimed their ambition to rule the entire earth.

Sargon reorganized the Sumerian and Akkadian gods and goddesses into a new pantheon to help unite the country and break down the traditional identification between cities and their deities. Under these Akkadians, Sumerian art faced a new task: the personal glorification of the sovereign. The most impressive work of this kind that has survived is a magnificent royal portrait head in bronze from Nineveh (fig. 94). Despite the gouged-out eyes (once inlaid with precious materials), it remains a persuasive likeness, majestic and humanly moving at the same time. Equally admirable is the richness of the surfaces framing the face. The plaited hair and the finely curled strands of the beard are shaped with incredible precision, yet without losing their organic character and becoming mere ornament. The complex technique of casting and chasing has been handled with an assurance that bespeaks true mastery. This head could hold its own in the company of the greatest works of any period.

STELE OF NARAM-SIN. Sargon's grandson, Naram-Sin, had himself and his victorious army immortalized in relief on a large stele (fig. 95)—an upright stone slab used as a marker—which owes its survival to the fact that at a later time it was carried off as booty to Susa, where modern archaeologists discovered it. Here rigid ground-lines have been discarded, and we see the king's forces advancing among the trees on a mountainside. Above them, Naram-Sin alone stands trium-

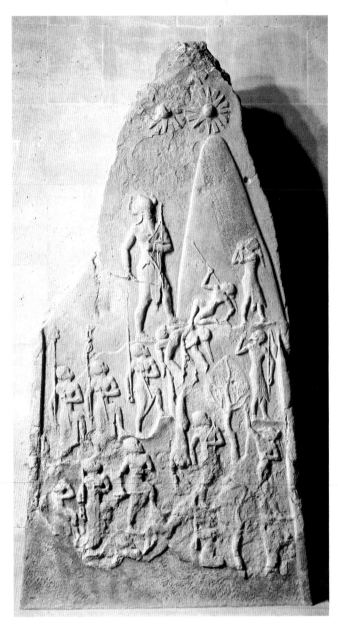

95. *Victory Stele of Naram-Sin.* c. 2300–2200 B.C.
Stone, height 6'6" (2 m). Musée du Louvre, Paris

phant, as the defeated enemy soldiers plead for mercy. He is as vigorously active as his men, but his size and his isolated position endow him with superhuman status. Moreover, he wears the horned crown hitherto reserved for the gods. There is nothing above him except the mountaintop and the celestial bodies, his "good stars."

Ur

The rule of the Akkadian kings came to an end when tribesmen from the northeast descended into the Mesopotamian plain and gained mastery of it for more than half a century. They were driven out in 2125 B.C. by the kings of Ur, who reestablished a united realm that was to last a hundred years.

GUDEA. During the period of foreign dominance, Lagash (the modern Telloh), one of the lesser Sumerian city-states, managed to retain local independence. Its ruler, Gudea, was

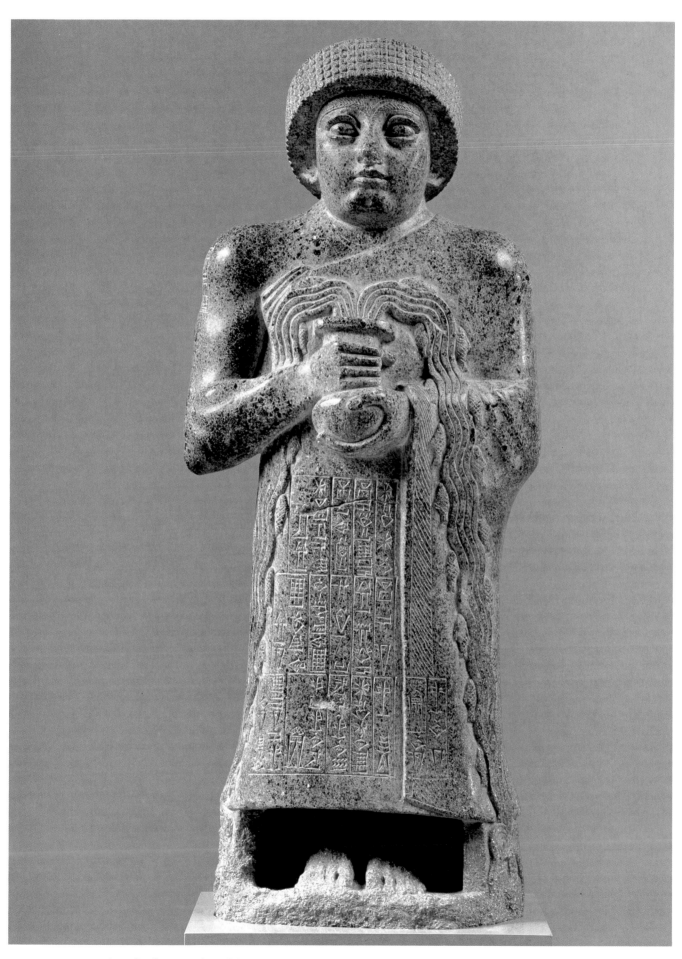

96. *Gudea,* from Lagash (Telloh), Iraq. c. 2120 B.C. Diorite, height 29" (73.7 cm). Musée du Louvre, Paris

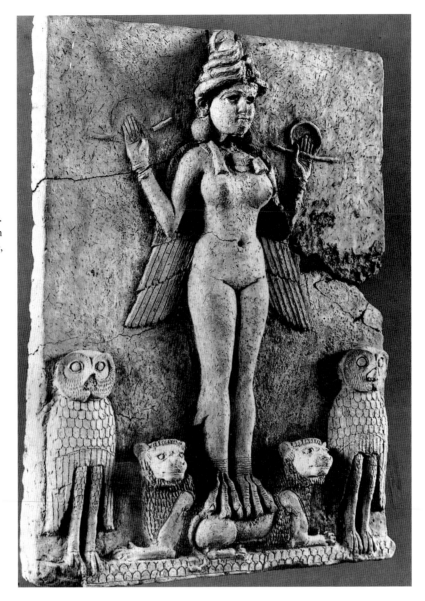

97. *Inanna-Ishtar.*
c. 2025–1763 B.C.
Terracotta, height approx.
20" (50.8 cm). Collection
Colonel Norman Colville,
United Kingdom

careful to reserve the title of king for the city-god, whose cult he promoted by an ambitious rebuilding of his temple. [See Primary Sources, no. 3, pages 212–13.] Of this architectural enterprise nothing remains today, but Gudea also had numerous statues of himself placed in the shrines of Lagash, and some twenty examples, all obviously of the same general type, have been found so far. Carved of diorite, an extremely hard stone favored by Egyptian sculptors, they are much more ambitious works than their predecessors from Tell Asmar. Even Gudea, however devoted he was to the traditional pattern of the Sumerian city-state, seems to have inherited something of the sense of personal importance that we felt in the Akkadian kings, although he prided himself on his intimate relations with the gods rather than on secular power.

The head in a statue of Gudea (fig. 96) appears much less distinctly individualized when compared with that of the Akkadian ruler, yet its fleshy roundness is far removed from the geometric simplicity of the Tell Asmar statues. Gudea holds a vase from which flow two streams of life-giving water representing the Tigris and Euphrates. (Mesopotamia was known as the Land of the Two Rivers.) This attribute was otherwise reserved for water goddesses and female votive figures, although the statue was dedicated to Geshtinanna, the goddess of poetry and interpreter of dreams. It probably alludes to the king's important role in providing irrigation canals for his people and attests to his beneficent rule. The stone has been worked to a high and subtly accented finish, inviting a wonderful play of light upon the features. The figure makes an instructive contrast with such Egyptian statues as in figures 63 and 65. The Sumerian carver has rounded off all the corners to emphasize the cylindrical quality of the forms. Equally characteristic is the muscular tension in Gudea's bare arm and shoulder, compared with the passive, relaxed limbs of Egyptian statues.

Babylonian

The second millennium B.C. was a time of almost continuous turmoil in Mesopotamia. The ethnic upheaval that brought the Hyksos to Egypt had an even more disruptive effect on the valley of the Tigris and Euphrates, where the invasion of the Elamites from the east and Amorites from the northwest gave rise to the rival city-states of Isin and Larsa after 2025 B.C. As we might expect, the art and architecture that have come down to us from this period of turmoil are unassuming. Sculpture consists for the most part of small terracotta reliefs.

Among them is a cult statue of remarkable quality (fig. 97). The sculpture is modeled so deeply as to be nearly in the round, lending it a monumentality that belies the modest size.

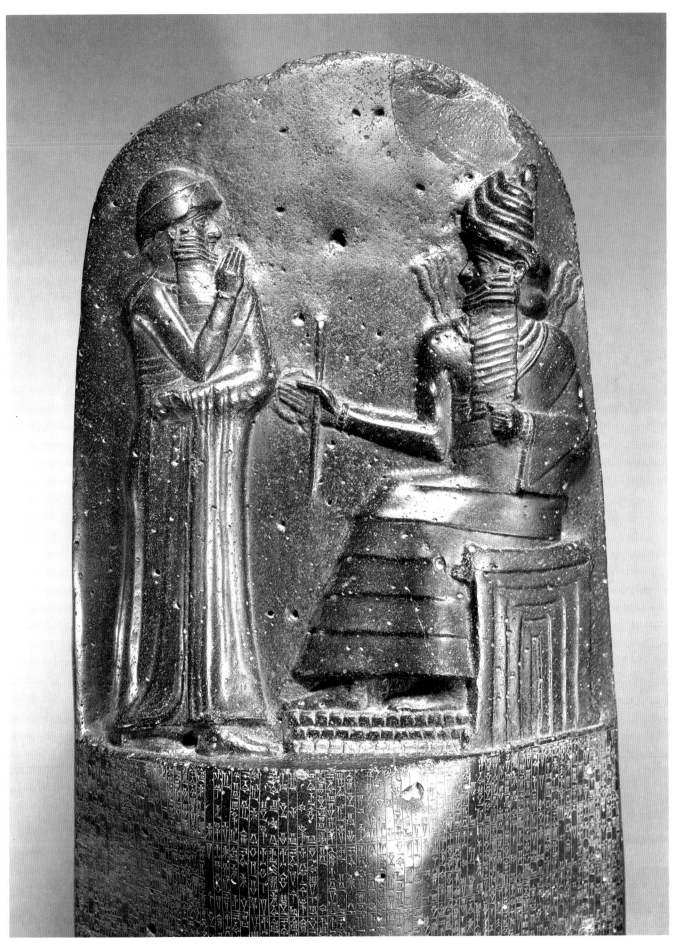

98. Upper part of stele inscribed with the Law Code of Hammurabi. c. 1760 B.C. Diorite, height of stele approx. 7' (2.1 m); height of relief 28" (71 cm). Musée du Louvre, Paris

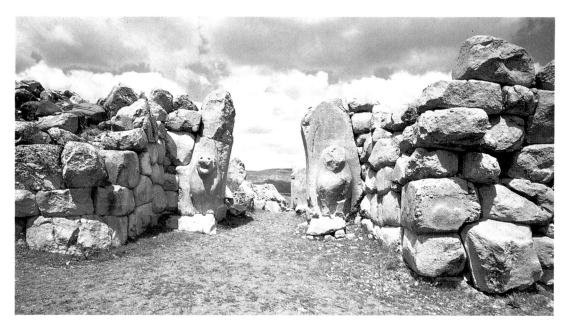

99. The Lion Gate, Bogazköy, Anatolia, Turkey. c. 1400 B.C.

Who can this winged creature with taloned feet be? She is Inanna-Ishtar, whose emblem is the lion. One of the most widely worshiped of all Mesopotamian deities, she unites the Sumerian goddess of fertility with the winged Semitic goddess of war and hunting. The four-horned headdress is a sign of divinity. Characteristic of Ishtar in her guise as the goddess of love, identified with the planet Venus, is the figure's voluptuous nudity. Missing, however, are Ishtar's key attributes: weapons in her hands and sprouting from her shoulders. Instead, she bears in each hand the rod and ring of kingship, which she brought with her in her descent into the underworld for her consort Tammuz's return. The myth of Ishtar's descent into the underworld is a paradigm of feminine self-discovery and empowerment: in it, she is stripped by the goddess of death of all her vestments, which are eventually returned to her, and she emerges transformed by the experience. She is, then, also a goddess of death and resurrection, further denoted by the owl, which also establishes her as Kilili, the forerunner of the Assyrian storm goddess Lilitu and the Semitic demon Lilith. This conflation of identities is typical of Sumerian religion as the ancient deities were united into a comprehensive pantheon. Yet the image, unprecedented in Mesopotamian art, remains unique, for it is never found again.

Central power by native rulers prevailed only from about 1760 to 1600 B.C., when Babylon assumed the role formerly played by Akkad and Ur. Hammurabi (c. 1792–1750 B.C.), the founder of the Babylonian dynasty, is by far the greatest figure of the age. Combining military prowess with a deep respect for Sumerian tradition, he saw himself as "the favorite shepherd" of the sun-god Shamash, whose mission was "to cause justice to prevail in the land." Under him and his successors, Babylon became the cultural center of Sumer. The city was to retain this prestige for more than a thousand years after its political power had waned.

CODE OF HAMMURABI. Hammurabi's most memorable achievement is his law code, justly famous as among the earliest uniform written bodies of laws and amazingly rational and humane in conception. He had it engraved on a tall diorite stele whose top shows Hammurabi confronting the sun-god, seen holding the ring and rod of kingship, which here stand for justice as well (fig. 98). The ruler's right arm is raised in a speaking gesture, as if he were reporting his work of codification to the divine king. Although this scene was carved four centuries after the Gudea statues, it is closely related to them in both style and technique. In fact, the relief here is so high that the two figures almost give the impression of statues sliced in half when we compare them with the pictorial treatment of the Naram-Sin stele (fig. 95). As a result, the sculptor has been able to render the eyes in the round, so that Hammurabi and Shamash gaze at each other with a force and directness unique in representations of this kind. They make us recall the statues from Tell Asmar (see fig. 89), whose enormous eyes indicate an attempt to establish the same relationships between humans and god in an earlier phase of Sumerian civilization.

ASSYRIAN ART

The city-state of Assur on the upper course of the Tigris owed its rise to power to a strange chain of events. During the earlier half of the second millennium B.C., Asia Minor had been invaded from the east by people of Indo-European language. One group, the Mitannians, created an independent kingdom in Syria and northern Mesopotamia, including Assur, while another, the Hittites, established themselves farther north on the rocky plateau of Anatolia. Their capital, near the present-day Turkish village of Bogazköy, was protected by impressive fortifications built of large, roughly cut stones. Flanking the gates were lions or other guardian figures protruding from the enormous blocks that formed the jambs of the doorway (fig. 99).

About 1360 B.C., the Hittites attacked the Mitannians, who were allies of the Egyptians. But the latter, because of the internal crisis provoked by the religious reforms of Akhenaten (see page 72), could send no effective aid. Consequently, the Mitannians were defeated and Assur regained its independence. Under a series of able rulers, the Assyrian domain grad-

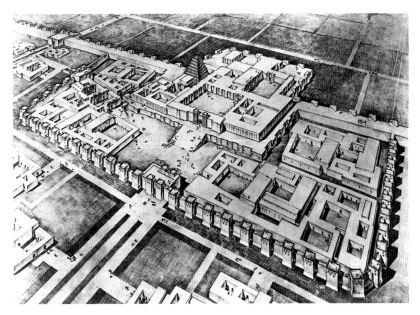

100. Citadel of Sargon II, Dur Sharrukin (Khorsabad), Iraq. 742–706 B.C. (reconstruction by Charles Altman)

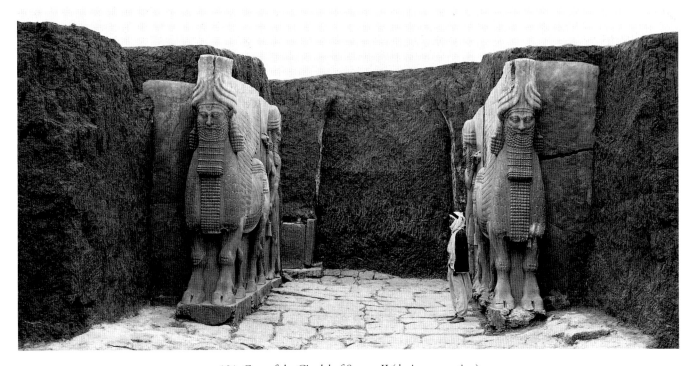

101. Gate of the Citadel of Sargon II (during excavation)

ually expanded until it embraced not only Mesopotamia proper but the surrounding regions as well. At the height of its power, from about 1000 to 612 B.C., the Assyrian empire stretched from the Sinai peninsula to Armenia. Even Lower Egypt was successfully invaded about 670 B.C.

Palaces and Their Decoration

The Assyrians, it has been said, were to the Sumerians what the Romans were to the Greeks. Assyrian civilization drew on the achievements of the south but reinterpreted them to fit its own distinct character. Thus the temples and ziggurats they built were adapted from Sumerian models, while the palaces of Assyrian kings grew to unprecedented size and magnificence.

DUR SHARRUKIN. One of these, that of Sargon II (died 705 B.C.) at Dur Sharrukin (the modern Khorsabad), dating from the second half of the eighth century B.C., has been explored sufficiently to permit a reconstruction (fig. 100). It was surrounded by a citadel with turreted walls that shut it off from the rest of the town. Figure 101 shows one of the two gates of the citadel in the process of excavation. Although the Assyrians, like the Sumerians, built in brick, they liked to line gateways and the lower walls of important interiors with great slabs of stone (which were less difficult to procure in northern Mesopotamia). These slabs were either decorated with low reliefs or, as in our case, elaborated into guardian demons that are an odd combination of relief and sculpture in the round. They must have been inspired by Hittite examples such as the

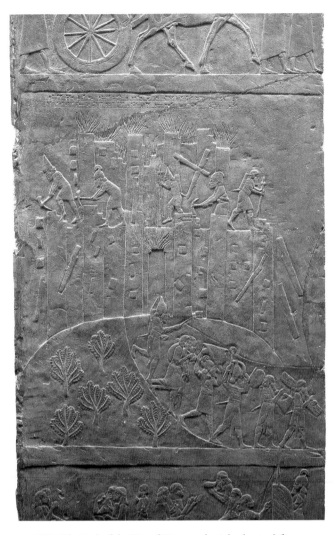

102. *The Sack of the City of Hamanu by Ashurbanipal,* from the Palace of Ashurbanipal, Nineveh (Kuyunjik), Iraq. c. 650 B.C. Limestone, 36 x 24¹/2" (92.7 x 62.2 cm). The British Museum, London

Lion Gate at Bogazköy (fig. 99). Awesome in size and appearance, the gates were meant to impress the visitor with the power and majesty of the king.

Inside the palace, the same impression was reinforced by long series of reliefs illustrating the conquests of the royal armies. Every campaign is described in detail, with inscriptions supplying further data. The Assyrian forces, relentlessly efficient, always seem to be on the march, meeting the enemy at every frontier of the overextended empire, destroying his strong points and carrying away booty and prisoners. There is neither drama nor heroism in these scenes—the outcome of the battle is never in doubt—and they are often depressingly repetitious. Yet, as the earliest large-scale efforts at narrative in the history of art, they represent an achievement of great importance. To describe the progress of specific events in time and space had been outside the scope of earlier Sumerian art; even the scene on the stele of Naram-Sin is symbolic rather than historic. The Assyrian artist thus had to develop an entirely new set of devices in order to cope with the requirements of pictorial storytelling.

NINEVEH. If the artist's results can hardly be called beautiful, they achieve their main purpose: to be clearly readable. This is certainly true of our example (fig. 102), from the Palace of Ashurbanipal (died 626? B.C.), at Nineveh (now Kuyunjik), which shows the sack of the Elamite city of Hamanu in the main register. Assyrian soldiers with pickaxes and crowbars are demolishing the fortifications (notice the falling timbers and bricks in midair) after they have set fire to the town itself. Still others are marching away from it, down a wooded hill, laden with booty. The latter group poses a particularly interesting problem in representation, for the road on which they walk widens visibly as it approaches the foreground, as if the artist had meant to render it in perspective. Yet the same road also serves as a curved band that frames the marchers. This may seem an odd mixture of modes, but it is an effective device for

103. *Ashurnasirpal II Killing Lions,* from the Palace of Ashurnasirpal II, Nimrud (Calah), Iraq. c. 850 B.C. Limestone, 3'3" x 8'4" (1 x 2.5 m). The British Museum, London

104. *Dying Lioness,* from Nineveh (Kuyunjik), Iraq. c. 650 B.C. Limestone, height of figure 13 3/4" (35 cm).
The British Museum, London

linking foreground and background. Below the main scene, we observe the soldiers at camp, relaxing with food and drink, while one of them, at far right, stands guard.

LION HUNTS. The mass of descriptive detail in the reliefs of military campaigns often leaves little room for the personal glorification of the king. This purpose is served more directly by another recurrent subject, the royal lion hunts. As in Egypt, whence they derive (see fig. 83), they were more in the nature of ceremonial combats than actual hunts: the animals for the king to kill were released from cages into a square formed by troops with shields. (Presumably, at a much earlier time, the hunting of lions in the field had been an important duty of Mesopotamian rulers as the "shepherds" of the communal flocks.) Here the Assyrian relief sculptor rises to his greatest heights. In figure 103, from the Palace of Ashurnasirpal II (died 860? B.C.) at Nimrud (Calah), the lion attacking the royal chariot from the rear is clearly the hero of the scene. Of magnificent strength and courage, the wounded animal seems to embody all the dramatic emotion that we miss in the pictorial accounts of war. The dying lion on the right is equally impressive in its agony. How differently the Egyptian artist (see fig. 83) had interpreted the same composition! We need only compare the horses: the Assyrian ones are less graceful but very much more energetic and alive as they flee from the attacking lion, their ears folded back in fear. The lion hunt reliefs from Nineveh, about two centuries later than those of

Nimrud, are the finest of all. Despite the shallowness of the actual carving, the bodies have a greater sense of weight and volume because of the subtle gradations of the surface. Images such as the dying lioness (fig. 104) have an unforgettable tragic grandeur.

Neo-Babylonian

The Assyrian empire came to an end in 612 B.C., when Nineveh fell before the combined onslaught of Medes and Scythians from the east. At that time the commander of the Assyrian army in southern Mesopotamia made himself king of Babylon. Under him and his successors the ancient city had a final brief flowering between 612 and 539 B.C., before it was conquered by the Persians. The best known of these Neo-Babylonian rulers was Nebuchadnezzar (died 562 B.C.), the builder of the Tower of Babel. That famous structure represented only one part of a very large architectural complex comparable to the Citadel of Sargon II at Dur Sharrukin.

Whereas the Assyrians had used carved stone slabs, the Neo-Babylonians (who were farther removed from the sources of such slabs) substituted baked and glazed brick. This technique, too, had been developed in Assyria, but now it was used on a far larger scale, both for surface ornament and for architectural reliefs. Its distinctive effect becomes evident if we compare the gate of Sargon's citadel (fig. 101) with the Ishtar Gate of Nebuchadnezzar's sacred precinct in Babylon, which

105. Ishtar Gate (restored), from Babylon, Iraq. c. 575 B.C. Glazed brick. Staatliche Museen zu Berlin, Preussischer Kulturbesitz, Vorderasiatisches Museum

has been rebuilt from the thousands of individual glazed bricks that covered its surface (fig. 105). The stately procession of bulls, dragons, and other animals of molded brick within a framework of vividly colored ornamental bands has a grace and gaiety far removed from the ponderous guardian monsters of the Assyrians. Here, for the last time, we sense again that special genius of ancient Mesopotamian art for the portrayal of animals which we noted in early dynastic times.

PERSIAN ART

Persia, the mountain-fringed high plateau to the east of Mesopotamia, takes its name from the people who occupied Babylon in 539 B.C. and became the heirs of what had been the Assyrian empire. Today the country is called Iran, its older and more suitable name, since the Persians, who put the area on the map of world history, were latecomers who had arrived on the scene only a few centuries before they began their epochal conquests. Inhabited continuously since prehistoric times, Iran seems always to have been a gateway for migratory tribes from the Asiatic steppes to the north as well as from India to the east. The new arrivals would settle down for a while, dominating or intermingling with the local population, until they in turn were forced to move on—to Mesopotamia,

to Asia Minor (roughly, Asian Turkey), to southern Russia— by the next wave of migrants.

These movements form a shadowy area of historical knowledge; all available information is vague and uncertain. Since nomadic tribes leave no permanent monuments or written records, we can trace their wanderings only by a careful study of the objects they buried with their dead. Such objects, of wood, bone, or metal, represent a distinct kind of portable art which we call the nomad's gear: weapons, bridles for horses, buckles, fibulas and other articles of adornment, cups, bowls, and the like. They have been found over a vast area, from Siberia to Central Europe, from Iran to Scandinavia. They have in common not only a jewellike concentration of ornamental design but also a repertory of forms known as the "animal style." And one of the sources of this animal style appears to be ancient Iran.

ANIMAL STYLE. Its main feature, as the name suggests, is the decorative use of animal motifs in a rather abstract and imaginative manner. We find its earliest ancestors on the prehistoric painted pottery of western Iran, such as the fine beaker in figure 106, which shows an ibex (a wild mountain goat) reduced to a few sweeping curves, so that the body of the animal becomes a mere appendage of the huge horns. The racing

106. Painted beaker, from Susa. c. 5000–4000 B.C. Height 11 1/4"
(28.3 cm). Musée du Louvre, Paris

107. Pole-top ornament, from Luristan(?),
western Iran. 10th–7th century B.C. Bronze, height 7 1/2" (19 cm).
The British Museum, London

108. *Stag,* from Kostromskaya. Scythian.
7th–6th century B.C. Chased gold, height approx. 12" (30.5 cm).
Hermitage Museum, St. Petersburg

hounds above the ibex are little more than horizontal streaks, and on closer inspection the striations below the rim turn out to be long-necked birds. In the historic art of Sumer, this style soon gave way to an interest in the organic unity of animal bodies (see figs. 90 and 92), but in Iran it survived despite the powerful influence of Mesopotamia.

Several thousand years later, in the tenth to seventh centuries B.C., the style reappears in the small bronzes that may come from the Luristan region in western Iran, though the origin and date are by no means certain. The pole-top ornament (fig. 107) represents nomad's gear of a particularly resourceful kind. It consists of a symmetrical pair of rearing ibexes with vastly elongated necks and horns. Originally, we suspect, they were pursued by a pair of lions, but the bodies of the latter have been absorbed into those of the ibexes, whose necks have been pulled out to dragonlike slenderness. By and for whom the Luristan bronzes were produced remains something of a mystery. There can be little doubt, however, that they are somehow linked with the animal-style metalwork of the Asiatic steppes, such as the splendid Scythian gold stag from southern Russia, which is somewhat later in date (fig. 108). The animal's body here shows far less arbitrary distortion, and the smoothly curved sections divided by sharp ridges have no counterpart among Luristan bronzes; yet the way the antlers have been elaborated into an abstract openwork ornament betrays a similar feeling for form. In its compact form we will recognize the descendant of the prehistoric *Bison* from La Madeleine (fig. 36).

Whether or not this typically Scythian piece reflects Central Asiatic sources independent of the Iranian tradition, the Scythians surely learned a good deal from the bronze casters of Luristan during their stay in Iran; as we shall see, they con-

tributed something in return to Persian art. The Scythians belonged to a group of nomadic Indo-European tribes, including the Medes and the Persians, that began to filter into the country soon after 1000 B.C. An alliance of Medes and Scythians, it will be recalled, had crushed Nineveh in 612 B.C. The Persians at that time were vassals of the Medes, but only 60 years later, under Cyrus the Great of the family of the Achaemenids, they reversed this situation.

109. *(left)* Plan of the Palace of Darius and Xerxes, Persepolis. 518–460 B.C. Solid triangles show the processional route taken by Persian and Mede notables; open triangles indicate the way taken by heads of delegations and their suites

0 25 50 75 100 meters
0 100 200 300 feet

Achaemenid

After conquering Babylon in 539 B.C., Cyrus (c. 600–529 B.C.) assumed the title king of Babylon along with the ambitions of the Assyrian rulers. The empire he founded continued to expand under his successors. Egypt as well as Asia Minor fell to them, and Greece escaped the same fate only by the narrowest of margins. At its high tide, under Darius I (c. 550–486 B.C.) and Xerxes (519–465 B.C.), the Persian empire was far larger than its Egyptian and Assyrian predecessors together. Moreover, this huge domain endured for two centuries, and during most of its life it was ruled both efficiently and humanely. For an obscure tribe of nomads to have achieved all this is little short of miraculous. Within a single generation, the Persians not only mastered the complex machinery of imperial administration but also evolved a monumental art of remarkable originality to express the grandeur of their rule. Despite their genius for adaptation, the Persians retained their own religious beliefs drawn from the prophecies of Zoroaster. This faith was based on the dualism of Good and Evil, embod-

110. Audience Hall of Darius and Xerxes, Persepolis, Iran. c. 500 B.C.

111. Bull capital, from Persepolis. c. 500 B.C. Musée du Louvre, Paris

bled on a raised platform—recalls the royal residences of Assyria (see fig. 100). Assyrian traditions are the strongest single element throughout. Yet they do not determine the character of the building, for they have been combined with influences from every corner of the empire in such a way that the result is a new, uniquely Persian style. Thus at Persepolis columns are used on a grand scale. The Audience Hall of Darius and Xerxes, a room 250 feet square, had a wooden ceiling supported by 36 columns 40 feet tall, a few of which are still standing (fig. 110). Such a massing of columns suggests Egyptian architecture (compare fig. 74), and Egyptian influence does indeed appear in the ornamental detail of the bases and capitals, but the slender, fluted shaft of the Persepolis columns is derived from the Ionian Greeks in Asia Minor, who are known to have furnished artists to the Persian court. Entirely without precedent in earlier architecture is the strange "cradle" for the beams of the ceiling, composed of the front parts of two bulls or similar creatures, that crowns the Persepolis columns (fig. 111). While the animals themselves are of Assyrian origin, the way they are combined suggests nothing so much as an enormously enlarged version of the pole-top ornaments of Luristan. This seems to be the only instance of Persian architects drawing upon their native artistic heritage of nomad's gear (fig. 107).

The double stairway leading up to the Audience Hall is decorated with long rows of solemnly marching figures in low relief (fig. 110). Their repetitive, ceremonial character emphasizes a subservience to the architectural setting that is typical of all Persian sculpture. We find it even in scenes of special importance, such as *Darius and Xerxes Giving Audience* (fig. 112). Here the expressive energy and narrative skill of Assyrian relief have been deliberately rejected.

ied in Ahuramazda (Light) and Ahriman (Darkness). Since the cult of Ahuramazda centered on fire altars in the open air, the Persians had no religious architecture. Their palaces, on the other hand, were huge and impressive structures.

PERSEPOLIS. The most ambitious palace, at Persepolis, was begun by Darius I in 518 B.C. Its general layout as shown in figure 109—a great number of rooms, halls, and courts assem-

PERSIAN STYLE. The style of these Persian carvings seems at first glance to be only a softer and more refined echo of the Mesopotamian tradition. Even so, we discover that the Assyrian-Babylonian heritage has been enriched in one important respect. There is no precedent in Near Eastern sculpture for the layers of overlapping garments, for the play of finely pleated folds such as we see in the Darius and Xerxes relief. Another

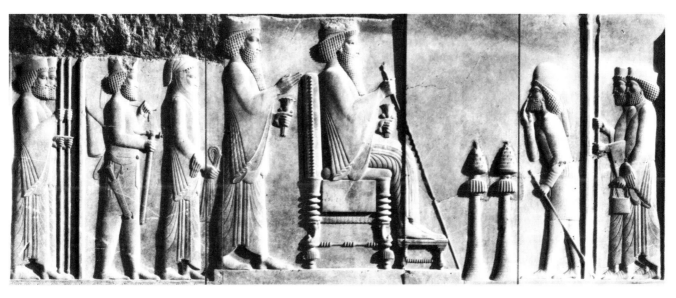

112. *Darius and Xerxes Giving Audience.* c. 490 B.C. Limestone, height 8'4" (2.5 m). Archaeological Museum, Teheran

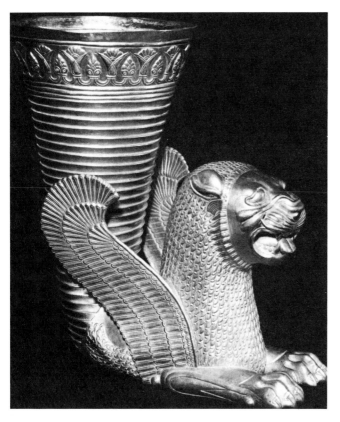

113. Gold rhyton. Achaemenid. 5th–3rd century B.C. Archaeological Museum, Teheran

surprising effect is the way the arms and shoulders of these figures press through the fabric of the draperies. These innovations stem from the Ionian Greeks, who had created them in the course of the sixth century B.C.

Persian art under the Achaemenids, then, is a remarkable synthesis of many diverse elements. Yet it lacked a capacity for growth. The style formulated under Darius I about 500 B.C. continued without significant change until the end of the empire. The Persians, it seems, maintained a preoccupation with decorative effects regardless of scale, a carry-over from their nomadic past that they never discarded. There is no essential difference between the bull capital (fig. 111) and the rhyton (drinking cup) in figure 113, which maintains the virtues of the animal style in its wonderfully imaginative transformation of the lion sprouting griffin's wings. The ferocious beast, descended from the magnificent animals of Assyrian reliefs (figs. 103 and 104), has been tamed, thanks to the small scale and fine goldsmith's work, which reveals a debt to the Scythian stag (fig. 108). The tradition of portable art in Achaemenid Persia, unlike that of monumental architecture and sculpture, somehow managed to survive the more than 500 years during which the Persian empire was under Greek and Roman domination, so that it could flower once more when Persia regained its independence.

Sassanian

The Achaemenids were toppled by Alexander the Great (356–323 B.C.) in 331 B.C. Following his death eight years

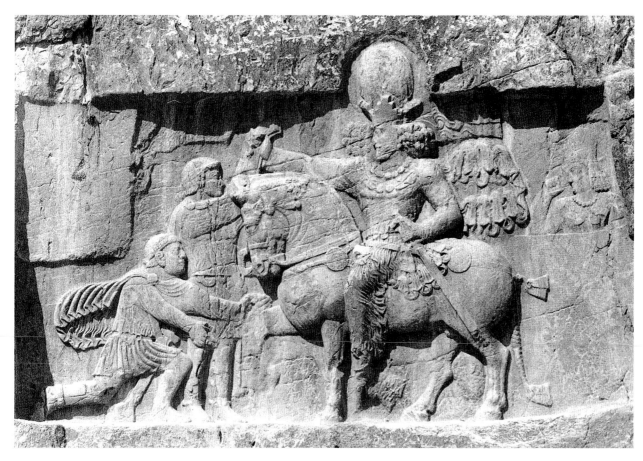

114. *Shapur I Triumphing over the Emperors Philippus the Arab and Valerian.* 260–72 A.D. Naksh-i-Rustam (near Persepolis), Iran

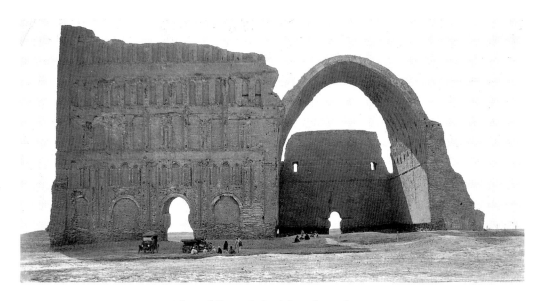

115. Palace of Shapur I, Ctesiphon, Iraq. 242–72 A.D.

later, his realm was divided among his generals. Seleucis (reigned 312–281 B.C.) received much of the Near East except Egypt, which was given to Ptolemy (died 284 B.C.). The Seleucids were succeeded by the Parthians, who established their control over the region in 238 B.C. The Parthians were ferocious fighters, who successfully fended off the Romans until the time of Trajan in the second century A.D. Although their power subsequently declined, it was not until 224 A.D. that Artabanus V, the last Parthian king, was overthrown by one of his governors, Ardashir (died 240 A.D.), who set up the Sassanian dynasty, which endured until it fell to the Arabs in 651 A.D. Throughout the Parthian and Sassanian eras, Mesopotamia was part of the Greek and Roman world, though it retained elements of its ancient culture.

The greatest Sassanian ruler, Shapur I (died 272 A.D.) had the political and artistic ambitions of Darius. At Naksh-i-Rustam, the burial place of the Achaemenid kings not far from Persepolis, he commemorated his victory over two Roman emperors in an enormous relief hewn into the rock (fig. 114). The formal source of this scene of triumph is a well-known composition in Roman sculpture, with the emperors now in the role of the humiliated barbarians. The style, too, is Roman (compare fig. 272), but the flattening of the volumes and the ornamental elaboration of the draperies indicate a revival of Persian qualities. The two elements hold each other in balance, and that is what makes the relief so strangely impressive. A blending of Roman and Near Eastern elements can also be observed in Shapur's palace at Ctesiphon, near Babylon, with its enormous brick-vaulted audience hall (fig. 115). The blind arcades of the facade, strikingly Roman in flavor (compare fig. 245), again emphasize decorative surface pattern.

But monumental art under Sassanian rule proved as incapable of further evolution as it had under the Achaemenids. Metalwork and textiles, on the other hand, continued to flourish. The chief glory of Sassanian art—and a direct echo of the ornamental tradition reaching back more than a thousand years to the Luristan bronzes—is its woven silks, such as the splendid example in figure 116. They were copiously exported both to Constantinople and to the Christian West, and we

116. Woven silk. Sassanian. c. 6th century A.D. Museo Nazionale del Bargello, Florence. Franchetti Collection

shall see that their wealth of colors and patterns exerted an important stimulus upon the art of the Middle Ages. And since their manufacture was resumed after the Sassanian realm fell to the Arabs in the mid-seventh century, they provided an essential treasury of design motifs for Islamic art as well.

CHAPTER FOUR

AEGEAN ART

If we sail from the Nile Delta northwestward across the Mediterranean, our first glimpse of Europe will be the eastern tip of Crete. Beyond it, we find a scattered group of small islands, the Cyclades, and, a little farther on, the mainland of Greece, facing the coast of Asia Minor across the Aegean Sea. To archaeologists, "Aegean" is not merely a geographical term. They have adopted it to designate the civilizations that flourished in this area during the third and second millenniums B.C., before the development of Greek civilization proper. There are three of these, closely interrelated yet distinct from each other: that of Crete, called Minoan after the legendary Cretan King Minos; that of the small islands north of Crete (Cycladic); and that of the Greek mainland (Helladic), which includes Mycenaean civilization. Each of them has in turn been divided into three phases, Early, Middle, and Late, which correspond, very roughly, to the Old, Middle, and New Kingdoms in Egypt. The most important remains, and the greatest artistic achievements, date from the latter part of the Middle phase and from the Late phase.

Aegean civilization was long known only from Homer's account of the Trojan War in the *Iliad* and the *Odyssey*, as well as from Greek legends centering on Crete. The earliest excavations (by Heinrich Schliemann during the 1870s in Asia Minor and Greece and by Sir Arthur Evans in Crete shortly before 1900) were undertaken to test the factual core of these tales. Since then, a great amount of fascinating material has been brought to light—far more than the literary sources would lead us to expect. But even now our knowledge of Aegean civilization is very much more limited than our knowledge of Egypt or the ancient Near East. Unfortunately, our reading of the archaeological evidence has so far received limited aid from the written records of the Aegeans.

MINOAN SCRIPT AND LINEAR B. In Crete a system of writing was developed about 2000 B.C. A late form of this Minoan script, called Linear B, which was in use about six centuries later both in Crete and on the Greek mainland, was deciphered in the early 1950s. The language of Linear B is Greek, yet this apparently was not the language for which Minoan script was used before the fifteenth century B.C., so that being able to read Linear B does not help us to understand the great mass of earlier Minoan inscriptions. Moreover, the Linear B texts are largely palace inventories and administrative records, although they do reveal something about the history, religion, and political organization of the people who composed them. We thus lack a great deal of the background knowledge necessary for an understanding of Aegean art. Its forms, although linked both to Egypt and the Near East on the one hand and to later Greek art on the other, are no mere transition between these two worlds. They have a haunting beauty of their own that belongs to neither. Among the many strange qualities of Aegean art, and perhaps the most puzzling, is its air of freshness and spontaneity, which makes us forget how little we know of its meaning.

CYCLADIC ART

After about 2800 B.C. the people who inhabited the Cycladic Islands often buried their dead with marble sculptures of a peculiarly impressive kind. Almost all of them represent a nude female figure with arms folded across the chest (fig. 117). They also share a distinctive shape, which at first glance recalls the angular, abstract qualities of Paleolithic and Neolithic sculpture: the flat, wedge shape of the body, the strong, columnar neck, the tilted, oval shield of the face, and the long, ridgelike nose. (Other features were painted in.) Within this narrowly defined and stable type, however, the Cycladic figures show wide variations in scale and form. This lends them a surprising individuality.

The best of these Cycladic figures, such as that in figure 117, represent a late, highly developed phase around 2500–2400 B.C. Our example has a disciplined refinement

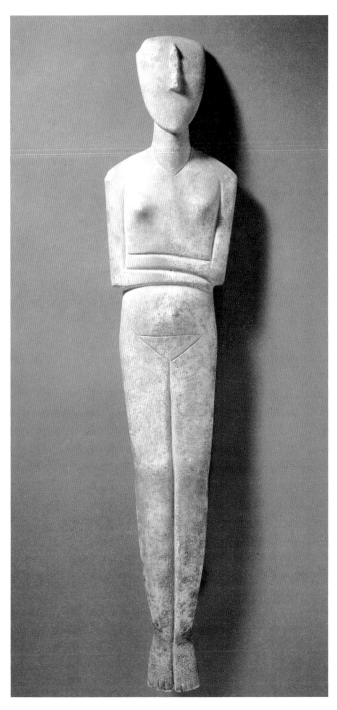

117. Figure, from Amorgos, Cyclades. c. 2500 B.C. Marble, height 30" (76.3 cm). Ashmolean Museum, Oxford, England

utterly beyond the range of Paleolithic or Neolithic art. The longer we study this piece, the more we come to realize that its qualities can only be defined as "elegance" and "sophistication," however incongruous such terms may seem in this context. What an extraordinary feeling for the organic structure of the body there is in the delicate curves of the outline, in the hints of convexity marking the knees and abdomen! Even if we discount its deceptively modern look, the figure seems a bold departure from anything we have seen before. There is no dearth of earlier female figures, but almost all of them betray their descent from the bulbous, heavy-bodied type of the Old Stone Age (fig. 35). In fact, the earliest Cycladic figurines, too, were of that kind.

We do not know what led Cycladic sculptors to adopt the lithe, "girlish" ideal of figure 117. The transformation was presumably related to a change in religious beliefs and practices *away* from the mother and fertility goddess known to us from Asia Minor and the ancient Near East, whose ancestry reaches far back to the Old Stone Age. The largest figures were probably cult statues to a female divinity who may have been identified with the sun in the great cycle of life and death, while the smaller ones might have been displayed in household shrines or even used as votive offerings. Although their meaning and function remain far from clear, their purpose was not simply funereal. Rather, they were important objects that were included in graves with others from everyday life, as either presents for the deity or provisions for the afterlife. Rarely were they free-standing. Most have been found in a reclining position, but they may also have been propped upright during normal use.

Be that as it may, the Cycladic sculptors of the third millennium B.C. produced the oldest large-scale figures of the female nude we know, and for many hundreds of years they were the only ones to do so. In Greek art, we find very few nude female statues until the middle of the fourth century B.C., when Praxiteles and others began to create cult images of the nude Aphrodite (see fig. 206). It can hardly be coincidence that the most famous of these Venuses were made for sanctuaries on the Aegean Islands or the coast of Asia Minor, the region where the Cycladic idols had flourished.

MINOAN ART

Minoan civilization is by far the richest, as well as the strangest, of the Aegean world. What sets it apart, not only from Egypt and the Near East but also from the Classical civilization of Greece, is a lack of continuity that appears to have been caused by archaeological accidents, as well as historical forces. The different phases appear and disappear so abruptly that their fate must have been determined by sudden violent changes affecting the entire island. Yet the character of Minoan art, which is gay, even playful, and full of rhythmic motion, conveys no hint of such threats.

Architecture

The first of these unexpected shifts occurred about 2000 B.C. Until that time, during the thousand years of the Early Minoan era, the Cretans had not advanced much beyond the Neolithic level of village life, even though they seem to have engaged in some overseas trade that brought them contact with Egypt. Then they created not only their own system of writing but an urban civilization as well, centering on several great palaces. At least three of them, at Knossos, Phaistos, and Mallia, were built in short order. Little is left today of this sudden spurt of large-scale building activity. The three early palaces were all destroyed at the same time, about 1700 B.C., demolished, it seems, by a catastrophic earthquake. After a short interval, new and even larger structures appeared on the same sites, only to suffer destruction, in their turn, by another earthquake about 1450 B.C. These were abandoned, except for the palace at Knossos, which was

118. Plan of the Palace of Minos, Knossos, Crete. The palace is organized in two wings, to east and west of a central court, and is on several levels: 1) stairway and theater area; 2) storerooms; 3) central court; 4) antechamber; 5) corridor of the procession; 6) throne room; 7) north pillar hall; 8) hall of the colonnade; 9) hall of the double axes; 10) queen's megaron; 11) queen's bath; 12) entrances and atriums

occupied by the Mycenaeans, who took over the island almost immediately.

Minoan civilization, therefore, has a complicated chronology. Archaeologists divide the period that concerns us into the Old Palace period, comprising Middle Minoan I and Middle Minoan II, which together lasted from 2000 B.C. until about 1700 B.C. The New Palace period includes Middle Minoan III (1700–1670 B.C.), Late Minoan IA (1670–1620 B.C.), and Late Minoan IB (1620–1490/1450 B.C.). The eruption of the volcano on the island of Thera (Santorini) occurred during the New Palace period, at the end of Late Minoan IA. It did little damage to Crete, however, and ushered in the Late Minoan IB period, which marked the peak of Minoan civilization. For our purposes, we need only remember that the Old Palace period coincides very roughly with the Middle Kingdom and the New Palace period with the onset of the New Kingdom in Egypt.

The "new" palaces are our main source of information on Minoan architecture. The one at Knossos, called the Palace of Minos, was the most ambitious, covering a large territory and composed of so many rooms that it survived in Greek legend as the labyrinth of the Minotaur (see fig. 118). It has been carefully excavated and partly restored. We cannot recapture the appearance of the building as a whole, but we can assume that the exterior probably did not look impressive compared with Assyrian or Persian palaces (see figs. 100 and 110). There was

119. Staircase, east wing, Palace of Minos, Knossos, Crete. c. 1500 B.C.

120. The Queen's Megaron, Palace of Minos, Knossos, Crete. c. 1700–1300 B.C.

no striving for unified, monumental effect. The individual units are generally rather small and the ceilings low (figs. 119 and 120), so that even those parts of the structure that were several stories high could not have seemed very tall.

Nevertheless, the numerous porticoes, staircases, and air-shafts must have given the palace a pleasantly open, airy quality. Some of the interiors, with their richly decorated walls, retain their atmosphere of intimate elegance to this day. The masonry construction of Minoan palaces is excellent through-out, but the columns were always of wood. Although none has survived (those in fig. 119 are reconstructions), their charac-teristic form (the smooth shaft tapering downward and topped by a wide, cushion-shaped capital) is known from rep-resentations in painting and sculpture. About the origins of this type of column, which in some contexts could also serve as a religious symbol, or about its possible links with Egyptian architecture, we can say nothing at all.

Who were the rulers that built these palaces? We do not know their names or deeds, except for the legendary Minos, but the archaeological evidence permits a few conjectures. They were not warrior princes, since no fortifications have been found anywhere in Minoan Crete, and military subjects are almost unknown in Minoan art. Nor is there any hint that they were sacred kings on the Egyptian or Mesopotamian model, although they may well have presided at religious fes-

tivals. The palaces certainly functioned as centers of religious life. However, the only parts that can be identified as places of worship are small chapels, suggesting that religious ceremonies took place out of doors, as well as at outlying shrines. On the other hand, the many storerooms, workshops, and "offices" at Knossos indicate that the palace was not only a royal residence but a great center of administrative and commercial activity. Shipping and trade formed an important part of Minoan eco-nomic life, to judge from elaborate harbor installations and from Cretan export articles found in Egypt and elsewhere. Perhaps, then, the king should be viewed as the head of a mer-chant aristocracy. Just how much power he wielded and how far it extended are still open to debate.

Sculpture

The religious life of Minoan Crete is even harder to define than the political or social order. It centered on certain sacred places, such as caves or groves; and its chief deity (or deities?) was fe-male, akin to the mother and fertility goddesses we have encountered before. Since the Minoans had no temples, we are not surprised to find that they lacked large cult statues as well, but even on a small scale, religious subjects in Minoan art are few in number and of uncertain significance. Two statuettes of about 1650 B.C. from Knossos must represent the goddess in

122. Rhyton in the shape of a bull's head, from Knossos. c. 1500–1450 B.C. Serpentine, crystal, and shell inlay (horns restored), height 8 1/8" (20.6 cm). Archaeological Museum, Heraklion, Crete

121. *"Snake Goddess."* c. 1650 B.C. Faience, height 11 5/8" (29.5 cm). Archaeological Museum, Heraklion, Crete

one of her several identities. One of them (fig. 121) shows her with three long snakes wound around her arms, body, and headdress. The meaning is clear: snakes are associated with earth deities and male fertility in many ancient religions, just as the bared breasts of our statuette suggest female fertility. Although the costume endows her with a secular, "fashionable" air, there can be little doubt that she is a goddess (compare fig. 123). The style of the statuette hints at a possible foreign source: the voluptuous bosom, the emphatically conical quality of the figure, and the large eyes and heavy, arched eyebrows suggest a kinship—remote and indirect, perhaps through Asia Minor—with Mesopotamian art (compare fig. 97).

Minoan civilization also featured a cult centering on bulls (see below). One of them is shown tamed on a splendid rhyton (drinking horn; fig. 122) carved from serpentine stone, with incised lines to indicate its shaggy fur, painted crystal eyes, and a shell-inlay muzzle, which create an astonishingly lifelike impression, despite its small size. (The horns are restored.) Not since the offering stand from Ur (fig. 90) have we seen such a magnificent beast in the round. Can it be that the Minoans learned how to carve from the artistic descendants of Mesopotamians more than a thousand years earlier?

Paintings, Pottery, and Reliefs

After the catastrophe that had wiped out the earlier palaces, there was what seems to our eyes an explosive increase in wealth and a remarkable outpouring of creative energy that produced most of what we have in Minoan architecture, sculpture, and painting. The most surprising aspect of this sudden efflorescence, however, is its great achievement in painting. Unfortunately, the murals that covered the walls of the new palaces have survived mainly in fragments, so that we rarely have a complete composition, let alone the design of an entire wall.

Amazingly enough, the settlement at Akrotiri on the island of Thera has been extensively excavated and a large number of frescoes recovered—the earliest Minoan examples we have. They belong to the Late Minoan IA period (that is, 1670–1620 B.C.), although they vary considerably in subject and style. Of these, the most remarkable is the scene of a young woman offering crocuses (the source of saffron) to a snake goddess, nicknamed "The Mistress of the Animals," who is seated on an altar with an oil jar (fig. 123). What an astonishing achievement it is, despite its fragmentary condition and the artist's difficulty with anatomy. Yet the contrast between the girlish charm of the crocus bearer and the awesomeness of the goddess

123. *Crocus Girl* (left) and *"The Mistress of the Animals"* (right). Mural fragments from Akrotiri, Thera (Santorini). c. 1670–1620 B.C. National Archaeological Museum, Athens

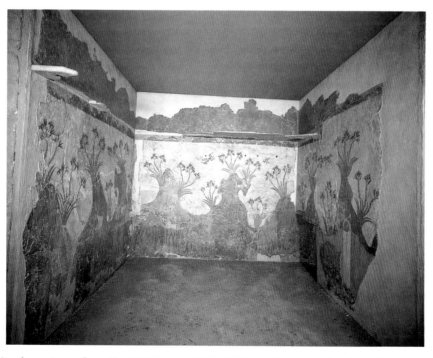

124. *Landscape.* Fresco from Akrotiri, Thera. c. 1600–1500 B.C. National Archaeological Museum, Athens

could hardly be more telling. We would recognize the latter's special status even without her elevated position on the altar and the snake in her hair—which makes her a clear forerunner of the Medusa—or the griffin behind her.

The flat forms, silhouetted against the landscape, recall Egyptian painting, and the acute observation of plants also suggests Egyptian art. If Minoan wall painting owes its origin to Egyptian influence, it betrays an attitude of mind very differ-

ent from that of the Nile Valley. To the Minoans, nature was an enchanted realm that provided the focus of their attention from the very beginning, whereas Egyptian painters could explore it only by loosening the rules that governed them. The frescoes at Akrotiri include the first pure landscape paintings we know of. Not even the most adventurous Egyptian artist of the Middle Kingdom would have dared to devote an entire composition to the out-of-doors. Our example (fig. 124) is a surprisingly

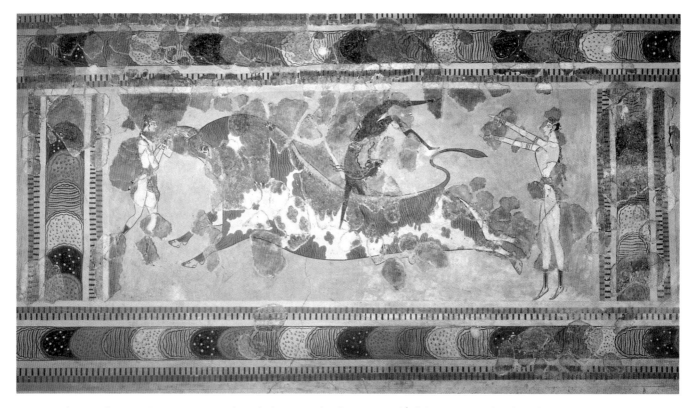

125. *"The Toreador Fresco."* c. 1500 B.C. Height including upper border approx. 24 ½" (62.3 cm). Archaeological Museum, Heraklion, Crete

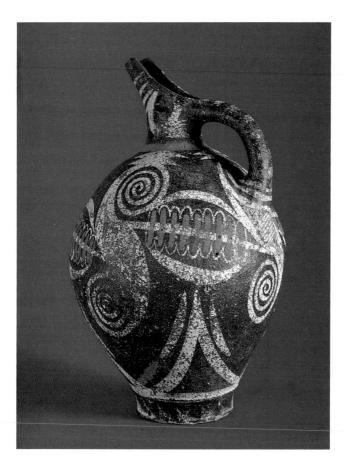

126. Beaked jug (Kamares style), from Phaistos. c. 1800 B.C.
Height 10 ⅝" (27 cm). Archaeological Museum, Heraklion, Crete

successful evocation of the dunes along the coast of Thera, but the artist has invested the scene with a lively fantasy and sense of beauty that bespeak the same sense of wonderment we found in the confrontation between mortal and divinity.

Marine life (as seen in the fish and dolphin fresco in fig. 120) was a favorite subject of Minoan painting after 1600 B.C., and the marine feeling pervades everything else as well. Instead of permanence and stability, we find a passion for rhythmic, undulating movement, and the forms themselves have an oddly weightless quality. They seem to float, or sway, in a world without gravity, as if the scene took place under water, even though a great many of them show animals and birds among luxuriant vegetation, as well as creatures of the sea. We sense this even in *"The Toreador Fresco,"* the most dynamic Minoan mural recovered so far (fig. 125). (The darker patches are the original fragments on which the restoration is based.) The conventional title should not mislead us. What we see here is not a bullfight but a ritual game in which the performers vault over the back of the animal. Two of the slim-waisted athletes are girls, differentiated (as in Egyptian art) mainly by their lighter skin color.

That the bull was a sacred animal and that bull-vaulting played an important role in Minoan religious life are beyond doubt. Scenes such as this still echo in the Greek legend of the youths and maidens sacrificed to the minotaur, a half-animal, half-human creature. The three figures in all likelihood show successive phases of the same action. But if we try to "read" the fresco as a description of what actually went on during these performances, we find it strangely ambiguous. This does not mean that the Minoan artist was deficient. It would be absurd to find fault for failing to accomplish what was never intended in the first place. Fluid, effortless ease of movement was clearly more important than factual precision or dramatic power. The

127. *"Octopus Vase,"* from Palaikastro, Crete. c. 1500 B.C. Height 11" (28 cm). Archaeological Museum, Heraklion, Crete

128. *Leaping Mountain Goat,* on a vase from the palace at Kato Zakro. c. 1500 B.C. Limestone, originally covered with gold foil, length of goat approx. 4" (10.3 cm). Archaeological Museum, Heraklion, Crete

129. *Harvester Vase,* from Hagia Triada. c. 1550–1500 B.C. Steatite, width 4 1/2" (11.3 cm). Archaeological Museum, Heraklion, Crete

painting, as it were, idealizes the ritual by stressing its harmonious, playful aspect to the point that the participants behave like dolphins gamboling in the sea.

The floating world of Minoan wall painting was an imaginative creation so rich and original that its influence can be felt throughout Minoan art during the era of the new palaces. At the time of the earlier palaces, between 2000 and 1700 B.C., Crete had developed a type of pottery (known as Kamares ware after the center where it was discovered) that was famous for its technical perfection and its dynamic, swirling ornament, consisting of organic abstractions filled with life (fig. 126). This in no way prepares us for the new repertory of designs drawn from plant and animal life. Some vessels are covered entirely with fish, shells, and octopuses, as if the ocean itself had been caught within them (fig. 127).

Monumental sculpture, had there been any, might have retained its independence, but the small-scale works to which the Minoan sculptor was confined are often closely akin to the style of the murals. The splendidly observed mountain goat carved on a stone vase (fig. 128) leaps in the same "flying" movement as the bull of *"The Toreador Fresco."* (These mountain goats, too, were sacred animals.) Even more vivid is the relief on the so-called *Harvester Vase* (fig. 129; the lower part is lost): a procession of slim, muscular men, nude to the waist, carrying long-handled implements that look like a combination of scythe and rake. A harvest festival? Quite probably, although here again the lively rhythm of the composition takes precedence over descriptive clarity.

Our view of the scene includes three singers led by a fourth who is swinging a sistrum (a rattle of Egyptian origin). They are bellowing with all their might, especially the "choirmaster," whose chest is so distended that the ribs press through the skin. What makes the entire relief so remarkable—in fact, unique—is its emphasis on physical strain, its energetic, raucous gaiety, which combines sharp observation with a consciously humorous intent. How many works of this sort, we wonder, did Minoan art produce? Only once have we met anything at all like it: in the relief of workmen carrying a beam (see fig. 81), carved almost two centuries later under the impact of the Akhenaten style (see pages 76–77). Is it possible

130. *(left)* Interior, Treasury of Atreus, Mycenae, Greece. c. 1300–1250 B.C.

131. *(below)* Section, Treasury of Atreus

that pieces similar to the *Harvester Vase* stimulated Egyptian artists during that brief but important period?

MYCENAEAN ART

Along the southeastern shores of the Greek mainland there were, during Late Helladic times (c. 1400–1100 B.C.), a number of settlements that corresponded in many ways to those of Minoan Crete. They, too, were grouped around palaces. Their inhabitants have come to be called Mycenaeans, after Mycenae, the most important of these settlements. Since the works of art unearthed there by excavation often showed a strikingly Minoan character, the Mycenaeans were at first regarded as having come from Crete, but it is now agreed that they were the descendants of the earliest Greek clans, who had entered the country soon after 2000 B.C.

Tombs and Their Contents

For some 400 years, these people had led an inconspicuous pastoral existence in their new homeland. Their modest tombs have yielded only simple pottery and a few bronze weapons. Toward 1600 B.C., however, they suddenly began to bury their dead in deep shaft graves and, a little later, in conical stone chambers, known as beehive tombs. This development reached its height toward 1300 B.C. in impressive structures such as the one shown in figures 130 and 131, built of concentric layers of precisely cut stone blocks that taper inward toward the highest point. (This method of spanning space is called corbeling.) Its discoverer thought it far too ambitious for a tomb and gave it the misleading name Treasury of Atreus. Burial places as elaborate as this can be matched only in Egypt during the same period.

The Treasury of Atreus had been robbed of its contents long ago, but other Mycenaean tombs were found intact, and what they yielded up caused even greater surprise: alongside the royal dead were placed masks of gold or silver, presumably to cover their faces. If so, these masks were similar in purpose

132. Rhyton in the shape of a lion's head, from a shaft grave at Mycenae. c. 1550 B.C. Gold, height 8" (20.3 cm). National Archaeological Museum, Athens

(if not in style) to the masks found in pharaonic tombs of the Middle and New Kingdoms (compare fig. 82). There was considerable personal equipment—drinking vessels, jewelry, weapons—much of it gold and exquisite in workmanship. Some of these pieces, such as the magnificent gold vessel in the shape of a lion's head (fig. 132), show a boldly expressive style of smooth planes bounded by sharp ridges which suggests contact with the Near East, while others are so Minoan in flavor that they might be imports from Crete.

Of the latter kind are the two famous gold cups from a Mycenaean tomb at Vaphio (figs. 133 and 134). They must

133, 134. *Vaphio Cups.* c. 1500 B.C. Gold, heights 3"; 3 ½" (7.5; 9 cm). Shown actual size. National Archaeological Museum, Athens

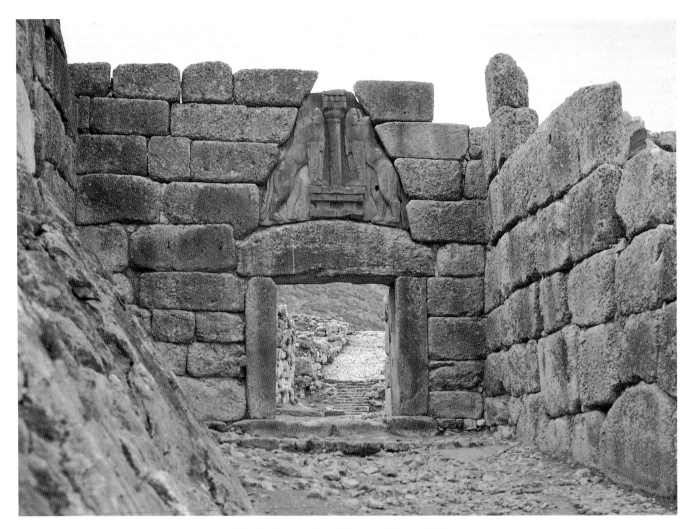

135. The Lioness Gate, Mycenae, Greece. 1250 B.C.

have been made about 1500 B.C., a few decades after the lion vessel, but where, for whom, and by whom? Here the problem "Minoan or Mycenaean?" becomes acute. The dispute is not as idle as it may seem, for it tests our ability to differentiate between the two neighboring cultures. It also forces us to consider every aspect of the cups. Do we find anything in their style or content that is un-Minoan? Our first impulse, surely, is to note the similarity of the human figures to those on the *Harvester Vase,* and the similarity of the bulls to the animal in *"The Toreador Fresco."* To be sure, the men on the *Vaphio Cups* are not engaged in the Cretan bull-vaulting game but in the far more mundane business of catching the animals on the range. However, this subject also occurs in Minoan art. On the other hand, we cannot overlook the fact that the design on the cups does not quite match the continuous rhythmic movement of Minoan compositions and that the animals, for all their physical power, have the look of cattle rather than of sacred animals. They nevertheless differ only in degree, not kind, from the wonderfully sturdy leaping goat in figure 128. It would seem, on balance, that the cups are by a Minoan artist working for Mycenaean patrons.

MYCENAE, CRETE, AND EGYPT. In the sixteenth century B.C., Mycenae thus presents a strange picture. What appears to be an Egyptian influence on burial customs is combined with a strong artistic influence from Crete and with an

136. Plan of a Mycenaean megaron

extraordinary material wealth as expressed in the lavish use of gold. What we need is a triangular explanation that involves the Mycenaeans with Crete as well as Egypt about a century before the destruction of the new palaces. Such a theory—fascinating and imaginative, if hard to confirm in detail—runs about as follows: between 1700 and 1580 B.C., the Egyptians were trying to rid themselves of the Hyksos, who had seized the Nile Delta (see page 71). For this they gained the aid of warriors from Mycenae, who returned home laden with gold (of which Egypt alone had an ample supply) and deeply impressed with Egyptian funerary customs. The Minoans, not military but famous as sailors, ferried the Mycenaeans back and forth, so that they, too, had a new and closer contact with Egypt. This may help to account for their sudden prosperity toward 1600 B.C., as well as for the rapid development of naturalistic wall painting at that time. In fact, such a theory is

supported by the recent discovery of a large group of Minoan frescoes in Egypt. The close relations between Crete and Mycenae, once established, were to last a long time.

Architecture

The great monuments of Mycenaean architecture were all built between 1400, when Linear B script began to appear, and 1200 B.C. Apart from such details as the shape of the columns or decorative motifs of various sorts, Mycenaean architecture owes little to the Minoan tradition. The palaces on the mainland were hilltop fortresses surrounded by defensive walls of huge stone blocks, a type of construction quite unknown in Crete but similar to the Hittite fortifications at Bogazköy (see fig. 99). The Lioness Gate at Mycenae (fig. 135) is the most impressive remnant of these massive ramparts, which inspired such awe in the Greeks of later times that they were regarded as the work of the Cyclopes, a mythical race of one-eyed giants. Even the Treasury of Atreus, although built of smaller and more precisely shaped blocks, has a Cyclopean lintel (see fig. 130).

Another aspect of the Lioness Gate foreign to the Minoan tradition is the great stone relief over the doorway. The two lionesses flanking a symbolic Minoan column have the same grim, heraldic majesty as the golden lion's head we encountered in figure 132. Their function as guardians of the gate, their tense, muscular bodies, and their symmetrical design again suggest an influence from the ancient Near East. We may at this point recall the Trojan War, which brought the Mycenaeans to Asia Minor soon after 1200 B.C. It seems likely, however, that they began to sally eastward across the Aegean, for trade or war, much earlier than that.

The center of the palace, at Mycenae and other mainland sites, was the royal audience hall, called the megaron. Only its plan is known for certain: a large rectangular room with a round hearth in the middle and four columns to support the roof beams (fig. 136). It was entered through a deep porch with two columns and an antechamber. This design is in essence no more than an enlarged version of the simple houses of earlier generations, for its ancestry can be traced back to Middle Helladic times. There may have been a rich decorative scheme of wall paintings and ornamental carvings to stress its dignity as the king's abode.

Sculpture

As in Crete, Mycenaean temple architecture was confined to modest structures with cult statues set apart from the palaces, which also included small shrines. A wide variety of gods were worshiped in them, although their exact identity is sometimes a matter of dispute. Mycenaean religion incorporated not only Minoan elements but also influences from Asia Minor, as well as deities of Greek origin inherited from their own forebears, including a number of the later Olympian gods, such as Poseidon. But gods have an odd way of merging or exchanging their identities, so that the religious images in Mycenaean art are hard to interpret.

What, for instance, are we to make of the exquisite little ivory group (fig. 137) unearthed at Mycenae in 1939? The

137. *Three Deities,* from Mycenae. c. 1500–1400 B.C. Ivory, height 3" (7.5 cm). National Archaeological Museum, Athens

style of the piece—its richly curved shapes and easy, flexible body movements—still echoes Minoan art, though the carving has an unmistakably Near Eastern air (compare figs. 88 and 98). The subject, however, is strange indeed. Two kneeling women, closely united, tend a single child. But whose is he? The natural interpretation would be to regard the now headless figure as the mother, since the child clings to her arm and turns toward her; the second woman, whose left hand rests on the other's shoulder, would then be the grandmother. Such three-generation family groups are a well-known subject in Christian art, in which we often find St. Anne, the Virgin Mary, and the Infant Christ combined in similar fashion.

It is the memory of these later works that colors our view of the Mycenaean ivory. Yet we search in vain for a subject in ancient religion that fits our reading of the group. On the other hand, there is a very widespread myth about the divine child who is abandoned by his mother and reared by nymphs, goddesses, or even animals. His name varies from place to place and includes Bacchus and Jupiter. We are thus forced to conclude that our ivory in all likelihood shows a motherless child god with his nurses. The real mystery, however, lies deeper: it is the tender play of gestures, the intimate human feeling, that binds the three figures together. Nowhere in the entire range of ancient art before the Greeks do we find gods—or people, for that matter—expressing affection with such warmth and eloquence.

Something quite basically new is reflected here, a familiar view of divine beings that makes even the Minoan snake goddess (fig. 121) seem awesome and remote. Was this change of attitude, and the ability to express it in art, a Mycenaean achievement? Or did they inherit it from the Minoans? However that may be, our ivory group opens up a dimension of experience that had never been accessible to Egypt or Mesopotamia.

CHAPTER FIVE

GREEK ART

To people of European heritage, the works of art we have come to know so far seem like fascinating strangers because of their "alien" background and the "language difficulties" they present, occasioned by the vast gap in time and culture. Greek architecture, sculpture, and painting, by contrast, appear not as strangers but as relatives, older members of a family that are immediately recognizable. A Greek temple will remind us at a glance of the bank around the corner, a Greek statue will bring to mind countless other statues we have seen somewhere, and a Greek coin will make us want to reach for the small change in our own pockets. The continuous tradition linking us with the ancient Greeks can be a handicap as well as an advantage in looking at Greek originals, whose contribution is sometimes obscured by familiarity with later imitations. However, we shall find that Greek art was indebted to its predecessors in countless ways, so that we may consider them, too, among the direct ancestors of Western civilization.

Another complication peculiar to the study of Greek art arises from the fact that we have three separate, and sometimes conflicting, sources of information on the subject. There are, first of all, the monuments themselves, a reliable but often woefully inadequate source. Then we have various copies made in Roman times that tell us something about important Greek works that would otherwise be lost to us entirely. These copies, however, always pose a problem. Some are of such high quality that we cannot be sure that they really are copies. Others make us wonder how faithfully they follow their model—especially if we have several copies, all slightly different, of the same lost original.

Finally, there are the literary sources. The Greeks were the first people in history to write at length about their own artists, and their accounts were eagerly collected by the Romans, who handed them down to us. From them we learn what the Greeks themselves considered their most important achievements in architecture, sculpture, and painting. This written testimony has helped us to identify some celebrated artists and monuments, but much of it deals with works of which no visible trace remains today, while other works, which do survive and which strike us as among the greatest masterpieces of their

time, are not mentioned at all. To reconcile the literary evidence with that of the copies and that of the original monuments, and to weave these strands into a coherent picture of the development of Greek art, is a difficult task indeed, despite the enormous amount of work that has been done since the beginnings of archaeological scholarship some 250 years ago.

Who were the Greeks? We have met some of them before, such as the Mycenaeans, who came to Greece about 2000 B.C. Other Greek-speaking tribes entered the peninsula from the north toward 1100 B.C., overwhelmed and absorbed the Mycenaean stock, and gradually spread to the Aegean Islands and Asia Minor. It was these tribes who during the following centuries created the great civilization for which we now reserve the name Greek. We do not know how many separate tribal units there were in the beginning, but three main groups, who settled mainland Greece, the coast of Asia Minor, and the Aegean Islands, stand out: the Aeolians, who took over the north; the Dorians, who inhabited the south, including the Cyclades; and the Ionians, who colonized Attica, Euboea, most of the Aegean Islands and the central coast of nearby Asia Minor. In the eighth century B.C., the Greeks also spread westward, founding important settlements in Sicily and southern Italy.

Despite a strong sense of kinship based on language and common beliefs, expressed in such traditions as the four great Panhellenic (all-Greek) festivals, the Greeks remained divided into many small, independent city-states. The pattern may be viewed as an echo of age-old tribal loyalties, as an inheritance from the Mycenaeans, or as a response to the geography of Greece, whose mountain ranges, narrow valleys, and jagged coastline would have made political unification difficult in any event. Perhaps all of these factors reinforced one another. The intense military, political, and commercial rivalry of these states undoubtedly stimulated the growth of ideas and institutions.

Our own thinking about government continues to make use of a number of key terms of Greek origin which reflect the evolution of the city-state: monarchy, aristocracy, tyranny, democracy, and, most important, politics (derived from *polites,* the citizen of the *polis,* or city-state). In the end, however, the Greeks paid dearly for their inability to broaden the

<center>amphora pelike volute krater krater hydria lekythos</center>

<center>oinochoe kylix skyphos kantharos aryballos</center>

<center>138. Some common Greek vessel forms</center>

concept of the state beyond the local limits of the *polis:* they engaged in almost continuous warfare. The Peloponnesian War (431–404 B.C.), in which the Spartans and their allies defeated the Athenians, was only the most notable among the series of conflicts that left Greece so weak that it was easily defeated by Alexander the Great in the late fourth century B.C.

GEOMETRIC STYLE

The formative phase of Greek civilization embraces about 400 years, from about 1100 to 700 B.C. Of the first three centuries of this period we know very little, but after about 800 B.C. the Greeks rapidly emerge into the full light of history. The earliest specific dates that have come down to us are from that time: 776 B.C., the founding of the Olympic Games and the starting point of Greek chronology, as well as several slightly later dates recording the founding of various cities. That time also saw the full development of the oldest characteristically Greek style in the fine arts, the so-called Geometric. We know it only from painted pottery and small-scale sculpture. (Monumental architecture and sculpture in stone did not appear until the seventh century.) The two forms are intimately related. The pottery was often adorned with figurines indistinguishable in form from sculpture, which was made of clay or bronze. These early bronzes leave little doubt that the Greeks learned the technique directly from the Mycenaeans.

Greek potters quickly developed a considerable variety of shapes. (The basic ones are shown in fig. 138.) Chief among these was the amphora, a two-handled vase for storing wine or oil. Variants were the pelike and stamnos, used for wine or water; these could also be dispensed from a type of jar known as an oinochoe. The principal vessel for water was the hydria. Wine was always heavily diluted with water in a krater, which came in assorted shapes. This mixture was drunk from a shallow cup, the kylix; a deeper one called a kantharos; or the bowl-shaped skyphos. The main oil bottles were the lekythos, often used for sepulchral offerings, and the tiny aryballos. Each type was wonderfully adapted to its function, which was aptly reflected in its form. Consequently, each shape presented unique challenges to a painter, and some became specialists at decorating certain types of vases, though the larger pots generally attracted the best artists because they proved more generous fields to work on. Since each was a complex and

139. Dipylon Vase. 8th century B.C. Height 40$^{1}/_{2}$" (102.8 cm). The Metropolitan Museum of Art, New York. Rogers Fund, 1914

demanding process in its own right, the making and decorating of vases were separate professions, but the finest painters were sometimes potters as well.

DIPYLON VASE. At first the pottery was decorated only with abstract designs: triangles, checkers, concentric circles. Toward 800 B.C. human and animal figures began to appear within the geometric framework, and in the most mature examples these figures could form elaborate scenes. Our specimen (fig. 139), from the Dipylon cemetery in Athens,

<center>GREEK ART *111*</center>

belongs to a group of very large vases that served as grave monuments. Its bottom has holes through which liquid offerings could filter down to the dead below. On the body of the vessel we see the deceased lying in state, flanked by figures with their arms raised in a gesture of mourning, and a funeral procession of chariots and warriors on foot.

The most remarkable thing about this scene is that it contains no reference to an afterlife. Its purpose is purely commemorative. Here lies a worthy man, it tells us, who was mourned by many and had a splendid funeral. Did the Greeks, then, have no conception of a hereafter? They did, but the realm of the dead to them was a colorless, ill-defined region where the souls, or "shades," led a feeble and passive existence without making any demands upon the living. When Odysseus, in the Homeric poem, conjures up the shade of Achilles, all the dead hero can do is mourn his own demise: "Speak not conciliatorily of death, Odysseus. I'd rather serve on earth the poorest man . . . than lord it over all the wasted dead." If the Greeks nevertheless marked and tended their graves, and even poured libations over them, they did so in a spirit of pious remembrance, rather than to satisfy the needs of the dead. Clearly, they had refused to adopt the elaborate burial customs of the Mycenaeans (see page 106). Nor is the Geometric style an outgrowth of the Mycenaean tradition but a fresh, and in some respects quite primitive, start. Yet it also owes a great deal to Near Eastern art: the repertory of forms can be traced back to prehistoric Mesopotamian pottery, though how they survived to be transmitted to the Greeks is as yet unknown.

Given the limited repertory of shapes, the artist who painted our vase has achieved an astonishingly varied effect. The spacing of the bands, their width and density, show a rather subtle relationship to the structure of the vessel. His interest in representation, however, is as yet very limited. The figures or groups, repeated at regular intervals, are little more than another kind of ornament, part of the same over-all texture, so that their size varies in accordance with the area to be filled. Organic and geometric elements still coexist in the same field, and the distinction between them is often difficult. Lozenges indicate legs, whether of a man, a chair, or a bier. Circles with dots may or may not be human heads. The chevrons, boxed triangles, and so on between the figures may be decorative or descriptive—we cannot tell.

Geometric pottery has been found not only in Greece but in Italy and the Near East as well, a clear indication that Greek traders were well established throughout the eastern Mediterranean in the eighth century B.C. What is more, they had already adopted the Phoenician alphabet and reshaped it for their own use, as we know from the inscriptions on these same vases. The greatest Greek achievements of this era, however, are the two Homeric epics, the *Iliad* and the *Odyssey*. The scenes on Geometric vases contain barely a hint of the narrative power of these poems. If our knowledge of eighth-century Greece were based on the visual arts alone, we would inevitably think of it as a far simpler and more provincial society than the literary evidence suggests.

There is a paradox here that needs to be resolved. Perhaps, at this particular time, Greek civilization was so language-minded that painting and sculpture played a less important role than they were to assume in the following centuries. In

140. *The Blinding of Polyphemus* and *Gorgons,* on a Proto-Attic amphora. c. 675–650 B.C. Height 56" (142.3 cm). Archaeological Museum, Eleusis, Greece

that event, the Geometric style may well have been something of an anachronism in the eighth century, a conservative tradition about to burst at the seams. Representation and narrative demand greater scope than the style could provide. The dam finally burst toward 700 B.C., when Greek art entered another phase, which we call the Orientalizing style, and new forms came flooding in.

ORIENTALIZING STYLE

As its name implies, the new style reflects powerful influences from Egypt and the Near East, stimulated by increasing trade with these regions. Between about 725 and 650 B.C. Greek art absorbed a host of Oriental motifs and ideas and was profoundly transformed in the process. It would be difficult to overestimate the contribution of these outside influences. Whereas earlier Greek art is Aegean in flavor, the Orientalizing phase is characterized by a new monumentality and variety that is wildly exuberant as painters and sculptors struggled to master the new forms that came in waves, like immigrants from afar. The subsequent development of Greek art is unthinkable without this vital period of experimentation. Some of the subjects and motifs that we think of as typically Greek were, in fact, derived from Mesopotamia and Egypt, where

All early civilizations and preliterate cultures had creation myths to explain the origin of the universe and humanity's place in it. Over time, these myths were elaborated into complex cycles that represent a comprehensive attempt to understand the world. The Greek stories of the gods and heroes—the myths and legends—were the result of combining local Doric and Ionic deities and folktales with the pantheon of Olympian gods. These tales had been brought to Greece from the ancient Near East through successive waves of immigration. The gods and goddesses, though immortal, were very human in behavior. They quarreled, and had children with each other's spouses and often with mortals as well. They were sometimes threatened and even overthrown by their own children. The principal Greek gods and goddesses, with their Roman counterparts in parentheses, are given below.

Zeus (Jupiter), god of sky and weather, was the king of the Olympian deities. His parents were Kronos and Rhea. It had been prophesied that one of Kronos' children would overthrow him, and Kronos had thus taken the precaution of eating his children as soon as they were born. After Zeus' birth, Rhea hid him so that he would not suffer the same fate as his siblings. Zeus later tricked Kronos into disgorging his other children, who then overthrew their father with the help of the earth goddess, Gaea. Gaea was both the mother and wife of the sky god Uranus and the wife of Pontus, god of the sea. She was also the mother of the Cyclopes, who forged the weapons of the Olympians, as well as the Titans and Hundred-Handed Ones. The descendants of the Titans included Atlas (who was credited with holding up the earth), Hecate (an underworld goddess), Selene (goddess of the moon), Helios (a god of the sun), and Prometheus (a demigod, who gave humanity the gift of fire and was severely punished for doing so). After the defeat of Kronos, Zeus divided the universe by lot with his brothers Poseidon (Neptune), who ruled the sea, and Hades (Pluto), who became lord of the underworld.

Zeus fathered Ares (Mars, the god of war), Hephaestus (Vulcan, the god of armor and the forge), and Hebe (the goddess of youth) with his queen, Hera (Juno), goddess of marriage and fruitfulness, who was both his wife and sister. He also had numerous children through his love affairs with other goddesses and with mortal women. Chief among his children was Athena (Minerva), goddess of war. She was born of the liaison between Metis and Zeus, who swallowed her alive because, like his own father, he was told he would be toppled by one of his offspring. Athena later emerged fully armed from the head of Zeus when it was split open by Hephaestus. Although a female counterpart to the war god Ares, Athena was also the goddess of peace, a protector of heroes, a patron of arts and crafts (especially spinning and weaving), and, later, of wisdom. She became the patron goddess of Athens, an honor she won in a contest with Poseidon. Her gift to the city was an olive tree, which she caused to sprout on the Acropolis. Poseidon had offered a useless saltwater spring.

Zeus sired other goddesses, perhaps the most notable of whom was Aphrodite (Venus), the goddess of love, beauty, and fertility. She became the wife of Hephaestus and a lover of Ares, by whom she bore Harmonia, Eros, and Anteros. Aphrodite was also the mother of Hermaphroditus (with Hermes), Priapus (with Dionysus), and Aeneas (with the Trojan prince Anchises). Artemis (Diana), who with her twin brother Apollo was born of Leto and Zeus, was the virgin goddess of the hunt. She was also sometimes considered a moon goddess with Selene and Hecate.

Zeus begat other major gods as well. Hermes (Mercury), son of Maia, was the messenger of the gods, conductor of souls to Hades, and the god of travelers and commerce. He was sometimes credited with inventing the lyre and the shepherd's flute. The main god of civilization (including art, music, poetry, law, and philosophy) was the sun-god Apollo (Helios), who was also the god of prophecy and medicine, flocks and herds. Apollo was opposite in temperament to Dionysus (Bacchus), the son of Zeus and of either Persephone (Proserpina), queen of the underworld, or the moon goddess Semele. Dionysus was raised on Mount Nysa, where he invented wine making. His followers, the half-man, half-goat satyrs (the oldest of whom was Silenus, the tutor of Dionysus) and their female companions, the nymphs and humans known as maenads (bacchantes), were given to orgiastic excess. However, there was a temperate side to Dionysus. As the god of fertility, he was also the god of vegetation, as well as the god of peace, hospitality, and the civilized arts.

In its inspiration and grandeur, Greek civilization represented a fusion of contrasting sensibilities—the Apollonian and the Dionysian. The origins of Classical tragedy lay in Dionysiac rites tempered by rational Apollonian influence. Fifth-century B.C. Greek playwrights such as Aeschylus, Sophocles, and Euripides recast the ancient myths and legends into dramatic form.

they had a long history reaching back to the very dawn of Near Eastern civilization. It was the merging with Aegean tendencies and the distinctive Greek cast of mind that soon gave rise to what we think of as Greek art proper.

ELEUSIS AMPHORA. The change becomes very evident if we compare the large amphora from Eleusis (fig. 140) with the *Dipylon Vase* of a hundred years earlier (fig. 139). Geometric ornament has not disappeared from this vase altogether, but it is confined to the peripheral zones: the foot, the handles, and the lip. New, curvilinear motifs—such as spirals, interlacing bands, palmettes, and rosettes—are conspicuous everywhere. On the shoulder of the vessel we see a frieze of fighting animals, derived from the repertory of Near Eastern art. The major areas, however, are given over to narrative, which has become the dominant element.

Narrative painting tapped a nearly inexhaustible source of subjects from Greek myths and legends (see box above). These tales were the result of mixing local Doric and Ionic deities and heroes into the pantheon of Olympian gods and Homeric

141. Proto-Corinthian perfume vase. c. 650 B.C. Height 2" (5 cm). Musée du Louvre, Paris

sagas. They also represent a comprehensive attempt to understand the world. Such an interest in heroes and deities also helps to explain the strong appeal exerted on the Greek imagination by Oriental lions and monsters. These terrifying creatures embodied the unknown forces of life faced by the hero. This fascination is clearly seen on the Eleusis amphora. The figures have gained so much in size and descriptive precision that the decorative patterns scattered among them can no longer interfere with their actions. Ornament of any sort now belongs to a separate and lesser realm, clearly distinguishable from that of representation.

As a result, the blinding of the giant one-eyed cyclops Polyphemus, a son of Poseidon, by Odysseus and his companions, whom Polyphemus had imprisoned, is enacted with memorable directness and dramatic force. (This scene on the neck of the amphora is taken from Homer's *Odyssey*.) If these men lack the beauty we will later expect of epic heroes in art, their movements have an expressive vigor that makes them seem thoroughly alive. The slaying of another monstrous creature is depicted on the body of the vase, the main part of which has been badly damaged so that only two figures have survived intact. They are Gorgons, the sisters of the snake-haired, terrible-faced Medusa whom Perseus (partly seen running away to the right) killed with the aid of the gods. Even here we notice an interest in the articulation of the body far beyond the limits of the Geometric style.

The Eleusis vase belongs to a group called Proto-Attic, the ancestors of the great tradition of vase painting that was soon to develop in Attica, the region around Athens. A second family of Orientalizing vases is known as Proto-Corinthian, since

it points toward the later pottery production of Corinth. These vessels, noted for their spirited animal motifs, show particularly close links with the Near East. Some of them, such as the perfume vase in figure 141, are molded in the shape of animals. The enchanting little owl, streamlined to fit the palm of a lady's hand and yet so animated in pose and expression, helps us to understand why Greek pottery came to be in demand throughout the Mediterranean world.

ARCHAIC VASE PAINTING

The Orientalizing phase of Greek art was a period of experiment and transition, in contrast to the stable and consistent Geometric style. Once the new elements from the East had been fully assimilated, there emerged another style, as well defined as the Geometric but infinitely greater in range: the Archaic, which lasted from the later seventh century to about 480 B.C., the time of the famous Greek victories over the Persians at Salamis and Plataea. During the Archaic period, we witness the unfolding of the artistic genius of Greece not only in vase painting but also in monumental architecture and sculpture. While Archaic art lacks the balance, the sense of perfection of the Classical style of the later fifth century, it has such freshness that many people consider it the most vital phase in the development of Greek art.

Greek architecture and sculpture on a large scale must have begun to develop long before the mid-seventh century. Until that time, however, both were mainly of wood, and nothing of them has survived except the foundations of a few buildings. The desire to build and sculpt in stone, for the sake of permanence, was the most important new idea that entered Greece during the Orientalizing period. Moreover, the revolution in material and technique must have brought about decisive changes of style as well, so that we cannot safely reconstruct the appearance of the lost wooden temples or statues on the basis of later works. In vase painting, on the other hand, there was no such break in continuity. It thus seems best to deal with Archaic vases before we turn to the sculpture and architecture of the period.

The significance of Archaic vase painting is in some ways completely unique. Decorated pottery, however great its value as an archaeologist's tool, rarely enters the mainstream of the history of art. We think of it, in general, as a craft or industry. This remains true even of Minoan vases, despite their exceptional beauty and technical refinement, and the same may be said of the vast bulk of Greek pottery. Yet if we study such pieces as the *Dipylon Vase* or the amphora from Eleusis, they are impressive not only by virtue of their sheer size but as vehicles of pictorial effort, and we cannot escape the feeling that they are among the most ambitious works of art of their day.

There is no way to prove this, of course—far too much has been lost—but it seems obvious that these are objects of highly individual character, rather than routine ware produced in quantity according to set patterns. Archaic vases are generally a good deal smaller than their predecessors, since pottery vessels no longer served as grave monuments (which were now made of stone). Their painted decoration, however, shows a far greater emphasis on pictorial subjects (fig. 143). Scenes from mythology, legend, and everyday life appear in endless

variety, and the artistic level is often very high indeed, especially among Athenian vases.

After the middle of the sixth century, the finest vases frequently bear the signatures of the artists who made them. This indicates not only that individual potters, as well as painters, took pride in their work, but also that they could become famous for their personal style. To us, such signatures in themselves do not mean a great deal. They are no more than convenient labels unless we know enough of an artist's work to gain some insight into his personality. Remarkably enough, that is possible with a good many Archaic vase painters. Some of them have so distinctive a style that their artistic "handwriting" can be recognized even without the aid of a signature. In a few cases we are lucky enough to have dozens (in one instance, over 200) of vases by the same hand, so that we can trace one master's development over a considerable period. Archaic vase painting thus introduces us to the first clearly defined personalities in the entire history of art. While it is true that signatures occur in Archaic sculpture and architecture as well, they have not helped us to identify the personalities of individual masters.

Archaic Greek painting was, of course, not confined to vases. There were murals and panels, too. Although nothing has survived of them except a few poorly preserved fragments, we can form a fair idea of what they looked like from the wall paintings in Etruscan tombs of the same period (see figs. 226 and 227). How, we wonder, were these large-scale works related to the vase pictures? We do not know, but one thing seems certain: all Archaic painting was essentially drawing filled in with solid, flat color, and therefore murals could not have been very different in appearance from vase pictures.

According to the literary sources, Greek wall painting did not come into its own until about 475–450 B.C., after the Persian wars, through the gradual discovery of modeling and spatial depth. [See Primary Sources, no. 4, page 213.] From that time on, vase painting became a lesser art, since depth and modeling were beyond its limited technical means, and by the end of the fifth century its decline was obvious. The great age of vase painting, then, was the Archaic era. Until about 475 B.C., good vase painters enjoyed as much prestige as other artists. Whether or not their work directly reflects the lost wall paintings, it deserves to be viewed as a major achievement.

BLACK-FIGURED STYLE. The difference between Orientalizing and Archaic vase painting is one of artistic discipline. In the amphora from Eleusis (fig. 140), the figures are shown partly as solid silhouettes, partly in outline, or as a combination of both. Toward the end of the seventh century, Attic vase painters resolved these inconsistencies by adopting the "black-figured" style, which means that the entire design is silhouetted in black against the reddish clay. Internal details are scratched in with a needle, and white and purple may be added on top of the black to make certain areas stand out. The virtues of this procedure, which favors a decorative, two-dimensional effect, are apparent in figure 142, a kylix (drinking cup) by Exekias of about 540 B.C. The slender, sharp-edged forms have a lacelike delicacy, yet also resilience and strength, so that the composition adapts itself to the circular surface without becoming mere ornament. Dionysus reclines in his boat (the sail

142. Exekias. *Dionysus in a Boat.* Interior of an Attic black-figured kylix. c. 540 B.C. Diameter 12" (30.5 cm). Staatliche Antikensammlungen, Munich

was once entirely white). It moves with the same ease as the dolphins, whose lithe forms are counterbalanced by the heavy clusters of grapes.

But why is he at sea? What does the happy poetry of Exekias' image mean? According to a Homeric hymn, the god of wine had once been abducted by pirates, whereupon he caused vines to grow all over the ship and frightened his captors until they jumped overboard and were turned into dolphins. We see him here on his return journey—an event to be gratefully recalled by every Greek drinker—accompanied by seven dolphins and seven bunches of grapes for good luck.

If the spare elegance of Exekias retains something of the spirit of Geometric pottery, the work of the slightly younger Psiax is the direct outgrowth of the forceful Orientalizing style of the blinding of Polyphemus in the Eleusis amphora. Herakles killing the Nemean lion, the first of his 12 labors (see box page 117), on an amphora attributed to Psiax (fig. 143), reminds us of the hero on the soundbox of the harp from Ur (see fig. 92). Both show a hero facing the unknown forces of life embodied by terrifying mythical creatures. The lion also serves to underscore the hero's might and courage against demonic forces. The scene is all grimness and violence. The two heavy bodies are truly locked in combat, so that they almost grow together into a single, compact unit. Incised lines and subsidiary colors have been added with utmost economy in order to avoid breaking up the massive expanse of black. Yet both figures show such a wealth of knowledge of anatomical structure and skillful use of foreshortening that they give an

143. Psiax. *Herakles Strangling the Nemean Lion,* on an Attic black-figured amphora from Vulci, Italy.
c. 525 B.C. Height 19 1/2" (49.5 cm). Museo Civico dell'Età Cristiana, Brescia

144. Euphronios. *Herakles Wrestling Antaios,* on an Attic red-figured krater. c. 510 B.C. Height 19" (48 cm). Musée du Louvre, Paris

145. Douris. *Eos and Memnon.* Interior of an Attic red-figured kylix. c. 490–480 B.C. Diameter 10¹/2" (26.7 cm). Musée du Louvre, Paris

amazing illusion of existing in the round. (Note the way the abdomen and shoulders of Herakles are rendered.) Only in such details as the eye of Herakles do we still find the traditional combination of front and profile views.

RED-FIGURED STYLE. Psiax must have felt that the silhouettelike black-figured technique made the study of foreshortening unduly difficult, for in some of his vases he tried the reverse procedure, leaving the figures red and filling in the background. This red-figured technique gradually replaced the older method toward 500 B.C. Its advantages are well shown in figure 144, a krater of about 510 B.C. by Euphronios showing Herakles wrestling Antaios. The details are now freely drawn with the brush, rather than laboriously incised, so the picture depends far less on the profile view than before. Instead, the artist exploits the internal lines that permit him to show boldly foreshortened and overlapping limbs, precise details of costume (note the pleated dresses of the giant's two sisters), and

intense facial expressions. He is so fascinated by all these new effects that he has made the figures as large as he possibly could. They almost seem to burst from the field of the vase!

A similar striving for monumental effect, but with more harmonious results, may be seen in the *Eos and Memnon* by Douris (fig. 145), one of the masterpieces of late Archaic vase painting. It shows the goddess of dawn holding the body of her son, who had been killed and despoiled of his armor by Achilles. In this moving evocation of grief, Greek art touches a mood that seems strangely prophetic of the Christian *Pietà* (see fig. 479). Notable, too, is the expressive freedom of the draftsmanship: the lines are as flexible as if they had been done with a pen. Douris knows how to trace the contours of limbs beneath the drapery and how to contrast vigorous, dynamic outlines with thinner and more delicate secondary strokes, such as those indicating the anatomical details of Memnon's body. This vase also has a special interest because of its elaborate inscription, which includes the signatures of both painter

The Hero in Greek Legend

The early Greeks grasped the meaning of events in terms of fate and human character rather than as accidents of history, in which they had little interest before about 500 B.C. The main focus in the writings of Greek authors was on explaining why the legendary heroes of the past seemed incomparably greater than contemporary men and women. Some of these heroes were historical figures, but all were believed to be descendants of the gods, who often had children with mortals. Such a lineage helped to explain the hero's extraordinary power. This power (called *arete* by the Greeks) could, in excess, lead to overweening pride (*hubris*) and consequently to error (*hamartia*). The tragic results of such pride were the subject of many Greek plays, especially those by Sophocles. The Greek ideal became moderation in all things, personified by Apollo, the god of art and civilization. Arete came to be identified over time with personal and civic virtues, such as modesty and piety.

The greatest of all Greek heroes was Herakles (Hercules to the Romans). The son of Zeus and the princess Alcmene, he became the only mortal ever to ascend to Mount Olympus upon his immolation on Mount Oite. His greatest exploits were the 12 labors undertaken during his dozen years at the court of King Eurystheus in Tiryns. They were done to atone for killing his wife and children.

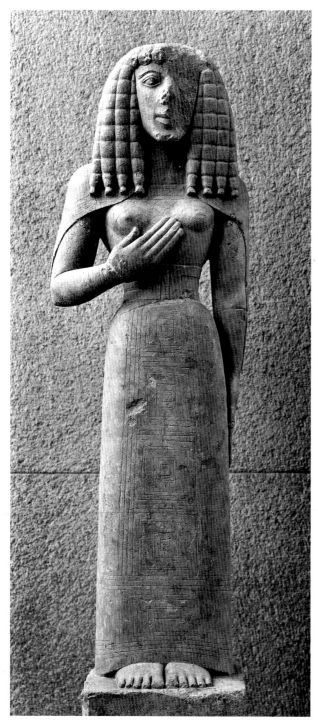

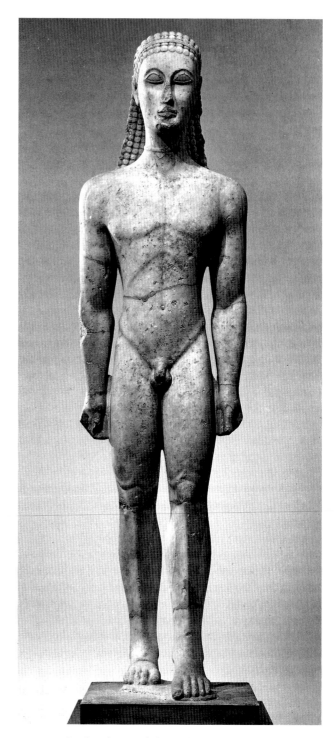

146. *Female Figure (Kore).* c. 650 B.C. Limestone,
height 24¹/2" (62.3 cm). Musée du Louvre, Paris

147. *Standing Youth (Kouros).* c. 600 B.C. Marble,
height 6'1¹/2" (1.88 m). The Metropolitan Museum of Art, New York.
Fletcher Fund, 1932

and potter, as well as a dedication typical of Greek vases: "Hermogenes is beautiful."

ARCHAIC SCULPTURE

The new motifs that distinguish the Orientalizing style from the Geometric—fighting animals, winged monsters, scenes of combat—had reached Greece mainly through the importation of ivory carvings and metalwork from Phoenicia or Syria, pieces that reflected Mesopotamian as well as Egyptian influences. Such objects have actually been found on Greek soil, so that we can regard this channel of transmission as well

established. They do not help us, however, to explain the rise of monumental architecture and sculpture in stone about 650 B.C., which must have been based on acquaintance with Egyptian works that could be studied only on the spot. We know that small colonies of Greeks existed in Egypt at the time, but why, we wonder, did Greece suddenly develop a taste for monumentality, and how did her artists acquire so quickly the Egyptian mastery of stone carving? All the earliest Greek sculpture we know from the Geometric period consists of simple clay or bronze figurines of animals and warriors only a few inches in size. The mystery may never be cleared up, for the oldest surviving Greek stone sculpture and architecture show that

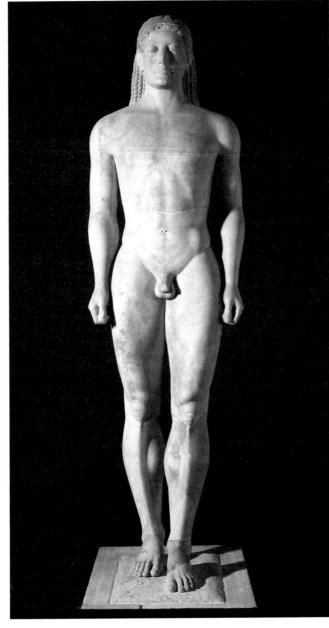

148. *Kroisos (Kouros from Anavysos)*. c. 525 B.C. Marble, height 6'4" (1.9 m). National Archaeological Museum, Athens

the Egyptian tradition had already been well assimilated and Hellenized, though their link with Egypt is still clearly visible.

Kouros and Kore

Let us consider two very early Greek statues, a small female figure of about 650 B.C. (fig. 146) and a lifesize nude youth of about 600 B.C. (fig. 147), and compare them with their Egyptian predecessors (fig. 64). The similarities are certainly striking. We note the block-conscious, cubic character of all four statues, the slim, broad-shouldered silhouette of the male figures, the position of their arms, their clenched fists, the way they stand with the left leg forward, the emphatic rendering of the kneecaps. The formalized, wiglike treatment of the hair, the close-fitting garment of the female figure, and her raised arm are further points of resemblance. Judged by Egyptian standards, the Archaic statues seem somewhat primitive: rigid, oversimplified, awkward, less close to nature. Whereas the

Egyptian sculptor allows the legs and hips of the female figure to press through the skirt, the Greek shows a solid, undifferentiated mass from which only the toes protrude.

But the Greek statues also have virtues of their own that cannot be measured in Egyptian terms. First of all, they are truly free-standing—the earliest large stone images of the human form in the entire history of art of which this can be said. The Egyptian carver had never dared to liberate such figures completely from the stone. They remain immersed in it to some degree, so that the empty spaces between the legs and between the arms and the torso (or between two figures in a double statue, as in fig. 64) always remain partly filled. There are never any holes in Egyptian stone figures. In that sense, they do not rank as sculpture in the round but as an extreme case of high relief. The Greek carver, on the contrary, does not mind holes in the least. The arms are separated from the torso and the legs from each other, unless they are encased in a skirt, and the carver goes to great lengths to cut away every bit of dead material. (The only exceptions are the tiny bridges between the fists and the thighs of the nude youth.) Apparently it is of the greatest importance to the sculptor that a statue consist only of stone that has representational meaning within an organic whole. The stone must be transformed; it cannot be permitted to remain inert, neutral matter.

This is not, we must insist, a question of technique but of artistic intention. The act of liberation achieved in our two figures endows them with a spirit basically different from that of any of the Egyptian statues. While the latter seem becalmed by a spell that has released them from every strain for all time to come, the Greek images are tense, full of hidden life. The direct stare of their huge eyes offers the most telling contrast to the gentle, faraway gaze of the Egyptian figures.

Whom do they represent? We call the female statues by the general name of Kore (Maiden), the male ones Kouros (Youth)—noncommittal terms that gloss over the difficulty of identifying them further. Nor can we explain why the Kouros is always nude while the Kore is clothed. Whatever the reason, both types were produced in large numbers throughout the Archaic era, and their general outlines remained extraordinarily stable. Some are inscribed with the names of artists ("So-and-so made me") or with dedications to various deities. These, then, were votive offerings. But whether they represent the donor, the deity, or a divinely favored person such as a victor in athletic games remains uncertain in most cases. Others were placed on graves, yet they can be viewed as representations of the deceased only in a broad (and completely impersonal) sense. This odd lack of differentiation seems part of the essential character of these figures. They are neither gods nor mortals but something in between, an ideal of physical perfection and vitality shared by mortal and immortal alike, just as the heroes of the Homeric epics dwell in the realms of both history and mythology.

If the type of Kouros and Kore is narrowly circumscribed, its artistic interpretation shows the same inner dynamic we have traced in Archaic vase painting. The pace of this development becomes strikingly clear from a comparison of the Kouros of figure 147 with another carved some 75 years later (fig. 148) and identified by the inscription on its base as the funerary statue of Kroisos, who had died a hero's death in the

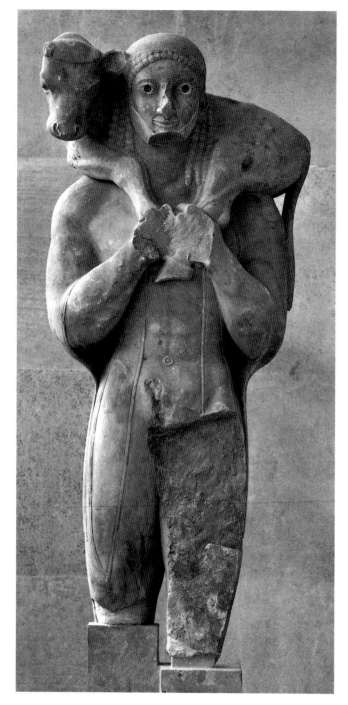

149. *Calf-Bearer.* c. 570 B.C. Marble, height of entire statue 65"
(165 cm). Acropolis Museum, Athens

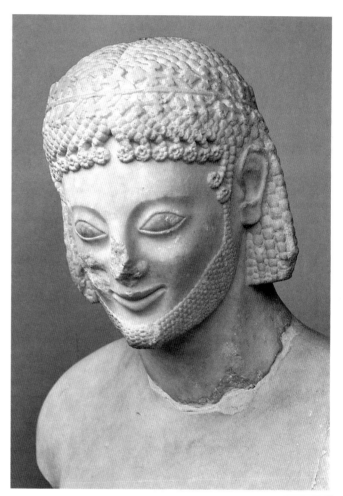

150. *Rampin Head.* c. 560 B.C. Marble, height 11 1/2" (29.3 cm).
Musée du Louvre, Paris

front line of battle. Like all such figures, it was originally painted. (Traces of color can still be seen in the hair and the pupils of the eyes.) Instead of the sharply contoured, abstract planes of the older statue, we now find swelling curves. The whole body displays a greater awareness of massive volumes, but also a new elasticity, and countless anatomical details are more functionally rendered than before. The style of the *Kroisos* thus corresponds exactly to that of Psiax's *Herakles* (fig. 143). Here we witness the transition from black-figured to red-figured in sculptural terms.

There are numerous statues from the middle years of the sixth century marking previous way stations along the same road. The magnificent *Calf-Bearer* of about 570 B.C. (fig. 149) is a votive figure representing the donor with the sacrificial ani-

mal he is offering to Athena. Needless to say, it is not a portrait, any more than the *Kroisos* is, but it shows a type: the beard indicates a man of mature years. The *Calf-Bearer* originally had the Kouros standing pose, and the body conforms to the Kouros ideal of physical perfection. Its vigorous, compact forms are emphasized, rather than obscured, by the thin cloak, which fits them like a second skin, detaching itself only momentarily at the elbows. The face, effectively framed by the soft curve of the animal, no longer has the masklike quality of the early Kouros. The features have, as it were, caught up with the rest of the body in that they, too, are permitted a gesture, a movement expressive of life: the lips are drawn up in a smile. We must be careful not to impute any psychological meaning to this "Archaic smile," for the same radiant expression occurs throughout sixth-century Greek sculpture, even on the face of the dead hero Kroisos. Only after 500 B.C. does it gradually fade out.

One of the most famous instances of this smile is the wonderful *Rampin Head* (fig. 150), which probably belonged to the body of a horseman. Slightly later than the *Calf-Bearer,* it shows the black-figured phase of Archaic sculpture at its highest stage of refinement. Hair and beard have the appearance of richly textured beaded embroidery that sets off the subtly accented planes of the face.

The Kore type is somewhat more variable than that of the Kouros, although it follows the same pattern of development. A clothed figure by definition, it poses a different problem: how to relate body and drapery. It is also likely to reflect chang-

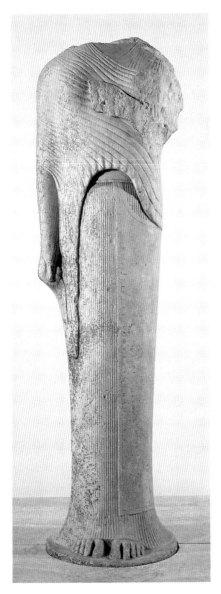

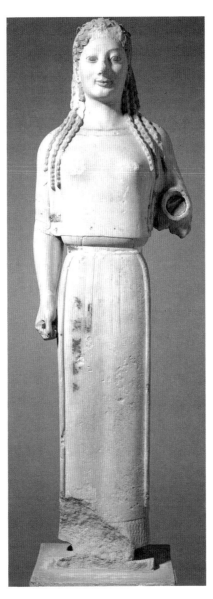

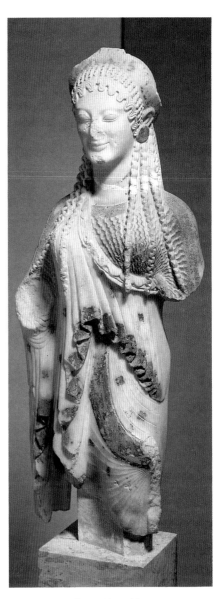

151. *"Hera,"* from Samos. c. 570–560 B.C. Marble, height 6'4" (1.9 m). Musée du Louvre, Paris

152. *Kore in Dorian Peplos.* c. 530 B.C. Marble, height 48" (122 cm). Acropolis Museum, Athens

153. *Kore,* from Chios (?). c. 520 B.C. Marble, height 21⅞" (55.3 cm). Acropolis Museum, Athens

ing habits or local differences of dress. Thus, the impressive statue in figure 151, carved about the same time as the *Calf-Bearer,* does not represent a more evolved stage of the Kore in figure 146 but an alternative approach to the same basic task. She was found in the Temple of Hera on the island of Samos and may well have been an image of the goddess because of her great size as well as her extraordinary dignity. If the earlier Kore echoes the planes of a rectangular slab, the *"Hera"* seems like a column come to life. Instead of clear-cut accents, such as the nipped-in waist in figure 146, we find here a smooth, continuous flow of lines uniting limbs and body. Yet the majestic effect of the statue depends not so much on its abstract quality as on the way the abstract form blossoms forth into the swelling softness of a living body. The great upward sweep of the lower third of the figure gradually subdivides to reveal several separate layers of garments, and its pace is slowed further (but never fully stopped) as it encounters the protruding shapes of arms, hips, and torso. In the end, the drapery, so completely architectonic up to the knee region, turns into a second skin of the kind we have seen in the *Calf-Bearer.*

The Kore of figure 152, in contrast, seems a linear descendant of our first Kore, even though she was carved a full century later. She, too, is blocklike rather than columnar, with a strongly accented waist. The simplicity of her garments is new and sophisticated, however. The heavy cloth forms a distinct, separate layer over the body, covering but not concealing the solidly rounded shapes beneath. And the left hand, which originally was extended forward, offering a votive gift of some sort, must have given the statue a spatial quality quite beyond the two earlier Kore figures we have discussed. Equally new is the more organic treatment of the hair, which falls over the shoulders in soft, curly strands, in contrast to the massive, rigid wig in figure 146. Most noteworthy of all, perhaps, is the full, round face with its enchantingly gay expression—a softer, more natural smile than any we have seen hitherto. Here, as in the *Kroisos,* we sense the approaching red-figured phase of Archaic art.

Our final Kore (fig. 153), about a decade later, has none of the severity of figure 152, though both were found on the Acropolis of Athens. In many ways she seems more akin to the

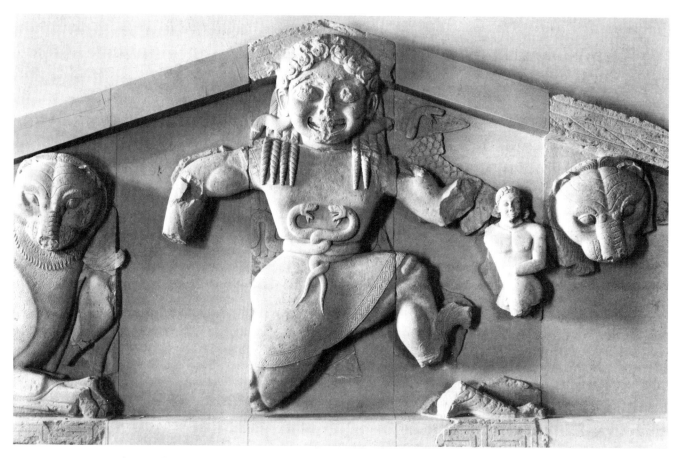

154. Central portion of the west pediment of the Temple of Artemis at Corfu, Greece. c. 600–580 B.C.
Limestone, height 9'2" (2.8 m). Archaeological Museum, Corfu, Greece

"Hera" from Samos. In fact, she probably came from Chios, another island of Ionian Greece. The architectural grandeur of her ancestress, though, has given way to an ornate refined grace. The garments still loop around the body in soft diagonal curves, but the play of richly differentiated folds, pleats, and textures has almost become an end in itself. Color must have played a particularly important role in such works, and we are fortunate that so much of it survives in this example.

Architectural Sculpture

When the Greeks began to build their temples in stone, they also fell heir to the age-old tradition of architectural sculpture. The Egyptians had been covering the walls and even the columns of their buildings with reliefs since the time of the Old Kingdom, but these carvings were so shallow (for example, figs. 68 and 81) that they left the continuity of the wall surface undisturbed. They had no weight or volume of their own, so that they were related to their architectural setting only in the same limited sense as Egyptian wall paintings, with which they were, in practice, interchangeable. This is also true of the reliefs on Assyrian, Babylonian, and Persian buildings (for example, figs. 103 and 112). There existed, however, another kind of architectural sculpture in the ancient Near East, originated, it seems, by the Hittites: the great guardian monsters protruding from the blocks that framed the gateways of fortresses or palaces (see figs. 99 and 101). This tradition

155. Reconstruction drawing of the west front of the Temple of Artemis at Corfu (after Rodenwaldt)

must have inspired, albeit perhaps indirectly, the carving over the Lioness Gate at Mycenae (see fig. 135). We must nevertheless note one important feature that distinguishes the Mycenaean guardian figures from their predecessors. Although they are carved in high relief on a huge slab, this slab is thin and light compared to the enormously heavy, Cyclopean blocks around it. In building the gate, the Mycenaean architect left an empty triangular space above the lintel, for fear that the weight of the wall above would crush it, and then filled the hole with the comparatively lightweight relief panel. Here,

then, we have a new kind of architectural sculpture: a work integrated with the structure yet also a separate entity rather than a modified wall surface or block.

TEMPLE OF ARTEMIS, CORFU. That the Lioness Gate relief is the direct ancestor of Greek architectural sculpture becomes evident when we compare it with the facade of the early Archaic Temple of Artemis on the island of Corfu, erected soon after 600 B.C. (figs. 154 and 155). Here again the sculpture is confined to a zone that is framed by structural members but is itself structurally empty: the triangle between the horizontal ceiling and the sloping sides of the roof. This area, called the pediment, need not be filled in at all except to protect the wooden rafters behind it against moisture. It demands not a wall but merely a thin screen. And it is against this screen that the pedimental sculpture is displayed.

Technically, these carvings are in high relief, like the guardian lionesses at Mycenae. Characteristically enough, however, the bodies are strongly undercut so as to detach them from the background. Even at this early stage of development, the Greek sculptor wanted to assert the independence of his figures from their architectural setting. The head of the central figure actually overlaps the frame. Who is this frightening creature? Not Artemis, surely, although the temple was dedicated to that goddess. As a matter of fact, we have met her before: she is a Gorgon, a descendant of those on the Eleusis amphora (fig. 140). Her purpose here was to serve as a guardian, along with the two huge lions, warding off evil from the temple and the sacred image of the goddess within. (The other pediment, of which only small fragments survive, had a similar figure.) She might be defined, therefore, as an extraordinarily monumental and still rather frightening hex sign. On her face, the Archaic smile appears as a hideous grin. And to emphasize further how alive and real she is, she has been represented running, or rather flying, in a pinwheel stance that conveys movement without locomotion.

The symmetrical, heraldic arrangement of the Gorgon and the two animals reflects an Oriental scheme which we know not only from the Lioness Gate at Mycenae but from many earlier examples as well (see fig. 50, bottom center, and fig. 92, top). Because of its ornamental character, it fits the shape of the pediment to perfection. Yet the early Archaic designer was not content with that. The pediment must contain narrative scenes. Therefore a number of smaller figures have been added in the spaces left between or behind the huge main group. The design of the whole thus shows two conflicting purposes in uneasy balance. As we might expect, narrative will soon win out over heraldry.

Aside from the pediment, there were not many places that the Greeks deemed suitable for architectural sculpture. They might put free-standing figures (often of terracotta) above the ends and the center of the pediment to break the severity of its outline. And they often placed reliefs in the zone immediately below the pediment. In Doric temples such as that at Corfu (fig. 155), this "frieze" consists of alternating triglyphs (blocks with three vertical markings) and metopes. The latter were originally the empty spaces between the ends of the ceiling beams; hence they, like the pediment, could be filled with sculpture. In Ionic architecture, the triglyphs were omitted,

156. Plan of the Treasury of the Siphnians

157. Reconstruction drawing of the Treasury of the Siphnians. Sanctuary of Apollo at Delphi. c. 525 B.C.

and the frieze became what the term usually conveys to us, a continuous band of painted or sculptured decoration. The Ionians would also sometimes elaborate the columns of a porch into female statues, which is not a very surprising development in view of the columnar quality of the "Hera" from Samos (fig. 151).

SIPHNIAN TREASURY, DELPHI. All these possibilities are combined in the Treasury (a miniature temple for storing votive gifts) erected at Delphi shortly before 525 B.C. by the inhabitants of the Ionian island of Siphnos. Although the building no longer stands, we can get a general idea of its appearance from the reconstruction in figures 156 and 157. Of its lavish sculptural décor, the most impressive part is the splendid frieze. The detail reproduced here (fig. 158) shows part of the battle of the Greek gods against the giants. On the extreme left, two lions (who pull the chariot of Cybele) are tearing apart an anguished giant. In front of them, Apollo and Artemis advance together, shooting their arrows. A dead giant, despoiled of his armor, lies at their feet, while three others enter from the right.

The high relief, with its deep undercutting, recalls the Corfu pediment, but the Siphnian sculptor has taken full advantage of the spatial possibilities offered by this technique. The projecting ledge at the bottom of the frieze is used as a

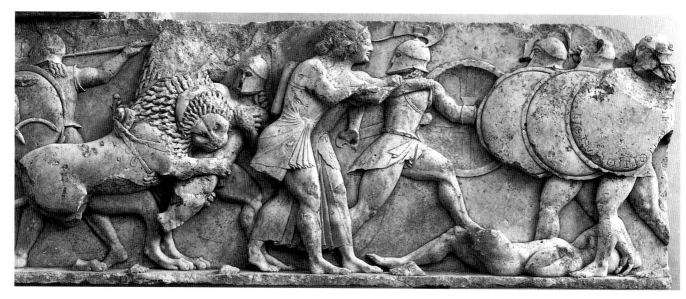

158. *Battle of the Gods and Giants,* from the north frieze of the Treasury of the Siphnians.
c. 530 B.C. Marble, height 26" (66 cm). Archaeological Museum, Delphi

stage on which he can place his figures in depth. The arms and legs of those nearest the beholder are carved completely in the round. In the second and third layers, the forms become shallower, yet even those farthest removed from us are never permitted to merge with the background. The result is a limited and condensed but very convincing space that permits a dramatic relationship between the figures such as we have never seen before in narrative reliefs. Any comparison with older examples (such as figs. 69, 102, 129, and 133) will show us that Archaic art has indeed conquered a new dimension here, not only in the physical but also in the expressive sense.

TEMPLE OF APHAIA, AEGINA. Meanwhile, in pedimental sculpture, relief has been abandoned altogether. Instead, we find separate statues placed side by side in complex dramatic sequences designed to fit the triangular frame. The most ambitious ensemble of this kind, that of the east pediment of the Temple of Aphaia at Aegina, was created about 490 B.C., and thus brings us to the final stage in the evolution of Archaic sculpture. The figures were found in pieces on the ground. The position of each within the pediment, however, can be determined, since their height (but not their scale) varies with the sloping sides of the triangle (fig. 159). The center is accented by the standing goddess Athena, who presides over the battle between Greeks and Trojans that rages to either side of her in symmetrically diminishing fashion.

The correspondence in the poses of the fighters on the two halves of the pediment makes for a balanced and orderly design. Yet it also forces us to see the statues as elements in an ornamental pattern and thus robs them of their individuality to some extent. They speak most strongly to us when viewed one by one. Among the most impressive are the fallen warrior from the left-hand corner (fig. 160) and the kneeling Herakles, who once held a bronze bow, from the right-hand half (fig. 161). Both are lean, muscular figures whose bodies seem marvelously functional and organic. That in itself, however, does

not explain their great beauty, much as we may admire the artist's command of the human form in action. What really moves us is their nobility of spirit, whether in the agony of dying or in the act of killing. These men, we sense, are suffering—or carrying out—what fate has decreed, with tremendous dignity and resolve. And this communicates itself to us in the very feel of the magnificently firm shapes of which they are composed.

ARCHITECTURE

Orders and Plans

In architecture, the Greek achievement has been identified since ancient Roman times with the creation of the three classical architectural orders: Doric, Ionic, and Corinthian. [See Primary Sources, no. 8, page 215.] Actually, there are only two, the Corinthian being a variant of the Ionic. (The dentils, or toothlike blocks, are sometimes found in the Doric and Ionic orders as well.) The Doric, so named because its home is a region of the Greek mainland, may well claim to be the basic order, since it is older and more sharply defined than the Ionic, which developed on the Aegean Islands and the coast of Asia Minor.

What do we mean by "architectural order"? By common agreement, the term is used only for Greek architecture (and its descendants); and rightly so, for none of the other architectural systems known to us produced anything like it. Perhaps the simplest way to make clear the unique character of the Greek orders is this: there is no such thing as "the Egyptian temple" or "the Gothic church." The individual buildings, however much they may have in common, are so varied that we cannot distill a generalized type from them. But "the Doric temple" is a real entity that inevitably forms in our minds as we examine the monuments themselves. We must be careful, of course, not to think of this abstraction as an ideal that permits us to measure

159. Reconstruction drawing of the east pediment of the Temple of Aphaia, Aegina (after Ohly)

160. *Dying Warrior,* from the east pediment of the Temple of Aphaia, Aegina. c. 490 B.C.
Marble, length 6' (1.83 m). Staatliche Antikensammlungen und Glyptothek, Munich

161. *Herakles,* from the east pediment of the Temple of Aphaia,
Aegina. c. 490 B.C. Marble, height 31" (78.7 cm). Staatliche Antiken-
sammlungen und Glyptothek, Munich

the degree of perfection of any given Doric temple. It simply means that the elements of which a Doric temple is composed are extraordinarily constant in number, in kind, and in their relation to one another. As a result of this narrowly circumscribed repertory of forms, Doric temples all belong to the same clearly recognizable family, just as the Kouros statues do. And like the Kouros statues, they show an internal consistency, a mutual adjustment of parts, that gives them a unique quality of wholeness and organic unity.

DORIC ORDER. The term *Doric order* refers to the standard parts, and their sequence, constituting the exterior of any Doric temple. Its general outlines are already familiar to us from the facade of the Temple of Artemis at Corfu (fig. 155). The diagram in figure 162 shows it in detail, along with the names of all the parts. To the nonspecialist, the detailed terminology may seem something of a nuisance. Yet a good many of these terms have become part of our general architectural vocabulary, to remind us of the fact that analytical thinking, in architecture as in countless other fields, originated with the Greeks. Let us first look at the three main divisions: the stepped platform (consisting of the stylobate and stereobate), the columns, and the entablature (which includes all the horizontal components that rest on the columns). The Doric column consists of the shaft, marked by shallow vertical grooves known as flutes, and the capital, which is made up of the flaring, cushionlike echinus and a square tablet called the abacus. The entablature is the most complex of the three major units.

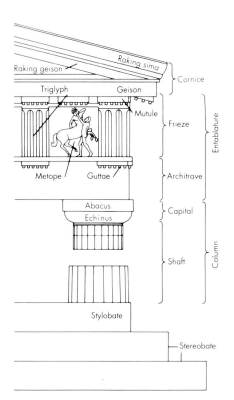
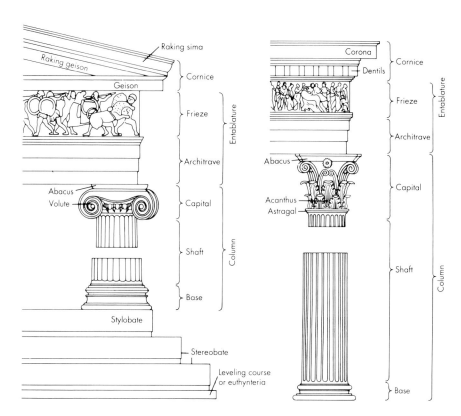

162. Doric, Ionic, and Corinthian orders

It is subdivided into the architrave (a series of stone blocks directly supported by the columns), the frieze with its triglyphs and metopes, and the projecting cornice, or geison, which may include a gutter (sima). The entablature in turn supports the triangular pediment and roof elements (the raking geison and raking sima).

The entire structure is built of stone blocks fitted together without mortar. They had to be shaped with extreme precision to achieve smooth joints. Where necessary, they were fastened together by means of metal dowels or clamps. Columns, with very rare exceptions, are composed of sections, called drums (clearly visible in fig. 165). The roof consisted of terracotta tiles supported by wooden rafters, and wooden beams were used for the ceiling, so that the threat of fire was constant.

TEMPLE PLANS. The plans of Greek temples are not directly linked to the orders (which, as we have seen, concern the elevation only). They may vary according to the size of the building or regional preferences, but their basic features are so much alike that it is useful to study them from a generalized "typical" plan (fig. 163). The nucleus is the cella or naos (the room in which the image of the deity is placed) and the porch (pronaos) with its two columns flanked by pilasters (antae). The Siphnian Treasury shows this minimal plan (see fig. 156). Often we find a second porch added behind the cella, to make

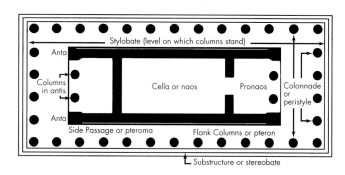

163. Ground plan of a typical Greek peripteral temple (after Grinnell)

the design more symmetrical. In the larger temples, this central unit is surrounded by a colonnade, called the peristyle, and the structure is then known as peripteral. The very largest temples of Ionian Greece may even have a double colonnade. The entrance to a Greek temple customarily faces east, toward the rising sun—an orientation that reaches back to Stonehenge (see fig. 47) and is continued in Christian basilicas (see page 234–35), which also face east but were entered from the west.

Doric Temples

How did the Doric originate? What factors shaped the rigid and precise vocabulary of the Doric order? These fascinating questions have occupied archaeologists for many years, but

even now they can be answered only in part, for we have hardly any remains from the time when the system was still in process of formation. The earliest stone temples known to us, such as that of Artemis at Corfu, show that the essential features of the Doric order were already well established soon after 600 B.C. How these features developed, individually and in combination, why they congealed into a system as rapidly as they seem to have done, remains a puzzle to which we have few reliable clues.

The early Greek builders in stone apparently drew upon three distinct sources of inspiration: Egypt, Mycenae, and pre-Archaic Greek architecture in wood and mud brick. The Mycenaean contribution is the most tangible, although probably not the most important, of these. The central unit of the Greek temple, the cella and porch, clearly derives from the megaron (see fig. 136), either through a continuous tradition or by way of revival. There is something oddly symbolic about the fact that the Mycenaean royal hall should have been converted into the dwelling place of the Greek gods. The entire Mycenaean era had become part of Greek mythology, as attested by the Homeric epics, and the walls of the Mycenaean fortresses were believed to be the work of mythical giants, the Cyclopes. The religious awe the Greeks felt before these remains also helps us to understand the relationship between the Lioness Gate relief at Mycenae and the sculptured pediments on Doric temples. Finally, the flaring, cushionlike capital of the Minoan-Mycenaean column is a good deal closer to the Doric echinus and abacus than is any Egyptian capital. The shaft of the Doric column, on the other hand, tapers upward, not downward as does the Minoan-Mycenaean column, and this definitely points to Egyptian influence.

Perhaps we will recall now—with some surprise—the fluted columns (or rather half-columns) in the funerary district of Djoser at Saqqara (see fig. 56) that had approximated the Doric shaft more than 2,000 years before its appearance in Greece. Moreover, the very notion that temples ought to be built of stone, and that they required large numbers of columns, must have come from Egypt. It is true, of course, that the Egyptian temple is designed to be experienced from the inside, while the Greek temple is arranged so that the impressive exterior matters most. (Few people were allowed to enter the dimly lit cella, and religious ceremonies usually took place at altars erected out-of-doors, with the temple facade as a backdrop.) A peripteral temple might be interpreted as the columned court of an Egyptian sanctuary turned inside-out. The Greeks also must have acquired much of their stonecutting and masonry techniques from the Egyptians, along with architectural ornament and the knowledge of geometry needed in order to lay out temples and to fit the parts together. Yet we cannot say just how they went about all this, or exactly what they took over, technically and artistically, although there can be little doubt that they owed more to the Egyptians than to the Minoans or the Mycenaeans.

DOES FORM FOLLOW FUNCTION? The problem of origins becomes acute when we consider a third factor: to what extent the Doric order can be understood as a reflection of wooden structures. Those historians of architecture who believe that form follows function—that an architectural form

will inevitably reflect the purpose for which it was devised—have pursued this line of approach at great length, especially in trying to explain the details of the entablature. Up to a point, their arguments are convincing. It seems plausible to assume that at one time the triglyphs did mask the ends of wooden beams, and that the droplike shapes below, called guttae (see fig. 162), are the descendants of wooden pegs. The peculiar vertical subdivisions of the triglyphs are perhaps a bit more difficult to accept as an echo of three half-round logs. And when we come to the flutings of the column, our doubts continue to rise. Were they really developed from adz marks on a tree trunk, or did the Greeks take them over ready-made from the "proto-Doric" stone columns of Egypt?

As a further test of the functional theory, we would have to ask how the Egyptians came to put flutes in their columns. They, too, after all, had once had to translate architectural forms from impermanent materials into stone. Perhaps it was they who turned adz marks into flutes? But the predynastic Egyptians had so little timber that they seem to have used it only for ceilings. The rest of their buildings consisted of mud brick, fortified by bundles of reeds. And since the proto-Doric columns at Saqqara are not free-standing but are attached to walls, their flutings might represent a sort of abstract echo of bundles of reeds. (There are also columns at Saqqara with convex rather than concave flutes that come a good deal closer to the notion of a bundle of thin staves.) On the other hand, the Egyptians may have developed the habit of fluting without reference to any earlier building techniques at all. Perhaps they found it an effective way to disguise the horizontal joints between the drums and to stress the continuity of the shaft as a vertical unit. Even the Greeks did not flute the shafts of their columns drum by drum, but waited until the entire column was assembled and in position. Be that as it may, fluting certainly enhances the expressive character of the column. A fluted shaft looks stronger, more energetic and resilient, than a smooth one. This, rather than its manner of origin, surely accounts for the persistence of the habit.

Why then did we enter at such length into an argument that seems at best inconclusive? Mainly in order to suggest the complexity, as well as the limitations, of the technological approach to problems of architectural form. The question, always a thorny one, of how far stylistic features can be explained on a functional basis will face us again and again. Obviously, the history of architecture cannot be fully understood if we view it only as an evolution of style in the abstract, without considering the actual purposes of building or its technological basis. But we must likewise be prepared to accept the purely aesthetic impulse as a motivating force. At the very start, Doric architects certainly imitated in stone some features of wooden temples, if only because these features were deemed necessary in order to identify a building as a temple. Thus, the trigylyphs were derived from the ends of ceiling beams decorated with three grooves and secured with wooden pegs, whose shape is dimly echoed in the guttae. Metopes evolved out of the boards that filled in the gaps between the triglyphs to guard against the elements. Likewise, mutules (flat projecting blocks) reflect the rafter ends of wooden roofs. When Greek architects enshrined them in the Doric order, however, they did not do so from blind conservatism or force of habit, but because the

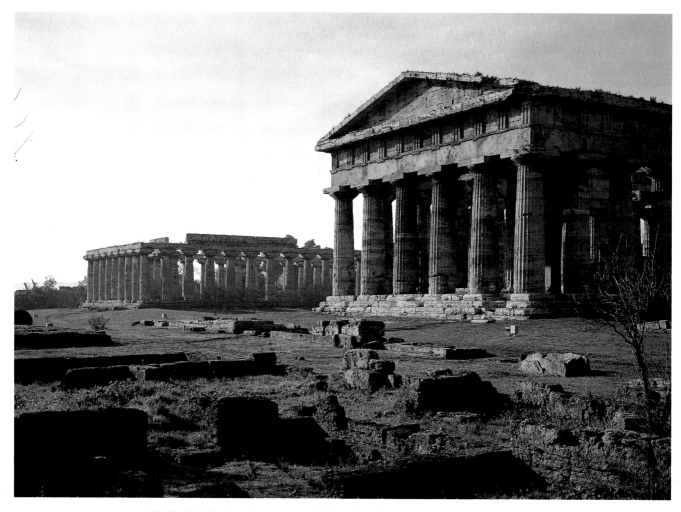

164. The "Basilica," c. 550 B.C., and the "Temple of Poseidon," c. 460 B.C. Paestum, Italy

wooden forms had by now been so thoroughly transformed that they were an organic part of the stone structure.

TEMPLES AT PAESTUM. We must confront the problem of function once more when we consider the best-preserved sixth-century Doric temple, the so-called "Basilica" at Paestum in southern Italy (fig. 164, left; fig. 165), in relation to its neighbor, the so-called "Temple of Poseidon" (fig. 164, right), which was built almost a century later. Both are Doric, but we at once note striking differences in their proportions. The "Basilica" seems low and sprawling (and not only because so much of the entablature is missing), while the "Temple of Poseidon" looks tall and compact. Even the columns themselves are different. Those of the older temple taper far more emphatically, their capitals are larger and more flaring. Why the difference?

The peculiar shape of the columns of the "Basilica" (peculiar, that is, compared to fifth-century Doric) has been explained as being due to overcompensation. The architect, not yet fully familiar with the properties of stone as compared with wood, exaggerated the taper of the shaft for greater stability and enlarged the capitals so as to narrow the gaps to be spanned by the blocks of the architrave. Maybe so, but if we accept this interpretation in itself as sufficient to account for the design of these Archaic columns, do we not judge them by the standards of a later age? To label them primitive or awkward would be to disregard the particular expressive effect that is theirs and theirs alone.

The "Basilica's" columns seem to be more burdened by their load than those of the "Temple of Poseidon," so that the contrast between the supporting and supported members of the order is dramatized rather than harmoniously balanced, as it is in the later building. Various factors contribute to this impression. The echinus of the "Basilica's" capitals is not only larger than its counterpart in the "Temple of Poseidon," but it also seems more elastic and hence more distended by the weight it carries, almost as if it were made of rubber. And the shafts not only show a more pronounced taper but also a particularly strong bulge or curve along the line of taper, so that they, too, convey a sense of elasticity and compression compared with the rigidly geometric blocks of the entablature. This curve, called entasis, is a basic feature of the Doric column. Although it may be very slight, it endows the shaft with a muscular quality unknown in Egyptian or Minoan-Mycenaean columns.

The "Temple of Poseidon" (figs. 164, 166, and 167)—it was probably dedicated to Hera—is among the best preserved of all Doric sanctuaries. Of special interest are the interior

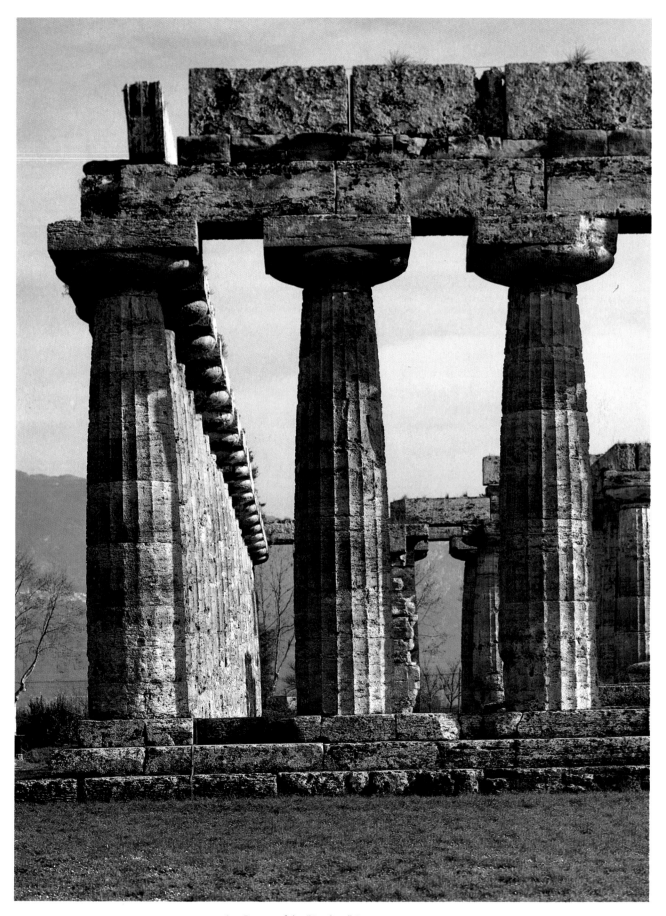

165. Corner of the "Basilica," Paestum. c. 550 B.C.

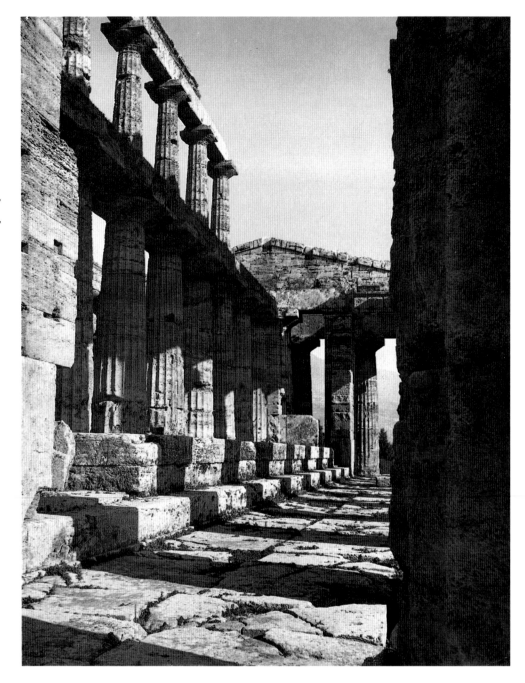

166. Interior, "Temple of Poseidon," Paestum. c. 460 B.C.

supports of the cella ceiling (fig. 166), two rows of columns, each supporting a smaller set of columns in a way that makes the tapering seem continuous despite the architrave in between. Such a two-story interior became a practical necessity for the cellas of the larger Doric temples. It is first found at the Temple of Aphaia at Aegina around the beginning of the fifth century, shown here in a reconstruction drawing to illustrate its construction scheme (fig. 168).

ATHENS, PERICLES, AND THE PARTHENON. In 480 B.C., shortly before their defeat, the Persians had destroyed the temple and statues on the Acropolis, the sacred hill above Athens which had been a fortified site since Mycenaean times. (For modern archaeologists, this disaster has turned out to be a blessing in disguise, since the debris, which was subsequently used as fill, has yielded many fine Archaic pieces, such as those in figures 149, 150, 152, and 153, which would hardly

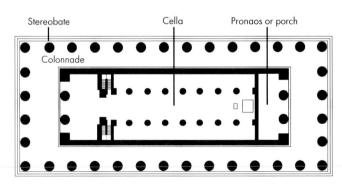

Stereobate Cella Pronaos or porch

Colonnade

167. Plan of the "Temple of Poseidon"

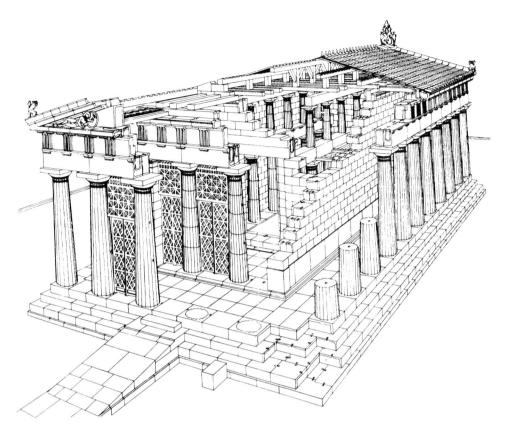

168. Sectional view (restored) of the Temple of Aphaia, Aegina

have survived otherwise.) The rebuilding of the Acropolis under the leadership of Pericles during the later fifth century was the most ambitious enterprise in the history of Greek architecture. [See Primary Sources, no. 12, page 216.] This is all the more surprising in light of the fact that, by today's standards, Athens was only a modest city, even at the height of its power. The Acropolis nevertheless represents the artistic climax of Greek art. Individually and collectively, these structures exemplify the Classical phase of Greek art in full maturity. The inspiration for such a complex can have come only from Egypt. So must Pericles' idea of treating it as a vast public works project, for which he spared no expense.

The greatest temple, and the only one to be completed before the Peloponnesian War (431–404 B.C.), is the Parthenon (figs. 169 and 170), dedicated to the virginal Athena, the patron deity in whose honor Athens was named. Built of marble on the most prominent site along the southern flank of the Acropolis, it dominates the city and the surrounding countryside, a brilliant landmark against the backdrop of mountains to the north. The history of the Parthenon is as extraordinary as its artistic significance. It is the only sanctuary we know that has served four different faiths in succession. The architects Ictinus, Callicrates, and Karpion erected it between 448 and 432 B.C., an amazingly brief span of time for a project of this size.

In order to meet the huge expense of building the largest and most lavish temple on the Greek mainland, Pericles delved into funds collected from states allied with Athens for mutual defense against the Persians. He may have felt that the danger was no longer a real one, and that Athens, the chief victim and victor at the climax of the Persian wars in 480–478 B.C., was

justified in using the money to rebuild what the Persians had destroyed. His act did weaken the position of Athens, however, and contributed to the disastrous outcome of the Peloponnesian War. (Thucydides openly reproached him for adorning the city "like a harlot with precious stones, statues, and temples costing a thousand talents.") In Christian times, the Virgin Mary displaced the virginal Athena: the Parthenon became first a Byzantine church, then a Catholic cathedral. Finally, under the Turks, it was a mosque. It has been a ruin since 1687, when a store of gunpowder the Turks had put into the cella exploded during a siege.

The Parthenon is unconventional in plan (see fig. 171). The cella is unusually wide and somewhat shorter than in other temples, so as to accommodate a second room behind it. The pronaos and its counterpart at the western end have almost disappeared, but there is an extra row of columns in front of either entrance. The architrave above these columns is more Ionic than Doric, since it has no triglyphs and metopes but a continuous sculptured frieze that encircles the entire cella (fig. 170). As the perfect embodiment of Classical Doric architecture, the Parthenon makes an instructive contrast with the "Temple of Poseidon" (fig. 164). Despite its greater size, it seems far less massive. Rather, the dominant impression it creates is one of festive, balanced grace within the austere scheme of the Doric order. This has been achieved by a general lightening and readjustment of the proportions. The entablature is lower in relation to its width and to the height of the columns, and the cornice projects less. The columns themselves are a good deal more slender, their tapering and entasis less pronounced, and the capitals are smaller and less flaring; yet the

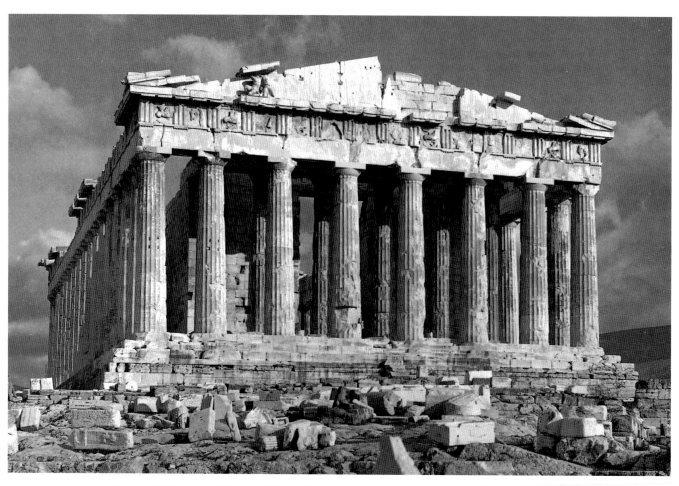

169. Ictinus, Callicrates, and Karpion. The Parthenon (view from the west), Acropolis, Athens. 448–432 B.C.

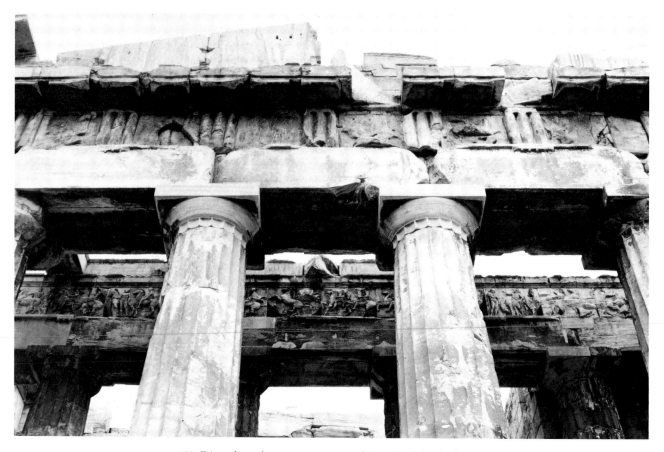

170. Frieze above the western entrance of the cella of the Parthenon

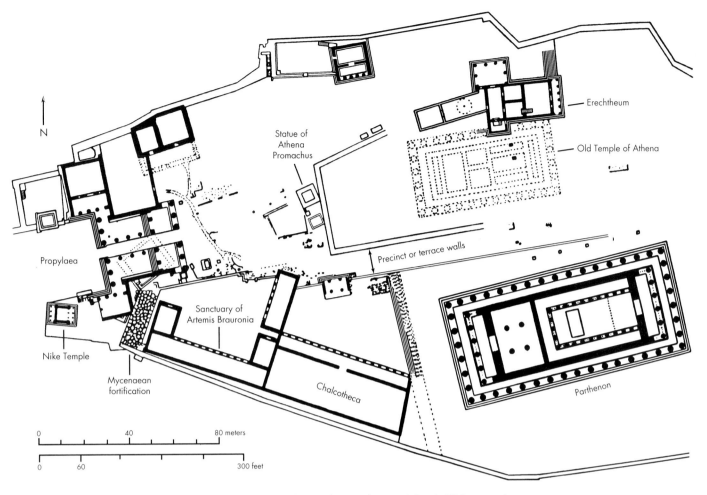

171. Plan of the Acropolis at Athens in 400 B.C. (after A. W. Lawrence)

spacing of the columns has become wider. We might say that the load carried by the columns has decreased, and consequently the supports can fulfill their task with a new sense of ease.

THE PARTHENON'S REFINEMENTS. These so-called refinements, intentional departures from the strict geometric regularity of the design for aesthetic reasons, are another feature of the Classical Doric style that can be observed in the Parthenon better than anywhere else. Thus the stepped platform and the entablature are not absolutely straight but slightly curved, so that the center is a bit higher than the ends; the columns lean inward; the interval between the corner column and its neighbors is smaller than the standard interval adopted for the colonnade as a whole; and every capital of the colonnade is slightly distorted to fit the curving architrave.

A great deal has been written about these deviations from mechanical exactitude. That they are planned rather than accidental is beyond doubt, but why did the architects go to the enormous trouble of carrying them through, since they are not a matter of necessity? They used to be regarded as optical corrections designed to produce the illusion of absolutely straight horizontals and verticals. Unfortunately, this functional explanation does not work. If it did, we should be unable to perceive the deviations except by careful measurement. Yet the fact is that, though unobtrusive, they are visible to the naked eye, even in photographs such as our figure 169. Moreover, in temples that do not have these refinements, the columns do

not give the appearance of leaning outward, nor do the horizontal lines look "dished." Plainly, then, the deviations were built into the Parthenon because they were thought to add to its beauty. They are a positive element that is meant to be noticed. And they do indeed contribute, in ways that are hard to define, to the integral, harmonious quality of the structure. These intentional departures from strict geometric regularity give us visual reassurance that the points of greatest stress are supported and provided with a counterstress as well.

Even this explanation fails to account fully for the Parthenon's remarkable persuasiveness, which has never been surpassed. The Roman architect Vitruvius records that Ictinus based his design on carefully considered proportions. But accurate measurements reveal them to be anything but simple or rigid. They, too, are replete with subtle adjustments, which lend the temple its surprisingly organic quality. In this respect the Parthenon closely parallels the underlying principles of Classical sculpture (see pages 139–40). Indeed, with its sculpture in place the Parthenon must have seemed animated with the same inner life that informs the pediment figures, such as the *Three Goddesses* (fig. 192).

PROPYLAEA. Immediately after the completion of the Parthenon, Pericles commissioned another splendid and expensive edifice, the monumental entry gate at the western end of the Acropolis, called the Propylaea (see plan, fig. 171). It was begun in 437 B.C. under the architect Mnesicles, who

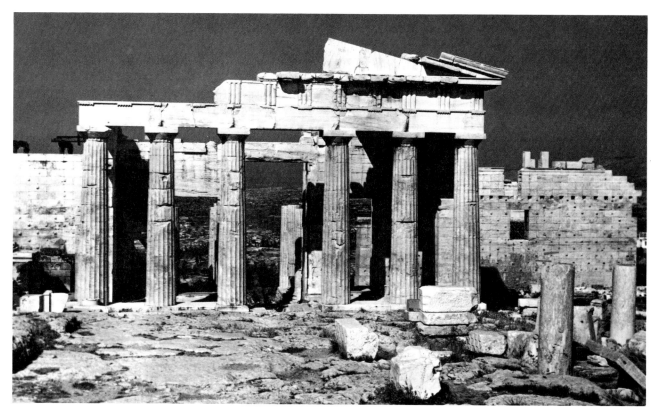

172. Mnesicles. The Propylaea (view from the east), Acropolis, Athens. 437–432 B.C.

completed the main part in five years; the remainder had to be abandoned because of the Peloponnesian War. Again the entire structure was built of marble and included refinements comparable to those of the Parthenon. It is fascinating to see how the familiar elements of a Doric temple have been adapted to a totally different task, on an irregular and steeply rising site. Mnesicles has indeed acquitted himself nobly. His design not only fits the difficult terrain but also transforms it from a rough passage among rocks into a splendid overture to the sacred precinct on which it opens.

Of the two porches (or facades) at either end, only the eastern one is in fair condition today (fig. 172). It resembles a Classical Doric temple front, except for the wide opening between the third and fourth columns. The western porch was flanked by two wings (figs. 173 and 174). The one to the north, considerably larger than its companion, included a picture gallery (*pinakotheke*), the first known instance of a room especially designed for the display of paintings. Along the central roadway that passes through the Propylaea, we find two rows of columns which are Ionic rather than Doric. Apparently at that time the trend in Athenian architecture was toward using Ionic elements inside Doric structures. (We recall the sculptured frieze of the Parthenon cella.)

Ionic Temples

Athens, with its strong Aegean orientation, had shown itself hospitable to the eastern Greek style of building from the

mid-fifth century on, and the finest surviving examples of the Ionic order are to be found among the structures of the Acropolis. The previous development of the order is known only in very fragmentary fashion. Of the huge Ionic temples that were erected in Archaic times on Samos and at Ephesus, little has survived except the plans. The Ionic vocabulary, however, seems to have remained fairly fluid, with strong affinities to the Near East (see figs. 110 and 111), and it did not really become an order in the strict sense until the Classical period. Even then it continued to be rather more flexible than the Doric order. Its most striking features are the continuous frieze, which lacks the alternating triglyphs and metopes of the Doric order, and the Ionic column, which differs from the Doric not only in body but also in spirit (see fig. 162). The Ionic column rests on an ornately profiled base of its own, perhaps used initially to protect the bottom from rain. The shaft is more slender, and there is less tapering and entasis. The capital shows a large double scroll, or volute, below the abacus, which projects strongly beyond the width of the shaft.

That these details add up to an entity very distinct from the Doric column becomes clear as soon as we turn from the diagram to an actual building (fig. 177). How shall we define it? The Ionic column is lighter and more graceful than its mainland cousin. It lacks the latter's muscular quality. Instead, it evokes a growing plant, something like a formalized palm tree. This vegetal analogy is not sheer fancy, for we have early ancestors, or relatives, of the Ionic capital that bear it out

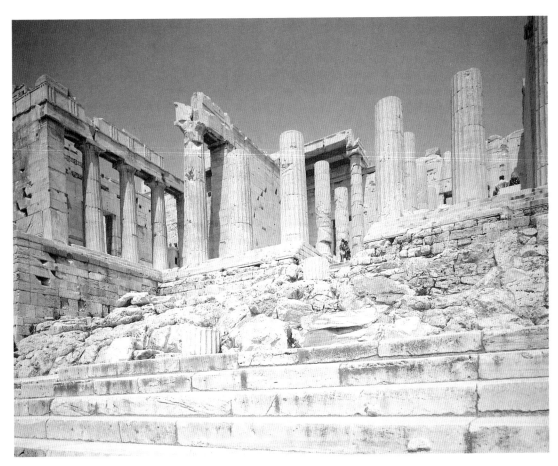

173. The Propylaea (with *pinakotheke*), western entrance

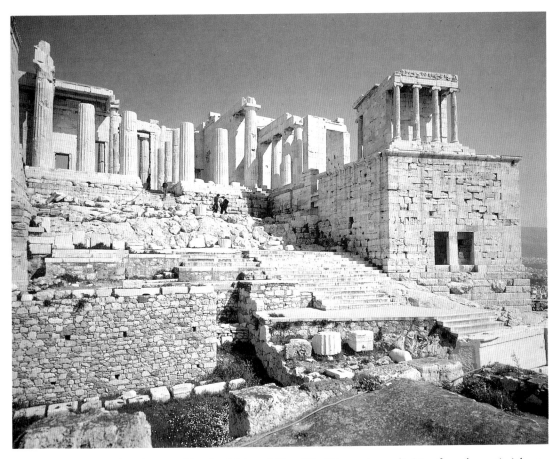

174. The Propylaea, 437–432 B.C.; Temple of Athena Nike, 427–424 B.C., Acropolis (view from the west), Athens

175. *(far left)* Aeolian capital, from Larissa. c. 600 B.C. Archaeological Museum, Istanbul, Turkey

176. *(left)* Corinthian capital, from the Tholos at Epidaurus. c. 350 B.C. Museum, Epidaurus, Greece

(fig. 175). If we were to pursue these plantlike columns all the way back to their point of origin, we would eventually find ourselves at Saqqara, where we encounter not only "proto-Doric" supports but also the wonderfully graceful papyrus half-columns of figure 58, with their curved, flaring capitals. It may well be, then, that the form of the Ionic column, too, had its ultimate source in Egypt, but instead of reaching Greece by sea, as we suppose the proto-Doric column did, it traveled a slow and tortuous path by land through Syria and Asia Minor.

In pre-Classical times, the only Ionic structures on the Greek mainland had been the small treasuries built by eastern Greek states at Delphi in the regional styles (see fig. 157). Hence the Athenian architects who took up the Ionic order about 450 B.C. at first thought of it as suitable only for small temples of simple plan. Such a building is the little Temple of Athena Nike on the southern flank of the Propylaea (fig. 174),

probably built between 427 and 424 B.C. from a design prepared 20 years earlier by Callicrates.

ERECHTHEUM. Larger and more complex is the Erechtheum (fig. 177 and plan, fig. 171) on the northern edge of the Acropolis opposite the Parthenon. It was erected between 421 and 405 B.C., probably by Mnesicles. Like the Propylaea, it is masterfully adapted to an irregular, sloping site. The area had various associations with the mythical founding of Athens, so that the Erechtheum served several religious functions at once. Apparently there were four rooms, in addition to a basement on the western side, although their exact purpose is under dispute. One held a statue of Erechtheus, a legendary king of Athens, who promoted the worship of Athena and from whom the building derives its name. The Erechtheum may have covered the spot where the contest between Athena and Poseidon, depicted on the east pediment of the Parthenon, was believed to have taken place. In any event, the eastern room was dedicated to Athena Polias (Athena the City Goddess) and contained the old statue replaced by Phidias, while another room was dedicated to Poseidon.

Instead of a west facade, the Erechtheum has two porches attached to its flanks, a very large one facing north and a small

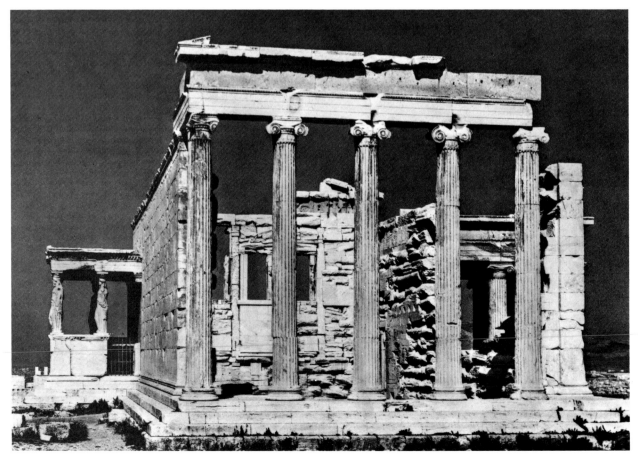

177. The Erechtheum (view from the east), Acropolis, Athens. 421–405 B.C.

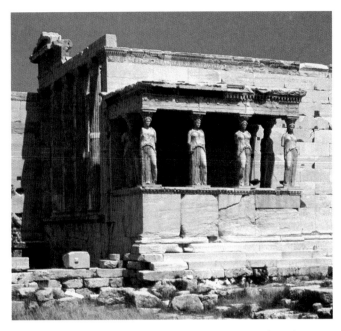

178. Porch of the Maidens, the Erechtheum, Acropolis, Athens. 421–405 B.C.

one toward the Parthenon. The latter is the famous Porch of the Maidens (fig. 178), so named because its roof is supported by six female figures (caryatids) on a high parapet, instead of regular columns (compare fig. 157). Here the exquisite refinement of the Ionic order conveys what Vitruvius might have called a "feminine" quality, compared with the "masculinity" of the Parthenon across the way. [See Primary Sources, no. 8, page 215.] Apart from the caryatids, sculptural decoration on the Erechtheum was confined to the frieze, of which very little survives. The pediments remained bare, perhaps for lack of funds at the end of the Peloponnesian War. However, the ornamental carving on the bases and capitals of the columns, and on the frames of doorways and windows, is extraordinarily delicate and rich. Its cost, according to the accounts inscribed on the building, was higher than that of figure sculpture.

CORINTHIAN CAPITAL. Such emphasis on ornament seems characteristic of the late fifth century. It was at this time that the Corinthian capital was invented as an elaborate substitute for the Ionic. (For a comparison of Doric, Ionic, and Corinthian capitals, see fig. 162.) Its shape is that of an inverted bell covered with the curly shoots and leaves of the acanthus plant, which seem to sprout from the top of the column shaft (fig. 176). At first, Corinthian capitals were used only for interiors. Not until a century later do we find them replacing Ionic capitals on the exterior. The earliest known instance is the Monument of Lysicrates in Athens (fig. 179), built soon after 334 B.C. It is not really a building in the full sense of the term—the interior, though hollow, has no entrance—but an elaborate support for a tripod won by Lysicrates in a contest. The round structure, resting on a tall base, is a miniature version of a tholos, a type of circular building of which several earlier examples are known to have existed. The columns here are engaged rather than free-standing, to make the monument more compact. Soon after, the Corinthian capital came to be employed on the exteriors of large buildings as well, and in Roman times it was the standard capital for almost any purpose.

179. Monument of Lysicrates, Athens. c. 334 B.C.

TOWN PLANNING AND THEATERS. During the three centuries between the end of the Peloponnesian War and the Roman conquest, Greek architecture shows little further development. Even before the time of Alexander the Great, the largest volume of building activity was to be found in the Greek cities of Asia Minor. There we encounter some structures of a new kind, often under Oriental influence, such as the huge Tomb of Mausolus at Halicarnassus (see figs. 202–204) and the Great Pergamum Altar (see figs. 211–13). Town planning on a rectangular grid pattern, first introduced at Miletus in the mid-fifth century, assumed new importance, as did the municipal halls (stoas) lining the marketplaces where the civic and commercial life of Greek towns was centered. Private houses, too, became larger and more ornate than before. Yet the architectural vocabulary, aesthetically as well as technically, remained essentially that of the temples of the late fifth century.

180. Theater, Epidaurus. c. 350 B.C.

The basic repertory of Greek architecture increased in one respect only: the open-air theater achieved a regular, defined shape. Before the fourth century, the auditorium had simply been a natural slope, preferably curved, equipped with stone benches. Now the hillside was provided with concentric rows of seats and with staircase-aisles at regular intervals, as at Epidaurus (figs. 180 and 181). In the center is the orchestra, where most of the action took place.

Contribution of Greek Architecture

In the end, the greatest achievement of Greek architecture was much more than just beautiful buildings. Greek temples are governed by a structural logic that makes them look stable because of the precise arrangement of their parts. The Greeks tried to regulate their temples in accordance with nature's harmony by constructing them of measured units which were so proportioned that they would all be in perfect agreement. ("Perfect" was as significant an idea to the Greeks as "forever" was to the Egyptians.) Now architects could create organic unities, not by copying nature, not by divine inspiration, but by design. Thus their temples seem to be almost alive. They achieved this triumph chiefly by expressing the structural forces active in buildings, known as architectonics. In the Classical period, expressions of force and counterforce in both Doric and Ionic temples were proportioned so exactly that their opposition produced the effect of a perfect balancing of forces and harmonizing of sizes and shapes. This, then, is the real reason why, for so many centuries, the orders have been considered the only true basis for beautiful architecture. They are so perfect that they could not be surpassed, only equaled.

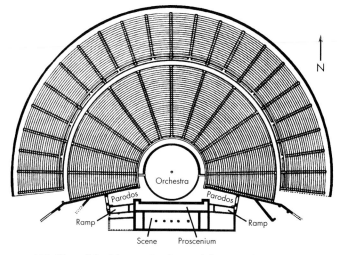

181. Plan of the Theater, Epidaurus (after Picard-Cambridge)

Limitations of Greek Architecture

How are we to account for the fact that Greek architecture did not grow significantly beyond the stage it had reached at the time of the Peloponnesian War? After all, neither intellectual life nor the work of sculptors and painters show any tendency toward staleness during the last 300 years of Greek civilization. Are we perhaps misjudging her architectural achievements after 400 B.C.? Or were there inherent limitations that prevented Greek architecture from continuing the pace of development it had maintained in Archaic and Classical times? A number of such limitations come to mind: the concern with monumental exteriors at the expense of interior space, the concentration of effort on temples of one particular type, and the lack of inter-

est in any structural system more advanced than the post-and-lintel (uprights supporting horizontal beams). Until the late fifth century, these had all been positive advantages. Without them, the great masterpieces of the Periclean age would have been unthinkable. But the possibilities of the traditional Doric temple were nearly exhausted by then, as indicated by the attention lavished on expensive refinements.

What Greek architecture needed after the Peloponnesian War was a breakthrough, a revival of the experimental spirit of the seventh century, that would create an interest in new building materials, vaulting, and interior space. What prevented the breakthrough? Could it have been the architectural orders, or rather the cast of mind that produced them? The suspicion will not go away that it was the very coherence and rigidity of these orders which made it impossible for Greek architects to break from the established pattern. What had been their great strength in earlier days became a tyranny. It remained for later ages to adapt the Greek orders to brick and concrete, to arched and vaulted construction. Such adaptation necessitated doing a certain amount of violence to the original character of the orders, something the Greeks, it seems, were incapable of.

CLASSICAL SCULPTURE

KRITIOS BOY. Among the statues excavated from the debris the Persians had left behind on the Acropolis, there is one Kouros (fig. 182) that stands apart from the rest. It must have been carved very shortly before the fateful year 480 B.C. This remarkable work, which some have attributed to the Athenian sculptor Kritios and which therefore has come to be known as the *Kritios Boy,* differs subtly but importantly from the Archaic Kouros figures we discussed above (figs. 147 and 148): it is the first statue we know that *stands* in the full sense of the word. Of course, the earlier figures also stand, but only in the sense that they are in an upright position and are not reclining, sitting, kneeling, or running. Their stance is really an arrested walk, with the weight of the body resting evenly on both legs. Thus, early Greek statues have an unintentional military air, as if they were soldiers standing at attention.

The *Kritios Boy,* too, has one leg placed forward, yet we never doubt for an instant that he is standing still. Just as in military drill, this is simply a matter of allowing the weight of the body to shift from equal distribution on both legs. When we compare the left and right half of his body, we discover that the strict symmetry of the Archaic Kouros has given way to a calculated nonsymmetry. The knee of the forward leg is lower than the other, the right hip is thrust down and inward, and the left hip up and outward. If we trace the axis of the body, we realize that it is not a straight vertical line but a faint, S-like curve (or, to be exact, a reversed S-curve). Taken together, all these small departures from symmetry tell us that the weight of the body rests mainly on the left leg and that the right leg plays the role of an elastic prop or buttress to make sure that the body keeps its balance.

CONTRAPPOSTO. The *Kritios Boy,* then, not only stands, he stands at ease. The artist has masterfully observed the balanced nonsymmetry of this relaxed natural stance. To describe

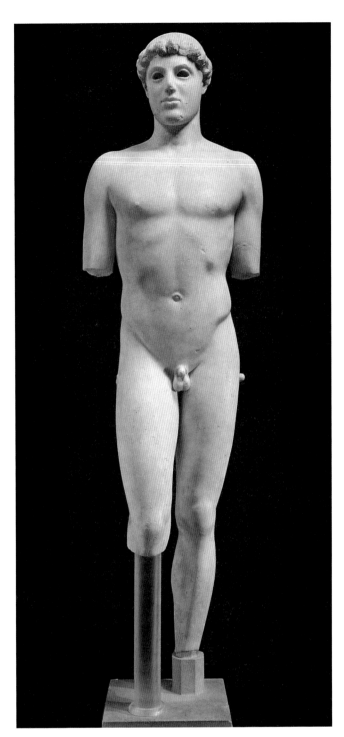

182. *Standing Youth (Kritios Boy).* c. 480 B.C. Marble, height 46" (116.7 cm). Acropolis Museum, Athens

it, we use the Italian word *contrapposto* (counterpoise). The leg that carries the main weight is commonly called the engaged leg; the other, the free leg. These terms are a useful shorthand, for from now on we shall have frequent occasion to mention contrapposto. It was a very basic discovery. Only by learning how to represent the body at rest could the Greek sculptor gain the freedom to show it in motion. But is there not plenty of motion in Archaic art? There is indeed (see figs. 154, 158, 160, and 161), but it is somewhat mechanical and inflexible in kind. We read it from the poses without really feeling it.

In the *Kritios Boy,* on the other hand, we sense for the first

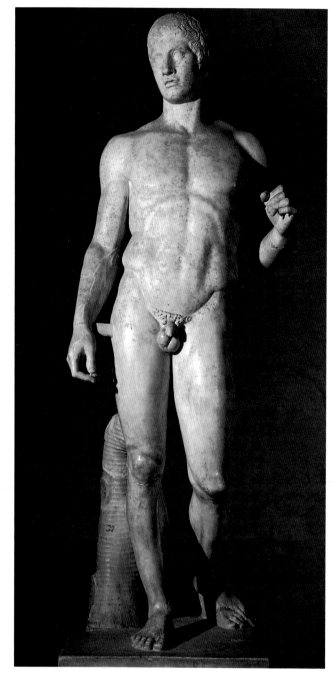

183. *Doryphorus (Spear Bearer)*. Roman copy after an original of c. 450–440 B.C. by Polyclitus. Marble, height 6'6" (2 m). Museo Archeologico Nazionale, Naples

that the Archaic smile, the "sign of life," is no longer needed. It has given way to a serious, pensive expression characteristic of the early phase of Classical sculpture (or, as it is often called, the Severe style). Once the Greek statue was free to move, as it were, it became free to think, not merely to act. The two are inseparable aspects of Greek classicism.

The new articulation of the body that appears in the *Kritios Boy* was to reach its full development within half a century in the mature Classical style of the Periclean era. The most famous Kouros statue of that time, the *Doryphorus (Spear Bearer)* by Polyclitus (fig. 183), is known to us only through Roman copies, which must convey little of the beauty of the original. Still, it makes an instructive comparison with the *Kritios Boy*. Everything is a harmony of complementary opposites. The contrapposto is now much more emphatic. The differentiation between the halves of the body can be seen in every muscle, and the turn of the head, barely hinted at in the *Kritios Boy*, is pronounced. The "working" left arm is balanced by the "engaged" right leg in the forward position, and the relaxed right arm by the "free" left leg. This studied poise, the precise anatomical details, and above all the harmonious proportions of the figure made the *Doryphorus* renowned as the standard embodiment of the Classical ideal of beauty. The ideal here must be understood in a dual sense as perfect model and universal prototype. According to one ancient writer, it was known simply as the Canon (rule, measure). [See Primary Sources, no. 5, pages 213–14.]

The *Doryphorus* was not simply an exercise in abstract geometry. It embodied not only *symmetria* (proportion), but also *rhythmos* (composition, movement), both fundamental aspects of Greek aesthetics derived from music and dance (see box pages 142–43). A faith in ratio can be found throughout Greek philosophy from the Pythagoreans, who believed that the harmony of the universe, like musical harmony, was expressible mathematically, to Plato, who made numbers the basis of his doctrine of ideal forms and acknowledged that the concept of beauty was commonly based on proportion. Moreover, Polyclitus' faith in numbers had a moral dimension: contemplation of harmonious proportions was equated with contemplation of the good. Rather than being opposed to naturalism, this elevated conception was inseparably linked to a more careful treatment of form that endows the human figure with a heightened liveliness as well as greater realism. Classical Greek sculpture appeals equally to the mind and the eye, so that human and divine beauty become one. No wonder that figures of victorious athletes have sometimes been mistaken for gods!

We can get some idea of what the *Doryphorus* might have looked like in its bronze original from a pair of impressive figures that created a sensation when they were found in the sea near Riace, Italy, in 1972 (figs. 184 and 185). They owe their importance to their fine workmanship and the extreme rarity of intact monumental bronze statues from ancient Greece. Miraculously, they still have their ivory and glass-paste eyes, bronze eyelashes, and copper lips, which combine with the detailed anatomy to create an astonishingly lifelike presence. They challenge our understanding of Greek sculpture in many ways. What or whom do these statues represent? When and where were they made? What purpose did they serve? To such questions we have as yet no certain answers. From both the

time not only a new repose but an animation of the body structure that evokes the experience we have of our own body, for contrapposto brings about all kinds of subtle curvatures: the bending of the free knee results in a slight swiveling of the pelvis, a compensating curvature of the spine, and an adjusting tilt of the shoulders. Like the refined details of the Parthenon, these variations have nothing to do with the statue's ability to maintain itself erect but greatly enhance its lifelike impression. In repose, it will still seem capable of movement; in motion, of maintaining its stability. Life now suffuses the entire figure, so

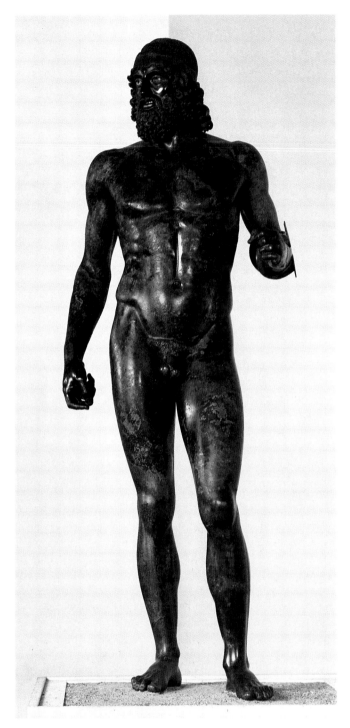

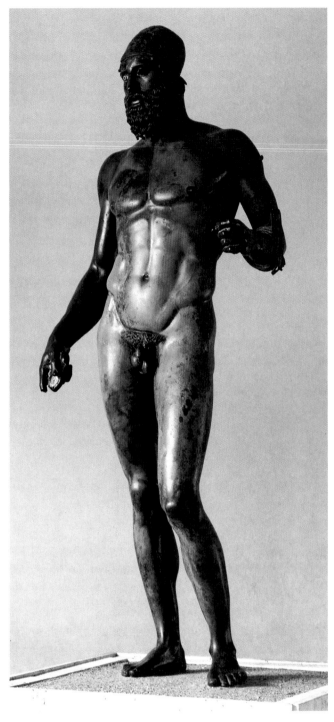

184. *Riace Warrior A,* found in the sea off Riace, Italy. c. 450 B.C. Bronze, height 6'8" (2.03 m). Museo Archeologico, Reggio Calabria, Italy

185. *Riace Warrior B,* found in the sea off Riace. c. 450 B.C. Bronze, height 6'8" (2.03 m). Museo Archeologico, Reggio Calabria

stylistic and technical evidence, they would seem to have been made around the same time as the *Doryphorus.* Although they have sometimes been dated slightly earlier, our sculptor may well have been an older artist who was accustomed to working in the Severe style and had not fully adapted to the new Classicism. (Compare the heads to that of *Zeus* in fig. 188.)

A tantalizing clue is provided by the statue in figure 185, which conforms to a widespread type right down to the proportions. (Examples of the second figure, however, are otherwise unknown.) He is, it appears, a warrior rather than an athlete, in contrast to the *Doryphorus.* Still to be explained is the extraordinary realism of the heads, so out of keeping with the idealization characteristic of Greek art as a whole. Were they meant to commemorate two heroes? It is tempting to think so. If that is the case, why were their names not recorded by ancient historians? Moreover, portraits are unknown from this time. Perhaps, then, their features were varied merely to distinguish the two among a larger group of unprecedented size, although free-standing groups of more than two figures are not recorded before the Late Classical era.

Although the earliest surviving evidence of Greek culture can be traced back to the eighth century B.C., it must have been preceded by at least 400 years now lost to us. In the eighth century we find the earliest remnants of Greek sculpture, painting, and architecture, however primitive they may be; the beginnings of Greek philosophy at Miletus; and, above all, the creation of two epic poems, the *Iliad* and the *Odyssey* (which probably treat an actual war of about 1200 B.C.), out of preexisting material. Homer, to whom these poems are attributed, lived in Asia Minor and chanted his poetry while playing a lyre. This unity of words and music, epitomized by the legendary bard Orpheus, whose music, it was said, could move even stones, was to be a constant feature of Greek poetry and theater.

Early Greek music as sung by the bards was of a very rudimentary sort called stithic: melodies consisted of only three or four notes sung repetitively in lines of simple rhythm and unchanging length. There was also a strophic form that could be closed (small, using a few basic meters, and clear in structure) or open (larger, more complex, with no fixed meter). Early Greek vocal music was accompanied by lyres having but a few strings ("lyric" poetry was sung to a lyre) or a primitive form of the aulos, an oboelike reed instrument that was always played in pairs. The harp, an import from Lydia and Ionia in Asia Minor, was preferred by Sappho of Lesbos (early sixth century B.C.) and remained chiefly an instrument for women, though it was also taken up by Alcaeus.

Because it involved only four notes, early Greek music was organized in tetrachords. At first, it was governed by the "enharmonic" (in tune) genus, meaning that the two inner (moving) notes were lower than the two outer (standing) ones and were separated by about a quarter-tone. By the fifth century B.C., a second genus, chromaticism, in which the moving notes of the tetrachord are separated by a semitone, began to gain favor because it was easier to play. Chromaticism virtually displaced the enharmonic genus toward the end of the fourth century B.C. Even easier was the diatonic genus, using full and half-tones, which was used for most late Greek music, as it has been for the vast majority of Western music since then. Two successive tetrachords were joined by a common note to form a seven-note scale, which gave rise to the standard seven-string kithara (lyre). Not until the early seventh century B.C. was the scale extended to the modern octave by Terpander. The concordant intervals nevertheless remained the fourth and the fifth, not the third and fifth used today.

These scales, with their varying intervals, were the basis of the modes. Although the notes can be reconstructed readily enough, each mode had certain rhythms, meters, and melodies associated with it that lent it a distinctive character (ethos) but that can only be guessed at, since all that remains of Greek music is some 51, mostly late, fragments supplemented by a small but crucial body of theory. The standard modes were the Dorian, used for invocations, lamentations, tragedy, and choral songs; the Phrygian, introduced into Athens by Sophocles, which could be cheerful and pious according to the philosopher Plato (427?–347 B.C.), or wildly emotional (orgiastic) according to his successor, Aristotle (384–322 B.C.); the Lydian, a "slack" (soft) mode used by the poet Anacreon (c. 570–c. 485 B.C.) at symposia that perhaps arose from the aulos airs composed by Olympus in the late eighth century B.C.; the Mixolydian, a highly emotional mode used by Sappho and deemed especially suitable for laments, which was the main tragic mode with the Dorian before the time of Sophocles; and the Ionian, a slack mode that was derived from Asiatic laments and was therefore also appropriate for tragedy. All other modes were likely derived from these five, whose names attest to the fact that Greece was a vast melting pot both musically and ethnically. In fact, there were rival musical centers throughout Greece. Sparta and Lesbos were the leaders throughout the seventh century B.C., only to be succeeded by Argos during the sixth century B.C., until Syracuse emerged as the capital of Greek music around 450 B.C., though Thebes continued to maintain its preeminence in the aulos.

The modes could be varied through modulations of genus, scale, key, and ethos. The growing complexity of music was spurred by the rise of instrumental music independent of singing. It began in Phrygia in the late eighth century B.C. with the first aulos player (*aulete*), variously considered to be Olympus or Hyagnis (Agnis), and was sufficiently advanced for a piper's contest (*agones*) to be added to the Phrygian games in 586 B.C., which was won by Sakada of Argos. The first kithara contest was added to the Phrygian games 28 years later. No longer tied to words, instrumental music was free to develop ever more novel, complex forms. It also underwent a change in character toward the ecstatic, serpentine music still found in the Near East today. By the mid-fifth century B.C., the emphasis was on virtuosity, which inevitably influenced vocal music as well. For example, Pindar (518?–c. 438 B.C.), the great composer of odes (music meant to be sung by a chorus), emphasized the intricacy and variety of his music. This trend reached its zenith in the late fifth century B.C. under Melanippides of Melos, a composer who created a more expressive singing style shaped to the words, and Timotheus the Milesian, whose *Persians* strikingly anticipates *The Battle of Issus* (fig. 199) in its representation of the sounds and color of combat. These innovations, however, met with stiff resistance from conservatives, who decried the loss of simplicity and dignity in favor of corrupt styles catering to popular taste. After the

invention in the sixth century B.C. of sophisticated lyres and auloi that could change modes without retuning, it became essential to unify the scales. The first coherent system was devised in the fourth century B.C. by Aristoxenus of Tarentum, a pupil of Aristotle, who devised a 13-note scale that was eventually superseded by a 15-note "perfect system," despite the attempt of Ptolemy in the second century B.C. to reduce the number back to seven. Surprisingly, the great age of Greek music was soon over. By the early fourth century, composers were replaced by star performers, who relied for the most part on the music of the past.

Music was of great importance in ancient Greece. The word *music* derives from *muse,* the personification and inspiration of the nine branches of art and learning. Thus, an educated person was a "musical" person. Music was closely linked to art through philosophy. Pythagoras (c. 582–c. 507 B.C.), who believed that the universe was governed by numbers, is generally credited with discovering that an octave is exactly half the length of the next lower one on a monochord over a graduated rule (kanon), although it may have actually been invented by the fifth-century theorist Simos. Also during the sixth century, Epigonos used a zither divided into quarter-tones to determine the relationships between the modal scales. From then on, Greek aesthetics as a branch of formal philosophical inquiry was founded on the belief in harmonious proportion, despite the fact that musical theory for the most part continued to be based on tonal intervals, which do not bear a simple mathematical relationship to each other. The importance of ratio was acknowledged by the great philosopher Plato, to whom we also owe the phrase "the music of the spheres," which was represented by eight Sirens taken from the eight notes of the standard diatonic scale.

During the fifth century B.C., moreover, Greek sculptors sought to infuse their work with inner life by investing it with *rhythmos* (composition, movement) and *symmetria* (proportion), terms taken from music and dance with strong philosophical connotations. Moreover, beauty itself was regarded by Plato and his successor, Aristotle, the teacher of Alexander the Great, as having inherent ethical associations and educative functions. This concept, too, was rooted in music. It was first adumbrated in the 440s by Damon, Pericles' teacher, who spelled out a comprehensive theory of modes according to their expressive effect and impact on character. Damon warned against revolutions in music as bad for society, an idea taken up as well by Plato, who had studied music under Damon's pupil Dracon. While it was challenged by the Epicurean philosophers in particular, the concept of musical ethos reached its height with Ptolemy, whose system of cosmic proportions was founded very much on his belief in the "tuning" of the soul.

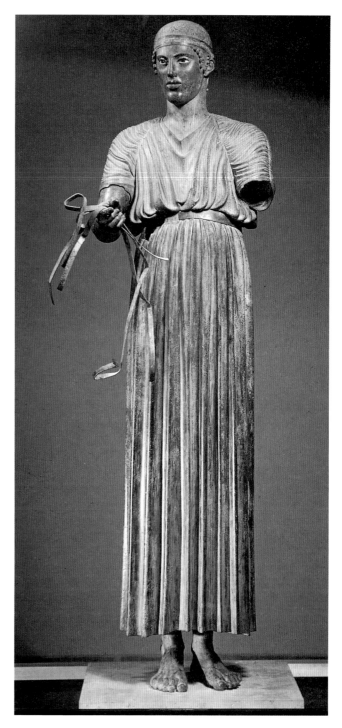

186. *Charioteer,* from the Sanctuary of Apollo at Delphi. c. 470 B.C. Bronze, height 71" (180 cm). Archaeological Museum, Delphi

This might help to explain why they seem to embody such a distinctive ethnic type. Conceptually, they are not altogether satisfying: the contrast between the individuality of the faces and the generalized treatment of the bodies is at once fascinating and disturbing. Were there similar statues about which we are ignorant simply because they have not survived? Our view of Greek sculpture may be as distorted by the incomplete record as was that of the poet Goethe, who could not accommodate the Aegina statues of Greek art into his understanding.

SEVERE STYLE. The splendid *Charioteer* from Delphi (fig. 186), one of the earliest surviving large bronze statues in

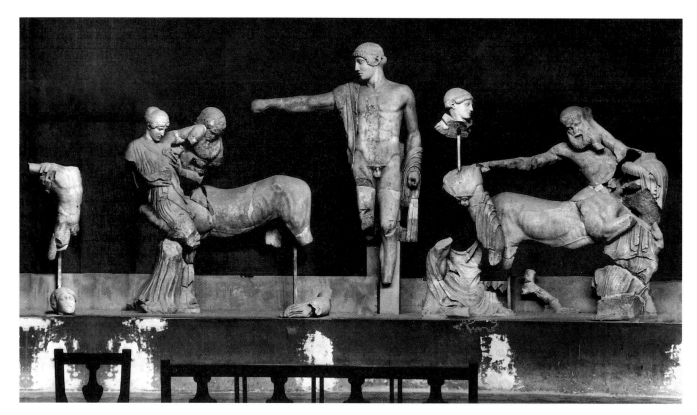

187. Photographic reconstruction (partial) of the *Battle of the Lapiths and Centaurs,* from the west pediment of the Temple of Zeus at Olympia. c. 460 B.C. Marble, slightly over-lifesize. Archaeological Museum, Olympia

Greek art, shows why the Severe style has been chosen as the term to describe the character of Greek sculpture during the years between about 480 and 450 B.C. It must have been made about a decade later than the *Kritios Boy,* as a votive offering after a race: the young victor originally stood on a chariot drawn by four horses. Despite the long, heavy garment, we sense a hint of contrapposto in the body. The feet are carefully differentiated so as to inform us that the left leg is the engaged one, and the shoulders and head turn slightly to the right. The garment is severely simple, yet compared with Archaic drapery the folds seem softer and more pliable. We feel (probably for the first time in the history of sculpture) that they reflect the behavior of real cloth.

Not only the body but the drapery, too, has been transformed by a new understanding of functional relationships, so that every fold is shaped by the forces that act upon it: the downward pull of gravity, the shape of the body underneath, and the belts or straps that constrict its flow. The face has the pensive, somewhat faraway look we saw in the *Kritios Boy,* but the color inlay of the eyes (fortunately preserved in this instance), as well as the slightly parted lips, give it a more animated expression. The bearing of the entire figure conveys the solemnity of the event it commemorates, for chariot races and similar contests at that time were competitions for divine favor, not sporting events in the modern sense.

TEMPLE OF ZEUS, OLYMPIA. The greatest sculptural ensemble of the Severe style is the pair of pediments of the Temple of Zeus at Olympia, carved about 460 B.C. and now reassembled in the local museum. In the west pediment, the more mature of the two, we see the victory of the Lapiths over the Centaurs. Centaurs were the offspring of Ixion, king of the Lapiths, and a phantom of Hera, whom he tried to seduce while in Olympus, where Zeus brought him to be purified for having murdered his father-in-law in order to avoid paying for his bride. In punishment for his impiety, Ixion was chained forever to a fiery wheel in Tartarus. Since they were the half-brothers of the Lapiths, the Centaurs were invited to the wedding of the Lapith king Peirithoös and Hippodamia, but because they were half-animals, they became drunk and got into a brawl with the Lapiths, who eventually subdued them.

The action takes place under the aegis of Apollo, who forms the center of the composition (fig. 187). His commanding figure is part of the drama and yet above it. The outstretched right arm and the strong turn of the head show his active intervention. He wills the victory but, as befits a god, does not physically help to achieve it. Nevertheless, there is a tenseness, a gathering of forces, in this powerful body that makes its outward calm doubly impressive. The forms themselves are massive and simple, with soft contours and undulating, continuous surfaces. In the group of the Centaur king, Eurytion, who has seized Hippodamia, we witness another achievement of the Severe style. The passionate struggle is expressed not only through action and gesture but through the emotions mirrored in the face of the Centaur, whose pain and desperate effort contrast vividly with the stoic calm on the face of the woman.

To the Greek, pose and expression conveyed character and feeling, which revealed the inner person and, with it, *arete*

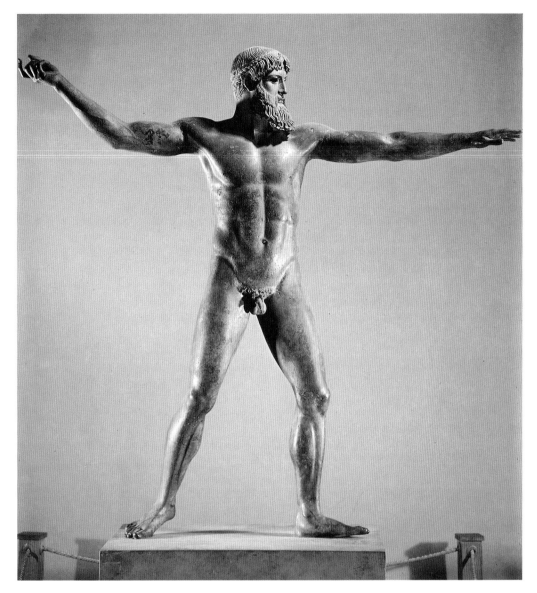

188. *Zeus.* c. 460–450 B.C. Bronze, height 6'10" (2.08 m). National Archaeological Museum, Athens

(excellence or virtue). The pediment makes a clear moral distinction in the contrast between the bestial Centaurs and the human protagonists, who partake of Apollo's nobility. Thus it is Apollo, as the god of music and poetry, who emerges as the real hero by ensuring the triumph of civilization. In general, the pediment stands for the victory of humanity's rational and moral sides over its animal nature. More specifically, however, it refers to the military threat of the Persians under Darius and his son, Xerxes I, which was repulsed by the Athenian navy at Marathon and Greek forces at the pass of Thermopylae in 480 B.C.

MOVEMENT IN STATUES. No Archaic artist would have known how to combine the two figures of Hippodamia and the Centaur into a group so compact, so full of interlocking movements. Strenuous action, of course, had already been investigated in pedimental sculpture of the late Archaic period (see figs. 160 and 161). However, such figures, although technically carved in the round, are not free-standing. They represent, rather, a kind of super-relief, since they are designed

to be seen against a background and from one direction only. To infuse the same freedom of movement into genuinely free-standing statues was a far greater challenge. Not only did it run counter to an age-old tradition that denied mobility to these figures, but also the unfreezing had to be done in such a way as to safeguard their all-around balance and self-sufficiency. The problem could not really be tackled until the concept of contrapposto had been established, but once this was done, the solution no longer presented serious difficulties.

Large, free-standing statues in motion are the most important achievement of the Severe style. The finest figure of this kind was recovered from the sea near the coast of Greece (fig. 188): a magnificent nude bronze, almost seven feet tall, of Zeus throwing a thunderbolt. Here, stability in the midst of action becomes outright grandeur. The pose is that of an athlete, yet it is not so much the arrested phase of a continuous succession of movements as an awe-inspiring gesture that reveals the power of the god. Hurling a weapon thus becomes a divine attribute here, rather than a specific act aimed at a particular adversary.

Greek tragic theater combined not only words and music but dance as well, reflecting its origin in rites, known as dithyrambs, which began in the ninth century B.C. as part of the orgies held four times yearly in honor of the wine god Dionysus (see page 113). (*Tragedy* meant goat song in ancient Greek.) These theatrical presentations were improvised until the early sixth century B.C., when they began to be set down in literary form by Arion of Corinth (c. 625–585 B.C.), which also claimed to have invented comedy. But the main development of Greek theater began in 534 B.C., the year Athens reorganized the Dionysian festival and held the first drama contest, won by Thespis, who added spoken texts to what had previously been sung. (Thespis, who was also the first actor, is honored with the term *thespian* to denote actors and actresses.) Unfortunately, we have only 31 plays out of the more than 1,000 that are recorded. These were composed by four writers in Athens during the fifth century B.C., all of whom possessed very different personalities. Of these authors, Aeschylus (c. 523–456) was the most philosophical, Sophocles (c. 496–406) the most pyschologically penetrating, and Euripides (c. 480–406) the most modern and gripping, albeit the least skillful. Despite their great differences, they all relied on past myths and history, which they freely altered.

Initially the author was also the principal actor, but this practice became unnecessary, as well as undesirable, after Aeschylus introduced a second actor, to which Sophocles added a third. In addition to writing and directing his play, each author was generally responsible for composing his own music, training the actors and chorus, and devising his own choreography for the annual contests. Even when the number of festivals was increased over time, acting never became a full-time profession, and the chorus was always made up solely of amateurs, though their training was as rigorous as a soldier's. Despite the fragmentary remains, we know that substantial portions of Greek tragedies were set to music: the Greek chorus, for example, intoned its lines to musical accompaniment while moving in intricate patterns on the stage. Although Sophocles introduced new musical modes and Euripides promoted chromaticism, drama generally followed the lead of the dithyrambs and citharodes (kithara players) in musical matters. Thus, Agathon, who won his first tragedy contest in 416, was an unabashed modernist noted for his sensuous and intricate melodies.

Our understanding of Greek tragedy is largely formed by Aristotle's *Poetics,* which were derived from his lectures at the Lyceum in Athens around 335 B.C. With his inquisitive mind, everything became the subject of systematic philosophical thought. Aristotle's argument proceeds from the belief that tragedy is the highest form of drama and that *Oedipus Rex* by Sophocles is its greatest representative. His theory is based on the complex idea of imitation, by which he means "not of men but of life, an action," which is conveyed by plot, words, song, costumes, and scenery. Plot is the very soul of tragedy, for through it is revealed the moral character (*ethos*) of the protagonist. In "complex" dramas, the protagonist achieves a new understanding (*peripety*) as a consequence of a reversal in fortune, which is brought about by error (*hamartia*) rather than evil intent. To be successful, the plot must have unity of action and preferably take place within one day, though not necessarily in the same place, as later theorists proclaimed. The concept of overweening pride (*hubris*) ascribed to Aristotle is nowhere to be found in the *Poetics,* and the importance of emotional release (*katharsis*) has been overstated, thanks to Sigmund Freud, the founder of early-twentieth-century psychiatry.

Comedy was represented by the bawdy satyr play, the distant ancestor of modern burlesque theater, which was apparently invented by Pratinas in the late sixth century B.C. The only surviving examples are Euripides' *Cyclops* and a fragment from Sophocles' *The Trackers,* which are parodies of tragic dramas. Entirely different in character and perhaps origin are the comic plays of Aristophanes (c. 448–c. 388 B.C.), which are commentaries on the contemporary scene: society, politics, war, and literature. No subject was too sacred for his irreverent satire. His favorite targets were philosophers and his fellow dramatists. Nothing of later Greek comedy remains, but we know from other documents that it centered on the daily life of the middle class.

Perhaps surprisingly, the visual arts contributed little to Greek theater, which made sparse use of scenery. (The term derives from *skena,* the hut where actors changed their costumes.) Scene painting probably began around the middle of the fifth century B.C. and is variously credited to Aeschylus or Sophocles. According to the first century B.C. Roman architect and historian Vitruvius, scene painting consisted of architectural designs on a flat surface; it also made use of *pinakes* (painted panels) and *periaktoi* (triangular prisms) that were rotated. However, like the poet Horace, who wrote about Greek tragedy and comedy, Vitruvius looked on the Classical past through distinctly Roman eyes. In actual fact, scenery was probably very simple and changes minimal. Indeed, the advances sometimes attributed to Greek scenographers, especially in illusionism, appear to have been much later developments made in Roman times not long before Vitruvius himself.

Some years after the *Zeus,* about 450 B.C., Myron created his famous bronze statue of the *Discobolus (Discus Thrower),* which came to enjoy a reputation comparable to that of the *Doryphorus.* Like the latter, it is known to us only from Roman copies (fig. 189). [See Primary Sources, no. 5, pages 213–14.] Here the problem of how to condense a sequence of movements into a single pose without freezing it is a much more complex one. It involves a violent twist of the torso in order to bring the arms into the same plane as the action of the legs. The pose conveys the essence of the action by presenting the fully coiled figure in perfect balance. (The copy makes the design seem harsher and less poised than it was in the original.)

CLASSICAL STYLE. The *Discobolus* brings us to the threshold of the second half of the century, the era of the mature Classical style. The conquest of movement in a free-standing

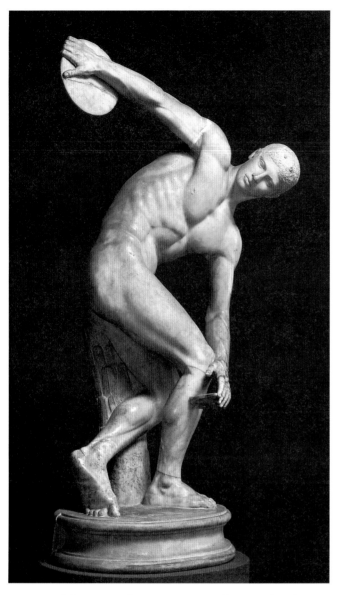

189. *Discobolus (Discus Thrower).* Roman marble copy after a bronze original of c. 450 B.C. by Myron. Lifesize. Museo delle Terme, Rome

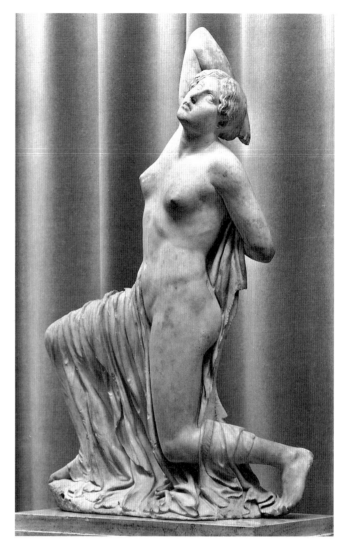

190. *Dying Niobid.* c. 450–440 B.C. Marble, height 59" (150 cm). Museo delle Terme, Rome

statue now exerted a liberating influence on pedimental sculpture as well, endowing it with a new spaciousness, fluidity, and balance. The *Dying Niobid* (fig. 190), a work of the 440s, was carved for the pediment of a Doric temple but is so richly three-dimensional, so self-contained, that we hardly suspect her original context. Niobe, according to legend, had humiliated the mother of Apollo and Artemis by boasting of her seven sons and seven daughters, whereupon the two gods killed all of Niobe's children. Our Niobid has been shot in the back while running. Her strength broken, she sinks to the ground while trying to extract the fatal arrow. The violent movement of her arms has made her garment slip off. Her nudity is thus a dramatic device, rather than a necessary part of the story.

The *Niobid* is the earliest known large female nude in Greek art. The artist's primary motive in devising it was to display a beautiful female body in the kind of strenuous action hitherto reserved for the male nude. Still, we must not misread the intent. It was not a detached interest in the physical aspect of the event alone but the desire to unite motion and emotion and thus to make the beholder experience the suffering of this victim of a cruel fate. Looking at the face of the *Niobid,* we feel that here, for the first time, human feeling is expressed as eloquently in the features as in the rest of the figure.

A brief glance backward at the wounded warrior from Aegina (fig. 160) will show us how very differently the agony of death had been conceived only half a century before. What separates the *Niobid* from the world of Archaic art is a quality summed up in the Greek word *pathos,* which means suffering, but particularly suffering conveyed with nobility and restraint so that it touches rather than horrifies us. Late Archaic art may approach it now and then, as in the Eos and Memnon group (fig. 145). Yet the full force of pathos can be felt only in Classical works such as the *Niobid.* Perhaps, in order to measure the astonishing development we have witnessed since the beginnings of Greek monumental sculpture less than two centuries before, we ought to compare the *Niobid* with the earliest pedimental figure we came to know, the Gorgon from Corfu (fig. 154). As we do so, we suddenly realize that these two, worlds apart as they may be, do in fact belong to the same artistic tradition, for the *Niobid,* too, shows the pinwheel stance, even though its meaning has been radically reinter-

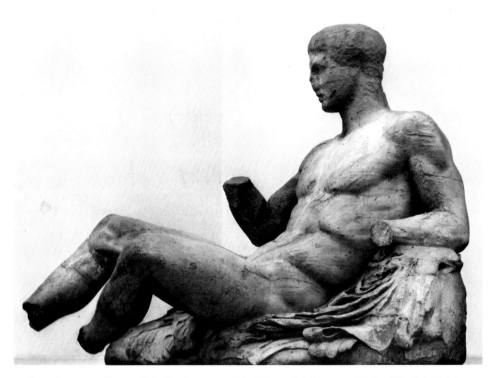

191. *Dionysus,* from the east pediment of the Parthenon. c. 438–432 B.C. Marble, over-lifesize. The British Museum, London

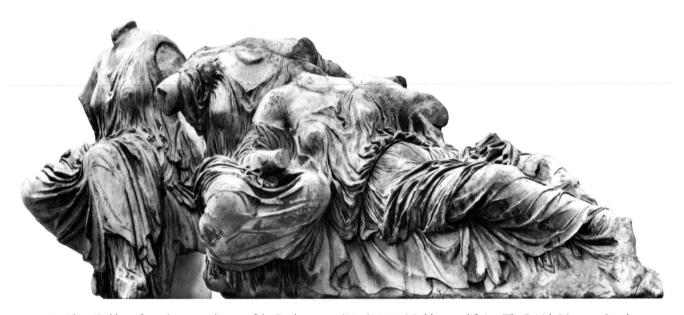

192. *Three Goddesses,* from the east pediment of the Parthenon. c. 438–432 B.C. Marble, over-lifesize. The British Museum, London

preted. Once we recognize the ancient origin of her pose, we understand better than before why the *Niobid,* despite her suffering, remains so monumentally self-contained.

THE PARTHENON. The largest, as well as the greatest, group of Classical sculptures at our disposal consists of the remains of the marble decoration of the Parthenon, most of them, unfortunately, in battered and fragmentary condition. Much of the sculpture was removed between 1801 and 1803 by Lord Elgin; the Elgin Marbles are today housed in the British Museum. The centers of both pediments are gone completely, and of the figures in the corners only those from the east pediment are sufficiently well preserved to convey

something of the quality of the ensemble. They represent various deities, most in sitting or reclining poses, witnessing the birth of Athena from the head of Zeus (figs. 191 and 192). (The west pediment was devoted to the struggle of Athena and Poseidon for Athens.)

Here, even more than in the case of the *Dying Niobid,* we marvel at the spaciousness, the complete ease of movement of these statues even in repose. There is neither violence nor pathos in them, indeed no specific action of any kind, only a deeply felt poetry of being. We find it equally in the relaxed masculine body of Dionysus and in the soft fullness of the three goddesses, enveloped in thin drapery that seems to share the qualities of a liquid substance as it flows and eddies around

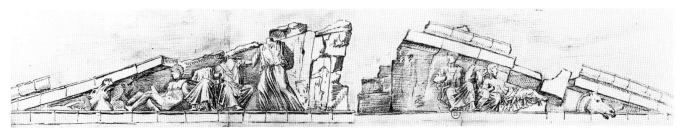

193. Jacques Carrey. Drawings of the east pediment of the Parthenon. 1674. Bibliothèque Nationale, Paris

194. *The Sacrifice of King Erechtheus' Daughters,* from the east frieze of the Parthenon. c. 440 B.C.
Marble, height 43" (109.3 cm). The British Museum, London

the forms underneath. Though all are seated or half-reclining, the turning of the bodies under the elaborate folds of their costumes makes them seem anything but static. Indeed, the "wet" drapery unites them in one continuous action, so that they seem in the process of arising.

The figures are so freely conceived in depth that they create their own aura of space. It is hard to imagine them "shelved" upon the pediment. Evidently the great master who achieved such lifelike figures also found this incongruous, for the composition as a whole (fig. 193) suggests that the triangular field is treated as no more than a purely physical limit. For example, two horses' heads are placed in the sharp angles at the corners at the feet of Dionysus and the reclining goddesses. They are meant to represent the chariots of the rising sun and the waning moon emerging into and dipping below the pedimental space, but visually the heads are merely two fragments arbitrarily cut off by the frame. Clearly, we are approaching the moment when the pediment will be rejected altogether as the focal point of Greek architectural sculpture. In fact, the sculptural decoration of later buildings tends to be placed in areas where it would seem less boxed in, as well as more readily visible.

The frieze of the Parthenon, a continuous band 525 feet in length (fig. 170), was long assumed to show a procession honoring Athena in the presence of the other Olympic gods. According to recent theory, however, the main scene depicts the sacrifice by King Erechtheus of his three daughters, as demanded by the oracle at Delphi, in order to save Athens from its enemies, though he himself was to perish during his victory over Eumolpos, the son of Poseidon (fig. 194). The subject was especially significant to the city following its victory over the Persians, who had desecrated the old Temple of Athena. It also integrates the frieze into the rest of the program of the Parthenon, which includes the struggle of Athena and Poseidon, and helps to explain why the Erechtheum was built on the Acropolis. Remarkably, the frieze is of the same high rank as the pedimental sculptures. In a somewhat different way it, too, suffered from its subordination to the architectural setting, for it must have been poorly lit and difficult to see, placed as it was immediately below the ceiling. The depth of the carving and the concept of relief are not radically different from the frieze of the Siphnian Treasury (figs. 157 and 158), but the illusion of space and of rounded form is now achieved with sovereign ease. The most remarkable quality of the Parthenon frieze is the rhythmic grace of the design, particularly striking in the spirited movement of the groups of horsemen.

The metopes, which date from the 440s, are very different in character from the rest of the sculpture on the Parthenon in showing violent action. We have encountered two of the subjects before: the combat of the gods and giants and the battle of Lapiths and Centaurs (see figs. 158 and 187). It is the other two subjects that provide the key to their meaning. They are the Sack of Troy by the Greeks, and Greeks fighting Amazons, who, according to legend, had desecrated the Acropolis. The entire cycle forms an extended allegory of the Athenian victory over the Persians, who likewise destroyed the Acropolis. But rather than presenting the war as historical fact, the Greek mind insisted on cloaking it in the guise of myth and legend in order to explain the outcome, as if preordained.

Although the metopes do not form a fully coherent

195. *Lapith and Centaur,* metope from the south side of the Parthenon. c. 440 B.C. Marble, height 56" (142.2 cm). The British Museum, London

196. *Nike,* from the balustrade of the Temple of Athena Nike. c. 410–407 B.C. Marble, height 42" (106.7 cm). Acropolis Museum, Athens

placed high above the ground, where it could barely be seen, the figures fill as much of the limited field as possible and are carved so deeply as to appear nearly in the round. If the action seems somewhat forced in both pose and expression, it has been beautifully choreographed for maximum clarity and impact.

PHIDIAS. Who was responsible for this magnificent array of sculptures? They have long been associated with the name of Phidias, the chief overseer of all artistic enterprises sponsored by Pericles. [See Primary Sources, no. 12, page 216.] According to ancient writers, Phidias was particularly famous for a huge ivory-and-gold statue of Athena he made for the cella of the Parthenon, a colossal figure of Zeus in the same technique for the temple of that god in Olympia, and an equally large bronze statue of Athena that stood on the Acropolis facing the Propylaea. None of these survives, and small-scale representations of them in later times are utterly inadequate to convey the artist's style. It is hard to imagine that enormous statues of this sort, burdened with the requirements of cult images and the demands of a difficult technique, shared the vitality of the Elgin Marbles. The admiration they elicited may have been due to their size, the preciousness of the materials, and the aura of religious awe surrounding them. Phidias' personality thus remains oddly intangible. He may have been simply a very able coordinator and supervisor, but more likely he was a great genius, comparable to Imhotep (see pages 64–65), capable of giving powerful expression to the ideas that motivated his patron, Pericles.

The term *Phidian style* used to describe the Parthenon sculptures is no more than a generic label; undoubtedly, a large number of masters were involved, since the frieze and the two pediments were executed in less than ten years (c. 440–432 B.C.). Albeit of questionable accuracy, it is justified by its convenience. The Phidian ideal was not merely artistic but no doubt extended to life itself: it denotes a distinctive attitude in which the gods are aware of, yet aloof from, human affairs as they fulfill their cosmic roles. This is an attitude that came to be widely shared among Greek philosophers, especially of the fourth century B.C.

It is hardly surprising that the Phidian style should have dominated Athenian sculpture until the end of the fifth century and beyond, even though large-scale sculptural enterprises gradually came to a halt because of the Peloponnesian War. The last of these was the balustrade erected around the small Temple of Athena Nike about 410–407 B.C. Like the Parthenon frieze, it shows a festive procession, but the participants are winged Nike figures (personifications of victory) rather than citizens of Athens. One Nike (fig. 196) is taking off her sandals in conformity with an age-old tradition, indicating that she is about to step on holy ground (see page 62). Her wings—one open, the other closed—are effectively employed to help her keep her balance, so that she performs this normally awkward act with consummate elegance of movement. Her figure is more strongly detached from the relief ground than are those on the Parthenon frieze, and her garments, with their deeply cut folds, cling to the body. (We have seen an earlier phase of this "wet" drapery in the *Three Goddesses* of the Parthenon, fig. 192.)

program and vary in the quality of their execution, the best of them, such as our scene of a Lapith fighting a Centaur (fig. 195), have a compelling dramatic force that is still grounded in the pediment at Olympia almost 20 years earlier (see fig. 187). Our sculptor has been remarkably successful in overcoming the obstacles presented by the metope. Because it was

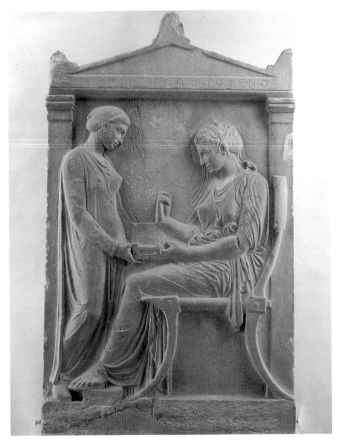

197. *Grave Stele of Hegeso.* c. 410–400 B.C. Marble,
height 59" (150 cm). National Archaeological Museum, Athens

198. *The Abduction of Proserpine.* Detail of a wall painting in
Tomb I, Vergina, Macedonia. c. 340–330 B.C.

"Phidian," too, and also from the last years of the century, is the beautiful *Grave Stele of Hegeso* (fig. 197). Memorials of this kind were produced in large numbers by Athenian sculptors, and their export must have helped to spread the Phidian style throughout the Greek world. Few of them, however, can match the harmonious design and the gentle melancholy of our example. The deceased is represented in a simple domestic scene that was a standard subject for sculptured and painted memorials of young women. She has picked a necklace from the box held by the girl servant and seems to be contemplating it as if it were a keepsake. The delicacy of the carving can be seen especially well in the forms farthest removed from the beholder, such as the servant's left arm supporting the lid of the jewel box, or the veil behind Hegeso's right shoulder. Here the relief merges almost imperceptibly with the background, so that the ground no longer appears as a solid surface but assumes something of the transparency of empty space. This novel effect was probably inspired by paintings.

CLASSICAL PAINTING

Documentary sources tell us a great deal about how Classical painting evolved, but rarely in sufficient detail for us to know what it looked like. The great age of Greek painting began in the Early Classical period with Polygnotos of Thasos and his collaborator, Mikon of Athens, who were sculptors as well. Polygnotos was the first artist to place figures at various heights in a landscape setting and to depict women in transparent drapery. But, above all, he inaugurated the "representation of emotion and character [and the] use of patterns of composition," which became as central to Classical painting as it was to sculpture. An important advance came a hundred years later with the invention of shading by Apollodoros of Athens.

Painting reached its zenith in the fourth century B.C., when it was recognized as one of the liberal arts. This period witnessed an explosion of rival schools as panel painting gradually supplanted wall painting. Among the leading masters mentioned by the Roman writer Pliny are Zeuxis of Herakleia, a master of texture; Parrhasios of Ephesus, who "first gave proportion to painting . . . and was supreme in painting contour lines, which is the most subtle aspect of painting"; Apelles of Kos, Alexander the Great's favorite artist and the most famous painter of his day, distinguished for his grace; and Nikomachos of Athens, renowned for his rapid brush.

We get a tantalizing glimpse of Classical painting, albeit just one facet, in *The Abduction of Proserpine* (fig. 198) from a Macedonian tomb at Vergina of about 340–330 B.C. Discovered only in 1976, it assumes great importance as one of the very few wall paintings to come to light in Greece itself. The subject is especially appropriate to the funereal setting. Proserpine, goddess of vegetation, was abducted by Hades, ruler of the underworld, to be his queen but, thanks to Zeus' intervention, was permitted to return to earth six months of every year. The painting may well be based on a famous work by

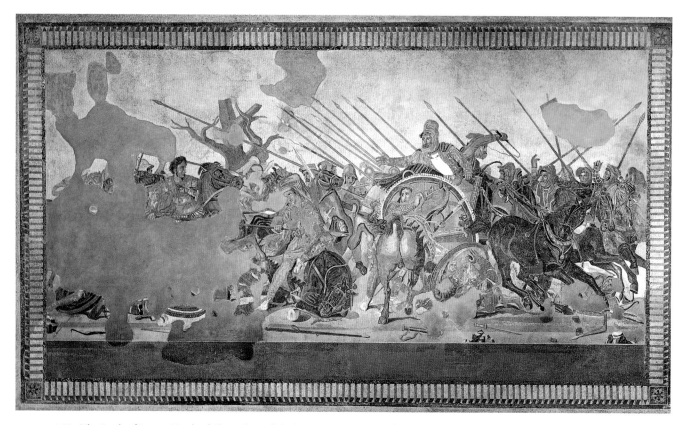

199. *The Battle of Issus* or *Battle of Alexander and the Persians.* Mosaic copy from Pompeii of a Hellenistic painting of c. 315 B.C. 8'11" x 16'9½" (2.7 x 5.1 m). Museo Archeologico Nazionale, Naples

Nikomachos of Athens. The forceful expressiveness more than makes up for any technical deficiencies of the artist, who was clearly not of the first rank: the scene has a magnificent sweep that captures the frenzy of the moment. The technique reflects the main tradition of Greek painting, which emphasized line, although there was also a competing coloristic tendency.

We can get some further idea of what Greek wall painting looked like from Roman copies and imitations, although their relation is extremely problematic (see pages 208–11). According to the Roman writer Pliny, Philoxenos of Eretria at the end of the fourth century painted the victory of Alexander the Great over Darius at Issus. [See Primary Sources, no. 4, pages 213.] The same subject—or, at any rate, another battle of Alexander's war against the Persians—is shown in an exceptionally large and technically accomplished floor mosaic from a Pompeian house of about 100 B.C. Figure 199 shows Darius and the fleeing Persians on the right, and, in the badly damaged left-hand portion, the figure of Alexander.

While there is no special reason to link this mosaic with Pliny's account (several others are recorded), we can hardly doubt that it is a copy—and an astonishingly proficient one— of a Hellenistic painting from the late fourth century B.C. The picture follows the four-color scheme (yellow, red, black, and white) that is known to have been widely used at that time. The crowding, the air of frantic excitement, the powerfully modeled and foreshortened forms, and the precise cast shadows make the scene far more complicated and dramatic than any other work of Greek art from the period. And for the first time it shows something that actually happened, without the symbolic overtones of *Herakles Strangling the Nemean Lion* or the *Battle of the Lapiths and Centaurs* (figs. 143 and 187). In

character and even in appearance, it is close to Roman reliefs commemorating specific historic events (see figs. 271–73). Yet, there can be little doubt that the mosaic was executed by a Greek, as this technique originated in Hellenistic times and remained a specialty of Greek artists to the end.

According to literary sources, Greek painters of the Classical period achieved a great breakthrough in mastering illusionistic space—a claim partially supported by murals discovered in Macedonia. [See page 151 and Primary Sources, no. 4, page 213, and no. 13, pages 216–17.] Vase painting by its very nature could echo the new concept of pictorial space only in rudimentary fashion. Still, there are vessels that form an exception to this rule. We find them mostly in the lekythoi (oil jugs) used as funerary offerings. These had a white coating on which painters could draw as freely and with the same spatial effect as their modern successors using pen and paper. The white ground is treated as empty space from which the forms seem to emerge—if the draftsman knows how to achieve this.

Not many lekythos painters were capable of bringing off the illusion. Foremost among them is the unknown artist, nicknamed the "Achilles Painter," who drew the woman in figure 200. Although some 25 years older than the Hegeso stele, this vase shows a similar scene, and there is the same mood of "Phidian" reverie, as a woman (perhaps a poetess seeking inspiration) listens to the muse playing her lyre on Mount Helikon accompanied by a nightingale. Our chief interest, however, is in the masterly draftsmanship. With a few lines, sure, fresh, and fluid, the artist not only creates a three-dimensional figure but reveals the body beneath the drapery as well. What persuades us that these shapes exist in depth rather than merely on the surface of the vase? First of all, the command of foreshorten-

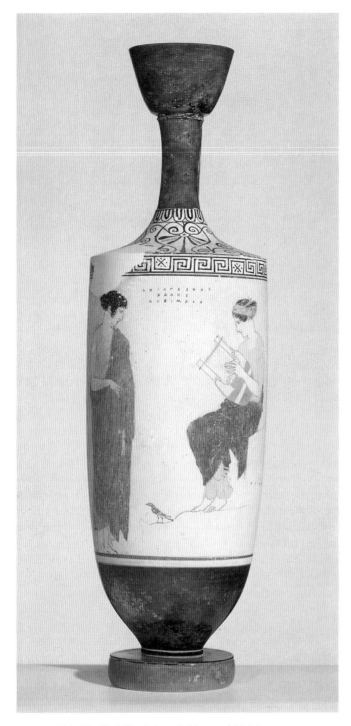

201. The "Marsyas Painter." *Peleus and Thetis,* on a
Kerch-style pelike. c. 340 B.C. Height 16³/4" (42.5 cm).
The British Museum, London

200. The "Achilles Painter." *Muse and Maiden,* on an
Attic white-ground lekythos. c. 440–430 B.C. Height 16" (40.7 cm).
Staatliche Antikensammlungen, Munich

ing. But the "internal dynamics" of the lines are equally impor-
tant. Their swelling and fading make some contours stand out
boldly while others merge with one another or disappear into
the white ground. The effect is completed by the color, unusu-
ally elaborate for a lekythos: vermilion for the himations and
the muse's head scarf, ocher for her chiton. The artist has made
skillful use of the white ground to enliven the "empty" space
by adding an inscription: "Axiopeithes, the son of Alkimachos,
is beautiful."

Considering its artistic advantages, we might expect a more
general adoption of the white-ground technique. Such, how-

ever, was not the case. Instead, from the mid-fifth century on,
the impact of monumental painting gradually transformed
vase painting as a whole into a satellite art that tried to repro-
duce large-scale compositions in a kind of shorthand dictated
by its own limited technique. The result, more often than not,
was spotty and overcrowded.

Even the finest examples suffer from this defect, as we can
see in figure 201, which is taken from a vase produced near the
end of the Classical period by an Athenian master known as
the "Marsyas Painter." It shows Thetis, who is about to bathe
in the sea, being abducted by Peleus as two of her maidservants
flee in panic. The main figures are placed on a firm ground-
line, with a bit of wavy water to suggest the spatial setting of
the scene. The others, intended to be farther away, seem sus-
pended in midair. Although the turning poses are a further
attempt to create the illusion of space, the effect remains flat
and silhouettelike, because of the obtrusive black background.

In an attempt to enlarge the color range, the body of Thetis
has been painted white, as has that of Eros crowning Peleus.
(Thetis' dress has been filled in with green as well.) This expedi-
ent, too, fails to solve the problem, since the medium does not
permit shading or modeling. Our artist must therefore rely on
the network of lines to hold the scene together and create a max-
imum of dramatic excitement—and, being a spirited drafts-
man, almost succeeds. Still, it is a success at second hand, for the
composition must have been inspired by a mural or panel pic-
ture. The "Marsyas Painter" is, as it were, battling for a lost cause.
We have reached the effective end of Greek vase painting, which
disappeared altogether by the end of the century.

FOURTH-CENTURY SCULPTURE

This Athenian style, so harmonious in both feeling and form, did not long survive the defeat of Athens by Sparta in the Peloponnesian War. Building and sculpture continued in the same tradition for another three centuries, but without the subtleties of the Classical age whose achievements we have just discussed. There is, unfortunately, no single word, like Archaic or Classical, that we can use to designate this third and final phase in the development of Greek art, which lasted from about 400 to the first century B.C. The 75-year span between the end of the Peloponnesian War and the rise of Alexander the Great used to be labeled "Late Classical," and the remaining two centuries and a half "Hellenistic," a term meant to convey the spread of Greek civilization southeastward to Asia Minor and Mesopotamia, Egypt, and the borders of India. It was perhaps natural to expect that the world-shaking conquests of Alexander between 333 and 323 B.C. would also effect an artistic revolution. However, the history of style is not always in tune with political history. Although the center of Greek thought shifted to Alexandria, the city founded by Alexander in Egypt, we have come to realize that there was no decisive break in the tradition of Greek art at the end of the fourth century. The art of the Hellenistic era is the direct outgrowth of developments that occurred, not at the time of Alexander, but during the preceding 50 years.

Here, then, is our dilemma: "Hellenistic" is a concept so closely linked with the political and cultural consequences of Alexander's conquest that we cannot very well extend it backward to the early fourth century, although there is wide agreement now that the art of the years 400 to 325 B.C. can be far better understood if we view it as pre-Hellenistic rather than as Late Classical. Until the right word is found and wins general acceptance, we shall have to make do with the existing

202. Reconstruction drawing of the Mausoleum at Halicarnassus. 359–351 B.C.

terms as best we can, always keeping in mind the essential continuity of the third phase that we are about to examine.

THE MAUSOLEUM AT HALICARNASSUS. The contrast between Classical and pre-Hellenistic is strikingly demonstrated by the only project of the fourth century that corresponds to the Parthenon in size and ambition. It is not a temple but a huge tomb—so huge, in fact, that its name, Mausoleum, has become a generic term for all oversized funerary monuments. It was designed by Pytheos of Priene and erected at Halicarnassus in Asia Minor just before and after 360 B.C. by Mausolus, who ruled the area as a satrap of the Persians,

203. Scopas (?). *Battle of the Greeks and Amazons,* from the east frieze of the Mausoleum, Halicarnassus. 359–351 B.C. Marble, height 35" (89 cm). The British Museum, London

and his widow, Artemisia. The structure itself is completely destroyed, but its dimensions and general appearance can be reconstructed on the basis of ancient descriptions and the excavated fragments, including a good deal of sculpture. [See Primary Sources, no. 6, page 214.]

The drawing in figure 202 does not pretend to be exact in detail. We do know, however, that the building rose in three stages to a height of about 160 feet. A tall rectangular base 117 feet wide and 82 feet deep supported a colonnade of Ionic columns 40 feet tall, and above this rose a pyramid crowned by a chariot with statues of Mausolus and Artemisia. The sculptural program consisted of two friezes showing Greeks battling Persians and Greeks fighting Amazons, each as long as the Parthenon frieze, with a row of Greek and Persian figures in between. Along the colonnade were 36 large statues of Mausolus' family. The roof featured a row of carved guardian lions and was surmounted by a huge quadriga, presumably with statues of the deceased.

The commemorative and retrospective character of the monument, based on the idea of human life as a glorious struggle or chariot race, is entirely Greek. Yet we immediately notice the un-Greek way it has been carried out. The huge size of the tomb, and more particularly the pyramid, derive from Egypt. They imply an exaltation of the ruler far beyond ordinary human status. His kinship with the gods may have been hinted at. Apparently Mausolus took this view of himself as a divinely ordained sovereign from the Persians, who in turn had inherited it from the Assyrians and Egyptians, although he seems to have wanted to glorify his individual personality as much as his high office. The structure embodying these ambitions must have struck his contemporaries as impressive and monstrous at the same time, with its multiple friezes and the receding faces of a pyramid in place of pediments above the colonnade.

SCOPAS. According to ancient sources, the sculpture on each of the four sides of the monument was entrusted to a different master, chosen from among the best of the time. Scopas, the most famous, did the main side, the one to the east. His dynamic style has been recognized in some portions of the Amazon frieze, such as the portion in figure 203. The Parthenon tradition can still be felt here, but there is also a decidedly un-Classical violence, physical as well as emotional, conveyed through strained movements and passionate facial expressions. (Deep-set eyes are a hallmark of Scopas' style.) As a consequence, we no longer find the rhythmic flow of the Parthenon frieze. Continuity and harmony have been sacrificed so that each figure may have greater scope for sweeping, impulsive gestures. Clearly, if we are to do justice to this explosive, energetic style we must not judge it by Classical standards. What the composition lacks in unity, it more than makes up for in bold innovation (note, for instance, the Amazon seated backward on her horse) and heightened expressiveness. In a sense, Scopas turned backward as well to the scenes of violent action so popular in the Archaic period. We will recognize its ancestor in the Siphnian *Battle of the Gods and Giants* (fig. 158), although he clearly learned from the example of the Parthenon metopes as well (see fig. 195).

The "pre-Hellenistic" flavor is even more pronounced in one of the portrait statues, sometimes presumed to represent

204. *"Mausolus,"* from the Mausoleum at Halicarnassus. c. 360 B.C. Marble, height 9'10" (3.1 m). The British Museum, London

Mausolus himself (fig. 204), from the colonnade. The figure must be the work of a man younger than Scopas and even less encumbered by Classical standards, probably Bryaxis, the master of the north side. Through Roman copies, we know of some Greek portraits of Classical times, but they seem to represent types rather than individuals. Such is probably the case here, for he is a distinctly non-Greek sort; not until Hellenistic times were individual likenesses to play an important part. The figure nevertheless possesses a surprisingly personal character in the head, with its heavy jaws and small, sensuous mouth—features later found in the Hellenistic portrait head from Delos (fig. 216). The thick neck and broad, fleshy body seem equally individual. The massiveness of the forms is further emphasized by the sharp-edged and stiff-textured drapery, which might be said to encase, rather than merely clothe, the body. The great volumes of folds across the abdomen and below the left arm seem designed for picturesque effect more than for functional clarity.

PRAXITELES. Some of the features of the Mausoleum sculpture recur in other important works of the period. Foremost among these is the wonderful seated figure of the goddess

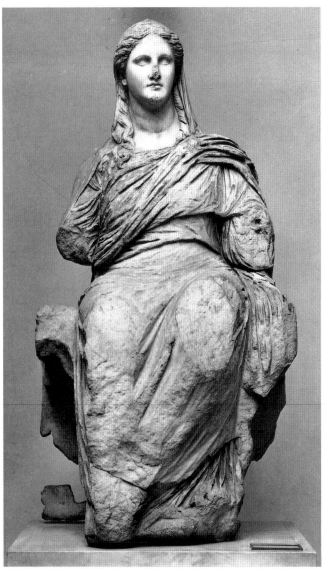

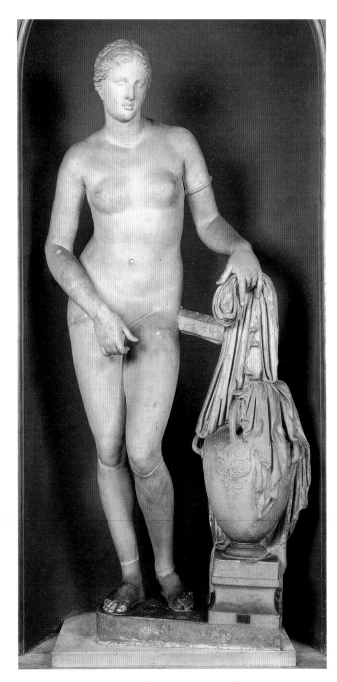

205. *Demeter,* from Cnidus. c. 330 B.C. Marble, height 60"
(152.3 cm). The British Museum, London

206. *Cnidian Aphrodite.* Roman copy after an original
of c. 340–330 B.C., by Praxiteles. Marble, height 6'8" (2 m).
Musei Vaticani, Museo Pio Clementino, Gabinetto delle Maschere,
Città del Vaticano, Rome

Demeter from her temple at Cnidus (fig. 205), a work close-ly related to the *"Mausolus."* Here again the drapery, though more finely textured, has an impressive volume of its own, while motifs such as the S-curve of folds across the chest form an effective counterpoint to the shape of the body beneath. The deep-set eyes gaze into the distance with an intensity that suggests the influence of Scopas. The modeling of the head, on the other hand, has a veiled softness that points to an alto-gether different source: Praxiteles, the master of feminine grace and sensuous evocation of flesh.

The *Demeter* is probably only slightly later in date than Prax-iteles' most acclaimed statue, an *Aphrodite* (fig. 206), which was likewise made for Cnidus about 340–330 B.C. [See Primary Sources, no. 6, page 214.] Hence, the sculptor who carved the *Demeter* would have had no difficulty incorporating some Prax-

itelean qualities into his own work. The *Cnidian Aphrodite* by Praxiteles achieved such fame that she is often referred to in ancient literature as a synonym for absolute perfection. To what extent her renown was based on her beauty, or on the fact that she was (so far as we know) the first completely nude cult image of the goddess, is difficult to say, for the statue is known to us only through Roman copies that can be no more than pallid reflections of the original. The viewer "discovers" her in the midst of bathing, yet through her pose and expression she main-tains a chaste modesty so as to disarm any critic.

A more faithful embodiment of Praxitelean beauty is the group of Hermes with the infant Bacchus (fig. 207). Pausanias mentions seeing such a statue by Praxiteles at the Temple of Hera at Olympia, where this marble was excavated in 1877. It is of such high quality that it was long regarded as Praxiteles'

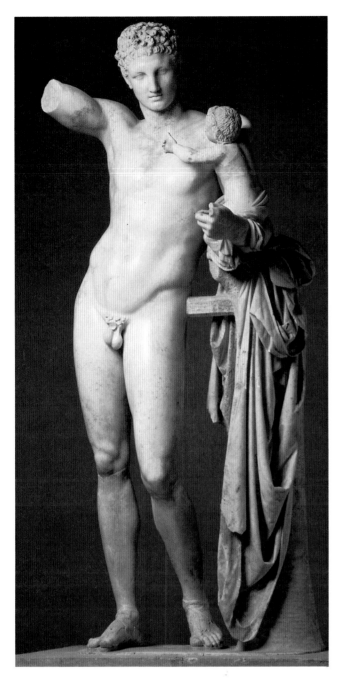

207. *Hermes.* Roman copy after an original of
c. 320–310 B.C., by Praxiteles. Marble, height 7'1" (2.16 m).
Archaeological Museum, Olympia

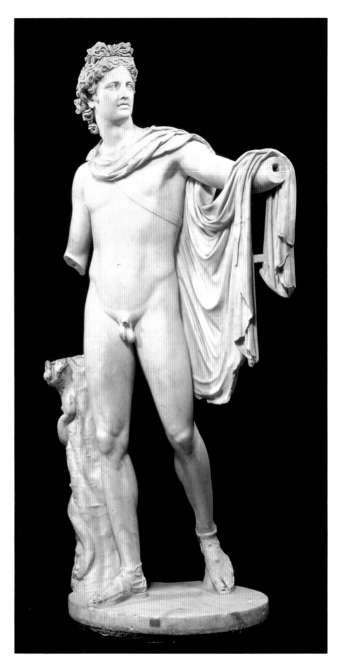

208. *Apollo Belvedere.* Roman marble copy, probably of
a Greek original of the late 4th century B.C. Height 7'4" (2.3 m).
Musei Vaticani, Museo Pio Clementino, Cortile Ottagono,
Città del Vaticano, Rome

own work, though most scholars now believe it to be a very fine later Greek copy because of the strut support and unfinished back. The dispute is of little consequence for us, except perhaps in one respect: it emphasizes the unfortunate fact that we do not have a single undisputed original by any of the famous sculptors of Greece. Nevertheless, the *Hermes* is the most completely Praxitelean statue we know. The sensuousness, the lithe proportions, the sinuous curve of the torso, the play of gentle curves, the sense of complete relaxation (enhanced by the use of an outside support for the figure to lean against), all agree well enough with the character of the *Cnidian Aphrodite.* We also find many refinements here that are ordinarily lost in a copy, such as the caressing treatment of the marble, the faint smile, the meltingly soft, "veiled" modeling of the features. Even the hair, left comparatively rough

for contrast, shares the silky feel of the rest of the work. Here, for the first time, is an attempt to modify the stony look of a statue by giving to it the illusion of an enveloping atmosphere.

APOLLO BELVEDERE. The same qualities recur in many other statues, all of them Roman copies of Greek works in a more or less Praxitelean vein. The best known is the *Apollo Belvedere* (fig. 208), which enjoyed tremendous popularity during the eighteenth and nineteenth centuries. Johann Joachim Winckelmann, Goethe, and other champions of the Greek Revival found it the perfect exemplar of Classical beauty. Plaster casts or reproductions of it were considered indispensable for all museums, art academies, or liberal arts colleges, and generations of students grew up in the belief that it embodied the essence of the Greek spirit. This enthusiasm tells us a good deal,

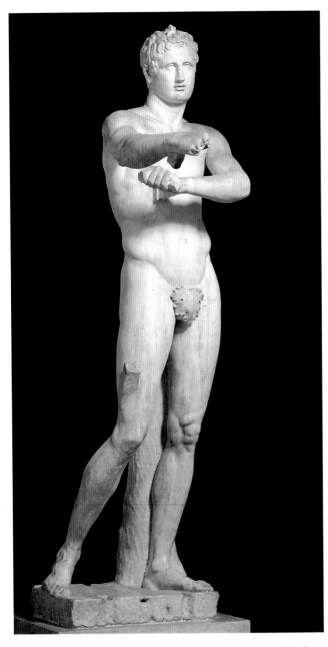

209. *Apoxyomenos (Scraper)*. Roman marble copy, probably after a bronze original of c. 330 B.C. by Lysippus. Height 6'9" (2.1 m). Musei Vaticani, Museo Pio Clementino, Gabinetto dell'Apoxyomenos, Città del Vaticano, Rome

not about the qualities of the *Apollo Belvedere* but about the character of the Greek Revival, although our own time takes a less enthusiastic view of the statue.

LYSIPPUS. Besides Scopas and Praxiteles, there is another great name in pre-Hellenistic sculpture: Lysippus, whose career may have begun as early as about 370 B.C. and continued to the end of the century. The main features of his style, however, are more difficult to grasp than those of his two famous contemporaries, because of the contradictory evidence of the Roman copies that are assumed to reproduce his work. Ancient authors praised him for replacing the canon of Polyclitus with a new set of proportions that produced a more slender body and a smaller head. [See Primary Sources, no. 5, pages 213–14.] His realism, too, was proverbial: he is said to have had no master other than nature. But these statements describe little more than a

general trend toward the end of the fourth century. Certainly the proportions of Praxiteles' statues are "Lysippic" rather than "Polyclitan." Nor could Lysippus have been the only artist of his time to conquer new aspects of reality.

Even in the case of the *Apoxyomenos* (fig. 209), the statue most insistently linked with his name, the evidence is far from conclusive. It shows a young athlete cleaning himself with a scraper, a motif often represented in Greek art from Classical times on. Unlike all other versions, here the arms are horizontally extended in front of the body. This bold thrust into space, at the cost of obstructing the view of the torso, is a noteworthy feat, whether or not we credit it to Lysippus. It endows the figure with a new capacity for spontaneous three-dimensional movement. A similar freedom is suggested by the diagonal line of the free leg. Even the unruly hair reflects the new trend toward spontaneity.

HELLENISTIC SCULPTURE

Of the artistic enterprises sponsored by Alexander the Great, such as the numerous portraits of the great conqueror by Lysippus, no direct evidence survives. In fact, we know very little of the development of Greek sculpture as a whole during the first hundred years of the Hellenistic era. Even after that, we have few fixed points of reference. Only a small fraction of the large number of works at our disposal can be securely identified as to date and place of origin. Moreover, Greek sculpture was now being produced throughout such a vast territory that the interplay of local and international currents must have formed a complex pattern, of which we can trace only some isolated strands.

Hellenistic sculpture nevertheless possesses a markedly different character from that of the Classical era. It has a more pronounced realism and expressiveness, as well as a greater variety of drapery and pose, which is often marked by extreme torsion. This willingness to experiment should be seen as a valid, even necessary, attempt to extend the subject matter and dynamic range of Greek art in accordance with a new temperament and outlook.

DYING TRUMPETER. The more human conception that characterizes the age is represented by the bronze groups dedicated by Attalus I of Pergamum (a city in northwestern Asia Minor) between about 240 and 200 B.C. to celebrate his victories over the Celts, who kept raiding the Greek states from Galatia, the area around present-day Ankara, until Attalus forced them to settle down. The bronze statues commemorating the Celts' defeat were reproduced in marble for the Romans, who may have had a special interest in them because of their own troubles with Celtic tribes in northwestern Europe. A number of these copies have survived, including the famous *Dying Trumpeter* (fig. 210), which presumably replicates a statue by Epigonos of Pergamum mentioned in Pliny's *Natural History*.

The sculptor must have known the Celts well, for the ethnic type is carefully rendered in the facial structure and in the bristly shock of hair. The torque around the neck is another characteristically Celtic feature. Otherwise, he shares the heroic nudity of Greek warriors, such as those on the Aegina pedi-

210. Epigonos of Pergamum (?). *Dying Trumpeter.* Roman copy after a bronze original of c. 230–220 B.C. Marble, lifesize. Museo Capitolino, Rome

211. The west front of the Great Pergamum Altar (restored). Staatliche Museen zu Berlin, Preussischer Kulturbesitz, Antikensammlung

212. Plan of the Great Pergamum Altar (after J. Schrammen)

ments (see fig. 160). If his agony seems infinitely more realistic in comparison, it still has considerable dignity and pathos. Clearly, the Celts were not considered unworthy foes. "They knew how to die, barbarians though they were," is the idea conveyed by the statue. Yet we also sense something else, an animal quality that had never before been part of Greek images of men. Death, as we witness it here, is a very concrete physical process. No longer able to move his legs, the Trumpeter puts all his waning strength into his arms, as if to prevent some tremendous invisible weight from crushing him against the ground.

PERGAMUM ALTAR. Some four decades later, we find a second sculptural style flourishing at Pergamum. About

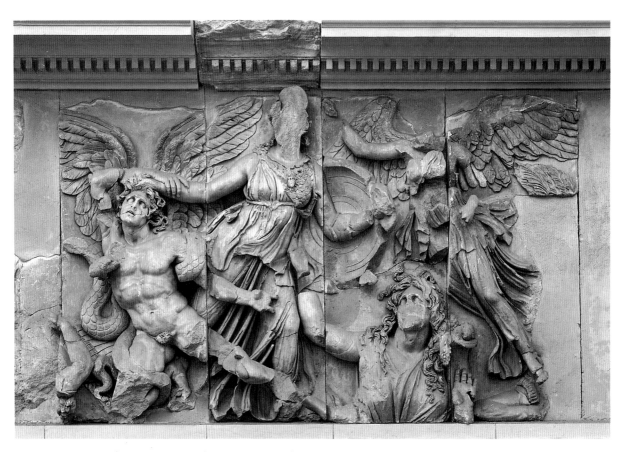

213. *Athena and Alcyoneus,* from the east side of the Great Frieze of the Great Pergamum Altar. c. 166–156 B.C. Marble, height 7'6" (2.29 m). Staatliche Museen zu Berlin, Preussischer Kulturbesitz, Antikensammlung

180 B.C., Eumenes II, the son and successor of Attalus I, had a mighty altar erected on a hill above the city to commemorate the victory of Rome and her allies over Antiochus the Great of Syria that had given him much of the Seleucid empire eight years earlier. A large part of the sculptural decoration has been recovered by excavation, and the entire west front of the altar, with its monumental flight of stairs leading to the entrance, has been reconstructed in Berlin (fig. 211). It is an impressive structure indeed. The altar proper occupies the center of a rectangular court surrounded by an Ionic colonnade, which rises on a tall base about 100 feet square (fig. 212). Altar structures of such great size seem to have been an Ionian tradition since Archaic times, but the Pergamum Altar is the most elaborate of all, as well as the only one of which considerable portions have survived. Its boldest feature is the great frieze covering the base, 400 feet long and over 7 feet tall. The huge figures, cut to such a depth that they seem almost detached from the background, have the scale and weight of pedimental statues, but freed from the confining triangular frame and transported to a frieze—a unique compound of two separate traditions that represents a thundering climax in the development of Greek architectural sculpture (fig. 213).

The carving of the frieze, though not very subtle in detail, has tremendous dramatic force. The heavy, muscular bodies rush at each other, and the high relief creates strong accents of light and dark, while the beating wings and windblown garments are almost overwhelming in their dynamism. A writhing movement pervades the entire design, down to the last lock of hair, linking the victors and the vanquished in a single continuous rhythm. This sense of unity disciplines the

physical and emotional violence of the struggle and keeps it—but just barely—from exploding its architectural frame. Indeed, the action spills out onto the stairs, where several figures are locked in mortal combat.

The subject, the battle of the gods and giants, is a traditional one for Ionic friezes. (We saw it before on the Siphnian Treasury, fig. 158.) At Pergamum, however, it has a novel significance. It promotes Pergamum as a new Athens—the patron goddess of both cities was Athena, who figures prominently in the great frieze. Moreover, it almost surely incorporates a sophisticated cosmological program whose meaning, however, remains under dispute. Finally, the victory of the gods is meant to symbolize Eumenes' own victories. Such a translation of history into mythology had been an established device in Greek art for a long time (see page 149). But to place Eumenes in analogy with the gods themselves implies an exaltation of the ruler that is Oriental rather than Greek in origin. This association was reinforced by a second frieze, entirely different in character, along the interior of the altar depicting the life of Telephos, the legendary founder of Pergamum and the son of Herakles, who was himself born of Zeus. After the time of Mausolus, who may have been the first to introduce it on Greek soil, the idea of divine kingship had been adopted by Alexander the Great and the lesser sovereigns who divided his realm, including the rulers of Pergamum. It later became central to Imperial Rome from Augustus onward (see page 190).

NIKE OF SAMOTHRACE. Equally dramatic in its impact is another great victory monument of the early second century B.C., the *Nike of Samothrace* (fig. 214), which perhaps com-

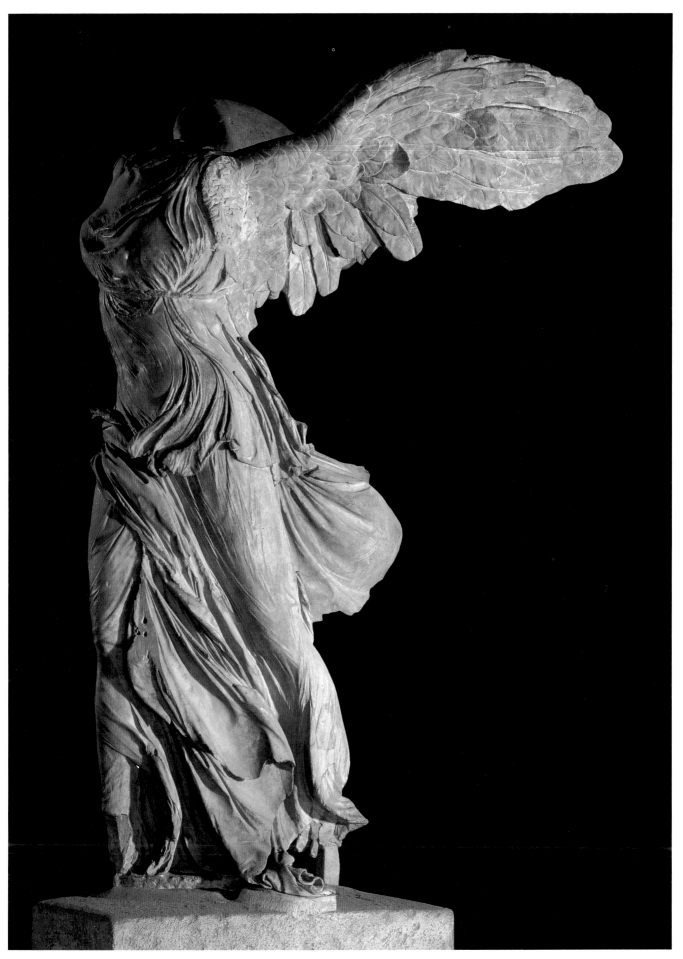

214. Pythokritos of Rhodes (?). *Nike of Samothrace.* c. 200–190 B.C. Marble, height 8' (2.4 m). Musée du Louvre, Paris

memorates the naval victory in 190 B.C. over Antiochus the Great by Eudamos of Rhodes. The style is Rhodian, and the statue may well have been carved by the island's leading sculptor, Pythokritos. The goddess has just descended to the prow of a ship. Her great wings spread wide, she is still partly airborne by the powerful head wind against which she advances. The invisible force of onrushing air here becomes a tangible reality. It not only balances the forward movement of the figure but also shapes every fold of the wonderfully animated drapery. As a result, there is an active relationship—indeed, an interdependence—between the statue and the space that envelops it, such as we have never seen before. By comparison, all earlier examples of active drapery seem inert. This is true even of the three goddesses from the Parthenon (fig. 192), whose wet drapery responds not to the atmosphere around it but to an inner impulse independent of all motion. Nor shall we see its like again for a long time to come. The *Nike of Samothrace* deserves all of her fame as the greatest masterpiece of Hellenistic sculpture.

LAOCOÖN. Until the *Nike* was discovered over 100 years ago, the most admired work of Hellenistic statuary had been a group showing the death of Laocoön and his two sons (fig. 215). [See Primary Sources, no. 6, page 214, and no. 14, pages 217–18.] It was found in Rome in 1506 and made a tremendous impression on Michelangelo and many others. The history of its fame is like that of the *Apollo Belvedere*. The two were treated as complementary, the *Apollo* exemplifying harmonious beauty, the *Laocoön* sublime tragedy. (Laocoön was the priest punished by the gods for telling the Trojans not to admit the Greeks' wooden horse into the city, but his warning went unheeded, which led to the Trojans' defeat.) Today we tend to find the pathos of the group somewhat calculated and rhetorical, and its meticulous surface finish strikes us as a display of virtuoso technique.

In style, including the relieflike spread of the three figures, it clearly descends from the Pergamum frieze, although its dynamism has become rather self-conscious. It was long accepted as a Greek original and identified with a group by Agesander, Athenodorus, and Polydorus of Rhodes that the Roman writer Pliny mentions in the palace of the emperor Titus; they, we now know, were skilled copyists active just before or after the birth of Christ. The subject must have held a special meaning for the Romans. Laocoön's fate forewarned Aeneas of the fall of Troy, prompting him to flee in time. Since Aeneas was believed to have come to Italy and to have been the ancestor of Romulus and Remus, the death of Laocoön could be viewed as the first link in a chain of events that ultimately led to the founding of Rome.

PORTRAITS. Individual likenesses were inconceivable in Classical art, which sought a timeless ideal. [See Primary Sources, no. 15, page 218.] Portraiture first arose as an important branch of Greek sculpture only in the mid-fourth century and continued to flourish in Hellenistic times. Its achievements, however, are known to us only indirectly, for the most part through Roman copies. One of the few originals is the extraordinarily vivid bronze head from Delos, a work of the early first century B.C. (fig. 216). It was not made as a bust but rather, in accordance with Greek custom, as part of a full-length statue. The identity of the sitter is unknown, but whoever he was, his individual likeness has been fused with a distinctive Hellenistic type (compare the face of Alcyoneus in figure 213) to provide an intensely private view of him that captures the character of the age.

The distant stare of the *"Mausolus"* (fig. 204) has been replaced by a troubled look. The fluid modeling of the somewhat flabby features, the uncertain, plaintive mouth, and the unhappy eyes under furrowed brows reveal an individual beset by doubts and anxieties—an extremely human, unheroic personality. There are echoes of noble pathos in these features, but it is a pathos translated into psychological terms of unparalleled immediacy. People of such inner turmoil had certainly existed earlier in the Greek world, just as they do today. Yet it is significant that their complex character could be conveyed in art only when Greek independence was about to come to an end, culturally as well as politically.

STATUETTES. Before we leave Hellenistic sculpture, we must cast at least a passing glance at another aspect of it, represented by the enchanting bronze statuette of a veiled dancer (fig. 217). She introduces us to the wide variety of small-scale works produced for private ownership, which comprise a special category unto themselves. They are often called Tanagra figures, after the site where many have been found. Such pieces were collected in much the same way as painted vases had been in earlier times. Like vase paintings, they show a range of subject matter far broader than that of monumental sculpture. Besides the familiar mythological themes, we encounter a wealth of everyday subjects: beggars, street entertainers, peasants, young ladies of fashion. The grotesque, the humorous, the picturesque—qualities that rarely enter into Greek monumental art—play a conspicuous role here. Most of these figurines are routine decorative pieces mass-produced in clay or bronze. But at their best, as in our example, they have an imaginative freedom rarely matched on a larger scale. The bold spiral twist of the veiled dancer, reinforced by the diagonal folds of the drapery, creates a multiplicity of interesting views that practically forces the beholder to turn the statuette in his hands. No less extraordinary is the rich interplay of concave and convex forms, the intriguing contrast between the compact silhouette of the figure and the mobility of the body within.

COINS

We rarely think of coins as works of art, and the great majority of them surely are not. The study of their history and development, known as numismatics, offers many rewards, but visual delight is the least of these. If many Greek coins form an exception to this general rule, it is not simply because they are the earliest. (The idea of stamping metal pellets of standard weight with an identifying design originated in Ionian Greece sometime before 600 B.C.) After all, the first postage stamps were no more distinguished than their present-day descendants. The reason, rather, is the persistent individualism of Greek political life. Every city-state had its own coinage, adorned with its particular emblem, and the designs were changed at frequent intervals so as to take account of treaties, victories, or other occasions for local pride. As a consequence,

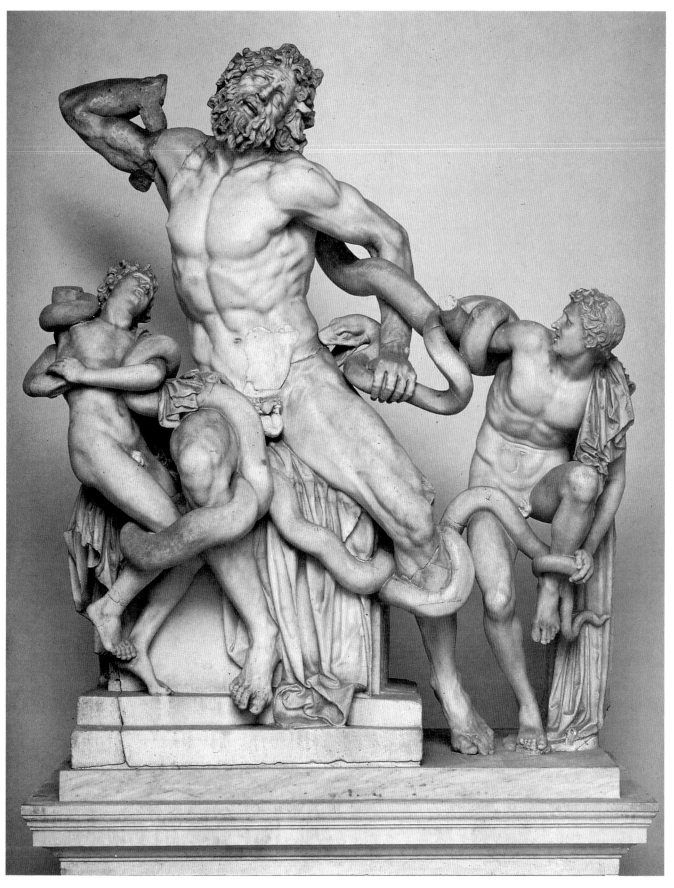

215. *The Laocoön Group.* Perhaps by Agesander, Athenodorus, and Polydorus of Rhodes (present state, former restorations removed). 1st century B.C. Marble, height 7' (2.1 m). Musei Vaticani, Museo Pio Clementino, Cortile Ottagono, Città del Vaticano, Rome

216. *Portrait Head,* from Delos. c. 80 B.C. Bronze, height 12³/4" (32.4 cm). National Archaeological Museum, Athens

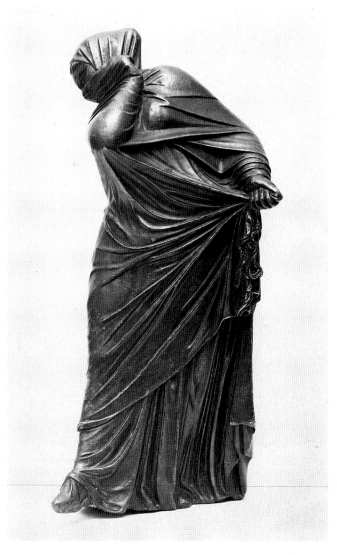

217. *Veiled Dancer.* c. 200 B.C.? Bronze statuette, height 8¹/8" (20.6 cm). The Metropolitan Museum of Art, New York. Bequest of Walter C. Baker, 1971

the number of coins struck at any one time remained relatively small, while the number of coinages was large.

The constant demand for new designs produced highly skilled specialists who took such pride in their work that they sometimes signed it. Greek coins thus are not only an invaluable source of historical knowledge but an authentic expression of the changing Greek sense of form. Within their own compass, they illustrate the development of Greek sculpture from the sixth to the second century B.C. as faithfully as the larger works we have examined. And since they form a continuous series, with the place and date of almost every item well established, they reflect this development more fully in some respects than do the works of monumental art.

Oddly enough, the finest coins of Archaic and Classical Greece were usually produced not by the most powerful states such as Athens, Corinth, or Sparta, but by the lesser ones along the periphery of the Greek world. Our first example (fig. 218), from the Aegean island of Peparethus, reflects the origin of

coinage: a square die deeply embedded in a rather shapeless pellet, like an impression in sealing wax. The winged god, his pinwheel stance so perfectly adapted to the frame, is a summary-in-miniature of Archaic art, down to the ubiquitous smile (see fig. 154). On the coin from Naxos in Sicily (fig. 219), almost half a century later, the die fills the entire area of the coin. The astonishingly monumental figure shows the articulation and organic vitality of the Severe style (compare fig. 187). Our third coin (fig. 220) was struck in the Sicilian town of Catana toward the end of the Peloponnesian War. It is signed with the name of its maker, Herakleidas, and it well deserves to be, for it is one of the true masterpieces of Greek coinage. Who would have thought it possible to endow the full-face view of a head in low relief with such plasticity! This radiant image of Apollo has all the swelling roundness of the mature Classical style. Its grandeur completely transcends the limitations of the tiny scale of a coin.

From the time of Alexander the Great onward, coins began

218. *Winged God.* Silver coin from Peparethus. c. 500 B.C. Diameter 1½" (3.7 cm). The British Museum, London

219. *Silenus.* Silver coin from Naxos. c. 460 B.C. Diameter 1¼" (3.3 cm). The British Museum, London

220. *Apollo.* Silver coin from Catana. c. 415–400 B.C. Diameter 1⅛" (3 cm). The British Museum, London

221. *Alexander the Great with Amun Horns.* Four-drachma silver coin issued by Lysimachus. c. 297–281 B.C. Diameter 1⅛" (3 cm)

222. *Antimachus of Bactria.* Silver coin. c. 185 B.C. Diameter 1¼" (3.3 cm). The British Museum, London

to show profile portraits of rulers. The successors of Alexander at first put his features on their coins to emphasize their link with the deified conqueror. Such a piece is shown in figure 221. Alexander here displays the horns identifying him with the ram-headed Egyptian god Amun. His "inspired" expression, conveyed by the half-open mouth and the upward-looking eyes, is characteristic of the emotionalism of Hellenistic art, as are the fluid modeling of the features and the agitated, snakelike hair. As a likeness, this head can have only the most tenuous relation to the way Alexander actually looked. Yet this idealized image of the all-conquering genius projects the flavor of the new era more eloquently than do the large-scale portraits of Alexander.

Once the Hellenistic rulers started putting themselves on their coins, the likenesses became more individual. Perhaps the most astonishing of these (fig. 222) is the head of Antimachus of Bactria (present-day Afghanistan), which stands at the opposite end of the scale from the Alexander-Amun. Its mobile features show a man of sharp intelligence and wit, a bit skeptical perhaps about himself and others, and, in any event, without any desire for self-glorification. This penetratingly human portrait seems to point the way to the bronze head from Delos (fig. 216) a hundred years later. It has no counterpart in the monumental sculpture of its own time and thus helps to fill an important gap in our knowledge of Hellenistic portraiture.

CHAPTER SIX

ETRUSCAN ART

The Italian peninsula did not emerge into the light of history until fairly late. The Bronze Age, which dawned first in Mesopotamia about 4000 B.C., came to an end in the Italian peninsula around 1100 B.C., when the Villanovan people brought an early Iron Age culture from Central Europe. They were succeeded by the Etruscans in the eighth century B.C., about the time the earliest Greeks began to settle along the southern shores of Italy and in Sicily. Interestingly, the Romans believed that their city had been founded in 753 B.C. by the descendants of refugees from Troy (see page 162) in Asia Minor. According to the Classical Greek historian Herodotus, however, the Etruscans had left their homeland of Lydia in Asia Minor about 1200 B.C. and settled in the area between Florence and Rome, which to this day is known as Tuscany, the country of the Tusci or Etrusci.

Herodotus' claim was already disputed in Roman times by the Greek historian Dionysius of Halicarnassus. Be that as it may, the Etruscans were strongly linked with Asia Minor and the ancient Near East culturally and artistically. Yet they also show many traits for which no parallels can be found anywhere. The sudden flowering of Etruscan civilization resulted in large part from the influx of Greek culture. For example, the Etruscans borrowed their alphabet from the Greeks toward the end of the eighth century. Nevertheless, their language, of which our understanding is still very limited, has no kin among any known tongues. The only Etruscan writings that have come down to us are brief funerary inscriptions and a few somewhat longer texts relating to religious ritual, though Roman authors tell us that a rich Etruscan literature once existed. We would, in fact, know practically nothing about the Etruscans at first hand were it not for their elaborate tombs. They were not molested when the Romans destroyed or rebuilt Etruscan cities and therefore have survived intact until modern times.

Italian Bronze Age burials had been of the modest sort found elsewhere in prehistoric Europe. The remains of the deceased, contained in a pottery vessel or urn, were placed in a simple pit along with the equipment they required in an afterlife: weapons for men, jewelry and household tools for women. In Mycenaean Greece, this primitive cult of the dead had been elaborated under Egyptian influence, as shown by the monumental beehive tombs. Something very similar happened eight centuries later in Tuscany. Toward 700 B.C., Etruscan tombs began to imitate, in stone, the interiors of actual dwellings, covered by great conical mounds of earth. They could be roofed by vaults or corbeled domes built of horizontal, overlapping courses of stone blocks, as was the Treasury of Atreus at Mycenae (see fig. 130). At the same time, the pot-

223. Human-headed cinerary urn. c. 675–650 B.C. Terracotta, height 25 1/2" (64.7 cm). Museo Etrusco, Chiusi, Italy

tery urns gradually took on human shape. The lid grew into the head of the deceased, and body markings appeared on the vessel itself, which could be placed on a sort of throne to indicate high rank (fig. 223). Alongside the modest beginnings of funerary sculpture, we find sudden evidence of great wealth in the form of exquisite goldsmiths' work decorated with motifs familiar from the Orientalizing Greek vases of the same period (see fig. 141), intermingled with precious objects imported from the ancient Near East.

The seventh and sixth centuries B.C. saw the Etruscans at the height of their power. Their cities rivaled those of the Greeks; their fleet dominated the western Mediterranean and protected a vast commercial empire that competed with the Greeks and Phoenicians; and their territory extended as far as Naples in the south and the lower Po Valley in the north. Rome itself was ruled by Etruscan kings for about a century, until the establishment of the Republic in 510 B.C. The kings threw the first defensive wall around the seven hills, drained the swampy plain of the Forum, and built the original temple on the Capitoline Hill, thus making a city out of what had been little more than a group of villages before.

But the Etruscans, like the Greeks, never formed a unified nation. They were no more than a loose federation of individual city-states given to quarreling among themselves and slow to unite against a common enemy. During the fifth and fourth centuries B.C., one Etruscan city after another succumbed to the Romans. By the end of the third century, all of them had lost their independence, although many continued to prosper, if we are to judge by the richness of their tombs during the period of political decline.

Tombs and Their Decoration

The flowering of Etruscan civilization thus coincides with the Archaic age in Greece. During this period, especially near the end of the sixth and early in the fifth century B.C., Etruscan art showed its greatest vigor. Greek Archaic influence had displaced the Orientalizing tendencies (many of the finest Greek vases have been found in Etruscan tombs of that time) but Etruscan artists did not simply imitate their Hellenic models. Working in a very different cultural setting, they retained their own clear-cut identity.

One might expect to see the Etruscan cult of the dead wane under Greek influence. On the contrary, tombs and equipment grew more elaborate as the skills of the sculptor and painter increased. The deceased could now be represented full-length, reclining on the lids of sarcophagi shaped like couches, as if they were participants in a festive repast, an Archaic

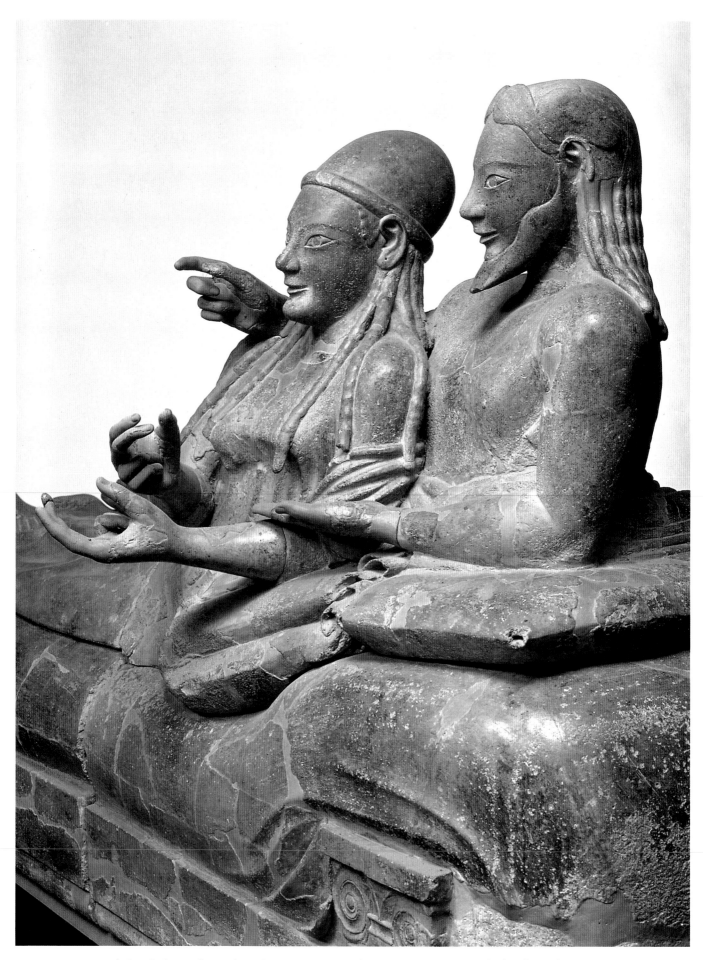

224. Detail of sarcophagus, from Cerveteri. c. 520 B.C. Terracotta. Museo Nazionale di Villa Giulia, Rome

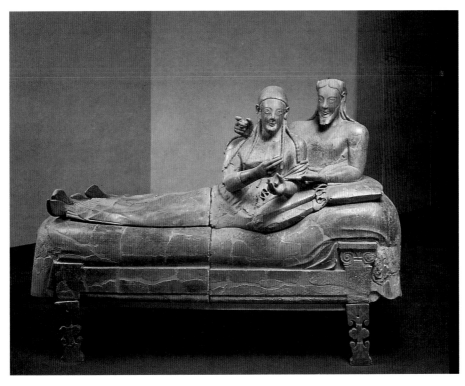

225. Sarcophagus, from Cerveteri. c. 520 B.C. Terracotta, length 6'7" (2 m).
Museo Nazionale di Villa Giulia, Rome

smile about their lips. The monumental example in figures 224 and 225 shows a husband and wife side by side, strangely gay and majestic at the same time. The entire work is of terracotta and was once painted in bright colors. The smoothly rounded, elastic forms betray the Etruscan sculptor's preference for modeling in soft materials, in contrast to the Greek love of stone carving. There is less formal discipline here but an extraordinary directness and vivacity characteristic of Etruscan art as a whole.

EARLY FUNERARY BELIEFS. We do not know precisely what ideas the Archaic Etruscans held about the afterlife. Effigies such as our reclining couple, which for the first time in history represent the deceased as thoroughly alive and enjoying themselves, suggest that they regarded the tomb as an abode not only for the body but for the soul as well (in contrast to the Egyptians, who thought of the soul as roaming freely and whose funerary sculpture therefore remained "inanimate"). How else are we to understand the purpose of the wonderfully rich array of murals in these funerary chambers? Since nothing of the sort has survived in Greek territory, they are uniquely important, not only as an Etruscan achievement but also as a possible reflection of Greek wall painting.

TOMB OF HUNTING AND FISHING. Perhaps the most astonishing murals are found in the Tomb of Hunting and Fishing at Tarquinia of about 520 B.C. Figure 226 shows a great marine panorama at one end of the low chamber: a vast, continuous expanse of water and sky in which the fishermen and the hunter with his slingshot play only an incidental part. The free, rhythmic movement of birds and dolphins is strangely reminiscent of Minoan painting of a thousand years earlier (see fig. 120), but the weightless, floating quality of Cretan art is absent. We might also recall Exekias' *Dionysus in a Boat* (see fig. 142) as the closest Greek counterpart to our scene. The differences, however, are as revealing as the similarities, and one wonders if any Greek Archaic artist knew how to place human figures in a natural setting as effectively as the Etruscan painter did. Could the mural have been inspired by Egyptian scenes of hunting in the marshes, such as the one in figure 68? They seem the most convincing precedent for the general conception of our subject. If so, the Etruscan artist has brought the scene to life, just as the reclining couple in figure 225 has been brought to life compared with Egyptian funerary statues.

TOMB OF THE LIONESSES. A somewhat later example

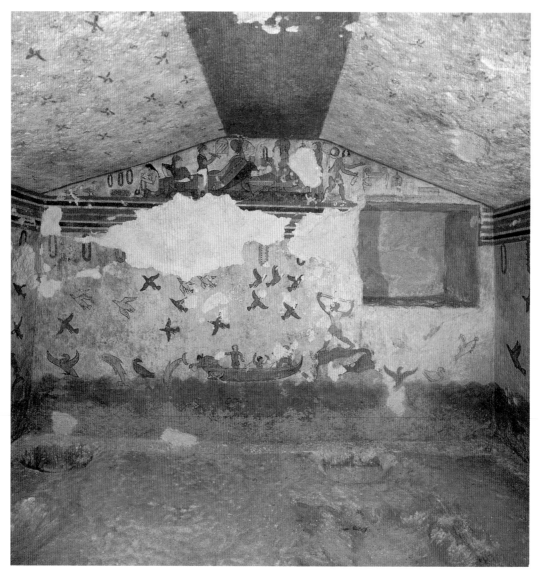

226. Tomb of Hunting and Fishing, Tarquinia, Italy. c. 520 B.C.

from another tomb in Tarquinia (fig. 227) shows a pair of ecstatic dancers. The passionate energy of their movements again strikes us as uniquely Etruscan rather than Greek in spirit. Of particular interest is the transparent garment of the woman, which lets the body shine through. In Greece, this differentiation appears only a few years earlier, during the final phase of Archaic vase painting. The contrasting body color of the two figures continues a practice introduced by the Egyptians more than 2,000 years before (see fig. 65).

LATER FUNERARY BELIEFS. During the fifth century, the Etruscan view of the hereafter must have become a good deal more complex and less festive. We notice the change immediately if we compare the group in figure 228, a cinerary container carved of soft local stone soon after 400 B.C., with its predecessor in figure 225. The woman now sits at the foot of the couch, but she is not the wife of the young man. Her wings indicate that she is the demon of death, and the scroll in her left hand records the fate of the deceased. The young man is pointing to it as if to say, "Behold, my time has come." The thoughtful, melancholy air of the two figures may be due to some extent to the influence of Classical Greek art which pervades the style of our group (compare fig. 197). A new mood of uncertainty and regret is felt. Human destiny is in the hands of inexorable supernatural forces, and death is now the great divide rather than a continuation, albeit on a different plane, of life on earth.

In later tombs, the demons of death gain an even more fearful aspect. Other, more terrifying demons enter the scene, often battling against benevolent spirits for possession of the soul of the deceased. One of these demons appears in the

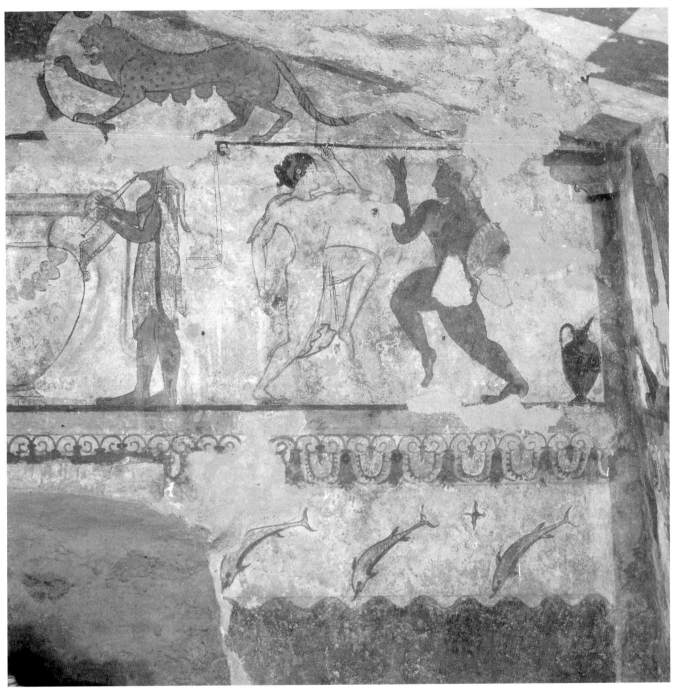

227. *Musicians and Two Dancers.* Detail of a wall painting. c. 480–470 B.C. Tomb of the Lionesses, Tarquinia, Italy

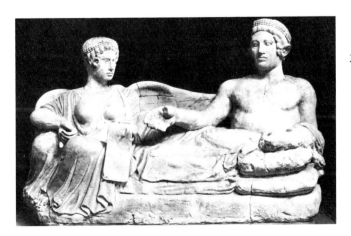

228. *Youth and Demon of Death.*
Cinerary container.
Early 4th century B.C. Stone
(pietra fetida), length 47"
(119.4 cm). Museo
Archeologico Nazionale,
Florence

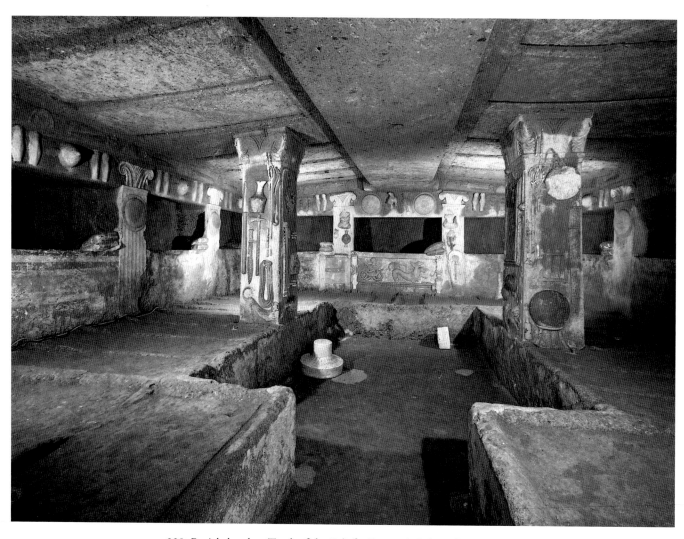

229. Burial chamber. Tomb of the Reliefs, Cerveteri, Italy. 3rd century B.C.

230. Reconstruction of an Etruscan temple. Museo delle Antichità Etrusche e Italiche, Rome

center of figure 229, a tomb of the third century B.C. at Cerveteri, richly decorated with stucco reliefs rather than paintings. The entire chamber, cut into the live rock, closely imitates the interior of a house, including the beams of the roof. The sturdy pilasters (note the capitals, which recall the Aeolian type from Asia Minor in fig. 175), as well as the wall surfaces between the niches, are covered with exact reproductions of weapons, armor, household implements, small domestic animals, and busts of the deceased. In such a setting, the snake-legged demon and his three-headed hound (whom we recognize as Cerberus, the guardian of the infernal regions) seem particularly disquieting.

Temples and Their Decoration

Only the stone foundations of Etruscan temples have survived, since the buildings themselves were built of wood. Apparently the Etruscans, although they were masters of masonry construction for other purposes, rejected for religious reasons the use of stone in temple architecture. The design of their sanctuaries bears a general resemblance to the simpler Greek temples (fig. 230), but with several distinctive features, some of them later perpetuated by the Romans. The entire structure rests on a tall base, or podium, that is no wider than the cella and has steps only on the south side; these lead to a deep porch, supported by two rows of four columns each, and to the cella beyond. The cella is generally subdivided into three compartments, for Etruscan religion was dominated by a triad of gods, the predecessors of the Roman Juno, Jupiter, and Minerva. The Etruscan temple, then, must have been of a squat, squarish shape compared to the graceful Greek sanctuaries, and more closely linked with domestic architecture. Needless to say, it provided no place for stone sculpture. The decoration usually consisted of terracotta plaques covering the architrave and the edges of the roof. Only after 400 B.C. do we occasionally find large-scale terracotta groups designed to fill the pediment above the porch.

VEII. We know, however, of one earlier attempt—and an astonishingly bold one—to find a place for monumental sculpture on the exterior of an Etruscan temple. The so-called Temple of Apollo at Veii, not very far north of Rome, was a structure of standard type in every other respect, but it also had four lifesize terracotta statues on the ridge of its roof (seen also in the reconstruction model, fig. 230). They formed a dramatic group of the sort we might expect in Greek pedimental sculpture: the contest of Hercules and Apollo for the sacred hind (female deer), in the presence of other deities. The best preserved of these figures is the *Apollo* (fig. 231), acknowledged to be the masterpiece of Etruscan Archaic sculpture. His massive body, completely revealed beneath the ornamental striations of the drapery; the sinewy, muscular legs; the hurried, purposeful stride—all these betray an expressive power that has no counterpart in free-standing Greek statues of the same date.

That Veii was indeed a sculptural center at the end of the sixth century seems to be confirmed by the Roman tradition that the last of the Etruscan rulers of the city called on a master from Veii to make the terracotta image of Jupiter for the temple on the Capitoline Hill. This image has disappeared, but an

231. *Apollo,* from Veii. c. 510 B.C. Terracotta, height 69" (175.3 cm). Museo Nazionale di Villa Giulia, Rome

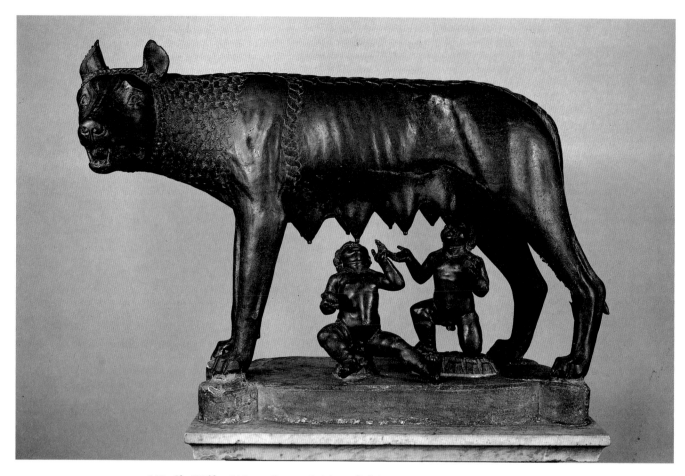

232. *She-Wolf.* c. 500 B.C. Bronze, height 33 1/2" (85 cm). Museo Capitolino, Rome

even more famous symbol of Rome, the bronze figure of the she-wolf that nourished Romulus and Remus, is still in existence (fig. 232). [See Primary Sources, no. 16, page 218.] The two babes are Renaissance additions, and the early history of the statue is obscure; some scholars, therefore, have even suspected it of being a medieval work. Nevertheless, it is almost surely an Etruscan Archaic original, for the wonderful ferocity of expression, the latent physical power of the body and legs, have the same awesome quality we sense in the *Apollo* from Veii. In any event, the she-wolf as the totemic animal of Rome has the strongest links with Etruscan mythology, in which wolves seem to have played an important part from very early times.

Portraiture and Metalwork

The Etruscan concern with effigies of the deceased might lead us to expect an early interest in individual portraiture. Yet the features of such funerary images as those in figures 225 and 228 are entirely impersonal, and it was only toward 300 B.C., under the influence of Greek portraiture, that individual likenesses began to appear in Etruscan sculpture. The finest of them are not funerary portraits, which tend to be rather crude and perfunctory, but the heads of bronze statues. *Portrait of a Boy* (fig. 233) is a real masterpiece of its kind. The firmness of modeling lends a special poignancy to the sensitive mouth and the gentle, melancholy eyes.

No less impressive is the very high quality of the casting

and finishing, which bears out the ancient fame of the Etruscans as master craftsmen in metal. Their ability in this respect was of long standing, for the wealth of Etruria was founded on the exploitation of copper and iron deposits. From the sixth century on, they produced large quantities of bronze statuettes, mirrors, and such, both for export and domestic consumption. The charm of these small pieces is well displayed by the engraved design on the back of a mirror done soon after 400 B.C. (fig. 234). Within an undulating wreath of vines, we see a winged old man, identified as Chalchas, examining a roundish object. The draftsmanship is so beautifully balanced and assured that we are tempted to assume that Classical Greek art was the direct source of inspiration.

DIVINATION. So far as the style of our piece is concerned, this may well be the case, but the subject is uniquely Etruscan, for the winged genius is gazing at the liver of a sacrificial animal. We are witnessing a practice that loomed as large in the lives of the Etruscans as the care of the dead: the search for omens or portents. The Etruscans believed that the will of the gods manifested itself through signs in the natural world, such as thunderstorms or the flight of birds, and that by reading them people could find out whether the gods smiled or frowned upon their enterprises. The priests who knew the secret language of these signs enjoyed enormous prestige. Even the Romans were in the habit of consulting them before any major public or private event. Divination (as the Romans

233. *Portrait of a Boy.* Early 3rd century B.C. Bronze, height 9" (23 cm). Museo Archeologico Nazionale, Florence

234. Engraved back of a mirror. c. 400 B.C. Bronze, diameter 6" (15.3 cm). Musei Vaticani, Museo Gregoriano Etrusco, Città del Vaticano, Rome

called the art of interpreting omens) can be traced back to ancient Mesopotamia, and the practice was not unknown in Greece, but the Etruscans carried it further than any of their predecessors. They put especial trust in the livers of sacrificial animals, on which, they thought, the gods had inscribed the hoped-for divine message. In fact, they viewed the liver as a sort of microcosm, divided into regions that corresponded, in their minds, to the regions of the sky.

Arcane and irrational as they were, these practices became part of our cultural heritage, and echoes of them persist to this day. True, we no longer try to tell the future by watching the flight of birds or examining animal livers, but tea leaves and horoscopes are still prophetic to many people. And we speak of auspicious events, that is, of events indicating a favorable future, unaware that "auspicious" originally referred to a favorable flight of birds. Perhaps we do not believe very seriously that four-leaf clovers bring good luck and black cats bad luck, yet a surprising number of us admit to being superstitious.

The Architecture of Cities

According to Roman writers, the Etruscans were masters of architectural engineering, and of town planning and surveying. That the Romans learned a good deal from them can hardly be doubted, but exactly how much the Etruscans con-

tributed to Roman architecture is difficult to say, since very little Etruscan or early Roman architecture remains standing above ground. Roman temples certainly retained many Etruscan features, and the atrium, the central hall of the Roman house (see fig. 255), likewise originated in Etruria. In town planning and surveying, too, the Etruscans have a good claim to priority over the Greeks.

The original homeland of the Etruscans, Tuscany, was too hilly to encourage geometric schemes. However, when they colonized the flatlands south of Rome in the sixth century, they laid out their newly founded cities as a network of streets centering on the intersection of two main thoroughfares, the *cardo* (which ran north and south) and the *decumanus* (which ran east and west). The four quarters thus obtained could be further subdivided or expanded, according to need. This system, which the Romans adopted for the new cities they were to found throughout Italy, western Europe, and North Africa, may have been derived from the plan of Etruscan military camps. Yet it also seems to reflect the religious beliefs that made the Etruscans divide the sky into regions according to the points of the compass and place their temples along a north-south axis. The Etruscans must also have taught the Romans how to build fortifications, bridges, drainage systems, and aqueducts, but hardly anything remains of their enterprises in these fields.

CHAPTER SEVEN

ROMAN ART

Among the civilizations of the ancient world, that of the Romans is far more accessible to us than any other. We can trace its history with a wealth of detail that continues to amaze us: the growth of the Roman domain from city-state to empire; its military and political struggles; its changing social structure, the development of its institutions; and the public and private lives of its leading personalities. Nor is this a matter of chance. The Romans themselves seem to have wanted it that way. Articulate and posterity-conscious, they have left a vast literary legacy, from poetry and philosophy to humble inscriptions recording everyday events, and an equally huge mass of visible monuments that were scattered throughout their empire, from England to the Persian Gulf, from Spain to Romania. Yet, paradoxically, there are few questions more difficult to answer than "What is Roman art?" The Roman genius, so clearly recognizable in every other sphere of human activity, becomes oddly elusive when we ask whether there was a characteristic Roman style in the fine arts, particularly painting and sculpture.

Why is this so? The most obvious reason is the great admiration the Romans had for Greek art of every period and variety. They imported originals of earlier date—Archaic, Classical, and Hellenistic—by the thousands and had them copied in even greater numbers. In addition, their own production was clearly based on Greek sources, and many of their artists, from Republican times (509–27 B.C.) to the end of the Empire (27 B.C.–A.D. 395), were of Greek origin. Moreover, Roman authors show little concern with the art of their own time. They tell us a good deal about the development of Greek art as described in Greek writings on the subject. Or they speak of artistic production during the early days of the Roman Republic, of which not a trace survives today, but rarely about contemporary works. While anecdotes or artists' names may be mentioned incidentally in other contexts, the Romans never developed a rich literature on the history, theory, and criticism of art such as had existed among the Greeks. Nor do we hear of Roman artists who enjoyed individual

fame, although the great names of Greek art—Polyclitus, Phidias, Praxiteles, Lysippus—were praised as highly as ever.

One might be tempted to conclude, therefore, that the Romans themselves looked upon the art of their time as being in decline compared with the great Greek past, whence all important creative impulses had come. This, indeed, was the prevalent attitude among scholars until not very long ago. Roman art, they claimed, is essentially Greek art in its final decadent phase—Greek art under Roman rule. Hence, there is no such thing as Roman style, only Roman subject matter. Yet the fact remains that, as a whole, the art produced under Roman auspices does look distinctly different from Greek art. Otherwise the "problem" would not have arisen. If we insist on evaluating this difference by Greek standards, it will appear as a process of decay. If, on the other hand, we interpret it as expressing different, un-Greek intentions, we are likely to see it in a less negative light.

Once we admit that art under the Romans had positive un-Greek qualities, we cannot very well regard these innovations as belonging to the final phase of Greek art, no matter how many artists of Greek origin we may find in Roman records. Actually, the Greek names of these men do not signify much. Most of the artists, it seems, were thoroughly Romanized. In any event, the great majority of Roman works of art are unsigned, and their makers, for all we know, may have come from any part of the far-flung Roman domain.

The Roman Empire was a cosmopolitan society in which national or regional traits were soon absorbed into the common all-Roman pattern set by the capital, the city of Rome. From the very start Roman society proved astonishingly tolerant of alien traditions. It had a way of accommodating them all, so long as they did not threaten the security of the state. The populations of newly conquered provinces were not forced into a uniform straitjacket but, rather, were put into a fairly low-temperature melting pot. Law and order, and a token reverence for the symbols of Roman rule, were imposed on them. At the same time, however, their gods and sages were

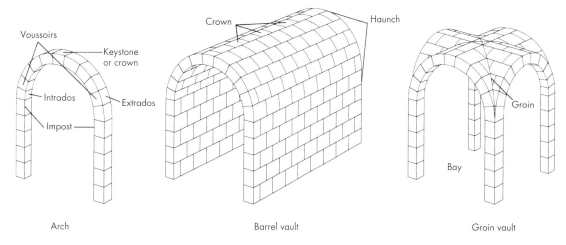

hospitably received in the capital, and eventually they themselves would be given the rights of citizenship. Roman civilization and Roman art thus acquired not only the Greek heritage but, to a lesser extent, that of the Etruscans, and of Egypt and the Near East as well. All this made for an extraordinarily complex and open society, homogeneous and diverse at the same time. The sanctuary of Mithras accidentally unearthed in the center of London offers a striking illustration of the cosmopolitan character of Roman society. The god is Persian in origin but he had long since become a Roman "citizen," and his sanctuary, now thoroughly and uniquely Roman in form, can be matched by hundreds of others throughout the empire.

Under such conditions, it would be little short of a miracle if Roman art were to show a consistent style such as we found in Egypt, or the clear-cut evolution that distinguishes the art of Greece. Its development, to the extent that we understand it today, might be likened to a counterpoint of divergent tendencies that may exist side by side, even within a single monument, and none of them ever emerges as overwhelmingly dominant. The "Roman-ness" of Roman art must be found in this complex pattern, rather than in a single and consistent quality of form—and that is precisely its strength.

ARCHITECTURE

If the originality of Roman sculpture and painting has been questioned, Roman architecture is a creative feat of such magnitude as to silence all doubts about its distinctive Roman character. Its growth, moreover, from the very start reflected a specifically Roman way of public and private life. Greek models, though much admired, no longer sufficed to accommodate the sheer numbers of people in large public buildings necessitated by the empire. And when it came to supplying the citizenry with everything it needed, from water to entertainment on a grand scale, radical new forms had to be invented, and cheaper materials and quicker methods had to be used.

From the beginning, the growth of Rome is hardly thinkable without the arch and the vaulting systems derived from it: the barrel vault, a half-cylinder; the groin vault, which consists of two barrel vaults intersecting each other at right angles;

and the dome (see figs. 235 and 325). True arches are constructed of wedge-shaped blocks, called voussoirs, each pointing toward the center of the semicircular opening. Such an arch is strong and self-sustaining, in contrast to the "false" arch composed of horizontal courses of masonry or brickwork (like the opening above the lintel of the Lioness Gate at Mycenae, fig. 135). The true arch, and its extension, the barrel vault, had been discovered in Egypt as early as about 2700 B.C., but the Egyptians had used it mainly in underground tomb structures and in utilitarian buildings, never in temples. Apparently they thought it unsuited to monumental architecture. In Mesopotamia the true arch was used for city gates and perhaps elsewhere as well, but to what extent we cannot determine for lack of preserved examples. The Greeks knew the principle from the fifth century on, but they confined the use of the true arch to underground structures or to simple gateways, because they refused to combine it with the elements of the architectural orders.

No less vital to Roman architecture was concrete, a mixture of mortar and gravel with rubble (small pieces of building stone and brick). Concrete construction had been invented in the Near East more than a thousand years earlier, but the Romans developed its potential until it became their chief building technique. The advantages of concrete are obvious: strong, cheap, and flexible, it alone made possible the vast architectural enterprises that are still the chief reminders of "the grandeur that was Rome." The Romans knew how to hide the unattractive concrete surface by adding a facing of brick, stone, or marble, or by covering it with smooth plaster. Today, this decorative skin has disappeared from the remains of most Roman buildings, leaving the concrete core exposed and thus depriving these ruins of the appeal that those of Greece have for us.

Religious Architecture

"TEMPLE OF FORTUNA VIRILIS." Any elements borrowed from the Etruscans or Greeks were soon marked with an unmistakable Roman stamp. These links with the past are strongest in the temple types developed during the Republican period (510–60 B.C.), the heroic age of Roman expansion.

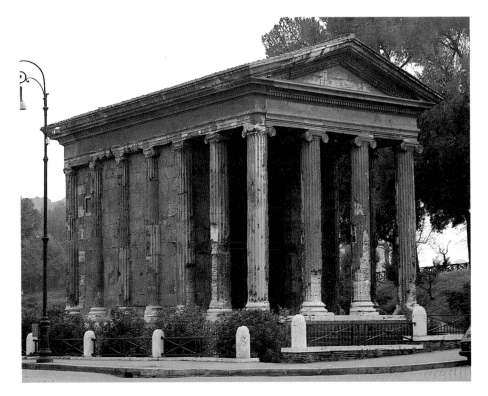

236. "Temple of Fortuna Virilis," Rome. Late 2nd century B.C.

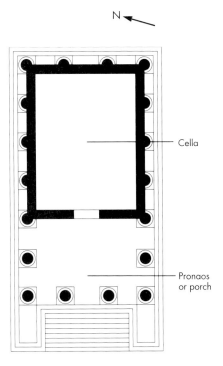

237. Plan of the "Temple of Fortuna Virilis"

Cella

Pronaos
or porch

N

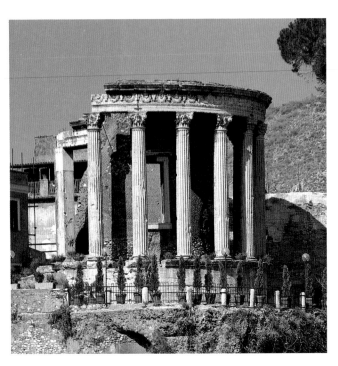

238. "Temple of the Sibyl," Tivoli. Early 1st century B.C.

N

239. Plan of the "Temple of the Sibyl"

The delightful small "Temple of Fortuna Virilis" is the oldest well-preserved example of its kind (fig. 236). (The name is sheer fancy, for the sanctuary seems to have been dedicated to the Roman god of harbors, Portunus.) Built in Rome during the last years of the second century B.C., it suggests, in the elegant proportions of its Ionic columns and entablature, the wave of Greek influence following the Roman conquest of Greece in 146 B.C. Yet it is not simply a copy of a Greek temple, for we recognize a number of Etruscan elements: the high podium, the deep porch, and the wide cella, which engages the columns of the peristyle. However, the cella is no longer subdivided into three compartments as it had been under the Etruscans; it now encloses a single unified space (fig. 237).

The Romans needed spacious temple interiors, since they used them not only for the image of the deity but also for the display of trophies (statues, weapons, etc.) brought back by their conquering armies. The "Temple of Fortuna Virilis" thus represents a well-integrated new type of temple designed for Roman requirements, not a haphazard cross of Etruscan and Greek elements. It was to have a long life. Numerous examples of it, usually large and with Corinthian columns, can be found as late as the second century A.D., both in Italy and in the provincial capitals of the empire.

240. Sanctuary of Fortuna Primigenia, Praeneste (Palestrina). Early 1st century B.C.

TEMPLE OF THE SIBYL. Another type of Republican temple is seen in the so-called "Temple of the Sibyl" at Tivoli (figs. 238 and 239), erected a few decades later than the "Temple of Fortuna Virilis." It, too, was the result of the merging of two separate traditions. Its original ancestor was a structure in the center of Rome in which the sacred flame of the city was kept. This building at first had the shape of the traditional round peasant huts in the Roman countryside. Later on it was redesigned in stone, under the influence of Greek structures of the tholos type (see page 106), and thus became the model for the round temples of late Republican times. Here again we find the high podium, with steps only opposite the entrance, and a graceful Greek-inspired exterior. As we look closely at the cella, we notice that while the door and window frames are of cut stone, the wall is built in concrete, visible now that the marble facing that once disguised it is gone.

SANCTUARY OF FORTUNA PRIMIGENIA. Roman buildings characteristically speak to us through their massive size and boldness of conception. The oldest monument in which these qualities are fully in evidence is the Sanctuary of Fortuna Primigenia at Palestrina, in the foothills of the Apennines east of Rome (fig. 240). Here, in what was once an important Etruscan stronghold, a strange cult had been established since early times, dedicated to Fortuna (Fate) as a mother deity and combined with a famous oracle. The Roman sanctuary dates from the early first century B.C. Its size and shape were almost completely hidden by the medieval town that had been built over it, until a bombing attack in 1944 destroyed most of the later houses and thus laid bare the remains of the huge ancient temple precinct. (The semicircular edifice is of much later date.)

The site originally had a series of ramps leading up to a broad colonnaded terrace, and the entire structure was crowned by a great colonnaded court (fig. 241). Arched openings, framed by engaged columns and architraves, played an important part in the second terrace, just as semicircular recesses did in the first. These openings were covered by barrel vaults, another characteristic feature of the Roman archi-

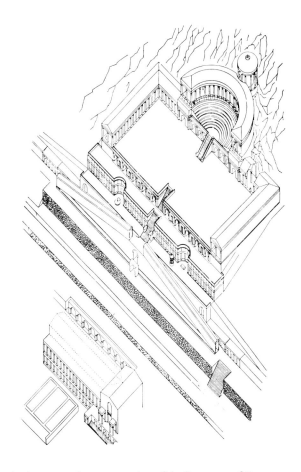

241. Axonometric reconstruction of the Sanctuary of Fortuna Primigenia, Praeneste

tectural vocabulary. Except for a niche with the columns and entablature on the lower terrace, all the surfaces now visible are of concrete, like the cella of the round temple at Tivoli. Indeed, it is hard to imagine how a complex as enormous as this could have been constructed otherwise.

What makes the sanctuary at Palestrina so imposing, however, is not merely its scale but the superb way it fits the site.

242. Plan of the Forums, Rome. 1) Temple of Capitoline Jupiter;
2) Temple of Trajan; 3) Basilica Ulpia; 4) Market of Trajan;
5) Temple of Venus Genetrix; 6) Forum of Trajan; 7) Temple of Mars
Ultor; 8) Forum of Augustus; 9) Forum of Julius Caesar;
10) Senate Chamber; 11) Temple of Concord; 12) Roman Forum;
13) Sacred Way; 14) Basilica Julia; 15) Temple of Castor and Pollux;
16) Arch of Augustus; 17) Temple of Vesta;
18) Temple of Julius Caesar; 19) Basilica Aemilia;
20) Temple of Antoninus and Faustina; 21) House of the Vestal Virgins;
22) Temple of Romulus; 23) Basilica of Maxentius and Constantine;
24) Forum of Vespasian; 25) Temple of Minerva;
26) Forum of Nerva

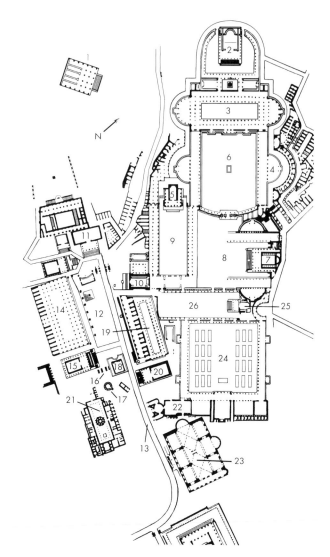

An entire hillside, comparable to the Acropolis of Athens in its commanding position, has been transformed and articulated so that the architectural forms seem to grow out of the rock, as if human beings had simply completed a design laid out by nature itself. Such a molding of great open spaces had never been possible, or even desired, in the Classical Greek world. The only comparable projects are found in Egypt (see the Temple of Queen Hatshepsut, figs. 72 and 73). Nor did it express the spirit of the Roman Republic. Significantly enough, the Palestrina sanctuary dates from the time of Sulla, whose absolute dictatorship (82–79 B.C.) marked the transition from Republican government to the one-man rule of Julius Caesar and his Imperial successors. Since Sulla had won a great victory against his enemies in the civil war at Palestrina, it is tempting to assume that he personally ordered the sanctuary built, both as an offering to Fortuna and as a monument to his own fame.

243. *(below)* Pont du Gard, Nîmes, France. Early 1st century A.D.

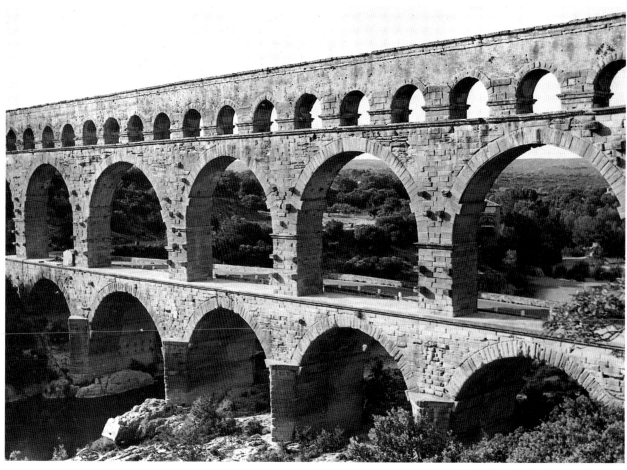

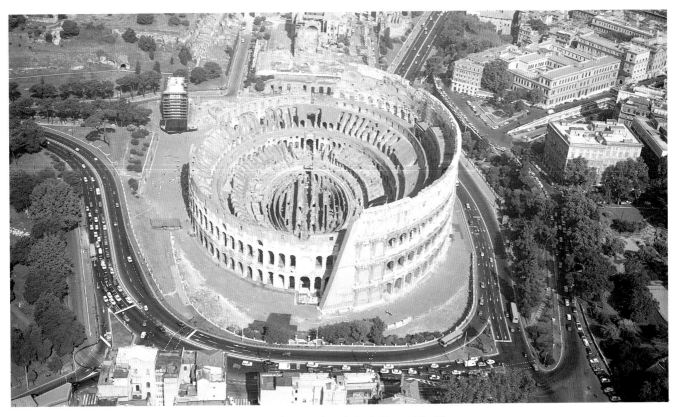

244. The Colosseum (aerial view), Rome. 72–80 A.D.

FORUMS. Perhaps inspired by the Palestrina complex, Julius Caesar, near the end of his life, sponsored a project planned on a similar scale in Rome itself: the Forum Julium, a great architecturally framed square adjoining the Temple of Venus Genetrix, the mythical ancestress of Caesar's family. Here the merging of religious cult and personal glory is even more overt. The Forum of Caesar set the pattern for all the later Imperial forums, which were linked to it by a common major axis, forming the most magnificent architectural sight of the Roman world (fig. 242). Unfortunately, nothing is left of the forums today but a field of ruins that conveys little of their original splendor.

Secular Architecture

The arch and vault, which we encountered at Palestrina as an essential part of Roman monumental architecture, also formed the basis of construction projects such as sewers, bridges, and aqueducts, designed for efficiency rather than beauty. The first enterprises of this kind were built to serve the city of Rome as early as the end of the fourth century B.C., but only traces of them survive today. There are, however, numerous others of later date throughout the empire, such as the exceptionally well-preserved aqueduct at Nîmes in southern France known as the Pont du Gard (fig. 243). Its rugged, clean lines that span the wide valley are a tribute not only to the high caliber of Roman engineering but also to the sense of order and permanence that inspired these efforts. It is these qualities, one may argue, that underlie all Roman architecture and define its unique character.

COLOSSEUM. They impress us again in the Colosseum, the enormous amphitheater for gladiatorial games in the center of Rome (figs. 244 and 245). Completed in 80 A.D., it is,

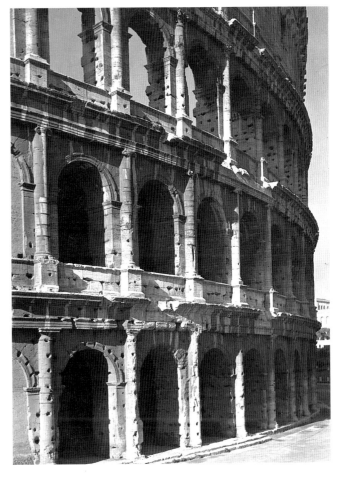

245. View of the outer wall of the Colosseum

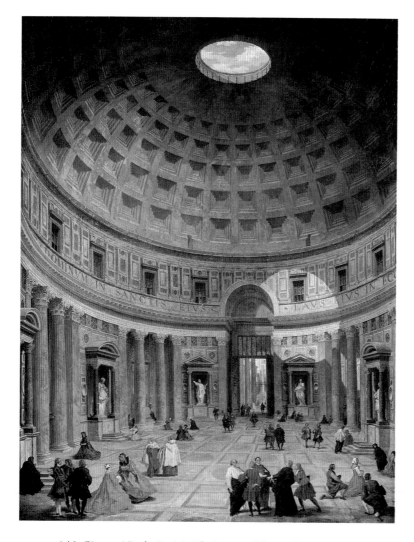

246. Giovanni Paolo Panini. *The Interior of the Pantheon.* c. 1740.
Oil on canvas, 50 1/2 x 39" (128.3 x 99.1 cm).
National Gallery of Art, Washington, D.C. Samuel H. Kress Collection

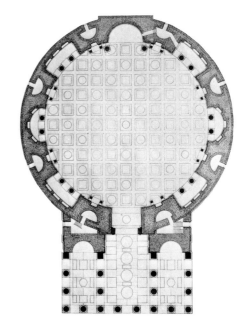

247. Plan of the Pantheon

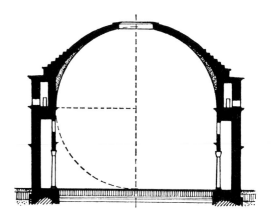

248. Transverse section of the Pantheon

in terms of sheer mass, one of the largest single buildings any-where; when intact, it accommodated more than 50,000 spec-tators. The concrete core, with its miles of stairways and barrel- and groin-vaulted corridors, is an outstanding feat of engineering efficiency devised to ensure the smooth flow of traffic to and from the arena. It utilizes both the familiar barrel vault and a more complex form, the groin vault (see fig. 235). The exterior, dignified and monumental, reflects the interior articulation of the structure but clothes and accen-tuates it in cut stone. There is a fine balance between vertical and horizontal elements in the framework of engaged columns and entablatures that contains the endless series of arches. The three Classical orders are superimposed according to their intrinsic "weight": Doric, the oldest and most severe, on the ground floor, followed by Ionic and Corinthian. The lighten-ing of the proportions, however, is barely noticeable, for the orders in their Roman adaptation are almost alike. Struc-turally, they have become ghosts; yet their aesthetic function continues unimpaired. It is through them that this enormous facade becomes related to the human scale.

Interiors

Arches, vaults, and concrete permitted the Romans to create huge uninterrupted interior spaces for the first time in the his-tory of architecture. These were explored especially in the great baths, or thermae, which had become important centers of social life in Imperial Rome. The experience gained there could then be applied to other, more traditional types of build-ings, sometimes with revolutionary results.

PANTHEON. Perhaps the most striking example of this process is the famous Pantheon in Rome, a very large round temple of the early second century A.D. whose interior is the best preserved, as well as the most impressive, of any surviving Roman structure (figs. 246–49). There had been round tem-ples long before this time, but their shape, as represented by the "Temple of the Sibyl" (see figs. 238 and 239), is so differ-ent from that of the Pantheon that the latter could not possi-bly have been derived from them. On the outside, the cella of the Pantheon appears as an unadorned cylindrical drum, sur-mounted by a gently curved dome. The entrance is empha-sized by a deep porch of the kind familiar to us from standard

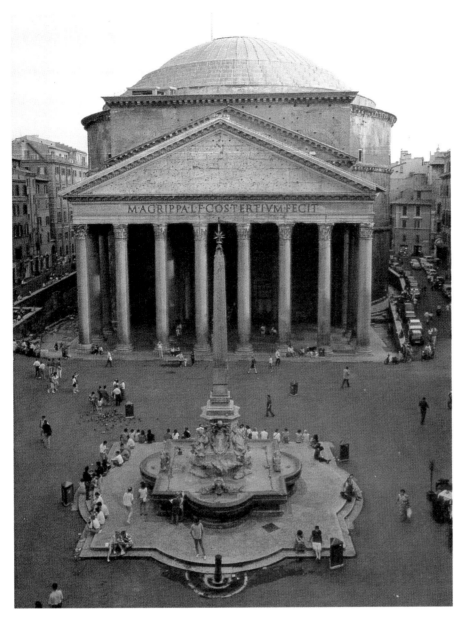

249. The Pantheon, Rome. 118–25 A.D.

Roman temples such as "Fortuna Virilis" (figs. 236 and 237).

The junction of these two elements seems rather abrupt, but we must remember that we no longer see the building raised high on a podium as it was meant to be seen. Today the level of the surrounding streets is a good deal higher than it was in antiquity, so that the steps leading up to the porch are now submerged. Moreover, the porch was designed to form part of a rectangular, colonnaded forecourt, which must have had the effect of detaching it from the rotunda. So far as the cella is concerned, therefore, the architect apparently discounted the effect of the exterior, putting all the emphasis on the great domed space that opens before us with dramatic suddenness as we step through the entrance.

That the architects did not have an easy time with the engineering problems of supporting the huge dome may be deduced from the heavy plainness of the exterior wall. Nothing on the outside, however, gives any hint of the interior. Indeed, its airiness and elegance are utterly different from what the rather forbidding exterior would lead us to expect. The impact of the interior, awe-inspiring and harmonious at the same time, is impossible to convey in photographs. Even the painting (fig. 246) that we use to illustrate it fails to do it justice.

The dome is a true hemisphere of ingenious design. The interlocking ribs form a structural cage that permits the use of relatively lightweight coffers arranged in five rings. The circular opening in its center (called the oculus, or eye) admits an ample and wonderfully even flow of light. The height from the floor to the eye is 143 feet, which is also the diameter of the dome's base and the interior (fig. 248). Dome and drum are likewise of equal heights, so that all the proportions are in exact balance. On the exterior, this balance could not be achieved, for the outward thrust of the dome had to be contained by making its base considerably heavier than the top. (The thickness of the dome increases downward from 6 feet to 20 feet.) The weight of the dome does not rest uniformly on the drum but is concentrated on the eight wide "pillars" (see fig. 247). Between them, niches are daringly hollowed out of the massive concrete, and although they are closed in back,

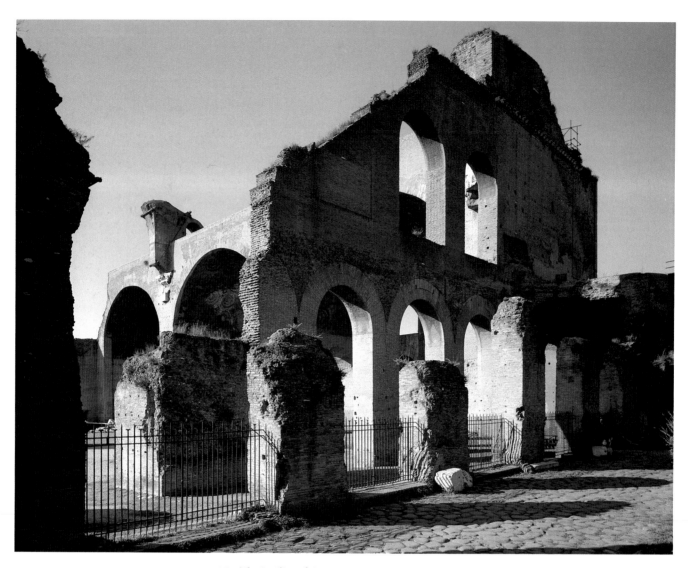

250. The Basilica of Constantine, Rome. c. 307–20 A.D.

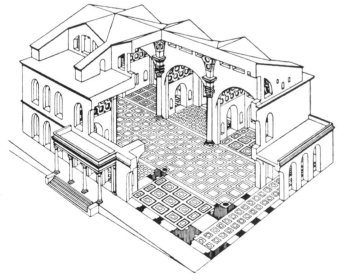

251. Reconstruction drawing of the Basilica of Constantine
(after Huelsen)

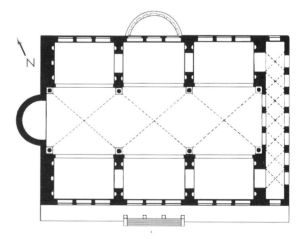

252. Plan of the Basilica of Constantine

the screen of columns gives them the effect of openings that lead to adjoining rooms. This sense of open space behind the supports helps to prevent us from feeling imprisoned inside the Pantheon and makes us feel that the walls are less thick and the dome much lighter than is actually the case. The columns, the colored marble paneling of the wall surfaces, and the floor remain essentially as they were in Roman times. Originally, however, the recessed coffers were gilded to make the dome resemble "the golden Dome of Heaven."

As its name suggests, the Pantheon was dedicated to all the gods or, more precisely, to the seven planetary gods. (There are seven niches.) It seems reasonable, therefore, to assume that

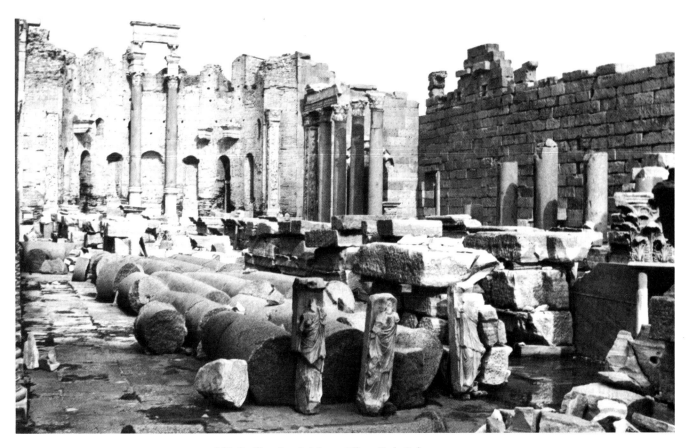

253. Basilica, Leptis Magna, Libya. Early 3rd century A.D.

the golden dome had a symbolic meaning, that it represented the Dome of Heaven. Yet this solemn and splendid structure grew from rather humble antecedents. The Roman architect Vitruvius, writing more than a century earlier, describes the domed steam chamber of a bathing establishment that anticipates (undoubtedly on a very much smaller scale) the essential features of the Pantheon: a hemispherical dome, a proportional relationship of height and width, and the circular opening in the center (which could be closed by a bronze shutter on chains to adjust the temperature of the steam room).

BASILICAS. The Basilica of Constantine, from the early fourth century A.D., is an even more direct example of how thermae were transformed in new applications. Unlike other basilicas, which we will discuss below, the Basilica of Constantine (it was actually begun by his predecessor, Maxentius) derives its shape from the main hall of the public baths built by two earlier emperors, Caracalla and Diocletian, but it is constructed on an even grander scale. It must have been the largest roofed interior in all of Rome. Today only the north aisle, consisting of three huge barrel-vaulted compartments, is still standing (fig. 250). The center tract, or nave, covered by three groin vaults (figs. 251 and 252), rose a good deal higher. Since a groin vault resembles a canopy, with all the weight and thrust concentrated at the four corners (see fig. 235), the upper walls of the nave could be pierced by large windows (called the clerestory), so that the interior of the basilica must have had a light and airy quality despite its enormous size. We meet its echoes in many later buildings, from churches to railway stations. The Basilica of Constantine was entered through

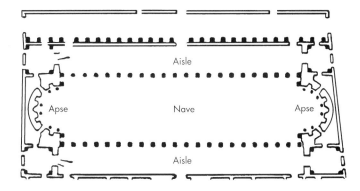

254. Plan of the Basilica, Leptis Magna

the entrance hall, or narthex, at the east end and terminated in a semicircular niche, called an apse, where the colossal statue of Constantine was found (see fig. 283). Perhaps to accommodate his cult statue, Constantine modified the building by adding a second entrance to the south and a second apse opposite it where he could sit as emperor.

Basilicas, long halls serving a variety of civic purposes, had first been developed in Hellenistic Greece. Under the Romans, they became a standard feature of every major town, where one of their chief functions was to provide a dignified setting for the courts of law that dispensed justice in the name of the emperor. [See Primary Sources, no. 9, page 215.] Rome itself had a number of basilicas, but very little remains of them today. Those in the provinces have fared somewhat better. The outstanding one at Leptis Magna in North Africa (figs. 253 and 254) has most of the characteristics of the standard type.

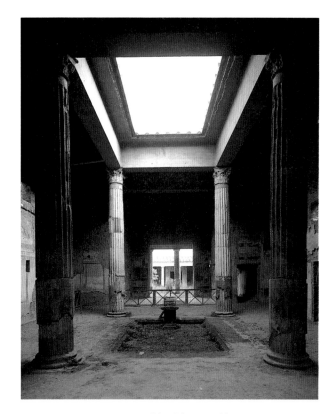

255. Atrium, House of the Silver Wedding, Pompeii.
Early 1st century A.D.

256. Insula of the House of Diana, Ostia. c. 150 A.D.

The long nave terminates in a semicircular apse at either end. Its walls rest on colonnades to provide access to the side aisles, which are lower than the nave to permit clerestory windows in the upper part of the nave wall.

These basilicas had wooden ceilings instead of masonry vaults, for reasons of convenience and tradition rather than technical necessity. They were thus subject to destruction by fire. The one at Leptis Magna, sadly ruined though it is, counts among the best-preserved examples. The Basilica of Constantine in Rome was a daring attempt to create a novel, vaulted type, but the design seems to have met with little public favor, as it had no direct successors. Perhaps people felt that it lacked dignity because of its obvious resemblance to the public baths. Whatever the reason, the Christian basilicas of the fourth century were modeled on the older, wooden-roofed type (see fig. 299). Not until 700 years later did vaulted basilican churches become common in western Europe.

Domestic Architecture

One of the delights in studying Roman architecture is that it includes not only great public edifices but also a wide variety of residential dwellings, from Imperial palaces to the quarters of the urban poor. If we disregard the extremes of this scale, we are left with two basic types that account for most of the domestic architecture that has survived. The *domus* is a single-family house based on ancient Italic tradition. Its distinctive feature is the atrium, a square or oblong central hall lit by an opening in the roof, around which the other rooms are grouped. In Etruscan times, it had been a rural dwelling, but the Romans "citified" and elaborated it into the typical home of the well-to-do.

Many examples of the domus in various stages of development have come to light at Herculaneum and Pompeii, the two towns that were buried under volcanic ash during an eruption of Mount Vesuvius in 79 A.D. As we enter the so-called House of the Silver Wedding at Pompeii, we see the view in figure 255, taken from the vestibule, along the main axis of the domus. Here the atrium has become a room of impressive size. The four Corinthian columns at the corners of the opening in the roof give it the quality of an enclosed court. There is a shallow basin in the center to catch the rainwater (the roof slants inward). The atrium was the traditional place for keeping portrait images of the ancestors of the family. At its far end, to the right, we see a recess for keeping family records (the *tablinum*) and beyond it the garden, surrounded by a colonnade (the peristyle). In addition to the chambers grouped around the atrium, there may be further rooms attached to the back of the house. The entire establishment is shut off from the street by windowless walls. Obviously, privacy and self-sufficiency were important to the wealthy Roman. [See Primary Sources, no. 10, page 215.]

Less elegant than the domus, and decidedly urban from the very start, is the *insula,* or city block, which we find mainly in Rome itself and in Ostia, the ancient port of Rome near the mouth of the Tiber. The insula anticipates many features of the modern apartment house. It is a good-sized concrete-and-brick building (or a chain of such buildings) around a small central court, with shops and taverns open to the street on the ground floor and living quarters for numerous families above. Some insulae had as many as five stories, with balconies above the second floor (fig. 256). The daily life of the artisans and shopkeepers who inhabited such an insula was oriented toward the street, as it still is to a large extent in modern Italy. The privacy of the domus was reserved for the minority who could afford it.

Late Roman Architecture

In discussing the new forms based on arched, vaulted, and domed construction, we have noted the continued allegiance to the Classical Greek orders. If they no longer relied on them in the structural sense, Roman architects remained faithful to their spirit by acknowledging the aesthetic authority of the post-and-lintel system as an organizing and articulating principle. Column, architrave, and pediment might be merely superimposed on a vaulted brick-and-concrete core, but their shape, as well as their relationship to each other, was still determined by the original grammar of the orders.

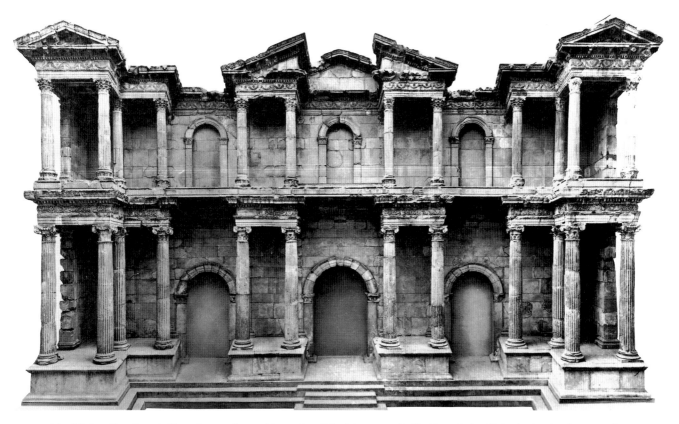

257. Market Gate from Miletus (restored). c. 160 A.D. Staatliche Museen zu Berlin, Preussischer Kulturbesitz, Antikensammlung

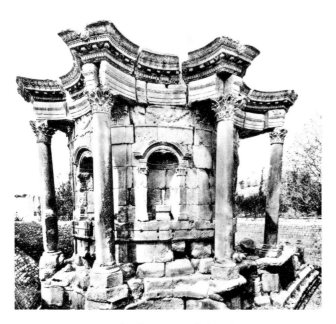

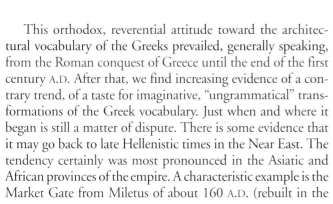

258. Temple of Venus, Baalbek, Lebanon.
First half of the 3rd century A.D.

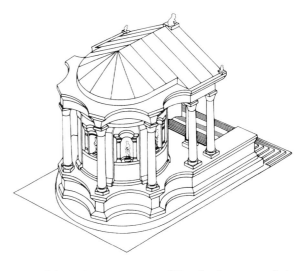

259. Schematic reconstruction of Temple of Venus, Baalbek

This orthodox, reverential attitude toward the architectural vocabulary of the Greeks prevailed, generally speaking, from the Roman conquest of Greece until the end of the first century A.D. After that, we find increasing evidence of a contrary trend, of a taste for imaginative, "ungrammatical" transformations of the Greek vocabulary. Just when and where it began is still a matter of dispute. There is some evidence that it may go back to late Hellenistic times in the Near East. The tendency certainly was most pronounced in the Asiatic and African provinces of the empire. A characteristic example is the Market Gate from Miletus of about 160 A.D. (rebuilt in the

state museums in Berlin; fig. 257). One might refer to it as display architecture in terms both of its effect and of its ancestry, for the picturesque facade, with its alternating recesses and projections, derives from the architectural stage backgrounds of the Roman theater. The continuous in-and-out rhythm has even seized the pediment above the central doorway, breaking it into three parts.

Equally astonishing is the small Temple of Venus at Baalbek, probably built in the early second century A.D. and refurbished in the third (figs. 258 and 259). The convex curve of the cella is effectively counterbalanced by the concave niches

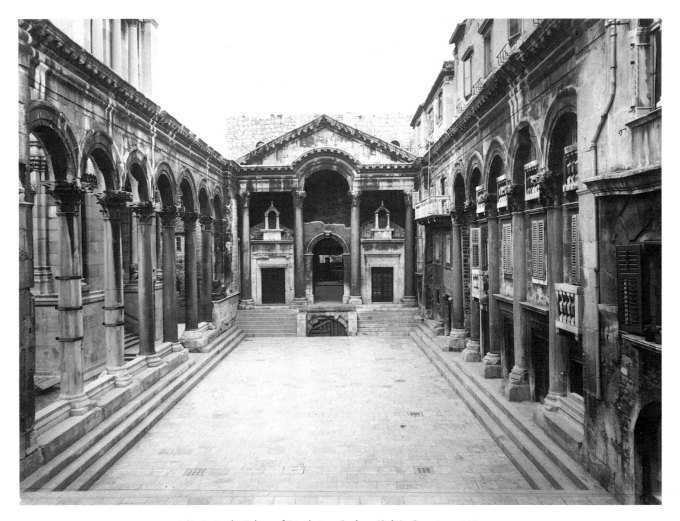

260. Peristyle, Palace of Diocletian, Spalato (Split), Croatia. c. 300 A.D.

and the scooped-out base and entablature, introducing a new play of forces into the conventional ingredients of the round temple (compare figs. 238 and 239).

By the late third century, unorthodox ideas such as these had become so well established that the traditional grammar of the Greek orders was in process of dissolution everywhere. At the end of the peristyle in the Palace of Diocletian (fig. 260) at Spalato (Split), the architrave between the two center columns is curved to create a novel effect by echoing the arch of the doorway below. On either side we see an even more revolutionary device: a series of arches resting directly on columns. A few isolated instances of such an arcade can be found earlier, but it was only now, on the eve of the victory of Christianity, that the marriage of arch and column became fully legitimate. The union, indispensable to the future development of architecture, seems so natural to us that we can hardly understand why it was ever opposed.

SCULPTURE

The dispute over the question "Is there such a thing as a Roman style?" has centered largely on the field of sculpture, and for quite understandable reasons. Even if we discount the wholesale importing and copying of Greek originals, the reputation of the Romans as imitators seems borne out by large quantities of works that are probably adaptations and variants of Greek models of every period. While the Roman demand for sculpture was tremendous, much of it may be attributed to a taste for antiquities, both the learned and the fashionable variety, and to a taste for sumptuous interior decoration. There are thus whole categories of sculpture produced under Roman auspices that deserve to be classified as "deactivated" echoes of Greek creations, emptied of their former meaning and reduced to the status of highly refined works of craftsmanship. At times this attitude extended to Egyptian sculpture as well, creating a vogue for pseudo-Egyptian statuary. On the other hand, there can be no doubt that some kinds of sculpture had serious and important functions in ancient Rome. They represent the living sculptural tradition, in contradistinction to the antiquarian-decorative trend. We shall concern ourselves here mainly with those aspects of Roman sculpture that are most conspicuously rooted in Roman society: portraiture and narrative relief.

Republican

We know from literary accounts that from early Republican times on, meritorious political or military leaders were honored by having their statues put on public display. The habit was to continue until the end of the empire a thousand years later. Its beginnings may well have derived from the Greek custom of placing votive statues of athletic victors and other

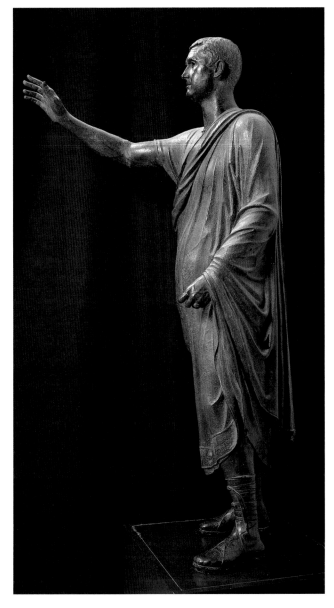

261. *Aulus Metellus (L'Arringatore)*. Early 1st century B.C. Bronze, height 71" (280 cm). Museo Archeologico Nazionale, Florence

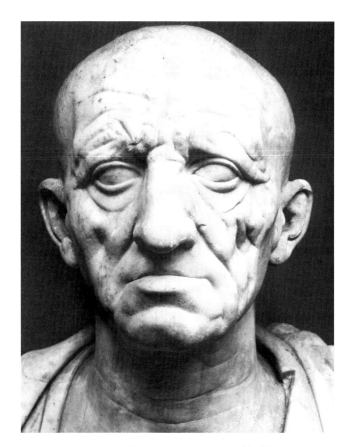

262. *Portrait of a Roman*. c. 80 B.C. Marble, lifesize. Palazzo Torlonia, Rome

important individuals in the precincts of such sanctuaries as Delphi and Olympia (see fig. 186). Unfortunately, the first 400 years of this Roman tradition are a closed book to us. Not a single Roman portrait has yet come to light that can be dated before the first century B.C. with any degree of confidence. How were those early statues related to Etruscan or Greek sculpture? Did they ever achieve any specifically Roman qualities? Were they individual likenesses in any sense, or were their subjects identified only by pose, costume, attributes, and inscriptions?

L'ARRINGATORE. Our sole clue in answer to these questions is the lifesize bronze statue of an orator called *L'Arringatore* (fig. 261), once assigned to the second century B.C. but now generally placed in the early years of the first. It comes from southern Etruscan territory and bears an Etruscan inscription that includes the name Aule Metele (Aulus Metellus in Latin), presumably the name of the official represented. He must have been a Roman, or at least a Roman-appointed

official. The workmanship is evidently Etruscan, as indicated by the inscription. But the gesture, which denotes both address and salutation, recurs in hundreds of Roman statues of the same sort. The costume, an early kind of toga, is Roman as well. One suspects, therefore, that our sculptor tried to conform to an established Roman type of portrait statue, not only in these externals but in style as well. We find very little here of the Hellenistic flavor characteristic of the later Etruscan tradition. What makes the figure remarkable is its serious, prosaically factual quality, down to the neatly tied shoelaces. The term "uninspired" suggests itself, not as a criticism but as a way to describe the basic attitude of the artist in contrast to the attitude of Greek or Etruscan portraitists.

PORTRAITS. That seriousness was consciously intended as a positive value becomes clear when we familiarize ourselves with Roman portrait heads of the years around 75 B.C., which show it in its most pronounced form. Apparently the creation of a monumental, unmistakably Roman portrait style was achieved only in the time of Sulla, when Roman architecture, too, came of age (see pages 179–80). We see it at its most impressive perhaps in the features of the unknown Roman of figure 262, contemporary with the fine Hellenistic portrait from Delos in figure 216. A more telling contrast could hardly be imagined. Both are extremely persuasive likenesses, yet they seem worlds apart. Whereas the Hellenistic head impresses us with its subtle grasp of the sitter's psychology, the Roman may strike us at first glance as nothing but a detailed record of facial topography. The sitter's character emerges only incidentally, as it were. Yet this is not really the case. The wrinkles are true to life, no

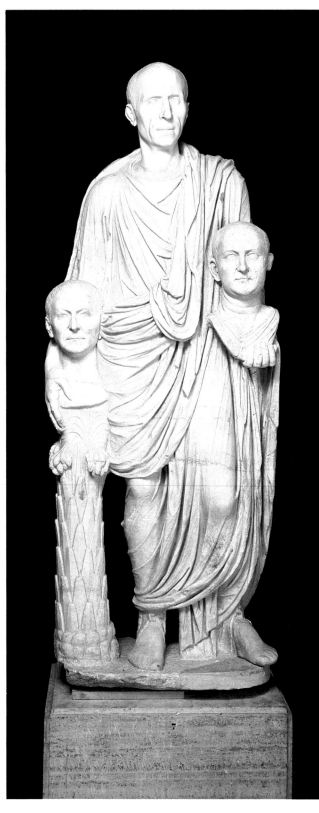

263. *A Roman Patrician with Busts of His Ancestors.*
Late 1st century B.C. Marble, lifesize. Museo Capitolino, Rome

Its peculiar flavor reflects a patriarchal Roman custom of considerable antiquity. [See Primary Sources, no. 17, pages 218–19.] At the death of the head of the family, a waxen image was made of his face, which was then preserved in a special shrine, or family altar. At funerals, these ancestral images were carried in the procession. The patrician families of Rome clung to this custom well into Imperial times. The images were, of course, records rather than works of art, and because of the perishability of wax they probably did not last more than a few decades. Thus the desire to have them duplicated in marble seems natural enough, but the demand did not arise until the early first century B.C. Perhaps the patricians, feeling their leadership endangered, wanted to make a greater public display of their ancestors, as a way of emphasizing their ancient lineage.

Such display certainly is the purpose of the statue in figure 263, carved about half a century later than our previous example. It shows an unknown man holding two busts of his ancestors, presumably his father and grandfather. The work has little distinction, though the somber face of our dutiful Roman is strangely affecting. Yet the "father-image" spirit can be felt even here. Needless to say, this quality was not present in the wax images themselves. It came to the fore when they were translated into marble, a process that not only made the ancestral images permanent but monumentalized them in the spiritual sense as well. Nevertheless, the marble heads retained the character of records, of visual documents, which means that they could be freely duplicated. What mattered was only the facial "text," not the "handwriting" of the artist who recorded it. The impressive head in figure 262 is itself a copy, made some 50 years later than the lost original, and so are the two ancestors in figure 263. (Differences in style and in the shape of the bust indicate that the original of the head on the left in fig. 263 is about 30 years older than that of its companion.) Perhaps this Roman lack of feeling for the uniqueness of the original, understandable enough in the context of their ancestor cult, also helps to explain why they developed so voracious an appetite for copies of famous Greek statues.

Imperial

PORTRAITS. As we approach the reign of the emperor Augustus (27 B.C.–14 A.D.), we find a new trend in Roman portraiture that reaches its climax in the images of Augustus himself. In his splendid statue from Primaporta (fig. 264), we may be uncertain at first glance whether it represents a god or a human being. This doubt is entirely appropriate, for the figure is meant to be both. Here, on Roman soil, we meet a concept familiar to us from Egypt and the ancient Near East: the divine ruler. It had entered the Greek world in the fourth century B.C. (see fig. 204). Alexander the Great then made it his own, as did his successors, who modeled themselves after him. The latter, in turn, transmitted it to Julius Caesar and the Roman emperors, who at first encouraged the worship of themselves only in the eastern provinces, where belief in a divine ruler was a long-established tradition.

The idea of attributing superhuman stature to the emperor, thereby enhancing his authority, soon became official policy, and while Augustus did not carry it as far as later emperors, the

doubt, but the carver has nevertheless treated them with a selective emphasis designed to bring out a specifically Roman personality—stern, rugged, iron-willed in its devotion to duty. It is a "father image" of frightening authority, and the minutely observed facial details are like individual biographical data that differentiate this father image from others.

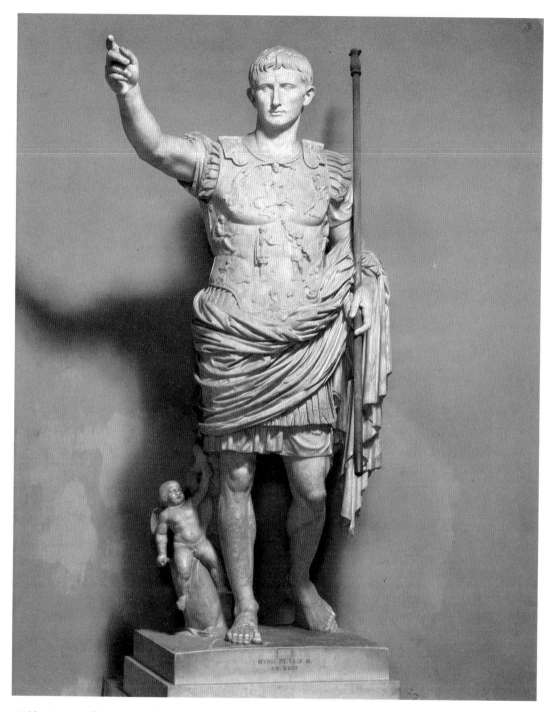

264. *Augustus of Primaporta.* Roman copy c. 20 A.D. of a Roman original of c. 15 B.C. Marble, height 6'8" (2 m). Musei Vaticani, Braccio Nuovo, Rome

Primaporta statue clearly shows him enveloped in an air of divinity. (He also was the chief priest of the state religion.) The heroic, idealized body is obviously derived from the *Doryphorus* of Polyclitus (fig. 183), while the Cupid at his feet suggests the infant Bacchus in Praxiteles' *Hermes* (fig. 207). However, the statue has an unmistakably Roman flavor. The emperor's gesture is familiar from *Aulus Metellus* (fig. 261). The head is idealized, or, better perhaps, "Hellenized." Small physiognomic details are suppressed, and the focusing of attention on the eyes gives it something of the "inspired" look we find in portraits of Alexander the Great (compare fig. 221). Nevertheless, the face is a definite likeness, elevated but clearly individual, as we know by comparison with the numerous other portraits of Augustus. All Romans would have recognized it immediately, for they knew it from coins and countless other representations. In fact, the emperor's image soon came to acquire the symbolic significance of a national flag.

Although it was found in the villa of Augustus' wife, Livia, the Primaporta statue is probably a later copy of a lost original: the bare feet indicate that he has been deified, so that the sculpture was made after his death. Myth and reality are compounded to glorify the emperor. The little Cupid on a dolphin serves both to support the heavy marble figure and as a reminder of the claim that the Julian family was descended from Venus; he has also been seen as a representation of Gaius Caesar, Augustus' nephew. The costume has a concreteness of

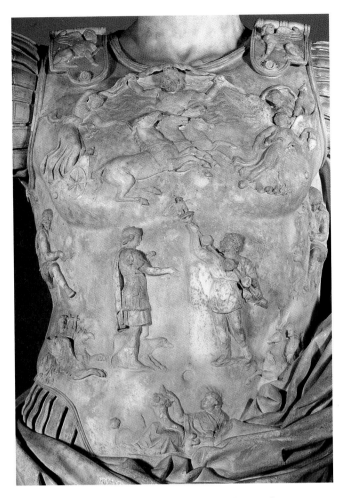

265. *Augustus of Primaporta.* Detail of breastplate

266. Ara Pacis. c. 13–9 B.C. Marble, width of altar approx. 35'
(10.7 m). Museum of the Ara Pacis, Rome

surface texture that conveys the actual touch of cloth, metal, and leather. The breastplate (fig. 265) illustrates Augustus' victory over the Parthians in 39–38 B.C., which avenged a Roman defeat at their hands nearly 15 years earlier.

Characteristically enough, however, the event is shown as an allegory: the presence of gods and goddesses raises it to cosmic significance, while the rich symbolic program proclaims that this triumph, which Augustus regarded as pivotal, inaugurated an era of peace and plenty. Representing their respective armies, a Parthian returns the captured military standard to a Roman. Are they merely personifications, as seems likely, or historical figures—Phraates IV and either Augustus himself or his stepson and successor Tiberius, who, according to Suetonius, was his intermediary? The issue may never be resolved.

NARRATIVE RELIEF. Imperial art, however, was not confined to portraiture. The emperors also commemorated their outstanding achievements in narrative reliefs on monumental altars, triumphal arches, and columns. Similar scenes are familiar to us from the ancient Near East (see figs. 95, 102, and 112) but not from Greece. Historical events—that is, events which occurred only once, at a specific time and in a particular place—had not been dealt with in Classical Greek sculpture. If a victory over the Persians was to be commemorated, it would be represented indirectly as a mythical event outside any space-time context: a combat of Lapiths and Centaurs or Greeks and Amazons (see figs. 195 and 203). Even in Hellenistic times, this attitude persisted, although not quite as

absolutely. When the kings of Pergamum celebrated their victories over the Celts, the latter were represented faithfully (see fig. 210) but in typical poses of defeat rather than in the framework of a particular battle.

Greek painters, on the other hand, had depicted historical subjects such as the Battle of Salamis as early as the mid-fifth century, although we do not know how specific these pictures were in detail. As we have seen, the mosaic from Pompeii showing the Battle of Issus (fig. 199) probably reflects a famous Hellenistic painting of about 315 B.C. depicting the defeat of the Persian king Darius by Alexander the Great. In Rome, too, historic events had been depicted from the third century B.C. on. A victorious military leader would have his exploits painted on panels that were carried in his triumphal procession, or he would show such panels in public places. These pictures seem to have had the fleeting nature of posters advertising the hero's achievements. None has survived. Sometime during the late years of the Republic, the temporary representations of such events began to assume more monumental and permanent form. They were no longer painted, but carved and attached to structures intended to last indefinitely. They were thus a ready tool for the glorification of Imperial rule, and the emperors did not hesitate to use them on a large scale.

ARA PACIS. Since the leitmotif of his reign was peace, Augustus preferred to appear in his monuments as the "Prince of Peace" rather than as the all-conquering military hero. The most important of these monuments was the Ara Pacis (Altar of Peace), voted by the Roman Senate in 13 B.C. and completed four years later. It is probably identical with the richly carved Augustan altar that bears this name today. The entire structure (fig. 266) recalls the Pergamum Altar, though on a much smaller scale (compare figs. 211 and 213). On the wall that screens the altar proper, a monumental frieze depicts allegorical and legendary scenes, as well as a solemn procession led by the emperor himself.

Here the "Hellenic," classicizing style we noted in the *Augustus of Primaporta* reaches its fullest expression. Nevertheless, a comparison of the Ara Pacis frieze (fig. 267) with that of the Parthenon (figs. 170 and 268) shows how different they

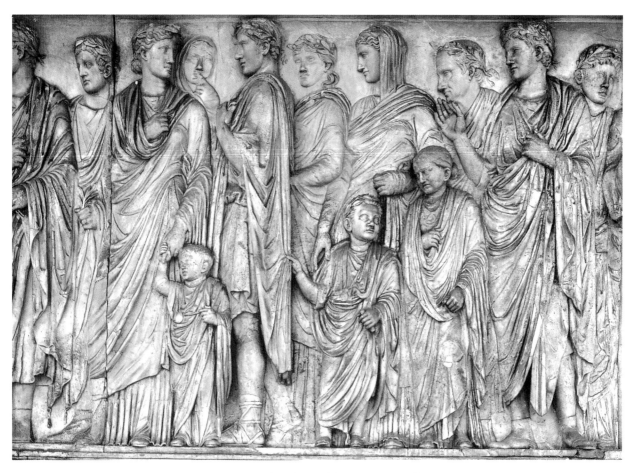

267. *Imperial Procession,* a portion of the frieze of the Ara Pacis. Marble, height 63" (160 cm)

268. *Procession,* a portion of the east frieze, Parthenon. c. 440 B.C.
Marble, height 43" (109.3 cm). Musée du Louvre, Paris

really are, despite all surface similarities. The Parthenon frieze belongs to an ideal, timeless world. It represents a procession that took place in the remote, mythic past, beyond living memory. What holds it together is the great formal rhythm of the ritual itself, not its variable particulars. On the Ara Pacis, in contrast, we see a procession in celebration of one particular recent event—probably the founding of the altar in 13 B.C.—idealized to evoke something of the solemn air that surrounds the Parthenon procession, yet filled with concrete details of a remembered event. The participants, at least so far as they belong to the Imperial family, are meant to be identifiable as portraits, including those of children dressed in

miniature togas but who are too young to grasp the significance of the occasion. (Note how the little boy in the center of our group is tugging at the mantle of the young man in front of him while the somewhat older child to his left smilingly seems to be telling him to behave.) The Roman artist also shows a greater concern with spatial depth than his Classical Greek predecessor. The softening of the relief background, which we first observed in the much earlier *Grave Stele of Hegeso* (see fig. 197), has been carried so far that the figures farthest removed from us seem partly immersed in the stone, such as the woman on the left whose face emerges behind the shoulder of the young mother in front of her.

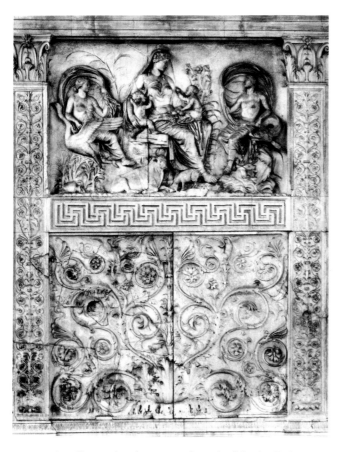

269. Allegorical and ornamental panels of the Ara Pacis

270. Stucco decoration from the vault of a Roman house. Late 1st century B.C. Museo delle Terme, Rome

The same interest in space appears even more strongly in the allegorical panel in figure 269, showing Mother Earth flanked by two personifications of winds. The embodiment of human, animal, and plant fertility, she also serves as a symbol of Augustus' reign that reflected a time of peace and plenty. Here the figures are placed in a real landscape setting of rocks, water, and vegetation, and the blank background clearly stands for the empty sky. Whether this pictorial treatment of space is a Hellenistic or Roman invention remains a matter of dispute. There can be no question, however, about the Hellenistic look of the three personifications, which represent not only a different level of reality but also a different, and less distinctly Roman, style from the Imperial procession. The acanthus ornament on the pilasters and the lower part of the wall, on the other hand, has no counterpart in Greek art, although the acanthus motif as such derives from Greece. The plant forms are wonderfully graceful and alive. Yet the design as a whole, with its emphasis on bilateral symmetry, never violates the discipline of surface decoration and thus serves as an effective foil for the spatially conceived reliefs above.

STUCCO DECORATION. Much the same contrast of flatness and depth occurs in the stucco decoration of a Roman house, a casual but enchanting product of the Augustan era

(fig. 270). The modeling, as suits the light material, is delicate and sketchy throughout, but the content varies a great deal. On the bottom strip of our illustration are two winged genii with plant ornament. Here depth is carefully avoided, since this zone belongs to the framework. Above it, we see what can only be described as a "picture painted in relief," an idyllic landscape of great charm and full of atmospheric depth, despite the fact that its space is merely suggested rather than clearly defined. The whole effect echoes that of painted room decorations (see fig. 290).

ARCH OF TITUS. The spatial qualities of the Ara Pacis reliefs reached their most complete development in the two large narrative panels on the triumphal arch erected in 81 A.D. to commemorate the victories of the emperor Titus. One of them (fig. 271) shows part of the triumphal procession celebrating the conquest of Jerusalem. The booty displayed includes the seven-branched menorah, or candlestick, and other sacred objects. The movement of a crowd of figures in depth is conveyed with striking success, despite the mutilated surface. On the right, the procession turns away from us and disappears through a triumphal arch placed obliquely to the background plane so that only the nearer half actually emerges from the background—a radical but effective compositional device.

271. *Spoils from the Temple in Jerusalem.* Relief in passageway, Arch of Titus, Rome. 81 A.D. Marble, height 7'10" (2.4 m)

272. *Triumph of Titus.* Relief in passageway, Arch of Titus

The companion panel (fig. 272) avoids such experiments, although the number of layers of relief is equally great here. We also sense that its design has an oddly static quality, despite the fact that this is simply another part of the same procession. The difference must be due to the subject, which shows the emperor himself in his chariot, crowned by the winged Victory behind him. Apparently the sculptor's first concern was to dis-play this set image, rather than to keep the procession moving. Once we try to read the Imperial chariot and the surrounding figures in terms of real space, we become aware of how strangely contradictory the spatial relationships are. Four horses, shown in strict profile view, move in a direction parallel to the bottom edge of the panel, but the chariot is not where it ought to be if they were really pulling it. Moreover, the bodies of the

273. Lower portion of the Column of Trajan, Rome. 106–13 A.D.
Marble, height of relief band approx. 50" (127 cm)

emperor and of most of the other figures are represented in frontal view, rather than in profile. These seem to be fixed conventions for representing the triumphant emperor which our artist felt constrained to respect, though they were in conflict with the desire to create the kind of consistent movement in space achieved so well in figure 271.

COLUMN OF TRAJAN. Just how incompatible the purposes of Imperial art, narrative or symbolic, could sometimes be with a realistic treatment of space becomes fully evident in the Column of Trajan, which was erected between 106 and 113 A.D. to celebrate that emperor's victorious campaigns against the Dacians (the ancient inhabitants of Romania). Single, free-standing columns had been used as commemorative monuments from Hellenistic times on; their ultimate source may have been the obelisks of Egypt. The Column of Trajan is distinguished not only by its great height (125 feet, including the base) but by the continuous spiral band of relief covering its surface (fig. 273) and recounting, in epic breadth, the history of the Dacian wars. The column was crowned by a statue of the emperor (destroyed in the Middle Ages), and the base served as a burial chamber for his ashes. If we could unwind the relief band, it would be 656 feet long, two-thirds the combined length of the three friezes of the Mausoleum at Halicarnassus and a good deal longer than the Parthenon frieze. In terms of the number of figures and the density of the narrative, however, our relief is by far the most ambitious frieze composition attempted up to that time. It is also the most frus-

trating, for viewers must "run around in circles like a circus horse" (to borrow the apt description of one scholar) if they want to follow the narrative, and can hardly see the wealth of detail above the fourth or fifth turn without binoculars.

One wonders for whose benefit this elaborate pictorial account was intended. In Roman times, the monument formed the center of a small court flanked by public buildings at least two stories tall, but even that does not quite answer our question. Nor does it explain the evident success of our column, which served as the model for several others of the same type. But let us take a closer look at the scenes visible in our figure 273. In the center of the bottom strip, we see the upper part of a large river-god representing the Danube. To the left are some riverboats laden with supplies, and a Roman town on the rocky bank, while to the right, the Roman army crosses the river on a pontoon bridge. The second strip shows Trajan addressing his soldiers (to the left) and the building of fortifications. The third depicts the construction of a garrison camp and bridge as the Roman cavalry sets out on a reconnaissance mission (on the right). In the fourth strip, Trajan's foot soldiers are crossing a mountain stream (center); to the right, the emperor addresses his troops in front of a Dacian fortress. These scenes are a fair sampling of the events depicted on the column. Among the more than 150 separate episodes, actual combat occurs only rarely, while the geographic, logistic, and political aspects of the campaign receive detailed attention, much as they do in Julius Caesar's famous account of his conquest of Gaul.

Only at one other time have we seen this matter-of-fact visualization of military operations—in Assyrian reliefs such as that in figure 102. Was there an indirect link between the two? And, if so, of what kind? The question is difficult to answer, especially since no examples of the Roman antecedents for our reliefs survive: the panels showing military conquests that were carried in triumphal processions (see page 192). At any rate, the spiral frieze on the Column of Trajan was a new and demanding framework for historic narrative, which imposed a number of difficult conditions upon the sculptor. Since there could be no clarifying inscriptions, the pictorial account had to be as self-sufficient and explicit as possible, which meant that the spatial setting of each episode had to be worked out with great care. Visual continuity had to be preserved without destroying the inner coherence of the individual scenes. And the actual depth of the carving had to be much shallower than in reliefs such as those on the Arch of Titus. Otherwise the shadows cast by the projecting parts would make the scenes unreadable from below.

Our artist has solved these problems with great success, but at the cost of sacrificing all but the barest remnants of illusionistic spatial depth. Landscape and architecture are reduced to abbreviated "stage sets," and the ground on which the figures stand is tilted upward. All these devices had already been employed in Assyrian narrative reliefs. Here they assert themselves once more, against the tradition of foreshortening and perspective space. In another 200 years, they were to become dominant, and we shall find ourselves at the threshold of medieval art. In this respect, the relief band on the Column of Trajan is curiously prophetic of both the end of one era and the beginning of the next.

depicted in a medallion on the Arch of Constantine, which was taken from a Hadrianic monument; see fig. 285, right). Then he had his wife, Sabina, deified. In her apotheosis relief (fig. 274) we see the deceased empress being borne aloft from her funeral pyre by the female genius of Eternity (identified by her torch), as Hadrian and the personification of the Campus Martius, where the royal cremation took place, witness the event to make it official. It is a strange sight indeed, yet it is rendered plausible by the Classical style, which permits allegory and reality to mingle with surprising ease.

SARCOPHAGUS OF MELEAGER. The time of Hadrian witnessed a major change in the attitude toward death as well. Sarcophagi quickly replaced cinerary urns as part of a new belief in an afterlife. In response to the sudden demand for sarcophagi, patterns for decorating them were based at first on Greek examples, but new designs were soon passed from shop to shop, probably in illustrated manuscripts. Preferences changed over time. For example, battle sarcophagi enjoyed a vogue under Marcus Aurelius. Later, in the third century, biographical and historical scenes projected the deceased's ideal of life, frequently with moral overtones. But the most popular scenes remained those taken from Classical mythology. Since these occur on sarcophagi and nowhere else, they must possess symbolic significance and not just antiquarian interest. Their general purpose seems to have been to glorify the deceased through visual analogy to the legendary heroes of the past.

Here, too, Hadrian took the lead. A second medallion on the Arch of Constantine (fig. 285, left) shows him slaying a wild boar as testimony not simply to his love of the chase but also his strength and courage in battle, for which hunting serves as a metaphor. Yet a third tondo on the other side showing a sacrifice to Hercules equates celebrated deeds with victory over death (fig. 284, far right). This explains the prevalence of Meleager on sarcophagi. In Homer's account, Meleager saved Calydon from a huge boar sent by Artemis to ravage his father's

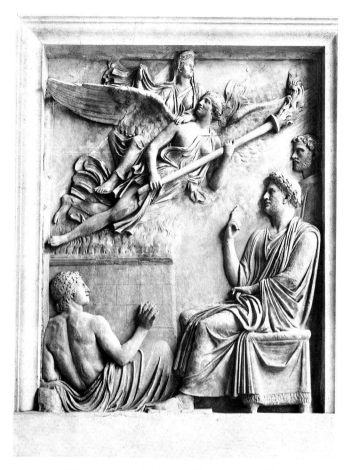

274. *Apotheosis of Sabina.* 136–38 A.D. Marble.
Museo dei Conservatori, Rome

APOTHEOSIS OF SABINA. Trajan's successor, Hadrian, who was educated in Athens, led a Classical revival that relied heavily on allegory for largely personal reasons. First, he proclaimed the beautiful youth Antinous a god and erected cult statues of him as Apollo throughout the empire. (One is

275. *Sarcophagus of Meleager.* c. 180 A.D. Marble. Galleria Doria Pamphili, Rome

276. *Vespasian.* c. 75 A.D. Marble, lifesize, with damaged
chin repaired. Museo delle Terme, Rome

277. *Portrait of a Lady.* c. 90 A.D. Marble, lifesize.
Museo Capitolino, Rome

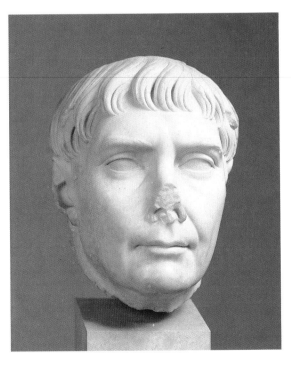

278. *Trajan.* c. 100 A.D. Marble, lifesize. Museum, Ostia

land, but then died in the battle over its pelt. He thus provided
an exemplar of noble *virtus,* or virtue, a concept akin to the
Greek *arete* (see page 117): heroism and death in the service of
country, for which he earned immortality. Figure 275 repro-
duces the finest example of the type. (The top shows the fallen
Meleager being carried from the field of combat.) It is skillfully
executed in a style indebted to Scopas (see fig. 203), but now
the poses are a bit stiff in the joints and the expressions filled
with the exaggerated pathos of Hellenistic sculpture. Charac-
teristic of Roman reliefs is the crowding of the entire surface
with figures (compare fig. 267).

PORTRAITS. The Ara Pacis, the Arch of Titus, and the Col-
umn of Trajan are monuments of key importance for the art
of Imperial Rome at the height of its power. To single out
equally significant works among the portraits of the same
period is much more difficult. Their production was vast, and
the diversity of types and styles mirrors the ever more complex
character of Roman society. If we regard the Republican ances-
tral image tradition and the Greek-inspired *Augustus of Prima-
porta* as opposite extremes, we can find almost any variety of
interbreeding between the two. The fine head of the emperor
Vespasian, of about 75 A.D., is a case in point (fig. 276). He
was the first of the Flavian emperors, a military man who came
to power after the Julio-Claudian (Augustan) line had died out
and who must have viewed the idea of emperor worship with
considerable skepticism. (When he was dying, he is reported

to have said, "It seems I am about to become a god.") His
humble origin and simple tastes may be reflected in the anti-
Augustan, Republican flavor of his portrait. The soft, veiled
quality of the carving, on the other hand, with its emphasis on
the texture of skin and hair, is so Greek that it immediately
recalls the seductive marble technique of Praxiteles and his
school (compare fig. 207).

A similar refinement can be felt in the surfaces of the slight-
ly later bust of a lady (fig. 277), probably the subtlest portrait

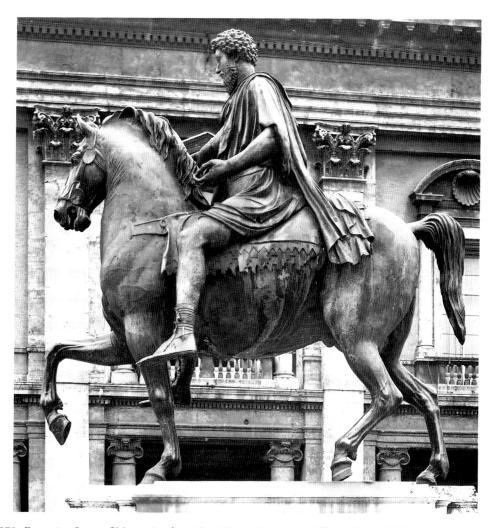

279. *Equestrian Statue of Marcus Aurelius.* 161–180 A.D. Bronze, over-lifesize. Piazza del Campidoglio, Rome

of a woman in all of Roman sculpture. The graceful tilt of the head and the glance of the large eyes convey a gentle mood of reverie. And how effectively the silky softness of skin and lips is set off by the many corkscrew curls of the fashionable coiffure! The wonderful head of Trajan (fig. 278), of about 100 A.D., is another masterpiece of portraiture. Its firm, rounded forms recall the *Augustus of Primaporta* (see fig. 264), as does the commanding look of the eyes, dramatized by the strongly projecting brows. The face radiates a strange emotional intensity that is difficult to define—a kind of Greek pathos transmuted into Roman nobility of character (compare fig. 216).

Trajan still conformed to age-old Roman custom by being clean-shaven. His successors, in contrast, adopted the Greek fashion of wearing beards as an outward sign of admiration for the Hellenic heritage. It is therefore not surprising to find a strong neo-Augustan, classicistic trend, often of a peculiarly cool, formal sort, in the sculpture of the second century A.D. This is especially true during the reigns of Hadrian and Marcus Aurelius, both of them private men deeply interested in Greek philosophy. We can sense this introspective quality in the equestrian bronze statue of Marcus Aurelius (fig. 279), which is remarkable not only as the sole survivor of this class of monument but as one of the few Roman statues that

remained on public view throughout the Middle Ages. The image showing the mounted emperor as the all-conquering lord of the earth had been a firmly established tradition ever since Julius Caesar permitted an equestrian statue of himself to be erected in the forum that he built. As depicted here, Marcus Aurelius, too, was meant to characterize the emperor as ever-victorious, for beneath the right front leg of the horse (according to medieval accounts) there once crouched a small figure of a bound barbarian chieftain. The wonderfully spirited and powerful horse expresses this martial spirit. But the emperor himself, without weapons or armor, presents a picture of stoic detachment. He is a bringer of peace rather than a military hero, for so he indeed saw himself and his reign (161–180 A.D.).

The late second century A.D. was the calm before the storm, for the third century saw the Roman Empire in almost perpetual crisis. Barbarians endangered its far-flung frontiers while internal conflicts undermined the authority of the Imperial office. To retain the throne became a matter of naked force, succession by murder a regular habit. The "soldier emperors," who were mercenaries from the outlying provinces of the realm, followed one another at brief intervals. The portraits of some of these men, such as Philippus the Arab

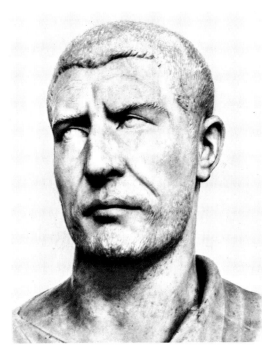

280. *Philippus the Arab.* 244–49 A.D. Marble, lifesize.
Musei Vaticani, Braccio Nuovo, Città del Vaticano, Rome

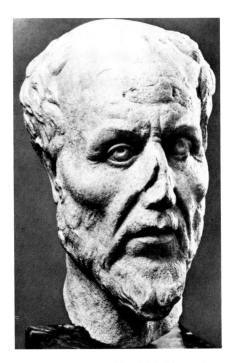

281. *Portrait Head* (probably Plotinus).
Late 3rd century A.D. Marble, lifesize. Museum, Ostia

(fig. 280; see fig. 114), who reigned from 244 to 249 A.D., are among the most powerful likenesses in all of art. Their facial realism is as uncompromising as that of Republican portraiture, but its aim is expressive rather than documentary. All the dark passions of the human mind—fear, suspicion, cruelty—suddenly stand revealed here, with a directness that is almost unbelievable. The face of Philippus mirrors all the violence of the time. Yet in a strange way it also moves us to pity. There is a psychological nakedness about it that recalls a brute creature, doomed and cornered. Clearly, the agony of the Roman world was not only physical but spiritual. That Roman art should have been able to create an image of a man embodying this crisis is a tribute to its continued vitality.

The results will remind us of the head from Delos (fig. 216). Let us note, however, the new plastic means through which the impact of these portraits is achieved. We are struck, first of all, by the way expression centers on the eyes, which seem to gaze at some unseen but powerful threat. The engraved outline of the iris and the hollowed-out pupils, devices alien to earlier portraits, serve to fix the direction of the glance. The hair, too, is rendered in thoroughly un-Classical fashion as a close-fitting, textured cap. The beard has been replaced by a stubble that results from roughing up the surfaces of the jaw and mouth with short chisel strokes.

A somewhat later portrait, probably that of the Greek philosopher Plotinus, suggests a different aspect of the third-century crisis (fig. 281). Plotinus' thinking—abstract, speculative, and strongly tinged with mysticism—marked a retreat from concern with the outer world that seems closer to the Middle Ages than to the Classical tradition of Greek philosophy. [See Primary Sources, no. 18, page 219.] It sprang from the same mood that, on a more popular level, expressed itself in the spread of Oriental mystery cults throughout the Roman empire. How trustworthy a likeness our head represents is hard to say. The ascetic features, the intense eyes and tall brow, may well portray inner qualities more accurately than outward appearance. According to his biographer, Plotinus was so contemptuous of the imperfections of the physical world that he refused to have any portrait made of himself. The body, he maintained, was an awkward enough likeness of the true, spiritual self. Why bother to make an even more awkward "likeness of a likeness"?

Such a view presages the end of portraiture as we have known it so far. If a physical likeness is worthless, a portrait becomes meaningful only as a visible symbol of the spiritual self. It is in these terms that we must view the statue of the Tetrarchs, who jointly ruled the four corners of the Roman Empire for a decade (fig. 282). To emphasize their equality, all are identical in appearance: they are of the same height, wear the same clothes, and bear the same features, nominally those of the emperor Diocletian, who conceived this unique form of government. Each Augustus embraces his Caesar, or junior partner, who was his designated successor and son-in-law. That this is the image they intended to project is beyond doubt: it is made of porphyry, an extremely hard Egyptian stone which was reserved for Imperial portraits. Yet the effect is hardly what was expected. They appear huddled together, as if seeking strength against the turbulent times, to which they lent a measure of stability.

Stranger still is the head of Constantine the Great, the first Christian emperor and reorganizer of the Roman state, who was named a tetrarch in 307 but became sole ruler only in 324 (fig. 283). Although it shows more individuality, the face is hardly a portrait in the proper sense of the term. No mere bust, this head is one of several remaining fragments of a huge statue from the apse of Constantine's gigantic basilica (see fig.

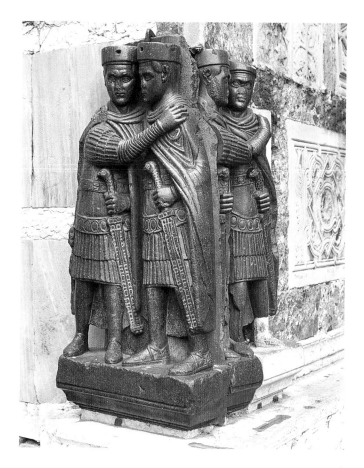

282. *The Tetrarchs.* c. 305 A.D.
Porphyry, height 51"
(129.5 cm). St. Mark's, Venice

251). Although imperial sculptures, including other colossal statues of the period, show the ruler standing, this one probably depicted him seated nude in the manner of Jupiter, with a mantle draped across his legs. It is probably the large statue mentioned by Bishop Eusebius, Constantine's friend and biographer, that held a cross-scepter, called a *labarum,* in its right hand. Following Constantine's conversion in 312, this Imperial device, originally a Roman military standard, became a Christian symbol through the addition of the Chi Rho insignia with a wreath. (Chi and Rho are the first two letters of Christ's name in Greek.) Thus, the colossal statue represented Constantine as a Christian ruler of the world, although the surviving hand points straight up. (The other hand most likely held an orb.) At the same time, it served as a cult statue to the emperor himself.

The head alone is eight feet tall. Everything is so out of proportion to the scale of ordinary people that we feel crushed by its immensity. The impression of being in the presence of some unimaginable power was deliberate. We may call it superhuman, not only because of its enormous size, but even more so perhaps as an image of Imperial majesty. It is reinforced by the massive, immobile features out of which the huge, radiant eyes stare with hypnotic intensity. All in all, the colossal head conveys little of Constantine's actual appearance, but it does tell us a great deal about his view of himself and his exalted office.

283. *Constantine the Great.* Early 4th century A.D. Marble, height 8' (2.4 m). Museo dei Conservatori, Rome

284. Arch of Constantine, Rome. 312–15 A.D.

ARCH OF CONSTANTINE. Constantine's conception of his role is clearly reflected in his triumphal arch (fig. 284), erected near the Colosseum between 312 and 315 A.D. One of the largest and most elaborate of its kind, it is decorated for the most part with sculpture taken from earlier Imperial monuments. This procedure has often been viewed as dictated by haste and by the poor condition of the sculptural workshops of Rome at that time. These may have been contributory factors, but there appears to be a conscious and carefully considered plan behind the way the earlier pieces were chosen and employed. All of them come from a related group of monuments dedicated to Trajan, Hadrian, and Marcus Aurelius, and the portraits of these emperors have been systematically reworked into likenesses of Constantine. Does this not convey Constantine's view of himself as the restorer of Roman glory, the legitimate successor of the "good emperors" of the second century? [See Primary Sources, no. 19, page 219.]

The arch also contains a number of reliefs made especially for it, however, such as the friezes above the lateral openings, and these show the new Constantinian style in full force. If we compare the medallions of figure 285, carved in Hadrian's time, with the relief immediately below them, the contrast is such that they seem to belong to two different worlds. The scene represents Constantine, after his entry into Rome in 312 A.D., addressing the Senate and the people from the rostrum in the Forum.

The first thing we notice here is the avoidance of all the numerous devices developed since the fifth century B.C. for creating spatial depth. We find no oblique lines, no foreshortening, and only the barest ripple of movement in the listening crowds. The architecture has been flattened out against the relief background, which thus becomes a solid, impenetrable surface. The rostrum and the people on or beside it form an equally shallow layer: the second row of figures appears simply as a series of heads above those of the first. The figures themselves have an oddly doll-like quality. The heads are very large, while the bodies seem not only dwarfish because of the thick, stubby legs, but they also appear to be lacking in articulation. The mechanism of contrapposto has disappeared completely, so that these figures no longer stand freely and by their own muscular effort. Rather, they seem to dangle from invisible strings.

Judged from the Classical point of view, all the characteristics we have described so far are essentially negative. They represent the loss of many hard-won gains—a throwback to earlier, more primitive levels of expression. Yet such an approach does not really advance our understanding of the new style. The Constantinian panel cannot be explained as the result of a lack of ability, for it is far too consistent within itself to be regarded as no more than a clumsy attempt to imitate earlier Roman reliefs. Nor can it be viewed as a return to

285. Medallions (117–38 A.D.) and frieze (early 4th century), Arch of Constantine

Archaic art, since there is nothing in pre-Classical times that looks like it. No, the Constantinian sculptor must have had a positive new purpose of his own that we can only surmise. Perhaps we can approach it best by stressing one dominant feature of our relief: its sense of self-sufficiency.

The scene fills the available area, and fills it completely. (Note how all the background buildings are made to have the same height.) Any suggestion that it continues beyond the frame is carefully avoided. It is as if our artist had asked, "How can I get all of this complicated ceremonial event into my panel?" In order to do so, an abstract order has been imposed upon the world of appearances. The middle third of the strip is given over to the rostrum with Constantine and his entourage, the rest to the listeners and the buildings that identify the Roman Forum as the scene of the action. They are all quite recognizable, even though their scale and proportions have been drastically adjusted. The symmetrical design also makes clear the unique status of the emperor. Constantine not only occupies the exact center, he is shown full-face (his head, unfortunately, has been knocked off), while all the other figures turn their heads toward him to express their dependent relationship. That the frontal pose is indeed a position of majesty reserved for sovereigns, human or divine, is nicely demonstrated by the seated figures at the corners of the rostrum, the only ones besides Constantine to face us directly.

These figures are statues of emperors—the same "good emperors" we met elsewhere on the arch, Hadrian and Marcus Aurelius. Looked at in this way, our relief reveals itself as a bold and original creation. It is the harbinger of a new vision that will become basic to the development of Christian art.

PAINTING

The modern viewer, whether expert or amateur, is apt to find painting the most exciting, as well as the most baffling, aspect of art under Roman rule. It is exciting because it represents the only large body of ancient painting after the Etruscan murals and because much of it, having come to light only in modern times, has the charm of the unfamiliar. Yet it remains baffling because we know much less about it than we do about Roman architecture or sculpture. The surviving material, with few exceptions, is severely limited in range. Almost all of the surviving examples consist of wall paintings, and the majority of these come from Pompeii, Herculaneum, and other settlements buried by the eruption of Mount Vesuvius in 79 A.D., or from Rome and its environs. Their dates cover a span of less than 200 years, from the end of the second century B.C. to the late first century A.D. What happened before remains largely a matter of guesswork, but Roman painting seems to have stagnated thereafter. And since we have no original Classical Greek

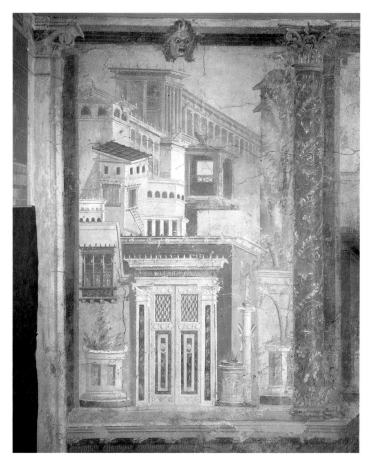

286. *Architectural View.* Wall painting from a villa at Boscoreale, near Naples.
1st century B.C. The Metropolitan Museum of Art, New York. Rogers Fund, 1903

or Hellenistic wall paintings on Greek soil, except for a handful of Macedonian tombs from Alexander's time, the problem of singling out the Roman element as against the Greek is far more difficult than in sculpture or architecture.

Four phases of Roman wall painting have been distinguished, but the differences among them are not always clear, and there seems to have been considerable overlapping in their sequence. The earliest phase, known from a few examples of the late second century B.C., must have been widespread in the Hellenistic world, since examples of it have also been found in the eastern Mediterranean. Unfortunately, it is not very informative for us, as it consists entirely of the imitation of colored marble paneling. About 100 B.C., this so-called First Style began to be displaced by a far more ambitious and elaborate style that sought to open up the flat surface of the wall by means of illusionistic architectural perspectives and "window effects," including landscapes and figures. [See Primary Sources, no. 7, page 214.]

The architectural vistas typical of the Second Style are represented by figure 286. Our artist is clearly a master of modeling and surface textures. The forms framing the vista—the lustrous, richly decorated columns, moldings, and mask at the top—have an extraordinary degree of three-dimensional reality. They effectively set off the distant view of buildings, which is flooded with light to convey a sense of free, open-air space. But as soon as we try to penetrate this architectural maze, we find ourselves lost. The individual structures cannot be disentangled from each other, and their size and relation-

ship are obscure. We quickly realize that the Roman painter has no systematic grasp of spatial depth, that the perspective is haphazard and inconsistent within itself. Apparently we were never intended to enter this space. Like a promised land, it remains forever beyond us.

When landscape takes the place of architectural vistas, exact foreshortening becomes less important, and the virtues of the Roman painter's approach outweigh his limitations. This is most strikingly demonstrated by the famous Odyssey Landscapes, a continuous stretch of landscape subdivided into eight compartments by a framework of pilasters. Each section illustrates an episode of the adventures of Odysseus (Ulysses). Vitruvius informs us that such cycles were common. [See Primary Sources, no. 11, page 216.] However, the narrative has large gaps, which suggests that the scenes have been excerpted from a larger cycle. In the adventure with the Laestrygonians (fig. 287), the airy, bluish tones create a wonderful feeling of atmospheric, light-filled space that envelops and binds together all the forms within this warm Mediterranean fairyland, where the human figures seem to play no more than an incidental role. Only upon further reflection do we realize how frail the illusion of coherence is. If we tried to map this landscape, we would find it just as ambiguous as the architectural perspective discussed above. Its unity is not structural but poetic, like that of the stucco landscape in figure 270.

The Odyssey Landscapes contrast with another approach to nature that we know from the murals in a room of the Villa of Livia at Primaporta (fig. 288), which have no precedent in

287. *The Laestrygonians Hurling Rocks at the Fleet of Odysseus.* Wall painting from a house on the Esquiline Hill, Rome.
Late 1st century B.C. Biblioteca Apostolica Vaticana, Città del Vaticano, Rome

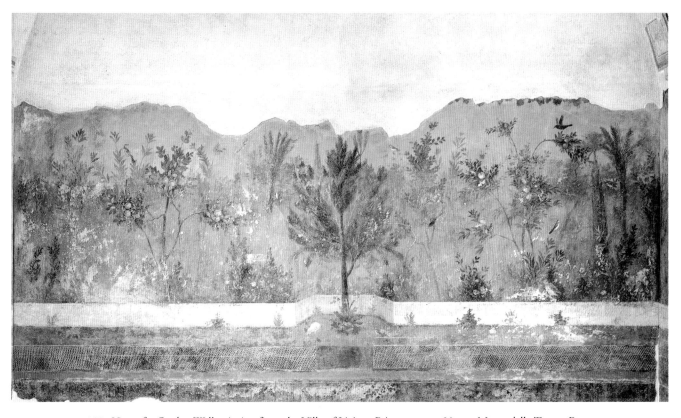

288. *View of a Garden.* Wall painting from the Villa of Livia at Primaporta. c. 20 B.C. Museo delle Terme, Rome

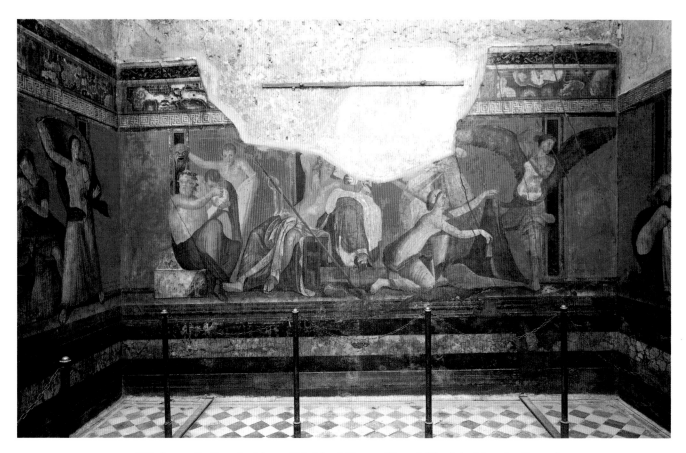

289. *Scenes of a Dionysiac Mystery Cult.* Mural frieze. c. 50 B.C. Villa of the Mysteries, Pompeii

Greek art. Here the architectural framework has been dispensed with altogether, and the entire wall is given over to a view of a delightful, serene garden full of colorful flowers, fruit trees, and birds. These charming details have the same tangible quality, the same concreteness of color and texture as the architectural framework of figure 286, and their apparent distance from the beholder is also about the same: they seem to be within arm's reach. At the bottom is a low trellis, beyond it a narrow strip of lawn with a tree in the center, then a low wall, and immediately after that the garden proper begins. Oddly enough, however, we cannot enter it. Behind the front row of trees and flowers lies an opaque mass of greenery that shuts off our view as effectively as a dense hedge. This garden, then, is another promised land made only for looking. The wall has not really been opened up but merely pushed back a few feet and replaced by a wall of plants. It is this very limitation of spatial depth that endows our mural with its unusual degree of coherence.

VILLA OF THE MYSTERIES. The great frieze in one of the rooms in the Villa of the Mysteries just outside Pompeii (fig. 289), like the garden view from the Villa of Livia, dates from the latter part of the first century B.C., when the Second Style was at its height. So far as the treatment of the wall space is concerned, the two works have more in common with each other than with other Second Style murals, for both of them are conceived in terms of rhythmic continuity and arm's-length depth. The result is a sweeping grandeur of design and

a coherence of style that is nearly unique in Roman painting.

The artist who created the frieze in the Villa of the Mysteries has placed his figures on a narrow ledge of green against a regular pattern of red panels separated by strips of black, a kind of running stage on which they enact their strange and solemn ritual. Who are they, and what is the meaning of the cycle? Many details remain puzzling, but the program as a whole represents various rites of the Dionysiac mysteries, a semisecret cult of very ancient origin that had been brought to Italy from Greece. The sacred rituals are performed, perhaps as part of an initiation into womanhood or marriage, in the presence of Dionysus and Adriadne, with their train of satyrs and sileni, so that human and mythical reality tend to merge into one. We sense the blending of these two spheres in the qualities all the figures have in common: their dignity of bearing and expression, the wonderful firmness of body and drapery, and the rapt intensity with which they participate in the drama of the ritual.

The Third Style, from about 20 B.C. until at least the middle of the first century A.D., eschewed illusionism altogether in favor of essentially flat, decorative surfaces with broad planes of intense color sometimes relieved by imitation panel paintings. By contrast, the Fourth Style, which prevailed at the time of the eruption of Mount Vesuvius in 79 A.D., was the most intricate of all. It united aspects of all three preceding styles to extravagant effect. The Ixion Room in the House of the Vettii at Pompeii (fig. 290) combines imitation marble paneling, conspicuously framed mythological scenes intended to give

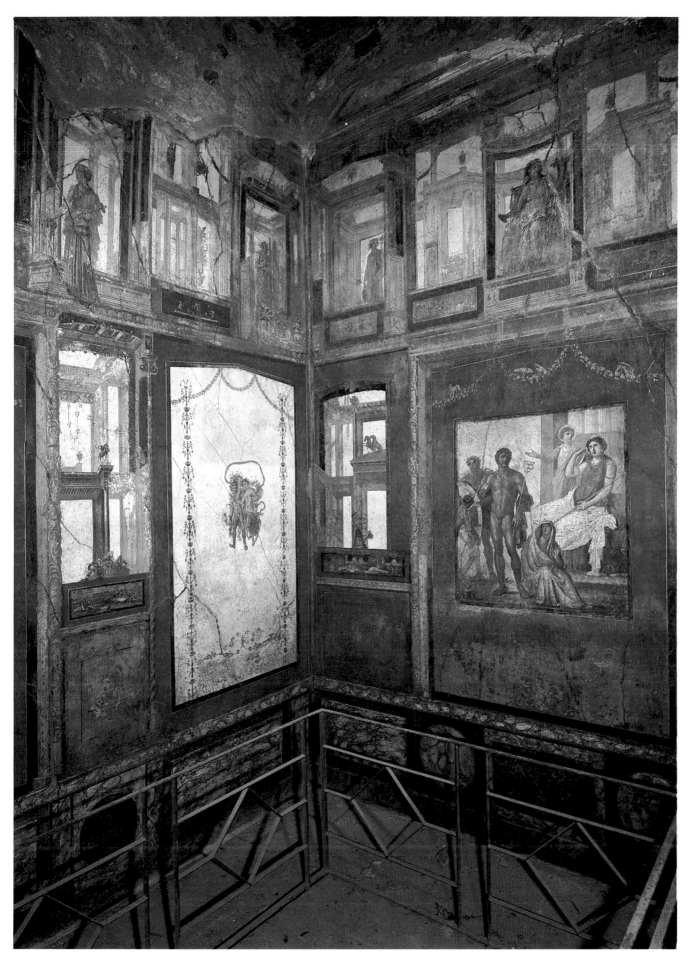

290. The Ixion Room, House of the Vettii, Pompeii. 63–79 A.D.

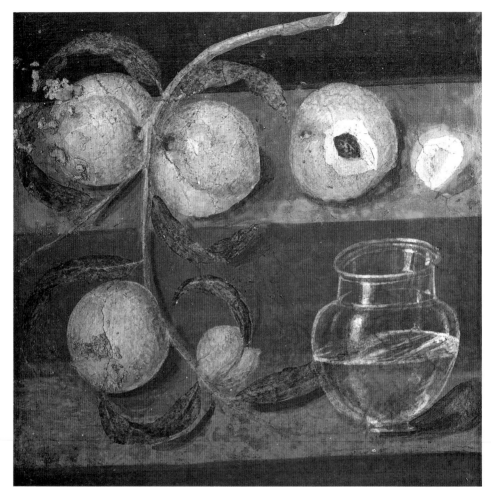

291. *Peaches and Glass Jar.* Wall painting from Herculaneum. c. 50 A.D. Museo Archeologico Nazionale, Naples

the effect of panel pictures set into the wall, and fantastic architectural vistas seen through make-believe windows, creating the effect of a somewhat disjointed compilation of motifs from various sources. This architecture has a strangely unreal and picturesque quality that is believed to reflect the architectural backdrops of the theaters of the time. It often anticipates effects such as that of the Market Gate of Miletus (see fig. 257), which shares the same source.

A unique feature of Roman mural decoration is the still lifes that sometimes make their appearance within the intricate architectural schemes of the Fourth Style. These usually take the form of make-believe niches or cupboards, so that the objects, which are often displayed on two levels, remain close to us. Our example (fig. 291) is particularly noteworthy for the rendering of the translucent glass jar half-filled with water. The reflections are so acutely observed that we feel the painter must have copied them from an actual jar illuminated in just this way. But if we try to determine the source and direction of the light in the picture, we find that this cannot be done, because the shadows cast by the various objects are not con-

sistent with each other. Nor do we have the impression that the jar stands in a stream of light. Instead, the light seems to be imprisoned within the jar.

Clearly, the Roman artist, despite striving for illusionistic effects, is no more systematic in the approach to light than in the handling of perspective. However sensuously real the details, the work nearly always lacks a basic unifying element in its overall structure. In the finest examples, this lack is amply compensated for by other qualities, so that our observation must not be regarded as condemning the Roman artist to an inferior status. Like the preference for shallow illusionistic space, the absence of a consistent view of the visible world should be thought of instead as a fundamental characteristic that distinguishes Roman painting.

Greek Sources

Since we have so few Classical Greek or Hellenistic wall murals on Greek soil and no panels whatsoever, the problem of singling out the Roman element as against the Greek is far more

According to contemporary sources, the Romans adopted Greek music, including its system of modes, with little modification. Roman theater, by contrast, was very different in many respects from that of Greece, for its origins lay even more in the region of Etruria. The Roman writer Livy (59 B.C.–17 A.D.) states that the first performances were held in 364 B.C., when musicians and dancers were imported from Etruria during a plague. Moreover, Tarquin the Elder, the Etruscan ruler of Rome between about 616 and 578 B.C., established the religious festivals known as *ludi Romani* (Roman games) to honor Jupiter each September; plays were part of the program. Perhaps more important, he introduced the Etruscan taste for spectacle and built the first Circus Maximus for horse races and similar events. Most Roman theater, in fact, fell into the category of modern carnival and circus acts, called *mimus,* or mime. A late form of popular theater was pantomine (all mime)—introduced from Greece in 22 B.C.—which involved a single dancer who acted out all the roles of a tragedy by changing masks.

Serious drama began in 240 B.C. with Livius Andronicus, a freed slave from south Italy, who produced a Latin translation of two Greek plays for the *ludi Romani* and became the first writer of Greek-style tragedies in Latin. Because Roman tragedies, which were always associated with religious festivals, reflected the stringent moral values of Republican Rome, they died out during the empire. The greatest author of comedies was Caecilius Statius (c. 219– 168 B.C.) but, as with Livius Andronicus, none of his works is left. During the first century B.C., Roman comic theater was taken over by the Fabula Atellana (named for the town of Atella near Naples). It was a coarse variety of farce that relied for its appeal on stock subjects with happy endings in the manner of late Greek comedy and was likewise accompanied by music.

All that remains of Roman theater are 21 comedies by Plautus (c. 254–184 B.C.), six comedies by the freed African slave Terence (190–156 B.C.), and nine tragedies by Seneca (4 B.C.–65 A.D.), the teacher of the emperor Nero, which may never have been performed. These writers exercised enormous influence on sixteenth-century Elizabethan theater by providing models of plot and style that were used by William Shakespeare and Christopher Marlowe. Roman playwrights have fallen into unjust neglect today, especially Seneca, whose works—far from being dry imitations of Greek prototypes—are powerful dramas with penetrating characterizations revealed in soliloquies fully the equal of Shakespeare's.

The architect and historian Vitruvius, writing in the late first century B.C., has left us a detailed account of Roman theater practices. He suggests that Roman architectural backdrops and painted scenery were considerably more elaborate than those of Greece. We can get a good idea of their probable appearance from the illusionistic treatment of architecture in Roman wall paintings (see fig. 290).

difficult in painting than in sculpture or architecture. That Greek designs were copied, and that Greek paintings as well as painters were imported, nobody will dispute. It is tempting to link Roman paintings with lost works recorded by Pliny, Vitruvius, and others. But *The Battle of Issus* (fig. 199) is one of the rare instances where this can be convincingly demonstrated.

For the most part, Roman painting appears to have been a specifically Roman development. Despite the fact that the characters' names are given in Greek, there is no reason to assume a Greek origin for the Odyssey Landscapes any more than for the *View of a Garden* from the Villa of Livia, although the latter's distant ancestor can be seen in the landscape fresco from Thera (fig. 124). Likewise, still-life painting began in Greece, but even when certain Classical Greek motifs were adopted, the form in which we know it is distinctively Roman, as can be ascertained by the changes in style and repertoire it underwent. Finally, the illusionistic tendencies that gained the upper hand in Roman murals during the first century B.C. represent a dramatic breakthrough without precedent in Greek art so far as we know.

The issue is more complex when it comes to narrative painting. Although not a trace of it exists, we can hardly doubt that Greek painting continued to evolve after the Classical era, much as Italian painting did after the High Renaissance. In fact, narrative painting underwent a decline in the late Hellenistic period, when earlier "Old Master" panels were highly prized by collectors. It was revived, so Pliny tells us, around the middle of the first century B.C. by Timomachus of Byzantium, who "restored its ancient dignity to the art of painting." This is the same time as the frescoes in the Villa of the Mysteries (fig. 289), which provide a test case of what is Roman in Roman painting. Many of the poses and gestures are taken from the repertory of Classical Greek art, yet they lack the studied and self-conscious quality we call classicism. An artist of exceptional greatness of vision has filled these forms with new life. Our painter was the legitimate heir of the Greeks in the same sense that the finest Latin poets of the Augustan age were the legitimate heirs to the Greek poetic tradition.

Roman painting as a whole shows the same genius for adapting Greek examples to Roman needs as do sculpture and architecture. This is true even of seemingly reproductive or imitative works. The mythological panels that occur like islands in the Third and Fourth Styles (see fig. 290) sometimes give the impression of relatively straightforward copies after Hellenistic originals. In several cases, however, we possess more than one variant of the same composition derived ultimately from the same, presumably Greek, source, and the divergences attest to how readily the original was copied and changed. Moreover, a closer reading shows that such panels, too, underwent a clear-cut evolution that reflects the changing taste of Roman artists and their patrons. Figures were

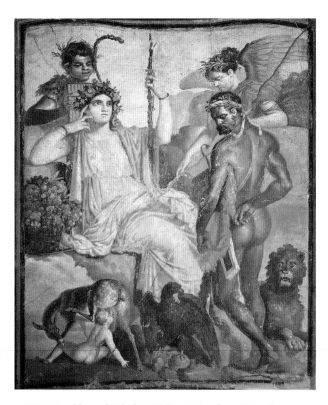

292. *Herakles and Telephos.* Wall painting from Herculaneum.
c. 70 A.D. Museo Archeologico Nazionale, Naples

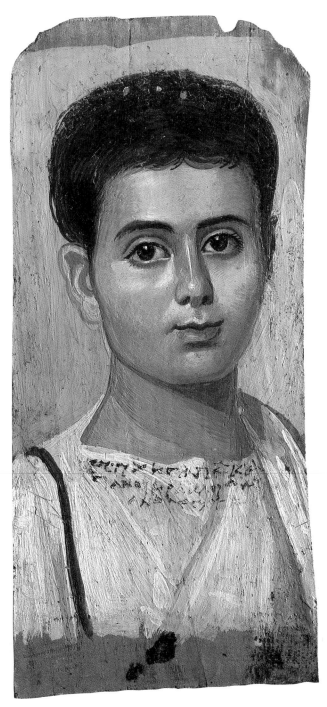

293. *Portrait of a Boy,* from the Faiyum, Lower Egypt.
2nd century A.D. Encaustic on panel, 15³/8 x 7¹/2" (39 x 19 cm).
The Metropolitan Museum of Art, New York
Gift of Edward S. Harkness, 1918

freely altered, rearranged, and recombined, often within very different settings, suggesting that they were made available in pattern books much like those for sarcophagi (see page 197). Thus, whatever the relation to the famous masterpieces of Greece that are lost to us forever, scenes such as Hermes overseeing the punishment of Ixion in figure 290 represent the highly electic Roman approach to painting, and it is likely that most were of recent vintage as well.

These pictures often have the rather disjointed character of compilations of motifs from diverse sources. A characteristic example of the latter is the picture of Herakles discovering the infant Telephos in Arcadia, from the basilica at Herculaneum (fig. 292). It may reflect a painting made in Pergamum, since a similar composition occurs in fragmentary form on the Great Altar (see pages 159–60). What stamps this as the handiwork of a Roman painter is its oddly unstable style. Almost everything here has the look of a "quotation," so that not only the forms, but even the brushwork vary from one figure to the next. Thus the personification of Arcadia, seated in the center, seems as cold, immobile, and tightly modeled as a statue,

whereas Herakles, although his pose is equally statuesque, exhibits a broader and more luminous technique. Or compare the Nemean Lion, emblem of Herakles, and the eagle of Jupiter, his father, which are painted in sketchy, agitated dabs, with the precise and graceful outlines of the doe and the suckling child. The sparkling highlights on the basket of fruit are derived from yet another source: still lifes such as figure 291. And the mischievously smiling young Pan in the upper left-hand corner is composed of quick, feathery brushstrokes that have an altogether different character. We recognize the same peculiarly Roman operating principle at work here as in the shifting decorative system of the Fourth Style as a whole, with its ambivalent perspective and inconsistent light.

PORTRAITS. Portrait painting, according to Pliny, was an established custom in Republican Rome, serving the ancestor cult as did the portrait busts discussed earlier (see pages 189–90). None of these panels has survived, and the few portraits found on the walls of Roman houses in Pompeii may well derive from a different, specifically Hellenistic, tradition. The only coherent group of painted portraits at our disposal comes instead from the Faiyum district in Lower Egypt. The earliest of them found so far seem to date from the second century A.D. We owe them to the survival (or revival) of an ancient Egyptian custom, that of attaching a portrait of the deceased to the wrapped, mummified body. Originally, these portraits

had been sculpted (compare fig. 82), but they were replaced in Roman times by painted ones such as the very fine and well-preserved wooden panel that is shown in figure 293.

The amazing freshness of its colors is due to the fact that it was done in a medium of great durability called encaustic, which means that the pigments are suspended in hot wax. The mixture can be opaque and creamy, like oil paint, or thin and translucent. At their best, these portraits have an immediacy and sureness of touch that have rarely been surpassed, thanks to the need to work quickly before the hot wax set. Our dark-haired boy is as solid, sparkling, and lifelike a piece of reality as anyone might wish. The style of the picture—and it does have style, otherwise we could not tell it from a snapshot— becomes apparent only when we compare it with other Faiyum portraits. Since they were produced quickly and in large numbers, they tend to have many elements in common, such as the emphasis on the eyes, the placing of the highlights and shadows, and the angle from which the face is seen. Over time, these conventional elements stiffen into a fixed type, whereas here they merely furnish a flexible mold within which to cast individual likeness. The artist has emphasized certain features, for example the eyes, but in this happy instance, the stylization has been made with the intention only of recalling the attractive personality of a beloved child. This way of painting was revived four centuries later in the earliest Byzantine icons, which were considered "portraits" of the Madonna and Child.

Primary Sources for Part One

The following is a selection of excerpts, in modern translations, from original texts by historians or writers from Egyptian times through the Roman era. These readings supplement the main text and are keyed to it. Their full citations are given in the Credits section at the end of the book.

1

The Pyramid Texts, from Utterance 373

This text is an "utterance" of Pharaoh Teti, who reigned in the Sixth Dynasty (2350–2190 B.C.). Inscriptions on Fifth- and Sixth-Dynasty pyramids at Saqqara are an important source of information about Egyptian ideas of the afterlife. They contain incantations ("utterances") intended to effect the resurrection of the pharaoh and his ascent to the realm of the gods.

Oho! Oho! Rise up, O Teti!
Take your head,
Collect your bones,
Gather your limbs,
Shake the earth from your flesh!
Take your bread that rots not,
Your beer that sours not,
Stand at the gates that bar the common people!
The gatekeeper comes out to you,
He grasps your hand,
Takes you into heaven, to your father Geb [earth god],
He rejoices at your coming,
Gives you his hands,
Kisses you, caresses you,
Sets you before the spirits, the imperishable stars.

2

From *The Story of Sinuhe*

The Story of Sinuhe *is the fictionalized Middle Kingdom account of a courtier who flees from Egypt to another country upon the death of the reigning pharaoh. He rises to prominence in a new land but longs to return to Egypt to die. Hearing of his plight, Pharaoh Sesostris I (1971–1928 B.C.) recalls Sinuhe to Egypt and provides lavishly for his funeral and tomb.*

A night is made for you with ointments and wrappings from the hand of Tait [goddess of weaving]. A funeral procession is made for you on the day of burial; the mummy case is of gold, its head of lapis lazuli. The sky is above you as you lie in the hearse, oxen drawing you, musicians going before you. The dance . . . is done at the door of your tomb; the offering-list is read to you; sacrifice is made before your offering-stone. Your tomb-pillars, made of white stone, are among (those of) the royal children. You shall not die abroad! . . .

A stone pyramid was built for me in the midst of the pyramids. The masons who build tombs constructed it. A master draughtsman designed in it. A master sculptor carved in it. The overseers of construction in the necropolis busied themselves with it. All the equipment that is placed in a tomb-shaft was supplied. Mortuary priests were given me. A funerary domain was made for me. It had fields and a garden in the right place, as is done for a Companion of the first rank. My statue was overlaid with gold, its skirt with electrum. It was his majesty who ordered it made. There is no commoner for whom the like has been done. I was in the favor of the king, until the day of landing came.

3

From *Cylinder A of Gudea*

Gudea's rebuilding of the temple, called Eninnu, to the god Ningirsu was recounted on three inscribed clay cylinders of about 2125 B.C. Cylinder A describes the construction of the temple. Gudea is presented as the architect, helped by Nidaba (goddess of writing, here representing the use of written sources) and Enki (god of builders).

For . . . Gudea . . . did Nidaba open
the house of understanding,
did Enki put right
 the design of the house.
To the house . . . did Gudea pace from south
to north on the fired [purified] mound, . . .
laid the measuring cord down
 on what was a true acre,
put in pegs at its sides,
 verified them himself.
It was cause of rejoicing
 for him. . . .
In the brick-mold shed he performed
 the pouring of water,
and the water sounded to the ruler
 as cymbals and *alu* lyres playing for him;
on the brick pit and its bricks
 he drenched the top layer,
hoed in honey, butter, and sweet princely oil; . . .
into the brick mold Gudea put the clay,
made "the proper thing" appear,
was establishing his name,
making the brick of the house appear. . . .

He placed the brick, paced off
 the house,
laid out the plan of the house,
(as) a very Nidaba knowing the inmost
 (secrets) of numbers,
and like a young man
 building his first house,
sweet sleep came not unto his eyes;
like a cow keeping an eye on its calf,
he went in constant worry to the house—
like a man who eats food sparingly
he tired not from going. . . .
Gudea made Ningirsu's house
come out like the sun from the clouds,
had it grow to be like sparkling foothills;
like foothills of white alabaster
he had it stand forth to be marveled at . . .
the house's stretching out
 along (substructure) walltops,
was like the heights of heaven
 awe-inspiring;
the roofing of the house, like a white cloud,
 was floating in the midst of heaven.
Its gate through which the owner entered
was like a lammergeier [vulture]
 espying a wild bull,
its curved gateposts standing
 at the gate
were like the rainbow
 standing in the sky. . . .
It (the house) kept an eye on the country;
no arrogant one could walk
 in its sight,
awe of Eninnu
covered all lands like a cloth.

4

Pliny the Elder (23–79 A.D.)
Natural History,
from Book 35 (on Greek painting)

The earliest preserved history of art appears in the work of the Roman naturalist and historian Pliny, who lived at the beginning of the Roman Imperial period and died in the eruption of Mount Vesuvius that destroyed Pompeii. Pliny says nothing about vase painting. For him the great era of painting began in the fifth century B.C., and its high point came in the fourth century B.C. Pliny lists the names and works of many artists who are otherwise unknown today. His anecdotes reveal the primacy placed on illusionism by Greeks and Romans. Pliny's work influenced Renaissance writers of art history, including Ghiberti and Vasari.

The origin of painting is obscure. . . . All, however, agree that painting began with the outlining of a man's shadow; this was the first stage, in the second a single colour was employed, and after the discovery of more elaborate methods this style, which is still in vogue, received the name of monochrome. . . .

Four colours only—white from Melos, Attic yellow, red from Sinope on the Black Sea, and the black called 'atramentum'—were used by Apelles, Aetion, Melanthios and Nikomachos in their . . . works; illustrious artists, a single one of whose pictures the wealth of a city could hardly suffice to buy. . . .

Apollodoros of Athens [in 408–405 B.C.] was the first to give his figures the appearance of reality. [He] opened the gates of art through which Zeuxis of Herakleia passed [in 397 B.C.]. The story runs that Parrhasios and Zeuxis entered into competition, Zeuxis exhibiting a picture of some grapes, so true to nature that the birds flew up to the wall of the stage. Parrhasios then displayed a picture of a linen curtain, realistic to such a degree that Zeuxis, elated by the verdict of the birds, cried out that now at last his rival must draw the curtain and show his picture. On discovering his mistake he surrendered the prize to Parrhasios, admitting candidly that he had deceived the birds, while Parrhasios had deluded himself, a painter. . . .

Apelles of Kos [in 332–329 B.C.] excelled all painters who came before or after him. He of himself perhaps contributed more to painting than all the others together; he also wrote treatises on his theory of art. . . .

Nikomachos' . . . pupils were his brother Ariston, his son Aristeides and Philoxenos of Eretria, who painted for king Kassander the battle between Alexander and Dareios, a picture second to none [compare fig. 199].

5

Pliny the Elder
Natural History, from Book 34 (on bronze)

Many of the best known Greek sculptors worked primarily in bronze, though their works are known to us in marble copies. This is true of Polyclitus, Myron, and Lysippus. Following the Roman conquest of Greece in the second century B.C., a number of these precious bronze originals were brought to Rome.

Besides his Olympian Zeus, a work which has no rival, Pheidias made in ivory the Athena at Athens, which stands erect in the Parthenon. . . . He is rightly held to have first revealed the capabilities of sculpture and indicated its methods.

Polykleitos . . . made an athlete binding the diadem about his head, which was famous for the sum of one hundred talents which it realized. This . . . has been described as 'a man, yet a boy': the . . . spear-bearer [fig. 183] as 'a boy, yet a man.' He also made the statue which sculptors call the 'canon,' referring to it as to a standard from which they can learn the first rules of their art. He is the only man who is held to have embodied

the principles of his art in a single work. . . . He is considered to have brought the scientific knowledge of statuary to perfection, and to have systematized the art of which Pheidias had revealed the possibilities. It was his peculiar characteristic to represent his figures resting their weight on one leg; . . .

Myron . . . [made an] athlete hurling the disk [fig. 189], a Perseus, . . . and the Herakles which is near the great Circus in the temple of the great Pompeius. . . . He was more productive than Polykleitos, and a more diligent observer of symmetry. Still he too only cared for the physical form, and did not express the sensations of the mind, . . .

Lysippos produced more works than any other artist, possessing, as I have said, a most prolific genius. Among them is the man scraping himself [fig. 209]. . . . In this statue the Emperor Tiberius took a marvellous delight, . . . he could not refrain from having the statue removed into his private chamber, substituting another in its place. . . . His chief contributions to the art of sculpture are said to consist in his vivid rendering of the hair, in making the heads smaller than older artists had done, and the bodies slimmer and with less flesh, thus increasing the apparent height of his figures. There is no word in Latin for the canon of symmetry which he was so careful to preserve, bringing innovations which had never been thought of before into the square canon of the older artists, and he often said that the difference between himself and them was that they represented men as they were, and he as they appeared to be. His chief characteristic is extreme delicacy of execution even in the smallest details.

6
Pliny the Elder
Natural History, from Book 36 (on marble)

Among the sculptors famous for their work in marble, Pliny mentions Praxiteles and Scopas. He also describes the collaborative Laocoön Group (fig. 215).

The art of [marble] sculpture is much older than that of painting or of bronze statuary, both of which began with Pheidias. . . .

Praxiteles . . . outdid even himself by the fame of his works in marble. . . . Famous . . . throughout the whole world, is the Aphrodite which multitudes have sailed to Knidos to look upon [fig. 206]. He had offered two statues of Aphrodite for sale at the same time, the second being a draped figure, which for that reason was preferred by the people of Kos with whom lay the first choice; the price of the two figures was the same, but they flattered themselves they were giving proof of a severe modesty. The rejected statue, which was bought by the people of Knidos, enjoys an immeasurably greater reputation. King Nikomedes subsequently wished to buy it from them, offering to discharge the whole of their public debt, which was enormous. They, however, preferred to suffer the worst that

could befall, and they showed their wisdom, for by this statue Praxiteles made Knidos illustrious. . . .

Bryaxis, Timotheos, and Leochares were rivals and contemporaries of Skopas, and must be mentioned with him, as they worked together on the Mausoleion [figs. 202 and 203]. This is the tomb erected by Artemisia in honour of her husband Mausolos, . . . and its place among the seven wonders of the world is largely due to these great sculptors. The length of the south and north sides is 163 feet; the two façades are shorter, and the whole perimeter is 440 feet; its height is 25 cubits [37½ feet], and it has thirty-six columns. . . . The sculptures of the eastern front are carved by Skopas, those on the north by Bryaxis, on the south by Timotheos, and on the west by Leochares. . . . Above the colonnade is a pyramid, of the same height as the lower structure, consisting of twenty-four retreating steps rising into a cone. On the apex stands a chariot and four horses in marble made by Pythis. . . .

In the case of certain masterpieces the . . . number of the collaborators is an obstacle to their individual fame, since neither can one man take to himself the whole glory, nor have a number so great a claim to honour. This is the case with the Laokoon in the palace of the Emperor Titus, a work superior to all the pictures and bronzes of the world [compare fig. 215]. Out of one block of marble did the illustrious artists Hagesander, Polydoros, and Athanodoros of Rhodes, after taking counsel together, carve Laokoon, his children, and the wondrous coils of the snakes.

7
Pliny the Elder
Natural History, from Book 35
(on Roman painting)

Pliny's account of the history of painting privileges the ancient Greeks, while Romans are relatively neglected. He does mention Studius, as well as several women painters whose works have not been identified. In judging Roman painters, Pliny puts a high value on speed of execution.

Studius, a painter of the days of Augustus, . . . introduced a delightful style of decorating walls with representations of villas, harbours, landscape gardens, sacred groves, woods, hills, fishponds, straits, streams and shores, any scene in short that took the fancy. . . .

Women too have been painters: . . . Iaia of Kyzikos, who remained single all her life, worked at Rome. . . . She painted chiefly portraits of women, and also a large picture of an old woman at Naples, and a portrait of herself, executed with the help of a mirror. No artist worked more rapidly than she did, and her pictures had such merit that they sold for higher prices than those of [other] well-known contemporary painters, whose works fill our galleries.

Vitruvius (1st century B.C.)
On Architecture, from Book IV
(on the Doric and Corinthian orders)

Vitruvius, like Pliny, was a Roman writer who admired the achievements of the Greeks. His treatise on architecture (c. 35–25 B.C.) reflects the classicizing taste of his time. Vitruvius' work was a principal source for Renaissance architects seeking the revival of antiquity. His account of the origin of the Greek orders is partly mythic, partly rational conjecture (see fig. 162).

For in Achaea and over the whole Peloponnese, Dorus . . . was king; by chance he built a temple . . . at the old city of Argos, in the sanctuary of Juno. . . . Afterwards [Greeks in Ionia] . . . established a temple as they had seen in Achaea. Then they called it Doric because they had first seen it built in that style. When they wished to place columns in that temple, not having their proportions, . . . they measured a man's footstep and applied it to his height. Finding that the foot was the sixth part of the height in a man, they applied this proportion to the column. Of whatever thickness they made the base of the shaft they raised it along with the capital to six times as much in height. So the Doric column began to furnish the proportion of a man's body, its strength and grace. . . .

But the third order, which is called Corinthian, imitates the slight figure of a maiden; because girls are represented with slighter dimensions because of their tender age, and admit of more graceful effects in ornament. Now the first invention of that capital is related to have happened thus. A girl, a native of Corinth, already of age to be married, was attacked by disease and died. After her funeral, the goblets which delighted her when living, were put together in a basket by her nurse, carried to the monument, and placed on the top. That they might remain longer, exposed as they were to the weather, she covered the basket with a tile. As it happened the basket was placed upon the root of an acanthus. Meanwhile about spring time, the root of the acanthus, being pressed down in the middle by the weight, put forth leaves and shoots. The shoots grew up the sides of the basket, and, being pressed down at the angles by the force of the weight of the tile, were compelled to form the curves of volutes at the extreme parts. . . .

Workmen of old, . . . when they had put beams reaching from the inner walls to the outside parts, built in the spaces between the beams. . . . Then they cut off the projections of the beams, as far as they came forward, to the line and perpendicular of the walls. But since this appearance was ungraceful, they fixed tablets shaped as triglyphs now are, against the cut-off beams, and painted them with blue wax, in order that the cut-off beams might be concealed so as not to offend the eyes. Thus in Doric structures, the divisions of the beams being hidden began to have the arrangement of the triglyphs, and, between the beams, of metopes. Subsequently other architects in other works carried forward over the triglyphs the projecting rafters, and trimmed the projections. . . . In the Doric style the detail . . . of the triglyphs . . . arose from this imitation of timber work.

Vitruvius
On Architecture,
from Book V (on public buildings)

Vitruvius' description of basilicas indicates that the proportional design prescribed for temples was expected of other columned buildings as well.

The sites of basilicas ought to be fixed adjoining the fora in as warm a quarter as possible, so that in the winter, business men may meet there without being troubled by the weather. And their breadth should be fixed at not less than a third, nor more than half their length, unless the nature of the site is awkward and forces the proportions to be changed. When the site is longer than necessary, the committee rooms are to be placed at the end of the basilica. . . . The columns of basilicas are to be of a height equal to the width of the aisle. The aisle is to have a width one third of the nave.

Vitruvius
On Architecture,
from Book VI (on private buildings)

We must go on to consider how, in private buildings, the rooms belonging to the family, and how those which are shared with visitors, should be planned. For into the private rooms no one can come uninvited, such as the bedrooms, dining-rooms, baths and other apartments which have similar purposes. The common rooms are those into which, though uninvited, persons of the people can come by right, such as vestibules, courtyards, peristyles and other apartments of similar uses. Therefore magnificent vestibules and alcoves and halls are not necessary to persons of a common fortune, because they pay their respects by visiting among others, and are not visited by others. . . . The houses of bankers and farmers of the revenue should be more spacious and imposing and safe from burglars. . . . For persons of high rank who hold office and magistracies, and whose duty it is to serve the state, we must provide princely vestibules, lofty halls and very spacious peristyles, plantations and broad avenues finished in a majestic manner.

11

Vitruvius

On Architecture,
from Book VII (on ornamentation)

Vitruvius' conservative taste approved of wall painting like the First and Second Styles, but disliked the kinds of fantasy that typify the Fourth Style.

The ancients who first used polished stucco, began by imitating the variety and arrangement of marble inlay; then the varied distribution of festoons, ferns, coloured strips.

Then they proceeded to imitate the contours of buildings, the outstanding projections of columns and gables; in open spaces, like exedrae, they designed scenery on a large scale in tragic, comic, or satyric style; in covered promenades, because of the length of the walls, they used for ornament the varieties of landscape gardening, . . . some have also the anatomy of statues, the images of the gods, or the representations of legends; further, the battles of Troy and the wanderings of Ulysses over the countryside [compare fig. 287] with other subjects taken in like manner from Nature.

But these which were imitations based upon reality are now disdained by the improper taste of the present. On the stucco are monsters rather than definite representations taken from definite things. Instead of columns there rise up stalks; instead of gables, striped panels with curled leaves and volutes. Candelabra uphold pictured shrines and above the summits of these, clusters of thin stalks rise from their roots in tendrils with little figures seated upon them at random. Again, slender stalks with heads of men and of animals attached to half the body [compare fig. 290].

Such things neither are, nor can be, nor have been. On these lines the new fashions compel bad judges to condemn good craftsmanship for dullness. For how can a reed actually sustain a roof, or a candelabrum the ornaments of a gable? . . . Pictures cannot be approved which do not resemble reality. Even if they have a fine and craftsmanlike finish, they are only to receive commendation if they exhibit their proper subject without transgressing the rules of art.

12

Plutarch (c. 46–after 119 A.D.)

Parallel Lives of Greeks and Romans, from
the lives of Pericles and Fabius Maximus

A Greek author of the Roman period, Plutarch wrote the Parallel Lives *to show that ancient Greece matched or exceeded Rome in its great leaders. Comparing Pericles (died 429 B.C.) with Fabius Maximus (died 203 B.C.), he concludes that Pericles' buildings surpass all the architecture of the Romans. Plutarch is the only ancient source to say that Phidias was the overseer of Pericles' works.*

But that which brought most delightful adornment to Athens, and the greatest amazement to the rest of mankind; that which alone now testifies for Hellas that her ancient power and splendour, of which so much is told, was no idle fiction,—I mean his construction of sacred edifices. . . . For this reason are the works of Pericles all the more to be wondered at; they were created in a short time for all time. Each one of them, in its beauty, was even then and at once antique; but in the freshness of its vigour it is, even to the present day, recent and newly wrought. Such is the bloom of perpetual newness, as it were, upon these works of his, which makes them ever to look untouched by time, as though the unfaltering breath of an ageless spirit had been infused into them.

His general manager and general overseer was Pheidias, although the several works had great architects and artists besides. Of the Parthenon, for instance, with its cella of a hundred feet in length, Callicrates and Ictinus were the architects. . . .

By the side of the great public works, the temples, and the stately edifices, with which Pericles adorned Athens, all Rome's attempts at splendour down to the times of the Caesars, taken together, are not worthy to be considered, nay, the one had a towering pre-eminence above the other, both in grandeur of design, and grandeur of execution, which precludes comparison.

13

Plato (c. 427–347 B.C.)
The Republic, from Book X

At the end of his treatise on the ideal state, the philosopher Plato attacks poets and painters. He claims that painters are only imitators of appearances, rather than of essences (forms or ideas), and therefore dishonest; he concludes that they must be banished from the state. Implicit in this argument is a condemnation of the new illusionistic practices in Greek art. The treatise is written in Socratic dialogue form, which consists of a series of questions designed to elicit clear and rational answers.

"Could you tell me what imitation in general is? . . . We are, presumably, accustomed to set down some one particular form for each of the particular 'manys' to which we apply the same name. Or don't you understand?"

"I do."

"Then let's now set down any one of the 'manys' you please; for example, if you wish, there are surely many couches and tables."

"Of course."

"But as for *ideas* for these furnishings, there are presumably

two, one of couch, one of table."

"Yes."

"Aren't we also accustomed to say that it is in looking to the *idea* of each implement that one craftsman makes the couches and another the chairs we use, and similarly for other things? For presumably none of the craftsmen fabricates the idea itself. How could he?"

"In no way."

"Well, now, see what you call this craftsman here."

"Which one?"

"He who makes everything that each one of the manual artisans makes separately. . . . This same manual artisan is not only able to make all implements but also makes everything that grows naturally from the earth, . . . all animals, . . . and everything in heaven and everything in Hades under the earth."

"That's quite a wonderful sophist you speak of," he said.

" . . . Aren't you aware that you yourself could in a certain way make all these things?"

"And what," he said, "is that way?". . .

"You could fabricate them quickly, . . . if you are willing to take a mirror and carry it around everywhere; quickly you will make the sun and the things in heaven; quickly, the earth; and quickly, yourself and the other animals and implements and plants. . . . "

"Yes," he said, "so that they look like they *are;* however, they surely *are* not the truth."

"Fine," I said, "and you attack the argument at just the right place. For I suppose the painter is also one of these craftsmen, isn't he?"

"Of course he is."

"But I suppose you'll say that he doesn't truly make what he makes. And yet in a certain way the painter too does make a couch, doesn't he?"

"Yes," he said, "he too makes what looks like a couch."

"And what about the couchmaker? Weren't you just saying that he doesn't make the form, which is what we, of course, say a couch is, but a certain couch?"

"Yes," he said. . . .

"Do you," I said, "want us . . . to investigate who this imitator is?"

"If you want to," he said.

"There turn out, then, to be these three kinds of couches: one that *is* in nature, which we would say, I suppose, a god produced. . . . And then one that the carpenter produced."

"Yes," he said.

"And the one that the painter produced, isn't that so?"

"Let it be so." . . .

"Now, the god . . . made only one, that very one which is a couch [that is, the essence of a couch]. . . . Do you want us to address him as [the couch's] nature-begetter or something of the kind?"

"That's just, at any rate," he said, "since by nature he has made both this and everything else."

"And what about the carpenter? Isn't he a craftsman of

a couch?"

"Yes."

"And is the painter also a craftsman and a maker of such a thing?"

"Not at all."

"But what of a couch will you say he is?"

"In my opinion," he said, "he would most sensibly be addressed as an imitator of that of which these others are craftsmen."

"All right," I said, "do you, then, call the man at the third generation from nature an imitator?"

"Most certainly," he said. . . .

"Now tell me this about the painter. In your opinion, does he in each case attempt to imitate the thing itself in nature, or the works of the craftsmen?"

"The works of the craftsmen," he said.

"Such as they are or such as they look? For you still have to make that distinction."

"How do you mean?" he said.

"Like this. Does a couch, if you observe it from the side, or from the front, or from anywhere else, differ at all from itself? Or does it not differ at all but only look different, and similarly with the rest?"

"The latter is so," he said. "It looks different, but isn't."

"Now consider this very point. Toward which is painting directed in each case—toward imitation of the being as it is or toward its looking as it looks? Is it imitation of looks or of truth?"

"Of looks," he said.

"Therefore, imitation is surely far from truth; and, as it seems, it is due to this that it produces everything—because it lays hold of a certain small part of each thing, and that part is itself only a phantom. For example, the painter, we say, will paint for us a shoemaker, a carpenter, and the other craftsmen, although he doesn't understand the arts of any one of them. But, nevertheless, if he is a good painter, by painting a carpenter and displaying him from far off, he would deceive children and foolish human beings into thinking that it is truly a carpenter."

"Of course."

14

Vergil (70–19 B.C.)
The Aeneid, from Book II

Vergil was the greatest Latin poet and the chief exponent of the Augustan age in literature. The Aeneid *is an epic poem about the hero Aeneas, who fled Troy when it was destroyed by the Greeks and settled in Italy. Book II tells of the fall of Troy, including the punishment by Minerva of Laocoön for trying to warn the Trojans against the trick wooden horse. The sculptural rendition of Laocoön shown in figure 215 closely resembles Vergil's description.*

The Vatican Vergil *(fig. 310) contains the complete* Aeneid *as well as other poetry by Vergil.*

Laocoön, by lot named priest of Neptune,
was sacrificing then a giant bull
upon the customary altars, when
two snakes with endless coils, from Tenedos
strike out across the tranquil deep. . . .
They lick their hissing jaws with quivering tongues.
We scatter at the sight, our blood is gone.
They strike a straight line toward Laocoön.
At first each snake entwines the tiny bodies
of his two sons in an embrace, then feasts
its fangs on their defenseless limbs. The pair
next seize upon Laocoön himself,
who nears to help his sons, carrying weapons.
They wind around his waist and twice around
his throat. They throttle him with scaly backs;
their heads and steep necks tower over him.
He struggles with his hands to rip their knots,
his headbands soaked in filth and in dark venom,
while he lifts high his hideous cries to heaven,
just like the bellows of a wounded bull.

15
Aristotle (384–322 B.C.)
The Politics, from Book VIII

The Politics *is a counterpart to Plato's* Republic, *a treatment of the constitution of the state. Books VII and VIII discuss the education prescribed for good citizens. Drawing is included as a liberal art—that is, a skill not only useful but also conducive to higher activities. Yet painting and sculpture are said to have only limited power to move the soul.*

There is a sort of education in which parents should train their sons, not as being useful or necessary, but because it is liberal or noble. . . . Further, it is clear that children should be instructed in some useful things—for example, in reading and writing—not only for their usefulness, but also because many other sorts of knowledge are acquired through them. With a like view they may be taught drawing, not to prevent their making mistakes in their own purchases, or in order that they may not be imposed upon in the buying or selling of articles [works of art], but perhaps rather because it makes them judges of the beauty of the human form. To be always seeking after the useful does not become free and exalted souls. . . .

The habit of feeling pleasure or pain at mere representations is not far removed from the same feeling about realities; for example, if any one delights in the sight of a statue for its beauty only, it necessarily follows that the sight of the original will be pleasant to him. The objects of no other

sense, such as taste or touch, have any resemblance to moral qualities; in visible objects there is only a little, for there are figures which are of a moral character, but only to a slight extent, and all do not participate in the feeling about them. Again, figures and colours are not imitations, but signs, of character, indications which the body gives of states of feeling. The connexion of them with morals is slight, but in so far as there is any, young men should be taught to look . . . at [the works] of Polygnotus, or any other painter or sculptor who expresses character.

16
Livy (59 B.C.–17 A.D.)
From the Founding of the City, from Book I

Livy, a historian, was a contemporary of Vitruvius and Vergil and also moved in the circle of the emperor Augustus. His history of Rome begins with Aeneas and includes the legend of the she-wolf that suckled Romulus and Remus (compare fig. 232).

The Vestal [Virgin, Rhea Silvia] was ravished, and having given birth to twin sons, named Mars as the father of her doubtful offspring. . . . But neither gods nor men protected the mother herself or her babes from the king's cruelty; the priestess he ordered to be manacled and cast into prison, the children to be committed to the river. . . . The story persists that when the floating basket in which the children had been exposed was left high and dry by the receding water, a she-wolf, coming down out of the surrounding hills to slake her thirst, turned her steps towards the cry of the infants, and with her teats gave them suck so gently, that the keeper of the royal flock found her licking them with her tongue. . . . He carried the twins to his hut and gave them to his wife Larentia to rear.

17
Polybius (c. 200–c. 118 B.C.)
Histories, from Book VI

Polybius was a Greek historian active during the Roman conquest of his homeland. His Histories *recount the rise of Rome from the third century B.C. to the destruction of Corinth in 146 B.C. In Book VI he considers cultural and other factors explaining Rome's success.*

Whenever any illustrious man dies, . . . they place the image of the departed in the most conspicuous position in the house, enclosed in a wooden shrine. This image is a mask reproducing with remarkable fidelity both the features and complexion of the deceased. On the occasion of public sacrifices they display these images, and decorate them with much care, and when any distinguished member of the family dies they take

them to the funeral, putting them on men who seem to them to bear the closest resemblance to the original in stature and carriage. These representatives wear togas, with a purple border if the deceased was a consul or praetor, whole purple if he was a censor, and embroidered with gold if he had celebrated a triumph or achieved anything similar. They all ride in chariots preceded by the fasces, axes, and other insignia . . . and when they arrive at the rostra they all seat themselves in a row on ivory chairs. There could not easily be a more ennobling spectacle for a young man who aspires to fame and virtue. For who would not be inspired by the sight of the images of men renowned for their excellence, all together and as if alive and breathing? . . . By this means, by this constant renewal of the good report of brave men, the celebrity of those who performed noble deeds is rendered immortal. . . . But the most important result is that young men are thus inspired to endure every suffering for the public welfare in the hope of winning the glory that attends on brave men.

18

Plotinus (205–270 A.D.)
Enneads, from Book I.6, "On Beauty"

A Greek philosopher who taught in Rome, Plotinus was a Neo-Platonist, the last great pagan expositor of the thought of Plato. Mystical in outlook, he conceived the cosmos as a hierarchical descent from the ineffable One (God) to matter. His reference to "images, traces, shadows" is a clear echo of Plato's argument in The Republic *and indicates his distrust of images. As the lowest form of existence in his scheme, matter could not be the site of true beauty. Plotinus' teachings were Christianized and transmitted to the Middle Ages by writers like Pseudo-Dionysius.*

Beauty is mostly in sight, but it is to be found too in things we hear, in combinations of words and also in music . . . and for those who are advancing upwards from sense-perception ways of life and actions and characters and intellectual activities are beautiful, and there is the beauty of virtue. . . .

How can one see the "inconceivable beauty" which . . . does not come out where the profane may see it? Let him who can . . . leave . . . the sight of his eyes . . . When he sees the beauty in bodies he must not run after them; we must know that they are images, traces, shadows, and hurry away to that

which they image. For if a man runs to the image and wants to seize it as if it was the reality . . . [he] will, . . . in soul, . . . sink down into the dark depths where intellect has no delight, and stay blind in Hades. . . . Shut your eyes, and change to and wake another way of seeing, which everyone has but few use. . . .

First of all . . . look at beautiful ways of life: then at beautiful works, not those which the arts produce, but the works of men who have a name for goodness: then look at the souls of the people who produce the beautiful works.

19

Ammianus Marcellinus (c. 330–395 A.D.)
History, from Book 16

The surviving books of the History *cover the years from 353 to 378 A.D. The author's description of the first sight of Rome by the emperor Constantius II, the son of Constantine the Great, in 357 shows how enormously impressive the ancient city was.*

So then he [the emperor] entered Rome, the home of empire and of every virtue, and when he had come to the Rostra, the most renowned forum of ancient dominion, he stood amazed; and on every side on which his eyes rested he was dazzled by the array of marvellous sights. . . . As he surveyed the sections of the city and its suburbs, lying within the summits of the seven hills, along their slopes, or on level ground, he thought that whatever first met his gaze towered above all the rest: the sanctuaries of Tarpeian Jove so far surpassing as things divine excel those of earth; the baths built up in the manner of provinces; the huge bulk of the amphitheatre [Colosseum], strengthened by its framework of Tiburtine stone, to whose top human eyesight barely ascends; the Pantheon like a rounded city-district, vaulted over in lofty beauty. . . . But when he came to the Forum of Trajan, a construction unique under the heavens, as we believe, and admirable even in the unanimous opinion of the gods, he stood fast in amazement, turning his attention to the gigantic complex about him, beggaring description and never again to be imitated by mortal men. . . . When the emperor had viewed many objects with awe and amazement, he complained of Fame as either incapable or spiteful, because while always exaggerating everything, in describing what there is in Rome, she becomes shabby.

	35,000–3500 B.C.	3500–3000 B.C.	3000–2500 B.C.
HISTORY AND POLITICS	**c. 35,000** First Paleolithic societies **c. 4000** Predynastic period in Egypt	**c. 3500–3000** Sumerian civilization, Mesopotamia **c. 3100** Narmer unites the Upper and Lower Kingdoms of Egypt. Beginning of Old Kingdom in Egypt (Dynasties 1–6, until c. 2190); divine kingship of the pharaoh **c. 3000** Rise of early Aegean civilizations: Cretan, Cycladic, and Helladic periods	
RELIGION			

Pyramids and Power The pyramids, built in Egypt during the Old Kingdom, are artworks in which the connection of public architecture to political power, religious ideology, and the development of high technology is particularly clear. Intentionally grandiose, they were designed to impress the viewer with their monumentality and to represent the might and wealth of the pharaohs who built them. The newly centralized government placed power directly in the hands of the monarch, administered by an efficient bureaucracy able to mobilize tens of thousands of workers and apply accurate astronomical calculations and the latest in surveying techniques (such as the plumb line and the A-frame). The pyramids display a high degree of skill in their precise architecture and fine masonry. Built in as little as 30 years as tombs for Egypt's rulers, they and their attendant temples and sculptures express on a grand scale the contemporary idea of the divinity of the pharaoh.

(left) "Venus" of Willendorf, c. 25,000–20,000 B.C.
(center) Cave painting, Altamira, c. 15,000–10,000 B.C.

(right) Female Head, Uruk, c. 3500–3000 B.C.

Inlay panel, Ur, c. 2600 B.C.

MUSIC, LITERATURE, AND PHILOSOPHY			**c. 3000–2500** *Epic of Gilgamesh,* early Sumerian heroic tale
SCIENCE AND TECHNOLOGY	**c. 8000** Husbandry and farming develop in the Near East	**c. 3500–3000** Wheeled carts in Sumer **c. 3500** Sailboats used on the Nile **c. 3300–3000** Invention of writing by Sumerians; use of potter's wheel and organic dyes	

2500–2000 B.C.	2000–1500 B.C.	1500–1000 B.C.
Sargon of Akkad, Akkadian ruler (r. 2340–2305), unifies Mesopotamian region and organizes first empire, encompassing land in Persia, Africa, and the Aegean **c. 2125** Gudea rules in Mesopotamia; c. 2060–1950, Third Dynasty of Ur comes to power in Sumeria, ushering in a period of great cultural development **2040–1674** Middle Kingdom in Egypt. After a period of chaos, Egyptian pharaohs strengthen the country, institute a centralized government, and conquer neighboring Nubia (present-day Ethiopia)	**c. 2000–750** Bronze Age in Europe **c. 1760–1600** Babylonian Empire, founded by Hammurabi, flourishes	**c. 1500–1145** New Kingdom in Egypt (Dynasties 18–20) **1478–1458** Queen Hatshepsut rules Egypt **c. 1450** Mycenaean forces conquer the Minoan city of Knossos on Crete **c. 1350** Assyrian Empire founded in Mesopotamia by Ashuruballit I; empire endures until 612 Pharaoh Akhenaten (r. 1348–1336/5) attempts radical alteration of Egyptian society. Deposed by Tutankhamen (r. 1336/5–1327) **c. 1319–1145** Ramesside period in Egypt (Dynasty 19), epitomized by Pharaoh Ramesses II, whose frequent wars against invaders bring about great expansion of Egyptian territory and influence **c. 1250** (traditional) Moses and Israelites flee to Palestine from Egypt to escape persecution **1184** (traditional) Attack on Troy in Asia Minor by united Greek armies under Agamemnon
		c. 1345 Akhenaten institutes a new monotheistic religion in Egypt **c. 1000** Hebrews in Palestine accept monotheism

The Great Sphinx, Egypt, c. 2570–2544 B.C. |

(left) Inanna-Ishtar, Mesopotamia, c. 2025–1763 B.C.

(right) Stonehenge, England, c. 2000 B.C. |

(top) "The Toreador Fresco," Crete, c. 1500 B.C.

(bottom) Tutankhamen Hunting, detail of a painted chest, Egypt, c. 1336/5–1327 B.C. |
| **c. 2350** *The Pyramid Texts,* early religious writings found on walls of Egyptian tombs | **c. 1900** *The Story of Sinuhe,* a Middle Kingdom Egyptian tale
c. 1760 Code of Hammurabi, first known legal document, carved on a stone monolith for the Babylonian king | **c. 1500** *Book of the Dead,* first manuscripts (on papyrus), encapsulating Egyptian religious thought |
| | **c. 2000** Iron used for tools and weapons in Asia Minor
c. 1725 Hyksos tribes introduce horse-drawn vehicles into Egypt
c. 1700 Babylonian mathematics flourish under Hammurabi: use of whole numbers, fractions, and square roots | **c. 1500** Chinese develop silk production
c. 1400 First Greek writing, known as Linear B, in general use in the Aegean |

	1000–600 B.C.	600–200 B.C.	200 B.C.– 1 A.D.
HISTORY AND POLITICS	**c. 1000–961** Israelite kingdom established by King David. Reign of his son, Solomon (961–922), is a time of legendary peace, justice, and stability **753** (traditional) Founding of Rome by Romulus **By 700** (traditional) Theseus unifies Athenian state Nebuchadnezzar, Neo-Babylonian king (r. 605–562). Under his rule the empire, based in Babylon, reaches its greatest extent, conquering Egypt (605) and Jerusalem (586)	**539** Persians conquer Babylonian Empire and Egypt (525). Expansion of Persian Empire **510** Roman Republic established **c. 510–508** Greece establishes the first government based on democratic principles **c. 499** Persians invade Greece; 490, defeated by Athenians at the Battle of Marathon **431–404** Peloponnesian War pits Greek city-states against one another; Athens is defeated by Sparta and its fleet destroyed at Syracuse **356–323** Alexander the Great leads Greek army in conquest of Egypt (333), Palestine, Phoenicia, and Persia (331) **264–201** Punic Wars waged between Rome and North Africa. Carthaginian general Hannibal marches from Spain and invades Italy (218), threatening Rome (211). He is defeated, and Roman expansion continues; Rome annexes Spain (201), by 147 dominates Asia Minor, Syria, Egypt, and Greece (146). Carthage destroyed (146)	**82–79** Sulla becomes first dictator of Roman state. Institutes substantial legal and legislative reforms **73–71** Slave rebellion led by the ex–gladiator Spartacus in Rome **51–30** Cleopatra, descendant of the Ptolemys, rules in Egypt **49–44** Julius Caesar (c. 101–44), Roman general, becomes dictator of Rome, after a military career in the provinces. Assassinated by a group of senators who fear his usurpation of power **31** Sea battle of Actium, on the western coast of Greece, in which Julius Caesar's cousin Octavian defeats Marc Antony, a rival, and consolidates the Roman Empire under his control. Octavian takes the name Augustus Caesar and rules with Imperial powers, 27 B.C.–14 A.D. Golden Age of Rome, the *Pax Romana*. Henceforth Roman emperors are hereditary, although the senate retains some powers
RELIGION	**776** First Olympic Games, established as a religious festival in Olympia, Greece	**c. 563** Siddhartha (Gautama Buddha), founder of Buddhism, born in Nepal **c. 250** Mithraism, worship of an ancient Persian warrior hero, grows in Roman Empire	**4** Birth of Jesus Christ, crucified c. 30 A.D.

Detail of *Ashurnasirpal II Killing Lions,* from the Palace of Ashurnasirpal II, Nimrud, Iraq, c. 850 B.C.

(left) The "Marsyas Painter" Red-figured pelike, Greece, c. 340 B.C
(right) *Nike of Samothrace,* c. 200–190 B.C.

Imperial Procession, from the Ara Pacis, Rome, c. 13–9 B.C.

MUSIC, LITERATURE, AND PHILOSOPHY	**c. 750–700** (traditional) Homer composes the epics *Iliad* and *Odyssey*	Confucius (551–c. 479), Chinese philosopher Pythagoras (c. 520), Greek philosopher **c. 500–400** Greek drama: Aeschylus (523–456), Sophocles (496–406), Euripides (480–406), Aristophanes (c. 448–385) **c. 450–300** Classical Greek philosophy: Socrates (470–399), Plato (c. 427?–c. 347), Aristotle (384–322) Demosthenes (384–322), Greek philosopher and orator	Cicero (106–43), Roman statesman and orator Vergil (70–19), Roman author of *The Aeneid,* epic poem narrating the mythic origins of the Romans Livy (59 B.C.–17 A.D.), author of *From the Founding of the City,* a history of Rome **c. 50** *Commentaries,* by Julius Caesar, detail the progress of his wars in France Ovid (43 B.C.–17 A.D.), poet of *The Metamorphoses,* amorous and mythological tales
SCIENCE AND TECHNOLOGY	**c. 800** Adoption of the Phoenician alphabet, ancestor of that of modern European languages, by Greeks **c. 700–600** Phoenician sailors circumnavigate African continent; c. 700, horseshoes invented in Europe by Celtic tribes **c. 650** Coins for currency imported from Asia Minor to Greece	**c. 500** Greek advances in metal working; invention of metal-casting and ore-smelting techniques **c. 300** Euclid, geometrician in Alexandria, writes *Elements,* fundamental text of mathematics and reasoning Pytheas, Greek explorer, travels the Atlantic coast of Europe, reaching points beyond Britain Archimedes (287–212), Greek mathematician	**c. 200** Standing army maintained by the Romans; development of the professional soldier; use of concrete as building material in the Roman Empire **c. 100** Earliest waterwheels Vitruvius' *On Architecture,* late first century B.C. manual of classical building methods and styles **46** Julius Caesar establishes the Julian calendar, in use until the 16th century A.D.

1 A.D.–100 A.D.	100–200 A.D.	200–300 A.D.
Claudius (r. 41–54), reluctant emperor of Rome, reconquers Britain In the reign of the emperor Nero (r. 54–68), a fire destroys most of Rome, which is soon rebuilt; first persecutions of Christians Emperor Trajan (r. 98–117) brings the Roman Empire to its greatest expansion, venturing into Persian territory and northern Germany. The city of Rome has an estimated population of one million **79** Eruption of Mount Vesuvius in southern Italy; destruction of cities of Pompeii and Herculaneum by lava and ash	**132–135** Jewish Diaspora begins; Jews expelled from Jerusalem Marcus Aurelius, emperor of Rome (r. 161–180), repulses the growing flood of Goth and Hun invaders from Northern Europe	**285** Emperor Diocletian (r. 284–305) divides Roman Empire among four emperors in separate zones. Beginning of Roman decline, loss of territories, economic troubles, and political dissent

Pompeii The sudden destruction of Pompeii by lava from Mount Vesuvius in 79 A.D. preserved intact an entire city. Private houses, public buildings, shops, plumbing systems, and even bits of furniture were encased in lava and mud. Pompeii was a town of modest importance in first-century Rome; it thus affords a remarkable view of daily life—both high and low—in the Empire. Grooves in paved streets mark the passage of carts and chariots. On the walls of fine villas are brightly colored paintings; on those of cheaper lodgings are scrawled political slogans and graffiti. Among the finest wall paintings, otherwise rare, are those of the luxurious villas of wealthy Pompeiians decorated lavishly with complex architectural scenes, figures, and landscape vistas. With ornate mosaic floors and elegant architecture, the Pompeiian villas illustrate the refinement of aristocratic Roman life.

c. 45–50 St. Paul spreads Christianity in Asia Minor and Greece St. Peter (died c. 64), first Bishop of Rome	**c. 130–68** Dead Sea Scrolls written; early manuscripts of Judaism and Christianity	**c. 250–302** Widespread persecution of Christians in Roman Empire

Spoils from the Temple in Jerusalem, from the Arch of Titus, Rome, 81 A.D.

(left) Pantheon, Rome, 118–125 A.D.

(right) Portrait of a Boy, Egypt, 2nd century A.D.

Seneca (4 B.C.–65 A.D.), prominent Roman Stoic philosopher and adviser to Emperor Nero Plutarch (c. 46–after 119), Greek essayist, author of *Parallel Lives of Greeks and Romans* **c. 47–49** Epistles of St. Paul, written during his missionary work in Asia Minor Tacitus (55–118), Roman historian and political commentator		Plotinus (205–270), Neo-Platonic Greek philosopher and author of the *Enneads,* teaches in Rome
c. 77 Pliny the Elder (23–79) writes his *Natural History,* an encyclopedic history, including a history of art Ptolemy (85–160), influential geographer and astronomer in Alexandria, popularizes the theory that the earth is at the center of the universe	**c. 100** Early glass-blowing techniques developed in Syria Galen (c. 130–200), Greek physician whose writings form the foundation of the study of human physiology	**By 200** Over 50,000 miles of paved roads built by Romans

PART TWO

THE MIDDLE AGES

When we think of great Western civilizations of the past, we tend to do so in terms of visible monuments that have come to symbolize the distinctive character of each: the pyramids of Egypt, the ziggurats of Babylon, the Parthenon of Athens, the Colosseum of Rome. The Middle Ages, in such a review of climactic achievements, would be represented by a Gothic cathedral—Notre-Dame in Paris, perhaps, or the cathedral of Chartres in France, or Salisbury Cathedral in England. We have many to choose from, but whichever one we pick, it will be well north of the Alps (although in territory that formerly belonged to the Roman Empire). And if we were to spill a bucket of water in front of the cathedral of our choice, this water would eventually make its way to the English Channel rather than to the Mediterranean Sea. Here, then, we have perhaps the most important single fact about the Middle Ages—the center of gravity of European civilization has shifted to what had been the northern boundaries of the Roman world. The Mediterranean, for so many centuries the great highway of commercial and cultural exchange binding together all the lands along its shores, has become a barrier, a border zone.

How did this dramatic shift come about? In 323 A.D. Constantine the Great made a fateful decision, the consequences of which are still felt today. He resolved to move the capital of the Roman Empire to the Greek town of Byzantium, which came to be known then as Constantinople and today as Istanbul. Six years later, after an energetic building campaign, the transfer was officially completed. In taking this step, the emperor acknowledged the growing strategic and economic importance of the eastern provinces, a development that had been evolving for some time. The new capital also symbolized the new Christian basis of the Roman state, since it was in the heart of the most thoroughly Christianized region of the empire.

Constantine could hardly have foreseen that shifting the seat of imperial power would result in splitting the realm. In 395, less than 75 years after the capital was relocated in the East, the division of the Roman Empire into the Eastern and Western empires was official and permanent. That separation eventually led to a religious split as well.

By the end of the fifth century, the bishop of Rome, who derived his authority from St. Peter, regained independence from the emperor and reasserted his claim as the acknowledged head—the pope—of the Christian Church. His claim to preeminence, however, soon came to be disputed by the Eastern counterpart to the pope, the patriarch of Constantinople. Differences in doctrine began to develop, and eventually the division of Christendom into a Western, or Catholic, and an Eastern, or Orthodox, Church became all but final. Institutionally, the differences between them went very deep. Roman Catholicism maintained its autonomy from imperial or any other state authority and became an international institution, reflecting its character

as the Universal Church. The Orthodox Church, on the other hand, was based on the union of spiritual and secular authority in the person of the emperor, who appointed the patriarch. It thus remained dependent on the power of the State, exacting a double allegiance from the faithful and sharing the vicissitudes of political power. This tradition did not die even with the fall of Constantinople to the Ottoman Turks in 1453. The czars of Russia claimed the mantle of the Byzantine emperors, Moscow became "the third Rome," and the Russian Orthodox Church was as closely tied to the State as was its Byzantine parent body.

Under Justinian (ruled 527–65), the Eastern (or Byzantine) Empire reached new power and stability after riots in 532 nearly deposed him. In contrast, the Latin West soon fell prey to invading Germanic peoples: Visigoths, Vandals, Franks, Ostrogoths, and Lombards. By the end of the sixth century, the last vestige of centralized authority had disappeared even though the emperors at Constantinople did not relinquish their claim to the western provinces. Yet these invaders, once they had settled in their new environment, accepted the framework of late Roman, Christian civilization, however imperfectly. The local kingdoms they founded—the Vandals in North Africa, the Visigoths in Spain, the Franks in Gaul, the Ostrogoths and Lombards in Italy—were all Mediterranean-oriented, provincial states on the periphery of the Byzantine Empire, subject to the pull of its military, commercial, and cultural power. As late as 630, after the Byzantine armies had recovered Syria, Palestine, and Egypt from the Sassanid Persians, the reconquest of the lost western provinces remained a serious possibility. Ten years later, the chance had ceased to exist, for a tremendous and completely unforeseen new force had made itself felt in the East: Islam.

Under the banner of Islam, the Arabs overran the African and Near Eastern parts of the Empire, and by 732, a century after Mohammed's death, they had absorbed Spain as well and threatened to add southwestern France to their conquests. In the eleventh century, the Turks occupied much of Asia Minor, while the last Byzantine possessions in the West (in southern Italy) fell to the Normans, from northwestern France. The Eastern Empire, with its domain reduced to the Balkan peninsula, including Greece, held on until 1453, when the Turks finally conquered Constantinople itself.

Islam had created a new civilization stretching to the Indus Valley (now Pakistan) in the East, a civilization that reached its highest point far more rapidly than did that of the medieval West. Baghdad, on the Tigris, the most important city of Islam in the eighth century, rivaled the splendor of Byzantium. Islamic art, learning, and crafts were to have a far-ranging influence on the European Middle Ages, from arabesque ornament, the manufacture of paper, and Arabic numerals to the transmission of Greek philosophy and science through the writings of Arab scholars. (The English language records this debt in such words of Arabic origin as *algebra* and *alcohol.*)

It would be difficult to exaggerate the impact of the lightning-like advance of Islam

on the Christian world. The Byzantine Empire, deprived of its western Mediterranean bases, concentrated all its efforts on keeping Islam at bay in the East. Byzantium's impotence in the West, where it retained only a precarious foothold on Italian soil, left the European shore of the western Mediterranean, from the Pyrenees to Naples, exposed to Arabic raiders from North Africa and Spain. Western Europe was thus forced to develop its own resources—political, economic, and spiritual.

The process was slow and difficult, however. The early medieval world, beset by unremitting upheaval, presents a constantly shifting picture. Not even the Frankish kingdom, ruled by the Merovingian dynasty from about 500 to 751, was capable of imposing more than temporary order. As the only international organization of any sort, Christianity was to play a critical role in promoting a measure of stability. Yet it, too, was divided between the papacy, whose influence was limited, and the monastic orders that spread quickly throughout Europe but remained largely independent of the Church in Rome.

This rapid expansion of Christianity, like that of Islam, cannot be explained simply in institutional terms, for the Church was at best an imperfect embodiment of Christian ideals. Moreover, its success was hardly guaranteed. In fact, its position was often precarious under Constantine's Latin successors. Instead, Christianity must have exercised an extraordinarily persuasive appeal, spiritual as well as moral, on the masses of people who heard its message.

Church and State gradually discovered that cooperation worked to their mutual advantage and that, in fact, they could not live without each other. What was needed, however, was an alliance between a strong central secular authority and a united church. This link was forged when the Catholic church, which had now gained the allegiance of the religious orders, broke its last ties with the East and turned for support to the Germanic north. There the energetic leadership of Charlemagne and his heirs—the Carolingian dynasty—made the Frankish kingdom into the leading power during the second half of the eighth century after overturning the Merovingian dynasty. In 800, the pope solemnized the new order of things by bestowing the title of emperor upon Charlemagne.

In placing himself and all of Western Christianity under the protection of the king of the Franks and Lombards, the pope nevertheless did not subordinate himself to the newly created Catholic emperor, whose legitimacy depended on the pope. (Formerly it had been the other way around: the emperor in Constantinople had ratified the newly elected pope.) This interdependent dualism of spiritual and political authority, of Church and State, was to distinguish the West from both the Orthodox east and the Islamic south. Its outward symbol was the fact that though the emperor had to be crowned in Rome, he did not reside there. Charlemagne built his capital at the center of his effective power, in Aachen, located, on the present-day map of Europe, in Germany and close to France, Belgium, and the Netherlands.

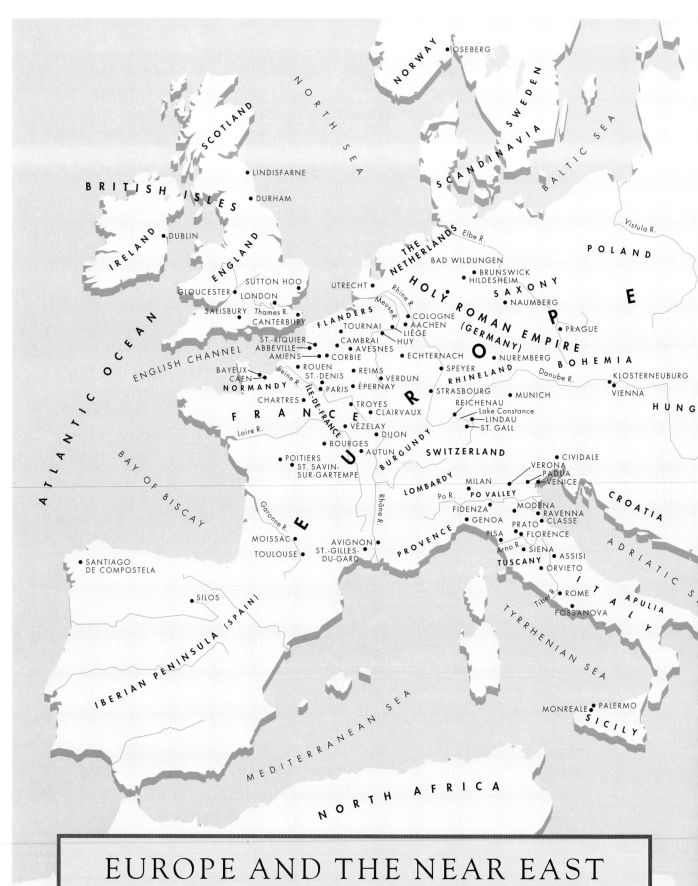

NORWAY
• OSEBERG

SWEDEN

SCANDINAVIA

NORTH SEA

BALTIC SEA

SCOTLAND

• LINDISFARNE

BRITISH ISLES

• DURHAM

IRELAND

• DUBLIN

ENGLAND

THE NETHERLANDS

Elbe R.

POLAND

Vistula R.

BAD WILDUNGEN

HOLY ROMAN EMPIRE (GERMANY)

BRUNSWICK
HILDESHEIM

SAXONY

• NAUMBERG

SUTTON HOO

UTRECHT

E
O
P

GLOUCESTER

LONDON

Rhine R.

PRAGUE

BOHEMIA

SALISBURY

Thames R.

CANTERBURY

FLANDERS

Meuse R.

COLOGNE
AACHEN
LIÈGE

TOURNAI

HUY

ECHTERNACH

NUREMBERG

ST.-RIQUIER
ABBEVILLE

CAMBRAI
AVESNES

CORBIE

SPEYER

RHINELAND

Danube R.

KLOSTERNEUBURG

AMIENS

BAYEUX
CAEN

NORMANDY

Seine R.

ROUEN
ST.-DENIS

REIMS

VERDUN

ÉPERNAY

STRASBOURG

REICHENAU

MUNICH

VIENNA

HUNG

U

PARIS

ÎLE-DE-FRANCE

CHARTRES

Lake Constance
LINDAU
ST. GALL

R

FRANCE

TROYES

CLAIRVAUX

VÉZELAY

Loire R.

DIJON

BOURGES

AUTUN

BURGUNDY

SWITZERLAND

CIVIDALE

POITIERS
ST. SAVIN-
SUR-GARTEMPE

E

LOMBARDY

VERONA
PADUA

MILAN

Po R.

PO VALLEY

VENICE

CROATIA

ATLANTIC OCEAN

ENGLISH CHANNEL

BAY OF BISCAY

Garonne R.

FIDENZA

GENOA

MODENA

RAVENNA

PRATO

CLASSE

PISA

FLORENCE

Rhône R.

PROVENCE

MOISSAC

TOULOUSE

AVIGNON
ST.-GILLES-
DU-GARD

Arno R.

SIENA

TUSCANY

ASSISI

ORVIETO

ADRIATIC S

I
T
A
L
Y

APULIA

SANTIAGO
DE COMPOSTELA

Tiber R.

ROME

FOSSANOVA

TYRRHENIAN SEA

SILOS

IBERIAN PENINSULA (SPAIN)

MEDITERRANEAN SEA

NORTH AFRICA

MONREALE • PALERMO

SICILY

EUROPE AND THE NEAR EAST
IN THE MIDDLE AGES

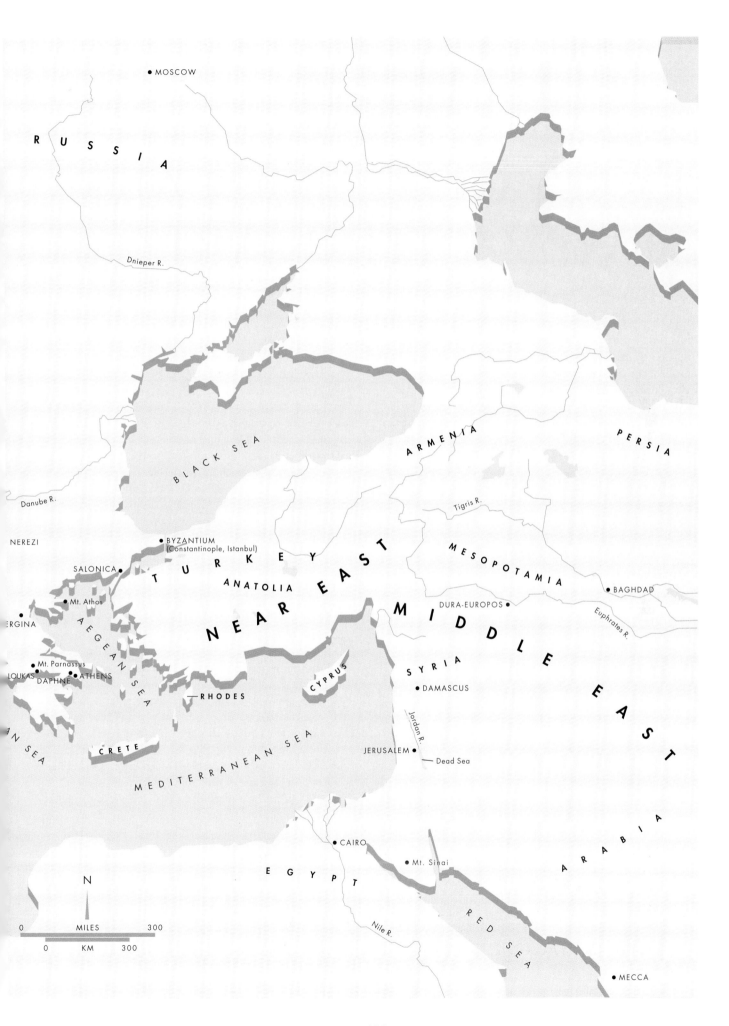

MOSCOW

R U S S I A

Dnieper R.

BLACK SEA

Danube R.

ARMENIA

PERSIA

Tigris R.

MESOPOTAMIA

BAGHDAD

NEREZI

BYZANTIUM
(Constantinople, Istanbul)

SALONICA

T U R K E Y

ANATOLIA

N E A R E A S T

M I D D L E E A S T

DURA-EUROPOS

Euphrates R.

Mt. Athos

ERGINA

A E G E A N S E A

Mt. Parnassus

LOUKAS

DAPHNE

ATHENS

RHODES

CYPRUS

SYRIA

DAMASCUS

Jordan R.

AN SEA

CRETE

JERUSALEM

Dead Sea

MEDITERRANEAN SEA

CAIRO

Mt. Sinai

E G Y P T

A R A B I A

RED SEA

Nile R.

MECCA

N

MILES

0 300

0 KM 300

229

CHAPTER ONE

EARLY CHRISTIAN AND BYZANTINE ART

In the third century A.D., the Roman world was gripped by a spiritual crisis that reflected broad social turmoil as the empire gradually disintegrated. Characteristic of the mood of the times was the spread of Oriental mystery religions. They were of various origins—Egyptian, Persian, Semitic—and their early development naturally centered in their home territory, the southeastern provinces and border regions of the Roman Empire. Although based on traditions in effect long before the conquest of these ancient lands by Alexander the Great, the cults had been strongly influenced by Greek ideas during the Hellenistic period. It was, in fact, to this fusion of Oriental and Greek elements that they owed their vitality and appeal.

At that time, the Near East was a vast religious and cultural melting pot where all of the many competing faiths (including Judaism, Christianity, Mithraism, Manichaeism, Gnosticism, and many more) tended to influence each other, so that they had a number of things in common, whatever their differences of origin, ritual, or nomenclature. Most of them shared such features as an emphasis on revealed truth, the hope of salvation, a chief prophet or messiah, the dichotomy of good and evil, a ritual of purification or initiation (baptism), and the duty to seek converts among "unbelievers." The last and, in the Near East, the most successful development of this period was Islam, which dominates the area to this day.

The growth of the Graeco-Oriental religions under Roman rule is difficult to trace, since many of them were underground movements that have left few tangible remains. This is true of Christianity as well. The Gospels of Mark, Matthew, Luke, and John (their probable chronological order) were written in the later first century and present somewhat varying pictures of Jesus and his teachings; in part, these reflect doctrinal differences between St. Peter, the first bishop of Rome, and St. Paul, a tireless proselytizer and the most important of the early converts. For the first three centuries after Christ, congregations were disinclined to worship in public. Instead, their simple services, held at best at portable altars with a minimum of implements or vestments (garments worn by those conducting services), took place in the houses of the wealthier members. The new faith spread first to the Greek-speaking communities, notably Alexandria, then to the Latin world by the end of the second century.

Even before it was declared a lawful religion in 261 by the emperor Gallienus, Christianity was rarely persecuted. It suffered chiefly under Diocletian, whose successor, Galerius, issued an edict of toleration in 309. Nevertheless, it had little standing until the conversion of Constantine the Great in 312, despite the fact that nearly one-third of Rome was by then Christian. According to Bishop Eusebius of Caesarea, based on Constantine's own account late in life, on the eve of the decisive battle against Constantine's rival Maxentius at the Milvian Bridge over the Tiber River in Rome, there appeared in the sky the sign of the cross with the inscription "In this sign, conquer." The next night, Christ came to Constantine in a dream with the sign (undoubtedly the Chi Rho monogram, the *labarum*) and commanded him to copy it, whereupon he had it emblazoned on his helmet and on the military standards of his soldiers. Following his victory, Constantine accepted the faith, if he had not done so already, although he was baptized only on his deathbed. The following year, 313, he and his fellow emperor, Licinius, promulgated the Edict of Milan, which proclaimed freedom of religion throughout the empire.

Constantine never declared Christianity the official state religion. Still, it enjoyed special status under his patronage. The emperor championed its cause and played an active role in shaping its theological program, partly in an effort to settle doctrinal disputes. Unlike his pagan predecessors, Constantine could no longer command the status of a deity, but he did claim that his authority was granted directly from God. Thus he retained a unique and exalted role by placing himself at the head of the Church as well as of the State. We recognize this claim as the adaptation of an ancient heritage: the divine kingship of Egypt and the Near East. Although the sincerity of Constantine's faith is not to be doubted, he set a pattern for future Christian rulers in using religion for personal and imperial ends, for example, by continuing to promote the cult of the emperor.

Eastern Religions

The area where the development of the Graeco-Oriental religions took place has been a theater of war and destruction so many times over the centuries that major finds, such as the

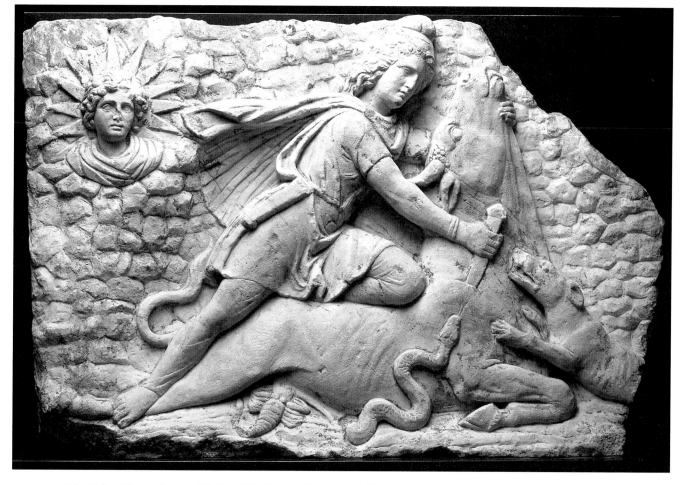

294. *Mithras Slaying the Sacred Bull.* c. 150–200 A.D. Limestone, 24 ⅝ x 37 ½" (62.5 x 95.2 cm). Cincinnati Art Museum.
Gift of Mr. and Mrs. Fletcher E. Nyce

discovery of the *Dead Sea Scrolls* in 1947, are rare events indeed. There is sufficient evidence, however, to indicate that the new faiths also gave birth to a new style in art, and that this style, too, resulted from a fusion of Graeco-Roman and Oriental elements.

MITHRAS. *Mithras Slaying the Sacred Bull* (fig. 294) shows an early stage in this process. It depicts the central myth of the cult: the god Mithras captures and sacrifices the bull, which was associated with spring, thereby releasing its vital life-giving forces to the snake, symbol of earth, as the scorpion, the astrological sign of autumn, is shown sapping the bull's strength. Originally a minor figure in the pantheon of the Persian prophet Zoroaster (Zarathustra; c. 628–c. 551 B.C.), Mithras emerged as the principal deity of Persia; from there Mithraism spread, eventually becoming the leading mystical sect of the Roman Empire during the second century, when our relief was carved. The image encompasses the principal features of the religion: the ceaseless struggle of good versus evil, and the triumph of life over death. These dualistic forces were represented by light and darkness, portrayed by the Roman sun-god Helios to the left and his counterpart, the moon goddess Luna, unfortunately missing at the right.

The composition is indebted to Late Classical reliefs (compare fig. 203), in which similar Persian figures appear in hunting scenes and battles against the Greeks. Indeed, Helios is astonishingly close to the head of the *Apollo Belvedere* (see fig. 208). The whole nevertheless has an exotic character that is unmistakably Oriental. This is not only evident in the subject and costume but is also inherent in the composition. The juxtaposition of hero and beast has an ancient history in the Near East, where the ancestry of the clear layout, with its symbolic intent, can also be found (compare figs. 92 and 97). So, too, does the sympathetic portrayal of the splendid bull in its death throes (see fig. 104), which is echoed as well in the struggling cows on the *Vaphio Cups* (figs. 133 and 134).

The sophisticated technique and classical style indicate that the Mithraic relief was carved in Rome itself, where it was found. These features are nevertheless unusual. For the most part, the artists who wrestled with the task of coining images to express the contents of these faiths were not among the most gifted of their time. They were provincial craftsmen of modest ambition who drew upon whatever visual sources happened to be available to them, adapting, combining, and reshaping these as best they could. Their efforts are often clumsy, yet it is here that we find the beginnings of a tradition that was to become of basic importance for the development of medieval art.

DURA-EUROPOS. The most telling illustrations of this new compound style have been found in the Mesopotamian town of Dura-Europos on the upper Euphrates, a Roman

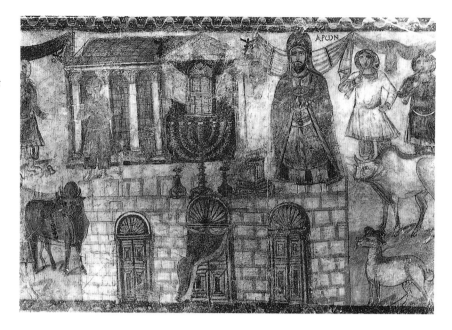

295. *The Consecration of the Tabernacle and Its Priests,* from the Assembly Hall of the Synagogue at Dura-Europos. 245–56 A.D. Mural, 4'8 1/4" x 7'8 1/4" (1.4 x 2.3 m). National Museum, Damascus, Syria

frontier station that was captured by the resurgent Persians under Shapur I about 256 A.D. (see page 97) and abandoned by its population soon after. Its ruins have yielded the remains of sanctuaries of several religions, including Mithraism and Christianity, decorated with murals which all show essentially the same Graeco-Oriental character. The finest and best preserved are those from the assembly hall of a synagogue, painted about 250 A.D. Of their numerous compartments, we illustrate the one representing the consecration of the tabernacle (fig. 295).

It is characteristic of the melting-pot conditions described above that even Judaism should have been affected by them. Momentarily, at least, the age-old injunction against images as idolatrous was relaxed so that the walls of the assembly hall could be covered with a richly detailed visual account of the history of the Chosen People and their Covenant with the Lord. [See Primary Sources, no. 20, page 382.] The new attitude seems to have been linked with a tendency to change Judaism from a national to a universal faith by missionary activity among the non-Jewish population. (Interestingly, some of the inscriptions on the murals, such as the name Aaron in figure 295, are in Greek.) In any event, we may be sure that the artists who designed these pictures faced an unaccustomed task, just as did the painters who worked for the earliest Christian communities. They had to cast into visible form what had hitherto been expressed only in words. How did they go about it? Let us take a closer look at our illustration. We can read the details—animals, human beings, buildings, cult objects—without trouble, but their relationship eludes us. There is no action, no story, only an assembly of forms and figures confronting us in the expectation that we will be able to establish the proper links between them. The frieze in the Villa of the Mysteries (fig. 289) presents a similar difficulty. There, too, the beholder is supposed to know what is represented. Yet it strikes us as much less puzzling, for the figures have an eloquence of gesture and expression that makes them meaningful even though we may not understand the context of the scenes.

If the synagogue painter fails to be equally persuasive, must we attribute this to a lack of competence, or are there other

reasons as well? The question is rather like the one we faced when discussing the Constantinian relief in figure 285, which resembles the Dura-Europos mural in a number of ways. The synagogue painter exhibits the same sense of self-sufficiency, of condensation for the sake of completeness, but the subject is far more demanding. The mural had to represent an historical event of great religious importance: the consecration of the tabernacle and its priests, which began the reconciliation of humanity and God, as described in detail in the Holy Scriptures. And it had to do so in such a way as to suggest that this was also a timeless, recurrent ritual. Thus the picture is burdened with a wealth of significance far greater and more rigidly defined than that of the Dionysiac frieze or the Constantinian relief. Nor did the artist have a well-established tradition of Jewish religious painting at his disposal to help him visualize the tabernacle and the consecration ceremony.

No wonder our painter has fallen back on a sort of symbolic shorthand composed of images borrowed from other, older traditions. The tabernacle itself, for instance, is shown as a Classical temple simply because our artist could not imagine it, in accordance with the biblical description, as a tentlike construction of poles and goat's-hair curtains. The attendant and the red heifer in the lower left-hand corner are derived from Roman scenes of animal sacrifice; hence, they show remnants of foreshortening not found among the other figures. Other echoes of Roman painting appear in the perspective view of the altar table next to the figure of Aaron, in the perfunctory modeling here and there, and in the rudimentary cast shadows attached to some of the figures. Did the painter still understand the purpose of these shadows? They seem to be mere empty gestures, since the rest of the picture betrays no awareness of either light or space in the Roman sense. Even the occasional overlapping of forms appears largely accidental.

The sequence of things in space is conveyed by other means: the seven-branched candlestick, or menorah, the two incense burners, the altar, and Aaron are to be understood as behind, rather than on top of, the crenellated wall that shields the precinct of the tabernacle. Their size, however, is governed by their importance, not by their position in space. Aaron, as the principal figure, is not only larger than the attendants but

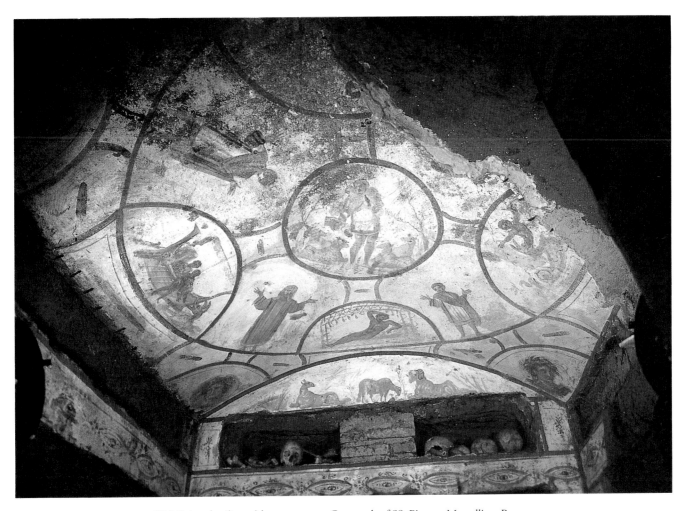

296. Painted ceiling. 4th century A.D. Catacomb of SS. Pietro e Marcellino, Rome

also more rigid and abstract. His costume, because of its ritual significance, is diagramed in detail, at the cost of obliterating the body underneath. The attendants, on the other hand, still show a residue of mobility and three-dimensional existence. Their garments, surprisingly enough, are Persian, an indication not only of the odd mixture of civilizations in this border area but of possible artistic influences from Persia.

Our synagogue mural, then, combines—in none-too-skillful a fashion—a considerable variety of formal elements whose only common denominator is the religious message of the whole. In the hands of a great artist, this message might have been a stronger unifying force, but even then the shapes and colors would have been no more than a humble, imperfect simile of the spiritual truth they were meant to serve. That, surely, was the outlook of the authorities who supervised the execution of the mural cycle and controlled its program. The essential quality of these pictures can no longer be understood in the framework of ancient art. They express an attitude that seems far closer to the Middle Ages. If we were to sum up their purpose in a single phrase, we could hardly do better than to quote a famous dictum justifying the pictorial representation of Christian themes: *Quod legentibus scriptura, hoc idiotis . . . pictura.* Translated freely it means: painting conveys the Word of God to the unlettered. [See Primary Sources, no. 21, page 382.]

EARLY CHRISTIAN ART

When and where the first Christian works of art were produced remain a matter of conjecture. Of the surviving monuments, none can be dated earlier than about 200 A.D., so that we lack all direct knowledge of art in the service of Christianity before that time. In fact, there is little we know for certain about Christian art until we reach the reign of Constantine the Great, because the third century, too, is poorly represented. The only Christian house found at Dura Europos has murals that are far less extensive or developed than the synagogue frescoes. The painted decorations of the Roman catacombs, the underground burial places of the Christians, provide the only sizable and coherent body of material, but these are only one among various possible kinds of Christian art that may have existed.

Catacombs

The catacomb paintings tell us a good deal about the spirit of the communities that sponsored them, even if the dearth of material from the eastern provinces of the empire makes it difficult to judge their position within the early development of Christian art. The burial rite and the safeguarding of the tomb were of vital concern to the early Christian, whose faith rested on the hope of eternal life in paradise. In the painted ceiling in figure 296, the imagery of the catacombs clearly expresses

this otherworldly outlook, although the forms are in essence still those of pre-Christian mural decoration. We recognize the division of the ceiling into compartments as a late and highly simplified echo of the illusionistic architectural schemes in Pompeian painting. The modeling of the figures, as well as the landscape settings, betray their descent from the same Roman idiom, which here, in the hands of an artist of very modest ability, has become debased by endless repetition. But the catacomb painter has used this traditional vocabulary to convey a new, symbolic content, and the original meaning of the forms is of little interest to him. Even the geometric framework shares in this task, for the great circle suggests the Dome of Heaven, inscribed with the Cross, the basic symbol of the faith. In the central medallion we see a youthful shepherd, with a sheep on his shoulders, in a pose that can be traced back as far as Greek Archaic art (compare fig. 149). He stands for Christ the Saviour, the Good Shepherd who gives his life for his flock.

The semicircular compartments tell the story of Jonah. On the left he is cast from the ship, on the right he emerges from the whale, and at the bottom he is safe again on dry land, meditating upon the mercy of the Lord. This Old Testament miracle, often juxtaposed with New Testament miracles, enjoyed great favor in Early Christian art as proof of the Lord's power to rescue the faithful from the jaws of death. The standing figures may represent members of the Church, with their hands raised in prayer, pleading for divine help. The entire scheme, though small in scale and unimpressive in execution, has a consistency and clarity that set it apart from its Graeco-Roman ancestors, as well as from the synagogue murals of Dura-Europos (see fig. 295). Here is, if not the reality, at least the promise of a truly monumental new form (compare fig. 341).

Architecture

Constantine's decision to sanction Christianity as a legal religion of the Roman Empire had a profound impact on Christian art. Now, almost overnight, an impressive architectural setting had to be created for the newly approved faith, so that the Church might be visible to all. Constantine himself devoted the full resources of his office to this task, and within a few years an astonishing number of large, imperially sponsored churches arose, not only in Rome but also in Constantinople, the Holy Land, and other important centers.

THE BASILICA. These structures were a new type, now called the Early Christian basilica, that provided the basic model for the development of church architecture in western Europe. Unfortunately, none of them has survived in its original form, but the plan of the greatest Constantinian church, Old St. Peter's in Rome, is known with considerable accuracy (figs. 297 and 298). [See Primary Sources, no. 22, page 382.] For an impression of the interior, we must draw upon the slightly later basilica of St. Paul Outside the Walls, built on the same pattern, which remained essentially intact until it was wrecked by fire in 1823 (fig. 299). The Early Christian basilica, as exemplified in these two monuments, has features of assembly hall, temple, and private house. It also has the qualities of an original creation that cannot be wholly explained in terms of its sources.

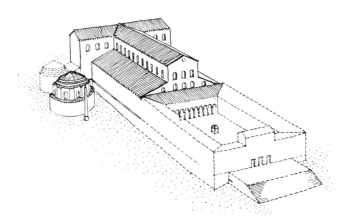

297. Reconstruction of Old St. Peter's, Rome. Begun c. 333 A.D. (after Frazer)

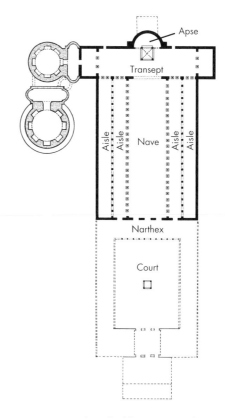

298. Plan of Old St. Peter's (after Frazer)

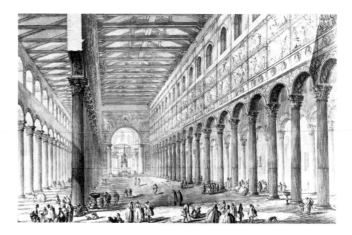

299. Interior, St. Paul Outside the Walls, Rome. Begun 386 A.D. (etching by G. B. Piranesi, 1749)

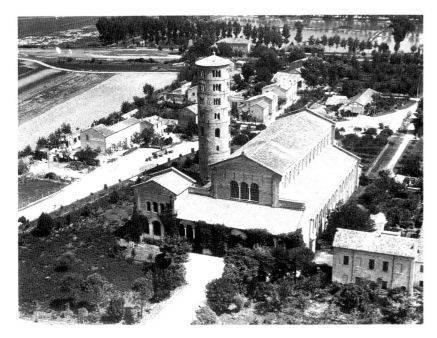

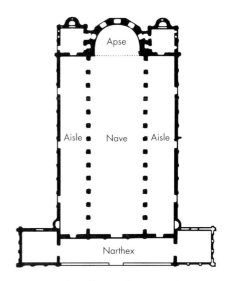

300. S. Apollinare in Classe, Ravenna, Italy. 533–49 A.D.

301. Plan of S. Apollinare in Classe
(after De Angelis d'Ossat)

The Early Christian basilica owes the long nave flanked by aisles and lit by clerestory windows, the apse, and the wooden roof to the imperial basilicas, such as that at Leptis Magna, erected a hundred years earlier (figs. 253 and 254). The Roman basilica was by no means unique to Christianity. It had already been employed by pagan cults and Judaism. It was nevertheless a suitable model for Constantinian churches, since it combined the spacious interior demanded by Christian ritual with imperial associations that proclaimed the privileged status of Christianity. But a church had to be more than an assembly hall. In addition to enclosing the community of the faithful, it was the sacred House of God, the Christian successor to the temples of old. In order to express this function, the basilica had to be redesigned. The plan of the Early Christian basilica (fig. 298) was given a new focus, the altar, which was placed in front of the apse at the eastern end of the nave, while the entrances, which in earlier basilicas had usually been on the flanks, were shifted to the western end. The Christian basilica was thus oriented along a single, longitudinal axis that

is curiously reminiscent of the layout of Egyptian temples (compare fig. 76).

Before entering the church proper, we traverse a colonnaded court, the atrium (a feature derived from the domus; see fig. 255), the far side of which forms an entrance hall, the narthex. Only when we step through the nave portal do we gain the view presented in figure 299. The steady rhythm of the nave arcade pulls us toward the great arch at the eastern end, which frames the altar and the vaulted apse beyond. As we come closer, we realize that the altar stands in a separate compartment of space placed at right angles to the nave and aisles forming a cross plan, the transept. (This feature is frequently omitted, especially in the lesser basilican churches.)

One essential aspect of Early Christian religious architecture has not yet emerged from our discussion: the contrast between exterior and interior. It is strikingly demonstrated in the sixth-century church of S. Apollinare in Classe (Classe is the seaport of Ravenna), which still retains its original appearance for the most part (figs. 300–302). Our view, taken from

<div style="border:1px solid;">

The central rite of many Christian churches is the Eucharist or communion service, a ritual meal that reenacts Jesus' Last Supper. In the Catholic church and in a few Protestant churches as well, this service is known as the Mass (from the Latin words *Ite, missa est,* "Go, [the congregation] is dismissed" at the end of the Latin service). The Mass was first codified by Pope Gregory the Great about 600. Each Mass consists of the "ordinary"—those prayers and hymns that are the same in all masses—and the "proper," the parts that vary, depending on the occasion. In addition to a number of specific prayers, the "ordinary" consists of five hymns: the *Kyrie Eleison* (Greek for "Lord have mercy on us"); the *Gloria in Excelsis* (Latin for "Glory in the highest"); *Credo* (Latin for "I believe," a statement of faith also called the Creed); *Sanctus* (Latin for "Holy"); and *Agnus Dei* (Latin for "Lamb of

The Liturgy of the Mass

God"). The "proper" of the Mass consists of prayers, two readings from the New Testament (one from the Epistles and one from the Gospels); a homily, or sermon, on these texts; and hymns, all chosen specifically for the day.

Musical settings for the five "ordinary" hymns, also called a mass, have been a major compositional form from 1400 into the twentieth century, although these masses follow no set tradition and have considerable variety. Many of the greatest composers have written masses, including Josquin Des Prés, Bach, Haydn, Mozart, Beethoven, Verdi, Stravinsky, Britten, and Bernstein. These works often depart rather freely from liturgical requirements of the Mass, as they were written for special occasions, such as the Requiem Mass for the dead, the Nuptial Mass for weddings, and the Coronation Mass.

</div>

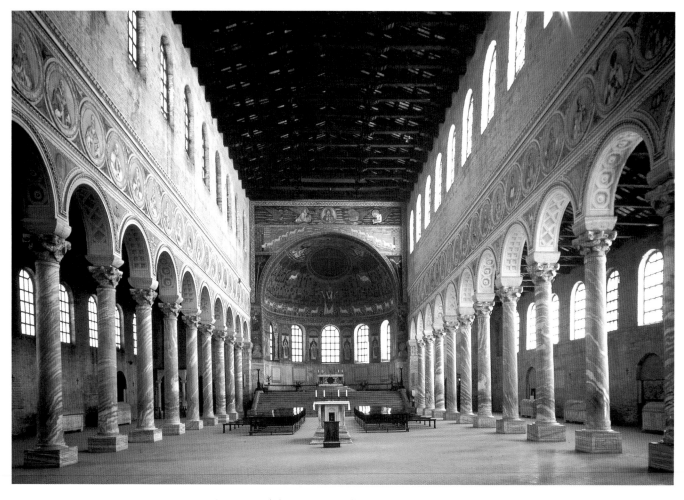

302. Interior (view toward the apse), S. Apollinare in Classe, Ravenna. 533–49 A.D.

the west, shows the narthex but not the atrium, which was torn down a long time ago. (The round bell tower, or campanile, is a medieval addition.) As the plan reveals, the church lacks a transept. The plain brick exterior remains conspicuously unadorned. It is only a shell whose shape reflects the interior space it encloses—the exact opposite of the Classical temple. This ascetic, antimonumental treatment of the exterior gives way to the utmost richness as we enter the church. Having left the everyday world behind, we find ourselves in a shimmering realm of light and color where precious marble surfaces and the brilliant glitter of mosaics evoke the spiritual splendor of the Kingdom of God.

DOMED STRUCTURES. We must take note of another type of structure that entered the tradition of Christian architecture in Constantinian times: round or polygonal buildings crowned with a dome. Also known as central-plan churches, they developed out of the elaborate Roman baths. (The design of the Pantheon, we will recall, was derived from that source; see pages 182–85.) Similar structures had been built by Roman emperors to serve as monumental tombs, or mausoleums. In the fourth century, this type of building was given a Christian meaning in the baptisteries (where the bath became the sacred rite of baptism) and in the funerary chapels (where the hope for eternal life was expressed) that were linked with basilican churches. Because of these symbolic associations, central-plan churches became widely adopted. Most were derived from a handful of venerated sites, such as the Church of the Holy Sepulchre in Jerusalem, but these served only as a point of departure, so that considerable liberties were taken with them. The sense of geometry was surprisingly loose. The shape could be round or polygonal and need incorporate only one or two significant features and measurements to establish the identity with its model. Symbolism even played an important role in the number of elements and their configuration. Octagons were favored, for example, because the number eight was a symbol of resurrection. This free approach was typical of Early Christian architecture as a whole. Thus we find wide variation from building to building—not only domed structures but basilican churches as well.

The finest surviving example is Sta. Costanza (figs. 303–5), the mausoleum of Constantine's daughter Constantia, originally attached to the (now ruined) Roman church of St. Agnes Outside the Walls. In contrast to its predecessors, it shows a clear articulation of the interior space into a domed cylindrical core lit by clerestory windows—the counterpart of the nave of a basilican church—and a ring-shaped "aisle" or ambulatory covered by a barrel vault. Once again the mosaic decoration plays an essential part in setting the mood of the interior. Here the motifs are secular in the ambulatory but Christian in the two apsidal chapels, a striking contrast that attests to how long the two motifs coexisted.

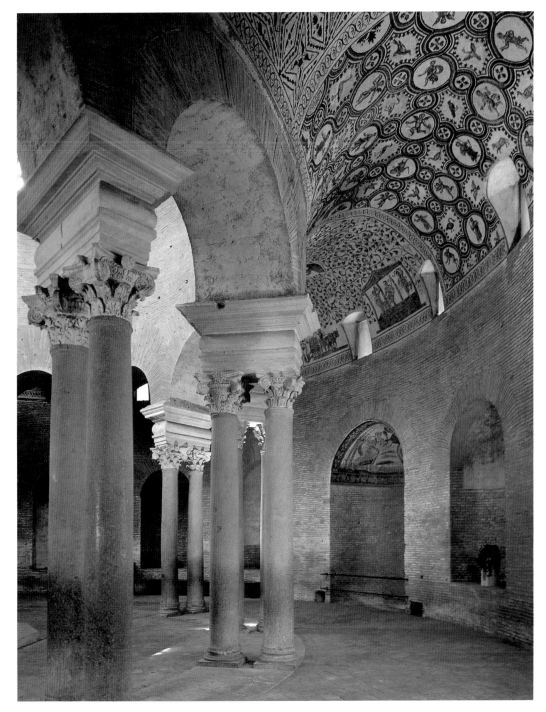

303. Interior, Sta. Costanza, Rome. c. 350 A.D.

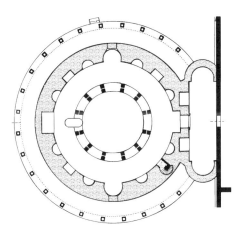

304. Plan of Sta. Costanza

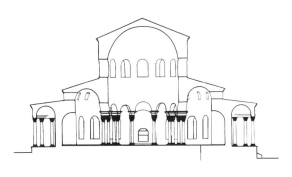

305. Section of Sta. Costanza

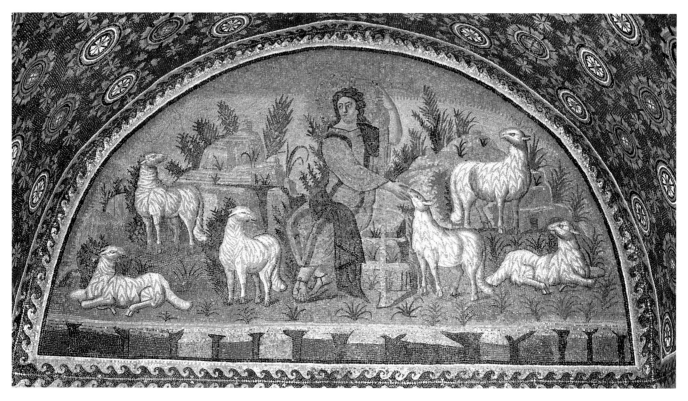

306. *Good Shepherd.* 425–50. Mosaic. Mausoleum of Galla Placidia, Ravenna

Mosaics

The rapid growth of Christian architecture on a large scale had a revolutionary effect on the development of Early Christian painting. All of a sudden, huge wall surfaces had to be covered with images worthy of their monumental framework. Who was equal to this challenge? Certainly not the humble artists who had decorated the catacombs with their limited stock of types and subjects. They were superseded by masters of greater ability—recruited, we may suppose, under imperial auspices, as were the architects of the new basilicas. Unfortunately, so little of the decoration of fourth-century churches has survived that its history cannot be traced in detail.

WALL MOSAICS. Out of this process emerged a great new art form, the Early Christian wall mosaic, which to a large extent replaced the older and cheaper medium of mural painting. Mosaics—designs composed of small pieces of colored material set in plaster—had been used by the Sumerians as early as the third millennium B.C. to embellish architectural surfaces. The Hellenistic Greeks and the Romans, employing small cubes of marble called tesserae, had refined the technique to the point that it could reproduce paintings, as in *The Battle of Issus* (see fig. 199). But these were mostly floor mosaics, and the color scale, although rich in gradations, lacked brilliance, since it was limited to the various kinds of colored marble found in nature. The Romans would also produce wall mosaics occasionally, but only for special purposes and on a limited scale.

The extensive and intricate wall mosaics of Early Christian art thus are essentially without precedent. The same is true of their material, for they consist of tesserae made of colored glass. These, too, were not entirely unknown to the Romans, yet their special virtues had never been exploited before. They offered colors, including gold, of far greater range and intensity than marble tesserae, but lacked the fine gradations in tone necessary for imitating painted pictures. Moreover, the shiny (and slightly irregular) faces of glass tesserae act as tiny reflectors, so that the overall effect is that of a glittering, immaterial screen rather than of a solid, continuous surface. All these qualities made glass mosaic the ideal complement of the new architectural aesthetic that confronts us in Early Christian basilicas.

The guiding principle of Graeco-Roman architecture, we recall, had been to express a balance of opposing forces, rather like the balance within the contrapposto of a Classical statue. The result was a muscular, physical display of active and passive, supporting and supported members, whether these were structurally real or merely superimposed on a concrete core. Viewed in such terms, Early Christian architecture is strangely inexpressive, even antimonumental. The tangible, material structure has become subservient to the creation and definition of immaterial space. Walls and vaults have the quality of weightless shells, their actual thickness and solidity hidden rather than emphasized as before. The brilliant color, the light-filled brightness of gold, the severe geometric order of the images in a mosaic complex such as that of S. Apollinare in Classe (fig. 302) fit the spirit of these interiors to perfection. One might say, in fact, that Early Christian and Byzantine churches *demand* mosaics the way Greek temples demand architectural sculpture.

EARLY SOURCES. Apparently, great pictorial cycles were spread over the nave walls, the triumphal arch, and the apse from the very start, first in painting, then in mosaic. These

307. Dome mosaic (detail). Late 4th century A.D. St. George, Salonica, Greece

cycles must have drawn upon a great variety of earlier sources, reflecting the whole range of Graeco-Roman painting as well as the art of other centers of Christianity. Before Constantine's reign, Rome did not embody the faith. Older and larger Christian communities existed in the great cities of North Africa and the Near East, such as Alexandria and Antioch. They had probably developed separate artistic traditions of their own, but few traces of them exist today. Paintings in an Orientalizing style similar to that of the extraordinary murals in the synagogue at Dura-Europos (see fig. 295) may have decorated the walls of Christian places of worship in Syria and Palestine, since the earliest Christian congregations were formed by dissident members of the Jewish community. Moreover, during the first or second century A.D., Alexandria, the home of a large and thoroughly Hellenized Jewish colony, may have produced illustrations of the Old Testament in a style akin to that of Pompeian murals. We meet echoes of such scenes in Christian art later on, but we cannot be sure when or where they originated, or by what paths they entered the Christian tradition. The importance of Judaic sources for Early Christian art is hardly surprising: the new faith also incorporated many aspects of the Jewish service into its own liturgy, including hymns, which were to provide the basis for medieval chants.

Be that as it may, the heritage of the past was not only absorbed but also transformed so as to make it fit its new environment physically and spiritually. A characteristic example is the *Good Shepherd* mosaic in the mausoleum of Galla Placidia

(fig. 306), the sister of Honorius, who initiated the first ambitious building program in Ravenna. The figure of the shepherd seated in a landscape expands the central subject of our catacomb painting (fig. 296) by being both more elaborately and more formally treated. In accordance with the preference of the time, Christ is depicted as a young man in the familiar pose of a philosopher. (We shall meet him again as a youthful philosopher in the *Sarcophagus of Junius Bassus;* see fig. 312.) The rest of his attributes, however, have been adapted from Imperial art, which provided a ready supply of motifs that was mined heavily in the early fifth century, when Christian imagery underwent intensive development. The halo was taken from representations of the emperor as sun-king, and even the cross had been an Imperial device.

CONTRASTS WITH GRAECO-ROMAN PAINTING. Roman mural painting had developed elaborate illusionistic devices in order to suggest a reality beyond the surface of the wall. In Early Christian mosaics the flatness of the wall surface is also denied, but for the purpose of achieving an "illusion of unreality," a luminous realm populated by celestial beings or symbols. The difference in intent becomes particularly striking whenever these mosaics make use of the old formulas of spatial illusionism. Figure 307 shows a section of the magnificent dome mosaics from the church of St. George at Salonica, done at the end of the fourth century. Two saints, their hands raised in prayer, stand against a background that clearly betrays its

308. *The Parting of Lot and Abraham.* c. 430 A.D. Mosaic.
Sta. Maria Maggiore, Rome

309. *The Betrayal of Christ.* c. 500 A.D. Mosaic.
S. Apollinare Nuovo, Ravenna

descent from the perspective vistas of "stage architecture" in Pompeian painting (see figs. 286 and 290). The foreshortening, to be sure, seems somewhat askew, but a surprising amount of it survives intact. Even so, the structure no longer seems real, for it lacks all physical substance. Its body consists of the same gold as the background, so that the entire building becomes translucent. (Other colors, mainly purple, blue, and green, are used only in the shaded portions and the ornament.) This is not a stage set but a piece of symbolic, otherworldly architecture meant to evoke such concepts as the Heavenly Jerusalem, the City of God. Here the disparity between pagan and Christian that we sensed in Sta. Costanza has been bridged by adapting the classical past for new spiritual ends.

The Parting of Lot and Abraham (fig. 308) is a scene from the oldest and most important surviving cycle of this kind, executed about 430 in the church of Sta. Maria Maggiore in Rome. Abraham, his son Isaac, and the rest of his family occupy the left half of the composition as they depart for the land of Canaan; Lot and his clan, including his two small daughters, turn toward the city of Sodom on the right. The task of the artist who designed our panel is comparable to that faced by the sculptors of the Column of Trajan (see fig. 273): how to condense complex actions into a visual form that would permit them to be read at a distance. In fact, many of the same "shorthand" devices are employed, such as the abbreviative formulas for house, tree, and city, or the trick of showing a crowd of people as a "grape-cluster of heads" behind the foreground figures. But in the Trajanic reliefs, these devices could be used only to the extent that they were compatible with the realistic aim of the scenes, which re-create actual historic events.

The mosaics in Sta. Maria Maggiore, on the other hand, depict the history of salvation, beginning with Old Testament scenes along the nave (in this instance from Genesis 13) and culminating in the life of Jesus as the Messiah on the triumphal arch across the nave. The scheme constitutes not only an historical cycle but, above all, a unified symbolic program that presents a higher reality—the Word of God. Hence, the artist need not clothe the scene with the concrete details of historic narrative. Glances and gestures are more important than theatrical movement or three-dimensional form. The symmetrical composition, with its cleavage in the center, makes clear the significance of this parting: the way of righteousness represented by Abraham, as against the way of evil, signified by the city of Sodom, which was destroyed by the Lord.

S. APOLLINARE NUOVO, RAVENNA. The challenge of inventing a body of Christian imagery brought forth an extraordinary creative outpouring, and by the end of the sixth century the process was essentially complete. It had taken less than 175 years to lay the foundation for a completely new artistic tradition—a remarkably short time indeed! The earliest cycle of mosaics to survive intact (preceded by others in Rome) are those in S. Apollinare Nuovo in Ravenna. Originally a naval station on the Adriatic, it had become the capital first of the West Roman emperors in 402 and then, at the end of the century, of Theodoric, king of the Ostrogoths, whose tastes were patterned after those of Constantinople. Under Justinian, Ravenna became the main stronghold of Byzantine rule in Italy. S. Apollinare Nuovo was originally built around 500 by Theodoric as his palace church and received its present name only in the ninth century. Along the nave are rows of male and female martyrs surmounted by prophets, patriarchs, and apostles between the windows. It is, however, the scenes depicting the ministry of Christ and the Passion that interest us, for although they have been relegated to a narrow band above the clerestory, they are of great importance.

The selection of subjects is unusual, perhaps reflecting Theodoric's Arian persuasion. In any event, *The Betrayal of Christ* (fig. 309) remains an astonishing achievement. We immediately recognize the kinship with *The Parting of Lot and Abraham* at Sta. Maria Maggiore (fig. 308). The figures still betray their Roman ancestry as well (compare figs. 267 and 268). Yet we are struck not by any debt to the past but by the newness of the scene, which is without precedent in Greek or Roman art. Its originality lies not so much in the particulars as in the approach. The drama has a clarity that is surprisingly intense. The protagonists are isolated between two equal groups of soldiers and disciples, so that we are forced to concentrate our attention on the central event and, above all, its meaning. So persuasive is the result that the scene became "classic" in its own right: it is the ancestor of countless others not only in Byzantium but also in the West, from Giotto through El Greco and Van Dyck.

Roll, Book, and Illustration

From what source did the designers of narrative mosaic cycles such as those of Sta. Maria Maggiore and S. Apollinare Nuovo derive their compositions? They were certainly not the first to illustrate scenes from the Bible in extensive fashion (see box below). For certain subjects, they could have found models among the catacomb murals, but some prototypes may have come from illustrated manuscripts. Because of their portability, the latter have been assigned an important role in disseminating religious imagery. In certain well-identified cases, manuscript illustrations unquestionably served as models for wall paintings, while in others it is apparent they must have been derived from frescoes. But in many more instances than have been acknowledged, the similarities between two pictures point to a common source that was probably a lost mural, not a manuscript.

As a scriptural religion, founded on the Word of God as revealed in Holy Writ, the early Christian Church must have sponsored the duplicating of the sacred text on a large scale. Every copy of it was handled with a reverence quite unlike the treatment of any book in Graeco-Roman civilization. But when did these copies become works of pictorial art as well? And what did the earliest Bible illustrations look like?

Books, unfortunately, are frail things. Thus their history in the ancient world is known to us largely from indirect evidence. It begins in Egypt (we do not know exactly when) with the discovery of a suitable material, paperlike but rather more brittle, made from the papyrus plant. Books of papyrus were made in the form of rolls throughout antiquity. Not until late Hellenistic times did a better substance become available: parchment, or vellum (thin, bleached animal hide), which is far more durable than papyrus. Vellum was strong enough to be creased without breaking, and thus made possible the kind

Versions of the Bible

The word *bible* is derived from the Greek word for books, since it was originally a compilation of a number of sacred texts. Over time, the books of the Bible came to be regarded as a unit, and thus the Bible is now generally considered a single book.

There is considerable disagreement between Christians and Jews, and among various Christian and Jewish sects, over which books should be considered canonical—that is, accepted as legitimate parts of the biblical canon, the standard list of authentic texts. However, every version of the Bible includes the Hebrew torah, or the Law (also called the Pentateuch, or Books of Moses), as the first five books. Also universally accepted by both Jews and Christians are the books known as the Prophets (which include texts of Jewish history as well as prophecy). There are also a number of other books known simply as the Writings, which include history, poetry (the Psalms and the Song of Songs), prophecy, and even folktales, some universally accepted, some accepted by one group, and some accepted virtually by no one. Books of doubtful authenticity are known as apocryphal books, or simply, Apocrypha, from a Greek word meaning obscure. The Jewish Bible or Hebrew Canon—the books which are accepted as authentic Jewish scripture—was agreed upon by Jewish scholars sometime before the beginning of the Christian era.

The Christian Bible is divided into two major sections, the Old Testament and the New Testament. The Old Testament contains many, but not all, of the Jewish scripture, while the New Testament, originally written in Greek, is specifically Christian. It contains four gospels—each written in the first century A.D. by one of the Early Christian missionaries known as the four evangelists, Mark, Matthew, Luke, and John. The Gospels tell, from slightly different points of view, the story of the life and teachings of Jesus of Nazareth. The Gospels are followed by the Epistles, letters written by Paul and a few other Christian missionaries to various congregations of the church. The final book is the Apocalypse, by John the Divine, also called the Book of Revelation, which foretells the end of the world.

Jerome (342–420), the foremost scholar of the early Church, selected the books considered canonical for the Christian Bible from a large body of Early Christian writings. It was due to his energetic advocacy that the Church accepted the Hebrew scriptures as representing the Word of God as much as the Christian texts, and therefore worthy to be included in the Bible. Jerome then translated the books he had chosen from Hebrew and Greek into Latin, the spoken language of Italy in his time. This Latin translation of the Bible was—and is—known as the Vulgate, because it was written in the vernacular (Latin *vulgaris*) language. The Vulgate remained the Church's primary text for the Bible for more than a thousand years. It was regarded with such reverence that in the fourteenth century, when early humanists first translated it into the vernacular languages of their time, they were sometimes suspected of heresy for doing so. The writings rejected for inclusion in the Bible by Jerome are known as Christian Apocrypha. Although not canonical, some of these books, such as the Life of Mary and the Gospel of James, were nevertheless used by artists and playwrights during the Middle Ages as sources for stories to illustrate and dramatize.

TORSITANITPINCUISHORTOSQUAECURACOLENDI
ORNARETCANEREMBITERIQUAEROSARINDISTI
QUOQMODOPOTISGAUDERENTINTIBARIUIS
ETUIRIDISATIORIEAETORIOSQULTERHERBAM
CRESCERETINUINTREMICUCUMISNECSERACOMANTI
NARCISSUMAUTIFLEXIIACULSSIUIMENACANTHI
TALLENTISHEDERASTAMANTISLITORAMYRTOS

310. Miniature, from the *Vatican Vergil.* Early 5th century A.D.
Biblioteca Apostolica Vaticana, Rome

of bound book we know today, technically called a codex.

Between the first and the fourth century A.D., the vellum codex gradually replaced the roll, whether vellum or papyrus. This change must have had an important effect on the growth of book illustration. As long as the roll form prevailed, illustrations seem to have been mostly line drawings, since layers of pigment would soon have cracked and come off in the process of rolling and unrolling. Only the vellum codex permitted the use of rich colors, including gold, that was to make book illustration—or, as we usually say, manuscript illumination—the small-scale counterpart of murals, mosaics, and panel pictures. There are still unsettled problems: when, where, and at what pace the development of pictorial book illumination took place; whether biblical, mythological, or historical subjects were primarily depicted; and how much of a carry-over there might have been from roll to codex.

VATICAN VERGIL. There can be little question that the earliest illuminations, whether Christian, Jewish, or classical, were done in a style strongly influenced by the illusionism of Hellenistic-Roman painting of the sort we met at Pompeii. One of the oldest illustrated manuscript books known, the *Vatican Vergil,* reflects this tradition, although the quality of the miniatures is far from inspired. The book was probably made in Italy about the time of the Sta. Maria Maggiore mosaics, to which it is closely linked in style. The picture (fig. 310), separated from the rest of the page by a heavy frame, has the effect of a window, and in the landscape we find remnants of deep space, perspective, and the play of light and shade.

VIENNA GENESIS. The oldest illustrated Bible manuscripts discovered thus far apparently belong to the early sixth century (except for one fragment of five leaves that seems related to the *Vatican Vergil*). They, too, contain echoes of the Hellenistic-Roman style, in various stages of adaptation to

religious narrative and often with a Near Eastern flavor that at times recalls the Dura-Europos murals (see fig. 295). The most important example, the *Vienna Genesis,* is a far more striking work than the *Vatican Vergil.* Written in silver (now turned black) on purple vellum and adorned with brilliantly colored miniatures, this Greek translation of the first book of the Bible achieves a sumptuous effect not unlike that of the mosaics we have seen. Figure 311 shows a number of scenes from the story of Jacob. (In the foreground, for example, we see him wrestling with the angel, then receiving the angel's benediction.) The picture thus does not show a single event but a whole sequence, strung out along a single U-shaped path, so that progression in space becomes progression in time. This method, known as continuous narration, has a complex and much debated history going back as far as ancient Egypt and Mesopotamia. Its appearance in miniatures such as ours may well reflect earlier illustrations made for books in roll form: our picture certainly looks like a frieze turned back upon itself.

For manuscript illustration, the continuous method offers the advantage of spatial economy. It permits the painter to pack a maximum of narrative content into the area at his disposal. Our artist evidently thought of his picture as a running account to be read like lines of text, rather than as a window demanding a frame. The painted forms are placed directly on the purple background that holds the letters, emphasizing the importance of the page as a unified field.

Sculpture

Compared to painting and architecture, sculpture played a secondary role in Early Christian art. The biblical prohibition of graven images in the Second Commandment was thought to apply with particular force to large cult statues, the idols worshiped in pagan temples. If religious sculpture was to avoid the taint of idolatry, it had to eschew lifesize representations of the human figure. It thus developed from the very start in an antimonumental direction: away from the spatial depth and massive scale of Graeco-Roman sculpture toward shallow, small-scale forms and lacelike surface decoration.

The earliest works of Christian sculpture are marble sarcophagi. These evolved from the pagan sarcophagi that replaced cinerary urns for the deceased in Roman society around the time of Hadrian, when belief in an afterlife arose as part of a major change in the attitude toward death. Patterns for decorating them were quickly set, probably by passing designs from shop to shop in illustrated manuscripts. The most popular scenes were taken from classical mythology which, since they occur on sarcophagi and nowhere else, must possess symbolic significance, not just antiquarian interest. Their general purpose seems to have been to glorify the deceased through visual analogy to the great legendary heroes of the past. Later, in the third century, biographical and historical scenes projected the deceased's ideal of life, often with moral overtones. From the middle of the third century on, sarcophagi were also produced for the more important members of the Christian Church. Before the time of Constantine, their decoration consisted mostly of the same limited repertory of themes familiar from catacomb murals—the Good Shepherd, Jonah and the

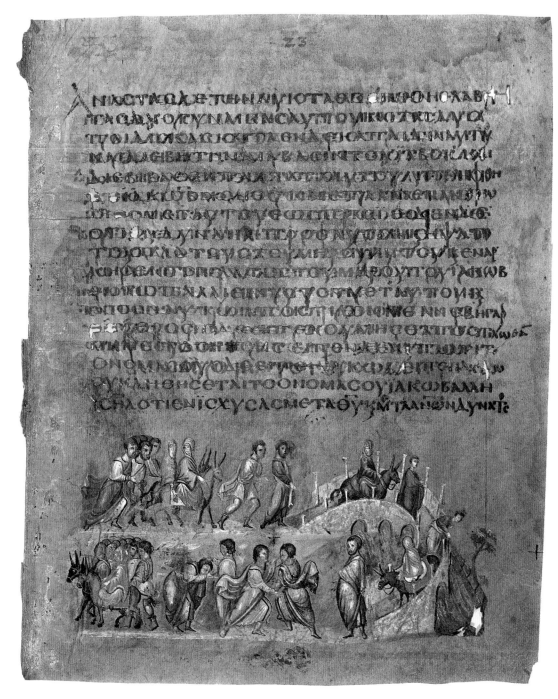

311. Page with *Jacob Wrestling the Angel,* from the *Vienna Genesis.* Early 6th century A.D. Tempera and silver on dyed vellum, 13¹/₄ x 9¹/₂" (33.6 x 24 cm). Österreichische Nationalbibliothek, Vienna

Whale, and so forth—but within a framework clearly borrowed from secular sarcophagi. Not until a century later do we find a significantly broader range of subject matter and form.

SARCOPHAGUS OF JUNIUS BASSUS. The finest Early Christian sarcophagus is the richly carved *Sarcophagus of Junius Bassus,* made for a prefect of Rome who died in 359 (figs. 312 and 313, page 246). Its colonnaded front, divided into ten square compartments, shows a mixture of Old and New Testament scenes. In the upper row we see (left to right) the Sacrifice of Isaac, St. Peter Taken Prisoner, Christ Enthroned between Sts. Peter and Paul, Christ before Pontius Pilate (two compartments); in the lower row are the Misery of Job, the Temptation of Adam and Eve (The Fall of Man), Christ's Entry

into Jerusalem, Daniel in the Lions' Den, and St. Paul Led to His Martyrdom. This choice, somewhat strange to the modern beholder, is characteristic of the Early Christian way of thinking, which stresses the divine rather than the human nature of Christ. Hence his suffering and death are merely hinted at. He appears before Pilate as a youthful, long-haired philosopher expounding the true wisdom (note the scroll), and the martyrdom of the two apostles is represented in the same discreet, nonviolent fashion. The two central scenes are also devoted to Christ (see box pages 246–47). Enthroned above Jupiter as the personification of the heavens, he dispenses the Law to Sts. Peter and Paul; below, he enters Jerusalem as Conquering Saviour (compare fig. 279). Adam and Eve, the original sinners, denote the burden of guilt redeemed by Christ, while the

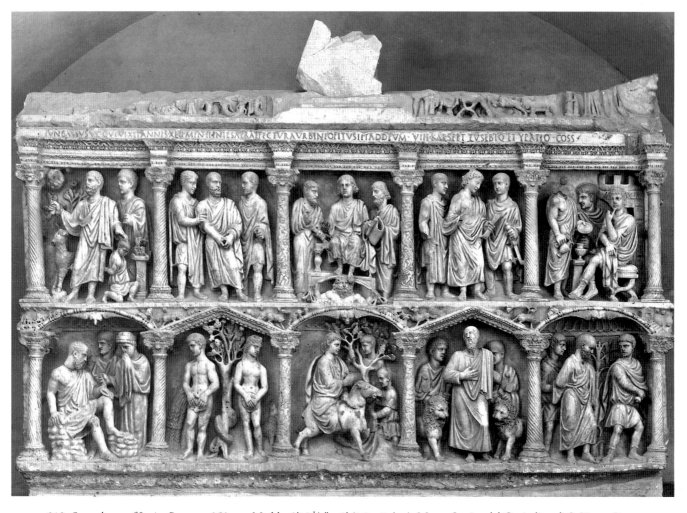

312. *Sarcophagus of Junius Bassus*. c. 359 A.D. Marble, 3'10 1/2" x 8' (1.2 x 2.4 m). Museo Storico del Capitolino di S. Pietro, Rome

313. *Christ Enthroned* (detail of fig. 312)

Sacrifice of Isaac is the Old Testament prefiguration of Christ's sacrificial death and resurrection. Job and Daniel carry the same message as Jonah in the catacomb painting (fig. 296): they fortify the hope of salvation.

When measured against the frieze on the Arch of Constantine, carved almost half a century before (see fig. 285), the *Sarcophagus of Junius Bassus* retains a veneer of classicism. The figures in their deeply recessed niches still recall the statuesque dignity of the Greek and Roman tradition. (Compare Eve to the *Cnidian Aphrodite* of Praxiteles; fig. 206). Yet beneath this superimposed classicism we sense a basic kinship to the Constantinian style in the doll-like bodies, the large heads, and the oddly becalmed, passive air of scenes calling for dramatic action. The events and personages confronting us are no longer intended to tell their own story, physically or emotionally, but to call to our minds a higher, symbolic meaning that binds them together.

CLASSICISM. Classicizing tendencies of this sort seem to have been a recurrent phenomenon in Early Christian sculpture from the mid-fourth to the early sixth century. Their causes have been explained in various ways. During this period paganism still had many important adherents who may have fostered such revivals as a kind of rear-guard action. Recent converts (including Junius Bassus himself, who was not baptized until shortly before his death) often kept their allegiance to values of the past, artistic and otherwise. There

314. *Priestess of Bacchus.* Leaf of a diptych. c. 390–400 A.D. Ivory, 11 3/4 x 5 1/2" (30 x 14 cm). Victoria & Albert Museum, London

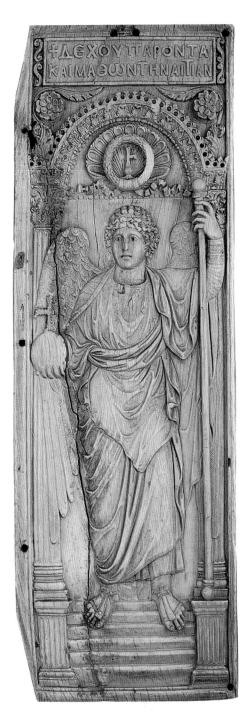

315. *The Archangel Michael.* Leaf of a diptych. Early 6th century A.D. Ivory, 17 x 5 1/2" (43.3 x 14 cm). The British Museum, London

were also important leaders of the Church who favored a reconciliation of Christianity with the heritage of classical antiquity, and with good reason: Early Christian theology depended a great deal on Greek and Roman philosophers, not only recent thinkers such as Plotinus (see fig. 281) but also Plato, Aristotle, and their predecessors. The imperial courts, too, both East and West, always remained aware of their institutional links with pre-Christian times, and could thus become centers for revivalist impulses. Whatever its roots in any given instance, classicism remained of considerable importance during this age of transition.

IVORY DIPTYCHS. This holds particularly true for a class of objects whose artistic importance far exceeds their physi-

cal size: ivory panels and other small-scale reliefs in precious materials. Designed for private ownership and meant to be enjoyed at close range, they often mirror a collector's taste, a refined aesthetic sensibility not found among the large, official enterprises sponsored by Church or State. Such a piece is the ivory (fig. 314) forming the right half of a hinged two-leaved tablet, or diptych, that was carved about 390–400, probably on the occasion of a wedding between the Nicomachi and Symmachi, two aristocratic Roman families. (The other half is poorly preserved.) The conservative outlook of this piece is reflected not only in the pagan subject (a priestess of Bacchus and her assistant before an altar of Jupiter) but also in the design, which harks back to the era of Augustus (compare fig. 267). At first glance, we might well mistake it

Events in the life of Jesus, from his birth through his ascension to Heaven, are traditionally grouped in cycles, each with numerous episodes. The scenes most frequently depicted in European art are presented here.

INCARNATION CYCLE AND THE CHILDHOOD OF JESUS

These episodes concern Jesus' conception, infancy, and youth.

Annunciation. The archangel Gabriel tells Mary that she will bear God's son. The Holy Spirit, shown usually as a dove, represents the Incarnation, the miraculous conception.

Visitation. The pregnant Mary visits her older cousin, Elizabeth, who is to bear John the Baptist and who is the first to recognize the divine nature of the baby Mary is carrying.

Nativity. Just after the birth of Jesus, the Holy Family—Mary, his foster father Joseph, and the child—is usually depicted in a stable or, in Byzantine representations, in a cave.

Annunciation to the Shepherds and Adoration of the Shepherds. An angel announces the night birth of Jesus to shepherds in the field. They then appear at the birthplace.

Adoration of the Magi. Wise men from the East (called the three kings in the Middle Ages), the Magi follow a bright star for 12 days until they find the Holy Family and present their precious gifts to the Infant Jesus.

Presentation in the Temple. Mary and Joseph take the baby Jesus to the Temple in Jerusalem, where Simeon, a high priest, and Anna, a prophetess, foresee Jesus' messianic (saviour's) mission and martyr's death.

Massacre of the Innocents and Flight into Egypt. King Herod orders all babies killed to preclude his being murdered by a rival newborn king. The Holy Family flees to Egypt.

PUBLIC MINISTRY CYCLE

Baptism. John the Baptist baptizes Jesus in the Jordan River, recognizing Jesus' incarnation as the Son of God and marking the beginning of his ministry.

Calling of Matthew. A tax collector, Matthew, becomes Jesus' first disciple (apostle) when Jesus calls to him, "Follow me."

Jesus Walking on the Water. During a storm, Jesus walks on the water to reach his apostles in a little boat.

Raising of Lazarus. Jesus brings his friend Lazarus back to life four days after Lazarus' death and burial.

Delivery of the Keys to Peter. Jesus names the apostle Peter his successor by giving him the keys to the kingdom of Heaven.

Transfiguration. As Jesus' closest disciples watch, God transforms Jesus into a dazzling vision and proclaims him to be his own son.

Cleansing the Temple. Enraged, Jesus clears the Temple of moneychangers and animal traders.

PASSION CYCLE

The Passion (from *passio,* Latin for suffering) cycle relates Jesus' death, resurrection from the dead, and ascension to Heaven.

Entry into Jerusalem. Welcomed by crowds as the Messiah, Jesus rides an ass into Jerusalem.

Last Supper. At the Passover seder, Jesus tells his disciples of his impending death and lays the foundation for the Christian rite of Eucharist: the taking of bread and wine in remembrance of Christ. (Jesus is called Jesus until he leaves his earthly physical form, after which he is called Christ.)

Jesus Washing the Disciples' Feet. Following the Last Supper, Jesus washes the feet of his disciples to demonstrate humility.

Agony in the Garden. In Gethsemane, the disciples sleep while Jesus wrestles with his mortal dread of suffering and dying.

Betrayal (Arrest). Disciple Judas Iscariot takes money to identify Jesus to Roman soldiers. Jesus is arrested.

Denial of Peter. As Jesus predicted, Peter denies knowing Jesus three times when questioned in the presence of the high priest Caiaphas.

Jesus Before Pilate. Jesus is charged with treason by the Roman governor Pontius Pilate for calling himself King of the Jews.

for a much earlier work, until we realize, from small spatial incongruities such as the priestess's right foot overlapping the frame, that these forms are quotations from earlier examples, reproduced with loving care but no longer fully understood. Significantly enough, the pagan theme did not prevent our panel from being incorporated into the shrine of a saint many centuries later; its cool perfection had an appeal for the Middle Ages as well.

Our second ivory (fig. 315, page 247) was done soon after 500 in the eastern Roman Empire. It shows a classicism that has become an eloquent vehicle of Christian content. The majestic archangel is a descendant of the winged Victories of

Flagellation (Scourging). Jesus is whipped by Romans.

Jesus Crowned with Thorns (Mocking). Pilate's soldiers make fun of Jesus by dressing him in robes, crowning him with thorns, and calling him King of the Jews.

Carrying of the Cross (Road to Calvary). Jesus carries the wooden cross on which he will be executed from Pilate's house to the hill of Golgatha, "the place of the skull."

Crucifixion. Jesus is nailed to the cross by his hands and feet and dies after much physical suffering.

Descent from the Cross (Deposition). Jesus' followers lower his body from the cross and wrap it for burial. Also present are the Virgin, the apostle John, and in some accounts Mary Magdalen.

Lamentation (*Pietà* or *Vesperbild*). The grief-stricken followers gather around Jesus' body. In the *Pietà,* his body lies across the lap of the Virgin.

Entombment. The Virgin and others place the wrapped body in a sarcophagus, a rock tomb.

Descent into Limbo (Harrowing of Hell). Christ descends to Hell, or limbo, to free deserving souls.

Resurrection (Anastasis). Christ rises from the dead on the third day after his entombment.

The Marys at the Tomb. As terrified soldiers look on, Christ's female followers (the Virgin Mary, Mary Magdalen, and Mary, mother of the apostle James) discover the empty tomb.

Noli me tangere, Supper at Emmaus, Doubting of Thomas. In three episodes during the 40 days between his resurrection and ascent into Heaven, Christ tells Mary Magdalen not to touch him (*Noli me tangere*); shares a supper with his disciples at Emmaus; and invites the apostle Thomas to touch the lance wound in his side.

Ascension. As his disciples watch, Christ is taken into Heaven from the Mount of Olives.

Graeco-Roman art, down to the richly articulated drapery (see fig. 196). Yet the power he heralds is not of this world, nor does he inhabit an earthly space. The architectural niche against which he appears has lost all three-dimensional reality. Its relationship to him is purely symbolic and ornamental, so that he seems to hover rather than to stand (notice the position of the

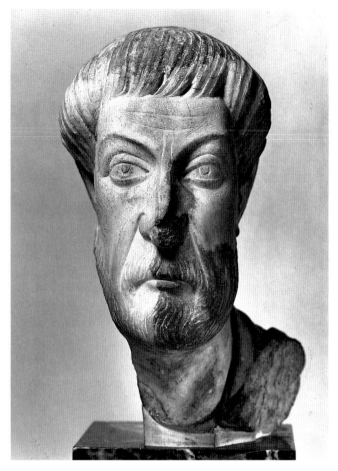

316. *Portrait of Eutropios.* c. 450 A.D. Marble, height 12 ¹/2" (31.7 cm). Kunsthistorisches Museum, Vienna

feet on the steps). It is this disembodied quality, conveyed through harmonious forms, that gives him so compelling a presence.

PORTRAITURE. If monumental statuary was discouraged by the Church, it retained, for a while at least, the patronage of the State. Emperors, consuls, and high officials continued the old custom of erecting portrait statues of themselves in public places as late as the reign of Justinian (527–65), and sometimes later than that. (The last recorded instance is in the late eighth century.) Here, too, we find retrospective tendencies during the latter half of the fourth century and the early years of the fifth, with a revival of pre-Constantinian types and a renewed interest in individual characterization. From about 450 on, however, the outward likeness gives way to the image of a spiritual ideal, sometimes intensely expressive, but increasingly impersonal. There were not to be any more portraits, in the Graeco-Roman sense of the term, for almost a thousand years to come.

The process is strikingly exemplified by the head of Eutropios from Ephesus (fig. 316), one of the most memorable of its kind. It reminds us of the strangely sorrowful features of "Plotinus" and of the masklike colossal head of Constantine (see figs. 281 and 283), but both of these have a physical concreteness that seems almost overwhelming compared to the extreme attentuation of Eutropios. The face is frozen in visionary ecstasy, as if the sitter were a hermit saint. It looks, in fact, more like that of a specter than of a being of flesh and blood.

Biblical, Church, and Celestial Beings

Much of Western art deals with biblical persons and celestial beings. Their names appear in titles of paintings and sculpture and in discussions of subject matter. Following is a brief guide to some of the most commonly encountered persons and beings in Christian art.

Patriarchs. Literally, head of a family, ruler of a tribe. Old Testament patriarchs are Abraham, Isaac, Jacob, and Jacob's 12 sons. Patriarch also refers to the bishops of the five chief bishoprics of Christendom: Alexandria, Antioch, Constantinople, Jerusalem, and Rome.

Prophets. In Christian art, prophets usually mean the Old Testament figures whose writings were seen to foretell the coming of Christ. The so-called major prophets are Isaiah, Jeremiah, and Ezekiel. The minor prophets are Hosea, Joel, Amos, Obadiah, Jonah, Micah, Nahum, Habakkuk, Zephaniah, Haggai, Zechariah, and Malachi.

Trinity. Central to Christian belief is the doctrine that One God exists in Three Persons: Father, Son (Jesus Christ), and Holy Spirit. The Holy Spirit is often represented as a dove.

Holy Family. The infant Jesus, his mother Mary, and his foster father Joseph constitute the Holy Family.

John the Baptist. The precursor of Jesus Christ, John is regarded by Christians as the last prophet before the coming of the Messiah, Jesus. John was an ascetic who baptized his disciples in the name of the coming Messiah; he recognized Jesus as that Messiah when he saw the Holy Spirit descend on Jesus at the moment of baptism.

Evangelists. There are four: Matthew, John, Mark, and Luke—each an author of one of the Gospels. The first two were among Jesus' 12 apostles. The latter two wrote in the second half of the first century.

Apostles. The apostles are the 12 disciples Jesus asked to convert nations to his faith. They are Peter (Simon Peter), Andrew, James the Greater, John, Philip, Bartholomew, Matthew, Thomas, James the Less, Jude (or Thaddaeus), Simon the Canaanite, and Judas Iscariot. After Judas betrayed Jesus, his place was taken by Matthias.

Disciples. See Apostles.

Angels and Archangels. Beings of a spiritual nature, angels are spoken of in the Old and New Testaments as having been created by God to be heavenly messengers between God and human beings, Heaven and earth. Spoken of first by the apostle Paul, archangels, unlike angels, have names: Michael, Gabriel, Tobias, and Raphael.

Cherubim and Seraphim. The celestial hierarchy devised by Pseudo-Dionysius about 500 A.D. had cherubim (with six wings) and seraphim (four wings) at the peak, encircling the throne of God and the Ark of the Covenant. After the Middle Ages, a cherub came to be represented as a rosy-cheeked, plump, and winged child.

Saints. Persons are declared saints only after death. The pope acknowledges sainthood by canonization, a process based on meeting rigid criteria of authentic miracles and beatitude. He ordains a public cult of the new saint throughout the Catholic church.

Martyrs. Originally, martyrs referred to all the apostles. Later, it signified those persecuted for their faith. Still later, the term was reserved for those who died in the name of Christ.

Pope. Meaning "father," the term refers to the bishop of Rome, the spiritual head of the Roman Catholic church. The pope dwells in and heads an independent state, Vatican City, within the city of Rome. His chief attribute is a shepherd's staff; he dresses in white.

Cardinals. Priests or higher religious officials chosen to help the pope administer the Church. They are of two types: those who live in Rome (the Curia), and those who remain in their dioceses. Together they constitute the Sacred College. One of their duties is to elect a pope after the death or removal of a sitting pope. They dress in red garments and wear broad-brimmed hats tied under the chin.

Diocese. A territorial unit administered in the Western church by a bishop and in the Eastern church by a patriarch. A cathedral is the diocese church and the seat of the bishop.

Bishops and Archbishops. A bishop is the highest order of minister in the Catholic church, with his administrative territory being the diocese. Bishops are ordained by archbishops, who also have the authority to consecrate kings. Bishops carry an elaborately curved staff called a crozier and wear a three-pointed hat.

Priests and Parishes. Priests did not exist in the early Church, because only bishops were authorized to offer the Eucharist and receive confession. As the Church grew, church officials called presbyters were designated by bishops to perform the Eucharist and ablutions in smaller administrative units, called parishes, and they became priests.

Abbots and Abbesses. Heads of large monasteries (called abbeys) and convents (nunneries).

Monks and Nuns. Men and women living in religious communities who have taken vows of poverty, chastity, and obedience to the rules of their orders.

The avoidance of solid volumes has been carried so far that the features are for the most part indicated only by thin ridges or shallow engraved lines. Their smooth curves emphasize the elongated oval of the head and thus reinforce its abstract, otherworldly character. Not only the individual person but the human body itself has ceased to be a tangible reality here—and with that the Greek tradition of sculpture in the round has reached the end of the road.

BYZANTINE ART

Early Byzantine Art

Since there is no clear-cut line of demarcation between Early Christian and Byzantine art, it could be argued that a Byzantine style (that is, a style associated with the imperial court of Constantinople) becomes discernible within Early Christian art as early as the beginning of the fifth century, soon after the effective division of the empire. However, we have avoided making this distinction, for East Roman and West Roman—or, as some scholars prefer to call them, Eastern and Western Christian—characteristics are often difficult to separate before the sixth century. Until that time, both areas contributed to the development of Early Christian art, although the leadership tended to shift more and more to the East as the position of the West declined. During the reign of Justinian this shift was completed. Constantinople not only reasserted its political dominance over the West but became the undisputed artistic capital as well. Justinian himself was an art patron on a scale unmatched since Constantine's day. The works he sponsored or promoted have an imperial grandeur that fully justifies the acclaim of those who have termed his era a golden age. They also display an inner unity of style that links them more strongly with the future development of Byzantine art than with the art of the preceding centuries.

S. VITALE, RAVENNA. The richest array of early Byzantine monuments survives today not in Constantinople, where much has been destroyed, but on Italian soil, in the town of Ravenna. The most important church of that time, S. Vitale, was begun by Bishop Ecclesius in 526, just before Theodoric's death, but built chiefly in 540–47 under Bishop Maximian, who also consecrated S. Apollinare in Classe two years later (see figs. 300–302). The structure of S. Vitale is of a type derived mainly from Constantinople. We find only the barest remnants of the longitudinal axis of the Early Christian basilica. Toward the east is a cross-vaulted compartment for the altar, backed by an apse; and on the other side a narthex, whose odd, nonsymmetrical placement has never been fully accounted for. We recognize its octagonal plan, with the domed central core (figs. 317–20), as a descendant of the mausoleum of Sta. Costanza in Rome (see figs. 303–5), but the intervening development seems to have taken place in the East, where domed churches of various kinds had been built during the previous century.

Remembering S. Apollinare in Classe (see figs. 300–302), built at the same time on a straightforward basilican plan, we are particularly struck by the different character of S. Vitale. How did it happen that the East favored a type of church

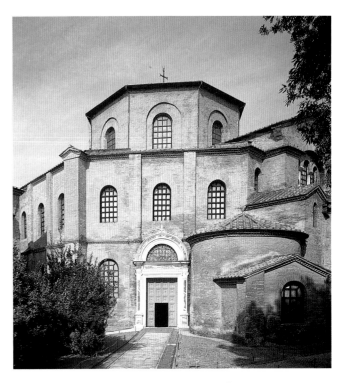

317. S. Vitale, Ravenna. 526–47 A.D.

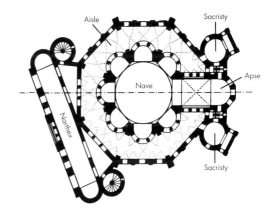

318. Plan of S. Vitale

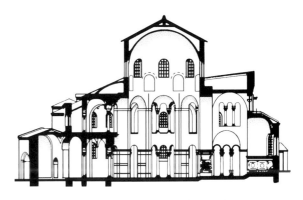

319. Transverse section of S. Vitale

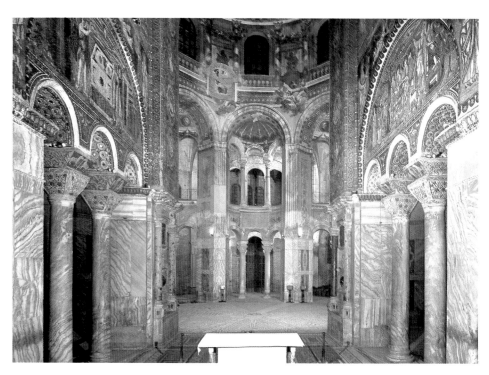

320. Interior (view from the apse into the choir), S. Vitale

building (as distinct from baptisteries and mausoleums) so radically different from the basilica? A number of different reasons have been suggested: practical, religious, political. All of them may be relevant, but if the truth be told, they fall well short of a really persuasive explanation. After all, the design of the basilica had been backed by the authority of Constantine; yet it never enjoyed the popularity that it had in the Latin West since early Imperial times. Moreover, it was Constantine who erected the first central-plan churches in Constantinople, thereby helping to establish the preference for the type in the eastern part of the Empire. In any event, domed, central-plan churches were to dominate the world of Orthodox Christianity as thoroughly as the basilican plan dominated the architecture of the medieval West.

Compared to Sta. Costanza, S. Vitale is both larger in scale and very much richer in its spatial effect (fig. 320). Below the clerestory, the central space turns into a series of semicircular niches that penetrate into the aisle and thus link it to the nave in a new and intricate way. The aisle itself has been given a second story: the galleries, which may have been reserved for women. A new economy in the construction of the vaulting permits large windows on every level, which flood the interior with light. The complexity of the interior is matched by its lavish decoration.

S. Vitale's link with the Byzantine court is manifest in the two famous mosaics flanking the altar (figs. 321 and 322), which depict Justinian and his empress, Theodora, accompanied by officials, the local clergy, and ladies-in-waiting. Although they did not attend the actual ceremonies, the royal couple are shown as present at the consecration of S. Vitale to demonstrate their authority over Church and State, as well as their support for their archbishop, Maximianus, who was initially unpopular with the citizens of Ravenna. In these large panels, whose design most likely came directly from the impe-

rial workshop, we find an ideal of human beauty quite different from the squat, large-headed figures we encountered in the art of the fourth and fifth centuries.

We have caught a glimpse of this emerging new ideal occasionally (figs. 296, 314, and 315), but only now do we see it complete: extraordinarily tall, slim figures, with tiny feet, small almond-shaped faces dominated by their huge, staring eyes, and bodies that seem to be capable only of slow ceremonial gestures and the display of magnificently patterned costumes. Every hint of movement or change is carefully excluded. The dimensions of time and earthly space have given way to an eternal present amid the golden translucency of Heaven, as the solemn, frontal images in the mosaics seem to present a celestial rather than a secular court. This union of political and spiritual authority accurately reflects the "divine kingship" of the Byzantine emperor. We are invited to see Justinian and Theodora as analogous to Christ and the Virgin. On the hem of Theodora's mantle (fig. 322) is conspicuous embroidery showing the three Magi carrying their gifts to Mary and the newborn King; Justinian (fig. 321) is flanked by 12 companions—the imperial equivalent of the 12 apostles (six are soldiers, crowded behind a shield with the monogram of Christ).

Justinian, Theodora, and their immediate neighbors were surely intended to be individual likenesses, and their features are indeed differentiated to a degree (those of Maximianus and Julianus Argentarius, the banker who underwrote the building, more so than the rest), but the ideal has molded the faces as well as the bodies, so that they all have a curious family resemblance. We shall meet the same large dark eyes under curved brows, the same small mouths and long, narrow, slightly aquiline noses countless times from now on in Byzantine art. As we turn from these mosaics to the interior space of the church, we realize that it, too, shares the quality of dematerialized, soaring slenderness that endows the figures with their air of mute exaltation.

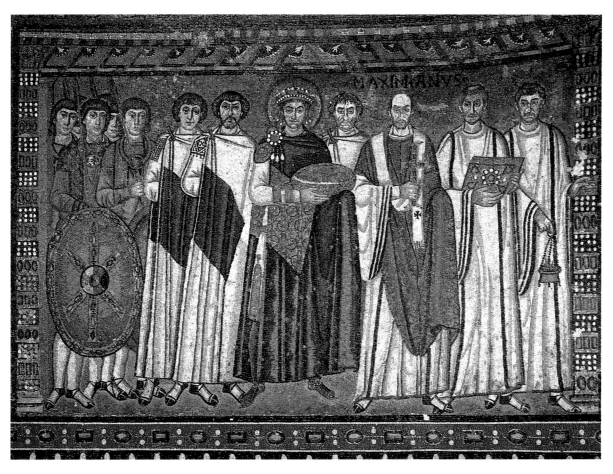

321. *Emperor Justinian and His Attendants.* c. 547 A.D. Mosaic. S. Vitale

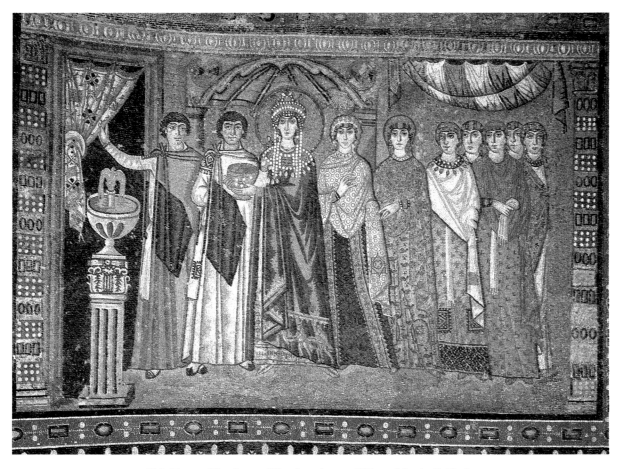

322. *Empress Theodora and Her Attendants.* c. 547 A.D. Mosaic. S. Vitale

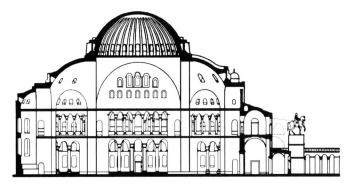

323. Section of Hagia Sophia (after Gurlitt)

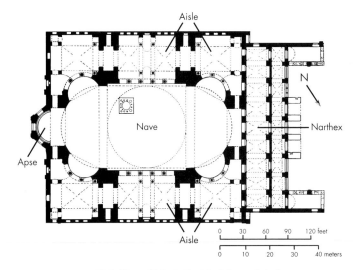

324. Plan of Hagia Sophia (after v. Sybel)

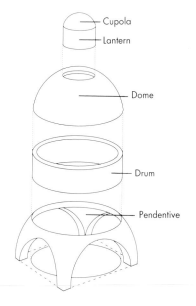

325. Parts of a dome

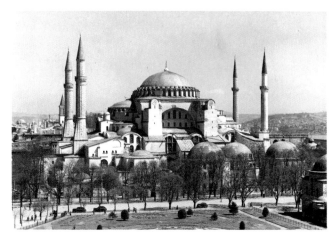

326. Anthemius of Tralles and Isidorus of Miletus. Hagia Sophia, Istanbul, Turkey. 532–37 A.D.

327. Capital, Hagia Sophia

HAGIA SOPHIA, ISTANBUL. Among the surviving monuments of Justinian's reign in Constantinople, the most important by far is Hagia Sophia (Church of Holy Wisdom), the architectural masterpiece of the era and one of the great creative triumphs of any age (figs. 323, 324, 326–28). The previous church, begun by Constantine and finished in 360, was destroyed, along with several other monuments, in the riots of 532 that almost deposed Justinian, who immediately rebuilt it. Completed in only five years, Hagia Sophia achieved such fame that the names of the architects, too, were remembered: Anthemius of Tralles, an expert in geometry and the theory of statics and kinetics, and Isidorus of Miletus, who taught physics and wrote on vaulting techniques. [See Primary Sources, no. 23, page 383.] After the Turkish conquest in 1453, it became a mosque (the four minarets were added then) and the mosaic decoration was largely hidden under whitewash. Some of the mosaics were uncovered in our century, after the building was turned into a museum (see fig. 338).

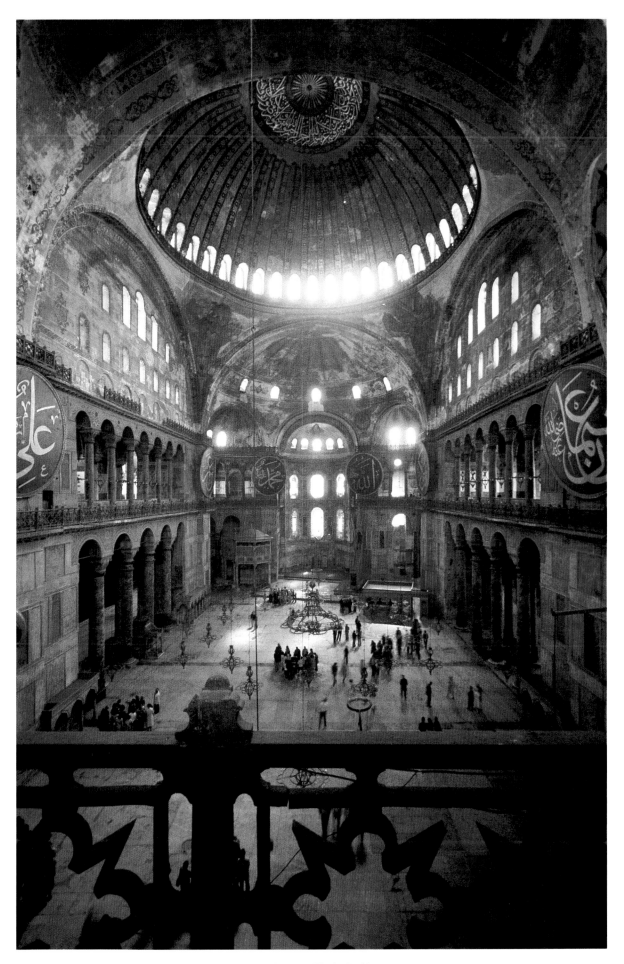

328. Interior, Hagia Sophia

The design of Hagia Sophia presents a unique combination of elements. It has the longitudinal axis of an Early Christian basilica, but the central feature of the nave is a square compartment crowned by a huge dome and abutted at either end by half-domes, so that the nave becomes a great ellipse. Attached to these half-domes are semicircular niches with open arcades, similar to those in S. Vitale. One might say, then, that the dome of Hagia Sophia has been inserted between the two halves of a central-plan church. The dome rests on four arches that carry its weight to the great piers at the corners of the square, so that the walls below the arches have no supporting function at all. The transition from the square formed by these arches to the circular rim of the dome is achieved by spherical triangles called pendentives (see fig. 325); hence we speak of the entire unit as a dome on pendentives. In conjunction with a new technique to build domes utilizing thin bricks embedded in mortar, this device permits the construction of taller, lighter, and more economical domes than the older method (seen in the Pantheon, Sta. Costanza, and S. Vitale) of placing the dome on a round or polygonal base. Where or when the dome on pendentives was invented we do not know. Hagia Sophia is the earliest case we have of its use on a monumental scale, and its example must have been of epoch-making importance. From that time on the dome on pendentives became a basic feature of Byzantine architecture and, somewhat later, of Western architecture as well.

There is, however, still another element that entered into the design of Hagia Sophia. The plan, the buttressing of the main piers, and the huge scale of the whole recall the Basilica of Constantine (figs. 250–52), the most ambitious achievement of Imperial Roman vaulted architecture and the greatest monument associated with a ruler for whom Justinian had particular admiration. Hagia Sophia thus unites East and West, past and future, in a single overpowering synthesis. Its massive exterior, firmly planted upon the earth like a great mound, rises by stages to a height of 184 feet—41 feet higher than the Pantheon—and therefore its dome, although its diameter is somewhat smaller (112 feet), stands out far more boldly.

Once we are inside, all sense of weight disappears, as if the material, solid aspects of the structure had been banished to the outside. Nothing remains but an expanding space that inflates, like so many sails, the apsidal recesses, the pendentives, and the dome itself. Here the architectural aesthetic we saw taking shape in Early Christian architecture (see pages 234–37) has achieved a new, magnificent dimension. Even more than previously, light plays a key role: the dome seems to float—"like the radiant heavens," according to a contemporary description of the building—because it rests upon a closely spaced ring of windows, and the nave walls are pierced by so many openings that they have the transparency of lace curtains.

The golden glitter of the mosaics must have completed the "illusion of unreality." We can sense the new aesthetic even in ornamental details such as moldings and capitals (fig. 327). The scrolls, acanthus foliage, and the like are motifs that derive from classical architecture, but their effect is radically different. Instead of actively cushioning the impact of heavy weight upon the shaft of the column, the capital has become a sort of openwork basket whose delicate surface pattern belies the strength and solidity of the stone.

THRONE OF MAXIMIANUS. Beyond architectural decorations and some sarcophagi, early Byzantine sculpture consists mainly of reliefs in ivory and silver, which survive in considerable numbers. Not surprisingly, they share characteristics with the capitals at Hagia Sophia, as we can see from the *Throne of Maximianus* (fig. 329). This magnificent episcopal chair (or *cathedra*) is covered with ivory panels (some are later replacements) devoted to the infancy of Christ (on the backrest), the story of Joseph in Egypt (on the sides), and John the Baptist flanked by the four evangelists (on the front). They are embedded in strips of the most luxurious ornamentation festooned with lacy foliage, including clusters of grapes, and inhabited by lions, stags, peacocks, and other creatures.

Considering its size, it is probable that the throne was the work of several people of outstanding ability from diverse backgrounds operating under royal patronage in Constantinople, which summoned the finest artists from around the Empire. In all likelihood, it was a gift from Justinian to Maximianus, the archbishop of Ravenna, upon the dedication of S. Vitale. Its origin at the Byzantine court is assured not only by the quality but also the style of the Baptist and his companions, which echoes the classicism of *The Archangel Michael* (fig. 315) while conforming to the aristocratic ideal of the S. Vitale mosaics (figs. 321 and 322), with its flattened forms. The arcade with frontal figures, derived from sarcophagi, was to have a long life: it is found on nearly all metal reliefs and ivory carvings (particularly book covers) through the Romanesque era.

JUSTINIAN DIPTYCH. The last vestiges of classicism can still be seen in the beautifully carved diptych of Justinian as Conqueror (fig. 330), from about the same time as the throne, which celebrates his victories in Italy, North Africa, and Asia. The subject is a restatement of the allegorical scene on the breastplate of the *Augustus of Primaporta* in appropriately Christian terms (see fig. 265). The figure of Victory appears twice: below the emperor, to his right, and as a statuette held by the Roman general at the left, who no doubt was mirrored in the missing panel at the right. Scythians, Indians, even ferocious lions and elephants offer gifts and pay homage, while a figure personifying Earth supports Justinian's foot to signify his dominion over the entire world. His role as triumphant general and ruler of the empire is blessed from Heaven above by Christ (note the sun, moon, and star), whose symbolic image is carried in a medallion by two heraldically arranged angels. Despite their ancestry, the stubby figures are hardly classical in style. They will remind us of Constantinian reliefs (compare fig. 285), but with a distinctly Oriental cast derived from the eastern provinces. The large head and bulging features of Justinian brim with the same energy as his charging steed. He is anything but the calm philosopher portrayed on the equestrian statue of Marcus Aurelius (fig. 279), from which the image derives.

ICONS. In the late sixth century, icons—paintings of Christ, the Enthroned Madonna, or saints—came to vie with relics as objects of veneration. They were considered "portraits," and understandably so, for such pictures had developed in Early Christian times out of Graeco-Roman portrait panels. One of the chief arguments in their favor was the claim that Christ

329. *Throne of Maximi:* ʹs. c. 547. Ivory over wood, 59 x 23 ¹/₂" (149.8 x 59.7 cm). Archepiscopal Museum, Ravenna

330. *Justinian as Conqueror.* c. 525–50 A.D. Ivory, 13 ¹/₂ x 10 ¹/₂" (34.2 x 26.8 cm). Musée du Louvre, Paris

331. *Virgin and Child Enthroned between Saints and Angels.* Late 6th century A.D. Encaustic on panel, 27 x 19 3/8" (68.5 x 49.2 cm). Monastery of St. Catherine, Mount Sinai, Egypt

had appeared with the Virgin to St. Luke and permitted him to paint their portrait, and that other portraits of Christ or of the Virgin had miraculously appeared on earth by divine fiat. These original, "true" sacred images were supposedly the source for the later, man-made ones. Little is known about their origins, for examples antedating the Iconoclastic Controversy are extremely scarce (see page 257).

Of the few discovered so far, the most revealing is the *Virgin and Child Enthroned between Saints and Angels* (fig. 331). Like late Roman murals (see pages 203–08), it is a compilation painted in several styles at once. Its link with Graeco-Roman portraiture is evident not only from the use of encaustic, a medium that went out of use after the Iconoclastic Controversy, but also from the fine gradations of light and shade in the Virgin's face, which is similar in treatment to that

of the little boy in our Faiyum portrait (fig. 293). She is flanked by the warrior saints Theodore on the left and George to the right, who recall the stiff mannequins accompanying Justinian in S. Vitale (fig. 321). Typical of early icons, however, their heads are too massive for their doll-like bodies. Behind them are two angels who come closest in character to Roman art (compare the personification of Arcadia in fig. 292), although their lumpy features show that classicism is no longer a living tradition. Clearly these figures are quotations from different sources, so that the painting marks an early stage in the development of icons. Yet it is typical of the conservative icon tradition that the unknown artist has tried to remain as faithful as possible to his sources, in order to preserve the likenesses of these holy figures. While hardly an impressive achievement in itself, it is worthy of our attention: this is the earliest

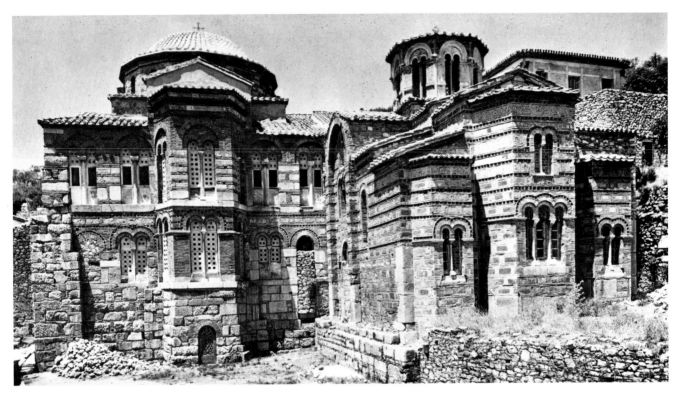

332. Churches of the Monastery of Hosios Loukas (St. Luke of Stiris), Greece. Early 11th century

representation we have of the Madonna and Child. We shall encounter its descendants again and again in the history of art.

Middle Byzantine Art

After the age of Justinian, the development of Byzantine art, not only painting and sculpture but architecture as well, was disrupted by the Iconoclastic Controversy, which began with an imperial edict of 726 prohibiting religious images. It raged for more than a hundred years, dividing the population into two hostile groups. The image-destroyers (Iconoclasts), led by the emperor and supported mainly in the eastern provinces of the realm, insisted on a literal interpretation of the biblical ban against graven images as conducive to idolatry; they wanted to restrict religious art to abstract symbols and plant or animal forms. Their opponents, the Iconophiles, were led by the monks and centered in the western provinces, where the imperial edict remained ineffective for the most part. [See Primary Sources, no. 20, page 382, and no. 24, pages 383–84.] The roots of the conflict went very deep. On the plane of theology they involved the basic issue of the relationship of the human and the divine in the person of Christ. Socially and politically, they reflected a power struggle between Church and State. The controversy also caused an irrevocable break between Catholicism and the Orthodox faith, although the two churches remained officially united until 1054, when the pope excommunicated the eastern patriarch for heresy.

Had the edict been enforceable throughout the Empire, it might well have dealt Byzantine religious art a fatal blow. It did succeed in greatly reducing the production of sacred images, but failed to wipe it out altogether, so that after the victory of the Iconophiles in 843 under the empress Theodora there was a fairly rapid recovery. Spearheaded by Basil I the Macedonian, this recovery lasted from the late ninth to the eleventh century.

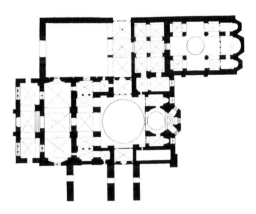

333. Plan of churches of the Monastery of Hosios Loukas (after Diehl)

MONASTIC ARCHITECTURE. Byzantine architecture never produced another structure to match the scale of Hagia Sophia. The churches built after the Iconoclastic Controversy were modest in size, and monastic rather than imperial or urban in spirit. Most were constructed for small groups of monks living in isolated areas. Their usual plan is that of a Greek cross (that is, a cross with arms of equal length) contained in a square, with a narthex added on one side and an apse (sometimes with flanking chapels) on the other. The central feature is a dome on a square base. It often rests on a cylindrical or octagonal drum with tall windows, which raises it high above the rest of the building, as in both churches of the Monastery of Hosios Loukas in Greece (figs. 332–34). They also show other characteristics of later Byzantine architecture: a tendency toward more elaborate exteriors, in contrast to the extreme severity we observed earlier (compare fig. 317), and a preference for elongated proportions. The full impact of this verticality, however, strikes us only when we enter the church

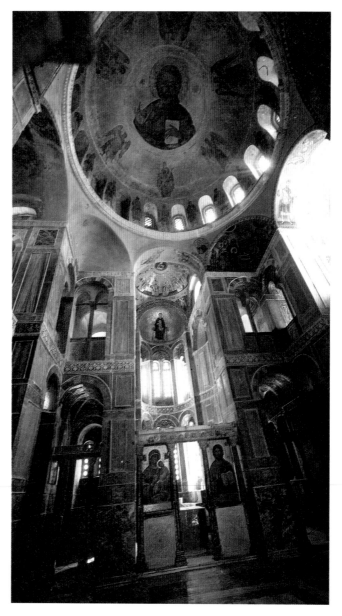

334. Interior, Katholikon, Hosios Loukas

(fig. 334 shows the interior of the Katholikon, on the left in figs. 332 and 333). The tall, narrow space compartments produce a sense of crowdedness, almost of compression, which is dramatically relieved as we raise our glance toward the luminous pool of space beneath the dome.

ST. MARK'S, VENICE. The largest and most lavishly decorated church of the period surviving today is St. Mark's in Venice, begun in 1063. The present structure, modeled on the Church of the Holy Apostles in Constantinople, which had been rebuilt by Justinian following the Nika riots and later destroyed, replaced two earlier churches of the same name on the site. The Venetians had long been under Byzantine sovereignty and remained artistically dependent on the East well after they had become politically and commercially powerful in their own right. St. Mark's, too, has the Greek-cross plan inscribed within a square, but here each arm of the cross is emphasized by a dome of its own (figs. 335 and 336). These domes are not raised on drums. Instead, they have been

encased in bulbous wooden helmets covered by gilt copper sheeting and topped by ornate lanterns, to make them appear taller and more conspicuous at a distance. They make a splendid landmark for the seafarer. The spacious interior, which is famous for its mosaics, shows that it was meant to receive the citizenry of a large metropolis and not just a small monastic community, as at Hosios Loukas.

ST. BASIL, MOSCOW. Byzantine architecture also spread to Russia, along with the Orthodox faith. There the basic type of the Byzantine church underwent an amazing transformation through the use of wood as a structural material. The most famous product of this native trend is the Cathedral of St. Basil adjoining the Kremlin in Moscow (fig. 337). Built during the reign of Ivan the Terrible, it seems as unmistakably Russian as that extraordinary ruler. The domes, growing in amazing profusion, have become fantastic towerlike structures as vividly patterned as the rest of the building. The total effect is extremely impressive. The church nevertheless conveys a

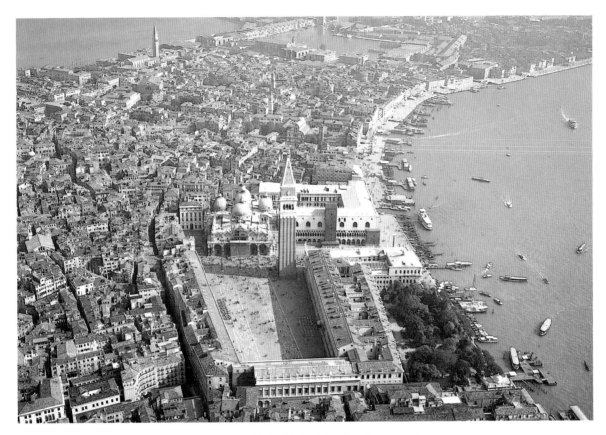

335. St. Mark's (aerial view), Venice. Begun 1063

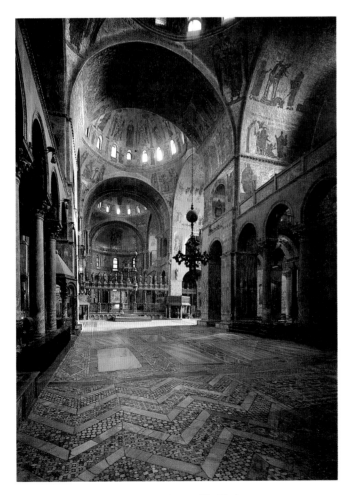

336. Interior, St. Mark's, Venice.

337. Cathedral of St. Basil, Moscow. 1554–60

338. *Virgin and Child Enthroned.* c. 843–67. Mosaic. Hagia Sophia, Istanbul

sense of the miraculous that is derived from the more austere miracles of Byzantine architecture.

ORTHODOX REVIVAL. We know little for certain about how the Byzantine artistic tradition managed to survive from the early eighth to the mid-ninth century, but survive it did. The most direct proof is the mosaic of the *Virgin and Child Enthroned* in Hagia Sophia (fig. 338). We know it was made sometime between the end of the Iconoclastic Controversy in 843 and 867, when it was unveiled to celebrate the triumph of Orthodoxy. It adheres closely to the earliest icon of the same subject (see fig. 331). Remarkably, the subtlety of modeling and color manages to perpetuate the best tradition of early

Byzantine art. Perhaps most important, there is a new human quality in the fullness of the figures, the more relaxed poses, and their more natural expressions that we have not seen before.

CLASSICAL REVIVAL. Basil I reopened the university in Constantinople, which led to an astonishing revival of classical learning, literature, and art. Much of it occurred in the early tenth century under Constantine VII, who was emperor in name only for most of his life and turned to classical scholarship and art. This renewed interest helps to explain the reappearance of Late Classical motifs in middle Byzantine art. *David Composing the Psalms* (fig. 339) is one of eight

339. *David Composing the Psalms,* from the *Paris Psalter.* c. 900 A.D. 14 1/8 x 10 1/4" (36 x 26 cm). Bibliothèque Nationale, Paris

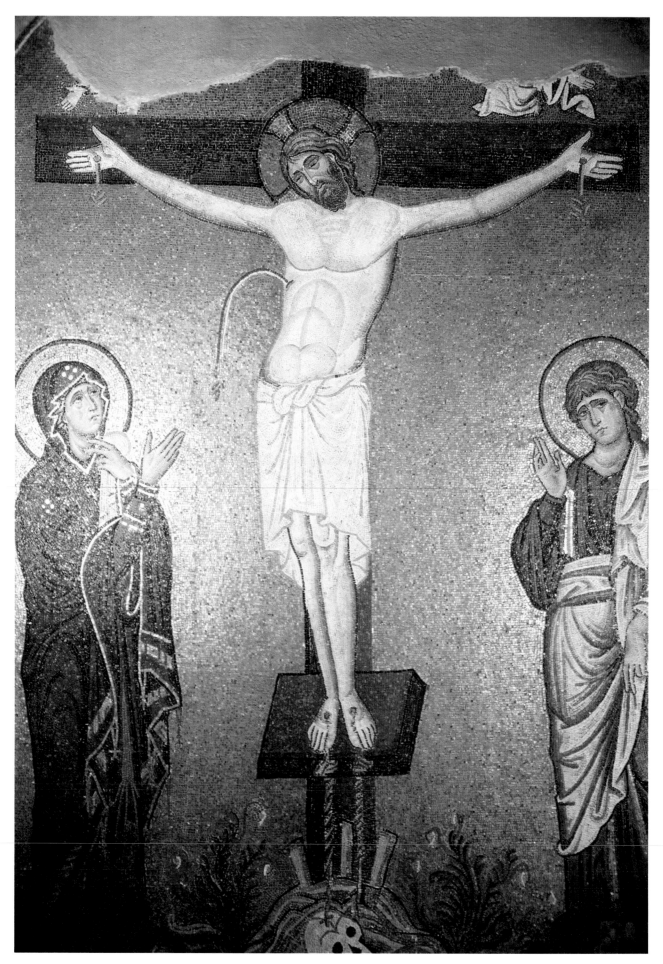

340. *The Crucifixion.* 11th century. Mosaic. Monastery Church, Daphné, Greece

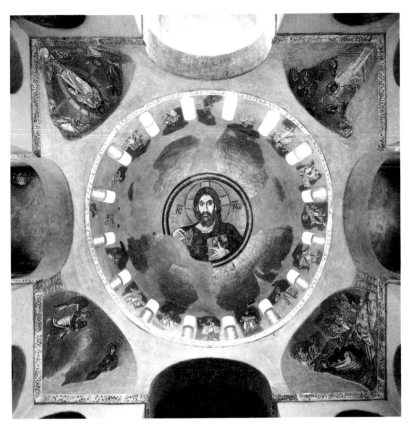

341. Dome mosaics. 11th century. Monastery Church, Daphné, Greece

full-page scenes in the so-called *Paris Psalter.* These scenes illustrating his life introduce the Psalms (which David was thought to have composed). The psalter was probably illuminated about 900, although the temptation to put it earlier is almost irresistible. Not only do we find a landscape that recalls Pompeian murals, but the figures, too, obviously derive from Roman models. David himself could well be mistaken for Orpheus charming the beasts with his music, and his companions prove even more surprising, since they are allegorical figures that have nothing at all to do with the Bible: the young woman next to David is Melody, the one coyly hiding behind a pillar is Echo, and the male figure with a tree trunk personifies the mountains of Bethlehem. The late date of the picture is evident only from certain qualities of style such as the abstract zigzag pattern of the drapery covering Melody's legs.

DAPHNÉ. The *Paris Psalter* betrays an almost antiquarian enthusiasm for the traditions of classical art. Such a direct revival, however, is an extreme case. More commonly classicism is harmoniously merged with the spiritualized ideal of human beauty we encountered in the art of Justinian's reign. Among these, the *Crucifixion* mosaic in the Greek monastery church at Daphné (fig. 340) enjoys special fame. Its classical qualities are more fundamental, and more deeply felt, than those of the *Paris Psalter,* yet they are also completely Christian. There is no attempt to re-create a realistic spatial setting, but the composition has a balance and clarity that are truly monumental. Classical, too, is the statuesque dignity of the figures, which seem extraordinarily organic and graceful compared to those of the Justinian mosaics at S. Vitale (figs. 321 and 322).

The most important aspect of these figures' classical heritage, however, is emotional rather than physical. The gestures and facial expressions convey a restrained and noble suffering of the kind we first met in Greek art of the fifth century B.C. (see pages 146–48). When and where this human interpretation of the Saviour made its first appearance we cannot say, but it seems to have developed primarily in the wake of the Iconoclastic Controversy, and reached its height during the Ducas and Comnene dynasties that ruled Byzantium from the middle of the eleventh through the late twelfth centuries. There are, to be sure, a few earlier examples of it, but none of them appeals to the emotions of the beholder so powerfully as the Daphné *Crucifixion.* To have introduced this compassionate view of Christ into sacred art was perhaps the greatest achievement of middle Byzantine art.

Early Christian art had been quite devoid of this quality. It stressed the Saviour's divine wisdom and power rather than his sacrificial death, so that the Crucifixion was depicted only rarely and in a notably unpathetic spirit. Alongside the new emphasis on the Christ of the Passion, however, the image of the Pantocrator (Ruler of the Universe), as we saw it on the *Sarcophagus of Junius Bassus* and above the apse of S. Apollinare in Classe (figs. 312 and 302), retained its importance. Staring down from the center of the majestic dome at Daphné is an awesome mosaic image of Christ the Pantocrator against a gold background (fig. 341), its huge scale emphasized by the

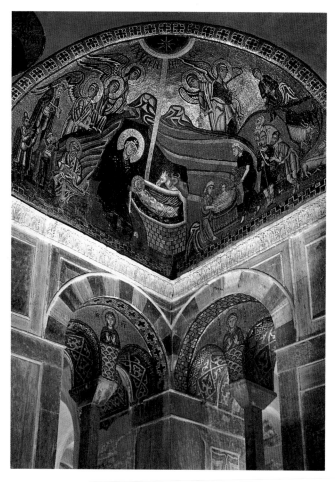

342. *Nativity.* Early 11th century. Mosaic.
Monastery of Hosios Loukas

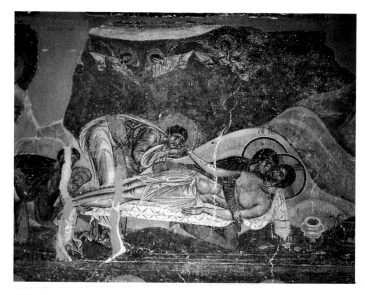

343. *Lamentation.* 1164. Fresco. St. Panteleimon, Nerezi, Macedonia

much smaller figures of the 16 Old Testament prophets between the windows. [See Primary Sources, no. 25, page 384.] Although it descends from images of Zeus, the mature, bearded visage of Jesus was first defined during the sixth century in the Mandylion, a "true portrait" on cloth that, according to legend, Jesus sent to King Agbar. Later it provided the basis for the miraculous image that appeared on the veil (*sudarium*) of St. Veronica (*vera icona*, or true image). Because of its historical "authenticity," the bearded Christ quickly replaced the youthful philosopher in art.

In the corners of the dome, we see four scenes revealing the divine and human natures of Christ: the Annunciation (bottom left) followed in counterclockwise order by the Birth, Baptism, and Transfiguration. The entire cycle represents a theological program perfectly in harmony with the geometric relationship of the images. A similarly strict order governs the distribution of subjects throughout the rest of the interior. The basic scheme probably dates back to the time of Basil I, who ordered decorations added to the Nea and the Church of the Apostles in Constantinople, both now destroyed.

HOSIOS LOUKAS. Byzantine art had managed somehow to preserve these and other biblical subjects from Early Christian times. In the eleventh century they enjoyed a revival, which thoroughly explored their narrative and pictorial potential. The *Nativity* in figure 342 from Hosios Loukas, which

employs the same composition as at Daphné but is somewhat earlier in date and in better condition, has a greater complexity than previous renderings. Instead of focusing simply on the Virgin and Child, the mosaicist used continuous narrative to include not only midwives bathing the newborn infant but also a host of angels and the Adoration of the Magi and the Annunciation to the Shepherds. The great variety of pose and expression lends a heightened sense of drama to the scene. Despite its schematic rendering, the mountainous landscape shows a new interest in illusionistic space as well. Missing only is the tender exchange of glances and gestures that is the most precious legacy of Daphné.

NEREZI. The emphasis on human content reaches its climax in the paintings at the church of St. Panteleimon in Nerezi, Macedonia. It was built by members of the Byzantine royal family and decorated by a team of artists summoned from Constantinople. From the beginning of Byzantine art in the sixth century, mural painting had served as a less expensive alternative to mosaic, which was preferred whenever possible. The best painters nevertheless participated fully in the new style; in some cases, they even felt free to introduce innovations of their own. The artist responsible for the Lamentation over the dead Christ (fig. 343) was a great master who expanded the latest advances. The gentle sadness of the Daphné *Crucifixion* has been replaced by a grief of almost unbearable

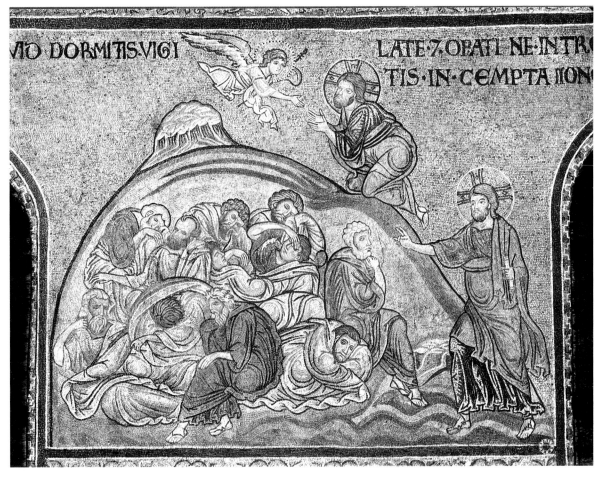

344. *Christ in the Garden of Gethsemane.* c. 1183. Mosaic. Cathedral, Monreale, Italy

intensity. The style remains the same, but its expressive quali-ties have been emphasized by subtle adjustments in the pro-portions and features. The subject seems to have been of recent invention, for it is otherwise unknown in earlier Byzan-tine art. Even more than the Daphné *Crucifixion,* its origins lie in Classical art: *Eos and Memnon* by Douris (fig. 145), which it echoes in composition and mood. Yet nothing pre-pares us for the Virgin's anguish as she clasps her dead son or the deep sorrow of St. John holding Christ's lifeless hand. We have entered a new realm of religious feeling that was to be fur-ther explored in the West.

MONREALE. The Byzantine manner was soon transmitted to Italy, where it was called the "Greek style" and had a deci-sive impact on Gothic painting (see pages 362–63). Some-times it was carried by miniature mosaic diptychs from Con-stantinople, but most often it was brought directly by visiting Byzantine artists. It made its first appearance in Sicily, a for-mer Byzantine holding, which was taken from the Moslems in 1091 by the Normans and was united with southern Italy. The new style is seen throughout the magnificent churches and monasteries erected in Palermo, the island's capital. The Nor-man kings considered themselves the equals of the Byzantine emperors and called in teams of mosaicists from Constan-tinople to decorate their splendid religious buildings. The mosaics at the Cathedral of Monreale, the last to be executed,

are in a thoroughly up-to-date Byzantine style, although the selection and disposition of subjects are purely Western in approach. *Christ in the Garden of Gethsemane* (fig. 344) is an astonishing premonition of El Greco's painting of the same subject (see fig. 17). The scene shows Christ comforted by the angel of the Lord (above); he then admonishes Peter and the sleeping disciples (below), who appear enclosed by the moun-tain behind them in order to conflate the two episodes within a single image. Even more important than the striking com-position is the attention paid to the figures, each of which is far more individualized than before. The artist's growing abil-ity to investigate subtleties of characterization traces the progress of Byzantine art.

IVORIES. Monumental sculpture, as we saw earlier (page 242), tended to disappear completely from the fifth century on. In Byzantine art, large-scale statuary died out with the last imperial portraits, and stone carving was confined almost entirely to architectural ornament (see fig. 327). But small-scale reliefs, especially in ivory and metal, continued to be pro-duced in considerable numbers.

Their extraordinary variety of content, style, and purpose is suggested by the two examples shown here, both of which date from the tenth century. One is *The Harbaville Triptych,* a small portable altar shrine with two hinged wings of the kind a high dignitary might carry for his private devotions while

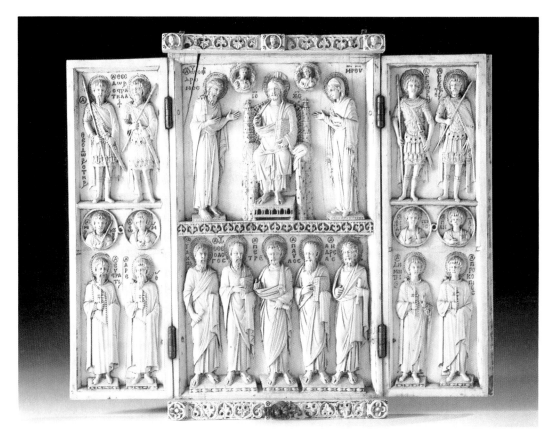

345. *The Harbaville Triptych.* Late 10th century. Ivory, 9 ¹/₂ x 11" (24 x 28 cm). Musée du Louvre, Paris

346. *The Sacrifice of Iphigenia.* Detail of ivory casket. 10th century. Victoria & Albert Museum, London

traveling (fig. 345). In the upper half of the center panel we see Christ Enthroned, flanked by St. John the Baptist and the Virgin, who plead for divine mercy on behalf of humanity. Below is John the Baptist flanked by the four apostles arranged in strictly frontal view. Only in the upper tier of each wing is this formula relaxed. There, surprisingly, we find an echo of Classical contrapposto in the poses of the two inner military saints. The exquisite refinement of this icon-in-miniature recalls the style of the Daphné *Crucifixion* (fig. 340).

Our second example, slightly later in date, is the Veroli Casket (fig. 346), meant for a wedding gift, which, rather surprisingly, is decorated with scenes of Greek mythology. Even more than the miniatures of the *Paris Psalter,* it illustrates the antiquarian aspects of Byzantine classicism after the Iconoclastic Controversy. The subject, the Sacrifice of Iphigenia, comes from a famous Greek drama by Euripides. The panel shows a major change in style that features deep undercutting of the relief. The composition (which nevertheless remains curiously shallow) probably derives from an illustrated manuscript rather than from a sculptural source. Though drained of all

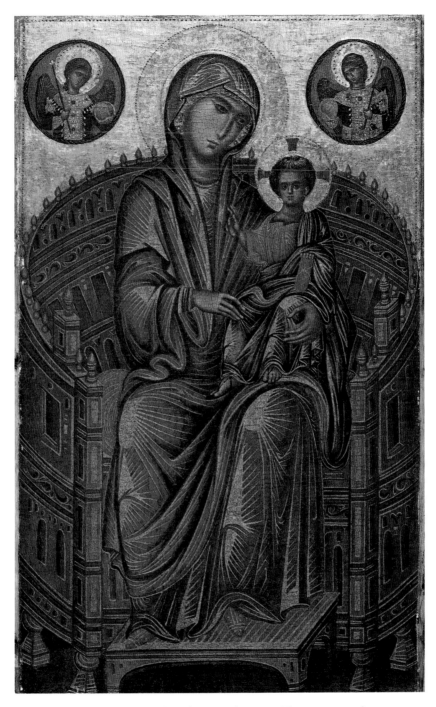

347. *Madonna Enthroned.* Late 13th century. Tempera on panel,
32 1/8 x 19 3/8" (81.9 x 49.3 cm). National Gallery of Art, Washington, D.C.
Andrew Mellon Collection

tragic emotion and reduced to a level of ornamental playfulness, these knobby little figures, with their distinctive grapecluster hair, form a coherent visual quotation from ancient art.

Late Byzantine Art

In 1204 Byzantium sustained an almost fatal defeat when the armies of the Fourth Crusade, instead of warring against the Turks, assaulted and took the city of Constantinople. For more than 50 years, the core of the Eastern Empire remained in Western hands. Byzantium, however, survived this catastrophe. In 1261 it once more regained its sovereignty under the Palaeo-

logue dynasty, and the fourteenth century saw a last flowering of Byzantine painting, with a distinct and original flavor of its own, before the Turkish conquest in 1453.

ICONS. Because of the veneration in which they were held, icons had to conform to strict formal rules, with fixed patterns repeated over and over again. As a consequence, the majority of them are more conspicuous for exacting craftsmanship than for artistic inventiveness. Although painted in the thirteenth century, the *Madonna Enthroned* (fig. 347) reflects a much earlier type. Echoes of middle Byzantine art abound: the graceful pose, the rich play of drapery folds, the tender melancholy of

348. *Elizabeth at the Well*. c. 1310. Mosaic. Kariye Camii (Church of the Saviour in Chora), Istanbul

the Virgin's face, and the elaborate architectural perspective of the throne (which looks rather like a miniature replica of the Colosseum). But all these elements have become oddly abstract. The throne, despite its foreshortening, no longer functions as a three-dimensional object, and the highlights on the drapery resemble ornamental sunbursts, in sharp contrast to the soft shading of hands and faces. The total effect is neither flat nor spatial but transparent, somewhat like that of a stained-glass window. The shapes look as if they were lit from behind. Indeed, the highly reflective gold background against which they are set and the gold highlights are so brilliant that even the shadows never seem wholly opaque.

This all-pervading celestial radiance, we will recall, is a quality first encountered in Early Christian mosaics (compare fig. 307). Panels such as ours, therefore, should be viewed as the aesthetic equivalent, on a smaller scale, of mosaics, and not simply as the descendants of the ancient panel painting tradi-

tion. In fact, some of the most precious Byzantine icons are miniature mosaics done on panels, rather than paintings.

MOSAICS AND MURAL PAINTING. Kariye Camii (the former Church of the Saviour in Chora) in Istanbul contains the finest extant cycle of late Byzantine mosaics, done about 1310–20. They present the climax of the humanism that emerged in middle Byzantine art, and with good reason: like Constantine VII, the emperor Theodore Metochites, who restored the church and paid for its decorations, was a scholar and poet. The unprecedented variety of poses and expressions in *Elizabeth at the Well* (fig. 348) shows the growing Byzantine fascination with storytelling. As part of this lively narrative, the setting has blossomed quite literally into a full landscape, complete with illusionistically rendered architecture. The scene resurrects a landscape style that had flourished in sixth-century secular mosaics and had been all but lost over the intervening

349. *Anastasis*. c. 1310–20. Fresco. Kariye Camii (Church of the Saviour in Chora), Istanbul

centuries. It reflects an illusionism familiar to us from Pompeian painting, which was also preserved in manuscripts of the classical revival of the tenth century (compare fig. 339).

Equally impressive are the paintings in the mortuary chapel attached to Kariye Camii. Because of the impoverished state of the greatly shrunken empire, murals often took the place of mosaics, but at Kariye Camii they exist on an even footing. In figure 349 we reproduce the *Anastasis,* which is Greek for resurrection. (Actually the scene depicts the traditional Byzantine image of this subject, an event before Christ's Resurrection on earth that Western Christians call Christ's Descent into Limbo or the Harrowing of Hell to rescue souls.) Surrounded by a radiant gloriole, the Saviour has vanquished Satan and battered

down the gates of Hell, and is raising Adam and Eve from the dead. (Note the bound Satan at his feet, in the midst of an incredible profusion of hardware.) What amazes us about this central group is its dramatic force, a quality we would hardly expect to find on the basis of what we have seen of Byzantine art so far. Christ here moves with extraordinary physical energy, tearing Adam and Eve from their graves, so that they appear to fly through the air—a magnificently expressive image of divine triumph. Such dynamism had been unknown in the earlier Byzantine tradition. Coming in the fourteenth century, it shows that eight hundred years after Justinian, when this subject made its first appearance, Byzantine art still had all its creative powers.

EARLY MEDIEVAL ART

The labels used for historical periods tend to be like the nicknames of people. Once established, they are almost impossible to change, even though they may no longer be suitable. Those who coined the term *Middle Ages* thought of the entire thousand years from the fifth to the fifteenth century as an age of darkness, an empty interval between classical antiquity and its rebirth, the Renaissance in Europe. Since then, our view of the Middle Ages has changed completely. We no longer think of the period as "benighted" but as a time of great cultural change and considerable creative activity. During the 200-year interval between the death of Justinian and the reign of Charlemagne, as we have already pointed out, the center of gravity of European civilization shifted northward from the Mediterranean Sea, and the economic, political, and spiritual framework of the Middle Ages began to take shape. We shall now see that the same centuries also gave rise to some important artistic achievements.

Celtic-Germanic Style

ANIMAL STYLE. The Celtic-Germanic style was a result of the widespread migrations after the fall of the Roman Empire. The Celts, who had settled the area later known to the Romans as Gaul in southwest Germany and eastern France during the second millennium B.C., spread across much of Europe and into Asia Minor, where they battled the Greeks (see page 158). Pressed by neighboring Germanic peoples, who originated in the Baltic region, they crossed the English Channel in the fourth century B.C. and colonized Britain and Ireland, where they were joined in the fifth century by the Angles and Saxons from today's Denmark and northern Germany. In 376 the Huns, who had pressed beyond the Black Sea from Central Asia, became a serious threat to Europe, first pushing the Visigoths westward into the Roman Empire from the Danube, and then under Attila (died 453) invading Gaul in 451 before attacking Rome a year later. These Germanic peoples from the east carried with them, in the form of nomads' gear, an ancient and widespread artistic tradition, the so-called animal style. We have encountered early examples of

it in the Luristan bronzes of Iran and the Scythian gold ornaments from southern Russia (see page 93 and figs. 107 and 108). This style, with its combination of abstract and organic shapes, of formal discipline and imaginative freedom, merged with the intricate ornamental metalwork of the Celts to create Celtic-Germanic art. An excellent example of this "heathen" style is the gold-and-enamel purse cover (fig. 350) from the grave at Sutton Hoo of an East Anglian king who died between 625 and 633.

On it are four pairs of symmetrical motifs. Each has its own distinctive character, an indication that the motifs have been assembled from four different sources. One motif, the standing man between confronted animals, has a very long history indeed—we first saw it in Egyptian art more than 3,800 years earlier (see fig. 50). The eagles pouncing on ducks bring to mind similar pairings of carnivore-and-victim in Luristan bronzes. The design above them, at center, on the other hand, is of more recent origin. It consists of fighting animals whose tails, legs, and jaws are elongated into bands forming a complex interlacing pattern. The fourth motif, interlacing bands as an ornamental device, on the top left and right, occur in Roman and Early Christian art, especially along the southern shore of the Mediterranean. However, their combination with the animal style, as shown here, seems to be an invention of Celtic-Germanic art, not much before the date of our purse cover.

Metalwork, in a variety of materials and techniques and often of exquisitely refined craftsmanship, had been the principal medium of the animal style. Such metal objects, small, durable, and eagerly sought after, account for the rapid diffusion of this idiom's repertory of forms. These forms migrated not only in the geographic sense but also technically and artistically, in the mediums used: from metal into wood, stone, and even pigment in manuscript illumination.

Wooden specimens, as we might expect, have not survived in large numbers. Most of them come from Scandinavia, where the animal style flourished longer than anywhere else. The splendid animal head of the early ninth century in figure 351 is the terminal, or decorated end, of a post that was found, along with much other equipment, in a buried Viking ship at

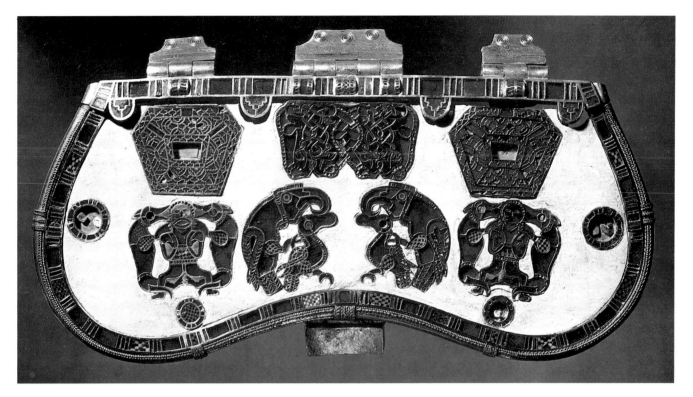

350. Purse cover, from the Sutton Hoo ship burial. 625–33 A.D. Gold with garnets and enamels, length 8" (20.3 cm). The British Museum, London

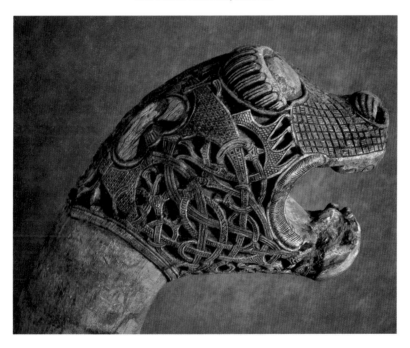

351. *Animal Head,* from the Oseberg ship burial. c. 825 A.D. Wood, height approx. 5" (12.7 cm). Institute for Art History and Classical Archaeology, University of Oslo, Norway

Oseberg in southern Norway. Like the motifs on the Sutton Hoo purse cover, it shows a peculiarly composite quality. The basic shape of the head is surprisingly realistic, as are certain details (teeth, gums, nostrils). But the surface has been spun over with interlacing and geometric patterns that betray their derivation from metalwork. Snarling monsters such as this used to rise from the prows of Viking ships, which endowed them with the character of mythical sea dragons.

Hiberno-Saxon Style

The earliest Christian works of art made north of the Alps also reflected the Germanic version of the animal style. In order to understand how they came to be produced, however, we must first acquaint ourselves with the important role played by the Irish (Hibernians), who assumed the spiritual and cultural leadership of western Europe during the early Middle Ages. The period 600 to 800 A.D. deserves, in fact, to be called the Golden Age of Ireland. Unlike their English neighbors, the Irish had

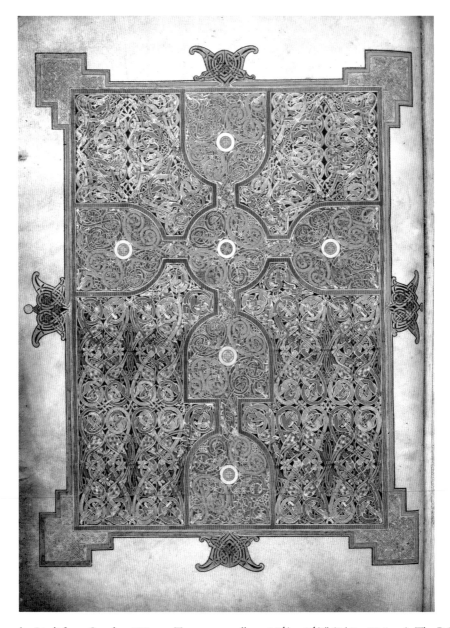

352. Cross page, from the *Lindisfarne Gospels*. c. 700 A.D. Tempera on vellum, 13 1/2 x 9 1/4" (34.3 x 23.5 cm). The British Library, London

never been part of the Roman Empire. Thus the missionaries who carried the Gospel to them from England in the fifth century found a Celtic society entirely barbarian by Roman standards. The Irish readily accepted Christianity, which brought them into contact with Mediterranean civilization, but they did not become Rome-oriented. Rather, they adapted what they had received in a spirit of vigorous local independence.

The institutional framework of the Roman Church, being essentially urban, was ill-suited to the rural character of Irish life. Irish Christians preferred to follow the example of the desert saints of Egypt and the Near East who had left the temptations of the city to seek spiritual perfection in the solitude of the wilderness. Groups of such hermits, sharing the ideal of ascetic discipline, had founded the earliest monasteries in Egypt and now did so in Ireland. By the fifth century, monasteries had spread as far north as western Britain, but only in Ireland did monasticism take over the leadership of the Church from the bishops.

Irish monasteries, unlike their Egyptian prototypes, soon became seats of learning and the arts. They developed a mis-

sionary fervor that sent Irish monks to preach to the heathen and to found monasteries not only in northern Britain but also on the European mainland, from present-day France to Austria. These Irish monks speeded the conversion to Christianity of Scotland, northern France, the Netherlands, and Germany. Further, they established the monastery as a cultural center throughout the European countryside. Although their Continental foundations were taken over before long by the monks of the Benedictine order, who were advancing north from Italy during the seventh and eighth centuries, Irish influence was to be felt within medieval civilization for several hundred years to come.

MANUSCRIPTS. In order to spread the Gospel, the Irish monasteries had to produce copies of the Bible and other Christian books in large numbers. Their scriptoria (writing workshops) also became centers of artistic endeavor, for a manuscript containing the Word of God was looked upon as a sacred object whose visual beauty should reflect the importance of its contents. Irish monks must have known Early

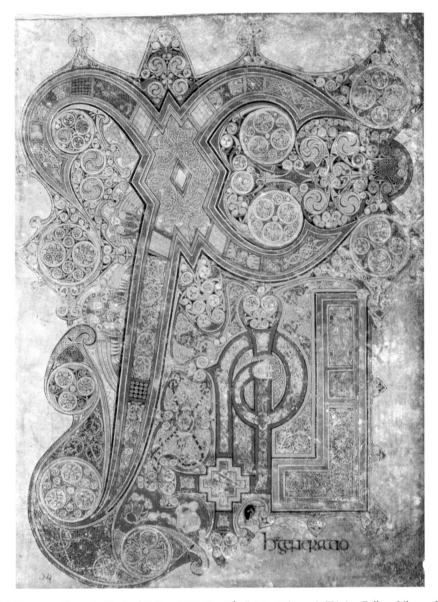

353. Chi-Rho page, from the *Book of Kells*. c. 800? 13 x 9 ½" (33 x 24.1 cm). Trinity College Library, Dublin

Christian illuminated manuscripts, but here, as in other respects, they developed an independent tradition instead of simply copying their models. While pictures illustrating biblical events held little interest for them, they devoted great effort to decorative embellishment. The finest of these manuscripts belong to the Hiberno-Saxon style—that Christian form which evolved from heathen Celtic-Germanic art and flourished in the monasteries founded by Irishmen in Saxon England. [See Primary Sources, no. 26, page 384.]

The Cross page in the *Lindisfarne Gospels* (fig. 352) is an imaginative creation of breathtaking complexity. The miniaturist, working with a jeweler's precision, has poured into the compartments of the geometric frame an animal interlace so dense and yet so full of controlled movement that the fighting beasts on the Sutton Hoo purse cover seem simple in comparison. It is as if these biting and clawing monsters had suddenly been subdued by the power of the Cross. In order to achieve this effect, our artist has had to work within an extremely severe discipline, following "rules of the game." These rules demand, for instance, that organic and geometric shapes must be kept separate and that within the animal compartments every line must turn out to be part of an animal's body, if we take the trou-

ble to trace it back to its point of origin. There are other rules, too complex to go into here, concerning symmetry, mirror-image effects, and repetitions of shapes and colors. Only by working these out for ourselves by intense observation can we hope to enter into the spirit of this strange, mazelike world.

Irish manuscripts reached a climax a hundred years later in the *Book of Kells*, the most varied and elaborate codex of Celtic art. Once renowned as "the chief relic of the Western world," it was done at the monastery on the island of Iona and left incomplete when the island was invaded by Vikings between 804 and 807. Its many pages present a summa of early medieval illumination, reflecting a wide array of influences from the Mediterranean to the English Channel. The justly famous Chi-Rho monogram (standing for Christ; fig. 353) has much the same swirling design as the Cross page from the *Lindisfarne Gospels*, but now the rigid geometry has been relaxed somewhat and, with it, the ban against human representation. Suddenly the pinnacle of the X-shaped Chi sprouts a thoroughly recognizable face, while along its shaft are three winged angels. And in a touch of enchanting fantasy, the tendrillike P-shaped Rho ends in a monk's head. More surprising still is the introduction of the natural world. Nearly hidden in

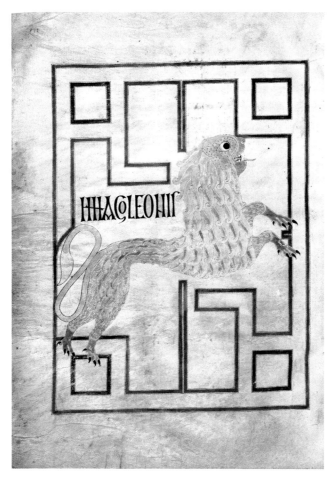

354. *Symbol of St. Mark,* from the *Echternach Gospels.* c. 690 A.D.
12³/₄ x 10³/₈" (32.4 x 26.4 cm). Bibliothèque Nationale, Paris

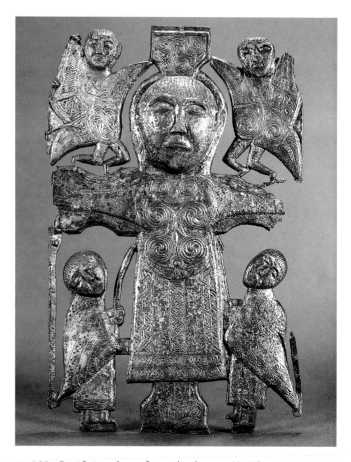

355. *Crucifixion,* plaque from a book cover (?). 8th century A.D.
Bronze, height 8¹/₄" (21 cm). National Museum of Ireland, Dublin

the profuse ornamentation, as if playing a game of hide-and-seek, are cats and mice, butterflies, even otters catching fish. No doubt they perform some as yet unclear symbolic function in order to justify their presence. Nevertheless, their appearance here is nothing short of astounding.

Of the representational images they found in Early Christian manuscripts, the Hiberno-Saxon illuminators generally retained only the symbols of the four evangelists, since these could be translated into their ornamental idiom without much difficulty. These symbols—the man (St. Matthew), the lion (St. Mark), the eagle (St. John), and the ox (St. Luke)—were derived from the Revelation of St. John the Divine and assigned to the evangelists by St. Augustine. The lion of St. Mark in the *Echternach Gospels* (fig. 354), sectioned and patterned like the enamel inlays of the Sutton Hoo purse cover, is animated by the same curvilinear sense of movement we saw in the animal interlaces of our previous illustration. Here again we marvel at the masterly balance between the shape of the animal and the geometric framework on which it has been superimposed (and which, in this instance, includes the inscription, *imago leonis*).

On the other hand, Celtic and Germanic artists showed little interest in the human figure for a long time. The bronze plaque of the *Crucifixion* (fig. 355), probably made for a book cover, shows a continuing concentration on flat patterns, even when faced with the image of a man. Although the composi-

tion is Early Christian in origin, the artist has conceived the human frame as a series of ornamental compartments, so that the figure of Jesus is disembodied in the most literal sense: the head, arms, and feet are all separate elements joined to a central pattern of whorls, zigzags, and interlacing bands. Clearly, there is a wide gulf between the Celtic-Germanic and the Mediterranean traditions, a gulf that the Irish artist who modeled the *Crucifixion* saw no need to bridge.

Lombard Style

The situation was much the same in Continental Europe. We even find it among the Lombards in northern Italy. The Germanic stone carver who did the marble balustrade relief in the Cathedral Baptistery at Cividale (fig. 356) was just as perplexed as the Irish by the problem of representation. The evangelists' symbols are strange creatures indeed. All four of them have the same spidery front legs, and their bodies consist of nothing but head, wings, and (except for the angel) a little spiral tail. Apparently the artist did not mind violating their integrity by forcing them into their circular frames in this Procrustean fashion. On the other hand, the panel as a whole has a well-developed sense of ornament. The flat, symmetrical pattern is an effective piece of decoration, rather like an embroidered cloth. It may, in fact, have been derived in part from Oriental textiles (compare fig. 116).

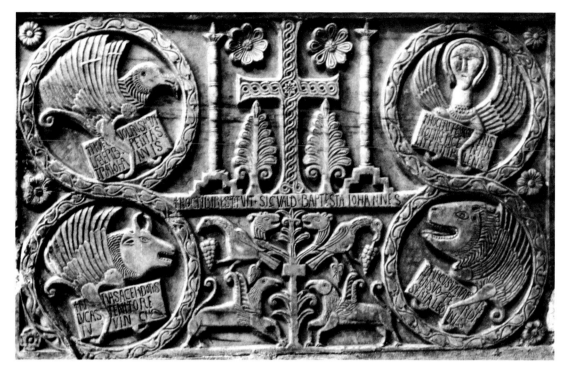

356. Balustrade relief inscribed by the Patriarch Sigvald (762–76 A.D.), probably carved c. 725–50 A.D. Marble, approx. 36 x 60" (91.3 x 152.3 cm). Cathedral Baptistery, Cividale, Italy

CAROLINGIAN ART

The cultural achievements of Charlemagne's reign have proved far more lasting than his empire, which began to disintegrate even before his death in 814. This very page would look different without them, for it is printed in letters whose shapes derive from the script in Carolingian manuscripts. The fact that these letters are known today as "Roman" rather than Carolingian recalls another aspect of the cultural reforms sponsored by Charlemagne: the collecting and copying of ancient Roman literature. The oldest surviving texts of a great many classical Latin authors are to be found in Carolingian manuscripts, which, until not very long ago, were mistakenly regarded as Roman; hence their lettering, too, was called Roman.

This interest in preserving the classics was part of an ambitious attempt to better the education of the court and the clergy as part of a larger reform program. Charlemagne's goals were to improve the administration of his realm and the teaching of Christian truths. Toward that end, he summoned a glittering array of the best minds from around the realm to his court, including Alcuin of York, the most learned scholar of the day, to restore ancient Roman learning and to establish a system of schools at every cathedral and monastery. The emperor, who could read but not write, took an active hand in this renewal, which went well beyond mere antiquarianism. To an astonishing extent, he succeeded. Thus, the "Carolingian revival" may be termed the first, and in some ways most important, phase of a genuine fusion of the Celtic-Germanic spirit with that of the Mediterranean world.

Architecture

During the Middle Ages, the word *architect* (which derives from the Greek word for master builder and was defined in its modern sense of designer and theoretician by the Roman writer Vitruvius during the first century A.D.) came to have different meanings. During the eighth century the distinction between design and construction, theory and practice, became increasingly blurred. As a result, the term nearly disappeared in northern Europe by the tenth century, and was replaced by a new vocabulary, in part because the building trades were strictly separated under the guild system. When it was used, architect could apply not only to masons, carpenters, and even roofers, but also to the person who commissioned or supervised a building. We know that in some instances the head abbot of a community of monks was the actual designer. Consequently, the design of churches became increasingly subordinate to liturgical and practical considerations. Their actual appearance, however, was largely determined by an organic construction process. Roman architectural principles and construction techniques, such as the use of cement, had been largely forgotten and were recovered only through cautious experimentation by builders of inherently conservative persuasion. Thus vaulting remained rudimentary and was limited to short spans, mainly the aisles, if it was used at all.

Not until about 1260 did Thomas Aquinas revive Aristotle's definition of architect as the person of intellect who leads or conducts, as opposed to the artisan who makes. In doing so, he acknowledged a change in practice that had

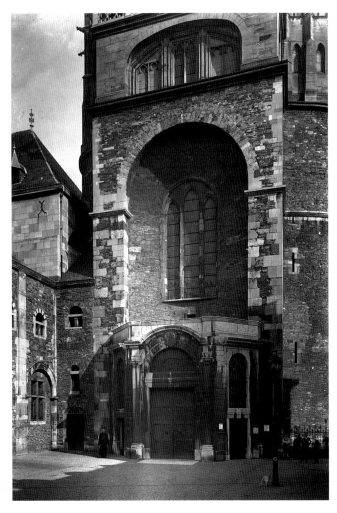

357. Entrance, Palace Chapel of Charlemagne, Aachen, Germany. 792–805 A.D.

(see page 341). The decisive step, however, came only in the early fifteenth century with the rediscovery of Vitruvius' writings, which provided the foundation for Renaissance theory.

PALACE CHAPEL, AACHEN. The achievement of Charlemagne's famous Palace Chapel (figs. 357–59) is all the more spectacular seen in this light. On his visits to Italy, he had become familiar with the architectural monuments of the Constantinian era in Rome and with those of the reign of Justinian in Ravenna. Charlemagne felt that his new capital at Aachen (the site was chosen for its mineral baths) must convey the majesty of empire through buildings of an equally impressive kind. The Palace Chapel, part of a large imperial complex, was inspired, in part, by S. Vitale (see figs. 317–20). The debt is particularly striking in cross section (compare fig. 359 to fig. 319). To erect such a structure on Northern soil was a difficult undertaking that was supervised by Einhard, Charlemagne's trusted adviser and biographer. Columns and bronze gratings had to be imported from Italy, and expert stonemasons must have been hard to find. The design, by Odo of Metz (probably the earliest architect north of the Alps known to us by name), is by no means a mere echo of S. Vitale but a vigorous reinterpretation, with piers and vaults of Roman massiveness and a geometric clarity of the spatial units very different from the fluid space of the earlier structure.

Equally significant is Odo's scheme for the western entrance, now largely obscured by later additions and rebuilding (fig. 357). At S. Vitale, the entrance consists of a broad, semi-detached narthex with twin stair turrets, at an odd angle to the main axis of the church (see fig. 318), while at Aachen these elements have been molded into a tall, compact unit, in line with the main axis and closely attached to the chapel proper. This monumental entrance structure, known as a westwork (from the German *Westwerk*), makes one of its first known appearances here, and already holds the germ of the two-tower facade familiar from so many later medieval churches. Charlemagne's throne was placed behind the great window above the entrance, where it faced an altar dedicated to Christ, who confers his blessing to the emperor from the dome mosaic. Thus, although contemporary documents say little about its function, the westwork seems to have served initially as a royal loge

occurred over the previous 150 years. Within a century the term was used by the humanist Petrarch to designate the artist in charge of a project. Petrarch thus acknowledged what had already become established practice in Florence, where first the painter Giotto and then the sculptors Andrea Pisano and Francesco Talenti were placed in charge of Florence Cathedral

Guilds: Masters and Apprentices

In the Middle Ages, the word *master* (Latin, *magister*) was a title conferred by a trade organization, or guild, signifying a member who had achieved the highest level of skill in the guild's profession or craft. In each city, trade guilds virtually controlled commercial life by establishing quality standards, setting prices, defining the limits of each guild's activity, and overseeing the admission of new members. The earliest guilds were formed in the eleventh century by merchants; but craftsmen, too, soon organized themselves in similar professional societies, whose power continued well into the sixteenth century. Most guilds admitted only men, but some, such as the painters' guild of Bruges, occasionally admitted women also. Guild membership established a certain level of social status for townspeople, who were neither nobility, clerics (people in religious life), nor peasantry.

A boy would begin as an apprentice to a master in his chosen guild, and after many years might advance to the rank of journeyman. In most guilds this meant that he was then a full member of the organization, capable of working without direction, and entitled to receive full wages for his work. Once he became a master, the highest rank, he could direct the work of apprentices and manage his own workshop, hiring journeymen to work with him.

In architecture, the master mason (sometimes called master builder) generally designed the building, that is, acted in the role of architect. In church-building campaigns, teams of carpenters (joiners), metalworkers, and glaziers (glassworkers) labored under the direction of the master builder.

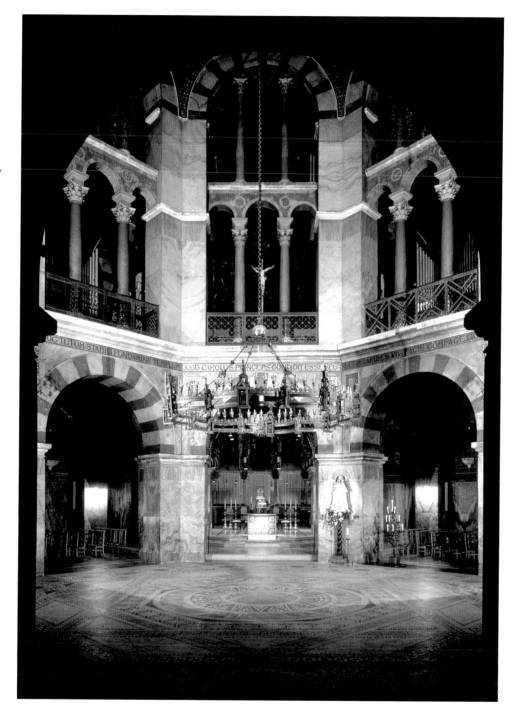

358. Interior of the Palace Chapel of Charlemagne, Aachen

or chapel, but both here and elsewhere it may have been used for a variety of other liturgical functions as the need arose.

ST.-RIQUIER, ABBEVILLE. An even more elaborate west-work formed part of the greatest basilican church of Carolingian times, that of the monastery of St.-Riquier (also called Centula), near Abbeville in northeastern France. Named for a monk who died in 645, it was established in 790 by Abbot Angilbert, a poet and scholar close to Charlemagne whose nick-name at the court was Homer. The monastery has been

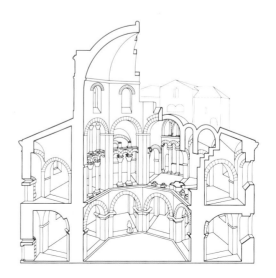

359. *(right)* Cross section of the Palace Chapel of Charlemagne (after Kubach)

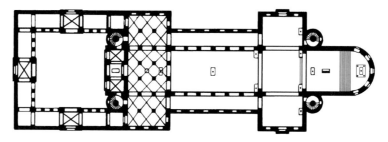

360. Plan of the Abbey Church of St.-Riquier, France. Consecrated 799 A.D. (after Effmann, 1912)

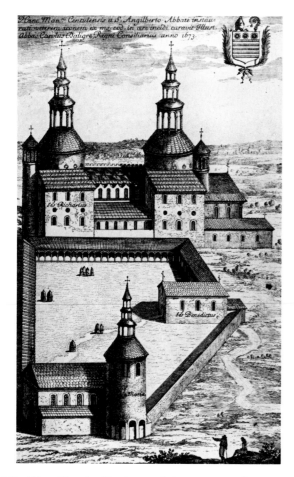

361. Abbey Church of St.-Riquier (1673 engraving after a 1612 view by Petau, from an 11th-century manuscript illumination)

completely destroyed, but its design is known in detail from drawings and descriptions (figs. 360 and 361). [See Primary Sources, nos. 27–29, pages 384–85.] Several innovations in the church were to become of basic importance for the future. The westwork leads into a vaulted narthex, which is in effect a western transept. Its crossing (the area where the transept intersects the nave) was crowned by a tower, as was the crossing of the eastern transept. Both transepts, moreover, featured a pair of round stair towers. The apse, unlike that of Early Christian basilicas (compare fig. 298), is separated from the eastern transept by a square compartment, called the choir. St.-Riquier was widely imitated in other Carolingian monastery churches, but these, too, have been destroyed or rebuilt in later times.

PLAN OF A MONASTERY, ST. GALL. The importance of monasteries and their close link with the imperial court are vividly suggested by a unique document of the period, the large drawing on five sheets of vellum of a plan for a monastery preserved in the chapter library at St. Gall in Switzerland (fig. 362). Its basic features seem to have been determined at a council held near Aachen in 816–17 that established the Benedictines as the official order under the Carolingians. This copy was then sent by Abbot Haito of Reichenau to Gozbert, the abbot of St. Gall, for "you to study only" in rebuilding the monastery. We may regard it, therefore, as a standard plan, intended to be modified according to local needs.

The monastery plan shows a complex, self-contained unit, filling a rectangle about 500 by 700 feet (fig. 363). The main path of entrance, from the west, passes between stables and a hostelry toward a gate that admits the visitor to a colonnaded semicircular portico flanked by two round towers—an early instance of a monumental western church front, or westwork—that loom impressively above the low outer buildings. The plan emphasizes the church as the center of the monastic community. The church is a basilica, with a transept and choir in the east but an apse and altar at either end. The nave and aisles, containing numerous other altars, do not form a single continuous space but are subdivided into compartments by screens. There are numerous entrances: two beside the western apse, others on the north and south flanks.

This entire arrangement reflects the functions of a monastery church, designed for the liturgical needs of the monks rather than for a lay congregation. Adjoining the church to the south is an arcaded cloister, around which are grouped the monks' dormitory (on the east side), a refectory (dining hall) and kitchen (on the south side), and a cellar. The three large buildings north of the church are a guesthouse, a school, and the abbot's house. To the east are the infirmary, a chapel and quarters for novices (new members of the religious community), the cemetery (marked by a large cross), a garden, and coops for chickens and geese. The south side is occupied by workshops, barns, and other service buildings. There is, needless to say, no monastery exactly like this plan anywhere—even in St. Gall the design was not carried out as drawn—yet its layout conveys an excellent notion of such establishments throughout the Middle Ages. [See Primary Sources, no. 30, pages 385–86.]

SPAIN. Outside of Germany, the vast majority of early medieval churches were small in size, simple in plan, and provincial in style. The best examples, such as Sta. Maria de

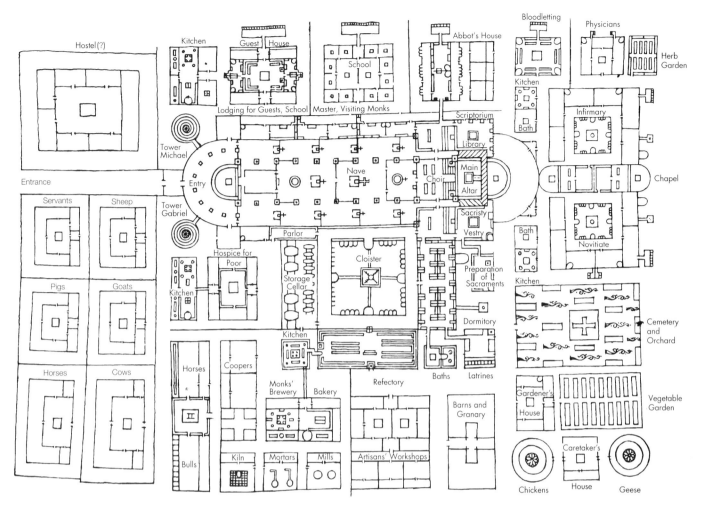

Hostel (?)

Kitchen
Guest House
School
Abbot's House
Bloodletting
Physicians
Herb Garden

Lodging for Guests, School Master, Visiting Monks
Kitchen
Scriptorium
Bath

Tower Michael
Entrance
Library
Infirmary

Servants Sheep
Tower Gabriel
Entry
Nave Choir
Main Altar
Chapel

Pigs Goats
Hospice for Poor
Sacristy
Vestry
Bath
Novitiate

Kitchen
Parlor
Storage Cellar
Cloister
Preparation of Sacraments
Kitchen

Horses Cows
Kitchen
Horses Coopers
Dormitory
Cemetery and Orchard

Monks' Brewery Bakery
Refectory Baths Latrines
Gardener's House
Vegetable Garden

Bulls
Kiln Mortars Mills Artisans' Workshops
Barns and Granary
Chickens Caretaker's House Geese

362. Plan of a monastery. Redrawn, with inscriptions translated into English from the Latin, from the original of c. 820 A.D. Red ink on parchment, 28 x 44 1/8" (71.1 x 112.1 cm). Stiftsbibliothek, St. Gall, Switzerland

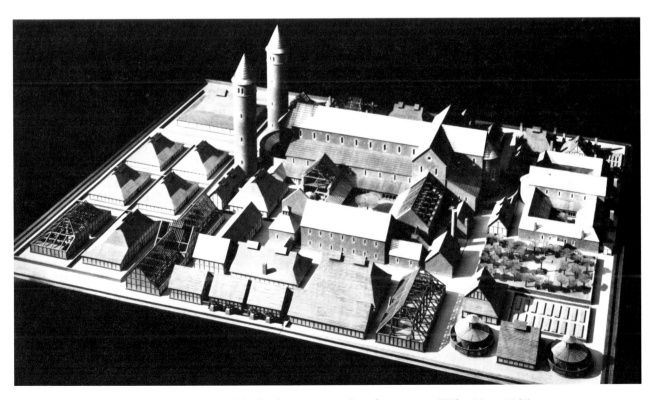

363. Reconstruction model, after the c. 820 A.D. plan of a monastery (Walter Horn, 1965)

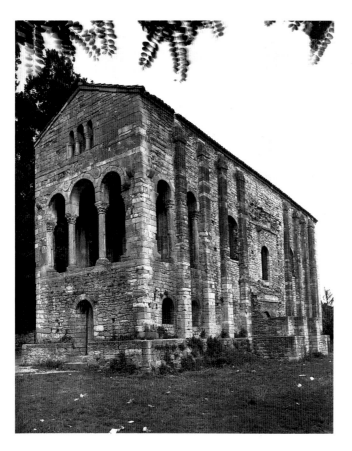

Naranco (fig. 364), are in Spain and owe their survival to their remote locations. Built by Ramiro I about 848 as part of his palace near Oviedo, it is, like Charlemagne's Palace Chapel, an audience hall and chapel (it even included baths) but on a much more modest scale. Remarkably, it features a tunnel vault along the upper story and arcaded loggias at either end that were clearly inspired by the interior of the Palace Chapel (fig. 358). The construction, however, is far more rudimentary, built of crudely carved, irregular blocks instead of the carefully dressed masonry (called ashlar) found at Aachen. We need only glance at S. Apollinare in Classe (fig. 300) to realize how much of the architectural past had been lost in only 300 years.

Manuscripts and Book Covers

GOSPEL BOOK OF CHARLEMAGNE. From the start, the fine arts played an important role in Charlemagne's cultural program. We know from literary sources that Carolingian churches contained murals, mosaics, and relief sculpture, but these have disappeared almost entirely. Illuminated manuscripts, carved ivories, and goldsmiths' work, on the other hand, have survived in considerable numbers. They demonstrate the impact of the Carolingian revival even more strikingly than the architectural remains of the period. The former Imperial Treasury in Vienna contains a Gospel Book said to have been found in the Tomb of Charlemagne and, in any event, is closely linked with his court at Aachen. Looking at the picture of St. Matthew from that manuscript (fig. 365), we can hardly believe that such a work could have been executed in northern Europe about the year 800. Were it not for the

364. Sta. Maria de Naranco, Oviedo, Spain. Dedicated 848

365. *St. Matthew,* from the *Gospel Book of Charlemagne.* c. 800–810 A.D. Ink and colors on vellum, 13 x 10" (33 x 25.4 cm). Kunsthistorisches Museum, Vienna

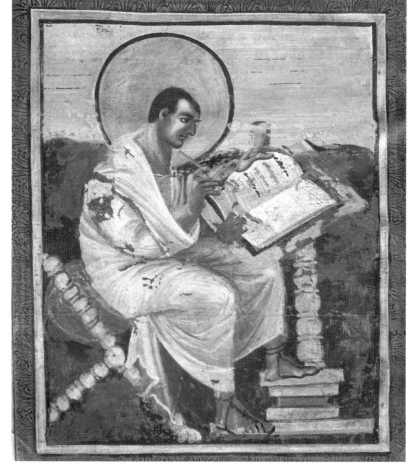

366. *Portrait of Menander.* c. 70 A.D. Wall painting. House of Menander, Pompeii

367. *St. Mark,* from the *Gospel Book of Archbishop Ebbo of Reims.* 816–35 A.D. Ink and colors on vellum, 10 1/4 x 8 3/16" (26 x 20.8 cm). Bibliothèque Municipale, Épernay, France

large golden halo, the evangelist Matthew might almost be mistaken for a classical author's portrait like the one of Menander (fig. 366), painted at Pompeii almost eight centuries earlier. Whether Byzantine, Italian, or Frankish, the artist plainly was fully conversant with the Roman tradition of painting, down to the acanthus ornament on the wide frame, which emphasizes the "window" treatment of the picture.

GOSPEL BOOK OF ARCHBISHOP EBBO. This *St. Matthew* represents the initial and most conservative phase of the Carolingian revival. It is the visual counterpart of copying the text of a classical work of literature. More typical is a slightly later miniature of St. Mark, painted some three decades later for the *Gospel Book of Archbishop Ebbo of Reims* (fig. 367), that shows the classical model translated into a Carolingian idiom. It must have been based on an evangelist's portrait of the same style as the *St. Matthew,* but now the entire picture is filled with a vibrant energy that sets everything into motion. The drapery swirls about the figure, the hills heave upward, the vegetation seems to be tossed about by a whirlwind, and even the acanthus pattern on the frame assumes a strange, flamelike character. The evangelist himself has been transformed from a Roman author setting down his own thoughts into a man seized with the frenzy of divine inspiration, an instrument for recording the Word of God. His gaze is fixed not upon his book but upon his symbol (the winged lion with a scroll), which acts as the transmitter of the sacred text. This dependence on the Word, so powerfully expressed here, characterizes the contrast between classical and medieval images of humanity. But the *means* of expression—the dynamism of line

that distinguishes our miniature from its predecessor—recalls the passionate movement in the ornamentation of Irish manuscripts (figs. 352 and 354).

UTRECHT PSALTER. The Reims School also produced the most extraordinary of all Carolingian manuscripts, the *Utrecht Psalter* (fig. 368, page 282). It displays the style of the *Ebbo Gospels* in an even more energetic form, since the entire book is illustrated with pen drawings. Here again the artist has followed a much older model, as indicated by the architectural and landscape settings of the scenes, which are strongly reminiscent of those on the Arch of Titus (see fig. 271), and by the use of Roman capital lettering, which had gone out of general use several centuries before. The wonderfully rhythmic quality of his draftsmanship, however, gives to these sketches a kind of emotional coherence that could not have been present in the earlier pictures. Without it, the drawings of the *Utrecht Psalter* would carry little conviction, for the poetic language of the Psalms does not lend itself to illustration in the same sense as the narrative portions of the Bible.

The Psalms can be illustrated only by taking each phrase literally and then by visualizing it in some manner. Thus, toward the bottom of the page, we see the Lord reclining on a bed, flanked by pleading angels, an image based on the words, "Awake, why sleepest thou, Oh Lord?" On the left, the faithful crouch before the Temple, "for . . . our belly cleaveth unto the earth," and at the city gate in the foreground they are killed "as sheep for the slaughter." In the hands of a pedestrian artist, this procedure could well turn into a wearisome charade. Here it has the force of a great drama.

QUARETRISTISESANIMA
MEA ETQUARECONTUR

BASME;
S PERAINDOQMADHUC

CONFITEBORILLI·SALU
TAREUULTUSMEIETDSMS;

XLII PSALMUS OXUID
IUDICAMEDSET
DISCERNECAUSAMMEIAM
DECENTENONSCA·ABHOMI
NEINIQUOETDOLOSOERU
EME;
QUIATUESDSFORTITUDO
MEA·QUAREMEREPPULIS
TIETQUARETRISTISINCEDO
DUMADFLICITMEINIMICUS

EMITTELUCEMTUAMETUERI
TATEMTUAM·IPSAMEDEDU
XERUNTETADDUXERIN
MONTEMSCMTUU·ETIN
TABERNACULATUA;
ETINTROIBOADALTAREDI
ADDMQUILAETIFICAT
IUUENTUTEMMEAM;

CONFITEBORTIBIINCI
THARADSDSMEUS?
QUARETRISTISESANIMA
MEAETQUARECONTUR
BASME;
SPERAINDOQNMADHUC
CONFITEBORILLI·SALU
TAREUULTUSMEIETDSMS;

368. Illustrations to Psalms 43 and 44, from the *Utrecht Psalter*. c. 820–32 A.D. University Library, Utrecht, The Netherlands

LINDAU GOSPELS COVER. The style of the Reims School can still be felt in the reliefs of the jeweled front cover of the *Lindau Gospels* (fig. 369), a work of the third quarter of the ninth century. This masterpiece of the goldsmith's art shows how splendidly the Celtic-Germanic metalwork tradition adapted itself to the Carolingian revival. The clusters of semi-precious stones are not mounted directly on the gold ground but raised on claw feet or arcaded turrets, so that the light can penetrate beneath them to bring out their full brilliance. Interestingly enough, the crucified Jesus betrays no hint of pain or death. He seems to stand rather than to hang, his arms spread

out in a solemn gesture. To endow him with the signs of human suffering was not yet conceivable, even though the means were at hand, as we can see from the eloquent expressions of grief among the small figures in the adjoining compartments.

OTTONIAN ART

Upon the death of Charlemagne's son, Louis I, in 843, the empire built by Charlemagne was divided into three parts by his grandsons: Charles the Bald, the West Frankish king, who established the French Carolingian dynasty; Louis the Ger-

369. Front cover of binding, *Lindau Gospels.* c. 870 A.D. Gold and jewels, 13 3/4 x 10 1/2" (35 x 26.7 cm). The Pierpont Morgan Library, New York

man, the East Frankish king, whose domain corresponded roughly to the Germany of today; and Lothair I, who inherited the middle kingdom and the title of Holy Roman Emperor. By dividing the king's domain among his heirs, the Carolingian dynasty made the same fatal mistake as its predecessors, the Merovingians. Charlemagne had tried to impose unified rule by placing his friends in positions of power throughout the realm, but they naturally became increasingly independent over time. During the late ninth and early tenth centuries this loose arrangement gradually gave way to the decentralized political and social system known today as feudalism in France and Germany, where it had deep historical roots. Knights (originally cavalry officers) held fiefs, or feuds, as their land was called, in return for service to their lords, to whom they were associated through a complex system of personal bonds—termed vassalage—that extended all the way to the king. The land itself was worked by the large class of generally downtrodden peasants (serfs and esnes), who were utterly powerless.

The Carolingians finally became so weak that Continental Europe once again lay exposed to attack. In the south, the Moslems resumed their depredations; Slavs and Magyars advanced from the east; and Vikings from Scandinavia ravaged the north and west. The Vikings (the Norse ancestors of today's Danes and Norwegians) had been raiding Ireland and Britain by sea from the late eighth century on. Now they invaded northwestern France as well and occupied the area that ever since has been called Normandy. Once established there, they soon adopted Christianity and Carolingian civilization, and from 911 on their leaders were recognized as dukes nominally subject to the authority of the king of France. During the eleventh century, the Normans assumed a role of major importance in shaping the political and cultural destiny of Europe, with William the Conqueror becoming king of England, while other Norman nobles expelled the Arabs from Sicily and the Byzantines from southern Italy.

In Germany, meanwhile, after the death of the last Carolingian monarch in 911, the center of political power had shifted north to Saxony. Beginning with Henry I, the Saxon kings (919–1024) reestablished an effective central government, and the greatest of them, Otto I, also revived the imperial ambitions of Charlemagne. After marrying the widow of a Lombard king, he extended his rule over most of Italy and in 962 was crowned emperor by Pope John XII, at whose request he conquered Rome and whom he subsequently deposed for conspiring against him. From then on the Holy

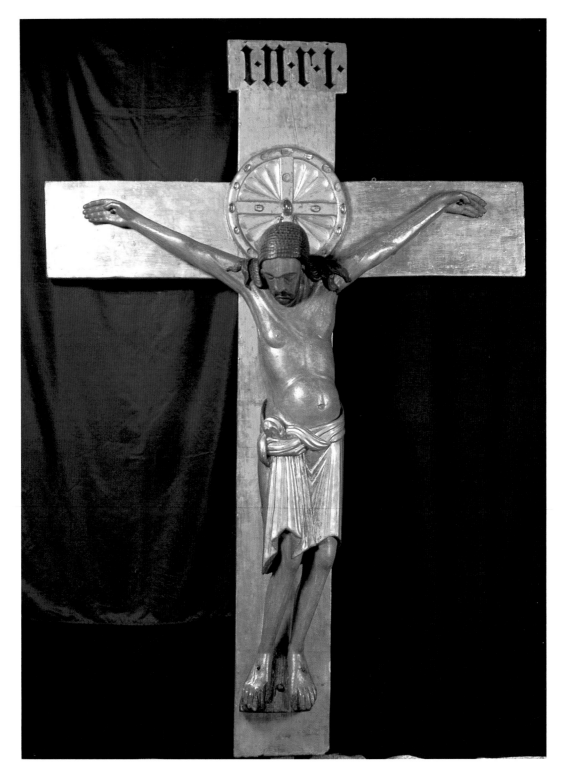

370. *The Gero Crucifix.* c. 975–1000 A.D. Wood, height 6'2" (1.88 m). Cathedral, Cologne, Germany

Roman Empire was to be a German institution—or perhaps we ought to call it a German dream, for Otto's successors never managed to consolidate their claim to sovereignty south of the Alps. Yet this claim had momentous consequences, since it led the German emperors into centuries of conflict with the papacy and local Italian rulers, linking North and South in a love-hate relationship whose echoes can be felt to the present day.

Sculpture

THE GERO CRUCIFIX. During the Ottonian period, from the mid-tenth century to the beginning of the eleventh,

Germany was the leading nation of Europe, artistically as well as politically. German achievements in both areas began as revivals of Carolingian traditions but soon developed new and original traits.

The change of outlook is impressively brought home to us if we compare the Christ on the cover of the *Lindau Gospels* with *The Gero Crucifix* (fig. 370) in the Cathedral at Cologne, which was done for Archbishop Gero of that city. The two works are separated by little more than a hundred years' interval, but the contrast between them suggests a far greater span. In *The Gero Crucifix* we meet an image of the crucified Saviour new to Western art: monumental in scale, carved in pow-

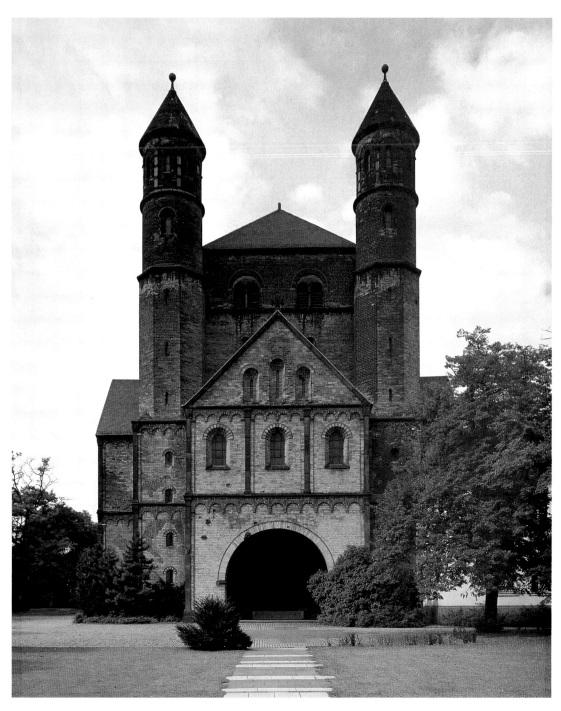

371. Westwork, St. Pantaleon, Cologne. Consecrated 980 A.D.

erfully rounded forms, and filled with a deep concern for the sufferings of the Lord. Particularly striking is the forward bulge of the heavy body, which makes the physical strain on arms and shoulders seem almost unbearably real. The face, with its deeply incised, angular features, has turned into a mask of agony, from which all life has fled.

How did the Ottonian sculptor arrive at this startlingly bold conception? *The Gero Crucifix* was clearly influenced by middle Byzantine art, which, we will recall, had created the compassionate view of Christ on the Cross (see fig. 340). Byzantine influence was strong in Germany at the time, for Otto II had married a Byzantine princess, establishing a direct link between the two imperial courts. The source alone is not sufficient to explain the results. It remained for the Ottonian artist to trans-

late the Byzantine image into large-scale sculptural terms and to replace its gentle pathos with an expressive realism that has been the main strength of German art ever since.

Architecture

Cologne was closely connected with the imperial house through its archbishop, Bruno, the brother of Otto I, who left a strong mark on the city through the numerous churches he built or rebuilt. His favorite among these, the Benedictine abbey of St. Pantaleon, became his burial place as well as that of the wife of Otto II. Only the monumental westwork (fig. 371) has retained its original shape essentially unchanged until modern times. We recognize it as a massive and well-proportioned successor to

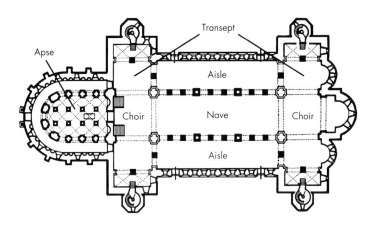

372. Reconstructed plan, Hildesheim Cathedral (St. Michael's), Germany. 1001–33
(after Beseler)

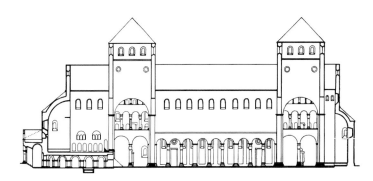

373. Reconstructed longitudinal section, Hildesheim Cathedral (after Beseler)

Carolingian westworks, with the characteristic tower over the crossing of the western transept and a deep porch flanked by tall stair turrets (compare fig. 361).

ST. MICHAEL'S, HILDESHEIM. Judged in terms of surviving works, however, the most ambitious patron of architecture and art in the Ottonian age was Bernward, who became bishop of Hildesheim after having been court chaplain and one of the tutors of Otto III during the regency of the empress Theophano. His chief monument is another Benedictine abbey church, St. Michael's (figs. 372–74). The plan, with its two choirs and lateral entrances, recalls the monastery church of the St. Gall plan (see fig. 362). But in St. Michael's the symmetry is carried much further. Not only are there two identical transepts, with crossing towers and stair turrets (see figs. 372 and 373), but the supports of the nave arcade, instead of being uniform, consist of pairs of columns separated by square piers. This alternate system divides the arcade into three equal units of three openings each. Moreover, the first and third units are correlated with the entrances, thus echoing the axis of the transepts. And since the aisles and nave are unusually wide in relation to their length, the architect's intention must have been to achieve a harmonious balance between the longitudinal and transverse axes throughout the structure.

The exterior as well as the choirs of Bernward's church have been disfigured by rebuilding, but the interior of the nave (figs. 373 and 374), with its great expanse of wall space be-

tween arcade and clerestory, retains the majestic spatial feeling of the original design following its recent restoration. (The capitals of the columns date from the twelfth century, the painted wooden ceiling from the thirteenth.) The Bernwardian western choir, as reconstructed in our plan, is particularly interesting. Its floor was raised above the level of the rest of the church to accommodate a half-subterranean basement chapel, or crypt, apparently a special sanctuary of St. Michael, which could be entered both from the transept and from the west. The crypt was roofed by groin vaults resting on two rows of columns, and its walls were pierced by arched openings that linked it with the U-shaped corridor, or ambulatory, wrapped around it. This ambulatory must have been visible above ground, enriching the exterior of the western choir, since there were windows in its outer wall. Such crypts with ambulatories, usually housing the venerated tomb of a saint, had been introduced into the repertory of Western church architecture during Carolingian times. But the Bernwardian design stands out for its large scale and its carefully planned integration with the rest of the building.

Metalwork

BRONZE DOORS OF BISHOP BERNWARD. How much importance Bernward himself attached to the crypt at St. Michael's can be gathered from the fact that he commissioned a pair of richly sculptured bronze doors that were probably meant for the two entrances leading from the transept to

374. Interior (view toward the apse, after restoration of 1950–60), Hildesheim Cathedral

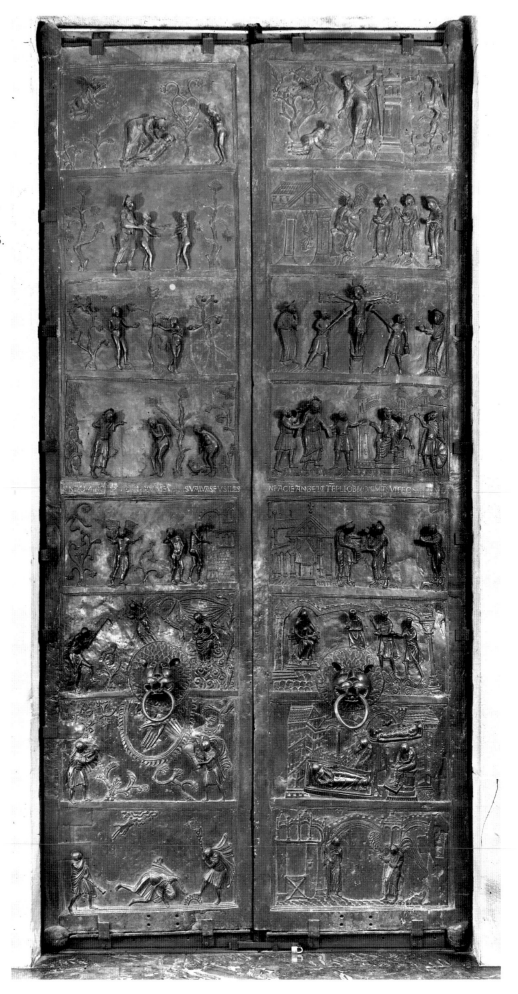

375. Doors of
Bishop
Bernward. 1015.
Bronze,
height approx.
16' (4.8 m).
Hildesheim
Cathedral

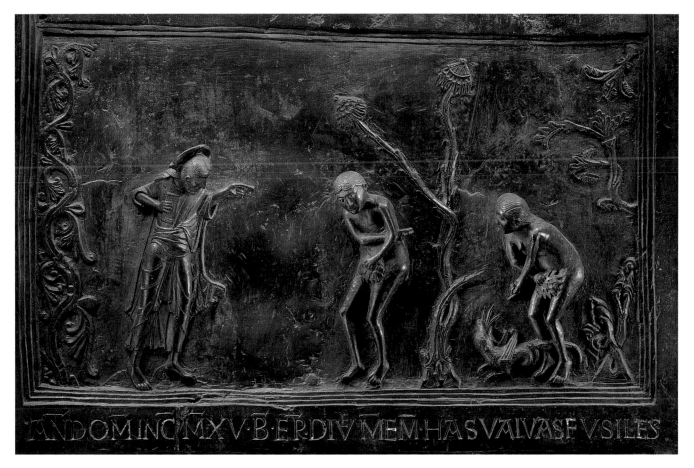

376. *Adam and Eve Reproached by the Lord,* from the Doors of Bishop Bernward. Bronze, approx. 23 x 43" (58.3 x 109.3 cm)

the ambulatory (fig. 375). They were finished in 1015, the year the crypt was consecrated. Bernward, according to his biographer, Thangmar of Heidelberg, excelled in the arts and crafts. The idea may have come to him as a result of his visit to Rome, where he could have seen ancient Roman (and perhaps Byzantine) bronze doors. The Bernwardian doors, however, differ from their predecessors. They are divided into broad horizontal fields rather than vertical panels, and each field contains a biblical scene in high relief. The subjects, taken from Genesis (left door) and the Life of Christ (right door), depict the origin and redemption of sin.

Our detail (fig. 376) shows Adam and Eve after the Fall. Below it, in inlaid letters remarkable for their classical Roman character, is part of the dedicatory inscription, with the date and Bernward's name. In these figures we find nothing of the monumental spirit of *The Gero Crucifix.* They seem far smaller than they actually are, so that one might easily mistake them for a piece of goldsmith's work such as the *Lindau Gospels* cover (compare fig. 369). The composition must have been derived ultimately from an illuminated manuscript, since very similar scenes are found in medieval Bibles. Even the oddly stylized bits of vegetation have a good deal of the twisting, turning movement we recall from Irish miniatures. Yet this is no slavish imitation, for the story is conveyed with splendid directness and expressive force. The accusing finger of the Lord, seen against a great void of blank surface, is the focal point of the drama. It points to a cringing Adam, who passes the blame to his mate, while Eve, in turn, passes it to the serpent at her feet.

Manuscripts

GOSPEL BOOK OF OTTO III. The same intensity of glance and of gesture found in the Bernwardian bronze doors characterizes Ottonian manuscript painting, which blends Carolingian and Byzantine elements into a new style of extraordinary scope and power. The most important center of manuscript illumination at that time was the Reichenau Monastery, on an island in Lake Constance, on the borders of modern-day Germany, Switzerland, and Austria. Perhaps its finest achievement—and one of the great masterpieces of medieval art—is the *Gospel Book of Otto III,* from which we reproduce two full-page miniatures (figs. 377 and 378).

The scene of Jesus washing the feet of St. Peter contains notable echoes of ancient painting, transmitted through Byzantine art. The soft pastel hues of the background recall the illusionism of Graeco-Roman landscapes (see figs. 287 and 288), and the architectural frame around Jesus is a late descendant of the kind of architectural perspectives we saw in the mural from Boscoreale (see fig. 286). These elements have been reformulated by the Ottonian artist, who has put them to a new use: what was once an architectural vista now becomes the Heavenly City, the House of the Lord filled with golden celestial space as against the atmospheric earthly space without.

The figures have undergone a similar transformation. In ancient art, this composition had been used to represent a doctor treating a patient. Now St. Peter takes the place of the sufferer, and Jesus that of the physician. (Note that Jesus is still the beardless young philosopher type here.) As a consequence, the emphasis has shifted from physical to spiritual action, and this

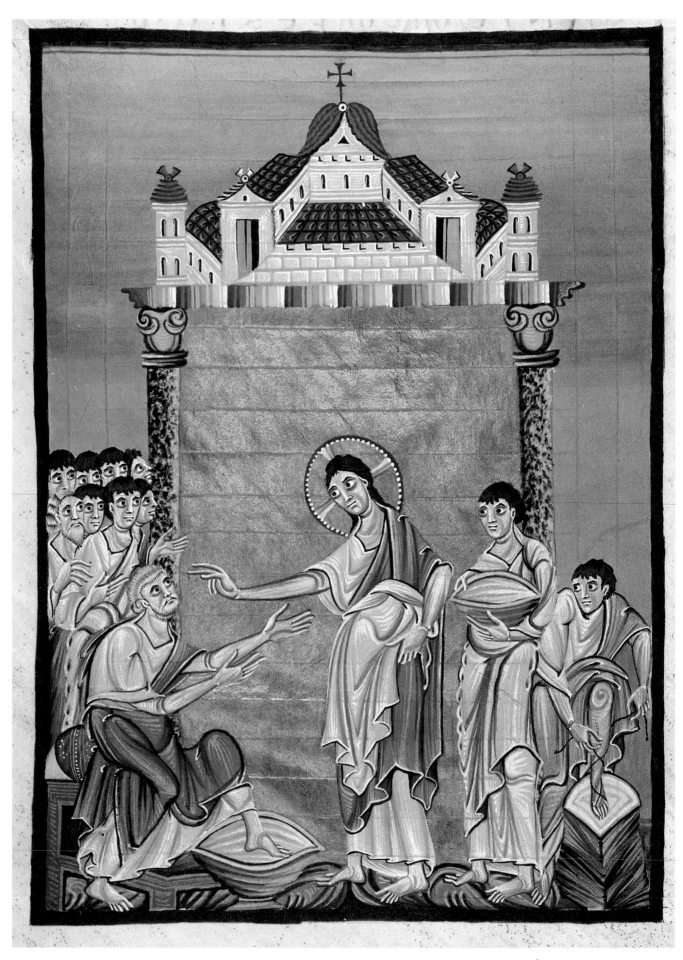

377. *Jesus Washing the Feet of Peter,* from the *Gospel Book of Otto III.* c. 1000. Tempera on vellum, 13 x 9 3/8" (33 x 23.8 cm).
Staatsbibliothek, Munich

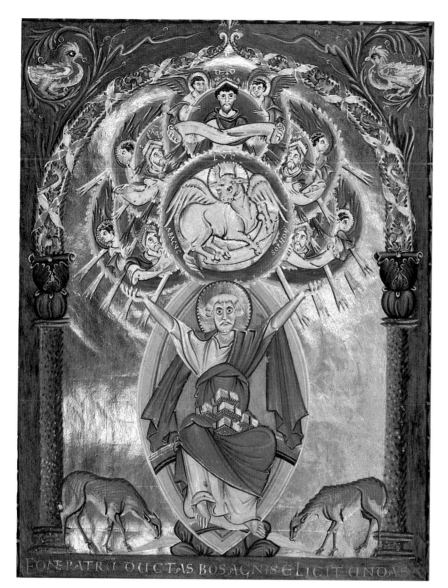

378. *St. Luke,* from the *Gospel Book of Otto III.* c. 1000. Tempera on vellum, 13 x 9 3/8" (33 x 23.8 cm). Staatsbibliothek, Munich

379. *Moses Receiving the Law* and *The Doubting of Thomas.* Early 11th century. Ivory, each 9 5/8 x 4" (24.5 x 10.2 cm). Staatliche Museen zu Berlin, Preussischer Kulturbesitz, Museum für Spätantike und Byzantische Kunst

new kind of action is not only conveyed through glances and gestures, it also governs the scale of things. Jesus and St. Peter, the most active figures, are larger than the rest; Jesus' "active" arm is longer than his "passive" one; and the eight apostles, who merely watch, have been compressed into a tiny space, so that we see little more than their eyes and hands. Even the fanlike Early Christian crowd from which this derives (see fig. 308) is not so literally disembodied. The scene straddles two eras. On the one hand, the nearly perfect synthesis of Western and Byzantine elements represents the culmination of the early medieval manuscript tradition; on the other, the expressive distortions look forward to Romanesque art, which incorporated them in heightened form to telling effect.

The other miniature, the painting of St. Luke, is a symbolic image of overwhelming grandeur. Unlike his Carolingian predecessors (see figs. 365 and 367), the evangelist is no longer shown writing. Instead, his Gospel lies completed on his lap. Enthroned on two rainbows, he holds aloft an awesome cluster of clouds from which tongues of light radiate in every direction. Within it we see his symbol, the ox, surrounded by five Old Testament prophets and an outer circle of angels. At the bottom, two lambs drink the life-giving waters that spring from beneath the evangelist's feet. The key to the entire design is in the inscription: *Fonte patrum ductas bos agnis elicit undas*—"From the source of the fathers the ox brings forth a flow of water for the lambs"—that is, St. Luke makes the prophets' message of salvation explicit for the faithful. The Ottonian artist has truly "illuminated" the meaning of this terse and enigmatic phrase.

IVORY DIPTYCHS. Closely related in style to the *Gospel Book of Otto III* is an ivory diptych with *Moses Receiving the Law* in the left panel and *The Doubting of Thomas* in the right (fig. 379). These two panels, which may have come from the abbey of Kues on the Mosel River, were probably done in nearby Trier, then a leading art center. It is certain that the artist was familiar with Byzantine ivories, among them the diptych of *Justinian as Conqueror* (fig. 330), which is known to have made its way to Trier as early as the seventh century. The artist, a great master, nevertheless avoids the Byzantine influences that continued to find favor in Ottonian art, and prefers instead the physical distortions, fluid drapery, and architectural treatment seen in *Jesus Washing the Feet of Peter.* These devices are used to squeeze an amazing amount of action into the two scenes, which adopt the format of *The Archangel Michael* (fig. 315) but depart entirely from its classicism. They also lend an impressive power to both panels that makes us feel the full force of the confrontation between mortal and God in divine and in human form, as the awestruck Moses strains to receive the Ten Commandments from Heaven and Thomas reaches up to touch the wound of Christ.

CHAPTER THREE

ROMANESQUE ART

Looking back over the ground we have covered in this book so far, a thoughtful reader will be struck by the fact that almost all of our chapter headings and subheadings might serve equally well for a general history of civilization. Some are based on technology (for example, the Old Stone Age), others on geography, ethnology, religion. Whatever the source, they have been borrowed from other fields, even though in our context they also designate artistic styles. There are only two important exceptions to this rule: Archaic and Classical are primarily terms of style. They refer to qualities of form rather than to the setting in which these forms were created. Why don't we have more terms of this sort? We do, as we shall see— but only for the art of the past 900 years.

Those who first conceived the idea of viewing the history of art as an evolution of styles started out with the conviction that art in the ancient world developed toward a single climax: Greek art from the age of Pericles to that of Alexander the Great. This style they called Classical (that is, perfect). Everything that came before was labeled Archaic, to indicate that it was still old-fashioned and tradition-bound, not-yet-Classical but striving in the right direction, while the style of post-Classical times did not deserve a special term since it had no positive qualities of its own, being merely an echo or a decadence of Classical art.

The early historians of medieval art followed a similar pattern. To them, the great climax was the Gothic style, from the thirteenth century to the fifteenth. For whatever was not-yet-Gothic they adopted the label Romanesque. In doing so, they were thinking mainly of architecture. Pre-Gothic churches, they noted, were round-arched, solid, and heavy, as against the pointed arches and the soaring lightness of Gothic structures. It was rather like the ancient Roman style of building, and the term "Romanesque" was meant to convey just that. In this sense, all of medieval art before 1200 could be called Romanesque insofar as it shows any link with the Mediterranean tradition. Some scholars speak of medieval art before

Charlemagne as pre-Romanesque, and of Carolingian and Ottonian as proto- or early Romanesque. They are right to the extent that Romanesque art proper—that is, medieval art from about 1050 to 1200—would be unthinkable without the contributions of these earlier styles. On the other hand, if we follow this practice we are likely to do less than justice to those qualities that make the art of the early Middle Ages and of Carolingian and Ottonian times different from the Romanesque.

Carolingian art, we will recall, was brought into being by Charlemagne and his circle, as part of a conscious revival policy, and even after his death, it remained strongly linked with his imperial court. Ottonian art, too, had this sponsorship, and a correspondingly narrow base. The Romanesque, in contrast, sprang up all over western Europe at about the same time. It consists of a large variety of regional styles, distinct yet closely related in many ways, and without a central source. In this respect, it resembles the art of the early Middle Ages rather than the Carolingian and Ottonian court styles that had preceded it, although it includes that tradition along with a good many other, less clearly traceable ones, such as Late Classical, Early Christian, and Byzantine elements, some Islamic influence, and the Celtic-Germanic heritage.

What welded all these different components into a coherent style during the second half of the eleventh century was not any single force but a variety of factors that made for a new burgeoning of vitality throughout the West. The millennium came and went without the Apocalypse (described in the Book of Revelation of St. John the Divine) that many had predicted. Christianity had at last triumphed everywhere in Europe. The Vikings, still largely heathen in the ninth and tenth centuries when their raids terrorized the British Isles and the Continent, had entered the Catholic fold, not only in Normandy but in Scandinavia as well. The Caliphate of Cordova had disintegrated in 1031 into many small Moslem states, opening the way for the reconquest of the Iberian Peninsula. And the Magyars had settled down in Hungary.

There was a growing spirit of religious enthusiasm, reflected in the greatly increased pilgrimage traffic to sacred sites and culminating, from 1095 on, in the crusades to liberate the Holy Land from Moslem rule. Equally important was the reopening of Mediterranean trade routes by the navies of Venice, Genoa, Amalfi, Pisa, and Rimini; the revival of trade and travel, which linked Europe commercially and culturally; and the consequent growth of urban life. During the turmoil of the early Middle Ages, the towns of the West Roman Empire had shrunk greatly in size. (The population of Rome, about one million in 300 A.D., fell to less than fifty thousand at one point.) Some cities were deserted altogether. From the eleventh century on, they began to regain their former importance. New towns sprang up everywhere, and, like the cities, they gained their independence thanks to a middle class of artisans and merchants who established itself between the peasantry and the landed nobility as an important factor in medieval society.

In many respects, then, western Europe between 1050 and 1200 became a great deal more "Roman-esque" than it had been since the sixth century, recapturing some of the international trade patterns, the urban quality, and the military strength of ancient imperial times. The central political authority was lacking, to be sure. Even the empire of Otto I did not extend much farther west than modern Germany does. But the central spiritual authority of the pope took its place to some extent as a unifying force. The monasteries of the Cistercians and Benedictines rivaled the wealth and power of secular rulers. Indeed, it was now the pope who sought to unite Europe into a single Christian realm. The international army that responded to Pope Urban II's call in 1095 for the First Crusade to liberate the Holy Land from Moslem rule was more powerful than anything a secular ruler could have raised for the purpose. The pope's authority was spiritual, not just temporal, as he was forced to combat the heresies that mushroomed throughout the Catholic realm. Papal assertion of dogmatic supremacy led to the final break (known as the Great Schism) with the Byzantine Orthodox church in 1054.

ARCHITECTURE

The most conspicuous difference between Romanesque architecture and that of the preceding centuries is the amazing increase in building activity. An eleventh-century monk, Raoul Glaber, summed it up well when he triumphantly exclaimed that the world was putting on a "white mantle of churches." These churches were not only more numerous than those of the early Middle Ages, they were also generally larger, more richly articulated, and more "Roman-looking." Their naves now had vaults instead of wooden roofs; their exteriors, unlike those of Early Christian, Byzantine, Carolingian, and Ottonian churches, were decorated with both architectural ornament and sculpture. Geographically, Romanesque monuments of the first importance are distributed over an area that might well have represented the world—the Catholic world, that is—to Raoul Glaber: from northern Spain to the Rhineland, from the Scottish-English border to central Italy. The richest examples, the greatest variety of regional types, and the most adventurous ideas are to be found in France. If we

add to this group those destroyed or disfigured buildings whose original designs are known to us through archaeological research, we have a wealth of architectural invention unparalleled by any previous era.

Southwestern France

ST.-SERNIN, TOULOUSE. We begin our survey of Romanesque churches with St.-Sernin, in the southern French town of Toulouse (figs. 380–83), one of a group of great churches of the "pilgrimage type," so called because they were built along the roads leading to the pilgrimage center of Santiago de Compostela in northwestern Spain. [See Primary Sources, no. 31, pages 386–87.] The plan immediately strikes us as much more complex and more fully integrated than the designs of earlier structures such as St.-Riquier, or St. Michael's at Hildesheim (see figs. 360 and 372). It is an emphatic Latin cross, with the center of gravity at the eastern end. Clearly this church was designed to serve not only a monastic community but also, like Old St. Peter's in Rome (fig. 297), to accommodate large crowds of lay worshipers in its long nave and transept.

The nave is flanked by two aisles on each side. The inner aisle continues around the arms of the transept and the apse, thus forming a complete ambulatory circuit anchored to the two towers of the west facade. The ambulatory, we will recall, had developed as a feature of the crypts of earlier churches such as St. Michael's. Now it has emerged above ground, where it is linked with the aisles of nave and transept and enriched with apsidal chapels that seem to radiate from the apse and continue along the eastern face of the transept. (Apse, ambulatory, and radiating chapels form a unit known as the pilgrimage choir.) The plan also shows that the aisles of St.-Sernin are groin-vaulted throughout. In conjunction with the features already noted, this imposes a high degree of regularity upon the entire design. The aisles are made up of square bays, which serve as a basic module for the other dimensions, so that the nave and transept bays equal two such units, the crossing and the facade towers four units. The spiritual harmony conveyed by the repetition of these units is perhaps the most striking achievement of the pilgrimage church.

On the exterior, this rich articulation, or interrelationship of elements, is further enhanced by the different roof levels that set off the nave and transept against the inner and outer aisles, the apse, the ambulatory, and the radiating chapels. This effect is enhanced by the buttresses, which reinforce the walls between the windows, to contain the outward thrust of the vaults. The windows and portals are further emphasized by decorative framing. The great crossing tower was completed later, in Gothic times, and is taller than originally intended. The two facade towers, unfortunately, have never been finished and remain stumps.

As we enter the nave, we are impressed with its tall proportions, the elaboration of the nave walls, and the dim, indirect lighting, all of which create a sensation very different from the ample and serene interior of St. Michael's, with its simple and clearly separated blocks of space (see figs. 373 and 374). If the nave walls of St. Michael's look Early Christian (see fig. 299), those of St.-Sernin seem more akin to structures

380. St.-Sernin, Toulouse, France (aerial view). c. 1080–1120

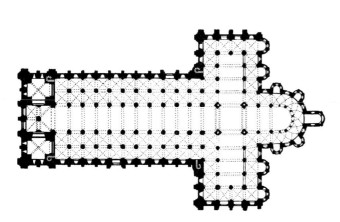

381. Plan of St.-Sernin (after Conant)

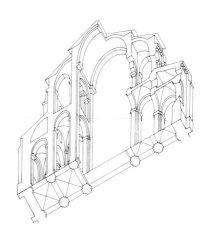

382. Axonometric projection of nave, St.-Sernin (after Choisy)

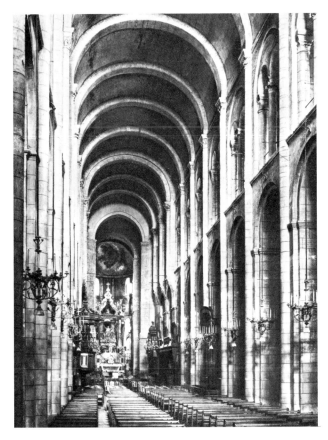

383. Nave and choir, St.-Sernin

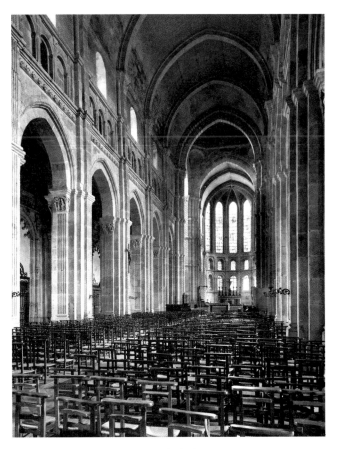

384. Nave wall, Autun Cathedral, France. c. 1120–32

such as the Colosseum (see fig. 245). The syntax of ancient Roman architecture—vaults, arches, engaged columns, and pilasters firmly knit together into a coherent order—has indeed been recaptured here to a remarkable degree. Yet the forces whose interaction is expressed in the nave of St.-Sernin are no longer the physical, muscular forces of Graeco-Roman architecture but spiritual forces of the kind we have seen governing the human body in Carolingian and Ottonian miniatures. The half-columns running the entire height of the nave wall would appear just as unnaturally drawn-out to an ancient Roman beholder as the arm of Jesus in figure 377. The columns seem to be driven upward by some tremendous, unseen pressure, hastening to meet the transverse arches that subdivide the barrel vault of the nave. Their insistently repeated rhythm propels us toward the eastern end of the church, with its light-filled apse and ambulatory (now obscured by a huge altar of later date).

In thus describing our experience we do not, of course, mean to suggest that the architect consciously set out to achieve this effect. Beauty and engineering were inseparable. Vaulting the nave to eliminate the fire hazard of a wooden roof was not only a practical aim; it provided a challenge to make the House of the Lord grander and more impressive. Since a vault becomes more difficult to sustain the farther it is from the ground, every resource had to be strained to make the nave as tall as possible. However, the clerestory was sacrificed for safety's sake. Instead, galleries are built over the inner aisles to abut the lateral pressure of the nave vault in the hope that

enough light would filter through them into the central space. St.-Sernin serves to remind us that architecture, like politics, is "the art of the possible," and that its success, here as elsewhere, is measured by the degree to which the architect has explored the limits of what seemed possible under those particular circumstances, structurally and aesthetically.

Burgundy and Western France

AUTUN CATHEDRAL. The builders of St.-Sernin would have been the first to admit that their answer to the problem of the nave vault was not a final one, impressive though it is in its own terms. The architects of Burgundy arrived at a more elegant solution, as evidenced by the Cathedral of Autun (fig. 384), which was begun by a Cluniac bishop, Étienne de Bage, and consecrated in 1132. Here the galleries are replaced by a blind arcade (called a triforium, since it often has three openings per bay) and a clerestory. What made this three-story elevation possible was the use of the pointed arch for the nave vault. The pointed arch probably reached France from Islamic architecture, where it had been employed for some time. (For reasons of harmony, it also appears in the nave arcade, where it is not needed for additional support.) By eliminating the part of the round arch that responds the most to the pull of gravity, the two halves of a pointed arch brace each other. The pointed arch thus exerts less outward pressure than the semicircular arch, so that not only can it be made as steep as possible, the walls can be perforated. The potentialities of the

People of many times, places, and religious faiths have renounced the world and wholly devoted themselves to a spiritual way of life. Some have chosen to live alone as hermits, often in isolated places, where they have led harsh ascetic existences. Others have come together in monasteries—religious communities—to share their faith and religious observance. Hermits have been especially characteristic of Hinduism, while the monastic life has been more common in Buddhism and Islam. Among the Jews of the first century B.C., there were both hermits, or anchorites (John the Baptist was one of these), and a kind of monasticism practiced by a sect known as the Essenes. Both forms are found in Christianity throughout most of its history as well. Their basis can be found in Scripture. On the one hand, Jesus urged giving up all earthly possessions as the road to salvation. On the other, the book of Acts in the Bible records that his followers came together in their faith after the Crucifixion.

The earliest monasticism practiced by Christians was the hermit's life. Chosen by a number of pious men and women who lived alone in the Egyptian desert in the second and third centuries A.D., this way of life was to remain fundamental to the Eastern Church, especially in Syria. But early on, communities emerged when colonies of disciples—both men and women—gathered around the most revered of the hermits, such as St. Anthony (fourth century), who achieved such fame as a holy man that he was pursued by people asking him to act as a divine intercessor on their behalf.

Monasteries (including communities for women, which are often called convents or nunneries) soon came to assume great importance in early Christian life. The earliest-known monastery was founded by Pachomius along the Nile around 320, which blossomed into nine monasteries and two nunneries by the time of his death a quarter-century later. Similar ones quickly followed in Syria, where monachism flourished until the 638 conquest by the Arabs. Syrian monasteries were for the most part sites along pilgrimage routes leading to the great monastery Qal'at Sim'ân, where Simeon Stylites (born 390) spent the last 30 years of his long life atop a tall column in almost ceaseless prayer.

Eastern monasticism was founded by Basil the Great (c. 330–379), bishop of Caesarea in Asia Minor. A remarkable man, he was the brother of Gregory of Nyssa and St. Macrina, successor to Eusebius as bishop of Caesarea, and one of the four Fathers of the Greek Church, along with his close friend Gregory Nazianzen. Basil's rules for this life established the basic characteristics of Christian monasticism: temperance, chastity, and humility. They emphasized prayer, scriptural reading, and work, not only within the monastery, but also for the good of lay people in the world beyond its walls, so that monasticism now assumed a social role. The oldest rules in the West are those of St. Augustine (354–430), who spread monasticism to Africa, where it proved short-lived due to the Vandal conquests. Monasticism had been brought even earlier to France by St. Martin of Tours (c. 316–397) around the middle of the fourth century and to Ireland by St. Patrick (c. 385–461) in the fifth century. Ireland wholeheartedly

Monasticism and Christian Monastic Orders

adopted a harsh form of anchoritism during the sixth century.

The most important figure in Western monasticism was Benedict of Nursia (c. 480–c. 553), the founder of the abbey at Monte Cassino in southern Italy. His rule, which was patterned after Basil's, divided the monk's day into periods of private prayer, communal ritual, and labor, and also mandated a moderate form of communal life, however strictly governed it may have been. This was the beginning of the Benedictine order, the first of the great monastic orders (or societies) of the Western church. The Benedictines thrived with the strong support of Pope Gregory the Great, himself a former monk, who codified the Western liturgy and the forms of Gregorian chant (see pages 326–27).

Because of their organization and continuity, monasteries were considered ideal seats of learning and administration under the Frankish kings of the eighth century, and they were even more strongly supported by Charlemagne and his heirs, who gave them land, money, and royal protection. As a result, they became rich and powerful, even exercising influence on international affairs. Monasteries and convents provided a place for the younger children of the nobility, and even talented members of the lower classes, to pursue challenging, creative, and useful lives as teachers, nurses, writers, and artists, opportunities that generally would have been closed to them in secular life (see "Hildegard of Bingen," page 316). Although they initially had considerable independence, the various orders eventually gave their loyalty to Pope Gregory the Great, thereby becoming a major source of power for the papacy in return for its protection. Through these linkages, Church and State over time became intertwined institutionally to their mutual benefit, thereby promoting growing stability.

Besides the Benedictines, the other important monastic orders of the West included the Cluniacs, the Cistercians, the Carthusians, the Franciscans, and the Dominicans. The Cluniac order (named after its original monastery at Cluny, in France) was founded as a renewal of the original Benedictine rule in 909 by Berno of Baume and 12 brethren on farmland donated by William of Aquitaine. It quickly emerged as the leading international force in Europe, thanks to its unique charter, which made it answerable only to the papacy, then at a low ebb in its power, even as it enjoyed close connections to the Ottonian rulers. Indeed, under the abbots Odilo (ruled 994–1049) and Hugh of Semur (ruled 1049–1109), its authority became so great that it could determine papal elections and influence imperial policy on the one hand while calling for crusades and the reconquest of Spain on the other.

Partly in reaction to the wealth and secular power of the Cluniac order and other church institutions, the Cistercian order was founded in 1098 by Robert of Molesme as a return to the Benedictine rule. The order, headquartered at Cîteaux, reached its apogee under St. Bernard (1090–1153), whose abbey in Clairvaux, settled with 12 brethren, came to surpass Cluny in population and power by the time of his death. Cistercian monasteries were deliberately sited in

remote places, where the monks would come into minimal contact with the outside world, and the rules of daily life were particularly strict. In keeping with this austerity, the order developed an architectural style known as Cistercian Gothic, recognizable by its simplicity and lack of ornamentation (see pages 336, 339).

The Carthusian order was founded by Bruno, an Italian monk, in 1084. Carthusians are in effect hermits, each monk or nun living alone in a separate cell, vowed to silence and devoted to prayer and meditation. The members of each house come together only for religious services and for communal meals several times a year. Because of the extreme austerity and piety of this order, several powerful dukes in the fourteenth and fifteenth centuries established Carthusian houses (charterhouses; French, *chartreuses*), so that the monks could pray perpetually for the souls of the dukes after they died. The most famous of these was the Chartreuse de Champmol, built in 1385 near Dijon, France, as the funerary church of Philip the Bold of Burgundy (see page 352) and his son, John the Fearless.

Eventually the conflict between poverty and work led to the creation of two orders of wandering friars: the Franciscans and the Dominicans. Founded with the blessing of Pope Innocent III, to whom they swore obedience, both orders became arms of papal policy and grew with astonishing rapidity until they inevitably became rivals, thanks in part to their contrasting missions: the Franciscans were devoted to spiritual reform by example, while the purpose of the Dominicans was to combat heresy. The Franciscan order was founded in 1209 by St. Francis of Assisi (c. 1181–1226) as a preaching community. Francis, who was perhaps the most saintly character since Early Christian times, insisted on a life of complete poverty, not only for the members personally, but for the order as a whole. The Poor Clares, established by Francis and St. Clare (1194–1253) near Assisi, was an enclosed order of nuns that followed the ascetic life while ministering to the sick. It, too, underwent spectacular growth, especially in Spain, where it was sponsored by the royal house. Franciscan monks and nuns were originally mendicant—that is, they begged for a living. However, this rule was revised in the fourteenth century.

The Dominican order was established in 1220 by St. Dominic (c. 1170–1221), a Spanish monk who had been a member of the Cistercians. Besides preaching, the Dominicans devoted themselves to the study of theology. They were considered the most intellectual of the religious orders in the late Middle Ages and the Early Renaissance. Whereas the Dominicans were well organized from the start, the Franciscan community did not become a formal order until a papal bull of 1230, and achieved its greatest prominence only under St. Bonaventure (1221–1274), who was, with the Dominican St. Thomas Aquinas (1225–1274), one of the great Doctors of the church. They even taught together at the University of Paris for a while during the early 1250s.

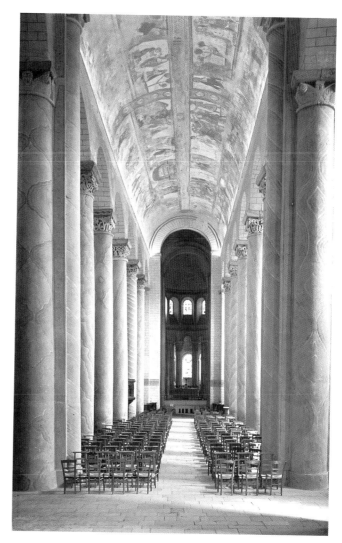

385. Choir (c. 1060–75) and nave (1095–1115), St.-Savin-sur-Gartempe, France

engineering advances that grew out of this discovery were to make possible the soaring churches of the Gothic period (see, for example, figs. 434, 437, and 438). Like St.-Sernin, Autun comes close to straining the limits of the possible. The upper part of the nave wall shows a slight but perceptible outward lean under the pressure of the vault, a warning against any further attempts to increase the height of the clerestory or to enlarge the windows.

HALL CHURCHES. A third alternative, with virtues of its own, appears in the west of France, in such churches as that of St.-Savin-sur-Gartempe (fig. 385). The nave vault here lacks the reinforcing arches, since it was meant to offer a continuous surface for murals (see fig. 416 for this cycle, the finest of its kind). Its great weight rests directly on the nave arcade, which is supported by a majestic set of columns. Yet the nave is fairly well lit, for the two aisles are carried almost to the same height, making it a "hall church," and their outer walls have generously sized windows. At the eastern end of the nave, there is a pilgrimage choir (happily unobstructed in this case) beyond the crossing tower.

The nave and aisles of hall churches are covered by a single roof, as at St.-Savin. The west facade, too, tends to be low and wide, and may become a richly sculptured screen. Notre-

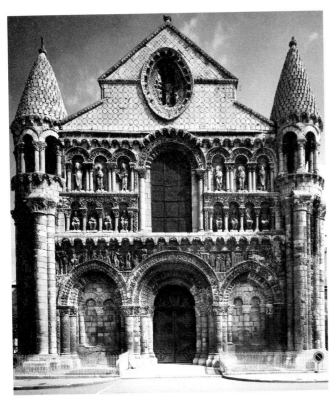

386. West facade, Notre-Dame-la-Grande, Poitiers, France.
Early 12th century

Dame-la-Grande at Poitiers (fig. 386), due west from St.-Savin, is particularly noteworthy in this respect. The sculptural program spread out over this entire area is a visual exposition of Christian doctrine that is a feast for the eyes as well as the mind. Below the elaborately bordered arcades housing large seated or standing figures, a wide band of relief stretches across the facade. Essential to the rich sculptural effect is the doorway, which is deeply recessed and framed by a series of arches resting on stumpy columns. Taller bundles of columns enhance the turrets; their conical helmets nearly match the height of the gable in the center, which rises above the actual height of the roof behind it.

Normandy and England

The next major development took place farther north, in Normandy, and for good reason. Ruled by a succession of weak Carolingians before being ceded by the aptly named Charles the Simple to the Danes in 911, the duchy developed under the Capetian dynasty into the most dynamic force in Europe by the middle of the eleventh century. Although it came late, Christianity was enthusiastically supported by the Norman dukes and barons, who played an active role in monastic reform and established numerous abbeys. Normandy soon became a cultural center of international importance.

ST.-ÉTIENNE, CAEN. The architecture of southern France was assimilated and merged with local traditions to produce a new school that evolved in an entirely different direction. The west facade of the abbey church of St.-Étienne at Caen (fig.

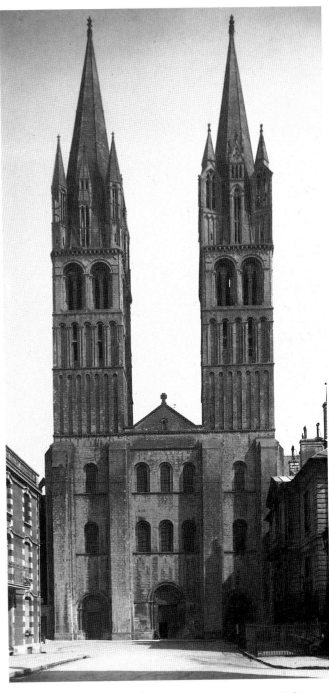

387. West facade, St.-Étienne, Caen, France. Begun 1068

387), founded by William the Conqueror a year or two after his invasion of England in 1066, offers a striking contrast with that of Notre-Dame-la-Grande. Decoration is at a minimum. Four huge buttresses divide the front of the church into three vertical sections, and the vertical impetus continues triumphantly in the two splendid towers, whose height would be impressive enough even without the tall Early Gothic helmets. St.-Étienne is cool and composed: a structure to be appreciated, in all its refinement of proportions, by the mind rather than the eye. The interior is equally remarkable, but in order to understand its importance we must first turn to the extraordinary development of Anglo-Norman architecture in Britain during the last quarter of the eleventh century.

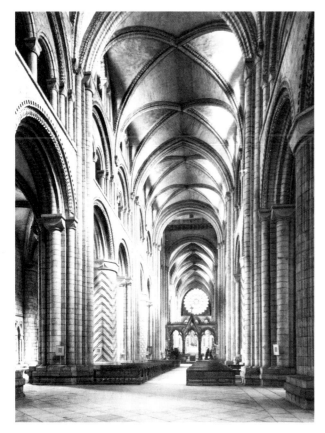

388. Nave (looking east), Durham Cathedral, England. 1093–1130

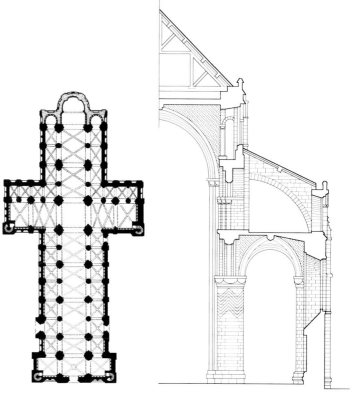

389. Plan of Durham Cathedral (after Conant)

390. Transverse section of Durham Cathedral (after Acland)

DURHAM CATHEDRAL. Its most ambitious product is the Cathedral of Durham (figs. 388–90), just south of the Scottish border, begun in 1093. Though somewhat more austere in plan, it has a nave one-third wider than St.-Sernin's, and a greater overall length (400 feet), which places it among the largest churches of medieval Europe. The nave may have been designed to be vaulted from the start. The vault over its eastern end had been completed by 1107, a remarkably short time, and the rest of the nave, following the same pattern, was finished by 1130. This vault is of great interest, for it represents the earliest systematic use of a ribbed groin vault over a three-story nave, and thus marks a basic advance beyond the solution we saw at Autun. Looking at the plan, we see that the aisles consist of the usual groin-vaulted compartments closely approaching a square, while the bays of the nave, separated by strong transverse arches, are decidedly oblong and groin-vaulted in such a way that the ribs form a double-design, dividing the vault into seven sections rather than the conventional four. Since the nave bays are twice as long as the aisle bays, the transverse arches occur only at the odd-numbered piers of the nave arcade, and the piers therefore alternate in size, the larger ones being of compound shape (that is, bundles of column and pilaster shafts attached to a square or oblong core), the others cylindrical.

Perhaps the easiest way to visualize the origin of this peculiar system is to imagine that the architect started out by designing a barrel-vaulted nave, with galleries over the aisles and without a clerestory, as at St.-Sernin, but with the trans-

verse reinforcing arches spaced more widely. The realization suddenly dawned that putting groin vaults over the nave as well as the aisles would gain a semicircular area at the ends of each transverse vault which could be broken through to make a clerestory, because it had no essential supporting functions (fig. 391, left). Each nave bay is intersected by two transverse barrel vaults of *oval* shape, so that it contains a pair of Siamese-twin groin vaults that divide it into seven compartments. The outward thrust and weight of the whole vault are concentrated at six securely anchored points on the gallery level. The ribs were necessary to provide a stable skeleton for the groin vault, so that the curved surfaces between them could be filled in with masonry of minimum thickness, thus reducing both weight and thrust. We do not know whether this ingenious scheme was actually invented at Durham, but it could not have been created much earlier, for it is still in an experimental stage. While the transverse arches at the crossing are round, those to the west of it are slightly pointed, indicating a continuous search for improvements.

There were other advantages to this system as well. Aesthetically, the nave at Durham is among the finest in all Romanesque architecture. The wonderful sturdiness of the alternating piers makes a splendid contrast with the dramatically lighted, saillike surfaces of the vault. This lightweight, flexible system for covering broad expanses of great height with fireproof vaulting without sacrificing the ample lighting of a clerestory marks the culmination of the Romanesque and the dawn of the Gothic.

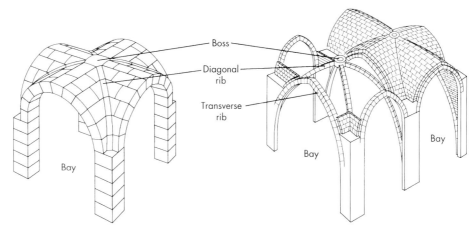

391. Rib vaults (after Acland)

ST.-ÉTIENNE, CAEN. Let us now return to the interior of St.-Étienne at Caen (fig. 392). The nave, it seems, had originally been planned to have galleries and a clerestory, with a wooden ceiling. After the experience of Durham, it became possible, in the early twelfth century, to build a groined nave vault instead, with only slight modifications of the wall design. But the bays of the nave here are approximately square, so that the double-X rib pattern could be replaced by a single X with an additional transverse rib (see fig. 391, right), producing a groin vault of six sections instead of seven. These sexpartite vaults are no longer separated by heavy transverse arches but by simple ribs—another saving in weight that also gives a stronger sense of continuity to the nave vault as a whole and makes for a less emphatic alternating system of piers. Compared to Durham, the nave of St.-Étienne creates an impression of graceful, airy lightness closely akin to the quality of the Gothic choir that was added in the thirteenth century. And structurally, too, we have here reached the point where Romanesque merges into Early Gothic.

Lombardy

We might have expected central Italy, which had been part of the heartland of the original Roman Empire, to have produced the noblest Romanesque of them all, since surviving classical originals were close at hand. Such was not the case, however. All of the rulers having ambitions to revive "the grandeur that was Rome," with themselves in the role of emperor, were in the north of Europe. The spiritual authority of the pope, reinforced by considerable territorial holdings, made imperial ambitions in Italy difficult to achieve. New centers of prosperity, whether arising from seaborne commerce or local industries, tended to consolidate a number of small principalities, which competed among themselves or aligned themselves from time to time, if it seemed politically profitable, with the pope or the German emperor. Lacking the urge to re-create the old empire, and furthermore having Early Christian church buildings as readily accessible as classical Roman architecture, the Tuscans were content to continue what are basically Early Christian forms, but enlivened them with decorative features inspired by pagan architecture.

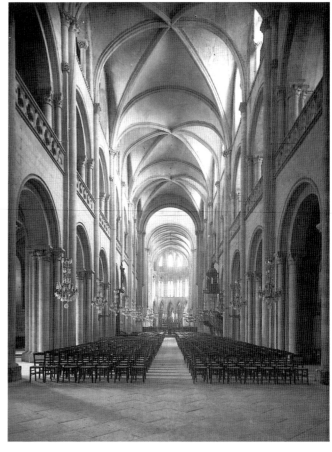

392. Nave (vaulted c. 1115–20), St.-Étienne, Caen

S. AMBROGIO, MILAN. Instead, the lead in developing the Romanesque in Italy was taken by Lombardy, where ancient cities had once again grown large and prosperous. At the time when the Normans and Anglo-Normans constructed their earliest ribbed groined nave vaults, the same problem was being explored in and around Milan, which had devised a rudimentary system of vaulting in the late ninth century during the so-called First Romanesque. Lombard Romanesque architecture was both nourished and impeded by a continuous building tradition reaching back to Roman and Early Christian times and including the monuments of Ravenna. We sense this background as we approach one of its most venerable and important structures, S. Ambrogio in Milan (figs.

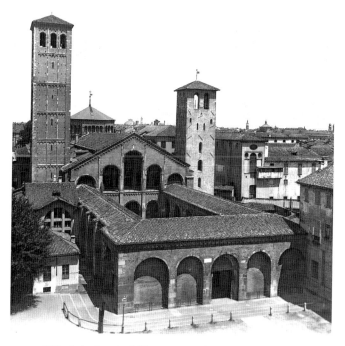

393. S. Ambrogio, Milan. Late 11th and 12th centuries

(see S. Apollinare in Classe and S. Vitale; figs. 300 and 317).

Upon entering the atrium, we are confronted by the severely handsome facade, with its deeply recessed arcades. Just beyond it are two bell towers, separate structures just touching the outer walls of the church. We had seen a round tower of this kind on the north side of S. Apollinare in Classe, probably the earliest surviving example, of the ninth or tenth century. Most of its successors are square, but the tradition of the free-standing bell tower, or campanile, remained so strong in Italy that they hardly ever became an integral part of the church proper.

The nave of S. Ambrogio, low and broad (it is some ten feet wider than that at Durham), consists of four square bays separated by strong transverse arches. There is no transept, but the easternmost nave bay carries an octagonal, domed crossing tower or lantern. This was an afterthought, but we can easily see why it was added. The nave has no clerestory and the windows of the lantern provide badly needed illumination. As at Durham, or Caen, there is an alternate system of nave piers, since the length of each nave bay equals that of two aisle bays. The latter are groin-vaulted, like the first three of the nave bays, and support galleries. The nave vaults, however, differ significantly from their northern counterparts. Constructed of brick and rubble, in a technique reminiscent of Roman groin vaults such as those in the Basilica of Constantine, they are a good deal heavier. The diagonal ribs, moreover, form true half-circles (at Durham and Caen, they are flattened), so that the vaults rise to a point considerably above the transverse arches.

393 and 394), on a site that had been occupied by a church since the fourth century. The present building was begun in the late eleventh century, except for the apse and southern tower, which date from the tenth. The brick exterior, though more ornate and far more monumental, recalls the proportions and the geometric simplicity of the Ravenna churches

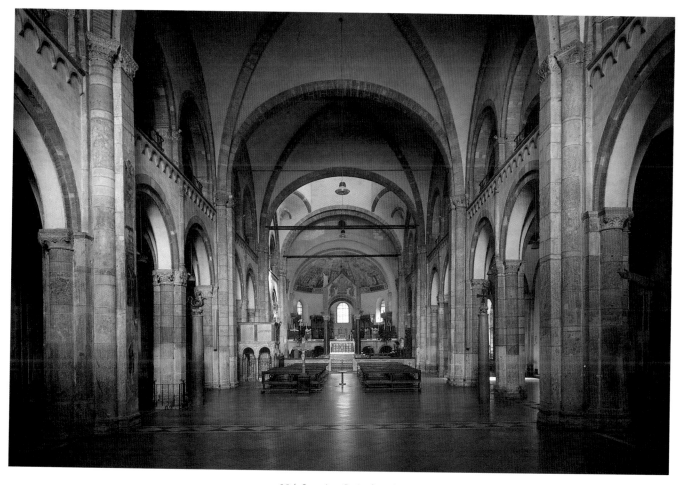

394. Interior, S. Ambrogio

Apart from further increasing the height of the vault, this produces a domed effect and gives each bay the appearance of a separate entity.

On a smaller scale, the Milanese architect might have attempted a clerestory instead of galleries. But the span of the nave was determined by the width of the tenth-century apse, and Lombardy had a taste for ample interior proportions, like those of Early Christian basilicas (compare fig. 302), instead of height and light, as in contemporary Norman churches. Under these circumstances, there was no reason to take risks by experimenting with more economical shapes and lighter construction, so that the ribbed groin vault in Lombardy remained conservative and never approached the proto-Gothic stage.

Germany and the Low Countries

SPEYER CATHEDRAL. German Romanesque architecture, centered in the Rhineland, was equally conservative. Because Speyer was an imperial church, its conservatism reflects the persistence of Carolingian-Ottonian rather than earlier traditions. Begun about 1030, Speyer was not completed until more than a century later. It has a westwork (now sheathed by a modern reconstruction) and an equally monumental eastern grouping of crossing tower and paired stair towers (fig. 395). As on many German facades of the same period, the architectural detail derives from the First Romanesque in Lombardy (compare S. Ambrogio), long a focus of German imperial ambitions. However, the tall proportions are northern, and the scale is so great as to dwarf every other church of the period. The nave, one-third taller and wider than that of

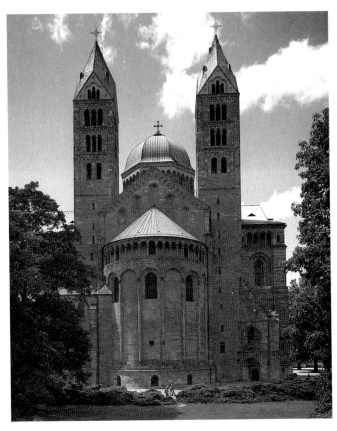

395. Speyer Cathedral, Germany, from the east. Begun 1030

Durham, has a generous clerestory, since it was planned for a wooden roof. Only in the early twelfth century was it divided into square bays and covered with heavy, unribbed groin vaults akin to the Lombard rather than the Norman type.

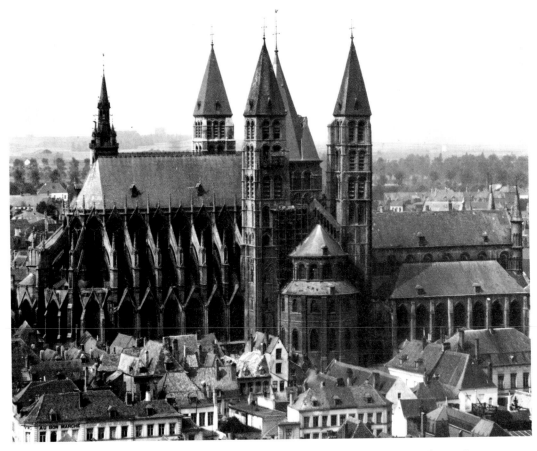

396. Tournai Cathedral, France. Nave, 1110–71; transept and crossing, c. 1165–1213

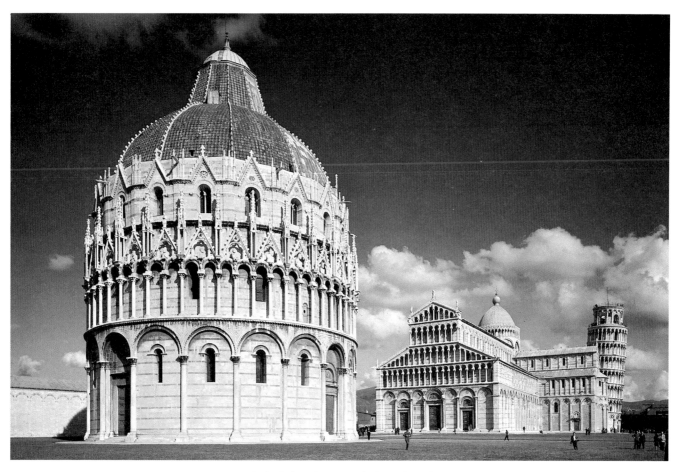

397. Pisa Baptistery, Cathedral, and Campanile (view from the west). 1053–1272

TOURNAI CATHEDRAL. The impressive eastern end of Speyer Cathedral is echoed in a number of churches of the Rhine Valley and the Low Countries. In the Cathedral of Tournai (fig. 396), it occurs twice, at either end of the transept. The result is the most memorable massing of towers anywhere in Romanesque architecture. Originally, there were to have been four more: two at the west facade (later reduced to turrets) and two flanking the eastern apse (replaced by a huge Gothic choir). Such multiple towers had been firmly established in medieval church design north of the Alps since the time of Charlemagne (see fig. 361), although few complete sets were ever finished and even fewer have survived. Their popularity can hardly be accounted for on the basis of their practical functions (whether stair towers, bell towers, or watchtowers). In a way not easily fathomed today, they expressed medieval man's relation to the supernatural, as the ziggurats had done for the ancient Mesopotamians. (The story of the Tower of Babel fascinated the people of the Middle Ages.) Perhaps their symbolic meaning is best illustrated by a "case history." A certain count had a quarrel with the people of a nearby town, led by their bishop. He finally laid siege to the town, captured it, and, to express his triumph and humiliate his enemies, he lopped the top off their cathedral tower. Evidently, loss of tower meant loss of face, for towers were considered architectural symbols of strength, power, and authority.

Tuscany

CAMPANILE, BAPTISTERY, AND CATHEDRAL, PISA. The most famous tower of all owes its renown to an accident: the Leaning Tower of Pisa (or, more precisely, the Campanile of Pisa Cathedral), designed by the sculptor Bonanno Pisano (active 1174–86), began to assume its present angle, because of poor foundations, even before completion (fig. 397). The tower forms part of a magnificent ensemble on an open site north of the city that includes the Cathedral and the circular, domed Baptistery to the west of it. They represent the most ambitious monument of the Tuscan Romanesque, reflecting the wealth and pride of the city-republic of Pisa after its naval victory at Palermo in 1062.

Far more than Lombardy, with its strong northward connections, Tuscany retained an awareness of its classical heritage throughout the Middle Ages. If we compare Pisa Cathedral, on the one hand, with S. Apollinare in Ravenna and, on the other, with St.-Sernin in Toulouse (see figs. 300 and 380), we are left in little doubt that the latter is its closer relation. But the essential features and even the detached bell tower still continue much as we see them in S. Apollinare. The plan of Pisa Cathedral is essentially that of an Early Christian basilica, elaborated into a Latin cross by the addition of two transept arms that resemble smaller basilicas in themselves, with apses of their own. The crossing is marked by a dome, but the rest of the church is wooden-roofed except for the aisles (four in the nave, two in the transept arms), which have groin vaults. The interior (fig. 398) has somewhat taller proportions than an Early Christian basilica, because there are galleries over the aisles, as well as a clerestory. Yet the splendid files of classical columns supporting the nave and aisle arcades inevitably recall such Roman structures as St. Paul Outside the Walls (see fig. 299).

The only deliberate revival of the antique Roman style in

398. Interior, Pisa Cathedral

399. Baptistery of S. Giovanni, Florence. c. 1060–1150

Cathedral and its companions, which are sheathed entirely in white marble inlaid with horizontal stripes and ornamental patterns in dark-green marble. It is combined with blind arcades and galleries, producing a lacelike richness of texture and color very different from the austerely simple Early Christian exteriors. But by now the time had long passed when it might be thought undesirable for a church to compete with the outward splendor of classical temples.

BAPTISTERY OF S. GIOVANNI, FLORENCE. In Florence, which was to outstrip Pisa commercially and artistically, the greatest achievement of the Tuscan Romanesque is the Baptistery (fig. 399), opposite the Cathedral. It is a domed octagonal structure of impressive size. Here the green-and-white marble paneling follows severe geometric lines, and the blind arcades are extraordinarily classical in proportion and detail. The entire building, in fact, exudes so classical an air that the Florentines themselves came to believe, a few hundred years later, that it had originally been a temple of Mars. And even today the controversy over its date has not yet been settled to everyone's satisfaction. We shall return to this baptistery a number of times, since it was destined to play an important role in the Renaissance.

SCULPTURE

The revival of monumental stone sculpture is even more surprising than the architectural achievements of the Romanesque era, since neither Carolingian nor Ottonian art had shown any tendencies in this direction. Free-standing statues, we will recall, all but disappeared from Western art after the fifth century. Stone relief in turn survived only in the form of architectural ornament or surface decoration, with the depth of the carving reduced to a minimum. Thus the only continuous sculptural tradition in early medieval art was that of sculpture-in-miniature: small reliefs and occasional statuettes, in metal or ivory. Ottonian art, in works such as the bronze doors of Bishop Bernward (see fig. 375), had enlarged the scale of this tradition but not its spirit. Moreover, its truly large-scale sculptural efforts, represented by the impressive *Gero Crucifix* (fig. 370), were limited almost entirely to wood. What little stone carving there was in western Europe before the mid-eleventh century hardly went beyond the artistic and technical level of the Sigvald relief (fig. 356).

Southwestern France

Fifty years later, the situation had changed dramatically. Just when and where the revival of stone sculpture began we cannot say with certainty, but the earliest surviving examples are found in southwestern France and northern Spain, along the pilgrimage roads leading to Santiago de Compostela. The link with the pilgrimage traffic seems logical enough, for architectural sculpture, especially when applied to the exterior of a church, is meant to appeal to the lay worshiper rather than to the members of a closed monastic community.

ST.-SERNIN, TOULOUSE. As in Romanesque architecture, the rapid development of stone sculpture shortly before

Tuscan architecture was in the use of a multicolored marble "skin" on the exteriors of churches. Little of this is left in Rome, a great deal of it having literally been "lifted" for the embellishment of later structures, but the interior of the Pantheon still gives us some idea of it (see fig. 246). We can recognize the desire to emulate such marble inlay in Pisa

In enlarging such a miniature, the carver of our relief has also reinflated it. The niche is a real cavity, the hair a round, close-fitting cap, the body severe and blocklike. Our *Apostle* has, in fact, much the same dignity and directness as the sculpture of Archaic Greece. The figure, somewhat more than half-lifesize, was not intended for viewing at close range only. Its impressive bulk and weight "carry" over a considerable distance. This emphasis on massive volume hints at what may well have been the main impulse behind the revival of large-scale sculpture. A stone-carved image, being tangible and three-dimensional, is far more "real" than a painted one. To the mind of a cleric steeped in the abstractions of theology, this might seem irrelevant, or even dangerous. For the unsophisticated laity, any large sculpture had something of the quality of an idol, and it was this fact that gave it such great appeal.

ST.-PIERRE, MOISSAC. Another important early center of Romanesque sculpture was the abbey at Moissac, some distance north of Toulouse. In figure 401 we see the magnificent trumeau (the center post supporting the lintel) and the western jamb of the south portal. (The parts of typical medieval portals are shown in fig. 403.) Both have a scalloped profile — apparently a bit of Moorish influence — and the shafts of the half-columns applied to jambs and trumeau follow this scalloped pattern, as if they had been squeezed from a giant pastry tube. Human and animal forms are treated with the same incredible flexibility, so that the spidery prophet on the side of the trumeau seems perfectly adapted to his precarious perch. (Notice how he, too, has been fitted into the scalloped outline.) He even remains free to cross his legs in a dancelike movement and to turn his head toward the interior of the church as he unfurls his scroll.

But what of the crossed lions that form a symmetrical zigzag on the face of the trumeau—do they have a meaning? So far as we know, they simply "animate" the shaft, just as the interlacing beasts of Irish miniatures (whose descendants they are) animate the compartments assigned to them. In manuscript illumination, this tradition had never died out. Our sculpture has undoubtedly been influenced by it, just as the agitated movement of the prophet has its ultimate origin in miniature painting (see fig. 414). The crossed lions reflect another source as well. We can trace them through textiles to Persian metalwork (although not in this towerlike formation), whence they can be traced back to the confronted animals of ancient Near Eastern art (see figs. 50, 92, and 135). Yet we cannot fully account for their presence at Moissac in terms of their effectiveness as ornament. They belong to an extensive family of savage or monstrous creatures in Romanesque art that retain their demoniacal vitality even though they are compelled, like our lions, to perform a supporting function. (A similar example may be seen in fig. 407.) Their purpose is thus not only decorative but expressive. They embody dark forces that have been domesticated into guardian figures or banished to a position that holds them fixed for all eternity, however much they may snarl in protest.

The south portal at Moissac displays the same richness of invention that St. Bernard of Clairvaux condemned in his famous letter of 1127 to Abbot William of St. Thierry about the sculpture of Cluny. [See Primary Sources, no. 32, *pages*

400. *Apostle.* c. 1090. Stone. St.-Sernin, Toulouse

1100 coincides with the growth of religious fervor among the lay population in the decades before the First Crusade. St.-Sernin at Toulouse contains several important examples probably carved about 1090, including the *Apostle* in figure 400. This panel is now in the ambulatory; its original location remains uncertain, but it perhaps decorated the front of an altar. Where have we seen its like before? The solidity of the forms has a strongly classical air, indicating that our artist must have had a close look at late Roman sculpture, of which there are considerable remains in southern France. But the solemn frontality of the figure and its placement in the architectural frame show that the design as a whole must derive from a Byzantine source, in all likelihood an ivory panel descended from the *Archangel Michael* in figure 315.

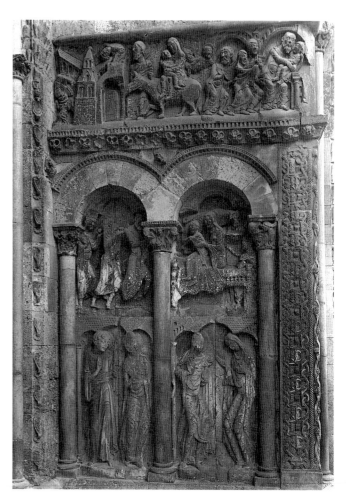

401. South portal (portion), St.-Pierre, Moissac, France.
Early 12th century

402. East flank, south portal, St.-Pierre, Moissac
(the angel of the *Annunciation,* bottom left, is modern)

387–88.] Although he did not object specifically to the role of art in teaching the unlettered, St. Bernard had little use for church decoration. He would surely have disapproved of the Moissac portal's excesses, which were clearly meant to appeal to the eye—as Bernard's begrudging admiration for the cloister at Cluny so eloquently attests.

The portal proper at Moissac is preceded by a deep porch, with lavishly sculptured sides. Within the arcade on the east flank (fig. 402) we see the *Annunciation* and *Visitation,* as well as the *Adoration of the Magi.* Other events from the early life of Christ are shown on the frieze above. Here we find the same thin limbs, the same eloquent gestures we saw in the prophet on the trumeau. (Note especially the wonderful play of hands in the *Visitation* and *Annunciation.*) Only the proportions of the bodies and the size of the figures vary with the architectural context. What matters is the vividness of the narrative, rather than consistency of treatment.

Burgundy

AUTUN CATHEDRAL. The tympanum (the lunette above the lintel) of the main portal of Romanesque churches usually holds a composition centered on the Enthroned Christ, most often the Apocalyptic Vision, or the Last Judgment, the most awesome scene of Christian art. At Autun Cathedral, this subject has been visualized with singularly expressive force by Giselbertus (fig. 404), who probably based his imagery on a contemporary account rather than relying on the Revelation of St. John the Divine. The apostles, at the viewer's left, observe the weighing of souls to the right. Four angels in the corners sound the trumpets of the Apocalypse. At the bottom, the dead rise from their graves in fear and trembling; some are already beset by snakes or gripped by huge, clawlike hands. Above, their fate quite literally hangs in the balance, with devils yanking at one end of the scales and angels at the other. The saved souls cling like children to the angels for protection before their ascent to the Heavenly Jerusalem (far left), while the condemned, seized by grinning devils, are cast into the mouth of Hell (far right).

These devils betray the same nightmarish imagination we observed in the Romanesque animal world. They are composite creatures, human in general outline but with spidery, birdlike legs, furry thighs, tails, pointed ears, and enormous, savage mouths. Their violence, unlike that of the animal monsters, is unchecked, and they enjoy themselves to the full in their grim occupation. No visitor, having "read in the marble" here (to speak with St. Bernard of Clairvaux), could fail to enter the church in a chastened spirit.

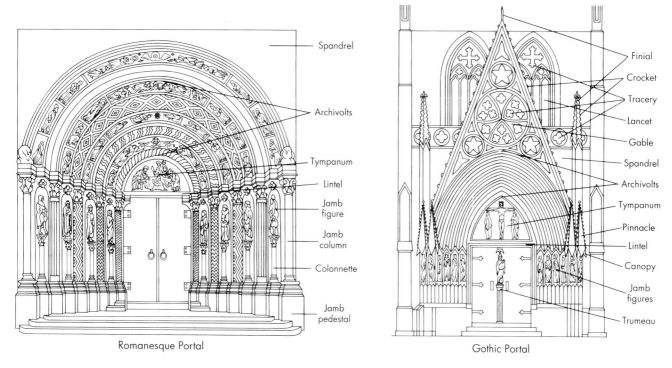

Spandrel

Archivolts

Tympanum

Lintel

Jamb figure

Jamb column

Colonnette

Jamb pedestal

Romanesque Portal

Finial

Crocket

Tracery

Lancet

Gable

Spandrel

Archivolts

Tympanum

Pinnacle

Lintel

Canopy

Jamb figures

Trumeau

Gothic Portal

403. Romanesque and High Gothic portal ensembles

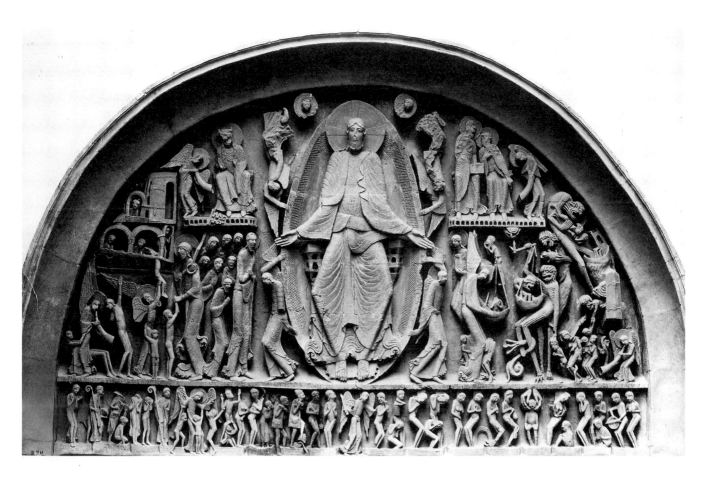

404. Giselbertus. *Last Judgment,* west tympanum, Autun Cathedral. c. 1130–35

405. Giselbertus. *Eve,* right half of lintel, north portal, from Autun Cathedral. Musée Rolin, Autun

The emergence of distinct artistic personalities in the twelfth century is a phenomenon that is rarely acknowledged, perhaps because it contradicts the widespread notion that all medieval art is anonymous. It does not happen very often, of course, but it is no less significant for all that. Giselbertus is not an isolated case. He cannot even claim to be the earliest. He is among a number of Romanesque sculptors who are known to us by name; nor is this an accident. Their highly individual styles made theirs the first identities worthy of being recorded since Anthemius of Tralles and Isidorus of Miletus a half-millennium earlier.

The work of Giselbertus is distinguished from that of his contemporaries by its unusually wide range. As at Moissac, it varies according to subject and location. His *Eve* (fig. 405) is as whimsical as the *Last Judgment* is terrifying. She is delicately plucking the apple from the Tree of Knowledge with an irresistible come-hither look at the missing Adam, who no doubt faced her. The languorous pose, necessitated by the door lintel she adorns, allows Giselbertus to model her figure with captivating—and surprisingly sensual—beauty.

STE.-MADELEINE, VÉZELAY. Giselbertus began his career at Cluny (see pages 316–17), where he may have served as chief assistant to the unknown master responsible for perhaps the most beautiful of all Romanesque tympanums, that of Ste.-Madeleine in Vézelay, not far from Autun (fig. 406). [See Primary Sources, no. 31, pages 386–87.] Its subject, the Mission of the Apostles, had a special meaning for this age of crusades, since it proclaims the duty of every Christian to spread the Gospel to the ends of the earth. From the hands of the majestic ascending Christ we see the rays of the Holy Spirit pouring down upon the apostles, all of them equipped with copies of the Scriptures in token of their mission. The lintel and the compartments around the central group are filled with representatives of the heathen world, a veritable encyclopedia

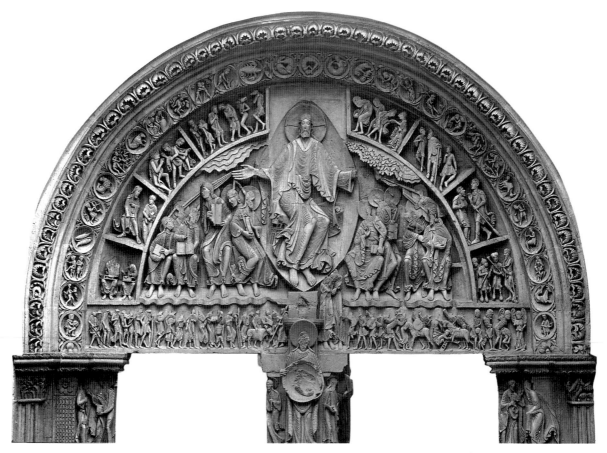

406. *The Mission of the Apostles,* tympanum of center portal of narthex, Ste.-Madeleine, Vézelay, France. 1120–32

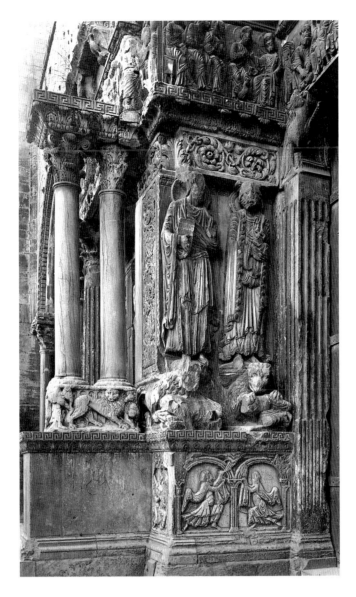

407. North jamb, center portal, St.-Gilles-du-Gard, France. Second quarter of the 12th century

of medieval anthropology which includes all sorts of legendary races. On the archivolt (the arch framing the tympanum) we recognize the signs of the zodiac and the labors appropriate to every month of the year, to indicate that the preaching of the Faith is as unlimited in time as it is in space.

Romanesque Classicism

PROVENCE. The portal sculpture at Moissac, Autun, and Vézelay, although varied in style, has many qualities in common: intense expression, unbridled fantasy, and a nervous agility of form that owes more to manuscript illumination and metalwork than to the sculptural tradition of antiquity. The *Apostle* from St.-Sernin, in contrast, had impressed us with its stoutly "Roman" flavor. The influence of classical monuments was particularly strong in Provence, the coastal region of southeastern France, which had been part of the Graeco-Roman world far longer than the rest of the country and is full of splendid Roman remains. Perhaps for this reason, the Romanesque style persisted longer in these areas than elsewhere. Looking at the center portal of the church at St.-Gilles-du-Gard (fig. 407), one of the great masterpieces of Romanesque art, we are struck immediately by the classical flavor of the architectural framework, with its free-standing columns, meander patterns, and fleshy acanthus ornament. The two large statues, carved almost in the round, have a sense of weight and volume akin to that of the *Apostle* from St.-Sernin, although, being half a century later in date, they also display the richness of detail we have observed in the intervening monuments. They stand on brackets supported by crouching beasts of prey, and these, too, show a Roman massiveness, while the small figures on the base (Cain and Abel) recall the style of Moissac.

Spain and Italy

STO. DOMINGO DE SILOS. The French style soon spread to Spain, first to Santiago da Compostela, where the sculpture has unfortunately been much rearranged, then to Sto. Domingo de Silos, which became an important destination in its own right, even though it lies some 60 miles off the pilgrimage route. Among the reliefs in the cloister of Sto. Domingo, which were probably carved in the second quarter of the twelfth century, is the splendid *Doubting of Thomas* in figure 408. The composition, with its apostles who appear to have been cut from the

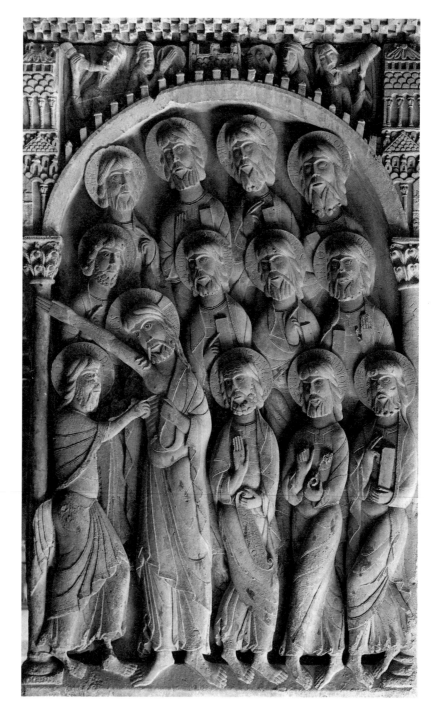

408. *The Doubting of Thomas.* c. 1130–40. Marble. Cloister, Sto. Domingo de Silos, Spain

same mold, is indebted to Ottonian art (compare fig. 377). The subtle carving technique owes something to France as well, in particular the corner piers of the cloister at Moissac. It shares other features found in Romanesque sculpture outside Spain: the elongated forms, angular poses, and emphatic gestures. Yet we cannot account for the appearance of this work solely in terms of external influences. *The Doubting of Thomas* is, in fact, a highly original achievement, for there is nothing like it elsewhere. The unaffected plainness is both disarming and deceptive—the extreme stylization lends the scene an expressiveness that is as moving as it is direct. Like the Gregorian chants for which Silos is still renowned, this relief is a testimony to faith of unmatched eloquence. They share similar formal means as well: both rely on the repetition of unadorned motifs in simple cadence for their cumulative effect.

WILIGELMO. Although the French style quickly became international, it was modified through interaction with local tradition. We see this process in the work of Wiligelmo, whose reliefs from Genesis (fig. 409) on the facade of Modena Cathedral are rightly credited with inaugurating Romanesque sculpture in Italy. The scenes show a surprising kinship to the doors of Bishop Bernward at Hildesheim (fig. 375), which suggests that Wiligelmo perhaps hailed from Germany, where he may have been trained as a goldsmith under the name Wilhelm. If so, he must also have been familiar with the Romanesque style then emerging in Burgundy, as a glance at the frieze depicting the early life of Christ along the porch at Moissac attests (fig. 402). Nevertheless, the figures show a knowledge of the nude that can have been gained only in Italy itself. Moreover, they have a ponderousness, derived from

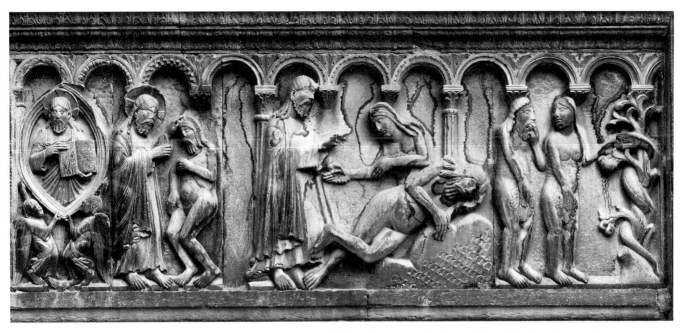

409. Wiligelmo. *Scenes from Genesis.* c. 1106–20. Marble, height approx. 36" (91.5 cm). Cathedral, Modena, Italy

Early Christian ivory panels done in Italy, that seems all the more astonishing in comparison to the spindly Adam and Eve at Hildesheim, from which they descend. This solidity in turn lends the scenes a solemn dignity, as against the urgent drama seen on Bernward's doors (compare fig. 376). The artist was proud of his work, and justly so: an inscription boasts, "Among sculptors, your work shines through, Wiligelmo." That Italian sculpture was revived by a German is by no means surprising: the tradition had all but died out by the middle of the eighth century, while northern Italy remained in the hands of German rulers, who also acted as protectors of the papacy in Rome.

ANTELAMI. The nascent classicism of Wiligelmo reaches its height toward the end of the twelfth century in the splendid figure of King David from the facade of Fidenza Cathedral in Lombardy (fig. 410) by Benedetto Antelami, the greatest sculptor of Italian Romanesque art. As we have seen, artists' signatures are far from rare in Romanesque times. What makes Antelami exceptional is the fact that his work shows a much greater degree of individuality than is evident in other artists' work, so that, for the first time since the ancient Greeks, we can begin to speak (though with some hesitation) of a personal style. Furthermore, unlike Wiligelmo he is a monumental sculptor at heart, not a relief carver. Thus, his *King David* approaches the ideal of the self-sufficient statue more closely than any medieval work we have seen so far. The *Apostle* from St.-Sernin is one of a series of figures, all of them immutably fixed to their niches, while Antelami's *King David* stands physically free and even shows an attempt to recapture the classical contrapposto. To be sure, he would look awkward if placed on a pedestal in isolation. He demands the architectural framework for which he was made, but certainly to a far lesser extent than do the two statues at St.-Gilles, to which he is otherwise kin. Nor is he subject to the group discipline of a series; his only companion is a second niche statue on the other side of the

410. Benedetto Antelami. *King David.* c. 1180–90.
West facade, Fidenza Cathedral, Italy

411. Renier of Huy. Baptismal Font. 1107–18. Bronze, height 25" (63.5 cm). St.-Barthélemy, Liège, Belgium

portal. We note, too, that the figure is lost in thought. Indeed, such expressiveness, new to Romanesque sculpture, is characteristic of Benedetto's work as a whole. We shall meet it again in the statues of Donatello. The *King David* is an extraordinary achievement indeed, especially if we consider that less than a hundred years separate it from the beginnings of the sculptural revival.

The Meuse Valley

The revival of individuality is also found in one particular region of the north, the valley of the Meuse River, which runs from northeastern France into Belgium and Holland. This region had been the home of the classicizing Reims style in Carolingian times (see figs. 367 and 368), and that awareness of classical sources pervades its art (called Mosan) during the Romanesque period. Here again, interestingly enough, the revival of individuality is linked with the influence of ancient art, although this influence did not produce works on a monumental scale.

Mosan Romanesque sculpture excelled in metalwork, such as the splendid baptismal font of 1107–18 in Liège (fig. 411), which is also the masterpiece of the earliest among the individually known artists of the region, Renier of Huy. The vessel rests on 12 oxen (symbols of the 12 apostles), like Solomon's basin in the Temple at Jerusalem as described in the Bible. The reliefs make an instructive contrast with those of Bernward's doors (see fig. 376), since they are about the same height. Instead of the rough expressive power of the Ottonian panel, we find here a harmonious balance of design, a subtle control of the sculptured surfaces, and an understanding of organic structure that, in medieval terms, are amazingly classical. The

412. Lion Monument. 1166. Bronze, length approx. 6' (1.8 m). Cathedral Square, Brunswick, Germany

figure seen from the back (beyond the tree on the left in our illustration), with its graceful turning movement and Greek-looking drapery, might almost be taken for an ancient work.

Germany

The one monumental free-standing statue of Romanesque art—perhaps not the only one made, but the only one that has survived—is that of an animal, and in a secular rather than a religious context: the lifesize bronze lion on top of a tall shaft that Duke Henry the Lion of Saxony had placed in front of his palace at Brunswick in 1166 (fig. 412). The wonderfully ferocious beast personifies the duke, or at least that aspect of his personality that earned him his nickname. It will remind us in a curious way of the archaic bronze she-wolf of Rome (see fig. 232). Perhaps the resemblance is not entirely coincidental, since the she-wolf was on public view in Rome at that time and must have had a strong appeal for Romanesque artists.

The more immediate relatives of the Brunswick lion, however, are the countless bronze water ewers in the shape of lions, dragons, griffins, and such, that came into use in the twelfth century for the ritual washing of the priest's hands during Mass. These vessels, another instance of monsters doing menial service for the Lord, were of Near Eastern inspiration. The beguiling specimen reproduced in figure 413 still betrays its descent from the winged beasts of Persian art, transmitted to the West through trade with the Islamic world.

413. Ewer. Mosan. c. 1130. Gilt bronze, height 7¼" (18.5 cm). Victoria & Albert Museum, London

PAINTING AND METALWORK

Unlike architecture and sculpture, Romanesque painting shows no sudden revolutionary developments that set it apart immediately from Carolingian or Ottonian. Nor does it look more "Roman" than Carolingian or Ottonian painting. This does not mean, however, that in the eleventh and twelfth centuries painting was any less important than it had been during the earlier Middle Ages. The absence of dramatic change merely emphasizes the greater continuity of the pictorial tradition, especially in manuscript illumination.

France

GOSPEL BOOK, CORBIE. Nevertheless, soon after the year 1000 we find the beginnings of a painting style that corresponds to—and often anticipates—the monumental qualities of Romanesque sculpture. The new attitude is clearly evident in the *St. Mark* (fig. 414), from a Gospel Book probably done toward 1050 at the monastery of Corbie in northern France. The twisting and turning movement of the lines, which pervades not only the figure of the evangelist but the winged lion, the scroll, and the curtain, recalls Carolingian miniatures of the Reims School such as the *Ebbo Gospels* (see fig. 367). This very resemblance helps us see the differences between the two works. In the Corbie manuscript, every trace of classical illusionism has disappeared. The fluid modeling of the Reims School, with its suggestion of light and space, has been replaced by firmly drawn contours filled in with bright, solid colors, so that the three-dimensional aspects of the picture are reduced to overlapped planes. Even Ottonian painting (see figs. 377 and 378) seems illusionistic in comparison. Yet

414. *St. Mark,* from a Gospel Book produced at Corbie. c. 1050. Bibliothèque Municipale, Amiens, France

by sacrificing the last remnants of modeling in terms of light and shade, the Romanesque artist has endowed his work with an abstract clarity and precision that had not been possible in Carolingian or Ottonian times. Only now can we truly say that the representational, the symbolic, and the decorative elements of the design are knit together into a single, unified structure.

This style of rhythmic lines and planes eschews all effects that might be termed specifically pictorial, including not only tonal values but the rendering of textures and highlights such as we still find in Ottonian painting. For that very reason, however, it gains a new universality of scale. The evangelists of the *Ebbo Gospels,* the drawings of the *Utrecht Psalter,* and the miniatures in the *Gospel Book of Otto III* are made up of open, spontaneous flicks and dashes of brush or pen that have an intimate, handwritten flavor. They would certainly look strange if copied on a larger scale or in another medium. The Corbie miniature, on the contrary, might be translated into a mural, a stained-glass window, a tapestry, or a relief panel without losing any of its essential qualities.

415. *The Battle of Hastings.* Detail of the *Bayeux Tapestry.* c. 1073–83. Wool embroidery on linen, height 20" (50.7 cm). Centre Guillaume le Conquerant, Bayeux, France

BAYEUX TAPESTRY. This monumentality is much the same as in the Vézelay tympanum (fig. 406), where similar pleated drapery patterns are rendered in sculptural terms. It is found again in the so-called *Bayeux Tapestry,* an embroidered frieze 230 feet long illustrating William the Conqueror's invasion of England. In our detail (fig. 415), portraying the Battle of Hastings, the designer has integrated narrative and ornament with consummate ease. The main scene is enclosed by two border strips that perform a framing function. The upper tier with birds and animals is purely decorative, but the lower strip is full of dead warriors and horses and thus forms part of the story. Although told in a direct style devoid of such pictorial devices of classical painting as foreshortening and overlapping (see fig. 199), the tapestry gives us an astonishingly vivid and detailed account of warfare in the eleventh century. The massed forms of the Graeco-Roman scene are gone, replaced by a new kind of individualism that makes of each combatant a potential hero, whether by force or cunning. (Observe how the soldier who has fallen from the horse that is somersaulting with its hind legs in the air is, in turn, toppling his adversary by yanking at the saddle girth of his mount.) The stylistic kinship with the Corbie manuscript is apparent in the lively somersaults of the falling horses, so strikingly like the pose of the lion in the miniature.

ST.-SAVIN-SUR-GARTEMPE. The firm outlines and a strong sense of pattern found in the English Channel region are equally characteristic of Romanesque wall painting in southwestern France. *The Building of the Tower of Babel* (fig. 416) is part of the most impressive surviving cycle, on the nave vault of the church at St.-Savin-sur-Gartempe (compare fig. 385). It is an intensely dramatic design, crowded with strenuous action. The Lord himself, on the far left, participates directly in the narrative as he addresses the builders of the colossal structure. He is counterbalanced, on the right, by the giant Nimrod, the leader of the enterprise, who frantically hands blocks of stone to the masons atop the tower, so that the entire scene becomes a great test of strength between God and human. The heavy dark contours and the emphatic play of gestures make the composition eminently readable from a distance. Yet, as we shall see, the same qualities occur in the illuminated manuscripts of the region, which can be equally monumental despite their small scale.

Where did the idea come from to cover such a vast area with murals? Surely not from France itself, which had no tradition of monumental painting, but from Byzantium (see fig. 349)— probably by way of Italy, which had strong ties to the East (see pages 238–40). Toward the end of the eleventh century, Greek artists decorated the newly constructed basilican church of

416. *The Building of the Tower of Babel.* Detail of painting on the nave vault, St.-Savin-sur-Gartempe. Early 12th century

417. *The Arrest of Christ.* c. 1085. Fresco. S. Angelo in Formis, Capua, Italy

the Benedictine monastery at Monte Cassino with mosaics at the invitation of Abbot Desiderius (later Pope Victor III). Although they no longer survive, their impact can be seen in the frescoes painted a short time later in the church of S. Angelo in Formis near Capua, also built by Desiderius. *The Arrest of Christ,* along the nave (fig. 417), is a counterpart to the mosaics and murals that line the arcades of Early Christian basilicas, whose splendor Desiderius sought to recapture (compare fig. 299). The painting shows its Byzantine heritage, but it has been adapted to Latin liturgical requirements and taste. What it lacks in sophistication this monumental style more than makes up for in expressive power. That very quality appealed to Western artists, as it was in keeping with the vigorous art that emerged at the same time in the *Bayeux Tapestry.*

The late tenth through the twelfth century witnessed the unprecedented rise of women, first as patrons of art and then as artists. This remarkable chapter began with the Ottonian dynasty, which forged an alliance with the Church by placing members of the family in prominent positions. Thus, Mathilde, Otto I's granddaughter, became abbess of the Holy Trinity convent at Essen in 974; later, the sister, daughters, and granddaughter of Otto II also served as abbesses of major convents. Hardly less important, though not of royal blood, were Hrosvitha, canoness at the monastery of Gandersheim, who was the first woman dramatist we know of, and the two abbesses of Niedermünster, both named Uota. They paved the way for Herrad of Hohenberg (died 1195), author of *The Garden of Delights,* an encyclopedia of knowledge and history compiled for the education of her nuns.

Most remarkable of all was the Benedictine abbess Hildegard of Bingen (1098–1179). Among the most brilliant women in history, she was in close contact with leaders throughout Europe. In addition to a musical drama in Latin, the *Ordo Virtutum,* about the struggle between the forces of good and evil, she composed almost 80 vocal works that rank with the finest of the day. She also wrote some 13 books on theology, medicine, and science. But she is known above all for her books of visions, which made her one of the great spiritual voices of her day. Although one (*To Know the Ways of God*) is now known only in facsimile (it was destroyed in 1945) and the other (*The Book of Divine Works*) in a later reproduction, it seems likely that the originals were executed under her direct supervision by nuns in her convent along the Rhine. It has also been argued that they were done by monks at nearby monasteries.

That there were women artists in the twelfth century is certain, although we know only a few of their names. In one instance, an initial in a manuscript includes a nun bearing a scroll inscribed, "Guda, the sinful woman, wrote and illuminated this book"; another book depicts Claricia, evidently a lay artist, swinging as carefree as any child from the letter Q she has decorated. Without these author portraits, we might never suspect the involvement of women illuminators.

"The Fountain of Life," detail from *Liber divinorum operum,* Vision 8, fol. 132r. 13th century. Tempera on vellum, 13^1/8 x 5^5/8" (33.3 x 14.4 cm). Biblioteca statale di Lucca, Italy

By the middle of the twelfth century Byzantine influences were in evidence everywhere, from Italy and Spain in the south to France, Germany, and England in the north. How were they disseminated? The principal conduit was most likely the Benedictine order, then at the height of its power. A Byzantine style must have been an important feature of the decorations in the abbey church at Cluny, the seat of Benedictine monasticism in France and the largest one ever built in Romanesque Europe. Unfortunately, the great church was almost completely destroyed after the French Revolution, but the Cluniac style is echoed in the early-twelfth-century frescoes at nearby Berzé-la-Ville; these have distinct Byzantine overtones that relate them directly to the paintings at S. Angelo in Formis.

The Channel Region

Although Romanesque painting, like architecture and sculpture, developed a wide variety of regional styles throughout western Europe, its greatest achievements emerged from the monastic scriptoria of northern France, Belgium, and southern England. The works from this area are so closely related in style that it is impossible at times to be sure on which side of the English Channel a given manuscript was produced.

GOSPEL BOOK OF ABBOT WEDRICUS. Thus, the style of the wonderful miniature of St. John (fig. 418) has been linked with both Cambrai, France, and Canterbury, England. Here the abstract linear draftsmanship of the Corbie manuscript (fig. 414) has been influenced by the Byzantine style (note the ropelike loops of drapery, whose origin can be traced back to such works as the *Crucifixion* at Daphné in fig. 340 and even further, to the ivory leaf in fig. 315), but without losing its energetic rhythm. It is the precisely controlled dynamics of every contour, both in the main figure and in the frame, that unite the varied elements of the composition into a coherent whole. This quality of line still betrays its ultimate source, the Celtic-Germanic heritage.

If we compare our miniature with one from the *Lindisfarne Gospels* (fig. 352), we see how much the interlacing patterns of the early Middle Ages have contributed to the design of the St. John page. The drapery folds and the clusters of floral ornament have an impulsive yet disciplined aliveness that echoes the intertwined snakelike monsters of the animal style, even though the foliage is derived from the classical acanthus and the human figures are based on Carolingian and Byzantine models. The unity of the entire page, however, is conveyed not only by the forms but by the content as well. The

418. *St. John the Evangelist,* from the *Gospel Book of Abbot Wedricus.*
c. 1147. Tempera on vellum, 14 x 9¹/₂" (35.5 x 24 cm).
Société Archéologique et Historique, Avesnes-sur-Helpe, France

419. *Portrait of a Physician,* from a medical treatise. c. 1160.
The British Museum, London

evangelist "inhabits" the frame in such a way that we could not remove him from it without cutting off his ink supply (offered by the donor of the manuscript, Abbot Wedricus), his source of inspiration (the dove of the Holy Spirit in the hand of God), or his identifying symbol (the eagle). The other medallions, less directly linked with the main figure, show scenes from the life of St. John.

PORTRAIT OF A PHYSICIAN. Soon after the middle of the twelfth century, however, an important change began to make itself felt in Romanesque manuscript painting on both sides of the English Channel. The *Portrait of a Physician* (fig. 419), from a medical manuscript of about 1160, is surprisingly different from the St. John miniature, although it was produced in the same region. Instead of abstract patterns, we suddenly find lines that have regained the ability to describe three-dimensional shapes. The drapery folds no longer lead an ornamental life of their own but suggest the rounded volume of the body underneath. There is even a renewed interest in foreshortening. At last, then, we see an appreciation for the achievements of antiquity missing in the murals at S. Angelo in Formis, as it is in those at St.-Savin-sur-Gartempe. Here again, the lead was taken by Cluny, which was an important center of manuscript production.

This style, too, stemmed from Byzantine art, which saw a revival of classicism during the tenth and eleventh centuries, but it was perhaps transmitted through Germany where, as we have seen, Byzantine elements had long been present in manuscript painting (compare figs. 365 and 377). The physician, seated in the pose of Christ as philosopher (compare fig. 313), will remind us of David from the *Paris Psalter* (see fig. 339), but he has been utterly transformed. The sharp, deliberate lines look as if they had been engraved in metal, rather than drawn with pen or brush. Thus our miniature is the pictorial counterpart of the classicism we saw earlier in the baptismal font of Renier of Huy at Liège (see fig. 411). In fact, it was probably done at Liège, too.

NICHOLAS OF VERDUN. That a new way of painting should have originated in metalwork is perhaps less strange than it might seem at first, for the style's essential qualities are sculptural rather than pictorial. Moreover, metalwork (which includes not only cast or embossed sculpture but also engraving, enameling, and goldsmithing) had been a highly developed art in the Meuse Valley area since Carolingian times. Its greatest practitioner after Renier of Huy was Nicholas of Verdun, in whose work the classicizing, three-dimensional style of draftsmanship reaches full maturity.

The Klosterneuburg Altar, which he completed in 1181 for provost Wernher, consists of numerous engraved and

420. Nicholas of Verdun. Klosterneuburg Altar. 1181. Gold and enamel, height approx. 28" (71.1 cm).
Klosterneuburg Abbey, Austria

enameled plaques originally in the form of a pulpit but rearranged as a triptych after a fire in 1330 (fig. 420). Laid out side by side like a series of manuscript illuminations from the Old and New Testaments to form a complex program, they have a sumptuousness that recalls, on a miniature scale, the glittering play of light across mosaics (compare fig. 340). Our detail of *The Crossing of the Red Sea* (fig. 421) clearly belongs to the same tradition as the Liège miniature, but the figures, clothed in rippling, "wet" draperies familiar to us from countless classical statues, have achieved so high a degree of organic body structure and freedom of movement that we tend to think of them as harbingers of Gothic art rather than as the final phase of the Romanesque. Whatever we choose to call it, the style of the Klosterneuburg Altar was to have a profound impact upon both painting and sculpture during the next 50 years (see figs. 469 and 470).

Equally revolutionary is a new expressiveness that unites all the figures, and even the little dog perched on the bag carried by one of the men, through the exchange of glances and gestures within the tightly knit composition. Not since late Roman times have we seen such concentrated drama, though its intensity is uniquely medieval. Indeed, the astonishing humanity of Nicholas of Verdun's art is linked to an appreciation of the beauty of ancient works of art, as well as a new regard for classical literature and mythology.

CARMINA BURANA. The general reawakening of interest in humanity and the natural world throughout northwestern Europe sometimes was expressed as a greater readiness to acknowledge the enjoyment of sensuous experience. This aspect is reflected particularly in such lighthearted poetry as the well-known *Carmina Burana,* composed during the later twelfth century and preserved in an illuminated manuscript

of the early thirteenth that was produced at a Benedictine monastery in Upper Bavaria. That a collection of verse devoted largely, and at times very frankly, to the delights of nature, love, and drinking should have been embellished with illustrations is significant in itself. We are even more surprised, however, to find that one of the miniatures (fig. 422), coupled with a poem praising summer, represents a landscape—the first, so far as we know, in Western art since Late Classical times.

Echoes of ancient landscape painting, derived from Early Christian and Byzantine sources, can be found in Carolingian art (see figs. 367 and 368), but only as background for the human figure. Later on, these remnants had been reduced still further, even when the subject required a landscape setting. For example, the Garden of Eden on Bernward's doors (see fig. 376) is no more than a few strangely twisted stems and bits of foliage. Thus the *Carmina Burana* illustrator, called upon to depict the life of nature in summertime, must have found the task a rather perplexing one. It has been solved in the only way possible at the time: by filling the page with a sort of anthology of Romanesque plant ornament interspersed with birds and animals.

The trees, vines, and flowers remain so abstract that we cannot identify a single species. The birds and animals, probably copied from a zoological treatise, are far more realistic. Yet they have an uncanny vitality of their own that makes them seem to sprout and unfold as if the growth of an entire season were compressed into a few frantic moments. These giant seedlings convey the exuberance of early summer, of stored energy suddenly released, far more intensely than any normal vegetation could. Our artist has created a fairytale landscape, but his enchanted world nevertheless evokes an essential underlying reality.

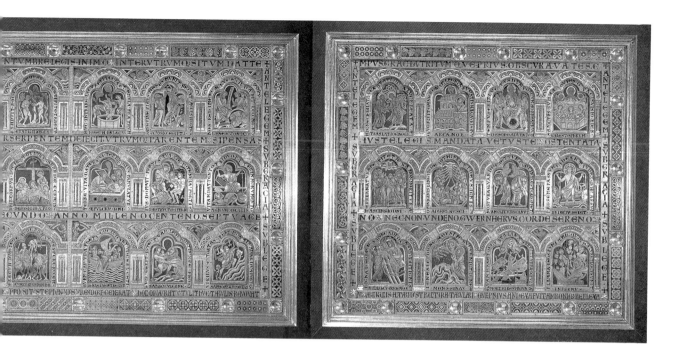

421. Nicholas of Verdun. *The Crossing of the Red Sea,* from the Klosterneuburg Altar. 1181. Enamel on gold plaque, height 5$^1/2$" (14 cm). Klosterneuburg Abbey

422. *(right)* Page with *Summer Landscape,* from a manuscript of *Carmina Burana.* Early 13th century. 7 x 4$^7/8$" (17.8 x 12.5 cm). Bayerische Staatsbibliothek, Munich

CHAPTER FOUR

GOTHIC ART

Time and space, we have been taught, are interdependent. Yet we tend to think of history as the unfolding of events in time without sufficient awareness of their unfolding in space. We visualize it as a stack of chronological layers, or periods, each layer having a specific depth that corresponds to its duration. For the more remote past, where our sources of information are scanty, this simple image works reasonably well. It becomes less and less adequate as we draw closer to the present and our knowledge grows more precise. Thus we cannot define the Gothic era in terms of time alone; we must consider the changing surface area of the layer as well as its depth.

At the start, about 1140, this area was small indeed. It embraced only the province known as the Île-de-France (that is, Paris and vicinity), the royal domain of the French kings. A hundred years later, most of Europe had "gone Gothic," from Sicily to Iceland, with only a few Romanesque pockets left here and there. Through the crusaders, the new style had even been introduced to the Near East. About 1450, the Gothic area began to shrink (it no longer included Italy) and by about 1550 had disappeared almost entirely. The Gothic layer, then, has a rather complicated shape, with its depth varying from close to 400 years in some places to a minimum of 150 in others. This shape, moreover, does not emerge with equal clarity in all the visual arts.

The term *Gothic* was first coined for architecture, and it is in architecture that the characteristics of the style are most easily recognized. Although we speak of Gothic sculpture and painting, there is, as we shall see, some uncertainty about the exact limits of the Gothic style in these fields. This evolution of our concept of Gothic art suggests the way the new style actually grew. It began with architecture, and for a century—from about 1150 to 1250, during the Age of the Great Cathedrals—architecture retained its dominant role. Gothic sculpture, at first severely architectural in spirit, tended to become less and less so after 1200; its greatest achievements are between the years 1220 and 1420. Painting, in turn, reached a climax of creative endeavor between 1300 and 1350 in central Italy.

North of the Alps, it became the leading art from about 1400 on. We thus find, in surveying the Gothic era as a whole, a gradual shift of emphasis from architecture to painting or, better perhaps, from architectural to pictorial qualities. Characteristically, Early Gothic sculpture and painting both reflect the discipline of their monumental setting, while Late Gothic architecture and sculpture strive for "picturesque" effects rather than clarity or firmness.

Overlying this broad pattern is another one: international diffusion as against regional independence. Starting as a local development in the Île-de-France, Gothic art radiates from there to the rest of France and to all Europe, where it comes to be known as *opus modernum* or *opus francigenum* (modern or French work). In the course of the thirteenth century, the new style gradually loses its imported flavor, and regional variety begins to reassert itself. Toward the middle of the fourteenth century, we notice a growing tendency for these regional achievements to influence each other until, about 1400, a surprisingly homogeneous "International Gothic" style prevails almost everywhere. Shortly thereafter, this unity breaks apart. Italy, with Florence in the lead, creates a radically new art, that of the Early Renaissance, while north of the Alps, Flanders assumes an equally commanding position in the development of Late Gothic painting and sculpture. A century later, finally, the Italian Renaissance becomes the basis of another international style.

This development roughly parallels what happened in the political arena. Supported by shifting alliances with the papacy, the kings of France and England emerged as the leading powers at the expense of the Germans in the early thirteenth century, which was generally a time of peace and prosperity. Under these ideal conditions the new Franciscan and Dominican orders were established, and Catholicism found its greatest intellect, St. Thomas Aquinas, since St. Augustine and St. Jerome some 850 years earlier. After 1290, however, the balance of power quickly broke down, resulting in the exile of the papacy to Avignon, France, in 1305 for more than 70 years.

423. Ambulatory, Abbey Church of St.-Denis, Paris. 1140–44

424. Plan of the choir and ambulatory of St.-Denis
(Peter Kidson)

ARCHITECTURE

France

ST.-DENIS AND ABBOT SUGER. We can pinpoint the origin of no previous style as exactly as that of Gothic. It was born between 1137 and 1144 in the rebuilding by Abbot Suger of the royal Abbey Church of St.-Denis just outside the city of Paris. If we are to understand how Gothic architecture happened to come into being at this particular spot, we must first acquaint ourselves with the special relationship between St.-Denis, Suger, and the French monarchy. The kings of France derived their claim to authority from the Carolingian tradition, although they belonged to the Capetian line (founded by Hugh Capet after the death of the last Carolingian in 987). But their power was eclipsed by that of the nobles who, in theory, were their vassals. The only area they ruled directly was the Île-de-France, and they often found their authority challenged even there. Not until the early twelfth century did the royal power begin to expand, and Suger, as chief adviser to Louis VI, played a key role in this process. It was he who forged the alliance between the monarchy and the Church, which brought the bishops of France (and the cities under their authority) to the king's side, while the king, in turn, supported the papacy in its struggle against the German emperors.

Suger championed the monarchy not only in practical politics but also in "spiritual politics." By investing the royal office with religious significance and glorifying it as the strong right arm of justice, he sought to rally the nation behind the king. His architectural plans for the abbey of St.-Denis must be understood in this context, for the church, founded in the late eighth century, enjoyed a dual prestige that made it ideally suitable for Suger's purpose. It was the shrine of St.-Denis, the Apostle of France and special protector of the realm, as well as the chief memorial of the Carolingian dynasty. Both Charlemagne and his father, Pepin, had been consecrated kings there, and it was also the burial place of Charles Martel, Pepin, and Charles the Bald. Suger wanted to make the abbey the spiritual center of France, a pilgrimage church to outshine the splendor of all the others, the focal point of religious as well as patriotic emotion. But in order to become the visible embodiment of such a goal, the old edifice had to be enlarged and rebuilt. The great abbot himself has described the campaign in considerable detail. Unfortunately, the west facade and its sculpture are sadly mutilated today, and the choir at the east end, which Suger regarded as the most important part of the church, retains its original appearance only in the ambulatory (figs. 423 and 424). [See Primary Sources, nos. 33 and 34, pages 388–89.]

The ambulatory and radiating chapels surrounding the arcaded apse are familiar elements from the Romanesque

pilgrimage choir (compare fig. 381), yet they have been integrated in strikingly novel fashion. The chapels, instead of remaining separate entities, are merged so as to form, in effect, a second ambulatory, and ribbed groin vaulting based on the pointed arch is employed throughout. (In the Romanesque pilgrimage choir, only the ambulatory had been groin-vaulted.) As a result, the entire plan is held together by a new kind of geometric order. It consists of seven nearly identical wedge-shaped units fanning out from the center of the apse. (The central chapel, dedicated to the Virgin, and its neighbors on either side are slightly larger, presumably because of their greater importance.) We experience this double ambulatory not as a series of separate compartments but as a continuous (though articulated) space, whose shape is outlined for us by the network of slender arches, ribs, and columns that sustains the vaults.

What distinguishes this interior immediately from its predecessors is its lightness, in both senses. The architectural forms seem graceful, almost weightless, as against the massive solidity of the Romanesque, and the windows have been enlarged to the point that they are no longer openings cut into a wall—they fill the entire wall area, so that they themselves become translucent walls. If we now examine the plan once more, we realize what makes this abundance of light possible. The outward pressure of the vaults is contained by heavy buttresses jutting out between the chapels. (In the plan, they look like stubby black arrows pointing toward the center of the apse.) The main weight of the masonry construction is concentrated there, visible only from the outside. No wonder, then, that the interior appears so amazingly airy and weightless, since the heaviest members of the structural skeleton are beyond our view. The same impression would be even more striking if we could see all of Suger's choir, for the upper part of the apse, rising above the double ambulatory, had very large, tall windows. The effect, from the nave, must have been similar to that of the somewhat later choir of Notre-Dame in Paris (see fig. 426).

SUGER AND GOTHIC ARCHITECTURE. In describing Suger's choir, we have also described the essentials of Gothic architecture. Yet none of the individual elements that entered into its design is really new. The pilgrimage choir plan, the pointed arch, and the ribbed groin vault can be found in various regional schools of the French and Anglo-Norman Romanesque, even though we never encounter them all combined in the same building until St.-Denis. The Île-de-France had failed to develop a Romanesque tradition of its own, so that Suger (as he himself tells us) had to bring together artisans from many different regions for his project. We must not conclude from this, however, that Gothic architecture originated as no more than a synthesis of Romanesque traits. If it were only that, we would be hard pressed to explain the new spirit that strikes us so forcibly at St.-Denis: the emphasis on geometric planning and the quest for luminosity. Suger's account of the rebuilding of his church stresses both of these as the highest values achieved in the new structure. "Harmony" (that is, the perfect relationship among parts in terms of mathematical proportions or ratios) is the source of all beauty, since it exemplifies the laws according to which divine reason has constructed the universe. Thus, it is suggested, the "miraculous" light that floods the choir through the "most sacred" windows becomes the Light Divine, a revelation of the spirit of God.

This symbolic interpretation of light and of numerical harmony had been established over the centuries in Christian thought. It derived in part from the writings of a fifth-century Greek theologian who, in the Middle Ages, was believed to have been Dionysius the Areopagite, an Athenian disciple of St. Paul. Through this identification, the works of another fifth-century writer, known as the Pseudo-Dionysius, came to be vested with great authority. In Carolingian France, however, Dionysius the disciple of St. Paul was identified both with the author of the Pseudo-Dionysian writings and with St.-Denis. Although these writings were available to Suger at St.-Denis, his debt to them seems rather general at best. Suger was not a scholar but a man of action, who was conventional in his thinking. It is probable that he consulted the contemporary theologian Hugh of St.-Victor, who was steeped in Dionysian thought, for the most obscure part of his program at the west end of the church. This does not mean that Suger's own writings are little more than a justification after the fact. On the contrary, he clearly knew his own mind. What, then, was he trying to achieve? Like the three blind men attempting to describe an elephant by touching different parts of the animal, scholars have come to surprisingly little agreement. For Suger, the material realm was the stepping stone for spiritual contemplation. Thus, the actual experience of dark, jewellike light that disembodies the material world lies at the heart of Suger's mystical intent, which was to be transported to "some strange region of the universe which neither exists entirely in the slime of earth nor entirely in the purity of Heaven."

SUGER AND THE MEDIEVAL ARCHITECT. The success of the choir design at St.-Denis is proved not only by its inherent qualities but also by its extraordinary impact. Every visitor, it seems, was overwhelmed by the achievement, and within a few decades the new style had spread far beyond the confines of the Île-de-France. The how and why of Suger's success are a good deal more difficult to explain. Here we encounter a controversy we have met several times before—that of form versus function. To the advocates of the functionalist approach, Gothic architecture has seemed the result of advances in architectural engineering, which made it possible to build more efficient vaults, to concentrate their thrust at a few critical points, and thus eliminate the solid walls of the Romanesque church. Suger, they would argue, was fortunate in securing the services of an architect who evidently understood the principles of ribbed groin vaulting better than anybody else at that time. If the abbot chose to interpret the resulting structure as symbolic of Dionysian theology, he was simply expressing his enthusiasm over it in the abstract language of the churchman, so that his account does not help us to understand the origin of the new style.

As the careful integration of its components suggests, the choir of St.-Denis is more rationally planned and constructed than any Romanesque church. The pointed arch (which can be "stretched" to reach any desired height regardless of the width of its base) has now become an integral part of the ribbed groin vault. As a result, these vaults are no longer restricted to square or near-square compartments. They have

425. Gerard Horenbout (Master of James IV of Scotland). *Elijah Begging for Fire from Heaven* (miniature) and *The Construction of the Tower of Babel* (border), from *Spinola Hours.* Flemish, c. 1510–20. Tempera on vellum, 9¹/₈ x 6¹/₂" (23.2 x 16.6 cm). The J. Paul Getty Museum, Los Angeles. Ms. Ludwig IX 18, fol. 32

gained a flexibility that permits them to cover areas of almost any shape (such as the trapezoids and pentagons of the ambulatory). The buttressing of the vaults, too, is more fully understood than before. How could Suger's ideas have led to these technical advances, unless we are willing to assume that he was a professionally trained architect? If we grant that he was not, can he claim any credit at all for the style of what he so proudly calls "his" new church? Oddly enough, there is no contradiction here. As we have seen (page 275), the term *architect* was understood in a very different way from the modern sense, which derives from Greece and Rome by way of the Italian Renaissance. To the medieval mind, he was the overall leader of the project, not the master builder responsible for its construction—as Suger's account makes abundantly clear, which is why he remains so silent about his helper. Furthermore, professional architectural training as we know it did not exist at the time.

Perhaps the question poses a false alternative, somewhat like the conundrum of the chicken and the egg. The function of a church, after all, is not merely to enclose a maximum of space with a minimum of material but to communicate the great religious ideas that lie behind it. For the master who built the choir of St.-Denis, the technical problems of vaulting must have been inextricably bound up with such ideas, as well as considerations of form—beauty, harmony, fitness, and so forth. As a matter of fact, the design includes various elements that express function without actually performing it, such as the slender shafts (called responds) that seem to carry the weight of the vaults to the church floor.

But in order to know what concepts to convey, the medieval architect needed the guidance of ecclesiastical authority. At a minimum, such guidance might be a simple directive to follow some established model, but in the case of Suger, it amounted to a more active role. It seems that he began with one master builder at the west end but was disappointed in the results and had it torn down. This not only indicates Suger's participation in the design process but also confirms his position as the architect of St.-Denis in the medieval sense. Suger's views no doubt helped to determine his choice of a second master of Norman background to translate them into the kind of structure he wanted, not simply as a matter of design preference. This great artist must have been singularly responsive to the abbot's objectives. Together, they created the Gothic. We have seen this kind of close collaboration between patron and architect before: it existed between Djoser and Imhotep, Pericles and Phidias, just as it does today.

CONSTRUCTING ST.-DENIS. Fittingly enough, St.-Denis required marshaling the combined resources of Church and State. Building such a large church was a hugely expensive and complex undertaking. For example, Suger used stone from quarries near Pontoise for the ambulatory columns and lumber from the forest of Yveline for the roof; both had to be transported by land and river over considerable distances, a slow and costly process. The master builder in charge of construction probably employed several hundred stonemasons and two or three times that many laborers. He was aided by advances in technology spurred by warfare. Of particular importance were improved cranes powered by windlasses or treadwheels that used counterweights and double pulleys for greater efficiency. These were easily put up and taken down, allowing for lighter scaffolding suspended from the wall instead of resting on the ground. Such enhancements permitted the construction techniques illustrated in the border of figure 425, and were essential to the construction of the new rib vaults.

426. *(above)* Plan of Notre-Dame, Paris. 1163–c. 1250

427. *(right)* Nave and choir, Notre-Dame, Paris

428. *(below)* Notre-Dame (view from the southeast), Paris

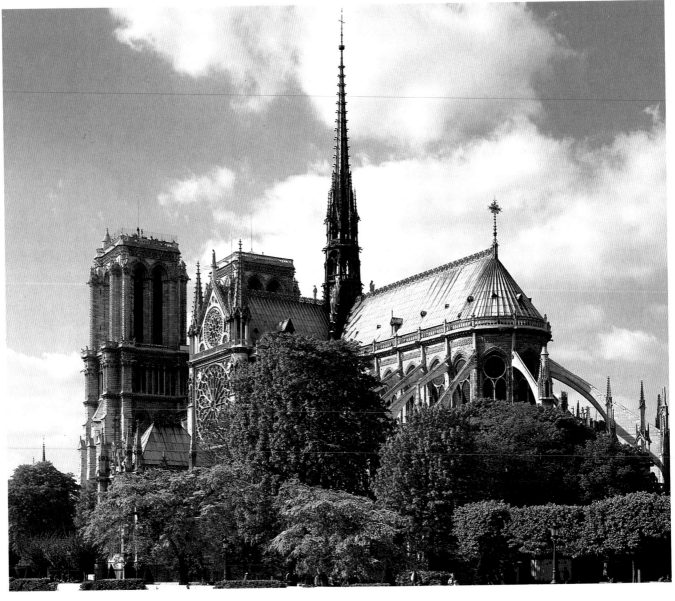

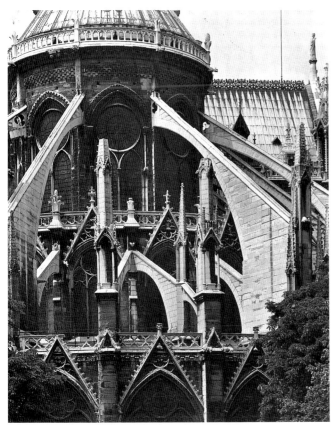

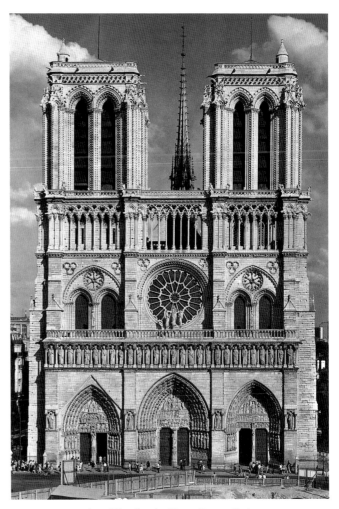

429. Flying arches and flying buttresses, Notre-Dame, Paris

430. West facade, Notre-Dame, Paris

NOTRE-DAME, PARIS. Although St.-Denis was an abbey, the future of Gothic architecture lay in the towns rather than in rural monastic communities. There had been a vigorous revival of urban life, we will recall, since the early eleventh century. This movement continued at an accelerated pace, and the growing weight of the cities made itself felt not only economically and politically but in countless other ways as well. Bishops and the city clergy rose to new importance. Cathedral schools and universities took the place of monasteries as centers of learning, while the artistic efforts of the age culminated in the great cathedral churches. (A cathedral is the seat of a bishopric, or see.)

Notre-Dame ("Our Lady," the Virgin Mary) at Paris, begun in 1163, reflects the salient features of Suger's St.-Denis more directly than does any other church (figs. 426–30). The plan (fig. 426), with its emphasis on the longitudinal axis, is extraordinarily compact and unified compared to that of major Romanesque churches. The double ambulatory of the choir continues directly into the aisles, and the stubby transept barely exceeds the width of the facade. The sexpartite nave vaults over squarish bays, although not identical with the "Siamese-twin" groin vaulting in Durham Cathedral (see fig. 388), continue the kind of structural experimentation that was begun by the Norman Romanesque.

Inside (fig. 427) we find other echoes of the Norman Romanesque: sexpartite nave vaults over squarish bays, and galleries above the inner aisles. The columns of the nave arcade are another conservative feature. Here, too, the use of pointed ribbed arches, which was pioneered in the western bays of the nave at Durham, has become systematic throughout the building. Yet the large clerestory windows and the lightness and slenderness of the forms create the weightless effect that we associate with Gothic interiors and make the nave walls seem thin. Gothic, too, is the verticality of the interior space. This depends less on the actual proportions of the nave—some Romanesque naves are equally tall relative to their width—than on the constant accenting of the verticals and on the soaring ease with which the sense of height is attained. Romanesque interiors (such as that in fig. 383), by contrast, emphasize the great effort required in supporting the weight of the vaults.

In Notre-Dame, as in Suger's choir, the buttresses (the "heavy bones" of the structural skeleton) are not visible from the inside. (The plan shows them as massive blocks of masonry that stick out from the building like a row of teeth.) Above the aisles, these piers turn into flying buttresses—arched bridges that reach upward to the critical spots between the clerestory windows where the outward thrust of the nave vault is concentrated (fig. 428). This method of anchoring vaults, a characteristic feature of Gothic architecture, certainly owed its origin to functional considerations. Even the flying buttress, however, soon became aesthetically important, and its shape could express support (apart from actually providing it) in a variety of ways, according to the designer's sense of style (fig. 429).

The most monumental aspect of the exterior of Notre-Dame is the west facade (fig. 430). Except for its sculpture,

As in ancient Greece, music and theater were intimately connected during the Middle Ages. Indeed, medieval theater was in large part a direct outgrowth of music. The only musical texts that survive from the Middle Ages before the late eleventh century are religious. Like Early Christian visual art, they bring together Roman, Greek, Jewish, and Syrian elements. Early medieval pieces, or chants, were in the form of plainsong, a single, unaccompanied line of melody in free rhythm. Plainsong continued many of the features of the ancient Greek modes (see pages 142–43), thanks mainly to the philosopher Boethius (c. 480–524), whose musical theories, set down around 500, were based on those of Pythagoras and other ancient Greek writers that are now mostly lost to us. By that time, however, Greek music was no longer a living tradition, having been modified by the Romans, so that it was adopted in altered form. One of the most important early medieval composers was Ambrose, a fourth-century bishop of Milan, who introduced an early variety of plainsong now known as Ambrosian chant. (He also converted the equally music-loving St. Augustine to Catholicism.) Over the next two centuries, Ambrosian chant was developed further, especially by the choir of the papal chapel in Rome. Around 600, Pope Gregory the Great (590–604) codified the Church's liturgy (the prescribed form for various worship services and other rites), including the music to be sung in each kind of service and the prayer hours to be observed by the monastic orders. The plainsong style in use in Rome at the time, which is still sung in many Catholic services, is popularly known as Gregorian chant.

At first, medieval chant was sung in unison, one word to a note, but gradually more notes were added for some syllables. Eventually some of these multinote passages were elaborated into long musical phrases (melismas), until there were so many notes for each word that additional, often unrelated, texts could be inserted into the work. These interpolated texts (tropes, from the Latin *tropus,* for "added melody") ultimately developed into medieval drama. The introduction of dramatic elements was also an outgrowth of the interplay between two choruses (antiphons), or between a soloist and a choir (responses).

The burgeoning complexity of medieval music stimulated the gradual evolution of music theory—an organized code of rules comparable to the grammar of a spoken language—that culminated in the thirteenth century, when a system for musical notation was perfected. The development of this body of theory may be compared to the gradual evolution of architectural principles during the Romanesque and Gothic eras, as musicians sought a comprehensive structure for their work. Of the many centers of chant, the most important was the Cathedral of Notre-Dame in Paris, where a new type of polyphonic music (music in parts), called organum, developed from the late ninth to the thirteenth century. Organum might have two or more voices, which sang the same words and melody a given interval apart, often with a plainsong underpinning (*cantus firmus*). During the late twelfth century, these pieces became so complex under Master Léonin and his pupil Master Pérotin, the first Western composers whose names and works we know, that around 1200 each voice was assigned its own text and melodic line. The resulting multivoiced composition, sometimes with instrumental accompaniment, was called a motet (from French *mot,* "word"). The motet was such an appealing form that it was quickly secularized, when vernacular verses, chiefly love poems, were substituted for religious texts.

Like Gothic architecture, the Notre-Dame style quickly spread throughout Europe, and lasted until about 1400. It was gradually replaced after 1325 by a new musical style, called *ars nova* (new art), which featured polyphony of ever-greater complexity and subtlety, especially in its elaborate rhythms. Despite its name, *ars nova*, like the Gothic paintings of Giotto, remained rooted in the past while looking to the future. The greatest exponent of *ars nova* was Guillaume de Machaut (c. 1300–1377), a cleric who served the kings of Bohemia and France and was also considered the finest poet of his day. A perfect blend of religious and secular talents characteristic of the Gothic era as a whole, Guillaume de Machaut represented a new figure in European culture: the professional composer. During the twelfth and thirteenth centuries, courtly music had been composed by aristocratic amateurs (called *trouvères,* troubadours, or *Minnesingers*) who wrote songs chiefly on the theme of courtly love, but often left the actual performance to minstrels, or *jongleurs.* Because of its sophistication, however, *ars nova* increasingly required professional musicians to compose and play it. In its elaboration, *ars nova* paralleled the complexly ornamented late phase of Gothic architecture. It may also be seen as a musical counterpart to late medieval Scholasticism, which presented an equally complex blend of theology and philosophy.

which suffered heavily during the French Revolution and is for the most part restored, it retains its original appearance. The design reflects the general disposition of the facade of St.-Denis, which in turn had been derived from Norman Romanesque facades such as that of St.-Étienne at Caen (see fig. 387). Comparing the latter with Notre-Dame, we note the persistence of some basic features: the pier buttresses that reinforce the corners of the towers and divide the facade into three main parts, the placing of the portals, and the three-story arrangement. The rich sculptural decoration, however, recalls the facades of western France (see fig. 386) and the elaborately carved portals of Burgundy, such as that at Vézelay.

Much more important than these resemblances are the qualities that distinguish the facade of Notre-Dame from its Romanesque ancestors. Foremost among these is the way all the details have been integrated into a wonderfully balanced and coherent whole. The meaning of Suger's emphasis on harmony, geometric order, and proportion becomes evident here even more strikingly than in St.-Denis itself. This formal discipline also embraces the sculpture, which is no longer permitted the spontaneous (and often uncontrolled) growth so characteristic of the Romanesque but has been assigned a pre-

Because of its pagan associations, theater was regarded as disreputable by early Christianity, and actors were forbidden to become members of the Church or to receive the sacraments, although Theodora, the wife of the Byzantine emperor Justinian, was a mime actress. Gradually, however, theater became associated with the great religious feasts, such as Christmas and Easter, although it, too, came eventually to rely on vernacular texts. Liturgical drama flourished at many of the same monasteries and churches that contributed to the development of medieval art and music, such as St. Gall in Switzerland. Not surprisingly, theater and music shared many of the same subjects, such as the Passion cycle. The close affiliation between them is illustrated by the career of such composer-playwrights as Hildegard of Bingen (see box page 316). Another link of the two performing arts to religious life was architectural: music and drama were presented exclusively inside churches before 1200. Religious plays, acted by the priests and choirboys, often involved intricate self-contained architectural sets called mansions. In the early thirteenth century, performances became so elaborate and independent that they were moved outdoors to the churchyards, where they were taken over by civic institutions. At the same time, secular plays and farces illustrating moral lessons began to develop out of religious drama.

During the late Middle Ages, theater flourished as towns grew prosperous and the major guilds began to shoulder the costs of staging religious pageants. The dramas best known today—such as the vast Corpus Christi cycle performed at York, England, the great Passion plays, and morality plays like *Everyman*—date from the fourteenth century and later. These were community affairs, mounted in town squares, in which guild members assumed all the roles, so that there was no clear distinction between religious and popular theater. The medieval tradition of music and theater continued well into the Renaissance, especially in the North. It was epitomized by Hans Sachs (1494–1576), the head of the shoemakers' guild in Nuremberg. A master singer and composer immortalized by Richard Wagner in his nineteenth-century German opera *Der Meistersinger*, Sachs wrote thousands of songs, fables, verses, religious plays, and secular farces.

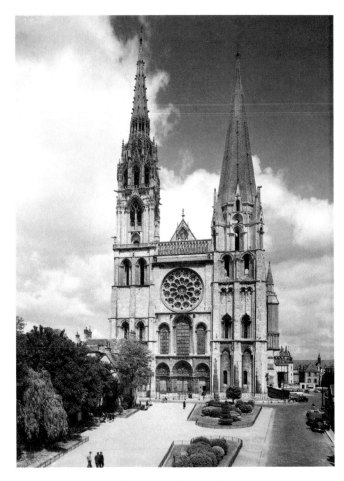

431. West facade, Chartres Cathedral
(north spire is from 16th century). 1145–1220

cisely defined role within the architectural framework. At the same time, the cubic solidity of the facade of St.-Étienne at Caen has been transformed into its very opposite. Lacelike arcades, huge portals and windows, dissolve the continuity of the wall surfaces, so that the total effect approximates that of a weightless openwork screen. How rapidly this tendency advanced during the first half of the thirteenth century can be seen by comparing the west front of Notre-Dame with the somewhat later facade of the south transept, visible in the center of figure 428. In the west facade, the rose window in the center is still deeply recessed and, as a result, the stone tracery

that subdivides the opening is clearly set off against the surrounding wall surface. On the transept facade, in contrast, we can no longer distinguish the rose window from its frame, as a single network of tracery covers the entire area.

CHARTRES CATHEDRAL. Toward 1145 the bishop of Chartres, who befriended Abbot Suger and shared his ideas, began to rebuild his cathedral in the new style. [See Primary Sources, no. 35, page 389.] Fifty years later, all but the west facade, which provided the main entrance to the church, and the east crypt were destroyed by a fire (for sculpture of the west portals, see figs. 466 and 467). A second rebuilding was begun in 1194 (fig. 431), and as the result of a huge campaign was largely accomplished within the astonishingly brief span of 26 years. The basic design is so unified that it must have been planned by a single master builder. However, because the construction proceeded in several stages and was never entirely finished, the church incorporates an evolutionary, rather than a systematic, harmony. For example, the two west towers, though similar, are by no means identical. Moreover, their spires are radically different: the north spire on the left dates from the early sixteenth century, nearly 300 years later than the other.

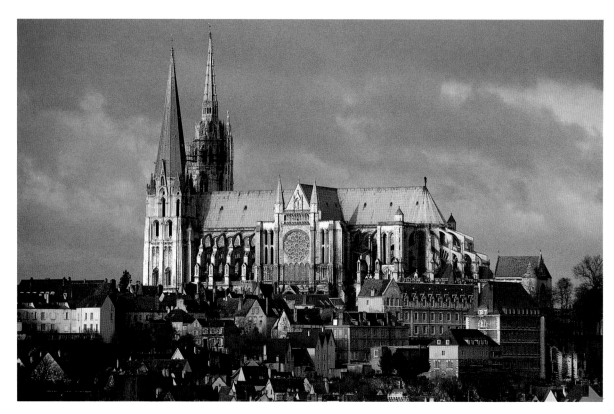

432. Chartres Cathedral

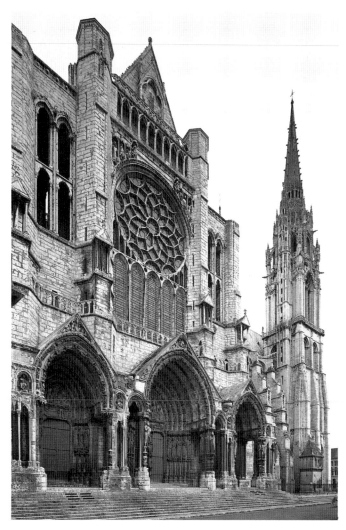

433. Portals, north transept, Chartres Cathedral (see also fig. 469)

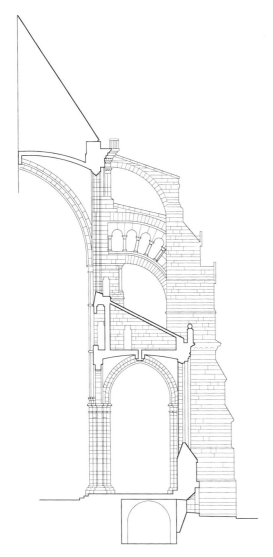

434. Transverse section of Chartres Cathedral (after Acland)

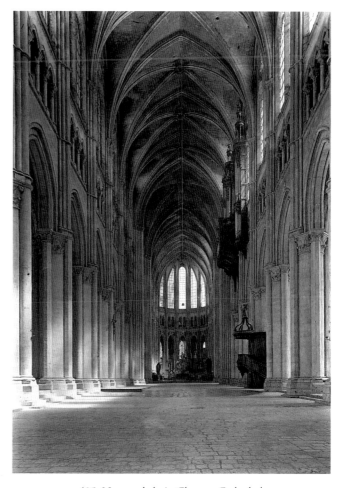

435. Nave and choir, Chartres Cathedral

The church was erected on the highest point in town and the spires can be seen for miles in the surrounding farmland (fig. 432). Had the seven other spires been completed as originally planned, Chartres would convey a less insistent directionality. Both arms of the transept have three deeply recessed portals lavishly embellished with sculpture and surmounted by an immense rose window over five smaller lancets (fig. 433). Perhaps the most striking feature of the flanks is the flying buttresses, whose massing lends a powerfully organic presence to the semicircular apse at the east end, with its seven subsidiary chapels (figs. 432 and 434).

The impressive west facade, divided into units of two and three, is a model of lucidity. Its soaring verticality and punctuated surface are important in shaping our expectations about the interior. The shape of the doors tells us that we will first be ushered into a low chamber. As soon as we enter the narthex (the covered anteroom) we have left the temporal world completely behind. It takes some time for our eyes to adjust to the darkness of the interior. The noise of daily life has been shut out as well; at first, sounds are eerily muffled, as if

swallowed up with light by the void. Once we recover from the disorienting effect of this cavernous realm, we become aware of a glimmering light, which guides us into the full height of the church.

Conceived one generation after the nave of Notre-Dame in Paris, the rebuilt nave (fig. 435) represents the first masterpiece of the mature, or High Gothic, style. The openings of the pointed nave arcade are taller and narrower (see fig. 427). They are joined to a clerestory of the same height by a short triforium screening the galleries, which have now been reduced to a narrow wall. Responds have been added to the columnar supports to stress the continuity of the vertical lines and guide our eye upward to the quadripartite vaults, which appear as diaphanous webs stretched across the slender ribs. Because there are so few walls, the vast interior space of Chartres Cathedral initially seems indeterminate. It is made to seem even larger by the sense of disembodied sound. The effect is so striking that it may well have been thought of from the beginning with music in mind, both antiphonal choirs and large pipe organs, which

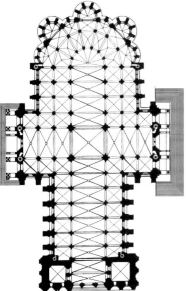

436. Plan, Chartres Cathedral

437. Triforium wall of the nave, Chartres Cathedral

had already been in use for more than two centuries in some parts of Europe.

The alternating sequence of round and octagonal piers that demark each bay extends down the nave toward the apse, where the liturgy is performed. Beneath the apse is the crypt, which houses Chartres' most important possession: remnants of the robe said to have been worn by the Virgin Mary, to whom the cathedral is dedicated. The venerable relic, which miraculously survived the great fire of 1194, drew pilgrims from all over Europe. In order to accommodate large numbers of visitors without disturbing worshipers, the church incorporates a wide aisle running the length of the nave and around the transept; it is joined at the choir by a second aisle, forming an ambulatory that connects the apsidal chapels (see plan, fig. 436).

Alone among all major Gothic cathedrals, Chartres still retains most of its more than 180 original stained-glass windows (see fig. 494). The magic of the colored light streaming down from the clerestory through the large windows is unforgettable to anyone who has experienced their intense, jewellike hues (fig. 437). The windows admit far less light than one might expect. They act mainly as multicolored dif-

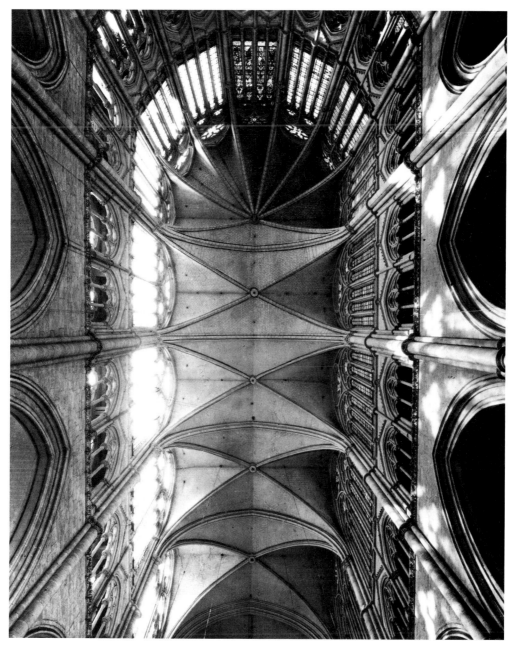

438. Choir vault, Amiens Cathedral. Begun 1220

fusing filters that change the quality of ordinary daylight, endowing it with the poetic and symbolic values—the "miraculous light"—so highly praised by Abbot Suger. The sensation of ethereal light, which dissolves the physical solidity of the church and, hence, the distinction between the temporal and the divine realms, creates the intensely mystical experience that lies at the heart of Gothic spirituality. The aisles, however, are considerably darker because the stained-glass windows on the outer walls, though relatively large, are nevertheless smaller and located at ground level, where they let in less light than at the clerestory level.

AMIENS CATHEDRAL. The High Gothic style defined at Chartres reaches its climax a generation later in the interior of Amiens Cathedral (figs. 438 and 439). Breathtaking height becomes the dominant aim, both technically and aesthetically (see fig. 440). The relatively swift progression toward verticality in French Gothic cathedral architecture is clearly seen in figure 442, while figure 443 shows how both height and large expanses of window were achieved. At Amiens, skeletal construction is carried to its most precarious limits. The inner logic of the system forcefully asserts itself in the shape of the vaults, taut and thin as membranes, and in the expanded

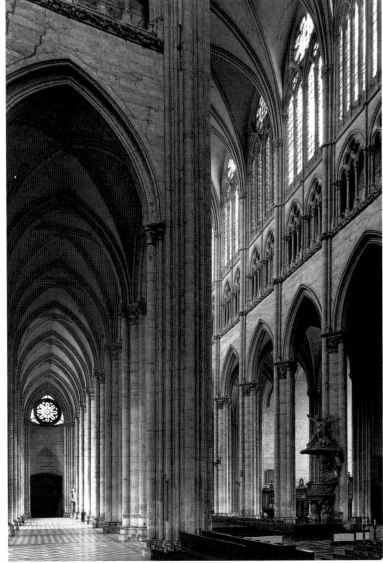

439. Nave and side aisle, Amiens Cathedral

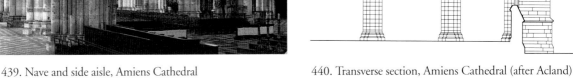

440. Transverse section, Amiens Cathedral (after Acland)

window area, which now includes the triforium so that the entire wall above the nave arcade becomes a clerestory.

REIMS CATHEDRAL. The same emphasis on verticality and translucency can be traced in the development of the High Gothic facade. The most famous of these, at Reims Cathedral (fig. 441), makes an instructive contrast with the west facade of Notre-Dame in Paris, even though its basic design was conceived only about 30 years later. Many elements are common to both (as the Coronation Cathedral of the kings of France, Reims was closely linked to Paris), but in the later structure they have been reshaped into a very different ensemble. The portals, instead of being recessed, are projected forward as gabled porches, with windows in place of tympanums above the doorways. The gallery of royal statues, which in Paris forms an incisive horizontal band between the first and second stories, has been raised until it merges with the third-story arcade. Every detail except the rose window has become taller and narrower than before. A multitude of pinnacles further accentuates the restless upward-pointing move-

ment. The sculptural decoration, by far the most lavish of its kind (see figs. 471 and 472), no longer remains in clearly marked-off zones. It has now spread to so many hitherto unaccustomed perches, not only on the facade but on the flanks as well, that the exterior of the cathedral begins to look like a dovecote for statues.

LATER THIRTEENTH-CENTURY GOTHIC. The High Gothic cathedrals of France represent a concentrated expenditure of effort such as the world has rarely seen before or since. They are truly national monuments, whose immense cost was borne by donations collected all over the country and from all classes of society—the tangible expression of that merging of religious and patriotic fervor that had been the goal of Abbot Suger. As we approach the second half of the thirteenth century, we sense that this wave of enthusiasm has passed its crest. Work on the vast structures begun during the first half now proceeds at a slower pace. New projects are fewer and generally on a far less ambitious scale. Lastly, the highly organized teams of masons and sculptors that had developed at the sites

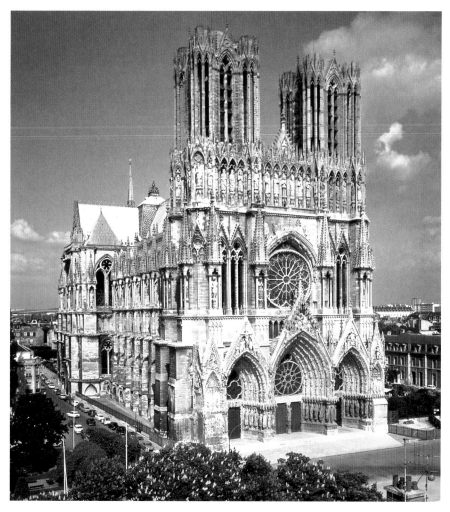

441. West facade, Reims Cathedral. c. 1225–99

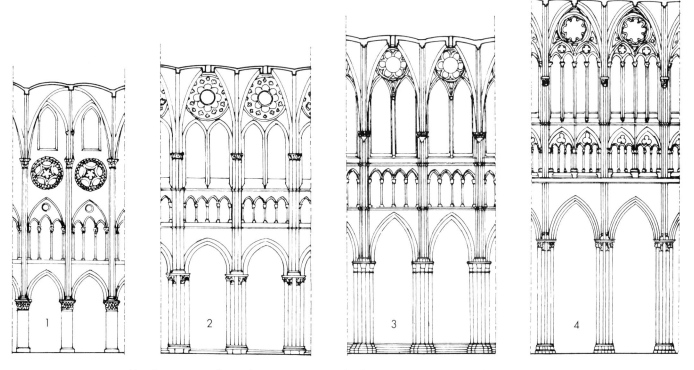

442. Comparison of nave elevations in same scale. 1) Notre-Dame, Paris; 2) Chartres Cathedral;
3) Reims Cathedral; 4) Amiens Cathedral (after Grodecki)

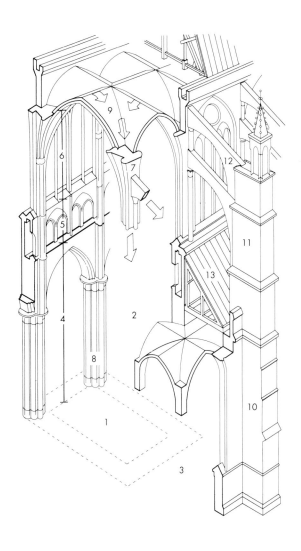

443. *(left)* Axonometric projection of a High Gothic cathedral (after Acland). 1) Bay; 2) Nave; 3) Side aisle; 4) Nave arcade; 5) Triforium; 6) Clerestory; 7) Pier; 8) Compound pier; 9) Sexpartite vault; 10) Buttress; 11) Flying buttress; 12) Flying arch; 13) Roof

of the great cathedrals during the preceding decades gradually break up into smaller units.

A characteristic church of the later years of the century, St.-Urbain in Troyes (figs. 444 and 445), leaves no doubt that the heroic age of the Gothic style is past. Refinement of detail, rather than towering monumentality, has become the chief concern. By eliminating the triforium and simplifying the plan, the designer has created a delicate glass cage (the choir windows begin ten feet above the floor), sustained by flying buttresses so thin as to be hardly noticeable. The same spiny, attenuated elegance can be felt in the architectural ornament.

FLAMBOYANT GOTHIC. In some respects, St.-Urbain is prophetic of the Late, or Flamboyant, phase of Gothic architecture. The beginnings of Flamboyant Gothic do indeed seem to go back to the late thirteenth century, but its growth was delayed by the Hundred Years' War (1338–1453) with England, so that we do not meet any full-fledged examples of it until the early fifteenth. Its name, which means flamelike, refers to the undulating patterns of curve and countercurve that are a prevalent feature of Late Gothic tracery, as at St.-Maclou in Rouen (fig. 446). Structurally, Flamboyant Gothic shows no significant developments of its own. What distinguishes St.-Maclou from such churches as St.-Urbain in

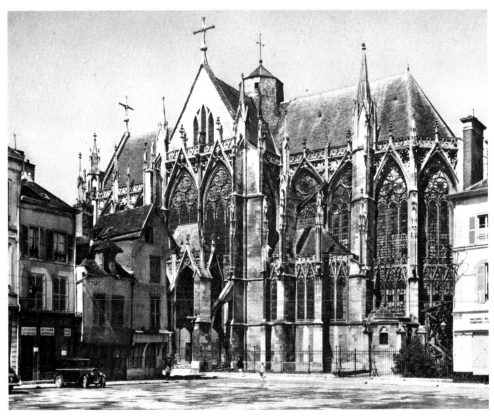

444. St.-Urbain, Troyes, France. 1261–75

Troyes is the luxuriant profusion of ornament. The architect has turned into a virtuoso who overlays the structural skeleton with a web of decoration so dense and fanciful as to obscure it almost completely. It becomes a fascinating game of hide-and-seek to locate the "bones" of the building within this picturesque tangle of lines.

SECULAR ARCHITECTURE. Since our account of medieval architecture is mainly concerned with the development of style, we have until now confined our attention to religious structures, the most ambitious as well as the most representative efforts of the age. Secular building reflects the same general trends, but these are often obscured by the diversity of types, ranging from bridges and fortifications to royal palaces, from barns to town halls. Moreover, social, economic, and practical factors play a more important part here than in church design, so that the useful life of the buildings is apt to be much briefer and their chance of preservation correspondingly less. (Fortifications, indeed, are often made obsolete by even minor advances in the technology of warfare.) As a consequence, our knowledge of secular structures of the pre-Gothic Middle Ages remains extremely fragmentary, and most of the surviving examples from Gothic times belong to the latter half of the period. This fact, however, is not without significance. Nonreligious architecture, both private and public, became far more elaborate during the fourteenth and fifteenth centuries than it had been before.

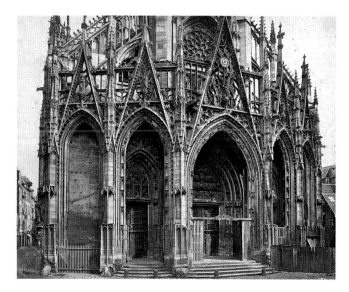

446. St.-Maclou, Rouen, France. Begun 1434

The history of the Louvre in Paris provides a telling example. The original building, erected about 1200, followed the severely functional plan of the castles of that time. It consisted mainly of a stout tower, the donjon or keep, surrounded by a heavy wall. In the 1360s, King Charles V had it built as a sumptuous royal residence. Although this second Louvre, too, has now disappeared, we know what it looked like from a fine miniature painted in the early fifteenth century (see fig. 522).

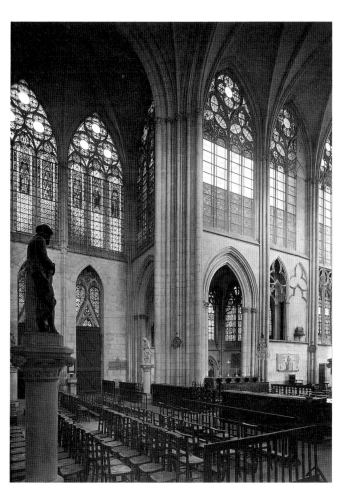

445. Interior toward northeast, St.-Urbain

447. Court, House of Jacques Coeur, Bourges, France. 1443–51

There is still a defensive outer wall, but the great structure behind it has far more the character of a palace than of a fortress. Symmetrically laid out around a square court, it provided comfortable quarters for the royal family and household (note the countless chimneys) as well as lavishly decorated halls for state occasions.

If the exterior of the second Louvre still has some of the forbidding qualities of a stronghold, the sides toward the court displayed a wealth of architectural ornament and sculpture. The same contrast also appears in the house of Jacques Coeur in Bourges, built in the 1440s. We speak of it as a house, not a palace, only because Jacques Coeur was a silversmith and merchant, rather than a nobleman. Since he also was one of the richest men of his day, he could well afford an establishment obviously modeled on the mansions of the aristocracy. The courtyard (fig. 447), with its high-pitched roofs, its pinnacles and decorative carvings, suggests the picturesque qualities familiar to us from Flamboyant church architecture (fig. 446). That we should find an echo of the Louvre court in a merchant's residence is striking proof of the importance attained by the urban middle class during the later Middle Ages.

England

Among the astonishing things about Gothic art is the enthusiastic response this "royal French style of the Paris region" evoked abroad. Even more remarkable was its ability to acclimate itself to a variety of local conditions—so much so, in fact, that the Gothic monuments of England and Germany have become objects of intense national pride in modern times, and critics in both countries have acclaimed Gothic as a peculiarly native style. A number of factors contributed to the rapid spread of Gothic art: the superior skill of French architects and stone carvers; the great intellectual prestige of French centers of learning, such as the Cathedral School of Chartres and the University of Paris; and the influence of the Cistercians, the reformed monastic order energized by St. Bernard of Clairvaux. In conformity with his ascetic ideals, Cistercian abbey churches were of a distinctive, severe type. Decoration of any sort was held to a minimum, and a square choir took the place of apse, ambulatory, and radiating chapels. For that very reason, however, Cistercian architects put special emphasis on harmonious proportions and exact craftsmanship. Their "anti-Romanesque" outlook also prompted them to adopt certain basic features of the Gothic style, even though Cistercian churches remained strongly Romanesque in appearance. During the latter half of the twelfth century, as the reform movement gathered momentum, this austere Cistercian Gothic came to be known throughout western Europe.

Still, one wonders whether any of the explanations we have mentioned really go to the heart of the matter. The ultimate reason for the international victory of Gothic art seems to have been the extraordinary persuasive power of the style itself, its ability to kindle the imagination and to arouse religious feeling even among people far removed from the cultural climate of the Île-de-France.

That England should have proved particularly receptive to the new style is hardly surprising. Yet English Gothic did not grow directly from Anglo-Norman Romanesque but rather from the Gothic of the Île-de-France, which was introduced in 1175 by the French architect who rebuilt the choir of Canterbury Cathedral, and from that of the Cistercians. Within less than 50 years, it developed a well-defined character of its own, known as the Early English style, which dominated the second quarter of the thirteenth century. Although there was a great deal of building activity during those decades, it consisted mostly of additions to Anglo-Norman structures. Many English cathedrals had been begun about the same time as Durham (see figs. 388–90) but remained unfinished. They were now completed or enlarged. As a consequence, we find few churches that are designed in the Early English style throughout.

SALISBURY CATHEDRAL. Among cathedrals, only Salisbury meets this requirement (figs. 448–50). We realize immediately how different the exterior is from its counterparts in France—and how futile it would be to judge it by French Gothic standards. Compactness and verticality have given way to a long, low, sprawling look. (The great crossing tower, which provides a dramatic unifying accent, was built a century later than the rest and is much taller than originally planned.) Since there is no straining after height, flying buttresses have been introduced only as an afterthought. The west facade has become a screen wall, wider than the church itself and stratified by emphatic horizontal bands of ornament and statuary, while the towers have shrunk to stubby turrets. The plan, with its strongly projecting double transept, retains the segmented quality of Romanesque structures, but the square east end derives from Cistercian architecture.

As we enter the nave, we recognize the same elements familiar to us from French interiors of the time, such as Chartres (see fig. 435), but the English interpretation of these elements produces a very different total effect. As on the facade, the horizontal divisions are stressed at the expense of the vertical, so that we see the nave wall not as a succession of bays but as a continuous series of arches and supports. These supports, carved of dark marble, stand out against the rest of the interior. This method of stressing their special function is one of the hallmarks of the Early English style. Another insular feature is the steep curve of the nave vault. The ribs ascend all the way from the triforium level. As a result, the clerestory gives the impression of being tucked away among the vaults. At Durham, more than a century earlier, the same treatment had been a technical necessity (compare fig. 390). Now it has become a matter of style, thoroughly in keeping with the character of English Early Gothic as a whole. This character might be described as conservative in the positive sense. It accepts the French system but tones down its revolutionary aspects so as to maintain a strong sense of continuity with the Anglo-Norman past.

PERPENDICULAR STYLE. The contrast between the bold upward thrust of the crossing tower and the leisurely horizontal progression throughout the rest of Salisbury Cathedral suggests that English Gothic had developed in a new direction during the intervening hundred years. The change becomes very evident if we compare the interior of Salisbury with the choir of Gloucester Cathedral, built in the second quarter of the next century (fig. 451). This is a striking example of

449. Plan of Salisbury Cathedral

450. Nave and choir, Salisbury Cathedral

451. (right) Choir, Gloucester Cathedral, England. 1332–57

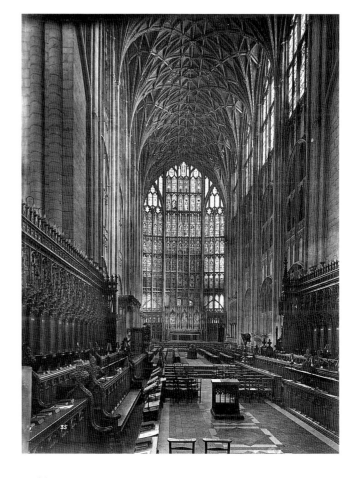

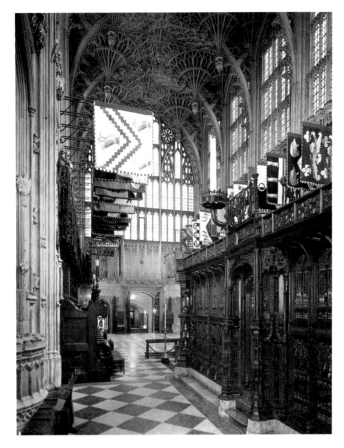

452. Chapel of Henry VII (view toward west), Westminster Abbey, London. 1503–19

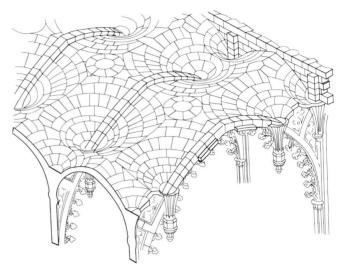

453. Diagram of vault construction, Chapel of Henry VII, Westminster Abbey (after Swaan)

English Late Gothic, also called "Perpendicular." The name certainly fits, since we now find the dominant vertical accent that is so conspicuously absent in the Early English style. (Note the responds running in an unbroken line from the vault to the floor.) In this respect Perpendicular Gothic is much more akin to French sources, yet it includes so many features we have come to know as English that it would look very much out of place on the Continent. The repetition of small uniform tracery panels recalls the bands of statuary on the west facade at Salisbury. The plan simulates the square east end of earlier English churches. And the upward curve of the vault is as steep as in the nave of Salisbury.

The ribs of the vaults, on the other hand, have assumed an altogether new role. They have been multiplied until they form an ornamental network that screens the boundaries between the bays and thus makes the entire vault look like one continuous surface. This, in turn, has the effect of emphasizing the unity of the interior space. Such decorative elaboration of the "classic" quadripartite vault is characteristic of the so-called Flamboyant style on the Continent as well, but the English started it earlier and carried it to greater lengths. The ultimate is reached in the amazing pendant vault of Henry VII's Chapel at Westminster Abbey, built in the early years of the sixteenth century (figs. 452 and 453), with its lanternlike knobs hanging from conical "fans." This fantastic scheme merges ribs and tracery patterns in a dazzling display of architectural pageantry.

Germany

In Germany, Gothic architecture took root a good deal more slowly than in England. Until the mid-thirteenth century, the

Romanesque tradition, with its persistent Ottonian reminiscences, remained dominant, despite the growing acceptance of Early Gothic features. From about 1250 on, however, the High Gothic of the Île-de-France had a strong impact on the Rhineland. Cologne Cathedral (begun in 1248) represents an ambitious attempt to carry the full-fledged French system beyond the stage of Amiens. Significantly enough, however, the building remained a fragment until it was finally completed in modern times. Nor did it have any successors.

HALL CHURCHES. Far more characteristic of German Gothic is the development of the hall church, or *Hallenkirche*. Such churches, with aisles and nave of the same height, are familiar to us from Romanesque architecture (see fig. 385). For reasons not yet well understood, the type found particular favor on German soil, where its artistic possibilities were very fully explored. The large hall choir added between 1361 and 1372 to the church of St. Sebald in Nuremberg (fig. 454) is one of many fine examples from central Germany. The space here has a fluidity and expansiveness that enfold us as if we were standing under a huge canopy. There is no pressure, no directional command to prescribe our path. And the unbroken lines of the pillars, formed by bundles of shafts which gradually diverge as they turn into ribs, seem to echo the continuous movement that we feel in the space itself.

Italy

Italian Gothic architecture stands apart from that of the rest of Europe. Judged by the formal criteria of the Île-de-France, most of it hardly deserves to be called Gothic at all. Yet the

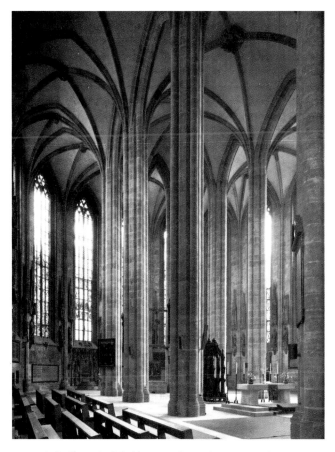

454. Choir, St. Sebald, Nuremberg, Germany. 1361–72

Gothic in Italy produced structures of singular beauty and impressiveness that cannot be understood as continuations of the local Romanesque. We must be careful, therefore, to avoid too rigid or technical a standard in approaching these monuments, lest we fail to do justice to their unique blend of Gothic qualities and Mediterranean tradition. It was the Cistercians, rather than the cathedral builders of the Île-de-France, who provided the chief exemplars on which Italian architects based their conception of the Gothic style. As early as the end of the twelfth century, Cistercian abbeys sprang up in both northern and central Italy, their designs patterned directly after those of the French abbeys of the order.

ABBEY CHURCH, FOSSANOVA. One of the finest buildings, at Fossanova, some 60 miles south of Rome, was consecrated in 1208 (figs. 455 and 456). Without knowing its location, we would be hard put to decide where to place it on a map—it might as well be Burgundian or English. The plan looks like a simplified version of Salisbury, and the finely proportioned interior bears a strong family resemblance to all Cistercian abbeys of the Romanesque and Gothic eras. There are no facade towers, only a lantern over the crossing, as befits the Cistercian ideal of austerity prescribed by the order's founder, St. Bernard of Clairvaux. The groin vaults, while based on the pointed arch, have no diagonal ribs; the windows are small; and the architectural detail retains a good deal of Romanesque solidity. Nevertheless, the flavor of the whole is unmistakably Gothic.

Churches such as the one at Fossanova made a deep impression upon the Franciscans, the monastic order founded by St. Francis of Assisi in the early thirteenth century. As mendicant friars dedicated to poverty, simplicity, and humility, they were the spiritual kin of St. Bernard, and the severe beauty of Cistercian Gothic must have seemed to them to express an ideal closely related to theirs. Thus, their churches from the first reflected Cistercian influence and played a leading role in establishing Gothic architecture in Italy.

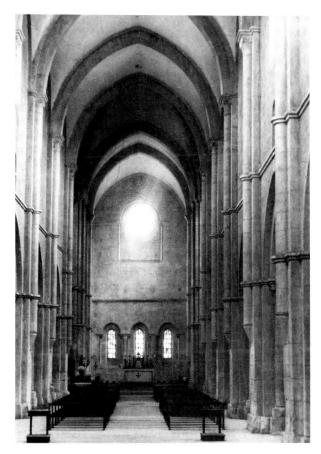

455. Nave and choir, Abbey Church of Fossanova, Italy.
Consecrated 1208

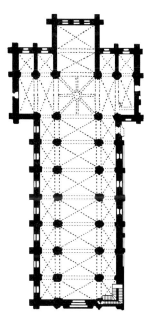

456. Plan of the Abbey Church of Fossanova

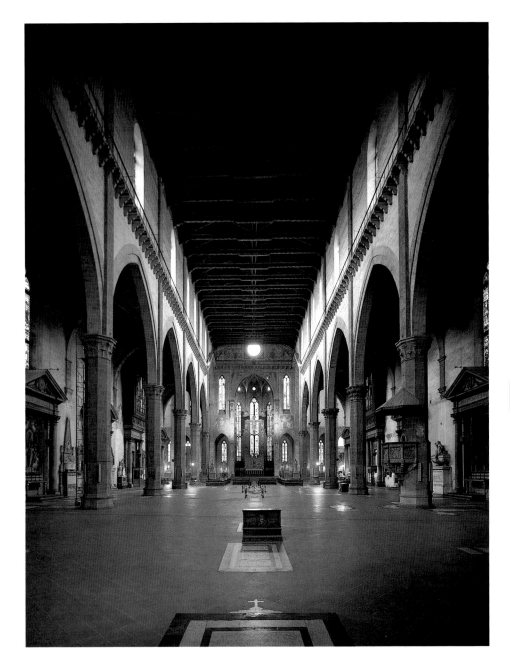

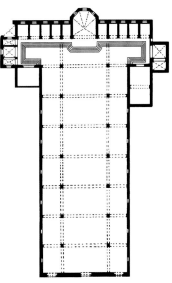

457. *(left)* Nave and choir, Sta. Croce, Florence. Begun c. 1295

458. Plan of Sta. Croce

STA. CROCE, FLORENCE. Sta. Croce in Florence, begun about a century after Fossanova, may well claim to be the greatest of all Franciscan structures (figs. 457 and 458). It is also a masterpiece of Gothic architecture, even though it has wooden ceilings instead of groin vaults, except in the choir. There can be no doubt that this was a matter of deliberate choice, rather than of technical or economic necessity. The choice was made not simply on the basis of local practice. (Wooden ceilings, we will recall, were a feature of the Tuscan Romanesque.) It also sprang perhaps from a desire to evoke the simplicity of Early Christian basilicas and, in doing so, to link Franciscan poverty with the traditions of the early Church. The plan, too, combines Cistercian and Early Christian features. We note, however, that it shows no trace of the Gothic structural system, except for the groin-vaulted apse. Hence, in contrast to Fossanova, there are no longer any buttresses, since the wooden ceilings do not require them. The walls thus remain intact as continuous surfaces. Indeed, Sta. Croce owes part of its fame to its wonderful murals. (Some of

these are visible on the transept and apse in our illustration.)

Why, then, do we speak of Sta. Croce as Gothic? Surely the use of the pointed arch is not sufficient to justify the term. A glance at the interior will dispel our misgivings, for we sense immediately that this space creates an effect fundamentally different from that of either Early Christian or Romanesque architecture. The nave walls have the weightless, "transparent" quality we saw in Northern Gothic churches, and the dramatic massing of windows at the eastern end conveys the dominant role of light as forcefully as Abbot Suger's choir at St.-Denis. Judged in terms of its emotional impact, Sta. Croce is Gothic beyond doubt. It is also profoundly Franciscan—and Florentine—in the monumental simplicity of the means by which this impact has been achieved.

FLORENCE CATHEDRAL. If in Sta. Croce the architect's main concern was an impressive interior, Florence Cathedral was planned as a monumental landmark to civic pride towering above the entire city (figs. 459 and 460). The original

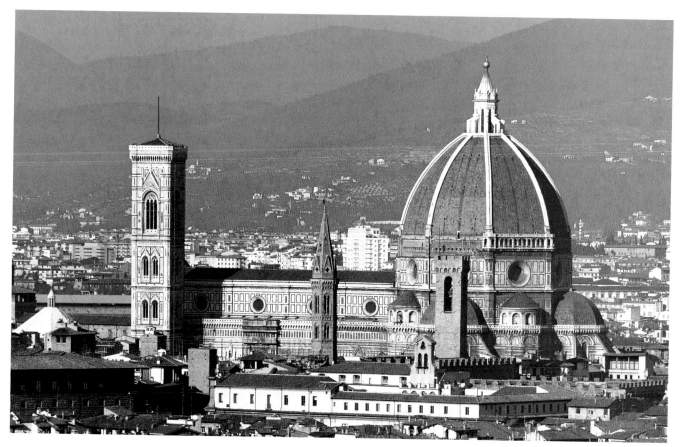

459. Florence Cathedral (Sta. Maria del Fiore). Begun by Arnolfo di Cambio, 1296; dome by Filippo Brunelleschi, 1420–36

460. Plan of Florence Cathedral and Campanile

461. Nave and choir, Florence Cathedral

design, by the sculptor Arnolfo di Cambio (c. 1245–c. 1310), which dates from 1296, a little after Sta. Croce was begun, is not known in detail. Although somewhat smaller than the present building, it probably showed the same basic plan. The building as we know it is based largely on a design by Francesco Talenti, who took over about 1343. The most striking feature is the great octagonal dome with its subsidiary half-domes, a motif ultimately of late Roman origin (see figs. 247, 248, and 303–5). It may have been thought of at first as an oversize dome above the crossing of nave and transept, but it soon grew into a huge central pool of space that makes the nave look like an afterthought. The basic characteristics of the dome were set by a committee of leading painters and sculptors in 1367. The actual construction, however, belongs to the early fifteenth century.

Apart from the windows and the doorways, there is nothing Gothic about the exterior of Florence Cathedral. (Flying buttresses to sustain the nave vault may have been planned but proved unnecessary.) The solid walls, encrusted with geometric marble inlays, are a perfect match for the Romanesque Baptistery nearby (see fig. 399). The interior, on the other hand, recalls Sta. Croce, even though the dominant impression is one of chill solemnity rather than lightness and grace. The ribbed groin vault of the nave rests directly on the nave arcade, producing an emphasis on width instead of height, and the architectural detail has a massive solidity that seems more Romanesque than Gothic (fig. 461). Thus the unvaulted interior of Sta. Croce reflects the spirit of the new style more faithfully than does the Cathedral, which,

462. *(left)* Bernardino Poccetti. Drawing of Arnolfo di Cambio's unfinished design for the facade of Florence Cathedral. c. 1587. Museo dell'Opera di S. Maria del Fiore, Florence

on the basis of its structural system, ought to be the more Gothic of the two.

Typical of Italy, a separate campanile takes the place of the facade towers familiar to us in Northern Gothic churches. It was begun by the great painter Giotto (see pages 365–70), who managed to finish only the first story, and continued by the sculptor Andrea Pisano (see page 358), who was responsible for the niche zone. The rest represents the work of Talenti, who completed it by about 1360.

The west facade, so dramatic a feature in French cathedrals, never achieved the same importance in Italy. It is remarkable how few Italian Gothic facades were ever carried to completion before the onset of the Renaissance. Those of Sta. Croce and Florence Cathedral both date from the nineteenth century. Fortunately, Arnolfo's design for the latter is preserved in a drawing made by Bernardino Poccetti just before being demolished in 1587 (fig. 462). Only the bottom half of the decorations is shown in detail, but it provides us with a clear idea of what an Italian Gothic facade would

463. Milan Cathedral (apse). Begun 1386

464. Palazzo Vecchio, Florence. Begun 1298

465. Ca' d'Oro, Venice. 1422–c. 1440

have looked like, though it is not without later alterations. Arnolfo devised an ornate scheme of pilasters and niches with sculptures to articulate the surface, which was further embellished by mosaics. The over-all effect must have been a dazzling fusion of sculpture and architecture, classical severity, and Gothic splendor.

MILAN CATHEDRAL. Work on Italian Gothic churches often continued for hundreds of years. Such was the case with Milan Cathedral, by far the largest Gothic church on Italian soil as well as the one most nearly comparable to Northern structures. Begun in 1386, it was completed only in 1910. Its structural design was the subject of a famous dispute between the local architects and consulting experts from France and Germany. Only the apse, begun first, retains the original flavor of the building, which belongs to the late, Flamboyant phase of Gothic architecture (fig. 463). Otherwise the decoration strikes us as an overly elaborate piling up of detail applied in mechanical fashion over the centuries without any unity of feeling.

SECULAR ARCHITECTURE. The secular buildings of Gothic Italy convey as distinct a local flavor as the churches. There is nothing in the cities of northern Europe to match the impressive grimness of the Palazzo Vecchio (fig. 464), the town hall of Florence. Fortresslike structures such as this reflect the factional strife among political parties, social classes, and prominent families so characteristic of life within the Italian city-states. The wealthy man's home (or *palazzo*, a term denoting any large urban house) was quite literally his castle, designed both to withstand armed assault and to proclaim the owner's importance. The Palazzo Vecchio, while larger and more elaborate than any private house, follows the same pattern. Behind its battlemented walls, the city government could feel well protected from the wrath of angry crowds. The tall tower not only symbolizes civic pride but has an eminently practical purpose: dominating the city as well as the surrounding countryside, it served as a lookout against enemies from without or within.

Among Italian cities Venice alone was ruled by a merchant aristocracy so firmly established that internal disturbances were the exception rather than the rule. As a consequence, Venetian palazzi, unhampered by defensive requirements, developed into graceful, ornate structures such as the Ca' d'Oro (fig. 465). There is more than a touch of the Orient in the delicate latticework effect of this facade, even though most of the decorative vocabulary derives from the Late Gothic of northern Europe. Its rippling patterns, ideally designed to be seen against their own reflection in the water of the Grand Canal, have the same fairy-tale quality we recall from the exterior of St. Mark's (see fig. 335).

466. West portal, Chartres Cathedral. c. 1145–70

SCULPTURE

France

Abbot Suger must have attached considerable importance to the sculptural decoration of St.-Denis, although his story of the rebuilding of the church does not deal at length with that aspect of the enterprise. The three portals of his west facade were far larger and more richly carved than those of Norman Romanesque churches. Unhappily, their condition today is so poor that they do not tell us a great deal about Suger's ideas of the role of sculpture within the total context of the structure he had envisioned.

CHARTRES CATHEDRAL, WEST PORTALS. We may assume, however, that Suger's ideas had prepared the way for the admirable west portals of Chartres Cathedral (fig. 466), begun about 1145 under the influence of St.-Denis, but even more ambitious. They probably represent the oldest full-fledged example of Early Gothic sculpture. Comparing them with Romanesque portals, we are impressed first of all with a new sense of order, as if all the figures had suddenly come to attention, conscious of their responsibility to the architectural framework. The dense crowding and the frantic movement of Romanesque sculpture have given way to an emphasis on symmetry and clarity. The figures on the lintels, archivolts, and

tympanums are no longer entangled with each other but stand out as separate entities, so that the entire design carries much further than that of previous portals.

Particularly striking in this respect is the novel treatment of the jambs (fig. 467), which are lined with tall figures attached to columns. Similarly elongated figures, we recall, had occurred on the jambs or trumeaux of Romanesque portals (see figs. 401 and 407), but they had been conceived as reliefs carved into or protruding from the masonry of the doorway. The Chartres jamb figures, in contrast, are essentially statues, each with its own axis. They could, in theory at least, be detached from their supports. Here, then, we witness a development of truly revolutionary importance: the first basic step toward the reconquest of monumental sculpture in the round since the end of classical antiquity. Apparently, this step could be taken only by borrowing the rigid cylindrical shape of the column for the human figure, with the result that these statues seem more abstract than their Romanesque predecessors. Yet they will not retain their immobility and unnatural proportions for long. The very fact that they are round endows them with a more emphatic presence than anything in Romanesque sculpture, and their heads show a gentle, human quality that

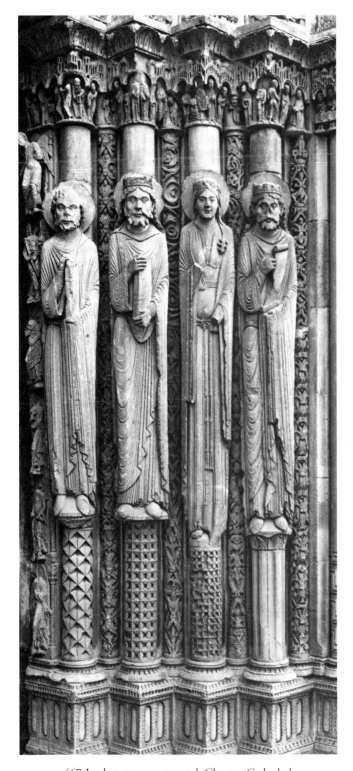

467. Jamb statues, west portal, Chartres Cathedral

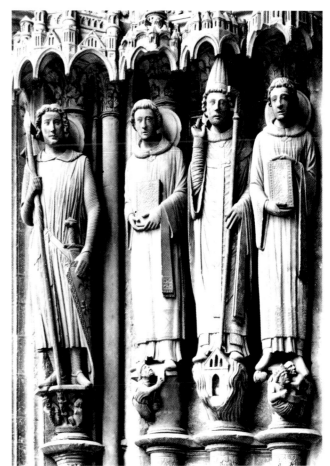

468. Jamb statues, south transept portal, Chartres Cathedral.
c. 1215–20

betokens the fundamentally realistic trend of Gothic sculpture.

Realism is, of course, a relative term whose meaning varies greatly according to circumstances. On the Chartres west portals, it appears to spring from a reaction against the fantastic and demoniacal aspects of Romanesque art. This response may be seen not only in the calm, solemn spirit of the figures and their increased physical bulk (compare the Christ of the center tympanum with that at Vézelay, fig. 406) but also in the rational discipline of the symbolic program underlying the entire scheme. While the subtler aspects of this program are accessible only to a mind fully conversant with the theology of the Chartres Cathedral School, its main elements can be readily understood.

The jamb statues form a continuous sequence linking all three portals (fig. 466). Together they represent the prophets, kings, and queens of the Bible. Their purpose is both to acclaim the rulers of France as the spiritual descendants of Old Testament royalty and to stress the harmony of spiritual and secular rule, of priests (or bishops) and kings—ideals insistently put forward by Abbot Suger. Christ himself appears enthroned above the main doorway as Judge and Ruler of the universe, flanked by the symbols of the four evangelists, with the apostles assembled below and the 24 elders of the Apocalypse in the archivolts. The right-hand tympanum shows Christ's incarnation: the Birth, the Presentation in the Temple, and the Infant Christ on the lap of the Virgin, who also stands for the Church. In the archivolts above are the personifications and representatives of the liberal arts as human wisdom paying homage to the divine wisdom of Christ. Finally, in the left-hand tympanum, we see the timeless Heavenly Christ (the Christ of the Ascension) framed by the ever-repeating cycle of the year: the signs of the zodiac and their earthly counterparts, the labors of the 12 months.

NORTH PORTALS. When Chartres Cathedral was rebuilt after the fire of 1195, the so-called Royal Portals of the west facade must have seemed rather small and old-fashioned in relation to the rest of the new edifice. Perhaps for that reason, the two transept facades each received three large and lavishly

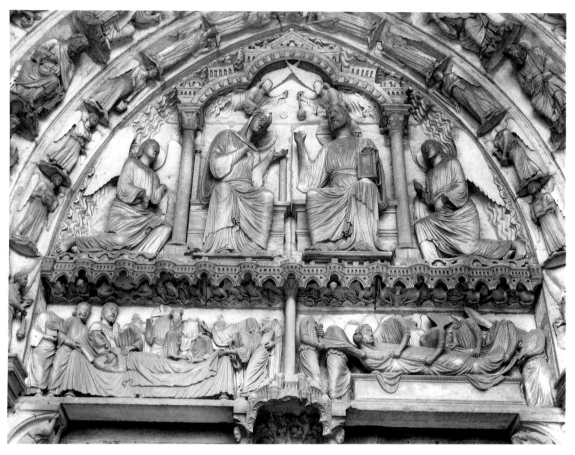

469. *Coronation of the Virgin* (tympanum), *Dormition and Assumption of the Virgin* (lintel), north portal, Chartres Cathedral. c. 1230

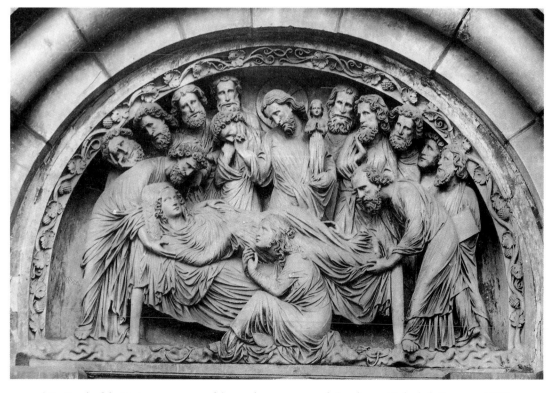

470. *Death of the Virgin*, tympanum of the south transept portal, Strasbourg Cathedral, France. c. 1220

carved portals preceded by deep porches. The north transept (fig. 469) is devoted to the Virgin. She had already appeared over the right portal of the west facade in her traditional guise as the Mother of God seated on the Throne of Divine Wisdom (fig. 466). Her new prominence reflects the increasing importance of the cult of the Virgin, which had been actively promoted by the Church since the Romanesque era. The growth of Mariology, as it is known, was linked to a new emphasis on divine love, which was enthusiastically embraced by the faithful as part of the more human view that became increasingly popular throughout the Gothic era. The cult of the Virgin received special emphasis about 1204, when Chartres, which is dedicated to her, received the head of her mother, St. Anne, as a relic.

Our tympanum depicts events associated with the Feast of the Assumption (celebrated on August 15), when Mary was transported to Heaven: the Death (Dormition), Assumption, and Coronation of the Virgin, which, with the Annunciation (see fig. 471), were to become the most characteristic subjects relating to her life. The appearance of all three here is extraordinary. It identifies Mary with the Church as the Bride of Christ and the Gateway to Heaven, in addition to her old role as divine intercessor. More important, it stresses her equality with Christ. Like him, she is transported to Heaven, where she becomes not only his companion (The Triumph of the Virgin) but also his Queen! Unlike earlier representations, which rely on Byzantine prototypes, the compositions here are of Western invention. The figures have a monumentality unprecedented in medieval sculpture, while the treatment is so pictorial that the scenes are virtually independent of the architectural setting into which they have been crammed.

GOTHIC CLASSICISM. The *Coronation of the Virgin* exemplifies an early phase of High Gothic sculpture. The jamb statues of these portals, such as the group shown in figure 468, show a similar evolution. By now, the symbiosis of statue and column has begun to dissolve. The columns are quite literally put in the shade by the greater width of the figures, by the strongly projecting canopies above, and by the elaborately carved bases of the statues.

In the three saints on the right, we still find echoes of the rigid cylindrical shape of Early Gothic jamb statues, but even here the heads are no longer strictly in line with the central axis of the body. St. Theodore, the knight on the left, already stands at ease, in a semblance of classical contrapposto. His feet rest on a horizontal platform, rather than on a sloping shelf as before, and the axis of his body, instead of being straight, describes a slight but perceptible S-curve. Even more astonishing is the abundance of precisely observed detail in the weapons and in the texture of the tunic and chain mail. Above all, there is the organic structure of the body. Not since Imperial Roman times have we seen a figure as thoroughly alive as this. Yet the most impressive quality of the statue is not its realism. It is, rather, the serene, balanced image which this realism conveys. In this ideal portrait of the Christian Soldier, the spirit of the crusades has been cast into its most elevated form.

The style of the *St. Theodore* could not have evolved directly from the elongated columnar statues of Chartres' west facade. It incorporates another, equally important tradition:

471. *Annunciation* and *Visitation,* west portal, Reims Cathedral. c. 1225–45

the classicism of the Meuse Valley, which we traced in the previous chapter from Renier of Huy to Nicholas of Verdun (compare figs. 411, 420, and 421). At the end of the twelfth century this trend, hitherto confined to metalwork and miniatures, began to appear in monumental stone sculpture as well, transforming it from Early Gothic to Classic High Gothic. The link with Nicholas of Verdun is striking in the *Death of the Virgin* (fig. 470), a tympanum at Strasbourg Cathedral slightly later than the Chartres north transept portals. Here the draperies, the facial types, and the movements and gestures have a classical flavor that immediately recalls the Klosterneuburg Altar (fig. 420).

What marks it as Gothic rather than Romanesque, however, is the deeply felt tenderness pervading the entire scene. We sense a bond of shared emotion among the figures, an ability to communicate by glance and gesture that surpasses even the Klosterneuburg Altar. This quality, too, has a long heritage reaching back to antiquity. We recall that it entered Byzantine art during the eleventh century as part of a renewed classicism (see figs. 340 and 343). Gothic expressiveness is unthinkable without such examples. But how much warmer and more eloquent it is at Strasbourg than at Chartres! What appears as merely one episode within the larger doctrinal statement of the earlier work now becomes the sole focus of attention—and the vehicle for an outpouring of emotion such as had never been seen in the art of western Christendom.

The climax of Gothic classicism is reached in some of the statues at Reims Cathedral. The most famous among them is the *Visitation* group (fig. 471, right). To have a pair of jamb figures enact a narrative scene such as this would have been

472. *Melchizedek and Abraham,* interior west wall,
Reims Cathedral. After 1251

473. *The Virgin of Paris.* Early 14th century. Stone.
Notre-Dame, Paris

unthinkable in Early Gothic sculpture. The fact that they can do so now shows how far the sustaining column has receded into the background. Now the S-curve resulting from the pronounced contrapposto is much more conspicuous than in the *St. Theodore.* It dominates the side view as well as the front view, and the physical bulk of the body is further emphasized by horizontal folds pulled across the abdomen. The relationship of the two women shows the same human warmth and sympathy we found in the Strasbourg tympanum, but their classicism is of a far more monumental kind. They remind us so forcibly of ancient Roman matrons (compare fig. 267) that we wonder if the artist could have been inspired directly by large-scale Roman sculpture.

The vast scale of the sculptural program for Reims Cathedral made it necessary to call upon the services of masters and workshops from various other building sites, and so we encounter several distinct styles among the Reims sculpture. Two of these styles, both clearly different from the classicism of the *Visitation,* appear in the *Annunciation* group (fig. 471, left). The Virgin exhibits a severe manner, with a rigidly vertical body axis and straight, tubular folds meeting at sharp angles, a style probably invented about 1220 by the sculptors of the west portals of Notre-Dame in Paris; from there it traveled to Reims as well as Amiens (see fig. 474, top center). The

angel, in contrast, is conspicuously graceful. We note the tiny, round face framed by curly locks, the emphatic smile, the strong S-curve of the slender body, the ample, richly accented drapery. This "elegant style," created around 1240 by Parisian masters working for the royal court, was to spread far and wide during the following decades. It soon became, in fact, the standard formula for High Gothic sculpture. We shall feel its effect for many years to come, not only in France but abroad.

A characteristic instance of the elegant style is the fine group of *Melchizedek and Abraham,* carved shortly after the middle of the century for the interior west wall of Reims Cathedral (fig. 472). Abraham, in the costume of a medieval knight, still recalls the vigorous realism of the *St. Theodore* at Chartres. Melchizedek, however, shows clearly his descent from the angel of the Reims *Annunciation.* His hair and beard are even more elaborately curled, the draperies more lavishly ample, so that the body almost disappears among the rich play of folds. The deep recesses and sharply projecting ridges betray a new awareness of effects of light and shadow that seem more pictorial than sculptural. The same may be said of the way the figures are placed in their cavernous niches.

A half-century later every trace of classicism has disappeared from Gothic sculpture. The human figure itself now becomes strangely abstract. Thus the famous *Virgin of Paris*

474. *Signs of the Zodiac* and *Labors of the Months (July, August, September)*, west facade, Amiens Cathedral. c. 1220–30

(fig. 473) in Notre-Dame Cathedral consists largely of hollows, the projections having been reduced to the point where they are seen as lines rather than volumes. The statue is quite literally disembodied—its swaying stance no longer bears any relationship to the classical contrapposto. Compared to such unearthly grace, the angel of the Reims *Annunciation* seems solid and tangible indeed. Yet it contains the seed of the very qualities so strikingly expressed in *The Virgin of Paris.*

When we look back over the century and a half that separates *The Virgin of Paris* from the Chartres west portals, we cannot help wondering what brought about this graceful manner. The new style was certainly encouraged by the royal court of France and thus had special authority, but smoothly flowing, calligraphic lines came to dominate Gothic art, not just in France but throughout northern Europe from about 1250 to 1400. It is clear, moreover, that the style of *The Virgin of Paris* represents neither a return to the Romanesque nor a complete repudiation of the earlier realistic trend.

Gothic realism had never been of the all-embracing, systematic sort. Rather, it had been a "realism of particulars," focused on specific details rather than on the over-all structure of the visible world. Its most characteristic products are not the classically oriented jamb statues and tympanum compositions of the early thirteenth century but small-scale carvings, such

as the *Labors of the Months* in quatrefoil frames on the facade of Amiens Cathedral (fig. 474), with their delightful observation of everyday life. This intimate kind of realism survives even within the abstract formal framework of *The Virgin of Paris.* We see it in the Infant Christ, who appears here not as the Saviour-in-miniature austerely facing the beholder, but as a thoroughly human child playing with his mother's veil. Our statue thus retains an emotional appeal that links it to the Strasbourg *Death of the Virgin* and to the Reims *Visitation.* It is this appeal, not realism or classicism as such, that is the essence of Gothic art.

England

The spread of Gothic sculpture beyond the borders of France began only toward 1200, so that the style of the Chartres west portals had hardly any echoes abroad. Once under way, however, it proceeded at an astonishingly rapid pace. England may well have led the way, as it did in evolving its own version of Gothic architecture. Unfortunately, so much English Gothic sculpture was destroyed during the Reformation that we can study its development only with difficulty. Our richest materials are the tombs, which did not arouse the iconoclastic zeal of anti-Catholics. They include a type, illustrated by the

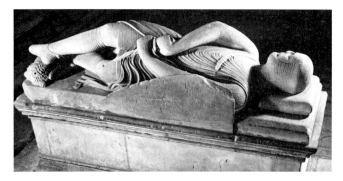

475. Tomb of a Knight. c. 1260. Stone. Dorchester Abbey,
Oxfordshire, England

splendid example in figure 475, that has no counterpart on the
other side of the Channel. It shows the deceased, not in the
quiet repose found on the vast majority of medieval tombs,
but in violent action, as a fallen hero fighting to the last breath.
According to an old tradition, these dramatic figures honor
the memory of crusaders who died in the struggle for the Holy
Land. As the tombs of Christian Soldiers, they carry a religious
meaning that helps to account for their compelling expressive
power. Their agony, which so oddly recalls the *Dying Trum-
peter* (see fig. 210), makes them among the finest achieve-
ments of English Gothic sculpture.

Germany

In Germany, the growth of Gothic sculpture can be traced
more easily. From the 1220s on, German masters trained in
the sculptural workshops of the great French cathedrals trans-
planted the new style to their homeland, although German
architecture at that time was still predominantly Romanesque.
Even after the middle of the century, however, Germany failed
to emulate the large statuary cycles of France. As a conse-
quence, German Gothic sculpture tended to be less closely
linked with its architectural setting. (The finest work was often
done for the interiors rather than the exteriors of churches.)
This, in turn, permitted it to develop an individuality and
expressive freedom greater than that of its French models.

THE NAUMBURG MASTER. These qualities are striking-
ly evident in the style of the Naumburg Master, an artist of real
genius whose best-known work is the magnificent series of
statues and reliefs of about 1240–50 for Naumburg Cathe-
dral. The *Crucifixion* (fig. 476) forms the central feature of the
choir screen; flanking it are statues of the Virgin and John the
Baptist. Enclosed by a deep, gabled porch, the three figures
frame the opening that links the nave with the sanctuary.
Rather than placing the group above the screen, in accordance
with the usual practice, our sculptor has brought the sacred
subject down to earth both physically and emotionally. The
suffering of Christ thus becomes a human reality because of
the emphasis on the weight and volume of his body. Mary and
John, pleading with the beholder, convey their grief more elo-
quently than ever before.

The pathos of these figures is heroic and dramatic, as
against the lyricism of the Strasbourg tympanum or the Reims
Visitation (see figs. 470 and 471). If the Classic High Gothic

476. *Crucifixion,* on the choir screen, Naumburg Cathedral,
Germany. c. 1240–50. Stone

477. *The Kiss of Judas,* on the choir screen,
Naumburg Cathedral. c. 1240–50. Stone

sculpture of France evokes comparison with Phidias, the
Naumburg Master might be termed the temperamental kin of
Scopas (see page 155). The same intensity of feeling domi-
nates the Passion scenes, such as *The Kiss of Judas* (fig. 477),
with its unforgettable contrast between the meekness of Christ
and the violence of the sword-wielding St. Peter. Attached to
the responds inside the choir are statues of nobles associated
with the founding of the cathedral. These men and women

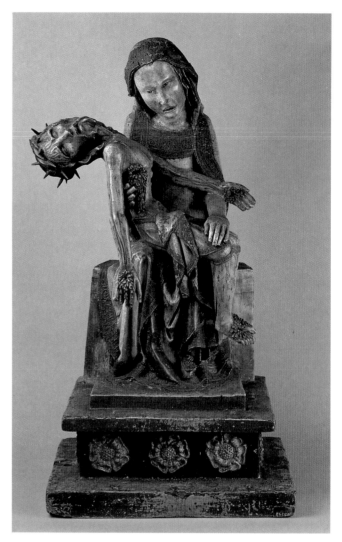

478. *Ekkehard and Uta.* c. 1240–50. Stone. Naumburg Cathedral

479. *Roettgen Pietà.* Early 14th century. Wood, height 34 1/2" (87.5 cm). Rheinisches Landesmuseum, Bonn

were not of the artist's own time, so that they were only as names in a chronicle. Yet the famous pair *Ekkehard and Uta* (fig. 478) are personalities as distinctive and forceful as if they had been portrayed from life. In this regard, they make an instructive contrast with the idealized portrait of *St. Theodore* at Chartres (see fig. 468, left).

THE PIETÀ. Gothic sculpture, as we have come to know it so far, reflects a desire to endow the traditional themes of Christian art with greater emotional appeal. Toward the end of the thirteenth century, this tendency gave rise to a new kind of religious imagery, designed to serve private devotion. It is often referred to by the German term *Andachtsbild* (contemplation image), since Germany played a leading part in its development. The most characteristic and widespread type of Andachtsbild was the *Pietà* (an Italian word derived from the Latin *pietas,* the root word for both pity and piety): a representation of the Virgin grieving over the dead Christ. No such scene occurs in the scriptural account of the Passion. The *Pietà* conflates two iconic types: the Madonna and Child and the Crucifixion, which were often paired as objects of veneration once they became familiar to Europeans following the conquest of Constantinople in 1204. Exactly where or when it

was invented we do not know, but it represents one of the Seven Sorrows of the Virgin, a tragic counterpart to the familiar motif of the Madonna and Child, which depicts one of her Seven Joys. [See Primary Sources, no. 36, pages 389–90.]

The *Roettgen Pietà,* reproduced in figure 479, is carved of wood, with a vividly painted surface. Like most such groups, this large cult statue was meant to be placed on an altar. The style, like the subject, responds to the emotional fervor of lay religiosity, which emphasized a personal relationship with the deity as part of the tide of mysticism that swept the fourteenth century. Realism here has become purely a vehicle of expression to enhance its impact. The agonized faces convey an almost unbearable pain and grief. The blood-encrusted wounds of Christ are enlarged and elaborated to an almost grotesque degree. The bodies and limbs have become puppet-like in their thinness and rigidity. The purpose of the work, clearly, is to arouse so overwhelming a sense of horror and pity that the faithful will share completely in Christ's suffering and identify their own feelings with those of the grief-stricken Mother of God. The ultimate goal of this emotional bond is a spiritual transformation that comprehends the central mystery of God in human form through compassion (which means "to suffer with").

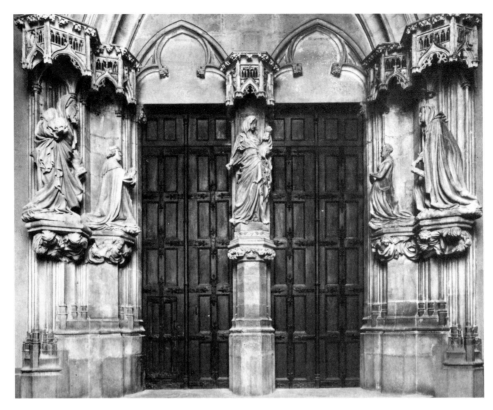

480. Claus Sluter. Portal of the Chartreuse de Champmol, Dijon, France. 1385–93. Stone

At a glance, our *Pietà* would seem to have little in common with *The Virgin of Paris* (fig. 473), which dates from the same period. Yet they share both a lean, "deflated" quality of form and a strong emotional appeal to the viewer that characterize the art of Northern Europe from the late thirteenth century to the mid-fourteenth. Only after 1350 do we again find an interest in weight and volume, coupled with a renewed impulse to explore tangible reality as part of a larger change in religious sensibility.

The International Style in the North

SLUTER. The climax of this new trend came about 1400, during the period of the International Style (see pages 377–81). Its greatest exponent was Claus Sluter, a sculptor of Netherlandish origin working at Dijon for the king's brother Philip the Bold, the duke of Burgundy. The portal of the charterhouse of Carthusian monks known as the Chartreuse de Champmol (fig. 480), which he decorated between 1385 and 1393, recalls the monumental statuary on thirteenth-century cathedral portals, but the figures have grown so large and expansive that they almost overpower their architectural framework. This effect is due not only to their size and the bold three-dimensionality of the carving, but also to the fact that the jamb statues (showing the duke and his wife, accompanied by their patron saints) are turned toward the Madonna on the trumeau, so that the five figures form a single, coherent unit, like the *Crucifixion* group at Naumburg. In both instances, the sculptural composition has simply been superimposed, however skillfully, on the shape of the doorway, not developed from it as at Chartres, Notre-Dame, or Reims. Significantly enough, the Champmol portal

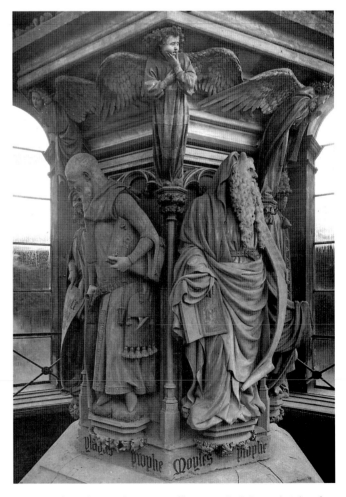

481. Claus Sluter. *The Moses Well.* 1395–1406. Stone, height of figures approx. 6' (1.8 m). Chartreuse de Champmol, Dijon

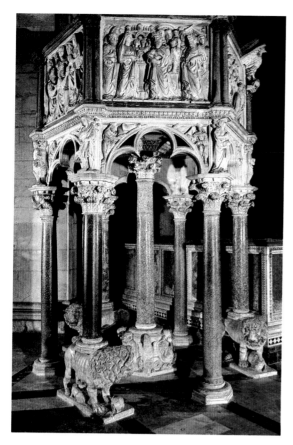

482. Nicola Pisano. Pulpit. 1259–60. Marble,
height 15' (4.6 m). Baptistery, Pisa

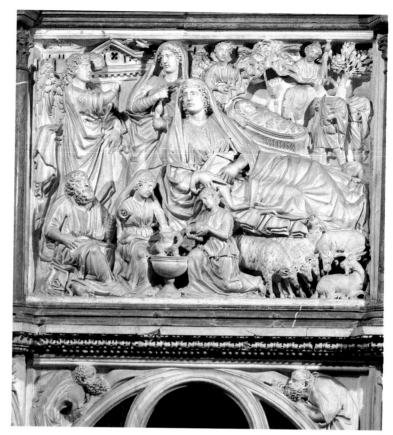

483. *Nativity,* detail of the pulpit by Nicola Pisano. Baptistery, Pisa

did not pave the way for a revival of architectural sculpture. Instead, it remained an isolated effort.

Sluter's other works belong to a different category that, for lack of a better term, we must label church furniture (tombs, pulpits, and the like), which combine large-scale sculpture with a small-scale architectural setting. The most impressive of these is *The Moses Well* at the Chartreuse de Champmol (fig. 481), a symbolic well surrounded by statues of Old Testament prophets and once surmounted by a crucifix. The majestic Moses epitomizes the same qualities we find in Sluter's portal statues. Soft, lavishly draped garments envelop the heavy-set body like an ample shell, and the swelling forms seem to reach out into the surrounding space, determined to capture as much of it as possible. (Note the outward curve of the scroll, which reads: "The children of Israel do not listen to me.") The effect must have been enhanced greatly by the polychromy added by Jean Malouel (see page 378), which has largely disappeared. At first glance, Moses seems a startling premonition of the Renaissance. (Compare Michelangelo's treatment of the same subject in fig. 608.) Only upon closer inspection do we realize that in his vocabulary Sluter remains firmly allied to the Gothic.

In the Isaiah, facing left in our illustration, what strikes us is the precise and masterful realism of every detail, from the minutiae of the costume to the texture of the wrinkled skin. The head, unlike that of Moses, has all the individuality of a portrait. Nor is this impression deceiving: Sluter has left us two splendid examples in the heads of the duke and duchess on the Chartreuse portal. This attachment to the tangible and specific distinguishes his realism from that of the thirteenth century.

Italy

We have left a discussion of Italian Gothic sculpture to the last, for here, as in Gothic architecture, Italy stands apart from the rest of Europe. The earliest Gothic sculpture on Italian soil was probably produced in the extreme south, in Apulia and Sicily, the domain of the German emperor Frederick II, who employed Frenchmen and Germans along with native artists at his court. Of the works he sponsored little has survived, but there is evidence that his taste favored a strongly classical style derived from the sculpture of the Chartres transept portals and the *Visitation* group at Reims (see figs. 468 and 471). This style not only provided a fitting visual language for a ruler who saw himself as the heir of the Caesars of old, it also blended easily with the classical tendencies in Italian Romanesque sculpture (see page 311).

NICOLA PISANO. Such was the background of Nicola Pisano (c. 1220/5–1284), who went to Tuscany from southern Italy about 1250 (the year of Frederick II's death). Ten years later he completed the marble pulpit in the Baptistery of Pisa Cathedral (fig. 482). His work has been well defined as that of "the greatest—and in a sense the last—of medieval classicists." Whether we look at the architectural framework or the sculptured parts, the classical flavor is indeed so strong in the Pisa Baptistery pulpit that the Gothic elements are at first hard to detect. But we do find such elements in the design of the arches, in the shape of the capitals, and in the standing figures at the corners, which look like small-scale descendants of the jamb statues on French Gothic cathedrals.

Most striking, perhaps, is the Gothic quality of human feeling in the reliefs of scenes such as the *Nativity* (fig. 483). The

484. *Fortitude,* detail of the pulpit by Nicola Pisano

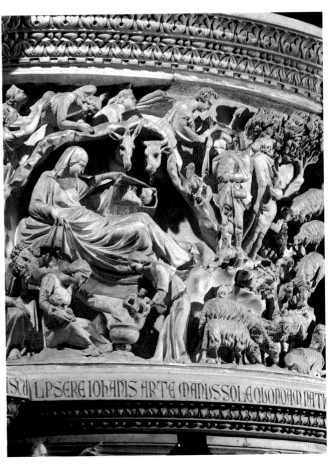

485. Giovanni Pisano. *The Nativity,* detail of pulpit. 1302–10. Marble. Pisa Cathedral

dense crowding of figures, on the other hand, has no counterpart in Northern Gothic sculpture. Aside from the Nativity, the panel also shows the Annunciation and the shepherds in the fields receiving the glad tidings of the birth of Christ. This treatment of the relief as a shallow box filled almost to the bursting point with solid, convex shapes tells us that Nicola Pisano must have been thoroughly familiar with Roman sarcophagi (compare fig. 312).

The figures atop the columns ringing the pulpit include an even more startling manifestation of Nicola's classicism: a nude male (fig. 484), instantly recognizable as Herakles by the lion cub on his shoulder and the skin of the Nemean lion he slew with his bare hands (compare fig. 143). But what is he doing here? He is the personification of Fortitude. Whenever we meet the unclothed body, from 800 to 1400, we may be sure, except for a few special cases, that such nudity has a moral significance, whether negative (Adam and Eve, or sinners in Hell) or positive (the nudity of the Christ of the Passion, of saints being martyred or mortifying the flesh). Herakles' presence as one of the seven Cardinal Virtues was therefore perfectly acceptable to the medieval mind.

We may also be sure that such figures are derived, directly or indirectly, from classical sources, no matter how unlikely this may seem in some instances. Such is the case with Nicola's *Herakles,* who betrays his descent from Praxiteles' *Hermes* (fig. 207). However, classical must be understood in a relative sense, for Herakles' nearest ancestors are miniature figures of Daniel in the lions' den on Early Christian sarcophagi of the fifth century, which have the same squat proportions;

his appearance here is thus based on eminently respectable sources. Like all medieval nudes, even the most accomplished, it is devoid of the sensual appeal that we take for granted in every nude of classical antiquity. This quality was purposely avoided rather than unattainable, for to the medieval mind the physical beauty of the ancient "idols," especially nude statues, embodied the insidious attraction of paganism. As seen in the bulging features and lumpy anatomy, Nicola's style remains Gothic, tempered as it were by classicism, despite his obvious fascination with antique sculpture.

GIOVANNI PISANO. Half a century later, Nicola's son Giovanni (1245/50–after 1314), who was an equally gifted sculptor, carved a marble pulpit for Pisa Cathedral. [See Primary Sources, no. 37, page 390.] It, too, includes a *Nativity* (fig. 485). Both panels have a good many things in common, as we might well expect, yet they also offer a sharp—and instructive—contrast. Giovanni's slender, swaying figures, with their smoothly flowing draperies, recall neither classical antiquity nor the *Visitation* group at Reims. Instead, they reflect the elegant style of the royal court at Paris that had become the standard Gothic formula during the later thirteenth century. And with this change there has come about a new treatment of relief: to Giovanni Pisano, space is as important as plastic form. The figures are no longer tightly packed together. They are now spaced far enough apart to let us see the landscape setting that contains them, and each figure has been allotted its own pocket of space. If Nicola's *Nativity* strikes us as essentially a sequence of bulging, rounded masses, Giovanni's

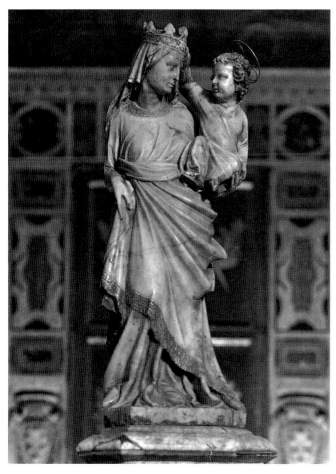

486, 487. Giovanni Pisano. *Madonna*. c. 1315. Marble, height 27" (68.7 cm). Prato Cathedral

appears to be made up mainly of cavities and shadows.

Giovanni Pisano, then, follows the same trend toward disembodiment that we encountered north of the Alps around 1300, only he does so in a more limited way. Compared to *The Virgin of Paris* (fig. 473), his *Madonna* at Prato Cathedral (figs. 486 and 487) immediately evokes memories of Nicola's style. The three-dimensional firmness of the modeling is further emphasized by the strong turn of the head and the thrust-out left hip. We also note the heavy, buttresslike folds that anchor the figure to its base. Yet there can be no doubt that the Prato statue derives from a French prototype which must have been rather like *The Virgin of Paris.* The back view, with its suggestion of "Gothic sway," reveals the connection more clearly than the front view, which hides the pose beneath a great swathe of drapery.

CHURCH FACADES. Italian Gothic church facades generally do not rival those of the French cathedrals as focal points of architectural and sculptural endeavor. The French Gothic portal, with its jamb statues and richly carved tympanum, never found favor in the south. Instead, we often find a survival of Romanesque traditions of architectural sculpture, such as statues in niches or small-scale reliefs overlaying the wall surfaces (compare figs. 410 and 462).

At Orvieto Cathedral, Lorenzo Maitani (before 1270–1330) covered the wide pilasters between the portals with relief carvings of such lacelike delicacy that we become aware of them only if we see them at close range. The tortures of the damned from *The Last Judgment* on the southernmost pilaster (fig. 488)

488. Lorenzo Maitani. *The Last Judgment* (detail), from the facade of Orvieto Cathedral, Italy. c. 1320

489. *Equestrian Statue of Can Grande della Scala,* from his tomb. 1330. Stone. Museo di Castelvecchio, Verona, Italy

490. Arnolfo di Cambio. Tomb of Guglielmode Braye. 1282. Marble. S. Domenico, Orvieto

make an instructive comparison with similar scenes in Romanesque art (such as fig. 404). The hellish monsters are as vicious as ever, but the sinners now evoke compassion rather than sheer horror. Even here, we feel the spirit of human sympathy that distinguishes the Gothic from the Romanesque.

TOMBS. If Italian Gothic sculpture failed to emulate the vast sculptural programs of Northern Europe, it excelled in the field that we have called church furniture, such as pulpits, screens, shrines, and tombs. Perhaps the most remarkable of all tombs is the monument of Can Grande della Scala, the lord of Verona. A tall structure built out-of-doors next to the church of Sta. Maria Antica and now in the courtyard of the Castelvecchio, it consists of a vaulted canopy housing the sarcophagus and surmounted by a truncated pyramid which in turn supports an equestrian statue of the deceased (fig. 489). The ruler, astride his richly caparisoned mount, is shown in

full armor, sword in hand, as if he were standing on a windswept hill at the head of his troops—and, in a supreme display of self-confidence, he wears a broad grin. Clearly, this is no Christian Soldier, no crusading knight, no embodiment of the ideals of chivalry, but a frank glorification of power.

Can Grande, remembered today mainly as the friend and protector of Dante, was indeed an extraordinary figure. [See Primary Sources, no. 38, pages 390–91.] Although he held Verona as a fief from the German emperor, he styled himself "the Great Khan," thus asserting his claim to the absolute sovereignty of an Asiatic potentate. His free-standing equestrian statue—a form of monument traditionally reserved for emperors (see fig. 279)—conveys the same ambition in visual terms.

ARNOLFO DI CAMBIO. The late thirteenth century witnessed the development of a new kind of tomb for leaders of the Catholic church. Its origins lie in French royal tombs, but

491. Jacobello and Pierpaolo dalle Masegne. *Apostles,*
on the choir screen. c. 1394. Marble,
height approx. 53" (134.6 cm). St. Mark's, Venice

492. Lorenzo Ghiberti. *The Sacrifice of Isaac.* 1401–2. Gilt bronze,
21 x 17" (53.3 x 43.4 cm). Museo Nazionale del Bargello, Florence

the type spread quickly to Italy, where Arnolfo di Cambio (1245–1302?) gave it definitive form. Arnolfo had been an assistant to Nicola Pisano, under whom he developed a classicizing style that became even more emphatic after he moved to Rome. There he entered the employment of Charles of Anjou, which exposed him directly to French influences. The monument of Cardinal Guglielmo de Braye (fig. 490) reflects the artist's diverse background, for it is a compound of previously separate prototypes: a carved effigy resting upon a sarcophagus and surmounted by a tableau of St. Mark presenting the deceased to the Virgin and Child. The ensemble was originally housed in an elaborate tabernacle (now lost) rather than in its present shallow niche. Arnolfo's solution proved so satisfying that it immediately became the model followed by all other Italian sculptors for sepulchral monuments. Even without its architectural setting, the tomb has a grandeur befitting a prince of the church. The two angels solemnly drawing the curtains to a close add a human note that is as unexpected as it is touching.

The International Style in the South

During the later fourteenth century, northern Italy proved particularly hospitable to artistic influences from across the Alps, not only in architecture (see Milan Cathedral, fig. 463), but in sculpture as well. The *Apostles* atop the choir screen of St. Mark's in Venice (fig. 491), carved by Jacobello and Pierpaolo dalle Masegne about 1394, reflect the trend toward greater realism and the renewed interest in weight and volume that culminated in the work of Claus Sluter, even though these qualities are not yet fully developed here. Both figures betray a marked "Gothic sway" as well. Yet their kinship with Benedetto Antelami's *King David* (fig. 410) of a century earlier is equally apparent. With the *Apostles* from St. Mark's, then, we are on the threshold of the "International Style," which flourished throughout western Europe about 1400 to 1420.

GHIBERTI. The outstanding representative of the International Style in Italian sculpture was Lorenzo Ghiberti (c. 1381–1455), a Florentine who as a youth must have had close contact with French art. We first encounter him in 1401–2, when he won a competition for a pair of richly decorated bronze doors for the Baptistery of S. Giovanni in Florence. (It took him more than two decades to complete these doors, which fill the north portal of the building.) Each of the competing artists had to submit a trial relief, in a Gothic quatrefoil frame, representing the Sacrifice of Isaac. [See Primary Sources, no. 41, page 392.] Ghiberti's panel (fig. 492) strikes us first of all with the perfection of its craftsmanship, which reflects his training as a goldsmith. The silky shimmer of the surfaces and the wealth of beautifully articulated detail make it easy to understand why this entry was awarded the prize. If

493. Andrea da Pisano. *The Baptism of Christ,* from the south doors, Baptistery of S. Giovanni, Florence. 1330–36. Gilt bronze

the composition seems somewhat lacking in dramatic force, that is characteristic of Ghiberti's calm, lyrical temper, which was very much to the taste of the period. Indeed, the figures, in their softly draped, ample garments, retain an air of courtly elegance even when they enact scenes of violence.

Ghiberti's doors were not the first ones on the Florence Baptistery. Some 70 years earlier Andrea da Pisano (no relation to Nicola or Giovanni Pisano; c. 1290–1348?) had received a commission for the south doors to rival those of Pisa Cathedral. In *The Baptism of Christ* (fig. 493), Andrea reveals himself an able follower of the painter Giotto (compare fig. 506). Ghiberti's doors are a direct outgrowth of Andrea's, which exercised great influence on Florentine art and helped to determine the appearance of Ghiberti's doors. Whatever the debt, the differences are equally important. Andrea's reliefs must have seemed hopelessly old-fashioned to Ghiberti in their stiff, angular poses and simplified compositions. Although both artists were strongly influenced by French metalwork, Ghiberti's work shows the fluid grace and the tactile reality of International Style sculpture. These are characteristics that also grew out of French manuscript painting (compare fig. 516), whose intimacy also appealed to Ghiberti.

However much his work may owe to French influence, Ghiberti proves himself thoroughly Italian in one respect: his admiration for ancient sculpture, as evidenced by the beautiful nude torso of Isaac. Here our artist revives a tradition of classicism that had reached its highest point in Nicola Pisano but had gradually died out during the fourteenth century.

But Ghiberti is also the heir of Giovanni Pisano. In Giovanni's *Nativity* panel (fig. 485) we noted a bold new emphasis on the spatial setting. The trial relief carries this same tendency a good deal further, achieving a far more natural sense of recession. For the first time since classical antiquity, we are made to experience the background of the panel not as a flat surface but as empty space from which the sculpted forms emerge toward the beholder, so that the angel in the upper right-hand corner seems to hover in midair. This pictorial quality relates Ghiberti's work to the painting of the International Style, where we find a similar concern with spatial depth and atmosphere (see pages 377–81). While not a revolutionary himself, he prepares the ground for the great revolution that will mark the second decade of the fifteenth century in Florentine art and that we call the Early Renaissance.

PAINTING

France

STAINED GLASS. Although Gothic architecture and sculpture began so dramatically at St.-Denis and Chartres, Gothic painting developed at a rather slow pace in its early stages. The new architectural style sponsored by Abbot Suger gave birth to a new conception of monumental sculpture almost at once but did not demand any radical change of style in painting. Suger's account of the rebuilding of his church, to be sure, places a great deal of emphasis on the miraculous effect of

494. *Notre Dame de la Belle Verrière.* c. 1170. Stained-glass window, height approx. 14' (4.27 m). Chartres Cathedral

stained-glass windows, with their "continuous light" flooding the interior. Stained glass was thus an integral element of Gothic architecture from the very beginning. Yet the technique of stained-glass painting had already been perfected in Romanesque times, and the style of stained-glass designs (especially single figures) sometimes remained Romanesque for nearly another hundred years. Nonetheless, the "many masters from different regions" whom Suger assembled to do the choir windows at St.-Denis faced a larger task and a more complex pictorial program than before.

During the next half-century, as Gothic structures became ever more skeletal and clerestory windows grew to huge size, stained glass displaced manuscript illumination as the leading form of painting. Since the production of stained glass was so intimately linked with the great cathedral workshops, the designers came to be influenced more and more by architectural sculpture. The majestic *Notre Dame de la Belle Verrière* (fig. 494) at Chartres Cathedral, the finest early example of this process, lacks some of the sculptural qualities of its relief counterpart on the west portal of the church (fig. 466) and still betrays its Byzantine ancestry. By comparison, however, even the mosaic of the same subject in Hagia Sophia (fig. 338) seems remarkably solid. The stained glass dissolves the group into a weightless mass that hovers effortlessly in indeterminate space.

The window consists of hundreds of small pieces of tinted glass bound together by strips of lead. The maximum size of these pieces was severely limited by the primitive methods of medieval glass manufacture, so that the design could not simply be "painted on glass." Rather, the window was painted *with* glass, by assembling it somewhat the way one would a mosaic or a jigsaw puzzle, out of odd-shaped fragments cut to fit the contours of the forms. Only the finer details, such as eyes, hair, and drapery folds, were added by actually painting—or, better perhaps, drawing—in black or gray on the glass surfaces. [See Primary Sources, no. 43, pages 392–93.] This process encourages an abstract, ornamental style, which tends to resist any attempt to render three-dimensional effects. Only in the hands of a great master could the maze of lead strips resolve itself into figures having such monumentality.

Apart from the peculiar demands of their medium, the stained-glass workers who filled the windows of the great Gothic cathedrals also had to face the difficulties arising from the enormous scale of their work. No Romanesque painter had ever been called upon to cover areas so vast or so firmly bound into an architectural framework. The task required a technique of orderly planning for which the medieval painting tradition could offer no precedent.

VILLARD DE HONNECOURT. Only architects and stonemasons knew how to deal with this problem, and it was their methods that the stained-glass workers borrowed in mapping out their own compositions. Gothic architectural design, as we recall from our discussion of the choir of St.-Denis (see figs. 423 and 424), uses a system of geometric relationships to establish numerical harmony. The same rules could be used to control the design of stained-glass windows, through which shines the Light Divine, or even of an individual figure.

We gain some insight into this procedure from the drawings in a notebook compiled about 1240 by the architect

495. Villard de Honnecourt. *Wheel of Fortune.* c. 1240.
Bibliothèque Nationale, Paris

496. Villard de Honnecourt. *Front View of a Lion.* c. 1240.
Bibliothèque Nationale, Paris

Villard de Honnecourt. [See Primary Sources, no. 44, page 393.] What we see in the *Wheel of Fortune* (fig. 495) is not the final version of the design but the scaffolding of circles and triangles on which the image is to be constructed. The pervasiveness of these geometric schemes is well illustrated by another drawing from the same notebook, the *Front View of a Lion* (fig. 496). According to the inscription, Villard has portrayed the animal from life, but a closer look at the figure will convince us that he was able to do so only after he had laid down a geometric pattern: a circle for the face (the dot between the eyes is its center) and a second, larger circle for the body. To Villard, then, drawing from life meant something far different from what it does to us: it meant filling in an abstract framework with details based on direct observation.

The period 1200–1250 might be termed the golden age of stained glass. After that, as architectural activity declined and the demand for stained glass began to slacken, manuscript illumination gradually recaptured its former position of leadership. By then, however, miniature painting had been thoroughly affected by the influence of both stained glass and stone sculpture, the artistic pacemakers of the first half of the century.

ILLUMINATED MANUSCRIPTS. The resulting change of style can be seen in figure 497, from a psalter done about 1260 for King Louis IX (St. Louis) of France. The scene illustrates I Samuel 11:2, in which Nahash the Ammonite threatens the Jews at Jabesh. We notice first of all the careful symmetry of the framework, which consists of flat, ornamented panels and of an architectural setting remarkably similar to the choir screen by the Naumburg Master (see fig. 476). The latter recalls the canopies above the heads of jamb statues (see fig.

467) and the arched twin niches enclosing the relief of *Melchizedek and Abraham* at Reims (fig. 472).

Against this emphatically two-dimensional background, the figures are "relieved" by smooth and skillful modeling. But their sculptural quality stops short at the outer contours, which are defined by heavy dark lines rather like the lead strips in stained-glass windows. The figures themselves show all the characteristics of the elegant style originated about 20 years before by the sculptors of the royal court: graceful gestures, swaying poses, smiling faces, neatly waved strands of hair (compare the Annunciation angel in figure 471 and Melchizedek in figure 472). Our miniature thus exemplifies the subtle and refined taste that made the court art of Paris the standard for all Europe. Of the expressive energy of Romanesque painting we find no trace (figs. 352 and 354).

Until the thirteenth century, the production of illuminated manuscripts had been centered in the scriptoria of monasteries. Now, along with a great many other activities once the special preserve of monasteries, it shifted ever more to urban workshops organized by laymen, the ancestors of the publishing houses of today. Here again the workshops of sculptors and stained-glass painters may have set the pattern.

Some members of this new, secular breed of illuminator are known to us by name, such as Master Honoré of Paris, who in 1295 did the miniatures in the *Prayer Book of Philip the Fair.*

497. *(opposite) Nahash the Ammonite Threatening the Jews at Jabesh,*
from the *Psalter of St. Louis.* c. 1260. 5 x 3¹/₂" (17.7 x 8.9 cm).
Bibliothèque Nationale, Paris

498. Master Honoré. *David and Goliath,* from the *Prayer Book of Philip the Fair.* 1295. Bibliothèque Nationale, Paris

Our sample (fig. 498) shows him working in a style derived from the *Psalter of St. Louis.* Significantly, however, the framework no longer dominates the composition. The figures have become larger, and their relieflike modeling is more emphatic. They are even permitted to overlap the frame, a device that helps to detach them from the flat pattern of the background and thus introduces a certain, though very limited, spatial range into the picture.

Italy

We must now turn our attention to Italian painting, which at the end of the thirteenth century produced an explosion of creative energy as spectacular, and as far-reaching in its impact on the future, as the rise of the Gothic cathedral in France. A single glance at Giotto's *Lamentation* (fig. 506) will convince us that we are faced with a truly revolutionary development. How, we wonder, could a work of such intense dramatic power be conceived by a contemporary of Master Honoré? What were the conditions that made it possible? Oddly enough, as we inquire into the background of Giotto's art, we find that it arose from the same "old-fashioned" attitudes we met in Italian Gothic architecture and sculpture.

Medieval Italy, although strongly influenced by Northern

art from Carolingian times on, had always maintained contact with Byzantine civilization. As a consequence, panel painting, mosaic, and murals—mediums that had never taken firm root north of the Alps—were kept alive on Italian soil. Indeed, a new wave of influences from Byzantine art, which enjoyed a major resurgence during the thirteenth century, overwhelmed the lingering Romanesque elements in Italian painting at the very time when stained glass became the dominant pictorial art in France.

There is a certain irony in the fact that this neo-Byzantine style made its appearance soon after the conquest of Constantinople by the armies of the Fourth Crusade in 1204. (One thinks of the way Greek art had once captured the taste of the victorious Romans of old.) In any event, this "Greek manner," as the Italians disparagingly called it, prevailed almost until the end of the thirteenth century. Giorgio Vasari, the chronicler of Renaissance art, later wrote that in the mid-thirteenth century, "Some Greek painters were summoned to Florence by the government of the city for no other purpose than the revival of painting in their midst, since that art was not so much debased as altogether lost."

There is probably more truth to this statement than is often acknowledged. The Byzantine tradition had preserved Early Christian narrative art virtually intact. When transmitted to the

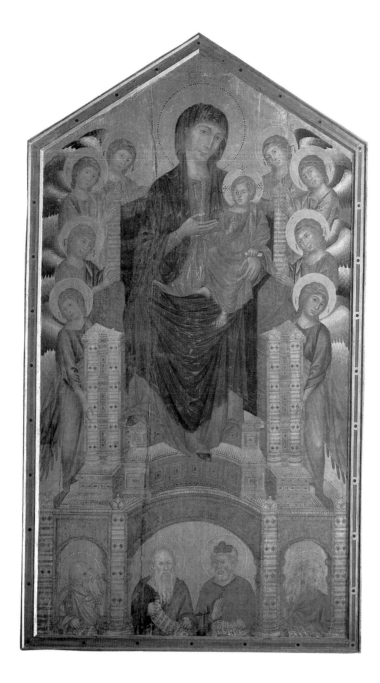

499. Cimabue. *Madonna
Enthroned.* c. 1280–90.
Tempera on panel,
12'7$^{1}/_{2}$" x 7'4" (3.9 x 2.2 m).
Galleria degli Uffizi, Florence

West this tradition led to an explosion of subjects and compositions that had been essentially lost for nearly 700 years. Many of them had been available all along in the mosaic cycles of Rome and Ravenna, and there had been successive waves of Byzantine influence throughout the early Middle Ages and the Romanesque period. Nevertheless, they lay dormant, so to speak, until interest in them was reawakened through closer relations with Constantinople, which enabled Italian painters to absorb Byzantine art far more thoroughly than ever before. During this same period, we recall, Italian architects and sculptors followed a very different course: untouched by the Greek manner, they were assimilating the Gothic style. Eventually, toward 1300, Gothic influence spilled over into painting as well, and the interaction of this element with the neo-Byzantine produced the revolutionary new style.

TEMPERA. Altarpieces during the Gothic era were painted on wood panel in tempera, an egg-based medium that dries quickly to form an extremely tough surface. The preparation of the panel was a complex, time-consuming process. First it was planed and coated with a mixture of plaster and glue known as gesso, which was sometimes reinforced with linen. Once the design had been drawn, the background was almost invariably filled in with gold leaf over red sizing. Then the underpainting, generally a green earth pigment (*terra verde*), was added. The image itself was executed in multiple layers of thin tempera with very fine brushes, a painstaking process that placed a premium on neatness, since few corrections were possible.

CIMABUE. Among the painters of the Greek manner, the Florentine master Cimabue (c. 1250–after 1300), who Vasari claims was apprenticed to a Greek painter and who in turn may have been Giotto's teacher, enjoyed special fame. His huge altar panel, *Madonna Enthroned* (fig. 499), rivals the finest Byzantine icons or mosaics (compare figs. 338 and 347). What distinguishes it from them is mainly a greater severity of

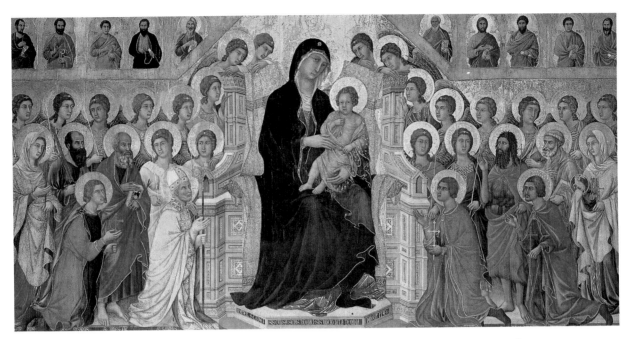

500. Duccio. *Madonna Enthroned,* center of the *Maestà Altar.* 1308–11. Tempera on panel, height 6'10 1/2" (2.1 m). Museo dell'Opera del Duomo, Siena

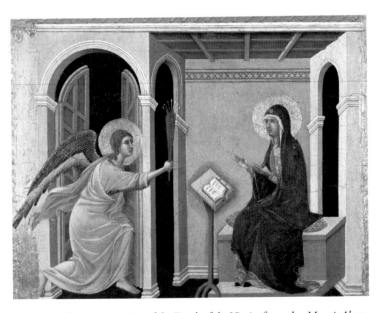

501. Duccio. *Annunciation of the Death of the Virgin,* from the *Maestà Altar*

design and expression, which befits its huge size. Panels on such a monumental scale had never been attempted in the East. Equally un-Byzantine is the picture's gabled shape and the way the throne of inlaid wood seems to echo it. The geometric inlays, like the throne's architectural style, remind us of the Florence Baptistery (see fig. 399).

DUCCIO. The *Madonna Enthroned* (fig. 500), painted a quarter century later by Duccio of Siena (c. 1255–before 1319) for the main altar of Siena Cathedral, was honored by being called the *Maestà* (majesty) to identify the Virgin's role

here as the Queen of Heaven surrounded by her celestial court of saints and angels. [See Primary Sources, no. 45, page 393.] At first glance, the picture may seem much like Cimabue's, since both follow the same basic scheme. Yet the differences are important. They reflect not only two contrasting personalities and contrasting local tastes—the gentleness of Duccio is characteristic of Siena—but also the rapid evolution of style.

In Duccio's hands, the Greek manner has become unfrozen. The rigid, angular draperies have given way to an undulating softness. The abstract shading-in-reverse with lines of gold is reduced to a minimum. The bodies, faces, and hands

are beginning to swell with a subtle three-dimensional life. Clearly, the heritage of Hellenistic-Roman illusionism that had always been part of the Byzantine tradition, however dormant or submerged, is asserting itself once more. But there is also a half-hidden Gothic element here. We sense it in the fluency of the drapery, the appealing naturalness of the Infant Christ, and the tender glances by which the figures communicate with each other. The chief source of this Gothic influence must have been Giovanni Pisano (see pages 354–55), who was in Siena from 1285 to 1295 as the sculptor-architect in charge of the cathedral facade.

Apart from the *Madonna*, the *Maestà* includes many small compartments with scenes from the lives of Christ and the Virgin on the reverse side. In these panels, the most mature works of Duccio's career, the cross-fertilization of Gothic and Byzantine elements has given rise to a development of fundamental importance: a new kind of picture space and, with it, a new treatment of narrative. The *Annunciation of the Death of the Virgin* (fig. 501) shows us something we have never seen before in the history of painting: two figures enclosed by an architectural interior.

Ancient painters and their Byzantine successors were quite unable to achieve this space. Their architectural settings always stay behind the figures, so that their indoor scenes tend to look as if they were taking place in an open-air theater, on a stage without a roof. Duccio's figures, in contrast, inhabit a space that is created and defined by the architecture, as if the artist had carved a niche into his panel. Perhaps we will recognize the origin of this spatial framework: it derives from the architectural "housing" of Gothic sculpture (compare especially figs. 472 and 476). Northern Gothic painters, too, had tried to reproduce these architectural settings, but they could do so only by flattening them out completely (as in the *Psalter of St. Louis*, fig. 497). The Italian painters of Duccio's generation, on the other hand, trained as they were in the Greek manner, had acquired enough of the devices of Hellenistic-Roman illusionism (see fig. 290) to let them render such a framework without draining it of its three-dimensional qualities. Duccio, however, is not interested simply in space for its own sake. The architecture is used to integrate the figures within the drama more tellingly than ever before.

Even in the outdoor scenes on the back of the *Maestà*, such as *Christ Entering Jerusalem* (fig. 502), the architecture keeps its space-creating function. The diagonal movement into depth is conveyed not by the figures, which have the same scale throughout, but by the walls on either side of the road leading to the city, by the gate that frames the crowd, and by the structures beyond. Whatever the shortcomings of Duccio's perspective, his architecture demonstrates its capacity to contain and enclose, and for that reason seems more intelligible than similar vistas in ancient or Byzantine art (compare figs. 286 and 348).

GIOTTO. Turning from Duccio to Giotto (1267?–1336/7), we meet an artist of far bolder and more dramatic temper. Ten to 15 years younger than Duccio, Giotto was less close to the Greek manner from the start, despite his probable apprenticeship under Cimabue. [See Primary Sources, nos. 39, 42, and 46, pages 391–94.] As a Florentine, he fell heir to

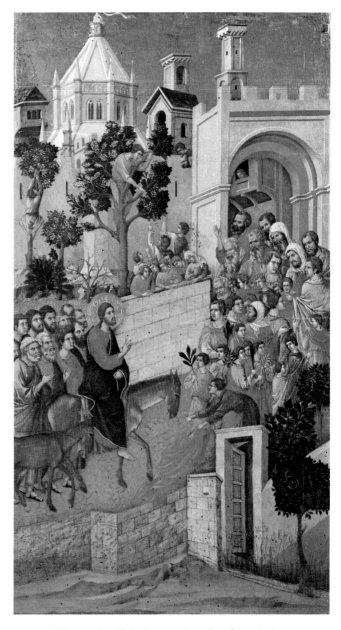

502. Duccio. *Christ Entering Jerusalem,* from the back of the *Maestà Altar.* 1308–11. Tempera on panel, 40 1/2 x 21 1/8" (103 x 53.7 cm). Museo dell'Opera del Duomo, Siena

Cimabue's sense of monumental scale, which made him a wall painter by instinct, rather than a panel painter. The art of Giotto is nevertheless so daringly original that its sources are far more difficult to trace than those of Duccio's style. Apart from his Florentine background as represented by the Greek manner of Cimabue, the young Giotto seems to have been familiar with the work of neo-Byzantine masters of Rome, among whom was Cimabue's contemporary Pietro Cavallini (documented 1272–1303), who practiced both mosaic and fresco. Cavallini's style is an astonishing blend of Byzantine, Roman, and Early Christian elements. The figures

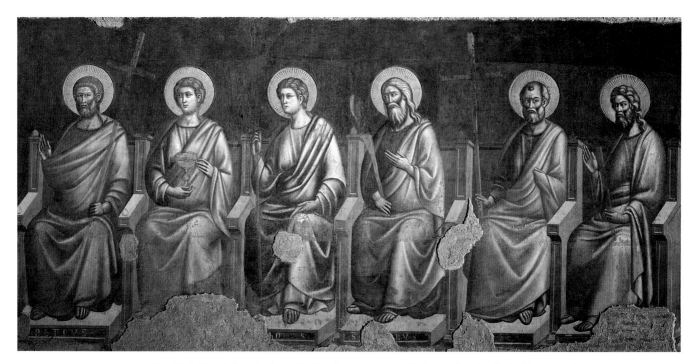

503. Pietro Cavallini. *Seated Apostles,* from *The Last Judgment.* c. 1290. Fresco. Sta. Cecilia in Trastevere, Rome

in his *Last Judgment* (fig. 503) are in the best up-to-date manner of late Byzantine art (compare the *Anastasis* in fig. 349), but he has modeled them in a soft daylight that can only have come from exposure to antique wall painting (see fig. 292). (He was also employed as a fresco restorer.) The result is an almost sculptural monumentality that is remarkably classical. Indeed, these saints have the same calm air and gentle gravity found on the *Sarcophagus of Junius Bassus* (fig. 312), but with the relaxed naturalness of the Gothic.

Cavallini set an important example for Giotto. In Rome Giotto, too, must have become acquainted with Early Christian and ancient Roman mural decoration. Classical sculpture likewise seems to have left an impression on him. More fundamental than any of these, however, was the influence of late medieval Italian sculptors: Nicola and Giovanni Pisano and especially Arnolfo di Cambio. They were the chief intermediaries through whom Giotto first came in contact with the world of Northern Gothic art. The latter remains the most important of all the elements that entered into Giotto's style. Indeed, Northern works such as those illustrated in figure 478 or figure 486 are almost certainly the ultimate source of the emotional impact that distinguishes his work from that of Cavallini and all others.

Of Giotto's surviving murals, those in the Arena Chapel in Padua, done in 1305–6, are the best preserved as well as the most characteristic. The decorations are devoted principally to scenes from the life of Christ, laid in a carefully arranged program consisting of three tiers of narrative scenes (fig. 505) and culminating in the *Last Judgment* at the west end of the chapel. [See Primary Sources, no. 40, page 391.] Giotto depicts many of the same subjects that we find on the reverse of Duccio's

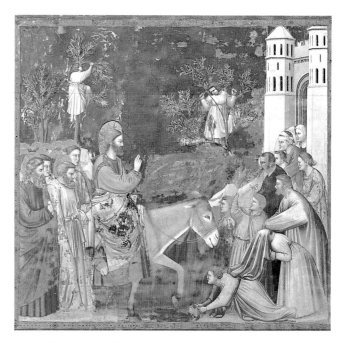

504. Giotto. *Christ Entering Jerusalem.* 1305–6. Fresco. Arena (Scrovegni) Chapel, Padua, Italy

Maestà, including *Christ Entering Jerusalem* (fig. 504). But where Duccio has enriched the traditional scheme, spatially as well as in narrative detail, Giotto subjects it to a radical simplification. The two versions have many elements in common, since they both ultimately derive from Byzantine sources. The difference is that Giotto's version must be based on a prototype of the early sixth century, while Duccio's is nearly 500 years later. In Giotto's painting, the action proceeds parallel to the picture plane. Landscape, architecture, and figures have been reduced to the essential minimum. The austerity of Giotto's art is further emphasized by the sober medium of fresco

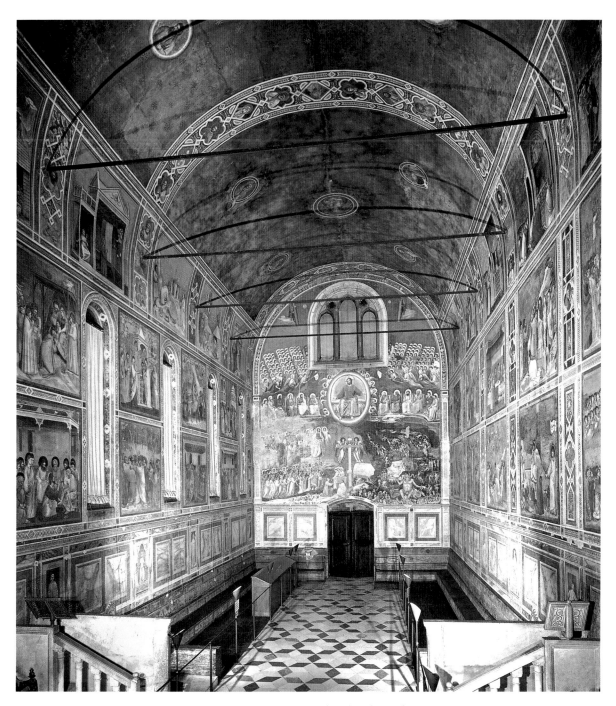

505. Interior, Arena (Scrovegni) Chapel, Padua, Italy. 1305–6

painting, with its limited range and intensity of tones. By contrast, Duccio's picture, which is executed in egg tempera on gold ground, has a jewellike brilliance and sparkling colors. Yet Giotto's work has the far more powerful impact of the two. It makes us feel so close to the event that we have a sense of being participants rather than distant observers.

How does the artist achieve this extraordinary effect? He does so, first of all, by having the entire scene take place in the foreground. Even more important, he presents it in such a way that the beholder's eye level falls within the lower half of the picture. Thus we can imagine ourselves standing on the same ground plane as these painted figures, even though we see

them from well below, whereas Duccio makes us survey the scene from above in "bird's-eye" perspective. The consequences of this choice of viewpoint are truly epoch-making. Choice implies conscious awareness—in this case, awareness of a relationship in space between the beholder and the picture. Duccio, certainly, does not yet conceive his picture space as continuous with the beholder's space. Hence we have the sensation of vaguely floating above the scene, rather than of knowing where we stand. Even ancient painting at its most illusionistic provides no more than a pseudo-continuity in this respect (see figs. 286 and 290). Giotto, on the other hand, tells us where we stand. Above all, he also endows his forms with a

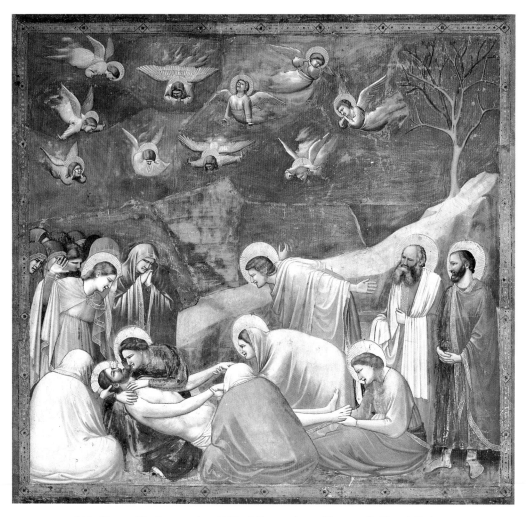

506. Giotto. *The Lamentation.* 1305–6. Fresco. Arena (Scrovegni) Chapel, Padua

three-dimensional reality so forceful that they seem as solid and tangible as sculpture in the round.

With Giotto it is the figures, rather than the architectural framework, that create the picture space. As a result, this space is more limited than Duccio's—its depth extends no further than the combined volumes of the overlapping bodies in the picture—but within its limits it is very much more persuasive. To Giotto's contemporaries, the tactile quality of his art must have seemed a near-miracle. It was this quality that made them praise him as equal, or even superior, to the greatest of the ancient painters, because his forms looked so lifelike that they could be mistaken for reality itself. Equally significant are the stories linking Giotto with the claim that painting is superior to sculpture. This was not an idle boast, as it turned out, for Giotto does indeed mark the start of what might be called "the era of painting" in Western art. The symbolic turning point is the year 1334, when he was appointed head of the Florence Cathedral workshop, an honor and responsibility hitherto reserved for architects or sculptors.

Giotto's aim was not simply to transplant Gothic statuary into painting. By creating a radically new kind of picture space, he had also sharpened his awareness of the picture surface. When we look at a work by Duccio (or his ancient and medieval predecessors), we tend to do so in installments, as it were. Our glance travels from detail to detail at a leisurely pace

until we have surveyed the entire area. Giotto, on the contrary, invites us to see the whole at one glance. His large, simple forms, the strong grouping of his figures, the limited depth of his "stage," all these factors help endow his scenes with an inner coherence such as we have never found before. Notice how dramatically the massed verticals of the "block" of apostles on the left are contrasted with the upward slope formed by the welcoming crowd on the right, and how Christ, alone in the center, bridges the gulf between the two groups. The more we study the composition, the more we come to realize its majestic firmness and clarity. Thus the artist has rephrased the traditional pattern of Christ's entry into Jerusalem to stress the solemnity of the event as the triumphal procession of the Prince of Peace.

Giotto's achievement as a master of design does not fully emerge from any single work. Only if we examine a number of scenes from the Padua fresco cycle do we understand how perfectly the composition in each instance is attuned to the emotional content of the subject. *The Lamentation* (fig. 506) was clearly inspired by a Byzantine example similar to the Nerezi fresco (see fig. 343), which was known in Italy early on. The tragic mood is brought home to us by the formal rhythm of the design as much as by the gestures and expressions of the participants. [See Primary Sources, no. 36, pages 389–90.] The very low center of gravity, and the hunched, bending fig-

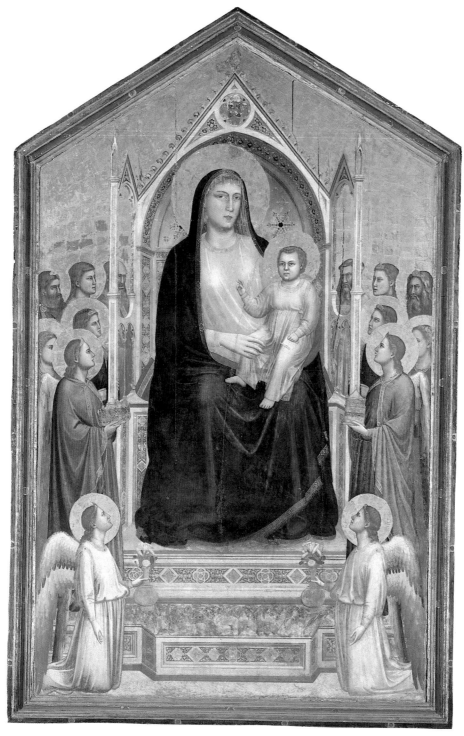

507. Giotto. *Madonna Enthroned.* c. 1310. Tempera on panel, 10'8" x 6'8" (3.3 x 2 m). Galleria degli Uffizi, Florence

ures communicate the somber quality of the scene and arouse our compassion even before we have grasped the specific meaning of the event depicted. With extraordinary boldness, Giotto sets off the frozen grief of the human mourners against the frantic movement of the weeping angels among the clouds, as if the figures on the ground were restrained by their collective duty to maintain the stability of the composition while the angels, small and weightless as birds, do not share this burden.

Once again the impact of the drama is heightened by the severely simple setting. The descending slope of the hill acts as a unifying element and at the same time directs our glance toward the heads of Christ and the Virgin, which are the focal point of the scene. Even the tree has a twin function. Its barrenness and isolation suggest that all of nature somehow shares in the Saviour's death. Yet it also invites us to ponder a more precise symbolic message: it alludes (as does Dante in a passage in the *Divine Comedy*) to the Tree of Knowledge, which the sin of Adam and Eve had caused to wither and which was to be restored to life through the sacrificial death of Christ.

What we have said of the Padua frescoes applies equally to the *Madonna Enthroned* (fig. 507), the most important among the small number of panel paintings by Giotto. Done about

greatness, however, tended to dwarf the next generation of Florentine painters, which produced only followers rather than new leaders. Their contemporaries in Siena were more fortunate in this respect, since Duccio never had the same overpowering impact. As a consequence, it was they, not the Florentines, who took the next decisive step in the development of Italian Gothic painting. Simone Martini (c. 1284–1344), who painted the tiny but intense *The Road to Calvary* (fig. 508) about 1340, may well claim to be the most distinguished of Duccio's disciples. He spent the last years of his life in Avignon, the town in southern France that served as the residence-in-exile of the popes during most of the fourteenth century. Our panel, originally part of a small altar, was probably done there, as it was commissioned by Philip the Bold of Burgundy for the Chartreuse de Champmol.

In its sparkling colors, and especially in the architectural background, it still echoes the art of Duccio (see fig. 502). The vigorous modeling of the figures, on the other hand, as well as their dramatic gestures and expressions, betray the influence of Giotto. While Simone Martini is not much concerned with spatial clarity, he proves to be an extraordinarily acute observer. The sheer variety of costumes and physical types and the wealth of human incident create a sense of down-to-earth reality very different from both the lyricism of Duccio and the grandeur of Giotto.

THE LORENZETTI BROTHERS. This closeness to everyday life also appears in the work of the brothers Pietro and Ambrogio Lorenzetti (both died 1348?), but on a more monumental scale and coupled with a keen interest in problems of space. The boldest spatial experiment is Pietro's triptych of 1342, the *Birth of the Virgin* (fig. 509), where the painted architecture has been correlated with the real architecture of the frame in such a way that the two are seen as a single system. Moreover, the vaulted chamber where the birth takes place occupies two panels. It continues unbroken behind the column that divides the center from the right wing. The left wing represents an anteroom which leads to a large and only partially glimpsed architectural space suggesting the interior of a Gothic church. What Pietro Lorenzetti achieved here is the outcome of a development that began three decades earlier in the work of Duccio (compare fig. 502): the conquest of pictorial space. Only now, however, does the painting surface assume the quality of a transparent window *through* which—not *on* which—we perceive the same kind of space we know from daily experience. Duccio's work alone is not sufficient to explain Pietro's astonishing breakthrough. It became possible, rather, through a combination of the *architectural* picture space of Duccio and the *sculptural* picture space of Giotto.

The same procedure enabled Ambrogio Lorenzetti to unfold a comprehensive view of the entire town before our eyes in his frescoes of 1338–40 in the Siena city hall (fig. 510). [See Primary Sources, no. 47, page 394.] We are struck by the distance that separates this precisely articulated "portrait" of Siena from Duccio's Jerusalem (fig. 502). Ambrogio's mural forms part of an elaborate allegorical program depicting the contrast of good and bad government. To the right on the far wall of figure 510, we see the Commune of Siena guided by Faith, Hope, and Charity and flanked by a host of other

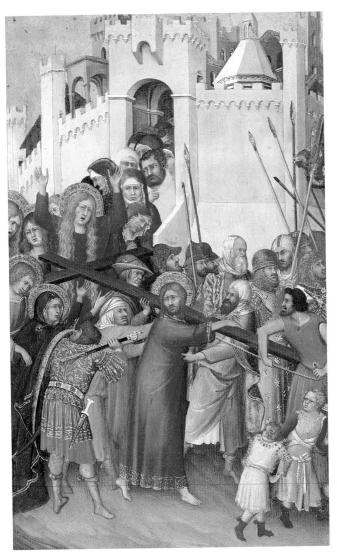

508. Simone Martini. *The Road to Calvary.* c. 1340. Tempera on panel, 9 7/8 x 6 1/8" (25 x 15.5 cm). Musée du Louvre, Paris

the same time as Duccio's *Maestà,* it illustrates once again the difference between Florence and Siena. Its architectural severity clearly derives from Cimabue (see fig. 499). The figures, however, have the same overpowering sense of weight and volume we saw in the frescoes in the Arena Chapel, and the picture space is just as persuasive—so much so, in fact, that the golden halos look like foreign bodies in it.

The throne, of a design based on Italian Gothic architecture, has now become a nichelike structure that encloses the Madonna on three sides and thus "insulates" her from the gold background. Its lavish ornamentation includes one feature of special interest: the colored marble surfaces of the base and of the quatrefoil within the gable. Such make-believe stone textures had been highly developed by ancient painters (see figs. 286 and 290), but the tradition had died out in Early Christian times. Its sudden reappearance here offers concrete evidence of Giotto's familiarity with whatever ancient murals could still be seen in medieval Rome.

MARTINI. There are few artists in the entire history of art who equal the stature of Giotto as a radical innovator. His very

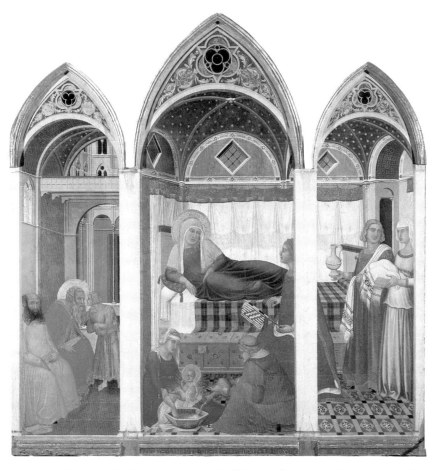

509. Pietro Lorenzetti. *Birth of the Virgin.* 1342. Tempera on panel, 6'1¹/₂" x 5'11¹/₂" (1.9 x 1.8 m). Museo dell'Opera del Duomo, Siena

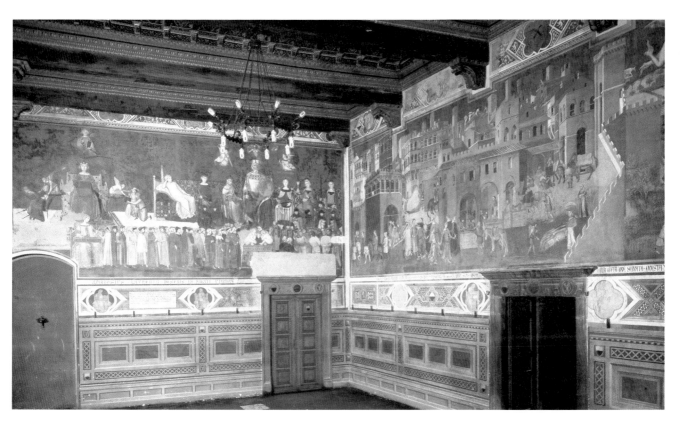

510. Ambrogio Lorenzetti. *The Commune of Siena* (left), *Good Government in the City* and portion of *Good Government in the Country* (right). 1338–40. Frescoes in the Sala della Pace, Palazzo Pubblico, Siena

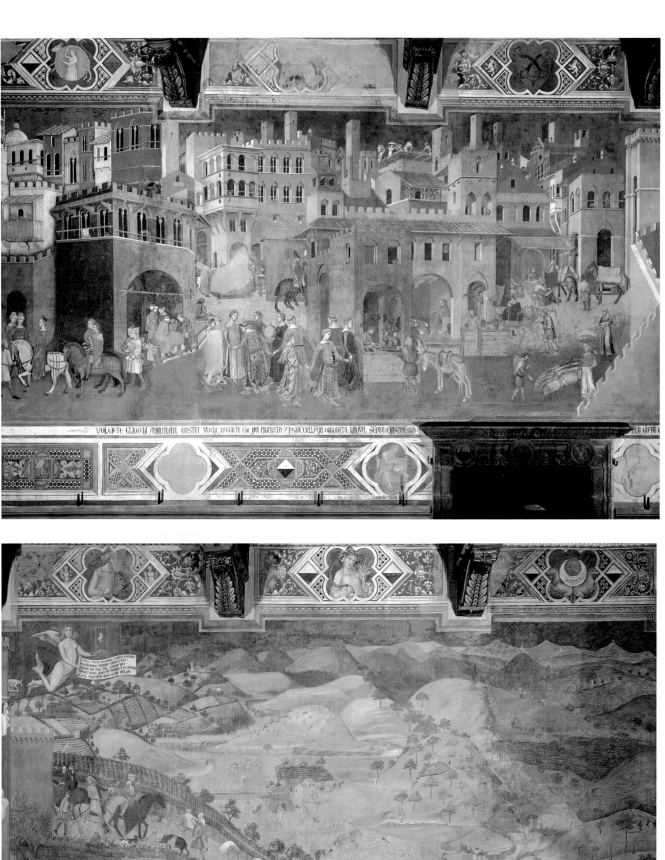

VOLGETE GLIOCCHI AMIRAR COSTEI VOLGE ROGETE CHE QVI FIGVRATA Z PVE CELLA QV CORONATA LAVAL SOPRA OGNISCVIR SVO...

ONE SERVATA QVESTA NITV ROPII VELTRA RISPRE OE ELLA GVRDE OIPEOE CH LEI OIOIRI Z LOR INTRICA Z RASCIE CH LA SVO RIVOE NASCIE EL CHVITER COLOR OPERIO PEDE Z HOLIRION OIR DEBITE PEDE

511. *(opposite, above)* Ambrogio Lorenzetti.
Good Government in the City. Fresco, width of entire wall
46' (14 m). Palazzo Pubblico, Siena

512. *(opposite, below)* Ambrogio Lorenzetti. *Good Government in the
Country.* Palazzo Pubblico, Siena

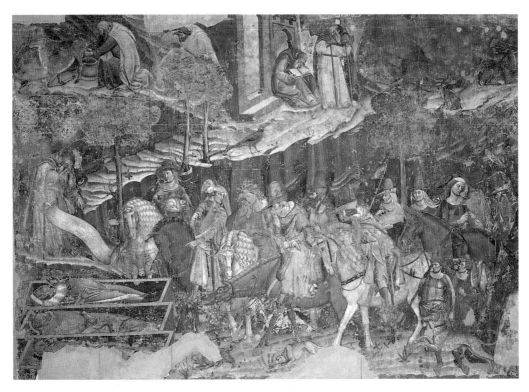

513. Francesco Traini. *The Triumph of Death* (detail). c. 1325–50. Fresco. Camposanto, Pisa

symbolic figures. The artist, in order to show the life of a well-ordered city-state, had to fill the streets and houses with teeming activity (fig. 511). The bustling crowd gives the architectural vista its striking reality by introducing the human scale. On the right, outside the city walls, the *Good Government* fresco provides a view of the Sienese countryside, fringed by distant mountains (fig. 512). It is a true landscape—the first since ancient Roman times—full of sweeping depth yet distinguished from its classical predecessors (such as fig. 287) by an ingrained orderliness, which lends it a domesticated air. Here the presence of people is not accidental. They have taken full possession of nature, terracing the hillsides with vineyards, patterning the valleys with the geometry of fields and pastures. In such a setting, Ambrogio observes the peasants at their seasonal labors, recording a rural Tuscan scene so characteristic that it has hardly changed during the past 600 years.

THE BLACK DEATH. The first four decades of the fourteenth century in Florence and Siena had been a period of political stability and economic expansion as well as of great artistic achievement. In the 1340s both cities suffered a series of catastrophes whose echoes were to be felt for many years. Banks and merchants went bankrupt by the score, internal upheavals shook the government, there were repeated crop failures, and in 1348 the epidemic of bubonic plague—the

Black Death—that spread throughout Europe wiped out more than half their urban population. [See Primary Sources, no. 48, page 394.] The popular reaction to these calamitous events was mixed. Many people regarded them as signs of divine wrath, warnings to a sinful humanity to forsake the pleasures of this earth; in such people the Black Death engendered a mood of otherworldly exaltation. To others, such as the gay company in Boccaccio's *Decameron,* the fear of sudden death merely intensified the desire to enjoy life while there was yet time. These conflicting attitudes are reflected in the pictorial theme of the Triumph of Death.

TRAINI. The most impressive version of this subject is an enormous fresco, attributed to the Pisan master Francesco Traini (documented c. 1321–1363), in the Camposanto, the cemetery building next to Pisa Cathedral. In a particularly dramatic detail (fig. 513), the elegantly costumed men and women on horseback have suddenly come upon three decaying corpses in open coffins. Even the animals are terrified by the sight and smell of rotting flesh. Only the hermit, having renounced all earthly pleasures, points out the lesson of the scene. But will the living accept the lesson, or will they, like the characters of Boccaccio, turn away from the shocking spectacle more determined than ever to pursue their hedonistic ways? The artist's own sympathies seem curiously divided. His style,

514. Francesco Traini. Sinopia drawing for *The Triumph of Death* (detail). Camposanto, Pisa

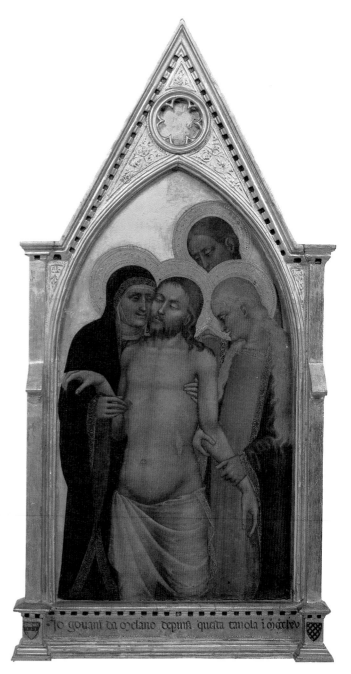

515. Giovanni da Milano. *Pietà*. 1365. Oil on panel, 48 x 22³/₄" (122 x 57.5 cm). Galleria dell'Accademia, Florence

far from being otherworldly, recalls the realism of Ambrogio Lorenzetti, although the forms are harsher and more expressive.

In a fire that occurred in 1944, Traini's fresco was badly damaged and had to be detached from the wall in order to save what was left of it. This procedure exposed the first, rough coat of plaster underneath, on which the artist had sketched out his composition (fig. 514). These drawings, of the same size as the fresco itself, are amazingly free and sweeping. They reveal Traini's personal style more directly than the painted version, which was carried out with the aid of assistants. Because they are done in red, these underdrawings are called *sinopie* (an Italian word derived from ancient Sinope, in Asia Minor, which was famous as a source of brick-red earth pigment).

FRESCO PAINTING. Sinopie serve to introduce us to the standard technique of painting frescoes in the fourteenth century. After the first coat of plaster (*arriccio* or *arricciato*) had dried, the wall was divided into squares using a ruler or chalk lines tied to nails. The design was then brushed in with a thin ocher paint, and the outline developed further in charcoal, with the details being added last in sinopia. During the Renaissance, sinopie were replaced by cartoons: sheets of heavy paper or cardboard (*cartone*) on which the design was drawn in the studio. The design was then pricked with small holes and transferred to the wall by dusting ("pouncing") it with chalk. In the High Renaissance, however, the contours were often simply pressed through the paper with a stylus. Be that as it may, each section of the wall was covered with just enough fresh plaster (*intonaco*) to last the current session, in order for the water-based paints to sink in. (Some insoluble pigments could only be applied *a secco* to dry plaster.) Each

day's work progressed in this manner. Since the work had to be done on a scaffold, it was carried out from the top down, usually in horizontal strips. Needless to say, fresco painting was a slow process requiring numerous assistants for large projects.

GIOVANNI DA MILANO. Traini still retains a strong link with the great masters of the second quarter of the century. More characteristic of Tuscan painting after the Black Death are the painters who reached maturity around the 1350s. None of them can compare with the earlier artists whose work we have discussed. Their style, in comparison, seems dry and formula-ridden. Yet they were capable, at their best, of expressing the somber mood of the time with memorable intensity. The *Pietà* of 1365 (fig. 515) by Giovanni da Milano (documented 1346–1369) has all the emotional appeal of a German *Andachtsbild* (compare fig. 479), although the heritage of Giotto can be clearly felt even here.

516. Jean Pucelle. *The Betrayal of Christ* and *Annunciation,* from the *Hours of Jeanne d'Evreux.* 1325–28. Tempera and gold leaf on parchment, each page, 3¹/₂ x 2⁷/₁₆" (8.9 x 6.2 cm). Shown larger than actual size. The Metropolitan Museum of Art, New York. The Cloisters Collection, Purchase, 1954

North of the Alps

ILLUMINATED MANUSCRIPTS. We are now in a position to turn once more to Gothic painting north of the Alps. What happened there during the latter half of the fourteenth century was determined in large measure by the influence of the great Italians. Some examples of this influence can be found even earlier, such as the *Annunciation* (fig. 516) from the private prayer book—called a "book of hours"—illuminated by Jean Pucelle in Paris about 1325–28 for Jeanne d'Evreux, queen of France. The style of the figures still recalls Master Honoré (see fig. 498), but the delicate *grisaille* (painting in gray) lends them a soft plasticity that was not explored by other artists for another 50 years. This is not Pucelle's only contribution: the architectural interior clearly derives from Duccio (fig. 501). It had taken less than 20 years for the fame of the *Maestà* to spread from Tuscany to the Île-de-France.

In taking over the new picture space, however, Jean Pucelle had to adapt it to the special character of a manuscript page, which lends itself far less readily than a panel to being treated as a window. The Virgin's chamber no longer fills the entire picture surface. It has become an ethereal cage that floats on the blank parchment background (note the supporting angel on the right) like the rest of the ornamental framework, so that the entire page forms a harmonious unit. As we explore the

details of this framework, we realize that most of them have nothing to do with the religious purpose of the manuscript: the kneeling queen inside the initial D is surely meant to be Jeanne d'Evreux at her devotions, but who could be the man with the staff next to her? He seems to be listening to the lute player perched on the tendril above him. The page is filled with other enchanting vignettes. A rabbit peers from its burrow beneath the girl on the left, and among the foliage leading up to the initial we find a monkey and a squirrel.

DRÔLERIE. These fanciful marginal designs—or *drôleries*—are a characteristic feature of Northern Gothic manuscripts. They had originated more than a century before Jean Pucelle in the regions along the English Channel, whence they spread to Paris and all the other centers of Gothic art. [See Primary Sources, no. 49, page 395.] Their subjects encompass a wide range of motifs: fantasy, fable, and grotesque humor, as well as acutely observed scenes of everyday life, appear side by side with religious themes. The essence of drôlerie is its playfulness, which marks it as a special domain where the artist enjoys almost unlimited freedom. It is this freedom, comparable to the license traditionally claimed by the court jester, that accounts for the wide appeal of drôlerie during the later Middle Ages.

517. Italian follower of Simone Martini (Matteo Giovannetti?). *Scenes of Country Life* (detail). c. 1345. Fresco. Palace of the Popes, Avignon

The innocent facade of Pucelle's drôleries nevertheless hides a serious intent. The four figures at the bottom of the right-hand page are playing a game of tag called Froggy in the Middle, a reference to the Betrayal of Christ on the opposite page. We will recognize this dramatic scene as the descendant, however indirect, of the mosaic in S. Apollinare Nuovo (see fig. 309). Below the *Betrayal* are two knights on goats jousting at a barrel. We may see in this image not only a mockery of courtly chivalry but also a veiled reference to Christ as a "scapegoat" and the spear of Longinus that will piece his side at the Crucifixion.

FRESCOES AND PANEL PAINTINGS. As we approach the middle years of the fourteenth century, Italian influence becomes ever more important in Northern Gothic painting. Sometimes this influence was transmitted by Italian artists active on northern soil, for example, Simone Martini (see page 370), who worked at the Palace of the Popes near Avignon (fig. 517).

One gateway of Italian influence was the city of Prague, the capital of Bohemia, thanks to Emperor Charles IV (1316–1378), the most remarkable ruler since Charlemagne. Charles received an excellent education in Paris at the French court of Charles IV, whose daughter he married and in whose

518. Bohemian Master. *Death of the Virgin.* 1355–60. Tempera on panel, 39 ³⁄₈ x 28" (100 x 71 cm). Museum of Fine Arts, Boston.

William Francis Warden Fund; Seth K. Sweetser Fund, The Henry C. and Martha B. Angell Collection, Juliana Cheney Edwards Collection, Gift of Martin Brimmer, and Mrs. Frederick Frothingham; by exchange

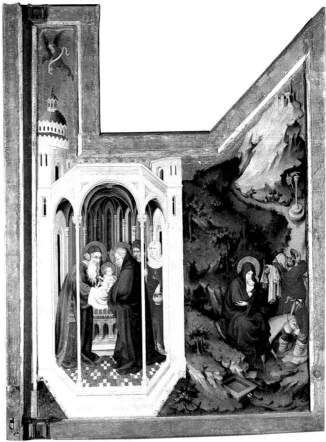

519. Melchior Broederlam. *Annunciation* and *Visitation; Presentation in the Temple;* and *Flight into Egypt.* 1394–99.
Tempera on panel, each 65 x 49¼" (167 x 125 cm). Musée des Beaux-Arts, Dijon, France

honor he changed his name from Wenceslaus. He returned to Prague and eventually succeeded his father as king of Bohemia in 1346. As a result of Charles' alliance with Pope Clement VI, who resided at Avignon during the papal exile, Prague became an independent archbishopric. It was also through Clement's intervention that Charles was elevated to Holy Roman Emperor at Aachen in 1349 by the German Electors. This title was confirmed by coronations in Milan and Rome six years later. In exchange, Charles supported Pope Urban V's return to Rome in 1367.

Like Charlemagne before him, Charles sought to make his capital a center of learning, and in 1348 he established a university along the lines of that in Paris, which attracted many of the best minds from throughout Europe. He also became an active patron of the arts, which he supported by founding an artists' guild. Prague rapidly developed into an international cultural center second only to Paris itself. Charles was nevertheless impressed most by the art he saw during his two visits to Italy. (He is known to have commissioned works by several Italian painters.) Thus, the *Death of the Virgin* (fig. 518), made by a Bohemian master about 1355–60, brings to mind the achievements of the great Sienese painters. Its glowing richness of color recalls Simone Martini, who, it will be remembered, had worked at Avignon. The carefully articulated architectural interior further betrays its descent from such works as Pietro Lorenzetti's *Birth of the Virgin* (fig. 509), but it lacks the spaciousness of its Italian models. Italian, too, is the vigorous modeling of the heads and the overlapping of the fig-

ures, which reinforces the three-dimensional quality of the design but raises the awkward question of what to do with the halos. (Giotto, we will remember, had faced the same problem in his *Madonna Enthroned;* compare fig. 507). Still, the Bohemian master's picture is not just an echo of Italian painting. The gestures and facial expressions convey an intensity of emotion that represents the finest heritage of Northern Gothic art. In this respect, our panel is far more akin to the *Death of the Virgin* at Strasbourg Cathedral (fig. 470) than to any Italian work.

The International Style

BROEDERLAM. Toward the year 1400, the merging of Northern and Italian traditions gave rise to a single dominant style throughout western Europe. This International Style was not confined to painting—we have used the same term for the sculpture of the period—but painters clearly played the main role in its development. Among the most important was Melchior Broederlam (flourished c. 1387–1409), a Fleming who worked for the court of the duke of Burgundy in Dijon, where he would have known Simone Martini's *The Road to Calvary* (fig. 508). Figure 519 shows the panels of a pair of shutters for an altar shrine that Broederlam did in 1394–99 for the Chartreuse de Champmol. (The interior consists of an elaborately carved relief by Jacques de Baerze showing the Adoration of the Magi, the Crucifixion, and the Entombment.) Each wing is really two pictures within one frame. Landscape and architecture stand abruptly side by side, even though the artist has

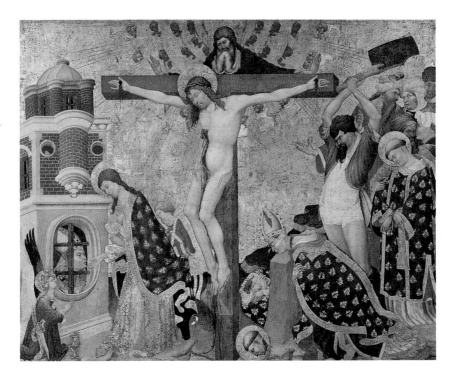

520. Jean Malouel and Henri Bellechose. *Martyrdom of St. Denis with the Trinity.* c. 1415. Tempera on panel, 5'3³/₈" x 6'10⁵/₈" (1.61 x 2.1 m). Musée du Louvre, Paris

tried to suggest that the scene extends around the building.

Compared to paintings by Pietro and Ambrogio Lorenzetti, Broederlam's picture space still strikes us as naïve in many ways. The architecture looks like a doll's house, and the details of the landscape are quite out of scale with the figures. Yet the panels convey a far stronger feeling of depth than we have found in any previous Northern work. The reason for this is the subtlety of the modeling. The softly rounded shapes and the dark, velvety shadows create a sense of light and air that more than makes up for any shortcomings of scale or perspective. This soft, pictorial quality is a hallmark of the International Style. It appears as well in the ample, loosely draped garments with their fluid curvilinear patterns of folds, which remind us of Sluter and Ghiberti (see figs. 481 and 492).

Our panels also exemplify another characteristic of the International Style: its "realism of particulars." It is the same kind of realism we encountered first in Gothic sculpture (see fig. 474) and somewhat later among the marginal drôleries of manuscripts. We find it in the left panel in the carefully rendered foliage and flowers of the enclosed garden to the left, and in the clear distinction between the Gothic antechamber and the Romanesque temple. We see it as well in the right panel, in the delightful donkey (obviously drawn from life), and in the rustic figure of St. Joseph, who looks and behaves like a simple peasant and thus helps to emphasize the delicate, aristocratic beauty of the Virgin. This painstaking concentration on detail gives Broederlam's work the flavor of an enlarged miniature rather than of a large-scale painting, even though the panels are more than five feet tall.

The expansion of subject matter during the International Style was allied to a comparable growth in symbolism. In the left panel, for example, the lily signifies Mary's virginity, as does the enclosed garden next to her, while the contrasting Romanesque and Gothic architecture stands for the Old and New Testaments, respectively. This important development paves the way for the dramatic elaboration of symbolic mean-ing that occurs a mere 25 years later under the Master of Flémalle.

MALOUEL AND BELLECHOSE. More monumental still is the somewhat later *Martyrdom of St Denis* (fig. 520), also from the Chartreuse de Champmol, which was probably begun by the court painter Jean Malouel (Jan Maelwel; active 1386–1415), but completed after his death by his successor, Henri Bellechose (died 1440/44), who likewise was born in the Netherlands. The subject of the painting is unique: it equates Denis' martyrdom with the Crucifixion. At the left Christ himself administers the last rites to Denis, while to the right we see the decapitation of the saint and his companions. Malouel also worked as an illuminator, but he was clearly a panel painter at heart. Although the oddly diminutive prison is a remnant of manuscript illustrations, the figures combine typically French gracefulness with an impressive bulk that can have come only from Italian art (compare fig. 515). The more robust figures, such as the executioner, were probably done by Bellechose, though the difference is one primarily of temperament than of style.

THE BOUCICAUT MASTER. Despite the growing importance of panel painting, book illumination remained the leading form of painting in northern Europe at the time of the International Style. Among the finest of the many manuscript painters employed by French courts was the Boucicaut Master, who was perhaps the Bruges artist Jacques Coen. In *The Story of Adam and Eve* (fig. 521) the promise of the Broederlam panels has been fulfilled, as it were: landscape and architecture are united in deep, atmospheric space, although the perspective is skewed. Even such intangible things as the starry sky have become paintable. Note, too, how the sky becomes lighter toward the horizon—the earliest-known example of atmospheric perspective. Every detail, be it divine or natural, is rendered as if it were a miraculous revelation. Stemming

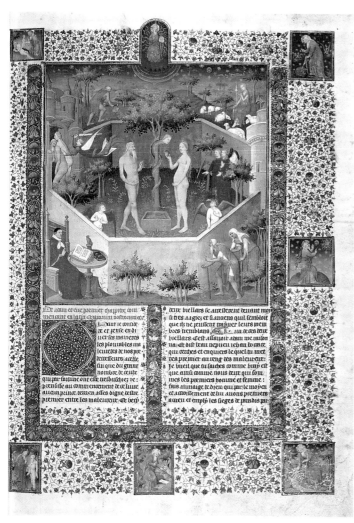

521. The Boucicaut Master. *The Story of Adam and Eve,* from Giovanni Boccaccio, *Des cas des nobles hommes et femmes* (The Fates of Illustrious Men and Women). Paris c. 1415. Gold leaf, gold paint, and tempera on vellum, 16³/4 x 11¹/2" (42.5 x 29.3 cm). The J. Paul Getty Museum, Los Angeles. Ms. 63, fol. 3

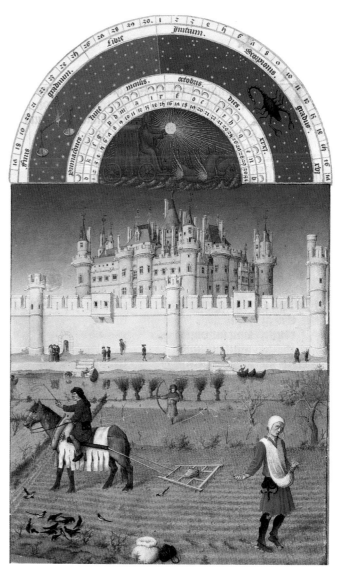

522. The Limbourg Brothers. *October,* from *Les Très Riches Heures du Duc de Berry.* 1413–16. 8⁷/8 x 5³/8" (22.5 x 13.7 cm). Musée Condé, Chantilly, France

from St. Augustine, who considered the temporal realm a metaphor of the spiritual, this attitude represents a decisive change that soon leads to Late Gothic art.

THE LIMBOURG BROTHERS. The International Style reached its most advanced phase in the luxurious book of hours known as *Les Très Riches Heures du Duc de Berry,* produced for the brother of the king of France, a man of far from admirable character but the most lavish art patron of his day. The artists were Pol de Limbourg and his two brothers, Flemings all who were introduced to the court by their uncle, who was none other than Jean Malouel. They must have visited Italy, for their work includes numerous motifs and whole compositions borrowed from the great masters of Tuscany.

The most remarkable pages of *Les Très Riches Heures* are those of the calendar, with their elaborate depiction of the life of humanity and nature throughout the months of the year. Such cycles, originally consisting of 12 single figures each performing an appropriate seasonal activity, had long been an established tradition in medieval art (compare fig. 474). Jean Pucelle had enriched the margins of the calendar pages of his

books of hours by emphasizing the changing aspects of nature in addition to the labors of the months. The Limbourg brothers, however, integrated all these elements into a series of panoramas of human life in nature.

The illustration for the month of October (fig. 522) shows the sowing of winter grain. It is a bright, sunny day, and the figures—for the first time since classical antiquity—cast visible shadows on the ground. We marvel at the wealth of realistic detail, such as the scarecrow in the middle distance or the footprints of the sower in the soil of the freshly plowed field. The sower is memorable in other ways as well. His tattered clothing, his unhappy air, go beyond mere description. Although peasants were often caricatured in Gothic art, the portrayal here is surprisingly sympathetic, as it is throughout this book of hours. He is meant to be a pathetic figure, to arouse our awareness of the miserable lot of the peasantry in contrast to the life of the aristocracy, as symbolized by the splendid castle on the far bank of the river. (The castle, we will recall, is a "portrait" of the Gothic Louvre, the most lavish structure of its kind at that time; see pages 335–36.)

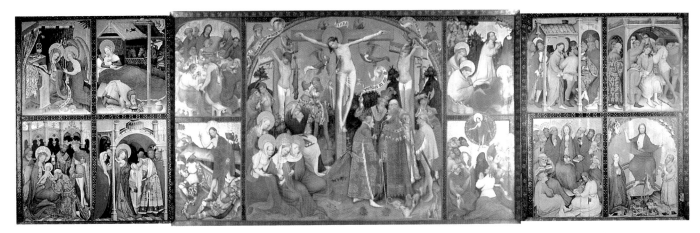

523. Konrad von Soest. *The Wildunger Altarpiece.* 1403? Panels, height 6'6³/4" (2 m). Church, Bad Wildungen, Germany

SOEST. The International Style spread to Germany from France and Bohemia primarily along the Rhine and Danube rivers until it eventually converged on Cologne and nearby Westphalia. The greatest representative of this regional style was Konrad von Soest (active 1394–1422) of Dortmund, whose *Wildunger Altarpiece* (fig. 523) is a truly international blend of elements drawn from throughout Europe. The *Crucifixion* is descended from Duccio's *Maestà* altar by way of Paris, which accounts for the willowy Christ and delicate Mary. Her grief is sweetly lyrical, in contrast to the anguished despair of St. John behind her. The genteel, courtly throng to the left of Christ (the "sinister" side) is patently wicked, however, and the contrast between the two groups could hardly be more telling. The side panels, however, derive entirely from Bohemian art. Densely packed with figures, they have a drama that is uniquely German but with the refinement characteristic of the International Style as a whole.

MASTER FRANCKE. This intensely expressive manner culminates in the paintings of Master Francke, a Netherlander who probably worked in Paris and Westphalia before settling in Hamburg as a member of the Dominican order. *Christ Carrying the Cross* (fig. 524) on the *Englandfahrer Altarpiece,* completed in 1424, has the physical brutality we encountered in the Naumburg Master's *Kiss of Judas* (fig. 477), but now it is matched by an expressive violence that makes us feel the full force of Jesus' suffering at the hands of the malevolent crowd, with its coarse, leering faces. Not until Hieronymus Bosch nearly a hundred years later will we again encounter such a pervasive sense of evil. Yet in the sorrowful faces to the left we can sense Master Francke's continuing allegiance to the elegant manner of the International Style.

GENTILE DA FABRIANO. Italy was also susceptible to the International Style, although it gave more than it received. The altarpiece with the three Magi and their train by Gentile da Fabriano (c. 1370–1427; fig. 525), the greatest Italian painter of the International Style, shows that he

524. Master Francke. *Christ Carrying the Cross,* from the *Englandfahrer Altarpiece.* 1424. Panel, 39 x 35" (99 x 88.9 cm). Kunsthalle, Hamburg

knew the work of the Limbourg brothers. The costumes here are as colorful, the draperies as ample and softly rounded, as in Northern painting. The Holy Family on the left almost seems in danger of being overwhelmed by the festive pageant pouring down upon it from the hills in the far distance. The foreground includes more than a dozen marvelously well-observed animals, not only the familiar ones but hunting leopards, camels, and monkeys. (Such creatures were eagerly collected by the princes of the period, many of whom kept private zoos.) The Oriental background of the Magi is fur-

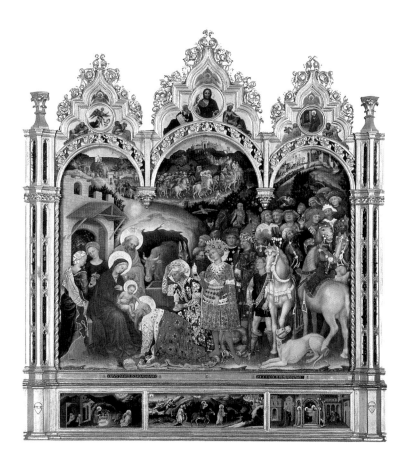

525. Gentile da Fabriano. *The Adoration of the Magi.* 1423. Oil on panel, 9'10 1/8" x 9'3" (3 x 2.8 m). Galleria degli Uffizi, Florence

526. Gentile da Fabriano. *The Nativity,* from the predella of the *Adoration of the Magi.* 1423. 12 1/4 x 29 1/2" (31 x 75 cm). Galleria degli Uffizi, Florence

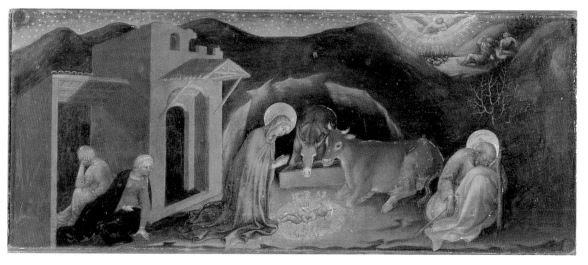

ther emphasized by the Mongolian facial cast of some of their companions. It is not these exotic touches, however, that mark our picture as the work of an Italian master but something else, a greater sense of weight, of physical substance, than we could hope to find among the Northern representatives of the International Style.

Despite his love of fine detail, Gentile is obviously a painter used to working on a large scale, rather than a manuscript illuminator at heart. The panels decorating the base, or predella, of the altarpiece have a monumentality that belies their small size. Gentile was thoroughly familiar with Sienese art. Thus, the *Flight into Egypt* in the center panel is indebted to Ambrogio Lorenzetti's frescoes in the Siena city hall (fig. 510), while the *Presentation in the Temple* to the right is based on another scene by the same artist that was also ultimately the source of Broederlam's depiction. They nevertheless show that Gentile, too, commanded

the delicate pictorial effects of a miniaturist when he wanted to.

Although he was not the first artist to depict it, the night scene in *The Nativity* in the left panel (fig. 526), partly based on the vision received by the fourteenth-century Swedish princess St. Bridget in Bethlehem, has an unprecedented poetic intimacy. The entire picture is dominated by the new awareness of light as an independent factor, separate from form and color, that we first observed in the October page of *Les Très Riches Heures.* Even though the main sources of illumination are the divine radiance of the newborn Child ("the light of the world") and of the angel bringing the glad tidings to the shepherds in the fields, their effect is as natural as if the Virgin were kneeling by a campfire. (Note the strong cast shadows.) Yet, the new world of artistic possibilities it opened up were not to be fully explored until two centuries later—characteristically enough, by Northern artists.

Primary Sources for Part Two

The following is a selection of excerpts, in modern translations, from original texts by poets, historians, religious figures, and artists of the Early Christian and Byzantine eras through the Middle Ages. These readings are intended to supplement the main text and are keyed to it. Their full citations are given in the Credits section at the end of the book.

20
The Holy Bible, Exodus 20:1–5

Exodus, the second book of the Old Testament, is one of five books traditionally attributed to Moses (these five are the Hebrew Torah). Exodus tells of the departure of the Jews from Egypt in the thirteenth century B.C. In chapter 20, God speaks to Moses on Mount Sinai and gives him the Ten Commandments. The second commandment pertains to images.

And the Lord spoke all these words: I am the Lord thy God, who brought thee out of the land of Egypt. . . .
Thou shalt not have strange gods before me.
Thou shalt not make to thyself a graven thing, nor the likeness of any thing that is in heaven above, or in the earth beneath, nor of those things that are in the waters under the earth.
Thou shalt not adore them, nor serve them.

21
Pope Gregory I (reigned 590–604)
From a letter to Serenus of Marseille

Bishop Serenus apparently moved to discourage excessive acts of devotion to paintings in his church by having the images destroyed. In this letter of 600 A.D., Pope Gregory the Great reprimands him, reminding him that images serve to teach those who cannot read. This remained the standard defense of figural painting and sculpture in the Western church through the Middle Ages.

Word has . . . reached us that you . . . have broken the images of the saints with the excuse that they should not be adored. And indeed we heartily applaud you for keeping them from being adored, but for breaking them we reproach you. . . . To adore images is one thing; to teach with their help what should be adored is another. What Scripture is to the educated, images are to the ignorant, who see through them what they must accept; they read in them what they cannot read in books. This is especially true of the pagans. And it particularly behooves you, who live among pagans, not to allow yourself to be carried away by just zeal and so give scandal to savage minds. Therefore you ought not to have broken that which was placed in the church not in order to be adored but solely in order to instruct the minds of the ignorant. It is not without reason that tradition permits the deeds of the saints to be depicted in holy places.

22
The Book of the Popes (Liber Pontificalis),
from the life of Pope Sylvester I

This text is an official history of the Roman papacy from St. Peter (died c. 64 A.D.) to the twelfth century. Its biographies of the early popes were compiled from archival documents, for example this list of gifts to Old St. Peter's by the emperor Constantine in the time of Pope Sylvester I (314–335 A.D.). Lavish imperial donations like these set a standard which subsequent popes and other prelates continued to match.

Constantine Augustus built the basilica of blessed Peter, the apostle, . . . and laid there the coffin with the body of the holy Peter; the coffin itself he enclosed on all sides with bronze. . . . Above he set porphyry columns for adornment and other spiral columns which he brought from Greece. He made a vaulted apse in the basilica, gleaming with gold, and over the body of the blessed Peter, above the bronze which enclosed it, he set a cross of purest gold, . . . He gave also 4 brass candlesticks, 10 feet in height, overlaid with silver, with figures in silver of the acts of the apostles, . . . 3 golden chalices, . . . 20 silver chalices, . . . 2 golden pitchers, . . . 5 silver pitchers, . . . a golden paten with a turret of purest gold and a dove, . . . a golden crown before the body, that is a chandelier, with 50 dolphins, . . . 32 silver lamps in the basilica, with dolphins, . . . for the right of the basilica 30 silver lamps, . . . the altar itself of silver overlaid with gold, adorned on every side with gems, 400 in number, . . . a censer of purest gold adorned on every side with jewels.

23
Procopius of Caesarea (6th century)
From *Buildings*

Procopius was an historian during the reign of Emperor Justinian. He wrote an entire book (c. 550 A.D.?) about the fortifications, aqueducts, churches, and other public buildings constructed by Justinian throughout the Byzantine Empire. The book begins with the greatest of these, Hagia Sophia (figs. 326–28).

The Emperor, disregarding all considerations of expense, . . . raised craftsmen from the whole world. It was Anthemius of Tralles, the most learned man in the discipline called engineering, . . . that ministered to the Emperor's zeal by regulating the work of the builders and preparing in advance designs of what was going to be built. He had as partner another engineer called Isidore, a native of Miletus. . . .

So the church has been made a spectacle of great beauty, stupendous to those who see it and altogether incredible to those who hear of it. . . . It subtly combines its mass with the harmony of its proportions, having neither any excess nor any deficiency, inasmuch as it is more pompous than ordinary [buildings] and considerably more decorous than those which are huge beyond measure; and it abounds exceedingly in gleaming sunlight. You might say that the [interior] space is not illuminated by the sun from the outside, but that the radiance is generated within, so great an abundance of light bathes this shrine all round. . . . In the middle of the church there rise four man-made eminences which are called piers, two on the north and two on the south, . . . each pair having between them exactly four columns. The eminences are built to a great height. . . . As you see them, you could suppose them to be precipitous mountain peaks. Upon these are placed four arches so as to form a square, their ends coming together in pairs and made fast at the summit of those piers, while the rest of them rises to an immense height. Two of the arches, namely those facing the rising and the setting sun, are suspended over empty air, while the others have beneath them some kind of structure and rather tall columns. Above the arches the construction rises in a circle. . . . Rising above this circle is an enormous spherical dome which makes the building exceptionally

beautiful. It seems not to be founded on solid masonry, but to be suspended from heaven by that golden chain and so cover the space. All of these elements, marvellously fitted together in mid-air, suspended from one another and reposing only on the parts adjacent to them, produce a unified and most remarkable harmony in the work, and yet do not allow the spectators to rest their gaze upon any one of them for a length of time, but each detail readily draws and attracts the eye to itself. Thus the vision constantly shifts round, and the beholders are quite unable to select any particular element which they might admire more than all the others. No matter how much they concentrate their attention on this side and that, and examine everything with contracted eyebrows, they are unable to understand the craftsmanship and always depart from there amazed by the perplexing spectacle.

24
St. Theodore the Studite (759–826 A.D.)
From *Second and Third Refutations of the Iconoclasts*

Theodore of the Stoudios monastery in Constantinople was a principal defender of icons against the Iconoclasts. He refuted their charges of idolatry by examining how an image is and is not identical to its prototype (the person portrayed). Some of his arguments reflect the Neo-Platonic theory expounded by Plotinus that the sense-world is related to the divine by emanation.

The holy Basil [St. Basil the Great, c. 329–379 A.D.] says, "The image of the emperor is also called 'emperor,' yet there are not two emperors, nor is his power divided, nor his glory fragmented. Just as the power and authority which rules over us is one, so also the glorification which we offer is one, and not many. Therefore the honor given to the image passes over to the prototype." . . . In the same way we must say that the icon of Christ is also called "Christ," and there are not two Christs; nor in this case is the power divided, nor the glory fragmented. The honor given the image rightly passes over to the prototype. . . .

Every image has a relation to its archetype; the natural image has a natural relation, while the artificial image has an

artificial relation. The natural image is identical both in essence and in likeness with that of which it bears the imprint: thus Christ is identical with His Father in respect to divinity, but identical with His mother in respect to humanity. The artificial image is the same as its archetype in likeness, but different in essence, like Christ and His icon. Therefore there is an artificial image of Christ, to whom the image has its relation. . . .

It is not the essence of the image which we venerate, but the form of the prototype which is stamped upon it, since the essence of the image is not venerable. Neither is it the material which is venerated, but the prototype is venerated together with the form and not the essence of the image. . . .

If every body is inseparably followed by its own shadow, and no one in his right mind could say that a body is shadowless, but rather we can see in the body the shadow which follows, and in the shadow the body which precedes: thus no one could say that Christ is imageless, if indeed He has a body with its characteristic form, but rather we can see in Christ His image existing by implication and in the image Christ plainly visible as its prototype. . . .

By its potential existence even before its artistic production we can always see the image in Christ; just as, for example, we can see the shadow always potentially accompanying the body, even if it is not given form by the radiation of light. In this manner it is not unreasonable to reckon Christ and His image among things which are simultaneous. . . .

If, therefore, Christ cannot exist unless His image exists in potential, and if, before the image is produced artistically, it subsists always in the prototype: then the veneration of Christ is destroyed by anyone who does not admit that His image is also venerated in Him.

25

Nicholas Mesarites (c. 1163–after 1214)
From *Description of the Church of the Holy Apostles*

The Church of the Holy Apostles in Constantinople, destroyed in the fifteenth century, was decorated with mosaics by the artist Eulalios in the twelfth century. As at Daphnē, the central dome displayed an image of the Pantocrator. In this text a contemporary author offers an interpretation of the placement of the image in the dome, its bust form, and its expression.

This dome . . . exhibits an image of the God-man Christ looking down, as it were, from the rim of heaven towards the floor of the church and everything that is in it. He is not [represented] full-length and entire, and this, I think, is a very profound conception that the artist has had in his mind and has expressed by means of his art to the unhurried spectator: first,

methinks, because at present our knowledge of things concerning Christ and His ways is but partial, as in a riddle or in a glass; second, because the God-man is going to appear to us from heaven once again at the time of His Second Coming to earth, and the time until that happens has not yet entirely elapsed, and because He both dwells in heaven in the bosom of His Father, and wishes to associate with men on earth together with His Father. . . . Wherefore He may be seen, to quote her who sings [in the Canticle], looking forth through the windows, leaning out down to his navel through the lattice which is near the summit of the dome, after the manner of irresistibly ardent lovers. . . . His eyes are joyful and welcoming to those who have a clean conscience . . . but to those who are condemned by their own judgment, they are wrathful and hostile. . . . The right hand blesses those who walk a straight path, while it admonishes those who do not and, as it were, checks them and turns them back from their disorderly course.

26

Lindisfarne Gospels
Colophon

Colophons are notes written at the end of some manuscripts recording who wrote them, when, for whom, etc. The colophon at the end of the Lindisfarne Gospels *(c. 700 A.D.) was written some 250 years after the text, but most scholars believe that its information is accurate. It names the scribe, the binder, the maker of the metal ornaments on the binding, and the author of the English translation of the Latin text, but no painter. The painting seems to have been done by Eadfrith, the scribe.*

Eadfrith, Bishop of the Lindisfarne Church, originally wrote this book, for God and for Saint Cuthbert and . . . for all the saints whose relics are in the Island. And Ethelwald, Bishop of the Lindisfarne islanders, impressed it on the outside and covered it—as he well knew how to do. And Billfrith, the anchorite, forged the ornaments which are on it on the outside and adorned it with gold and with gems and also with gilded-over silver—pure metal. And Aldred, unworthy and most miserable priest, glossed it in English between the lines with the help of God and Saint Cuthbert. . . .

27

Hariulf (c. 1060–1143)
From *History of the Monastery of St.-Riquier*

Hariulf was a monk at St.-Riquier until 1105, when he became abbot of St. Peter's at Oudenbourg in Belgium.

The church dedicated to the Saviour and St. Richarius . . . was among all other churches of its time the most famous. . . . The eastern tower is close to the sepulchre of St. Richarius. . . . The western tower is especially dedicated to the Saviour. . . .

If one surveys the place, one sees that the largest church, that of St. Richarius, lies to the north. The second, somewhat smaller one, which has been built in honor of our Lady on this side of the river, lies to the south. The third one, the smallest, lies to the east. The cloisters of the monks are laid out in a triangular fashion, one roof extending from St. Richarius' to St. Mary's, one from St. Mary's to St. Benedict's and one from St. Benedict's to St. Richarius'. . . . The monastery is so arranged that, according to the rule laid down by St. Benedict, all arts and all necessary labors can be executed within its walls. The river flows through it, and turns the mill of the brothers.

28
St. Angilbert (c. 750–814)
From *Customary for the Different Devotions*

Angilbert, a member of Charlemagne's court, became lay abbot of St.-Riquier in 781 and sponsored the monastery's rebuilding. His description reveals how the resident monks moved from one part of the basilica to another while chanting the devotions prescribed in the Rule *of St. Benedict.*

When the brethren have sung Vespers and Matins at the altar of the Saviour, then one choir should descend on the side of the holy Resurrection, the other one on the side of the holy Ascension, and having prayed there the processions should in the same fashion as before move singing towards the altars of St. John and St. Martin. After having prayed they should enter from both sides through the arches in the middle of the church and pray at the holy Passion. From there they should go to the altar of St. Richarius. After praying they should divide themselves again as before and go to the altars of St. Stephen and St. Lawrence and from there go singing and praying to the altar of the Holy Cross. Thence they should go again to the altar of St. Maurice and through the long gallery to the church of St. Benedict.

29
From *Inventory of the Treasury of Centula*

The fabulously rich adornment of the monastery church, recorded in this document of 831 A.D., harks back to the imperial endowment of Old St. Peter's and anticipates the equally extravagant commissions by Abbot Suger for St.-Denis.

In the main church are three altars, . . . made out of marble, gold, silver, gems, and various kinds of stones. Over the three altars stand three canopies of gold and silver, and from them hang three crowns, one for each, made of gold and costly stones with little golden crosses and other ornaments. In the same church are three lecterns, made of marble, silver and gold. Thirty reliquaries, made of gold, silver and ivory, five large crosses and eight smaller ones. . . . Fifteen large candlesticks of metal with gold and silverwork, seven smaller ones. Seven circular chandeliers of silver, seven of gilded copper, six silver lamps, six lamps of gilded copper. . . . Eight censers of gilded silver and one of copper. A silver fan. Sidings around the head end of the shrine of St. Richarius, and two small doors made of silver, gold and precious stones, six small doors made of gold and silver around the foot of his shrine, and six others which are similar. . . . One gospel book, written in gold and its silver box set with jewels and gems. Two other boxes for gospel books, of silver and gold, and a folding chair made of silver, belonging to them. Four golden chalices, two large silver chalices and thirteen small ones. Two golden patens, four large silver patens and thirteen smaller ones. . . . One large silver bowl, four small silver bowls, one brass bowl. . . . One golden staff, fitted with silver and crystal. One crook of crystal.

30
St. Benedict of Nursia (c. 480–c. 553)
From *The Rule*

Monastic communities generally had a rule, or set of regulations, prescribing the discipline of their members' daily life. The rule written by St. Benedict for his community at Monte Cassino in southern Italy was admired by Pope Gregory the Great and by Charlemagne, who obtained an exact copy of it when he visited Monte Cassino in 787. The plan of St. Gall was part of a Carolingian effort to impose the Benedictine rule on all monasteries in France and Germany. The Rule *requires complete renunciation of the world in order to maintain a routine of collective prayer and chanting seven times a day, about four hours of reading and meditation on the Bible, and some manual labor.*

CHAPTER 16:
The Day Office
The prophet says: "Seven times daily I have sung Your praises" (Ps. 119:164). We will cleave to this sacred number if we perform our monastic duties at Lauds, Prime, Tierce, Sext, None, Vespers and Compline.

CHAPTER 17:
The number of psalms said in the Day Office
Three psalms are to be chanted for Prime, each with a separate Gloria. An appropriate hymn is sung, before the psalms. . . . After the psalms a lesson from the apostle is recited, and the Hour is finished with the versicle, the Kyrie and dismissal. The Hours of Tierce, Sext and None are to be conducted in the same order.

CHAPTER 22:

How the monks are to sleep

All the monks shall sleep in separate beds. . . . If possible they should all sleep in one room. However, if there are too many for this, they will be grouped in tens or twenties, a senior in charge of each group. Let a candle burn throughout the night. They will sleep in their robes, belted but with no knives, thus preventing injury in slumber. The monks then will always be prepared to rise at the signal and hurry to the Divine Office. But they must make haste with gravity and modesty.

The younger brothers should not be next to each other. Rather their beds should be interspersed with those of their elders. When they arise for the Divine Office, they ought encourage each other, for the sleepy make many excuses.

CHAPTER 48:

Daily manual labor

Idleness is an enemy of the soul. Therefore, the brothers should be occupied according to schedule in either manual labor or holy reading. . . . From Easter to October, the brothers shall work at manual labor from Prime until the fourth hour. From then until the sixth hour they should read. After dinner they should rest (in bed) in silence. However, should anyone desire to read, he should do so without disturbing his brothers.

None should be chanted at about the middle of the eighth hour. Then everyone shall work as they must until Vespers. If conditions dictate that they labor in the fields (harvesting), they should not be grieved for they are truly monks when they must live by manual labor, as did our fathers and the apostles. Everything should be in moderation, though, for the sake of the timorous. . . .

All shall read on Saturdays except those with specific tasks. If anyone is so slothful that he will not or cannot read or study, he will be assigned work so as not to be idle.

CHAPTER 53:

The reception of guests

The kitchen of the abbot and guests should be separate from that of the community so as not to disturb the brothers, for the visitors, of whom there are always a number, come and go at irregular hours. . . .

No one may associate or converse with guests unless ordered. If one meets or sees a guest, he is to greet him with humility . . . and ask a blessing. If the guest speaks, the brother is to pass on, telling the guest that he is not permitted to speak.

CHAPTER 55:

Clothing and shoes

Each monk needs only two each of tunics and cowls, so he will be prepared for night wear and washing. Anything else is superfluous and should be banished. . . .

Bedding shall consist of a mattress, coverlet, blanket and pillow. The abbot will make frequent inspections of the bedding to prevent hoarding. Any infractions are subject to the severest discipline and, so that this vice of private ownership may be cut away at the roots, the abbot is to furnish all necessities: cowl, tunic, shoes, stockings, belt, knife, pen, needle, towel and writing tablet.

CHAPTER 57:

Artisans and craftsmen

Craftsmen present in the monastery should practice their crafts with humility, as permitted by the abbot. But if anyone becomes proud of his skill and the profit he brings the community, he should be taken from his craft and work at ordinary labor. This will continue until he humbles himself and the abbot is satisfied. If any of the works of these craftsmen are sold, the salesman shall take care to practice no fraud. . . .

In pricing, they should never show greed, but should sell things below the going secular rate.

CHAPTER 66:

The porter of the monastery

The monastery should be planned, if possible, with all the necessities—water, mill, garden, shops—within the walls. Thus the monks will not need to wander about outside, for this is not good for their souls.

31

From *Pilgrim's Guide to Santiago de Compostela*

The Pilgrim's Guide, *written in the mid-twelfth century, gives a vivid account of the routes and what was to be met along them by pilgrims to the shrine of the Apostle James in Compostela. Describing Ste.-Madeleine (the church of St. Mary Magdalen) at Vézelay (fig. 406), the* Guide *recounts a medieval legend that Mary Magdalen journeyed to France after Christ's death and died in Aix-en-Provence.*

There are four roads which, leading to Santiago, converge to form a single road at Puente la Reina, in Spanish territory. One crosses Saint-Gilles [fig. 407], Montpellier, Toulouse [figs. 380–83] and the pass of Somport; another goes through Notre-Dame of Le Puy, Sainte-Foy of Conques and Saint-Pierre of Moissac [figs. 401 and 402]; another traverses Sainte-Marie-Madeleine of Vézelay [fig. 406], Saint Léonard in the Limousin as well as the city of Périgueux; still another cuts through Saint-Martin of Tours, Saint-Hilaire of Poitiers, Saint-Jean-d'Angély, Saint-Eutrope of Saintes and the city of Bordeaux. . . .

One needs three more days of march, for people already tired, to traverse the Landes of the Bordelais.

This is a desolate region deprived of all good: there is here no bread, wine, meat, fish, water or springs; villages are rare here. The sandy and flat land abounds none the less in honey, millet, panic-grass, and wild boars. If perchance you cross it in summertime, guard your face diligently from the enormous flies that greatly abound there and which are called in the vulgar wasps or horseflies; and if you do not watch your feet carefully, you will rapidly sink up to the knees in the sea-sand copiously found all over.

Having traversed this region, one comes to the land of Gascon rich in white bread and excellent red wine. . . . The Gascons are fast in words, loquacious, given to mockery, libidinous, drunkards, prodigal in food. . . . However, they are well-trained in combat and generous in the hospitality they provide for the poor. . . .

They have the habit of eating without a table and of drinking all of them out of one single cup. In fact, they eat and drink a lot, wear rather poor clothes, and lie down shamelessly on a thin and rotten straw litter, the servants together with the master and the mistress.

On leaving that country, . . . on the road of St. James, there are two rivers. . . . There is no way of crossing them without a raft. May their ferrymen be damned! . . . They have the habit of demanding one coin from each man, whether poor or rich, whom they ferry over, and for a horse they ignominiously extort by force four. . . . When boarding . . . one must be most careful not to fall by chance into the water. . . .

Many times the ferryman, having received his money, has such a large troop of pilgrims enter the boat that it capsizes and the pilgrims drown in the waves. Upon which the boatmen, having laid their hands upon the spoils of the dead, wickedly rejoice.

ST. MARY MAGDALENE

On the route that through Saint-Léonard stretches towards Santiago, the most worthy remains of the Blessed Mary Magdalene must first of all be rightly worshipped by the pilgrims. She is . . . that glorious Mary who, in the house of Simon the Leprous, watered with her tears the feet of the Savior, wiped them off with her hair, and anointed them with a precious ointment while kissing them most fervently. . . . It is she who, arriving after the Ascension of the Lord from the region of Jerusalem . . . went by sea as far as the country of Provence, namely the port of Marseille.

In that area she led for some years . . . a celibate life and, at the end, was given burial in the city of Aix. . . . But, after a long time, a distinguished man called Badilon, beatified in monastic life, transported her most precious earthly remains from that city to Vézelay, where they rest up to this day in a much honored tomb. In this place a large and most beautiful basilica as well as an abbey of monks were established [fig. 406]. Thanks to her love, the faults of the sinners are here remitted by God, vision is restored to the blind, the tongue of the mute is untied, the lame stand erect, the possessed are

delivered, and unspeakable benefices are accorded to many. Her sacred feast is celebrated on July 22.

THE STONECUTTERS OF THE CHURCH [OF ST. JAMES] AND THE BEGINNING AND COMPLETION OF THEIR WORK
The master stonecutters that first undertook the construction of the basilica of the Blessed James were called Master Bernard the elder—a marvelously gifted craftsman—and Robert, as well as other stonecutters, about fifty in number, who worked assiduously under the most faithful administration of Don Wicart, the head of the chapter Don Segeredo, and the abbot Don Gundesindo, during the reign of Alphonso king of Spain and during the bishopric of Don Diego I, a valiant soldier and a generous man.

The church was begun in the year 1116 of the era. . . . And from the year that the first stone of the foundations was laid down until such a time that the last one was put in place, forty-four years have elapsed.

32

St. Bernard of Clairvaux (1090–1153)
From *Apologia to Abbot William of St.-Thierry*

Bernard of Clairvaux was a member of the Cistercians, an ascetic order founded in the eleventh century in opposition to the increasing opulence of the Benedictines. His letter to the Benedictine abbot William of St.-Thierry of about 1127 denounces all monastic luxury, especially the presence of art in cloisters. Like many others, Bernard believed that monks were spiritually superior to the "carnal" layfolk and so should not need material inducements to devotion.

As a monk, I put to monks the same question that a pagan used to criticize other pagans: "Tell me, priests," he said, "what is gold doing in the holy place?" I, however, say, . . . "Tell me, poor men, if indeed you are poor men, what is gold doing in the holy place?" For certainly bishops have one kind of business, and monks another. We [monks] know that since they [bishops] are responsible for both the wise and the foolish, they stimulate the devotion of a carnal people with material ornaments because they cannot do so with spiritual ones. But we who have withdrawn from the people, we who have left behind all that is precious and beautiful in this world for the sake of Christ, we who regard as dung all things shining in beauty, soothing in sound, agreeable in fragrance, sweet in taste, pleasant in touch—in short, all material pleasures— . . . whose devotion, I ask, do we strive to excite in all this? . . .

Does not avarice . . . cause all this . . . ? Money is sown with such skill that it may be multiplied. . . . The very sight of these costly but wonderful illusions inflames men more to give than

to pray. In this way wealth is derived from wealth. . . . Eyes are fixed on relics covered with gold and purses are opened. The thoroughly beautiful image of some male or female saint is exhibited and that saint is believed to be the more holy the more highly colored the image is. People rush to kiss it, they are invited to donate, and they admire the beautiful more than they venerate the sacred. . . . What do you think is being sought in all this? The compunction of penitents, or the astonishment of those who gaze at it? O vanity of vanities . . . ! The Church is radiant in its walls and destitute in its poor. . . . It serves the eyes of the rich at the expense of the poor. The curious find that which may delight them, but those in need do not find that which should sustain them. . . .

But apart from this, in the cloisters, before the eyes of the brothers while they read—what is that ridiculous monstrosity doing, an amazing kind of deformed beauty and yet a beautiful deformity? What are the filthy apes doing there? The fierce lions? The monstrous centaurs? The creatures, part man and part beast? The striped tigers? The fighting soldiers? The hunters blowing horns? You may see many bodies under one head, and conversely many heads on one body. On one side the tail of a serpent is seen on a quadruped, on the other side the head of a quadruped is on the body of a fish. Over there an animal has a horse for the front half and a goat for the back; here a creature which is horned in front is equine behind. In short, everywhere so plentiful and astonishing a variety of contradictory forms is seen that one would rather read in the marble than in books, and spend the whole day wondering at every single one of them than in meditating on the law of God. Good God! If one is not ashamed of the absurdity, why is one not at least troubled at the expense?

<div style="text-align:center">

33

Suger of St.-Denis (1081–1151)
From *On the Consecration of the Church of St.-Denis*

</div>

Abbot Suger left two accounts of his rebuilding of the Abbey Church of St.-Denis: a booklet that describes the entire campaign from its conception to the consecration of the new east end on June 11, 1144; and a record of the precious outfittings, including the stained-glass windows, in a review of his accomplishments as abbot. In these excerpts from the first text (1144–47), Suger justifies his enlargement of the Carolingian building with reference to its overcrowding on religious holidays, and he recounts the auspicious discovery of a local quarry and the appearance of the workmen needed to execute his project. After rebuilding the west end of the Carolingian church, he destroyed its eastern apse and built a much larger, more elaborate choir over

the old crypt. Suger notes as his principal innovation the radiating chapels filled with stained glass.

Through a fortunate circumstance . . . —the number of the faithful growing and frequently gathering to seek the intercession of the Saints—the [old] basilica had come to suffer grave inconveniences. Often on feast days, completely filled, it disgorged through all its doors the excess of the crowds as they moved in opposite directions, and the outward pressure of the foremost ones not only prevented those attempting to enter from entering but also expelled those who had already entered. At times you could see . . . that no one among the countless thousands of people because of their very density could move a foot; that no one, because of their very congestion, could [do] anything but stand like a marble statue, stay benumbed or, as a last resort, scream. The distress of the women . . . was so great and so intolerable that you could see . . . how they cried out horribly . . . how several of them, . . . lifted by the pious assistance of men above the heads of the crowd, marched forward as though upon a pavement; and how many others, gasping with their last breath, panted in the cloisters of the brethren to the despair of everyone. . . .

Through a gift of God a new quarry, yielding very strong stone, was discovered such as in quality and quantity had never been found in these regions. There arrived a skillful crowd of masons, stonecutters, sculptors and other workmen, so that—thus and otherwise—Divinity relieved us of our fears and favored us with Its goodwill by comforting us and by providing us with unexpected [resources]. I used to compare the least to the greatest: Solomon's riches could not have sufficed for his Temple any more than did ours for this work had not the same Author [God] of the same work abundantly supplied His attendants. The identity of the author and the work provides a sufficiency for the worker. . . .

Upon consideration, then, it was decided to remove that vault, unequal to the higher one, which, overhead, closed the apse containing the bodies of our Patron Saints, all the way [down] to the upper surface of the crypt to which it adhered; so that this crypt might offer its top as a pavement to those approaching by either of the two stairs, and might present the chasses [reliquaries] of the Saints, adorned with gold and precious gems, to the visitors' glances in a more elevated place. Moreover, it was cunningly provided that—through the upper columns and central arches which were to be placed upon the lower ones built in the crypt—the central nave of the old [church] should be equalized, by means of geometrical and arithmetical instruments, with the central nave of the new addition; and, likewise, that the dimensions of the old side-aisles should be equalized with the dimensions of the new side-aisles, except for that elegant and praiseworthy extension, in [the form of] a circular string of chapels, by virtue of which the whole [church] would shine with the wonderful and uninterrupted light of most luminous windows, pervading the interior beauty.

34

Suger of St.-Denis
From *On What Was Done Under His Administration*

St.-Denis was a Benedictine abbey, though its church was open to laufolk and attracted them in large numbers. The ostentatious embellishment of the church was the type of material display deplored by St. Bernard of Clairvaux. Suger's descriptions of it, recorded between 1144 and 1149, suggest a sensuous love of precious materials, but also a belief that contemplation of these materials could lead the worshiper to a state of heightened spiritual awareness. Like the Byzantine rationale for icons, the notion of "anagogical" transportation to another dimension is indebted to Neo-Platonism.

We insisted . . . that the adorable, life-giving cross . . . should be adorned. . . . Therefore we searched around everywhere by ourselves and by our agents for an abundance of precious pearls and gems. . . . One merry but notable miracle which the Lord granted us in this connection we do not wish to pass over. . . . For when I was in difficulty for want of gems and could not sufficiently provide myself with more (for their scarcity makes them very expensive): then, lo and behold, [monks] from three abbeys of two Orders—that is, from Cîteaux and another abbey of the [Cistercian] Order, and from Fontevrault . . . offered us for sale an abundance of gems such as we had not hoped to find in ten years, hyacinths, sapphires, rubies, emeralds, topazes. Their owners had obtained them from Count Thibaut for alms; and he in turn had received them, through the hands of his brother Stephen, King of England [reigned 1135–54], from the treasures of his uncle, the late King [Henry I, reigned 1100–1135], who had amassed them throughout his life in wonderful vessels. We, however, freed from the worry of searching for gems, thanked God and gave four hundred pounds for the lot though they were worth much more. . . .

We hastened to adorn the Main Altar of the blessed Denis where there was only one beautiful and precious frontal panel from Charles the Bald [843–77], the third Emperor; for at this [altar] we had been offered to the monastic life. . . .

The rear panel, of marvelous workmanship and lavish sumptuousness (for the barbarian artists were even more lavish than ours), we ennobled with chased relief work equally admirable for its form as for its material. . . . Much of what had been acquired and more of such ornaments of the church as we were afraid of losing—for instance, a golden chalice that was curtailed of its foot and several other things—we ordered to be fastened there. . . .

Often we contemplate . . . these different ornaments both new and old. . . . When . . . the loveliness of the many-colored gems has called me away from external cares, and worthy meditation has induced me to reflect, transferring that which is material to that which is immaterial, on the diversity of the sacred virtues: then it seems to me that I see myself dwelling, as it were, in some strange region of the universe which neither exists entirely in the slime of the earth nor entirely in the purity of Heaven; and that, by the grace of God, I can be transported from this inferior to that higher world in an anagogical manner. . . .

We [also] caused to be painted, by the exquisite hands of many masters from different regions, a splendid variety of new windows. . . .

Because [these windows] are very valuable on account of their wonderful execution and the profuse expenditure of painted glass and sapphire glass, we appointed an official master craftsman for their protection and repair.

35

Robert de Torigny (died 1186)
From *Chronicle*

Chartres Cathedral burned twice in the twelfth century, in 1134 and 1194. This contemporary notice of the rebuilding of the west front (fig. 431) in the 1140s stresses the participation of masses of lay volunteers. This kind of piety was later referred to as the "cult of the carts."

In this same year, primarily at Chartres, men began, with their own shoulders, to drag the wagons loaded with stone, wood, grain, and other materials to the workshop of the church, whose towers were then rising. Anyone who has not witnessed this will not see the like in our time. Not only there, but also in nearly the whole of France and Normandy and in many other places, [one saw] everywhere . . . penance and the forgiveness of offenses, everywhere mourning and contrition. One might observe women as well as men dragging [wagons] through deep swamps on their knees, beating themselves with whips, numerous wonders occurring everywhere, canticles and hymns being offered to God.

36

From *Meditations on the Life of Christ*

This late-thirteenth-century text, addressed to a Franciscan nun, represents a long-standing tendency to embellish the New Testament account of Christ's life with apocryphal detail. Unlike earlier such embellishments, this one dwells especially on the

emotions of the participants in the story. From the twelfth century on, worshipers (especially women) were encouraged to experience Scripture through visualization and emotion rather than as words alone. In its purpose the Meditations *is related to such two- and three-dimensional representations as figures 479 and 506.*

Attend diligently and carefully to the manner of the Deposition. Two ladders are placed on opposite sides of the cross. Joseph [of Arimathea] ascends the ladder placed on the right side and tries to extract the nail from His hand. But this is difficult . . . and it does not seem possible to do it without great pressure on the hand of the Lord. . . . The nail pulled out, John makes a sign to Joseph to extend the said nail to him, that the Lady [Virgin Mary] might not see it. Afterwards Nicodemus extracts the other nail from the left hand and similarly gives it to John. Nicodemus descends and comes to the nail in the feet. Joseph supported the body of the Lord: happy indeed is this Joseph, who deserves thus to embrace the body of the Lord! . . . The nail in the feet pulled out, Joseph descends part way, and all receive the body of the Lord and place it on the ground. The Lady supports the head and shoulders in her lap, the Magdalen the feet at which she had formerly found so much grace. The others stand about, all making a great bewailing over Him: all most bitterly bewail Him, as for a first-born son.

After some little time, when night approached, Joseph begged the Lady to permit them to shroud Him in linen cloths and bury Him. She strove against this, saying, "My friends, do not wish to take my Son so soon; or else bury me with Him." She wept uncontrollable tears; she looked at the wounds in His hands and side, now one, now the other; she gazed at His face and head and saw the marks of the thorns, the tearing of His beard, His face filthy with spit and blood, His shorn head; and she could not cease from weeping and looking at Him. . . . The hour growing late, John said, "Lady, let us bow to Joseph and Nicodemus and allow them to prepare and bury the body of our Lord. . . ." She resisted no longer, but blessed Him and permitted Him to be prepared and shrouded. . . . The Magdalen . . . seemed to faint with sorrow. . . . She gazed at the feet, so wounded, pierced, dried out, and bloody: she wept with great bitterness. . . . Her heart could hardly remain in her body for sorrow; and it can well be thought that she would gladly have died, if she could, at the feet of the Lord.

37

Inscriptions on the pulpit in Pisa Cathedral by Giovanni Pisano

Giovanni Pisano's pulpit (1302–10) in Pisa Cathedral has two lengthy inscriptions, one of which is visible in figure 485. In the first inscription Giovanni praises his own talent; in the second,

on the base of the pulpit, he laments that his work is not properly appreciated.

I praise the true God, the creator of all excellent things, who has permitted a man to form figures of such purity. In the year of Our Lord thirteen hundred and eleven the hands of Giovanni, son of the late Nicola, by their own art alone, carved this work. . . . Giovanni who is endowed above all others with command of the pure art of sculpture, sculpting splendid things in stone, wood and gold . . . would not know how to carve ugly or base things even if he wished to do so. There are many sculptors, but to Giovanni remain the honours of praise. . . .

Giovanni has encircled all the rivers and parts of the world endeavouring to learn much and preparing everything with heavy labour. He now exclaims: 'I have not taken heed. The more I have achieved the more hostile injuries have I experienced. But I bear this pain with indifference and a calm mind.' That I (the monument) may free him from this envy, mitigate his sorrow and win him recognition, add to these verses the moisture (of your tears).

38

Dante Alighieri (1265–1321) *The Divine Comedy: Paradise,* from Canto XVII

When Dante wrote the three books of The Divine Comedy, *he placed many of his contemporaries in Hell, Purgatory, and Paradise. In Paradise he meets his ancestor Cacciaguida, who describes Dante's exile from Florence for political reasons and his protection by Bartolommeo della Scala, father of Can Grande della Scala (fig. 489). Dante stayed at Can Grande's court in Verona from 1314 to 1317.*

"Your first abode, your first refuge, will be the courtesy
 of the great Lombard lord [Bartolommeo della Scala]
 who[se coat of arms] bears the sacred bird [the eagle]
 upon the ladder,

and he will hold you in such high regard
 that in your give and take relationship
 the one will give before the other asks.

With him you shall see one [Can Grande] who at his birth
 was stamped so hard with this star's [Mars'] seal that all
 of his achievements will win great renown.

The world has not yet taken note of him;
 he is still very young, for Heaven's wheels
 have circled round him now for just nine years.

But even before the Gascon [Pope Clement V] tricks proud
 Henry [Emperor Henry VII, reigned 1308–13],
 this one [Can Grande] will show some of his mettle's sparks
 by scorning wealth and making light of toil.

Knowledge of his munificence will yet
 be spread abroad: even his enemies
 will not be able to deny his worth.

Look you to him, expect from him good things.
 Through him the fate of many men shall change,
 rich men and beggars changing their estate.

Now write this in your mind but do not tell
 the world"—and he said things concerning him
 incredible even to those who see

them all come true. . . .

39

Dante Alighieri
The Divine Comedy: Purgatory, from Canto XI

*In the first circle of Purgatory are those guilty of the sin of pride.
Dante meets a famous manuscript illuminator who has learned
the vanity of pride and the fleeting nature of fame, illustrated by
the rapidity with which Giotto eclipsed Cimabue.*

"Oh!" I said, "*you* must be that Oderisi,
 honor of Gubbio, honor of the art
 which men in Paris call 'Illuminating.'"

"The pages Franco Bolognese paints,"
 he said, "my brother, smile more radiantly;
 his is the honor now—mine is far less.

Less courteous would I have been to him,
 I must admit, while I was still alive
 and my desire was only to excel.

For pride like that the price is paid up here;
 I would not even be here, were it not
 that, while I still could sin, I turned to God.

Oh, empty glory of all human power!
 How soon the green fades from the topmost bough,
 unless the following season shows no growth!

Once Cimabue thought to hold the field
 as painter; Giotto now is all the rage,
 dimming the lustre of the other's fame."

40

Dante Alighieri
The Divine Comedy: Hell, from Canto XVII

*In the seventh circle of Hell, Dante encounters the usurers, who
are identified by the coats of arms on the purses that hang around
their necks. Among them is Rinaldo Scrovegni of Padua, the
father of Enrico Scrovegni, who was the patron of the Arena
Chapel, painted in fresco by Giotto (figs. 504–6). Many schol-
ars believe that Enrico sponsored the chapel to expiate his father's
sins.*

I carefully examined several faces
 among this group caught in the raining flames
 and did not know a soul, but I observed
that around each sinner's neck a pouch was hung,
 each of a different color, with a coat of arms,
 and fixed on these they seemed to feast their eyes.

And while I looked about among the crowd,
 I saw something in blue on a yellow purse
 that had the face and bearing of a lion;

and while my eyes continued their inspection
 I saw another purse as red as blood
 exhibiting a goose more white than butter.

And one [Rinaldo Scrovegni] who had a blue sow, pregnant-
 looking,
 stamped on the whiteness of his moneybag
 asked me: "What are you doing in this pit?

Get out of here! And since you're still alive,
 I'll tell you that my neighbor Vitaliano
 will come to take his seat on my left side.

Among these Florentines I sit, one Paduan:
 time after time they fill my ears with blasts
 of shouting: 'Send us down the sovereign knight

who will come bearing three goats on his pouch.'"
 As final comment he stuck out his tongue—
 as far out as an ox licking its nose.

41
Lorenzo Ghiberti (c. 1381–1455)
The Commentaries, from Book 2

Ghiberti's incomplete Commentaries *is an important early document of art history. The first book consists largely of extracts from Pliny and Vitruvius; the second is about art in Italy in the thirteenth and fourteenth centuries, and ends with an account of his own work (fig. 492). Like Giovanni Pisano, Ghiberti was not reluctant to praise himself.*

Whereas all gifts of fortune are given and as easily taken back, but disciplines attached to the mind never fail, but remain fixed to the very end, . . . I give greatest and infinite thanks to my parents, who . . . were careful to teach me the art, and the one that cannot be tried without the discipline of letters. . . . Whereas therefore through parents' care and the learning of rules I have gone far in the subject of letters or learning in philology, and love the writing of commentaries, I have furnished my mind with these possessions, of which the final fruit is this, not to need any property or riches, and most of all to desire nothing. . . . I have tried to inquire how nature proceeds . . . and how I can get near her, how things seen reach the eye and how the power of vision works, and how visual [word missing] works, and how visual things move, and how the theory of sculpture and painting ought to be pursued.

In my youth, in the year of Our Lord 1400, I left Florence because of both the bad air and the bad state of the country. . . . My mind was largely directed to painting. . . . Nevertheless . . . I was written to by my friends how the board of the temple of St. John the Baptist was sending for well-versed masters, of whom they wanted to see a test piece. A great many very well qualified masters came through all the lands of Italy to put themselves to this test. . . . Each one was given four bronze plates. As the demonstration, the board of the temple wanted each one to make a scene . . . [of] the sacrifice of Isaac. . . . These tests were to be carried out in a year. . . . The competitors were . . . : Filippo di ser Brunellesco, Simone da Colle, Niccolo D'Arezzo, Jacopo della Quercia from Siena, Francesco da Valdambrino, Nicolo Lamberti. . . . The palm of victory was conceded to me by all the experts and by all those who took the test with me. The glory was conceded to me universally, without exception. Everyone felt I had gone beyond the others in that time, without a single exception, with a great consultation and examination by learned men. . . . The judges were thirty-four, counting those of the city and the surrounding areas; the endorsement in my favor of the victory was given by all, and by the consuls and board and the whole body of the merchants' guild, which has the temple of St. John the Baptist in its charge. It was . . . determined that I should do this bronze door for this temple, and I exe-cuted it with great diligence. And this is the first work; with the frame around it, it added up to about twenty-two thousand florins.

42
Lorenzo Ghiberti
The Commentaries, from Book 2

Ghiberti, and Vasari after him, traced the origins of modern painting to Giotto. Giotto is presented here as a natural genius and hence unfettered by the "Greek manner" of his teacher.

The art of painting began to arise [again] in Etruria. In a village near the city of Florence, called Vespignano, a boy of marvelous genius was born. He was drawing a sheep from life, and the painter Cimabue, passing on the road to Bologna, saw the boy sitting on the ground and drawing a sheep on a flat rock. He was seized with admiration. . . . And seeing he had his skill from nature, he asked the boy what his name was. He answered and said, I am called Giotto by name, my father is called Bondone and lives in this house close by. Cimabue went with Giotto to his father; he made a very fine appearance. He asked the father for the boy; the father was very poor. He handed the boy over to him and Cimabue took Giotto with him and he was Cimabue's pupil. He [Cimabue] used the Greek manner, and in that manner he was very famous in Etruria. And Giotto grew great in the art of painting.

He brought in the new art, . . . and many pupils were taught on the level of the ancient Greeks. Giotto saw in art what no others added. He brought in natural art, and grace with it. . . . He was . . . the inventor and discoverer of much learning that had been buried some six hundred years.

43
Theophilus Presbyter
On Divers Arts, from Book II:
The Art of the Worker in Glass

"Theophilus" may have been the pseudonym of Roger of Helmarshausen, a Benedictine monk and metalworker. Metalwork is the subject of the third book of this treatise, following books on painting and stained glass. Theophilus' text, written in the twelfth century, is the first in the Western tradition to give a practitioner's account of the technology of art production.

CHAPTER 17: LAYING OUT WINDOWS
When you want to lay out glass windows, first make yourself a smooth flat wooden board. . . . Then take a piece of chalk,

scrape it with a knife all over the board, sprinkle water on it everywhere, and rub it all over with a cloth. When it has dried, take the measurements . . . of one section in a window, and draw it on the board with a rule and compasses. . . . Draw as many figures as you wish, first with [a point made of] lead or tin, then with red or black pigment, making all the lines carefully, because, when you have painted the glass, you will have to fit together the shadows and highlights in accordance with [the design on] the board. Then arrange the different kinds of robes and designate the color of each with a mark in its proper place; and indicate the color of anything else you want to paint with a letter.

After this, take a lead pot and in it put chalk ground with water. Make yourself two or three brushes out of hair from the tail of a marten, badger, squirrel, or cat or from the mane of a donkey. Now take a piece of glass of whatever kind you have chosen, but larger on all sides than the place in which it is to be set, and lay it on the ground for that place. Then you will see the drawing on the board through the intervening glass, and, following it, draw the outlines only on the glass with chalk.

CHAPTER 18. GLASS CUTTING

Next heat on the fireplace an iron cutting tool, which should be thin everywhere except at the end, where it should be thicker. When the thicker part is red-hot, apply it to the glass that you want to cut, and soon there will appear the beginning of a crack. If the glass is hard [and does not crack at once], wet it with saliva on your finger in the place where you had applied the tool. It will immediately split and, as soon as it has, draw the tool along the line you want to cut and the split will follow.

44

Villard de Honnecourt (13th century)
From *Sketchbook*

The first inscription below addresses the user of Villard's sketchbook and suggests what the book might be for. The others appear on the leaves shown in figures 495 and 496.

Villard de Honnecourt greets you and begs all who will use the devices found in this book to pray for his soul and remember him. For in this book will be found sound advice on the virtues of masonry and the uses of carpentry. You will also find strong help in drawing figures according to the lessons taught by the art of geometry.

Here is a lion seen from the front. Please remember that he was drawn from life. This is a porcupine, a little beast that shoots its quills when aroused.

Here below are the figures of the Wheel of Fortune, all seven of them correctly pictured.

45

Agnolo di Tura del Grasso
From *History*

Duccio's Maestà *(figs. 500–502) stood on the main altar of Siena Cathedral until 1506, when it was removed to the transept. It was sawn apart in 1771, and some panels were acquired subsequently by museums in Europe and the United States. This local history of about 1350 describes the civic celebration that accompanied the installation of the altarpiece in 1311.*

This [the *Maestà*] was painted by master Duccio di Niccolò, painter of Siena, who was in his time the most skillful painter one could find in these lands. The panel was painted outside the Porta a Stalloreggi . . . in the house of the Muciatti. The Sienese took the panel to the cathedral at noontime on the ninth of June [1311], with great devotions and processions, with the bishop of Siena, . . . with all of the clergy of the cathedral, and with all the monks and nuns of Siena, and the Nove, with the city officials, the Podestà and the Captain, and all the citizens with coats of arms and those with more distinguished coats of arms, with lighted lamps in hand. . . . The women and children went through Siena with much devotion and around the Campo in procession, ringing all the bells for joy, and this entire day the shops stayed closed for devotions, and throughout Siena they gave many alms to the poor people, with many speeches and prayers to God and to his mother, Madonna ever Virgin Mary, who helps, preserves and increases in peace the good state of the city of Siena and its territory, . . . and who defends the city from all danger and all evil. And so this panel was placed in the cathedral on the high altar. The panel is painted on the back . . . with the Passion of Jesus Christ, and on the front is the Virgin Mary with her son in her arms and many saints at the side. Everything is ornamented with fine gold; it cost three thousand florins.

46

Franco Sacchetti (1332?–1400)
From *Three Hundred Stories*

Like Boccaccio, Sacchetti composed a collection of stories, many of which feature contemporary or historical figures of Italy. This tale about Giotto and his sense of humor is representative of a growing interest in artists' personalities.

Whoever is acquainted with Florence knoweth that upon thest Sunday of each month it is the custom for men and women to go to [the church of] San Gallo in company, and they go there rather to make merry than for the Pardon. Upon one of these Sundays Giotto started out to go thither with his companions. And having halted a moment in the street called Cocomero to relate a certain tale, there passed by some pigs of St. Anthony, and one of these, running violently, ran between Giotto's legs in such a manner that Giotto fell to the ground. Rising up of his own accord, [he] shook himself, and neither cursed the pigs nor cried out at them, but turning to his companions, half-smiling, he said: "Are they not in the right? For I in my day have earned many thousands of lire with their bristles, and never have I given unto them even a dish of swill."

47
Inscriptions on the frescoes in the Palazzo Pubblico, Siena

The first inscription is painted in a strip below the fresco of Good Government (figs. 511 and 512), which is dated between 1338 and 1340. The second is held by the personification of "Security" who hovers over the landscape in figure 512.

Turn your eyes to behold her,
you who are governing, [Justice] who is portrayed here,
crowned on account of her excellence,
who always renders to everyone his due.
Look how many goods derive from her
and how sweet and peaceful is that life
of the city where is preserved
this virtue who outshines any other.

She guards and defends
those who honor her, and nourishes and feeds them.
From her light is born
Requiting those who do good
and giving due punishment to the wicked.

Without fear every man may travel freely
and each may till and sow,
so long as this commune
shall maintain this lady [Justice] sovereign,
for she has stripped the wicked of all power.

48
Giovanni Boccaccio (1313–1375)
Decameron, from *The First Day*

The young people who tell the 100 stories of Boccaccio's Decameron *have fled Florence to escape the bubonic plague. At the beginning of the book, Boccaccio describes the horror of the disease and the immensity of the epidemic, as well as the social dissolution it produced.*

The years of the fruitful Incarnation of the Son of God had attained to the number of one thousand three hundred and forty-eight, when into the notable city of Florence, fair over every other of Italy, there came the death-dealing pestilence, . . . through the operation of the heavenly bodies or of our own iniquitous doings, being sent down upon mankind for our correction by the just wrath of God. . . . In men and women alike there appeared, at the beginning of the malady, certain swellings, either on the groin or under the armpits, whereof some waxed to the bigness of a common apple, others to the size of an egg, . . . and these the vulgar named

plague-boils. From these two parts the aforesaid death-bearing plague-boils proceeded, in brief space, to appear and come indifferently in every part of the body; wherefrom, after awhile, the fashion of the contagion began to change into black or livid blotches. . . .

Well-nigh all died within the third day from the appearance of the aforesaid signs, this one sooner and that one later, and for the most part without fever or other complication. . . . The mere touching of the clothes or of whatsoever other thing had been touched or used by the sick appeared of itself to communicate the malady to the toucher. . . .

Well-nigh all tended to a very barbarous conclusion, namely, to shun and flee from the sick and all that pertained to them. . . . Some there were who conceived that to live moderately and keep oneself from all excess was the best defense; . . . they lived removed from every other, taking refuge and shutting themselves up in those houses where none were sick and where living was best. . . . Others, inclining to the contrary opinion, maintained that to carouse and make merry and go about singing and frolicking and satisfy the appetite in everything possible and laugh and scoff at whatsoever befell was a very certain remedy for such an ill. . . .

The common people (and also, in great part, . . . the middle class) . . . fell sick by the thousand daily and being altogether untended and unsuccored, died well-nigh all without recourse. Many breathed their last in the open street, by day and by night, while many others, though they died in their homes, made it known to the neighbors that they were dead rather by the stench of their rotting bodies than otherwise; and of these and others who died all about, the whole city was full. . . . The consecrated ground not sufficing for the burial of the vast multitude of corpses . . . there were made throughout the churchyards, . . . vast trenches, in which those who came . . . were laid by the hundred, . . . being heaped up therein by layers, as goods are stowed aboard ship. . . .

So great was the cruelty of heaven . . . that, between March and the following July, . . . it is believed for certain that upward of a hundred thousand human beings perished within the walls of the city of Florence. . . . Alas, how many great palaces, how many goodly houses, how many noble mansions, once full of families, of lords and of ladies, remained empty even to the meanest servant! How many memorable families, how many ample heritages, how many famous fortunes were seen to remain without lawful heir! How many valiant men, how many fair ladies, how many sprightly youths, . . . breakfasted in the morning with their kinsfolk, comrades and friends and that same night supped with their ancestors in the other world!

49

Christine de Pizan (c. 1363–c. 1430)
From *The Book of the City of Ladies*

Born in Venice but active in Paris and the courts of France, Christine de Pizan was a learned and well-known writer who championed the cause of women. This passage from her history of women (1404–5) mentions a manuscript illuminator who would have been a contemporary of the Limbourg brothers.

Regarding what you say about women expert in the art of painting, I know a woman today, named Anastasia, who is so learned and skilled in painting manuscript borders and miniature backgrounds that one cannot find an artisan in all the city of Paris—where the best in the world are found—who can surpass her, nor who can paint flowers and details as delicately as she does, nor whose work is more highly esteemed, no matter how rich or precious the book is. People cannot stop talking about her. And I know this from experience, for she has executed several things for me which stand out among the ornamental borders of the great masters.

Timeline Two: 300 to 1350

	300–600	600–700	700–750
HISTORY AND POLITICS	Constantine the Great (r. 306–37) reunites Roman Empire, moving capital Constantinople, formerly Byzantium; 313, proclaims Edict of Milan, allowing religious toleration; c. 312, converts to Christianity. The religion spreads rapidly through the Roman world **410** Sack of Rome by the Visigoth Alaric **451** Attila, leader of the Huns, invades Gaul from Eastern Europe and, in 452, Italy **476** Western Roman Empire falls, its territories divided among local rulers **c. 493** Theodoric, Eastern Roman Emperor, establishes Ostrogoth kingdom in Italy Justinian, Eastern Roman Emperor (r. 527–65) with Empress Theodora. Their reign is marked by peace, legal reforms, and attempts to reunite the Empire **568** Lombard kingdom created in northern Italy	**600–800** Golden Age of Celtic culture **669–690** Theodore of Tarsus begins organization of English rival groups; period of Greco-Roman cultural revival **697** (traditional) First doge of Venice elected by governing council	**711–15** Conquest of North Africa and Spain by Moslems; much of the Mediterranean controlled by the Arabs **717** Leo III, Byzantine emperor (r. 717–41) defeats Arab invaders and establishes a period of peace; 726, his prohibition of images in churches sparks the Iconoclastic Controversy
RELIGION	**395** Christianity becomes official religion of the Roman Empire **432** St. Patrick (died c. 461) founds Celtic church in Ireland **529** St. Benedict (c. 480– c. 553), founds Benedictine monastic order		

Iconoclasm From the earliest days of Christianity, painted and carved images were used in churches as decorations, representing holy figures, biblical narratives, miracles, and other pious scenes. Such works of art have usually been considered precious and were sometimes venerated as holy themselves; but at some moments in history they have been attacked as idolatrous. In the eighth century the Byzantine emperor Leo III harshly criticized such images, placing himself in opposition to the pope, who declared them sacred. In 726 Leo issued a decree prohibiting images in churches. This touched off a power struggle between the Eastern emperor and the Western papacy. The controversy raised fundamental religious questions regarding the interpretation of the Bible and the divinity of Christ. In the course of it, Leo's followers, called Iconoclasts, destroyed much of the Byzantine art that existed at the time in churches, especially in the East. The Iconoclastic Controversy was no small event: cities revolted; battles were fought, and though the debate over artworks may have mainly been the excuse for a clash of the political forces of church and state, the importance of images—their power to move and stir people—should not be underestimated.

An effect of the ban on pious images was that artistic energies were temporarily channeled into secular and private art—for example, illuminated manuscripts for private use. The debate was settled in favor of holy images in 843, when image-worship was established by the pope as doctrinal. Grand cycles of mosaics like those formerly found in Byzantine churches reappeared slowly and these displayed a new humanism derived from the secular, classicizing work of the Iconoclastic period.

Virgin and Child Enthroned Between Saints and Angels, Monastery of St. Catherine, Mount Sinai, late 6th century

	300–600	600–700	700–750
MUSIC, LITERATURE, AND PHILOSOPHY	Ammianus Marcellinus (c. 330–95), Roman historian Boethius (c. 480–524), Roman philosopher whose *Consolation of Philosophy* held the struggle for knowledge to be the highest expression of love of God	**c. 600** Gregorian chants widely used in Catholic Mass Isidore of Seville (died 636), encyclopedist The Venerable Bede (673–735), English writer and historian, primary member of Theodore of Tarsus' intellectual group	**Early 700s** *Beowulf,* English epic
SCIENCE, TECHNOLOGY, AND EXPLORATION	**c. 410** First records of alchemical experiments, in which science and myth are utilized to try to create gold from metal **c. 550** Procopius of Caesarea writes *Buildings,* on architecture and public works of the Byzantine Empire **c. 600** Chinese invent woodblock printing	**c. 600** Stirrup introduced in Western Europe **604** First church bell made in Rome	

750–800	800–850	850–900
756 Pepin the Short, king of the Franks (r. 747–68), defeats the Lombards in Italy and destroys their kingdom. His gift of conquered Central Italian lands to the pope (the Papal States) allows the papacy to be independent and earns France a privileged position Charlemagne (r. 768–814), Pepin's successor, establishes control of most of Europe. His organization of European society into semiautonomous regional centers (called marks) becomes the basis for feudal society; 800, crowned Holy Roman Emperor by the pope. Charlemagne's empire is divided after his death into eastern and western Frankish kingdoms (approximately present-day France and Germany) Irene, first empress of Byzantium (r. 797–802)	**800–900** Invasions by Scandinavian peoples in the North, Moslems in the Mediterranean, and Magyars from the East destabilize much of Europe, which suffers extended warfare **804–807** Vikings invade Ireland and, 856–75, British Isles. By 878, Danes control Scotland	**c. 850–900** Angkor Thom, capital of the Khmer people, founded in what is now Cambodia. The moated city covers five square miles and has elaborate temples and palaces **c. 900** Toltec people settle in Mexico; they clash with the Maya in Yucatan
St. Angilbert (c. 750–814), monk at Charlemagne's court, rebuilds St.-Riquier abbey St. Boniface (died 755) converts Germanic peoples to Christianity St. Theodore the Studite (759–826) defends use of icons	**Charlemagne** In the late eighth century, Charlemagne consolidated much of what is now France, Germany, Italy, and the Balkans into a single kingdom, with his court at Aachen in Germany. So much territory in the West had not been under one rule since Roman times. His coronation by the pope in Rome in 800 was clearly understood throughout Europe as a sign of his power over the papacy and the strength of his position. As such, it was seen as a threat by the Byzantine Empire in Constantinople, and signaled the definitive division of the Christian world into two rival realms. Charlemagne was a great founder of schools, monasteries, and systems of civil administration. In the Carolingian period, named for his dynasty, the arts flourished as they often do in times of relative stability.	

(left) Crucifixion, bronze plaque from a book cover(?), Ireland, 8th century

(right) Chi-Rho page, from the *Book of Kells,* Ireland, c.800?

Virgin and Child Enthroned, mosaic, Hagia Sophia, Constantinople, c. 843–67

Lindau Gospels, upper cover of binding, c. 870

750–800	800–850	850–900
Hrabanus Maurus (784–856), German encyclopedist	**c. 800** Carolingian schools chartered by Charlemagne, encouraging study of Latin texts **c. 800** First version of *The Thousand and One Nights,* a collection of Arabian stories of the court of Hārūn al-Rashīd	
	822 Earliest documented church organ, Aachen	**c. 850** Horse collar adopted in Western Europe for draft work **860** Danish Vikings discover Iceland; c. 866, they attack England; c. 980, they find Greenland

	900–950	950–1000	1000–1050
HISTORY AND POLITICS	**907** In China, the Five Dynasties period sees the land politically divided	**962** Otto I the Great, ruler of Germany (r. 936–73), defeats Magyar invaders and assumes crown of the Holy Roman Empire Capetian kings (later, kings of France, 987–1792) come to power in Frankish kingdom with Hugh Capet (r. 987–96)	**1016** Normans arrive in Italy from northern France, establishing a kingdom in the south, 1071, by taking Bari; between 1072 and 1091 they take Sicily, evicting the Arabs who had possessed the island First kings of Scotland; Duncan I (r. 1034–40), murdered by the usurper Macbeth (r. 1040–57), himself defeated by Malcolm Canmore (r. 1057–93). Beginning of Anglicization of Scotland Henry III the Black (r. 1039–56) aggressively asserts German imperial authority by personally nominating new popes and mastering the duchies of Poland, Hungary, and Bohemia
RELIGION	**c. 900** Russia converts to Christianity under the Eastern Orthodox church **910** Abbey of Cluny founded in France. Cluniac organization of monasteries and reforming methods spread through Europe	Bishop Bernward (bishop 993–1022) makes Hildesheim, in Germany, a cultural and artistic center	

Monasteries The great European monastic orders of the Middle Ages were founded during a time of weak governments and economic uncertainty; neither education nor literacy was common. Financed by kings, private patrons, and the papacy, abbeys such as Lindisfarne in England (635), Cluny (910) and Clairvaux (1115) in France, Hildesheim in Germany (1001–33), and Assisi in Italy (1209) were stable, self-contained societies in which strict religious observance was combined with intellectual and artistic experimentation, in a blend peculiar to the Middle Ages. Exempt from taxation, they became wealthy and powerful. Monastic life was dedicated to the furthering of Christian doctrine; this often meant not only pious works but the search for knowledge. Monks copied and wrote books; studied architecture, engineering, mathematics, medicine, and philosophy; painted frescos and panels, and illuminated manuscripts.

(left) Interior, Hildesheim Cathedral, 1001–33

(right) The Harbaville Triptych, ivory altar, late 10th century

The Crucifixion, mosaic, Greece, 11th century

	900–950	950–1000	1000–1050
MUSIC, LITERATURE, AND PHILOSOPHY			**c. 1000** Ottonian revival in Germany **c. 1000** Development of modern music notation system in Europe Solomon ibn Gabirol (1020–70) Jewish poet and philosopher active in Moslem Spain
SCIENCE, TECHNOLOGY, AND EXPLORATION		Ibn Sînâ (Avicenna) (980–1037?), Arab physician and interpreter of Aristotle, active in Persia and the Middle East; chief medical authority of the Middle Ages	**c. 1000** Urban development of Europe begins; cities grow steadily in importance and size throughout the Middle Ages. Use of abacus for computation in Europe **1002** Leif Ericson sails to North America and establishes a settlement

1050–1100	1100–1150	1150–1200

1066 French Normans under William the Conqueror, duke of Normandy, invade England and defeat local forces under King Harold at Battle of Hastings. William crowned king of England

1083 Henry IV, Holy Roman Emperor (ruler of Germany), invades Italy in a dispute with the pope; 1084, Rome sacked by Normans. Ensuing political chaos results in increased power of individual German principates and weakening of papacy

1096 First Crusade, called by Pope Urban II in 1095, to retake the Holy Land from the Moslems for Christianity. A disorganized mass of mostly French, Norman, and Flemish nobles and peasants, 30,000 or more, leaves Europe for Palestine in several waves; an estimated 12,000 are killed in Asia Minor; 1097–99, the crusading force takes Nicaea, Antioch, and Jerusalem, which they sack

Foundation of the crusading orders of knighthood: 1113, Knights Hospitalers; 1118, Templars; 1190, Teutonic Knights

1122 Suger becomes abbot of St.-Denis, near Paris, and adviser to kings Louis VI and Louis VII

1147–49 Second Crusade called, urged by the preaching of St. Bernard of Clairvaux; it achieves little. Suger is regent of France

1171 Salah al-Din (Saladin), ruler of Egypt, dominates Damascus and captures Syria; 1187, he recaptures Jerusalem for Islam

1189–92 Third Crusade, a fruitless attempt to regain Jerusalem, led by Frederick I Barbarossa, Holy Roman Emperor, King Richard I the Lionhearted, of England, and King Philip II of France, all of them rivals; the papacy is largely excluded. Project ends with capture of English king Richard I. The crusading armies, unable to oust Saladin from Palestine, conclude a pact with him that permits Christian pilgrims to visit Jerusalem unmolested

1054 Final schism between Eastern (Orthodox) and Western (Catholic) Christian Churches

c. 1115 St. Bernard (1090–1153) heads the ascetic Cistercian order at the abbey of Clairvaux, in northern France

> **Suger, St.-Denis, and Architectural Symbolism** The prelate Suger, made abbot in 1122 of the Abbey Church of St.-Denis, was regent of France while King Louis VII was away on the Second Crusade. As such, his rebuilding of the church, begun c. 1140, was more than a simple architectural project. It set the standard for Gothic churches and is an early example of architecture used to represent political power and a philosophical idea.
>
> The aesthetic design of the building has been attributed to Suger's interest in Scholasticism and Neo-Platonism. Thus, the individual parts of the building support the entire structure, much as the individual believer upholds the Christian faith as a whole. St.-Denis was intended to be seen as the Christian universe in microcosm, an architectural experience of beauty through which the visitor comes to an emotional understanding of Christ. Technological innovations allowed the walls to be pierced with large windows that filled the interior with brilliant colored light. In Neo-Platonist terms, the stupendous stained-glass windows of the choir were meant not merely to illuminate the altar but to represent divine light itself, the ineffable spirit of God made visible.
>
> In addition, as depository of holy relics and burial place of the kings of France, the Abbey Church had an important political function. Suger's new design served to glorify the nascent French state and to affirm the role of the monarch as defender of the faith. The building was thus created as a network of religious, aesthetic, and political ideas.

(left) Speyer Cathedral, Germany, begun 1030

(right) The Arrest of Christ, fresco, S. Angelo in Formis, Capua, c. 1085

c. 1050 *Chanson de Roland,* French epic tale

Hariulf (c. 1060–1143), a monk at St.-Riquier, author of a history of the monastery

Peter Abelard (1079?–1144), French Nominalist philosopher at the University of Paris, author of *Sic et Non,* a theological inquiry, and opponent of St. Bernard of Clairvaux

c. 1100 Chrétien de Troyes, French poet, writes Arthurian romances

Omar Khayyam (c. 1100), Persian poet

Early 1100s Troubadour poetry and music, a courtly, intricate style, often on the theme of love, popular in France and Italy

Ibn Rushd (Averroës) (c. 1126–98), Spanish Moslem physician and philosopher, author of treatises on Plato and Aristotle

c. 1160 *Nibelungenleid,* German epic

Nicholas Mesarites (c. 1163–after 1214), Byzantine chronicler

Late 1100s *Carmina Burana,* a collection of popular secular poems

Albertus Magnus (1192–1280), German Scholastic philosopher

Matthew Paris (c. 1200–59), French historian

1086 Domesday survey in England, first full census of a population, for taxation purposes. Domesday Book, containing collected data, compiled

1100s Moorish paper mills in operation; use in Italy of lateen sail for improved sailing; soap in widespread use; Theophilus Presbyter, German scholar, publishes manual on building and decorating a cathedral

c. 1150 Crossbow, more effective than the standard bow and arrow, in widespread use

c. 1170 Leonardo of Pisa, Italian mathematician, introduces Hindu mathematics, geometry, and algebra

1180–1223 Philip II of France embarks on a rebuilding of Paris. Roads are paved, walls erected, and, c. 1200, the Louvre palace is begun

1193 First merchant guild, England

	1200–1225	**1225–1250**	**1250–1275**
HISTORY AND POLITICS	**1202–4** Fourth Crusade sets out for Palestine in Venetian ships. Diverted to Christian Constantinople, crusaders sack the city; entire enterprise excommunicated by the pope; 1208–74, numerous other crusades shift possession of lands in the Middle East from one of the Western powers to another, and confront the Moslems, who nevertheless hold Jerusalem from 1244 until 1917 **1206–23** Mongol ruler Genghis Khan crosses Asia and Russia, threatening Europe **1215** Magna Carta, a pact between the English monarch and the feudal barons, signed by King John. The document, limiting the absolute powers of the monarchy, is the genesis of a new constitution that places the law over the will of the king, contains new legal, religious, and taxation rights for the individual, including the right to a trial and other reforms, and establishes a parliament	Louis IX, king of France (St. Louis, r. 1226–70), leads Seventh and Eighth Crusades	**1254–73** Period of strife in Germany, with contested claims to the throne of the Holy Roman Empire, confirms fractured nature of individual German states and signals the end of the empire as a political power **By 1263** Papal grant to trade awarded to Teutonic Knights, originally a crusading order of chivalry. The order grows powerful in the absence of any strong monarch and controls much of Prussia, northern Germany, and parts of Lithuania and Poland. Founds numerous independent cities as a mercantile corporation; these later form part of the Hanseatic League of free trading cities of Northern Europe **1271–95** The trader Marco Polo travels from Venice to the court of Kublai Khan. His journeys through India, China, Burma, and Persia open the first diplomatic relations between European and Asian nations
RELIGION	**1215** Fourth Lateran Council of bishops, in Rome, establishes major Catholic doctrines: transubstantiation, practice of confession, and worship of relics **1223** St. Francis of Assisi founds Franciscan monastic order, emphasizing poverty	**Courtly Life and the International Style** Intricate miniature illuminations, small personal diptychs, and precious, jeweled objects epitomize one aesthetic thread of the fourteenth century. The small scale and great elegance of these works reflect the rise, particularly in France, of a class of wealthy nobles whose refined taste and habit of traveling required art to be both beautiful and portable. Illuminated books of hours containing daily prayers, calendars, and parts of the Gospels were fashionable items that advertised the owner's wealth, piety, good taste, and connoisseurship. Contemporary with this graceful, decorative style was a parallel new style in literature—secular, romantic, and written in contemporary language, rather than the educated Latin of previous generations; the troubadour poets in Provençal, the *Roman de la Rose* in French, and much of Dante's and Petrarch's poetry in Italian are examples. Poems and paintings alike celebrate the sensual pleasures of the material world.	
	 (left) Interior, Chartres Cathedral, c. 1194–1220 *(right)* Notre-Dame, Paris, 1163–c. 1250		
MUSIC, LITERATURE, AND PHILOSOPHY	**1200** Foundation of the University of Paris (called the Sorbonne after 1257); 1209, University of Valencia; 1242, University of Salamanca; these become centers for interchange between Arabs and Christians	St. Thomas Aquinas (1225–74), Italian Scholastic philosopher. His *Summa Theologica*, a founding text of Catholic teaching, examines the relationship between faith and intellect, religion and society	Vincent of Beauvais (died 1264), French encyclopedist Dante Alighieri (1265–1321), author of *The Divine Comedy*, in Tuscan vernacular. The poem is immensely influential for the development of the Italian language **1266–83** *The Golden Legend*, a collection of apocryphal religious stories by the Italian prelate Jacopo da Voragine (c. 1228–98)
SCIENCE, TECHNOLOGY, AND EXPLORATION	**1200s** Use of coal gains over wood fuel; mining begins in Liège, France. Advances in seafaring: sternpost rudder and compass in use in Europe; spinning wheel and gunpowder introduced	Roger Bacon (died 1292), English scientist who utilized observation and experiment in studying natural forces	

1275–1300	1300–1325	1325–1350
1289 John of Montecorvino establishes a permanent Christian mission in China **1290** Jews expelled from England; 1306, from France **1295** King Edward I of England institutes the Model Parliament, first bicameral English parliament	**1302** First known convocation of French estates-general, parliamentary assembly of the crown, clergy, and commons, to support Philip IV the Fair in his struggle with Pope Boniface VIII over questions of papal authority **1305** Fearing political anarchy and desperate conditions in Rome, Pope Clement V establishes Avignon as the primary residence of the papacy; beginning of the so-called Babylonian Captivity (to 1376) **1310–13** Holy Roman Emperor Henry VII invades Italy to reestablish imperial rule	**1325** Foundation of the city of Tenochtitlán by the Aztecs **1337** Hundred Years' War between England and France begins (until 1453) **1347–50** Black Death in Europe. Bubonic plague kills an estimated one-third of population

Europe and the East The relationship of Christian European cultures to non-Christian nations had been alternately cordial and combative since the Moslem conquest of the Mideast and Spain in the eighth century. Arab scholarship and technology were commonly exchanged with that of Europe through trade and travel, and the crusades did much to increase knowledge of Arab culture in the West, but the regions farther to the East were little known. European contacts with Asia underwent a transformation in the late thirteenth century, after the Venetian trader Marco Polo, traveling to the courts of the Mongol emperor Kublai Kahn, China, India, and Persia, brought back the first accurate account of these places. As understanding of Asia grew, trade routes and trading colonies were established, as well as Christian missions. Lured by the prospect of great profit from trade in silk, exotic spices, and gold, as well as by adventure, merchants began to venture to these previously hostile nations in great numbers. Much of the zeal for the later crusades has been attributed not only to religious fervor but to the opportunity to open trade routes and mercantile contacts with Eastern countries. The effect on European culture was dramatic. The city of Venice became a thriving center for trade from the East, as did the Spanish coastal cities; these cities became not only mercantile but cultural centers for the exchange of arts and ideas. The influence of Asian taste can be seen in such images as the English heraldic lion, which is thought to derive from a Chinese dragon figure, no doubt woven in a precious silk textile.

JEAN PUCELLE
Illuminated pages from the *Hours of Jeanne d'Evreux*, Paris, 1325–28

1275–1300	1300–1325	1325–1350
c. 1297 Publication of Marco Polo's *Book of Various Experiences*. These enormously popular tales of travels in the Far East fostered a general interest in foreign lands	**c. 1300** The *Roman de la Rose*, satire on society written in vernacular French William of Ockham (c. 1300–49), English Nominalist philosopher, stresses mystical experience over rational understanding Petrarch (1304–74), Italian humanist scholar and poet Giovanni Boccaccio (1313–75), Italian author of *The Decameron*, a collection of tales	**1325–27** Ibn Batutah (1304–c. 1368), Arab traveler and scholar, visits North Africa, the Mideast, and Persia; 1334, reaches India and later, 1342, China; his memoirs contain commentary on political and social customs Franco Sacchetti (1332?–1400), Italian poet and author of *Three Hundred Stories* Geoffrey Chaucer (1340–1400), English diplomat and author of *The Canterbury Tales*
Late 1200s Arabic numerals introduced in Europe **c. 1286** Spectacles invented	**Early 1300s** Earliest cast iron in Europe; gunpowder first used for launching projectiles	**1335–45** Artillery first used on ships **1340** Francesco Pegolotti writes The *Merchant's Handbook,* an Italian manual for traders **1346** Longbow replaces crossbow: at the Battle of Crécy the English use it to defeat the French, including cavalry; greater participation of foot soldiers in warfare follows

BOOKS FOR FURTHER READING

by Max Marmor

In the literature of art—as in art itself—the best is not always the newest. We have, therefore, sought to achieve a judicious balance between standard works and current publications. Some works listed here are valuable chiefly for their reproductions, the text being outdated. We have not tried to indicate which titles are currently in print. But most listed here should be available in the art section of a local public or academic library. Your librarian can help you determine whether any specific title is readily available for purchase.

In the literature of art, the best is not always a book. But this list is limited to books, despite the fact that much important art-historical literature appears in periodicals and other types of publications. We have listed below a few of the standard indexes to art periodicals. These, too, should be available in a local library.

In the literature of art, the best is not always written in English. This list is, however, limited to books published in English. If, therefore, some areas of art history seem less well served here than others, readers may assume that the appropriate English literature on those subjects is similarly limited. In an era of multiculturalism and global scholarship, the student of art history is obliged to learn to read foreign languages.

In the literature of art, the best is not always obvious. To help the interested reader explore beyond the self-imposed limits of this list, we include below a list of several general art bibliographies; and more specialized bibliographies may be found throughout, in their appropriate places. We also include a list of standard art dictionaries and encyclopedias.

In the literature of art, the best is not infrequently the artists' own words or those of their contemporaries. We have therefore included a selective list of anthologies of "sources and documents" readily available in English translation.

In the literature of art, the best is not always printed at all. We therefore include a brief list of some electronic resources of interest to the student of art history.

A final note. Monographs on individual artists are legion, and only a handful are included here. Because greatness is established over time, we have been especially economical about listing monographs on individual twentieth-century artists. Your librarian can help you identify scholarly books on artists not included here.

REFERENCE RESOURCES IN ART HISTORY

1. ANTHOLOGIES OF SOURCES AND DOCUMENTS

Documents of Modern Art. 14 vols. Wittenborn, New York, 1944–61. A series of specialized anthologies.
The Documents of Twentieth-Century Art. G. K. Hall, Boston. A new series of specialized anthologies, individually listed below.
Goldwater, R., and M. Treves, eds. *Artists on Art, from the Fourteenth to the Twentieth Century.* 3rd ed. Pantheon, New York, 1974.
Holt, E. G., ed. *A Documentary History of Art.* Vol. 1, *The Middle Ages and the Renaissance.* Vol. 2, *Michelangelo and the Mannerists. The Baroque and the Eighteenth Century.* Vol. 3, *From the Classicists to the Impressionists.* 2nd ed. Princeton University Press, Princeton, 1981.
Sources and Documents in the History of Art Series. General ed. H. W. Janson. Prentice Hall, Englewood Cliffs, N.J. Specialized anthologies, listed individually below.

2. BIBLIOGRAPHIES AND RESEARCH GUIDES

Arntzen, E., and R. Rainwater. *Guide to the Literature of Art History.* American Library Association, Chicago, 1980.
Barnet, S. *A Short Guide to Writing About Art.* 4th ed. HarperCollins College, New York, 1993.
Chiarmonte, P. *Women Artists in the United States: A Selective Bibliography and Resource Guide to the Fine and Decorative Arts, 1750–1986.* G. K. Hall, Boston, 1990.
Ehresmann, D. *Architecture: A Bibliographical Guide to Basic Reference Works, Histories, and Handbooks.* Libraries Unlimited, Littleton, Colo., 1984.
———. *Fine Arts: A Bibliographical Guide to Basic Reference Works, Histories, and Handbooks.* 3rd ed. Libraries Unlimited, Littleton, Colo., 1990.
Freitag, W. *Art Books: A Basic Bibliography of Monographs on Artists.* Garland, New York, 1985.
Goldman, B. *Reading and Writing in the Arts: A Handbook.* Wayne State Press, Detroit, 1972.
Kleinbauer, W., and T. Slavens. *Research Guide to Western Art History.* American Library Association, Chicago, 1982.
Reference Publications in Art History. G. K. Hall, Boston. Specialized bibliographies, individually listed below.

3. DICTIONARIES AND ENCYCLOPEDIAS

Baigell, M. *Dictionary of American Art.* Harper & Row, New York, 1979.
Chilvers, I., and H. Osborne, eds. *The Oxford Dictionary of Art.* Oxford University Press, New York, 1988.
Dictionary of Art, The. 34 vols. Grove's Dictionaries, New York, 1996.
Duchet-Suchaux, G., and M. Pastoureau. *The Bible and the Saints.* Flammarion Iconographic Guides. Flammarion, Paris and New York, 1994.
Encyclopedia of World Art. 14 vols., with index and supplements. McGraw-Hill, New York, 1959–68.
Fleming, J., and H. Honour. *A Dictionary of Architecture.* 4th ed. Penguin, Baltimore, 1991.
———. *The Penguin Dictionary of Decorative Arts.* New ed. Viking, London, 1989.
Hall, J. *Illustrated Dictionary of Symbols in Eastern and Western Art.* HarperCollins, New York, 1994.
———. *Subjects and Symbols in Art.* 2nd ed. Harper & Row, New York, 1979.
Havlice, P. P. *World Painting Index.* 2 vols. Scarecrow Press, Metuchen, N.J., 1977. 2 vols. supplement, 1982.
Hutchinson Dictionary of the Arts, The. Helicon, London, 1994.
Janson, H. W., and D. J., eds. *Key Monuments of the History of Art.* Harry N. Abrams, New York, 1959.
Lever, J., and J. Harris. *Illustrated Dictionary of Architecture, 800–1914.* Faber & Faber, Boston, 1993.
Mayer, Ralph. *The HarperCollins Dictionary of Art Terms & Techniques.* 2nd ed. HarperCollins, New York, 1991.
———. *The Artist's Handbook of Materials and Techniques.* 5th ed. Viking, New York, 1991.
McGraw-Hill Dictionary of Art. Ed. B. S. Myers. 5 vols. McGraw-Hill, New York, 1969.
Millon, H. A., ed. *Key Monuments of the History of Architecture.* Harry N. Abrams, New York, 1964.
Murray, P. and L. *A Dictionary of Art and Artists.* 5th ed. Penguin, New York, 1988.
Osborne, H., ed. *Oxford Companion to Art.* Oxford, Clarendon Press, 1970.
Pierce, J. S. *From Abacus to Zeus: A Handbook of Art History.* 5th ed. Prentice Hall, Englewood Cliffs, N.J., 1995.

Placzek, A. K., ed. *Macmillan Encyclopedia of Architects.* 4 vols. Macmillan, New York, 1982.
Reid, J. D., ed. *The Oxford Guide to Classical Mythology in the Arts 1300–1990.* 2 vols. Oxford University Press, New York, 1993.
Teague, E. *World Architecture Index: A Guide to Illustrations.* Greenwood Press, New York, 1991.
Worldwide Bibliography of Art Exhibition Catalogues, 1963–1987, The. 3 vols. Kraus, Millwood, N.Y., 1992.
Wright, C., comp. *The World's Master Paintings: From the Early Renaissance to the Present Day: A Comprehensive Listing of Works by 1,300 Painters and a Complete Guide to Their Locations Worldwide.* 2 vols. Routledge, New York, 1991.

4. INDEXES, PRINTED AND ELECTRONIC

Increasingly, the standard indexes to art literature are being made available by computer.
Art Index. 1929 to present. A standard quarterly index to more than 200 art periodicals. Data since 1984 also available electronically.
ART bibliographies MODERN. 1969 to present. A semi-annual publication indexing and annotating more than 300 art periodicals, as well as books, exhibition catalogues, and dissertations. Data since 1984 also available electronically.
Avery Index to Architectural Periodicals. 1934 to present. 15 vols., with supplementary vols. G. K. Hall, Boston, 1973. Also available electronically.
BHA: Bibliography of the History of Art. 1991 to present. The merger of two standard indexes: *RILA* (*Répertoire International de la Littérature de l'Art/International Repertory of the Literature of Art,* vol. 1, 1975) and *Répertoire d'Art et d'Archéologie* (vol. 1, 1910). Like those indexes, scheduled to be available electronically in the near future.

5. GENERAL SOURCES

Barasch, M. *Theories of Art: From Plato to Winckelmann.* New York University Press, New York, 1985.
Baxandall, M. *Patterns of Intention: On the Historical Explanation of Pictures.* Yale University Press, New Haven, 1985.
Bois, Y.-A. *Painting as Model.* MIT Press, Cambridge, 1990.
Broude, N., and M. Garrard, eds. *Feminism and Art History: Questioning the Litany.* Harper & Row, New York, 1982.
———. *The Expanding Discourse: Feminism and Art History.* Harper & Row, New York, 1992.
Bryson, N., ed. *Vision and Painting: The Logic of the Gaze.* Yale University Press, New Haven, 1983.
———, et al., eds. *Visual Theory: Painting and Interpretation.* Cambridge University Press, New York, 1991.
Cahn, W. *Masterpieces: Chapters on the History of an Idea.* Princeton University Press, Princeton, 1979.
Chadwick, W. *Women, Art, and Society.* Thames and Hudson, New York, 1990.
Freedberg, D. *The Power of Images: Studies in the History and Theory of Response.* University of Chicago Press, Chicago, 1989.
Gage, J. *Color and Culture: Practice and Meaning from Antiquity to Abstraction.* Little, Brown, Boston, 1993.
Gombrich, E. H. *Art and Illusion.* 4th ed. Pantheon, New York, 1972.
Harris, A. S., and L. Nochlin. *Women Artists, 1550–1950.* Knopf, New York, 1976.
Kemal, S., and I. Gaskell. *The Language of Art History.* Cambridge Studies in Philosophy and the Arts. Cambridge University Press, New York, 1991.

Kleinbauer, W. E. *Modern Perspectives in Western Art History: An Anthology of Twentieth-Century Writings on the Visual Arts.* Reprint of 1971 ed., University of Toronto Press, Toronto, 1989.

Kostof, S. A. *History of Architecture: Settings and Rituals.* 2nd ed. Oxford University Press, New York, 1995.

Kris, E. *Psychoanalytic Explorations in Art.* International Universities Press, New York, 1962.

———, and O. Kurz. *Legend, Myth, and Magic in the Image of the Artist: A Historical Experiment.* Yale University Press, New Haven, 1979.

Kultermann, U. *The History of Art History.* Abaris Books, New York, 1993.

Nochlin, L. *Women, Art, and Power, and Other Essays.* Harper & Row, New York, 1988.

Panofsky, E. *Meaning in the Visual Arts.* Reprint of 1955 ed., University of Chicago Press, 1982.

Parker, R., and G. Pollock. *Old Mistresses: Women, Art, and Ideology.* Pantheon, New York, 1981.

Penny, N. *The Materials of Sculpture.* Yale University Press, New Haven, 1993.

Podro, M. *The Critical Historians of Art.* Yale University Press, New Haven, 1982.

Pollock, G. *Vision and Difference: Feminity, Feminism, and the Histories of Art.* Routledge, New York, 1988.

Rees, A. L., and F. Borzello. *The New Art History.* Humanities Press International, Atlantic Highlands, N.J., 1986.

Roth, L. *Understanding Architecture: Its Elements, History, and Meaning.* Harper & Row, New York, 1993.

Shikes, R. E. *The Indignant Eye: The Artist as Social Critic in Prints and Drawings from the Fifteenth Century to Picasso.* Beacon Press, Boston, 1969.

Summerson, J. *The Classical Language of Architecture.* MIT Press, Cambridge, 1963.

Tagg, J. *Grounds of Dispute: Art History, Cultural Politics, and the Discursive Field.* University of Minnesota Press, Minneapolis, 1992.

Trachtenberg, M., and I. Hyman. *Architecture: From Prehistory to Post-Modernism.* Harry N. Abrams, New York, 1986.

Watkin, D. *The Rise of Architectural History.* University of Chicago Press, Chicago, 1980.

Wittkower, R. and M. *Born Under Saturn: The Character and Conduct of Artists: A Documented History from Antiquity to the French Revolution.* Norton, New York, 1963.

Wölfflin, H. *Principles of Art History: The Problem of the Development of Style in Later Art.* Dover, New York, 1932.

Wolff, J. *The Social Production of Art.* 2nd ed. New York University Press, New York, 1993.

Wollheim, R. *Art and Its Objects.* Cambridge University Press, New York, 1980.

PART ONE: THE ANCIENT WORLD

GENERAL REFERENCES

Groenewegen-Frankfort, H. A., and B. Ashmole. *Art of the Ancient World: Painting, Pottery, Sculpture, Architecture from Egypt, Mesopotamia, Crete, Greece, and Rome.* Harry N. Abrams, New York, 1975.

Lloyd, S., H. Müller, and R. Martin. *Ancient Architecture: Egypt, Mesopotamia, Greece.* Harry N. Abrams, New York, 1974.

Van Keuren, F. *Guide to Research in Classical Art and Mythology.* American Library Association, Chicago, 1991.

Wolf, W. *The Origins of Western Art: Egypt, Mesopotamia, the Aegean.* Universe Books, New York, 1989.

1. PREHISTORIC ART

Bandi, H.-G., and H. Breuil. *The Art of the Stone Age: Forty Thousand Years of Rock Art.* 2nd ed. Methuen, London, 1970.

Breuil, H. *Four Hundred Centuries of Cave Art.* Reprint of 1952 ed., Hacker, New York, 1979.

Chauvet, J.-M., É. B. Deschamps, and C. Hilaire. *Dawn of Art: The Chauvet Cave.* Harry N. Abrams, New York, 1995.

Gimbutas, M. *The Gods and Goddesses of Old Europe, 7000–3500 B.C.: Myths, Legends, and Cult Images.* University of California Press, Berkeley, 1974.

Graziosi, P. *Paleolithic Art.* McGraw-Hill, New York, 1960.

Leroi-Gourhan, A. *The Dawn of European Art: An Introduction to Palaeolithic Cave Painting.* Cambridge University Press, New York, 1982.

Powell, T. G. E. *Prehistoric Art.* The World of Art. Oxford University Press, New York, 1966.

Ruspoli, M. *The Cave of Lascaux: The Final Photographs.* Harry N. Abrams, New York, 1987.

Sandars, N. *Prehistoric Art in Europe.* 2nd ed. Yale University Press, New Haven, 1985.

Sieveking, A. *The Cave Artists.* Thames and Hudson, London, 1979.

Twohig, E. S. *The Megalithic Art of Western Europe.* Oxford University Press, New York, 1981.

2. EGYPTIAN ART

Aldred, C. *The Development of Ancient Egyptian Art, from 3200 to 1315 B.C.* 3 vols. in 1. Academy Editions, London, 1972.

Badawy, A. *A History of Egyptian Architecture.* 3 vols. University of California Press, Berkeley, 1954–68.

Davis, W. *The Canonical Tradition in Ancient Egyptian Art.* Cambridge University Press, New York, 1989.

Edwards, I. E. S. *The Pyramids of Egypt.* Rev. ed., Penguin, Harmondsworth, England, 1991.

Lange, K., and M. Hirmer. *Egypt: Architecture, Sculpture, Painting in Three Thousand Years.* 4th ed. Phaidon, London, 1968.

Mahdy, C., ed. *The World of the Pharaohs: A Complete Guide to Ancient Egypt.* Thames and Hudson, London, 1990.

Mendelssohn, K. *The Riddle of the Pyramids.* Thames and Hudson, New York, 1986.

Panofsky, E. *Tomb Sculpture: Four Lectures on Its Changing Aspects from Ancient Egypt to Bernini.* Introduction by M. Kemp. Harry N. Abrams, New York, 1992.

Schaefer, H. *Principles of Egyptian Art.* Clarendon Press, Oxford, 1986.

Smith, W., and W. Simpson. *The Art and Architecture of Ancient Egypt.* Pelican History of Art. Reprint of 1981 2nd ed., Yale University Press, New Haven, 1993.

Wilkinson, R. *Reading Egyptian Art: A Hieroglyphic Guide to Ancient Egyptian Painting and Sculpture.* Thames and Hudson, New York, 1992.

3. ANCIENT NEAR EASTERN ART

Akurgal, E. *Art of the Hittites.* Harry N. Abrams, New York, 1962.

Amiet, P. *Art of the Ancient Near East.* Harry N. Abrams, New York, 1980.

Collon, D. *First Impressions: Cylinder Seals in the Ancient Near East.* University of Chicago Press, Chicago, 1987.

Crawford, H. *Sumer and the Sumerians.* Cambridge University Press, New York, 1991.

Frankfort, H. *The Art and Architecture of the Ancient Orient.* Pelican History of Art. 4th ed. Yale University Press, New Haven, 1970.

Ghirshman, R. *Persian Art, the Parthian and Sassanian Dynasties, 249 B.C.–A.D. 651.* The Arts of Mankind. Golden Press, New York, 1962.

———. *The Arts of Ancient Iran: From Its Origins to the Time of Alexander the Great.* The Arts of Mankind. Golden Press, New York, 1964.

Leick, G. *A Dictionary of Ancient Near Eastern Architecture.* Routledge, New York, 1988.

Lloyd, S. *The Art of the Ancient Near East.* Oxford University Press, New York, 1963.

———. *The Archaeology of Mesopotamia: From the Old Stone Age to the Persian Conquest.* Rev. ed. Thames and Hudson, New York, 1984.

Mellaart, J. *Earliest Civilizations of the Near East.* McGraw-Hill, New York, 1965.

Moscati, S. *The Phoenicians.* Abbeville, New York, 1988.

Oates, J. *Babylon.* Rev. ed. Thames and Hudson, London, 1986.

Parrot, A. *The Arts of Assyria.* Braziller, New York, 1961.

———. *Sumer: The Dawn of Art.* Golden Press, New York, 1961.

Porada, E. *The Art of Ancient Iran: Pre-Islamic Cultures.* Crown, New York, 1965.

Reade, J. *Mesopotamia.* British Museum, London, 1991.

4. AEGEAN ART

Barber, R. *The Cyclades in the Bronze Age.* University of Iowa Press, Iowa City, 1987.

Boardman, J. *Pre-Classical: From Crete to Archaic Greece.* Penguin, Harmondsworth, England, 1967.

Demargne, P. *Aegean Art: The Origins of Greek Art.* The Arts of Mankind. Thames and Hudson, London, 1964.

Getz-Preziosi, P. *Sculptors of the Cyclades.* University of Michigan Press, Ann Arbor, 1987.

Graham, J. *The Palaces of Crete.* Rev. ed. Princeton University Press, Princeton, 1987.

Hampe, R., and E. Simon. *The Birth of Greek Art from the Mycenean to the Archaic Period.* Oxford University Press, New York, 1981.

Higgins, R. *Minoan and Mycenaean Art.* The World of Art. Rev. ed. Oxford University Press, New York, 1981.

Hood, S. *The Arts in Prehistoric Greece.* Pelican History of Art. Penguin, Harmondsworth, England, 1978.

———. *The Minoans: The Story of Bronze Age Crete.* Praeger, New York, 1981.

Hurwit, J. *The Art and Culture of Early Greece, 1100–480 B.C.* Cornell University Press, Ithaca, 1985.

McDonald, W. *Progress into the Past: The Rediscovery of Mycenaean Civilization.* 2nd ed. Indiana University Press, Bloomington, 1990.

Mylonas, G. *Mycenae and the Mycenaean Age.* Princeton University Press, Princeton, 1966.

Renfrew, C. *The Emergence of Civilization: The Cyclades and the Aegean in the Third Millennium B.C.* Methuen, London, 1972.

Vermeule, E. *Greece in the Bronze Age.* University of Chicago Press, Chicago, 1972.

5. GREEK ART

Arias, P., and M. Hirmer. *History of 1000 Years of Greek Vase Painting.* Harry N. Abrams, New York, 1963.

Beazley, J. D. *Attic Black-Figure Vase-Painters.* Reprint of 1956 ed., Hacker, New York, 1978.

———. *The Development of Attic Black-Figure.* Rev. ed. University of California Press, Berkeley, 1986.

Boardman, J. *Greek Gems and Finger Rings: Early Bronze Age to Late Classical.* Harry N. Abrams, New York, 1970.

———. *Athenian Black Figure Vases: A Handbook.* Thames and Hudson, New York, 1985.

———. *Greek Sculpture: The Archaic Period: A Handbook.* New ed. The World of Art. Thames and Hudson, New York, 1985.

———. *Greek Sculpture: The Classical Period: A Handbook.* New ed. The World of Art. Thames and Hudson, New York, 1985.

———. *Athenian Red Figure Vases: The Classical Period: A Handbook.* The World of Art. Thames and Hudson, New York, 1989.

———. *Athenian Red Figure Vases: The Archaic Period: A Handbook.* The World of Art. Thames and Hudson, New York, 1991.

———, ed. *The Oxford History of Classical Art.* Oxford University Press, New York, 1993.

Carpenter, T. H. *Art and Myth in Ancient Greece: A Handbook.* The World of Art. Thames and Hudson, New York, 1991.

Charbonneaux, J., R. Martin, and F. Villard. *Archaic Greek Art.* The Arts of Mankind. Braziller, New York, 1971.

———. *Classical Greek Art.* The Arts of Mankind. Braziller, New York, 1972.

———. *Hellenistic Greek Art.* The Arts of Mankind. Braziller, New York, 1973.

Coulton, J. J. *Ancient Greek Architects at Work: Problems of Structure and Design.* Cornell University Press, Ithaca, 1977.

Dinsmoor, W. *The Architecture of Ancient Greece.* Reprint of 1950 ed., Norton, New York, 1975.

Kraay, C., and M. Hirmer. *Greek Coins.* Harry N. Abrams, New York, 1966.

Lawrence, A. *Greek Architecture.* Pelican History of Art. 4th ed., rev. Penguin, Harmondsworth, England, 1983.

Moon, W., ed. *Ancient Greek Art and Iconography.* University of Wisconsin Press, Madison, 1983.

Papaioannou, K. *The Art of Greece.* Harry N. Abrams, New York, 1989.

Pedley, J. *Greek Art and Archaeology.* 2nd ed. Harry N. Abrams, New York, 1997.

Pollitt, J. *Art and Experience in Classical Greece.* Cambridge University Press, New York, 1972.

———. *The Ancient View of Greek Art: Criticism, History, and Terminology.* Yale University Press, New Haven, 1974.

———. *Art in the Hellenistic Age.* Cambridge University Press, New York, 1986.

———, ed. *Art of Greece, 1400–31 B.C.: Sources and Documents.* 2nd ed. Prentice-Hall, Englewood Cliffs, N.J., 1990.

Richter, G. M. A. *The Sculpture and Sculptors of the Greeks.* 4th ed., rev. Yale University Press, New Haven, 1970.

———. *Portraits of the Greeks.* Ed. R. Smith. Oxford University Press, New York, 1984.

———. *A Handbook of Greek Art.* 9th ed. Da Capo, New York, 1987.

Ridgway, B. S. *The Severe Style in Greek Sculpture.* Princeton University Press, Princeton, 1970.

———. *The Archaic Style in Greek Sculpture.* Princeton University Press, Princeton, 1976.

———. *Fifth Century Styles in Greek Sculpture.* Princeton University Press, Princeton, 1981.

———. *Hellenistic Sculpture.* Vol. 1, *The Styles of ca. 331–200 B.C.* Bristol Classical Press, Bristol, 1990.

Robertson, D. *Greek and Roman Architecture.* 2nd ed. Cambridge University Press, Cambridge, 1969.

Robertson, M. *History of Greek Art.* 2 vols. Cambridge University Press, Cambridge, 1975.

———. *The Art of Vase Painting in Classical Athens.* Cambridge University Press, New York, 1992.

Schefold, K. *Myth and Legend in Early Greek Art.* Harry N. Abrams, New York, 1966.

———. *Gods and Heroes in Late Archaic Greek Art.* Cambridge University Press, New York, 1992.

Smith, R. *Hellenistic Sculpture.* The World of Art. Thames and Hudson, New York, 1991.

Stewart, A. F. *Greek Sculpture: An Exploration.* Yale University Press, New Haven, 1990.

6. ETRUSCAN ART

Boethius, A. *Etruscan and Early Roman Architecture.* Pelican History of Art. 2nd ed. Penguin, Harmondsworth, England, 1978.

Bonfante, L., ed. *Etruscan Life and Afterlife: A Handbook of Etruscan Studies.* Wayne State University Press, Detroit, 1986.

Brendel, O. *Etruscan Art.* Pelican History of Art. Yale University Press, New Haven, 1995.

Pallottino, M. *Etruscan Painting.* Skira, Geneva, 1953.

Richardson, E. *The Etruscans: Their Art and Civilization.* Reprint of 1964 ed., with corrections, University of Chicago Press, Chicago, 1976.

Sprenger, M., G. Bartoloni, and M. Hirmer. *The Etruscans: Their History, Art, and Architecture.* Harry N. Abrams, New York, 1983.

Steingräber, S., ed. *Etruscan Painting: Catalogue Raisonné of Etruscan Wall Paintings.* Johnson Reprint, New York, 1986.

7. ROMAN ART

Andreae, B. *The Art of Rome.* Harry N. Abrams, New York, 1977.

Bianchi-Bandinelli, R. *Rome: The Center of Power.* The Arts of Mankind. Braziller, New York, 1970.

———. *Rome: The Late Empire.* The Arts of Mankind. Braziller, New York, 1971.

Brilliant, R. *Roman Art from the Republic to Constantine.* Phaidon, London, 1974.

Jenkyns, R., ed. *The Legacy of Rome: A New Appraisal.* Oxford University Press, New York, 1992.

Kent, J., and M. Hirmer. *Roman Coins.* Harry N. Abrams, New York, 1978.

Kleiner, D. *Roman Sculpture.* Yale University Press, New Haven, 1992.

Ling, R. *Roman Painting.* Cambridge University Press, New York, 1991.

L'Orange, H. *Art Forms and Civic Life in the Late Roman Empire.* Princeton University Press, Princeton, 1965.

Macdonald, W. *The Architecture of the Roman Empire.* 2 vols. Rev. ed. Yale University Press, New Haven, 1982–86.

Maiuri, A. *Roman Painting.* Skira, Geneva, 1953.

Nash, E. *Pictorial Dictionary of Ancient Rome.* 2 vols. Reprint of 1968 2nd ed., Hacker, New York, 1981.

Pollitt, J. *The Art of Rome and Late Antiquity: Sources and Documents.* Prentice-Hall, Englewood Cliffs, N.J., 1966.

Ramage, N. and A. *The Cambridge Illustrated History of Roman Art.* Cambridge University Press, Cambridge, 1991.

Strong, D. E. *Roman Art.* Pelican History of Art. 2nd ed. Penguin, Baltimore, 1976.

Vitruvius, the Ten Books on Architecture. Trans. M. H. Morgan. Reprint of 1914 ed., Dover, New York, 1960.

Ward-Perkins, J. B. *Roman Architecture.* Harry N. Abrams, New York, 1977.

———. *Roman Imperial Architecture.* Pelican History of Art. 2nd ed. Penguin, New York, 1981.

Zanker, P. *The Power of Images in the Age of Augustus.* University of Michigan Press, Ann Arbor, 1988.

PART TWO: THE MIDDLE AGES

GENERAL REFERENCES

Alexander, J. J. G. *Medieval Illuminators and Their Methods of Work.* Yale University Press, New Haven, 1992.

Calkins, R. G. *Illuminated Books of the Middle Ages.* Cornell University Press, Ithaca, 1983.

———. *Monuments of Medieval Art.* Reprint of 1979 ed., Cornell University Press, Ithaca, 1985.

Cassidy, B., ed. *Iconography at the Crossroads.* Princeton University Press, Princeton, 1993.

Katzenellenbogen, A. *Allegories of the Virtues and Vices in Medieval Art.* Reprint of 1939 ed., University of Toronto Press, Toronto, 1989.

Pächt, O. *Book Illumination in the Middle Ages: An Introduction.* Miller, London, 1986.

Pelikan, J. *Mary through the Centuries: Her Place in the History of Culture.* Yale University Press, New Haven, 1996.

Schapiro, M. *Late Antique, Early Christian, and Mediaeval Art.* Meyer Schapiro, Selected Papers, 3. Braziller, New York, 1979.

Schiller, G. *Iconography of Christian Art.* 2 vols. New York Graphic Society, Greenwich, 1971–72.

Snyder, J. *Medieval Art: Painting, Sculpture, Architecture, 4th–14th Century.* Harry N. Abrams, New York, 1989.

Tasker, E. *Encyclopedia of Medieval Church Art.* Batsford, London, 1993.

1. EARLY CHRISTIAN AND BYZANTINE ART

Beckwith, J. *The Art of Constantinople: An Introduction to Byzantine Art (330–1453).* 2nd ed. Phaidon, New York, 1968.

———. *Early Christian and Byzantine Art.* Pelican History of Art. 2nd ed. Penguin, New York, 1979.

Demus, O. *Byzantine Art and the West.* New York University Press, New York, 1970.

Grabar, A. *The Beginnings of Christian Art, 200–395.* The Arts of Mankind. Odyssey, New York, 1967.

———. *Christian Iconography: A Study of Its Origins.* Princeton University Press, Princeton, 1968.

Kitzinger, E. *Byzantine Art in the Making.* Harvard University Press, Cambridge, 1977.

Kleinbauer, W. *Early Christian and Byzantine Architecture: An Annotated Bibliography and Historiography.* G. K. Hall, Boston, 1993.

Krautheimer, R. *Rome: Profile of a City, 312–1308.* Princeton University Press, Princeton, 1980.

———. *Early Christian and Byzantine Architecture.* Pelican History of Art. 4th ed. Yale University Press, New Haven, 1986.

Maguire, H. *Art and Eloquence in Byzantium.* Princeton University Press, Princeton, 1981.

Mango, C. *Byzantine Architecture.* Harry N. Abrams, New York, 1974.

———. *The Art of the Byzantine Empire, 312–1453: Sources and Documents.* Reprint of 1972 ed., University of Toronto Press, Toronto, 1986.

Mark, R., and A. Ş. Çakmak, eds. *Hagia Sophia from the Age of Justinian to the Present.* Cambridge University Press, New York, 1992.

Mathews, T. *The Byzantine Churches of Istanbul: A Photographic Survey.* Pennsylvania State University Press, University Park, Pa., 1976.

———. *The Clash of Gods: A Reinterpretation of Early Christian Art.* Princeton University Press, Princeton, 1993.

Milburn, R. *Early Christian Art and Architecture.* University of California Press, Berkeley, 1988.

Rodley, L. *Byzantine Art and Architecture: An Introduction.* Cambridge University Press, New York, 1994.

Simson, O. G. von. *Sacred Fortress: Byzantine Art and Statecraft in Ravenna.* Reprint of 1948 ed., Princeton University Press, Princeton, 1987.

Talbot Rice, D. *The Beginnings of Christian Art.* Abingdon Press, Nashville, Tenn., 1957.

———. *Art of the Byzantine Era.* The World of Art. Thames and Hudson, London, 1963.

Volbach, W. *Early Christian Art.* Harry N. Abrams, New York, 1962.

Weitzmann, K. *Late Antique and Early Christian Book Illumination.* Braziller, New York, 1977.

2. EARLY MEDIEVAL ART

Alexander, J. J. G. *Insular Manuscripts, Sixth to the Ninth Century.* Survey of Manuscripts Illuminated in the British Isles. Miller, London, 1978.

Backhouse, J., ed. *The Lindisfarne Gospels.* Phaidon, Oxford, 1981.

———. *The Golden Age of Anglo-Saxon Art, 966–1066.* Indiana University Press, Bloomington, 1984.

Conant, K. *Carolingian and Romanesque Architecture, 800–1200.* Pelican History of Art. 3rd ed. Penguin, Harmondsworth, England, 1973.

Davis-Weyer, C. *Early Medieval Art, 300–1150: Sources and Documents.* Reprint of 1971 ed., University of Toronto Press, Toronto, 1986.

Deshman, R. *Anglo-Saxon and Anglo-Scandinavian Art: An Annotated Bibliography.* G. K. Hall, Boston, 1984.

Dodwell, C. R. *Anglo-Saxon Art: A New Perspective.* Cornell University Press, Ithaca, 1982.

———. *The Pictorial Arts of the West, 800–1200.* Pelican History of Art. New ed. Yale University Press, New Haven, 1993.

Henry, F., ed. *Irish Art in the Early Christian Period, to 800 A.D.* Cornell University Press, Ithaca, 1965.

———. *Irish Art During the Viking Invasions, 800–1020 A.D.* Cornell University Press, Ithaca, 1967.

———. *The Book of Kells.* Reprint of 1974 ed., Knopf, New York, 1988.

Horn, W., and E. Born. *The Plan of St. Gall.* 3 vols. University of California Press, Berkeley, 1979.

Hubert, J., J. Porcher, and W. Volbach. *Europe of the Invasions.* The Arts of Mankind. Braziller, New York, 1969.

Hubert, J. *The Carolingian Renaissance.* The Arts of Mankind. Braziller, New York, 1970.

Kitzinger, E. *Early Medieval Art, with Illustrations from the British Museum.* Rev. ed. Indiana University Press, Bloomington, 1983.

Lasko, P. *Ars Sacra, 800–1200.* Pelican History of Art. 2nd ed. Yale University Press, New Haven, 1994.

Mayr-Harting, M. *Ottonian Book Illumination: An Historical Study.* 2 vols. Miller, London, 1991–93.

Mütherich, F., and J. Gaehde. *Carolingian Painting.* Braziller, New York, 1976.

Nees, L. *From Justinian to Charlemagne: European Art, 567–787: An Annotated Bibliography.* G. K. Hall, Boston, 1985.

Nordenfalk, C. *Celtic and Anglo-Saxon Painting: Book Illumination in the British Isles, 600–800.* Braziller, New York, 1977.

Palol, P. de, and M. Hirmer. *Early Medieval Art in Spain.* Harry N. Abrams, New York, 1967.

Rickert, M. *Painting in Britain: The Middle Ages.* Pelican History of Art. 2nd ed. Penguin, Harmondsworth, England, 1965.

Stone, L. *Sculpture in Britain: The Middle Ages.* Pelican History of Art. 2nd ed. Penguin Books, Harmondsworth, England, 1972.

Temple, E. A*nglo-Saxon Manuscripts, 900–1066.* Survey of Manuscripts Illuminated in the British Isles. Miller, London, 1976.

Werner, M. *Insular Art: An Annotated Bibliography.* G. K. Hall, Boston, 1984.

Wilson, D. M. *Anglo-Saxon Art: From the Seventh Century to the Norman Conquest.* Overlook Press, Woodstock, N.Y., 1984.

Wormald, F. *Collected Writings,* Vol. 1, *Studies in Medieval Art from the Sixth to the Twelfth Centuries.* Oxford University Press, New York, 1984.

3. ROMANESQUE ART

Aubert, M. *Romanesque Cathedrals and Abbeys of France.* House and Maxwell, New York, 1966.

Bizzarro, T. *Romanesque Architectural Criticism: A Prehistory.* Cambridge University Press, New York, 1992.

Boase, T. S. R. *English Art, 1100–1216.* Oxford History of English Art. Clarendon Press, Oxford, 1953.

Cahn, W. *Romanesque Bible Illumination.* Cornell University Press, Ithaca, 1982.

Chapman, G. *Mosan Art: An Annotated Bibliography.* Reference Publications in Art History. G. K. Hall, Boston, 1988.

Davies, M. *Romanesque Architecture: A Bibliography.* G. K. Hall, Boston, 1993.

Demus, O. *Romanesque Mural Painting.* Harry N. Abrams, New York, 1970.

Focillon, H. *The Art of the West in the Middle Ages.* Ed. J. Bony. 2 vols. Reprint of 1963 ed., Cornell University Press, Ithaca, 1980.

Glass, D. F. *Italian Romanesque Sculpture: An Annotated Bibliography.* Reference Publications in Art History. G. K. Hall, Boston, 1983.

Grabar, A., and C. Nordenfalk. *Romanesque Painting from the Eleventh to the Thirteenth Century: Mural Painting.* Skira, Geneva, 1958.

Hearn, M. F. *Romanesque Sculpture: The Revival of Monumental Stone Sculpture.* Cornell University Press, Ithaca, 1981.

Kaufmann, C. *Romanesque Manuscripts, 1066–1190.* Survey of Manuscripts Illuminated in the British Isles. Miller, London, 1978.

Kubach, H. E. *Romanesque Architecture.* Harry N. Abrams, New York, 1975.

Lyman, T. W. *French Romanesque Sculpture: An Annotated Bibliography.* Reference Publications in Art History. G. K. Hall, Boston, 1987.

Mâle, E. *Religious Art in France, the Twelfth Century: A Study of the Origins of Medieval Iconography.* Bollingen series, 90:1. Princeton University Press, Princeton, 1978.

Nichols, S. *Romanesque Signs: Early Medieval Narrative and Iconography.* Yale University Press, New Haven, 1983.

Pächt, O. *The Rise of Pictorial Narrative in Twelfth-Century England.* Clarendon Press, Oxford, 1962.

Petzold, A. *Romanesque Art.* Perspectives. Harry N. Abrams, 1995.

Platt, C. *The Architecture of Medieval Britain: A Social History.* Yale University Press, New Haven, 1990.

Porcher, J. *French Miniatures from Illuminated Manuscripts.* Collins, London, 1960.

Porter, A. K. *Romanesque Sculpture of the Pilgrimage Roads.* 10 vols. Reprint of 1923 ed., Hacker, New York, 1969.

Schapiro, M. *Romanesque Art.* Braziller, New York, 1977.

Stoddard, W. *Art and Architecture in Medieval France.* Harper & Row, New York, 1972.

Swarzenski, H. *Monuments of Romanesque Art: The Art of Church Treasures in North-Western Europe.* 2nd ed. University of Chicago Press, Chicago, 1967.

4. GOTHIC ART

Avril, F. *Manuscript Painting at the Court of France: The Fourteenth Century, 1310–1380.* Braziller, New York, 1978.

Belting, H. *The Image and Its Public: Form and Function of Early Paintings of the Passion.* Caratzas, New Rochelle, 1990.

Blum, P. *Early Gothic Saint-Denis: Restorations and Survivals.* University of California Press, Berkeley, 1992.

Bomford, D. *Art in the Making: Italian Painting Before 1400.* Exh. cat. National Gallery of Art, London, 1989.

Bony, J. *The English Decorated Style: Gothic Architecture Transformed, 1250–1350.* Cornell University Press, Ithaca, 1979.

———. *French Gothic Architecture of the Twelfth and Thirteenth Centuries.* University of California Press, Berkeley, 1983.

Bowie, T., ed. *The Sketchbook of Villard de Honnecourt.* Reprint of 1968 ed., Greenwood, Westport, Conn., 1982.

Branner, R. *St. Louis and the Court Style in Gothic Architecture.* Zwemmer, London, 1965.

———. *Chartres Cathedral.* Norton, New York, 1969.

Brieger, P. *English Art, 1216–1307.* Oxford History of English Art. Clarendon Press, Oxford, 1957.

Camille, M. *Gothic Art: Glorious Visions.* Perspectives. Harry N. Abrams, New York, 1997.

———. *The Gothic Idol: Ideology and Image Making in Medieval Art.* Cambridge University Press, New York, 1989.

Caviness, M. H. *Stained Glass Before 1540: An Annotated Bibliography.* G. K. Hall, Boston, 1983.

———. *Sumptuous Arts at the Royal Abbeys of Reims and Braine.* Princeton University Press, Princeton, 1990.

Cennini, C. *The Craftsman's Handbook (Il Libro dell'Arte).* Dover, New York, 1954.

Erlande-Brandenburg, A. *Gothic Art.* Harry N. Abrams, New York, 1989.

Frankl, P. *Gothic Architecture.* Pelican History of Art. Penguin, Harmondsworth, England, 1962.

Frisch, T. G. *Gothic Art, 1140–c. 1450: Sources and Documents.* Reprint of 1971 ed., University of Toronto Press, Toronto, 1987.

Gerson, P., ed. *Abbot Suger and Saint-Denis: A Symposium.* Metropolitan Museum of Art, New York, 1986.

Grodecki, L. *Gothic Architecture.* Harry N. Abrams, New York, 1977.

———, and C. Brisac. *Gothic Stained Glass, 1200–1300.* Cornell University Press, Ithaca, 1985.

Jantzen, H. *High Gothic: The Classic Cathedrals of Chartres, Reims, Amiens.* Reprint of 1962 ed., Princeton University Press, Princeton, 1984.

Katzenellenbogen, A. *The Sculptural Programs of Chartres Cathedral.* Johns Hopkins University Press, Baltimore, 1959.

Krautheimer, R., and T. Krautheimer-Hess. *Lorenzo Ghiberti.* 2nd ed. Princeton University Press, Princeton, 1970.

Lord, C. *Royal French Patronage of Art in the Fourteenth Century: An Annotated Bibliography.* G. K. Hall, Boston, 1985.

Mâle, E. *Religious Art in France, the Thirteenth Century: A Study of Medieval Iconography and Its Sources.* Ed. H. Bober. Princeton University Press, Princeton, 1984.

Meiss, M. *Painting in Florence and Siena After the Black Death.* Princeton University Press, Princeton, 1951.

———. *French Painting in the Time of Jean de Berry: The Late Fourteenth Century and the Patronage of the Duke.* Braziller, New York, 1967.

———, and E. Beatson. *The "Belles Heures" of Jean, Duke of Berry.* Braziller, New York, 1974.

Meulen, J. van der. *Chartres: Sources and Literary Interpretation: A Critical Bibliography.* Reference Publications in Art History. G. K. Hall, Boston, 1989.

Morgan, N. *Early Gothic Manuscripts.* Survey of Manuscripts Illuminated in the British Isles. 2 vols. Miller, London, 1982–88.

Murray, S. *Beauvais Cathedral: Architecture of Transcendence.* Princeton University Press, Princeton, 1989.

Panofsky, E. *Gothic Architecture and Scholasticism.* Reprint of 1951 ed., New American Library, New York, 1985.

———, ed. and trans. *Abbot Suger on the Abbey Church of Saint-Denis and Its Art Treasures.* 2nd ed. Princeton University Press, Princeton, 1979.

Pope-Hennessy, J. *Italian Gothic Sculpture.* 3rd ed. Oxford University Press, New York, 1986.

Sandler, L. *Gothic Manuscripts, 1285–1385.* Survey of Manuscripts Illuminated in the British Isles. Miller, London, 1986.

Sauerländer, W. *Gothic Sculpture in France, 1140–1270.* Harry N. Abrams, New York, 1972.

Simson, O. von. *The Gothic Cathedral: Origins of Gothic Architecture and the Medieval Concept of Order.* 3rd ed. Princeton University Press, Princeton, 1988.

Stubblebine, J. *Assisi and the Rise of Vernacular Art.* Harper & Row, New York, 1985.

———. *Dugento Painting: An Annotated Bibliography.* G. K. Hall, Boston, 1985.

Vigorelli, G. *The Complete Paintings of Giotto.* Harry N. Abrams, New York, 1966.

White, J. *Duccio: Tuscan Art and the Medieval Workshop.* Thames and Hudson, New York, 1979.

———. *Art and Architecture in Italy, 1250–1400.* Pelican History of Art. 3rd ed. Yale University Press, New Haven, 1993.

Williamson, P. *Gothic Sculpture, 1140–1300.* Yale University Press, New Haven, 1995.

Wilson, C. *The Gothic Cathedral.* Thames and Hudson, New York, 1990.

GLOSSARY

ABACUS. A slab of stone at the top of a classical CAPITAL, just beneath the ARCHITRAVE (figs. 162, 164).

ABBEY. 1) A religious community headed by an abbot or abbess. 2) The buildings which house the community. An abbey church often has an especially large CHOIR to provide space for the monks or nuns (fig. 423).

ACADEMY. A place of study, the word coming from the Greek name of a garden near Athens where Plato and, later, Platonic philosophers held philosophical discussions from the 5th century B.C. to the 6th century A.D. The first academy of fine arts, properly speaking, was the Academy of Drawing, founded 1563 in Florence by Giorgio Vasari. Important later academies were the Royal Academy of Painting and Sculpture in Paris, founded 1648, and the Royal Academy of Arts in London, founded 1768. Their purpose was to foster the arts by systematic teaching, exhibitions, discussion, and occasionally by financial assistance.

ACANTHUS. 1) A Mediterranean plant having spiny or toothed leaves. 2) An architectural ornament resembling the leaves of this plant, used on MOLDINGS, FRIEZES, and Corinthian CAPITALS (figs. 162, 176, 407).

AISLE. See SIDE AISLE.

ALLA PRIMA. A painting technique in which pigments are laid on in one application with little or no UNDERPAINTING.

ALTAR. 1) A mound or structure on which sacrifices or offerings are made in the worship of a deity. 2) In a Catholic church, a tablelike structure used in celebrating the Mass.

ALTARPIECE. A painted or carved work of art placed behind and above the ALTAR of a Christian church. It may be a single panel (fig. 525) or a TRIPTYCH or a POLYPTYCH having hinged wings painted on both sides. Also called a reredos or retable.

ALTERNATE SYSTEM. A system developed in Romanesque church architecture to provide adequate support for a GROIN-VAULTED NAVE having BAYS twice as long as the SIDE-AISLE bays. The PIERS of the nave ARCADE alternate in size; the heavier COMPOUND piers support the main nave vaults where the THRUST is concentrated, and smaller, usually cylindrical piers support the side-aisle vaults (figs. 388, 394).

AMAZON. One of a tribe of female warriors said in Greek legend to dwell near the Black Sea (fig. 203).

AMBULATORY. A covered walkway. 1) In a BASILICAN church, the semicircular passage around the APSE (fig. 423). 2) In a CENTRAL-PLAN church, the ring-shaped AISLE around the central space (fig. 318). 3) In a CLOISTER, the covered COLONNADED or ARCADED walk around the open courtyard.

AMPHITHEATER. A double THEATER. A building, usually oval in plan, consisting of tiers of seats and access corridors around the central theater area (figs. 180, 244).

AMPHORA (pl. **AMPHORAE**). A large Greek storage vase with an oval body usually tapering toward the base; two handles extend from just below the lip to the shoulder (figs. 140, 143).

ANDACHTSBILD. German for devotional picture. A picture or sculpture with a type of imagery intended for private devotion, first developed in Northern Europe (fig. 479).

ANNULAR. From the Latin word for ring. Signifies a ring-shaped form, especially an annular barrel VAULT (fig. 303).

ANTA (pl. **ANTAE**). The front end of a wall of a Greek temple, thickened to produce a PILASTER-like member. Temples having COLUMNS between the antae are said to be "in antis" (fig. 163).

APOCALYPSE. The Book of Revelation, the last book of the New Testament. In it, St. John the Evangelist describes his visions, experienced on the island of Patmos, of Heaven, the future of humankind, and the Last Judgment.

APOSTLE. One of the 12 disciples chosen by Jesus to accompany him in his lifetime, and to spread the GOSPEL after his death. The traditional list includes Andrew, Bartholomew, James the Greater (son of Zebedee), James the Less (son of Alphaeus), John, Judas Iscariot, Matthew, Peter, Philip, Simon the Canaanite, Thaddaeus (or Jude), and Thomas. In art, however, the same 12 are not always represented since "apostle" was sometimes applied to other early Christians, such as St. Paul.

APSE. 1) A semicircular or polygonal niche terminating one or both ends of the NAVE in a Roman BASILICA (figs. 254). 2) In a Christian church, it is usually placed at the east end of the nave beyond the TRANSEPT or CHOIR (fig. 298); it is also sometimes used at the end of transept arms.

AQUEDUCT. Latin for duct of water. 1) An artificial channel or conduit for transporting water from a distant source. 2) The overground structure which carries the conduit across valleys, rivers, etc. (fig. 243).

ARCADE. A series of ARCHES supported by PIERS or COLUMNS (fig. 299). When attached to a wall, these form a blind arcade (fig. 399).

ARCH. A curved structure used to span an opening. Masonry arches are built of wedge-shaped blocks, called voussoirs, set with their narrow side toward the opening so that they lock together (fig. 235). The topmost voussoir is called the keystone. Arches may take different shapes, as in the pointed Gothic arch (fig. 450), but all require support from other arches or BUTTRESSES.

ARCHBISHOP. The chief BISHOP of an ecclesiastic district.

ARCHITRAVE. The lowermost member of a classical ENTABLATURE, i.e., a series of stone blocks that rest directly on the COLUMNS (figs. 162, 164).

ARCHIVOLT. A molded band framing an ARCH, or a series of such bands framing a TYMPANUM, often decorated with sculpture (fig. 403).

ARIANISM. Early Christian belief, initiated by Arius, a 4th-century A.D. priest in Alexandria. Now largely obscure, it was later condemned as heresy and suppressed.

ARRICCIO. See SINOPIA.

ATRIUM. 1) The central court of a Roman house (fig. 255), or its open entrance court. 2) An open court, sometimes COLONNADED or ARCADED, in front of a church (figs. 298, 393).

ATTIC. A low upper story placed above the main CORNICE or ENTABLATURE of a building, and often decorated with windows and PILASTERS.

BACCHANT (fem. **BACCHANTE**). A priest or priestess of the wine god, Bacchus (in Greek mythology, Dionysus), or one of his ecstatic female followers, who were sometimes called maenads (fig. 314).

BALUSTRADE. 1) A railing supported by short pillars called balusters. 2) Occasionally applied to any low parapet (figs. 196, 430).

BAPTISTERY. A building or a part of a church, often round or octagonal, in which the sacrament of baptism is administered (fig. 399). It contains a baptismal font, a receptacle of stone or metal which holds the water for the rite (fig. 411).

BARREL VAULT. See VAULT.

BASE. 1) The lowermost portion of a COLUMN or PIER, beneath the SHAFT (figs. 162, 177). 2) The lowest element of a wall, DOME, or building, or occasionally of a statue or painting (see PREDELLA).

BASILICA. 1) In ancient Roman architecture, a large, oblong building used as a hall of justice and public meeting place, generally having a NAVE, SIDE AISLES, and one or more APSES (fig. 254). 2) In Christian architecture, a longitudinal church derived from the Roman basilica, and having a nave, apse, two or four side aisles or side chapels, and sometimes a NARTHEX. 3) One of

the seven main churches of Rome (St. Peter's, St. Paul Outside the Walls, St. John Lateran, etc.), or another church accorded the same religious privileges.

BATTLEMENT. A parapet consisting of alternating solid parts and open spaces designed originally for defense and later used for decoration (fig. 464).

BAY. A subdivision of the interior space of a building, usually in a series bounded by consecutive architectural supports (fig. 443).

BENEDICTINE ORDER. Founded at Monte Cassino in 529 A.D. by St. Benedict of Nursia (c. 480–c. 553). Less austere than other early ORDERS, it spread throughout much of western Europe and England in the next two centuries.

BISHOP. The spiritual overseer of a number of churches or a diocese. His throne, or cathedra, placed in the principal church of the diocese, designates it as a cathedral.

BLIND ARCADE. See ARCADE.

BOOK COVER. The stiff outer covers protecting the bound pages of a book. In the medieval period, frequently covered with precious metal and elaborately embellished with jewels, embossed decoration, etc. (fig. 369).

BOOK OF HOURS. A private prayer book containing the devotions for the seven canonical hours of the Roman Catholic church (matins, vespers, etc.), liturgies for local saints, and sometimes a calendar (fig. 522). They were often elaborately ILLUMINATED for persons of high rank, whose names are attached to certain extant examples (fig. 516).

BRACKET. A stone, wooden, or metal support projecting from a wall and having a flat top to bear the weight of a statue, CORNICE, beam, etc. (fig. 407). The lower part may take the form of a SCROLL: it is then called a scroll bracket.

BROKEN PEDIMENT. See PEDIMENT.

BRONZE AGE. The earliest period in which bronze was used for tools and weapons. In the Middle East, the Bronze Age succeeded the NEOLITHIC period in c. 3500 B.C., and preceded the Iron Age, which commenced c. 1900 B.C.

BUTTRESS. 1) A projecting support built against an external wall, usually to counteract the lateral THRUST of a VAULT or ARCH within (fig. 428). 2) FLYING BUTTRESS. An arched bridge above the aisle roof that extends from the upper nave wall, where the lateral thrust of the main vault is greatest, down to a solid pier (figs. 429, 443).

BYZANTIUM. City on the Sea of Marmara, founded by the ancient Greeks and renamed Constantinople in 330 A.D. Today called Istanbul.

CAESAR. The surname of the Roman dictator, Caius Julius Caesar, subsequently used as the title of an emperor; hence the German *Kaiser*, and the Russian *czar (tsar)*.

CALLIGRAPHY. From the Greek word for beautiful writing. 1) Decorative or formal handwriting executed with a quill or reed pen, or with a brush (fig. 310). 2) A design derived from or resembling letters, and used to form a pattern (fig. 352).

CAMPAGNA. Italian word for countryside. When capitalized, it usually refers to the countryside near Rome.

CAMPANILE. From the Italian word *campana*, meaning bell. A bell tower, either round or square in plan, and sometimes freestanding (figs. 300, 393).

CAMPOSANTO. Italian word for holy field. A cemetery near a church, often enclosed.

CANOPY. In architecture, an ornamental, rooflike projection or cover above a statue or sacred object (fig. 468).

CAPITAL. The uppermost member of a COLUMN or PILLAR supporting the ARCHITRAVE (figs. 162, 176).

CARDINAL. In the Roman Catholic church, a member of the Sacred College, the ecclesiastical body which elects the pope and constitutes his advisory council.

CARMELITE ORDER. Originally a 12th-century hermitage claimed to descend from a community of hermits established by the prophet Elijah on Mt. Carmel, Palestine. In the early 13th century it spread to Europe and England, where it was reformed by St. Simon Stock and became one of the three great mendicant orders (see FRANCISCAN, DOMINICAN).

CARTHUSIAN ORDER. See CHARTREUSE.

CARVING. 1) The cutting of a figure or design out of a solid material such as stone or wood, as contrasted to the additive technique of MODELING. 2) A work executed in this technique.

CARYATID. A sculptured female figure used as an architectural support (figs. 157, 178). A similar male figure is an atlas (pl. atlantes).

CASTING. A method of duplicating a work of sculpture by pouring a hardening substance such as plaster or molten metal into a mold. See CIRE-PERDU PROCESS.

CATACOMBS. The underground burial places of the early Christians, consisting of passages with niches for tombs, and small chapels for commemorative services.

CATHEDRA, CATHEDRAL. See BISHOP.

CELLA. 1) The principal enclosed room of a temple, to house an image (fig. 163). Also called the naos. 2) The entire body of a temple as distinct from its external parts.

CENTERING. A wooden framework built to support an ARCH, VAULT, or DOME during its construction.

CENTRAL-PLAN CHURCH. 1) A church having four arms of equal length. The CROSSING is often covered with a DOME. Also called a Greek-cross church. 2) A church having a circular or polygonal plan (fig. 318).

CHANCEL. See CHOIR.

CHAPEL. 1) A private or subordinate place of worship. 2) A place of worship that is part of a church, but separately dedicated.

CHARTREUSE. French word for a Carthusian monastery (in Italian, *Certosa*). The Carthusian ORDER was founded by St. Bruno (c. 1030–1101) at Chartreuse near Grenoble in 1084. It is an eremetic order, the life of the monks being one of silence, prayer, and austerity.

CHASING. 1) A technique of ornamenting a metal surface by the use of various tools. 2) The procedure used to finish a raw bronze cast.

CHEVET. In Gothic architecture, the term for the developed and unified east end of a church, including choir, apse, ambulatory, and radiating chapels (fig. 436).

CHOIR. In church architecture, a square or rectangular area between the APSE and the NAVE or TRANSEPT (fig. 424). It is reserved for the clergy and the singing choir, and is usually marked off by steps, a railing, or a CHOIR SCREEN. Also called the chancel. See PILGRIMAGE CHOIR.

CHOIR SCREEN. A screen, frequently ornamented with sculpture, separating the CHOIR of a church from the NAVE or TRANSEPT (figs. 336, 476). In Orthodox Christian churches it is decorated with ICONS, and thus called an iconostasis (fig. 334).

CIRE-PERDU PROCESS. The lost-wax process of CASTING. A method in which an original is MODELED in wax or coated with wax, then covered with clay. When the wax is melted out, the resulting mold is filled with molten metal (often bronze) or liquid plaster.

CISTERCIAN ORDER. Founded at Citeaux in France in 1098 by Robert of Molesme with the objective of reforming the BENEDICTINE ORDER, and reasserting its original ideals of a life of severe simplicity.

CITY-STATE. An autonomous political unit comprising a city and the surrounding countryside.

CLERESTORY. A row of windows in the upper part of a wall that rises above an adjoining roof; built to provide direct lighting, as in a BASILICA or church (figs. 437, 442, 443).

CLOISTER. 1) A place of religious seclusion such as a monastery or nunnery. 2) An open court attached to a church or monastery and surrounded by a covered ARCADED walk or AMBULATORY, as in Salisbury Cathedral. Used for study, meditation, and exercise.

CLUNIAC ORDER. Founded at Cluny, France, by Berno of Baume in 909. Leading religious reform movement in the Middle Ages. Had close connections to Ottonian rulers and to the papacy.

CODEX (pl. CODICES). A manuscript in book form made possible by the use of PARCHMENT instead of PAPYRUS. During the 1st to 4th centuries A.D. it gradually replaced the roll or SCROLL previously used for written documents.

COFFER. 1) A small chest or casket. 2) A recessed, geometrically shaped panel in a ceiling. A ceiling decorated with these panels is said to be coffered (fig. 246).

COLONNADE. A series of regularly spaced COLUMNS supporting a LINTEL or ENTABLATURE (fig. 74).

COLUMN. An approximately cylindrical, upright architectural support, usually consisting of a long, relatively slender SHAFT, a BASE, and a CAPITAL (figs. 162, 164). When imbedded in a wall, it is called an engaged column (fig. 179). Columns decorated with spiral RELIEFS were used occasionally as freestanding commemorative monuments (fig. 273).

COMPOUND PIER. See PIER.

CONCRETE. A mixture of sand or gravel with mortar and rubble, invented in the ancient Near East and further developed by the Romans (figs. 244, 245). Largely ignored during the Middle Ages, it was revived by Bramante in the early 16th century for St. Peter's.

CONTRAPPOSTO. Italian word for set against. A method developed by the Greeks to represent freedom of movement in a figure. The parts of the body are placed asymmetrically in opposition to each other around a central axis, and careful attention is paid to the distribution of the weight (figs. 182, 183).

CORBELING. Roofing technique in which each layer of stone projects inward slightly over the previous layer (corbel) until all sides meet (figs. 130, 131).

CORINTHIAN ORDER. See **ORDER, ARCHITECTURAL.**

CORNICE. 1) The projecting, framing members of a classical PEDIMENT, including the horizontal one beneath and the two sloping or "raking" ones above (figs. 162, 164). 2) Any projecting, horizontal element surmounting a wall or other structure, or dividing it horizontally for decorative purposes.

CRENELATED. See **BATTLEMENT.**

CROMLECH. From the Welsh for concave stone. A circle of large upright stones, or DOLMENS, probably the setting for religious ceremonies in prehistoric Britain (figs. 46, 47).

CROSSING. The area in a church where the TRANSEPT crosses the NAVE, frequently emphasized by a DOME (fig. 397), or crossing tower (fig. 380).

CROSS SECTION. See **SECTION.**

CRYPT. In a church, a VAULTED space beneath the CHOIR, causing the floor of the choir to be raised above the level of that of the NAVE (fig. 374).

CUNEIFORM. Describes the wedge-shaped characters written on clay by the ancient Mesopotamians (fig. 96).

CYCLOPEAN. An adjective describing masonry with large, unhewn stones, thought by the Greeks to have been built by the Cyclopes, a legendary race of one-eyed giants (fig. 135).

DENTIL. A small, rectangular toothlike block in a series, used to decorate a classical entablature (fig. 162).

DIORITE. An igneous rock, extremely hard and usually black or dark gray in color (fig. 96).

DIPTYCH. 1) Originally a hinged two-leaved tablet used for writing. 2) A pair of ivory CARVINGS or PANEL paintings, usually hinged together (figs. 314, 315).

DIPYLON VASE. A Greek funerary vase with holes in the bottom through which libations were poured to the dead (fig. 139). Named for the cemetery near Athens where the vases were found.

DOLMEN. A structure formed by two or more large, upright stones capped by a horizontal slab; thought to be a prehistoric tomb (fig. 45).

DOME. A true dome is a VAULTED roof of circular, polygonal, or elliptical plan, formed with hemispherical or ovoidal curvature (fig. 249). May be supported by a circular wall or DRUM (fig. 337), and by PENDENTIVES (fig. 320) or related constructions. Domical coverings of many other sorts have been devised (fig. 459).

DOMINICAN ORDER. Founded as a mendicant ORDER by St. Dominic in Toulouse in 1220.

DOMUS. Latin word for house. A Roman detached, one-family house with rooms grouped around one, or frequently two, open courts. The first, the ATRIUM, was used for entertaining and conducting business; the second, usually with a garden and surrounded by a PERISTYLE or COLONNADE, was for the private use of the family (fig. 255).

DONOR. The patron or client at whose order a work of art was executed; the donor may be depicted in the work.

DORIC ORDER. See **ORDER, ARCHITECTURAL.**

DRÔLERIES. French word for jests. Used to describe the lively animals and small figures in the margins of late medieval manuscripts (fig. 516) and occasionally in wood CARVINGS on furniture.

DRUM. 1) A section of the SHAFT of a COLUMN (figs. 172, 253). 2) A wall supporting a DOME (fig. 249).

ECHINUS. In the Doric or Tuscan ORDER, the round, cushionlike element between the top of the SHAFT and the ABACUS (figs. 162, 165).

ELEVATION. 1) An architectural drawing presenting a building as if projected on a vertical plane parallel to one of its sides (fig. 442). 2) Term used in describing the vertical plane of a building.

ENAMEL. 1) Colored glassy substances, either opaque or translucent, applied in powder form to a metal surface and fused to it by firing. Two main techniques developed: "champlevé" (from the French for raised field), in which the areas to be treated are dug out of the metal surface; and "cloisonné" (from the French for partitioned), in which compartments or "cloisons" to be filled are made on the surface with thin metal strips. 2) A work executed in either technique (figs. 350, 421).

ENCAUSTIC. A technique of painting with pigments dissolved in hot wax (fig. 293).

ENGAGED COLUMN. See **COLUMN.**

ENTABLATURE. 1) In a classical order, the entire structure above the COLUMNS; this usually includes ARCHITRAVE, FRIEZE, and CORNICE (figs. 162, 164). 2) The same structure in any building of a classical style.

ENTASIS. A swelling of the SHAFT of a COLUMN (figs. 165, 169).

EVANGELISTS. Matthew, Mark, Luke, and John, traditionally thought to be the authors of the GOSPELS, the first four books of the New Testament, which recount the life and death of Christ. They are usually shown with their symbols, which are probably derived from the four beasts surrounding the throne of the Lamb in the Book of Revelation or from those in the vision of Ezekiel: a winged man or angel for Matthew, a winged lion for Mark (fig. 367), a winged ox for Luke (fig. 378), and an eagle for John (fig. 418). These symbols may also represent the evangelists (fig. 356).

FACADE. The principal face or the front of a building.

FATHERS OF THE CHURCH. Early teachers and defenders of the Christian faith. Those most frequently represented are the four Latin fathers: St. Jerome, St. Ambrose, and St. Augustine, all of the 4th century, and St. Gregory of the 6th.

FIBULA. A clasp, buckle, or brooch, often ornamented.

FINIAL. A relatively small, decorative element terminating a GABLE, PINNACLE, or the like (fig. 403).

FLUTING. In architecture, the ornamental grooves channeled vertically into the SHAFT of a COLUMN or PILASTER (fig. 172). They may meet in a sharp edge, as in the Doric ORDER, or be separated by a narrow strip or fillet, as in the Ionic, Corinthian, and Composite orders.

FLYING BUTTRESS. See **BUTTRESS.**

FONT. See **BAPTISTERY.**

FORUM (pl. **FORA**). In an ancient Roman city, the main, public square which was the center of judicial and business activity, and a public gathering place (fig. 242).

FRANCISCAN ORDER. Founded as a mendicant ORDER by St. Francis of Assisi (Giovanni de Bernardone, c. 1181–1226). The monks' aim was to imitate the life of Christ in its poverty and humility, to preach, and to minister to the spiritual needs of the poor.

FRESCO. Italian word for fresh. 1) True fresco is the technique of painting on moist plaster with pigments ground in water so that the paint is absorbed by the plaster and becomes part of the wall itself (fig. 505). Fresco secco is the technique of painting with the same colors on dry plaster. 2) A painting done in either of these techniques.

FRIEZE. 1) A continuous band of painted or sculptured decoration (figs. 157, 267). 2) In a classical building, the part of the ENTABLATURE between the ARCHITRAVE and the CORNICE. A Doric frieze consists of alternating TRIGLYPHS and METOPES, the latter often sculptured (fig. 169). An Ionic frieze is usually decorated with continuous RELIEF sculpture (fig. 162).

GABLE. 1) The triangular area framed by the CORNICE or eaves of a building and the sloping sides of a pitched roof (fig. 371). In classical architecture, it is called a PEDIMENT. 2) A decorative element of similar shape, such as the triangular structures above the PORTALS of a Gothic church (figs. 403, 441), and sometimes at the top of a Gothic picture frame.

GALLERY. A second story placed over the SIDE AISLES of a church and below the CLERESTORY (figs. 427, 443) or, in a church with a four-part ELEVATION, below the TRIFORIUM and above the NAVE ARCADE that supports it on its open side.

GESSO. A smooth mixture of ground chalk or plaster and glue, used as the basis for TEMPERA PAINTING and for oil painting on PANEL.

GILDING. 1) A coat of gold or of a gold-colored substance that is applied mechanically or chemically to surfaces of a painting, sculpture, or architectural decoration (fig. 525). 2) The process of applying same.

GLAZE. 1) A thin layer of translucent oil color applied to a painted surface or to parts of it in order to modify the tone. 2) A glassy coating applied to a piece of ceramic work before firing in the kiln, as a protective seal and often as decoration.

GLORIOLE or **GLORY.** The circle of radiant light around the heads or fig-

ures of God, Christ, the Virgin Mary, or a saint. When it surrounds the head only, it is called a halo or nimbus (fig. 518); when it surrounds the entire figure with a large oval (figs. 349, 466), it is called a *mandorla* (the Italian word for almond). It indicates divinity or holiness, though originally it was placed around the heads of kings and gods as a mark of distinction.

GOLD LEAF, SILVER LEAF. 1) Gold beaten into very thin sheets or "leaves," and applied to ILLUMINATED MANUSCRIPTS and PANEL paintings (figs. 418, 518), to sculpture, or to the back of the glass TESSERAE used in MOSAICS (figs. 302, 322). 2) Silver leaf is also used, though ultimately it tarnishes (fig. 311). Sometimes called gold foil, silver foil.

GORGON. In Greek mythology, one of three hideous, female monsters with large heads and snakes for hair (fig. 154). Their glance turned men to stone. Medusa, the most famous of the Gorgons, was killed by Perseus only with help from the gods.

GOSPEL. 1) The first four books of the New Testament. They tell the story of Christ's life and death, and are ascribed to the EVANGELISTS Matthew, Mark, Luke, and John. 2) A copy of these, usually called a Gospel Book, often richly ILLUMINATED (figs. 365, 367).

GREEK-CROSS CHURCH. See **CENTRAL-PLAN CHURCH.**

GROIN VAULT. See **VAULT.**

GROUND PLAN. An architectural drawing presenting a building as if cut horizontally at the floor level.

GUTTAE. In a Doric ENTABLATURE, small peglike projections above the FRIEZE; possibly derived from pegs originally used in wooden construction (figs. 162, 164).

HALLENKIRCHE. German word for hall church. A church in which the NAVE and the SIDE AISLES are of the same height. The type was developed in Romanesque architecture, and occurs especially frequently in German Gothic churches (figs. 385, 454).

HALO. See **GLORIOLE.**

HIEROGLYPH. A picture of a figure, animal, or object, standing for a word, syllable, or sound. These symbols are found on ancient Egyptian monuments as well as in Egyptian written records (fig. 71).

HIGH RELIEF. See **RELIEF.**

ICON. From the Greek word for image. A PANEL painting of one or more sacred personages such as Christ, the Virgin, a saint, particularly venerated in the ORTHODOX Catholic church (fig. 347).

ICONOSTASIS. See **CHOIR SCREEN.**

ILLUMINATED MANUSCRIPT. A MANUSCRIPT decorated with drawings (fig. 368) or with paintings in TEMPERA colors (figs. 377, 378, 418).

ILLUSIONISM. In artistic terms, the technique of manipulating pictorial or other means in order to cause the eye to perceive a particular reality. May be used in architecture and sculpture (fig. 270), as well as in painting (figs. 286, 291).

IN ANTIS. See **ANTA.**

INSULA (pl. **INSULAE**). Latin word for island. 1) An ancient Roman city block. 2) A Roman "apartment house": a CONCRETE and brick building or chain of buildings around a central court, up to five stories high. The ground floor contained shops, and above were living quarters (fig. 256).

IONIC ORDER. See **ORDER, ARCHITECTURAL.**

JAMBS. The vertical sides of an opening. In Romanesque and Gothic churches, the jambs of doors and windows are often cut on a slant outward, or "splayed," thus providing a broader surface for sculptural decoration (figs. 466, 467).

KEEP. 1) The innermost and strongest structure or central tower of a medieval castle, sometimes used as living quarters, as well as for defense. Also called a donjon (fig. 522). 2) A fortified medieval castle.

KEYSTONE. See **ARCH.**

KORE (pl. **KORAI**). Greek word for maiden. An Archaic Greek statue of a clothed, standing female (fig. 152).

KOUROS (pl. **KOUROI**). Greek word for male youth. An Archaic Greek statue of a standing, nude youth (fig. 148).

KRATER. A Greek vessel, of assorted shapes, in which wine and water are mixed. Calyx krater—a bell-shaped vessel with handles near the base; volute krater—a vessel with handles shaped like scrolls (fig. 144).

KYLIX. In Greek and Roman antiquity, a shallow drinking cup with two horizontal handles, often set on a stem terminating in a foot (fig. 142).

LABORS OF THE MONTHS. The various occupations suitable to the months of the year. Scenes or figures illustrating these were frequently represented in ILLUMINATED manuscripts (fig. 522); sometimes with the symbols of the ZODIAC signs, CARVED around the PORTALS of Romanesque and Gothic churches (figs. 466, 474).

LANTERN. A relatively small structure crowning a DOME, roof, or tower, frequently open to admit light to an enclosed area below (fig. 249).

LAPITH. A member of a mythical Greek tribe that defeated the Centaurs in a battle, scenes from which are frequently represented in vase painting and sculpture (fig. 187).

LEKYTHOS (pl. **LEKYTHOI**). A Greek oil jug with an ellipsoidal body, a narrow neck, a flanged mouth, a curved handle extending from below the lip to the shoulder, and a narrow base terminating in a foot. It was used chiefly for ointments and funerary offerings (fig. 200).

LIBERAL ARTS. Traditionally thought to go back to Plato, they comprised the intellectual disciplines considered suitable or necessary to a complete education, and included grammar, rhetoric, logic, arithmetic, music, geometry, and astronomy. During the Middle Ages and the Renaissance, they were often represented allegorically in painting, engravings, and sculpture (fig. 466).

LINTEL. See **POST AND LINTEL.**

LONGITUDINAL SECTION. See **SECTION.**

LOW RELIEF. See **RELIEF.**

MAESTÀ. Italian word for majesty, applied in the 14th and 15th centuries to representations of the Madonna and Child enthroned and surrounded by her celestial court of saints and angels (fig. 500).

MAGUS (pl. **MAGI**). 1) A member of the priestly caste of ancient Media and Persia. 2) In Christian literature, one of the three Wise Men or Kings who came from the East bearing gifts to the newborn Jesus (fig. 525).

MANDORLA. See **GLORIOLE.**

MANUSCRIPT. From the Latin word for handwritten. 1) A document, scroll, or book written by hand, as distinguished from such a work in print (i.e., after c. 1450). 2) A book produced in the Middle Ages, frequently ILLUMINATED.

MASTABA. An ancient Egyptian tomb, rectangular in shape, with sloping sides and a flat roof. It covered a chapel for offerings and a shaft to the burial chamber (fig. 54).

MAUSOLEUM. 1) The huge tomb erected at Halicarnassus in Asia Minor in the 4th century B.C. by King Mausolus and his wife Artemisia (fig. 202). 2) A generic term for any large funerary monument.

MEANDER. A decorative motif of intricate, rectilinear character, applied to architecture and sculpture (figs. 269, 407).

MEGALITH. A huge stone such as those used in CROMLECHS and DOLMENS.

MEGARON (pl. **MEGARONS**, or **MEGARA**). From the Greek word for large. The central audience hall in a Minoan or Mycenaean palace or home (fig. 120).

MESOLITHIC. Transitional period of the Stone Age, between the PALEOLITHIC and the NEOLITHIC.

METOPE. In a Doric FRIEZE, one of the panels either decorated or plain, between the TRIGLYPHS. Originally it probably covered the empty spaces between the ends of the wooden ceiling beams (figs. 162, 169).

MINIATURE. 1) A single illustration in an ILLUMINATED manuscript (figs. 352, 353). 2) A very small painting, especially a portrait on ivory, glass, or metal.

MINOTAUR. In Greek mythology, a monster having the head of a bull and the body of a man, who lived in the Labyrinth of the palace of Knossos on Crete.

MODEL. 1) The preliminary form of a sculpture, often finished in itself but preceding the final CASTING or CARVING. 2) Preliminary or reconstructed form of a building, made to scale (fig. 363). 3) A person who poses for an artist.

MODELING. 1) In sculpture, the building up of a figure or design in a soft substance such as clay or wax (fig. 231). 2) In painting and drawing, producing a three-dimensional effect by changes in color, the use of light and shade, etc.

MOLDING. In architecture, any of various long, narrow, ornamental bands having a distinctive profile, which project from the surface of the structure and give variety to the surface by means of their patterned contrasts of light and shade (figs. 157, 270).

MOSAIC. Decorative work for walls, VAULTS, ceilings, or floors, composed of small pieces of colored materials (called TESSERAE) set in plaster or CONCRETE. The Romans, whose work was mostly for floors, used regularly shaped pieces of marble in its natural colors (fig. 199). The early Christians used pieces of glass whose brilliant hues, including gold, and slightly irregular surfaces produced an entirely different, glittering effect (figs. 321, 322). See also GOLD LEAF.

MURAL. From the Latin word for wall, *murus*. A large painting or decoration, either executed directly on a wall (FRESCO) or done separately and affixed to it.

MUSES. In Greek mythology, the nine goddesses who presided over various arts and sciences. They are led by Apollo as god of music and poetry, and usually include Calliope, muse of epic poetry; Clio, muse of history; Erato, muse of love poetry; Euterpe, muse of music; Melpomene, muse of tragedy; Polyhymnia, muse of sacred music; Terpsichore, muse of dancing; Thalia, muse of comedy; and Urania, muse of astronomy.

NAOS. See CELLA.

NARTHEX. The transverse entrance hall of a church, sometimes enclosed but often open on one side to a preceding ATRIUM (fig. 298).

NAVE. 1) The central aisle of a Roman BASILICA, as distinguished from the SIDE AISLES (fig. 254). 2) The same section of a Christian basilican church extending from the entrance to the APSE or TRANSEPT (fig. 298).

NEOLITHIC. The New Stone Age, thought to have begun c. 9000–8000 B.C. The first society to live in settled communities, to domesticate animals, and to cultivate crops, it saw the beginning of many new skills such as spinning, weaving, and building (fig. 38).

NEW STONE AGE. See NEOLITHIC.

NIKE. The ancient Greek goddess of victory, often identified with Athena, and by the Romans with Victoria. She is usually represented as a winged woman with windblown draperies (figs. 196, 214).

NIMBUS. See GLORIOLE.

OBELISK. A tall, tapering, four-sided stone shaft with a pyramidal top. First constructed as MEGALITHS in ancient Egypt (fig. 74); certain examples since exported to other countries.

OLD STONE AGE. See PALEOLITHIC.

ORCHESTRA. 1) In an ancient Greek theater, the round space in front of the stage and below the tiers of seats, reserved for the chorus (fig. 180). 2) In a Roman theater, a similar space usually reserved for important guests.

ORDER, ARCHITECTURAL. An architectural system based on the COLUMN and its ENTABLATURE, in which the form of the elements themselves (CAPITAL, SHAFT, BASE, etc.) and their relationships to each other are specifically defined. The five classical orders are the Doric, Ionic, Corinthian, Tuscan, and Composite (fig. 162). See also SUPERIMPOSED ORDER.

ORDER, MONASTIC. A religious society whose members live together under an established set of rules. See BENEDICTINE, CARMELITE, CHARTREUSE, CISTERCIAN, CLUNIAC, DOMINICAN, FRANCISCAN.

ORTHODOX. From the Greek word for right in opinion. The Eastern Orthodox church, which broke with the Western Catholic church during the 5th century A.D. and transferred its allegiance from the pope in Rome to the Byzantine emperor in Constantinople and his appointed patriarch. Sometimes called the Byzantine church.

PALAZZO (pl. PALAZZI). Italian word for palace (in French, *palais*). Refers either to large official buildings (fig. 464), or to important private town houses.

PALEOLITHIC. The Old Stone Age, usually divided into Lower, Middle, and Upper (which began about 35,000 B.C.). A society of nomadic hunters who used stone implements, later developing ones of bone and flint. Some lived in caves, which they decorated during the latter stages of the age (fig. 31), at which time they also produced small CARVINGS in bone, horn, and stone (figs. 35, 36).

PALETTE. 1) A thin, usually oval or oblong board with a thumbhole at one end, used by painters to hold and mix their colors. 2) The range of colors used by a particular painter. 3) In Egyptian art, a slate slab, usually decorated with sculpture in low RELIEF. The small ones with a recessed circular area on one side are thought to have been used for eye makeup. The larger ones were commemorative objects (figs. 51, 52).

PANEL. 1) A wooden surface used for painting, usually in TEMPERA, and prepared beforehand with a layer of GESSO. Large ALTARPIECES require the joining together of two or more boards. 2) Panels of Masonite or other composite materials recently have come into use.

PANTHEON. A temple dedicated to all the gods (figs. 246, 247), or housing tombs of the illustrious dead of a nation, or memorials to them.

PANTOCRATOR. A representation of Christ as ruler of the universe which appears frequently in the DOME or APSE MOSAICS of Byzantine churches (fig. 340).

PAPYRUS. 1) A tall aquatic plant that grows abundantly in the Near East, Egypt, and Abyssinia. 2) A paperlike material made by laying together thin strips of the pith of this plant, and then soaking, pressing, and drying the whole. The resultant sheets were used as writing material by the ancient Egyptians, Greeks, and Romans. 3) An ancient document or SCROLL written on this material.

PARCHMENT. From Pergamum, the name of a Greek city in Asia Minor where parchment was invented in the 2nd century B.C. 1) A paperlike material made from bleached animal hides, used extensively in the Middle Ages for MANUSCRIPTS (fig. 354). Vellum is a superior type of parchment, made from calfskin. 2) A document or miniature on this material (fig. 377).

PASSION. 1) In ecclesiastic terms, the events of Christ's last week on earth. 2) The representation of these events in pictorial, literary, theatrical, or musical form (figs. 505, 508).

PEDIMENT. 1) In classical architecture, a low GABLE, typically triangular, framed by a horizontal CORNICE below and two raking cornices above; frequently filled with relief sculpture (fig. 159). 2) A similar architectural member, either round or triangular, used over a door, window, or niche. When pieces of the cornice are either turned at an angle or broken, it is called a broken pediment (fig. 257).

PELIKE. A Greek storage jar with two handles, a wide mouth, little or no neck, and resting on a foot (fig. 201).

PENDENTIVE. One of the spherical triangles which achieves the transition from a square or polygonal opening to the round BASE of a DOME or the supporting DRUM (figs. 328, 334).

PERIPTERAL. An adjective describing a building surrounded by a single row of COLUMNS or COLONNADE (figs. 163, 169).

PERISTYLE. 1) In a Roman house or DOMUS, an open garden court surrounded by a COLONNADE (fig. 260). 2) A colonnade around a building or court (fig. 163).

PICTURE PLANE. The flat surface on which a picture is painted.

PIER. An upright architectural support, usually rectangular, and sometimes with CAPITAL and BASE (fig. 229). When COLUMNS, PILASTERS, or SHAFTS are attached to it, as in many Romanesque and Gothic churches, it is called a compound pier (fig. 388).

PIETÀ. Italian word for both pity and piety. A representation of the Virgin grieving over the dead Christ (fig. 479). When used in a scene recording a specific moment after the Crucifixion, it is usually called a Lamentation (fig. 506).

PILASTER. A flat, vertical element projecting from a wall surface, and normally having a BASE, SHAFT, and CAPITAL. It has generally a decorative rather than structural purpose.

PILGRIMAGE CHOIR. The unit in a Romanesque church composed of the APSE, AMBULATORY, and RADIATING CHAPELS (figs. 381, 424).

PILLAR. A general term for a vertical architectural support which includes COLUMNS, PIERS, and PILASTERS.

PINNACLE. A small, decorative structure capping a tower, PIER, BUTTRESS, or other architectural member, and used especially in Gothic buildings (figs. 444, 446).

PLAN. See GROUND PLAN.

PODIUM. 1) The tall base upon which rests an Etruscan or Roman temple (fig. 236). 2) The ground floor of a building made to resemble such a base.

POLYPTYCH. An ALTARPIECE or devotional work of art made of several panels joined together, often hinged.

PORCH. General term for an exterior appendage to a building which forms a covered approach to a doorway (fig. 441). See PORTICO for porches consisting of columns.

PORTA. Latin word for door or gate.

PORTAL. A door or gate, usually a monumental one with elaborate sculptural decoration (figs. 466, 480).

PORTICO. A columned porch supporting a roof or an ENTABLATURE and PEDIMENT, often approached by a number of steps (fig. 236). It provides a monumental covered entrance to a building, and a link with the space surrounding it.

POST AND LINTEL. A basic system of construction in which two or more uprights, the posts, support a horizontal member, the lintel. The lintel may be the topmost element (fig. 47), or support a wall or roof (fig. 135).

PREDELLA. The base of an ALTARPIECE, often decorated with small scenes which are related in subject to that of the main panel or panels (fig. 525).

PRONAOS. In a Greek or Roman temple, an open vestibule in front of the CELLA (fig. 163).

PROPYLAEUM (pl. **PROPYLAEA**). 1) The entrance to a temple or other enclosure, especially when it is an elaborate structure. 2) The monumental entry gate at the western end of the Acropolis in Athens (fig. 172).

PSALTER. 1) The book of Psalms in the Old Testament, thought to have been written in part by David, king of ancient Israel. 2) A copy of the Psalms, sometimes arranged for liturgical or devotional use, and often richly ILLUMINATED (fig. 339).

PULPIT. A raised platform in a church from which the clergy deliver a sermon or conducts the service. Its railing or enclosing wall may be elaborately decorated (fig. 482).

PYLON. Greek word for gateway. 1) The monumental entrance building to an Egyptian temple or forecourt, consisting of either a massive wall with sloping sides pierced by a doorway, or of two such walls flanking a central gateway (fig. 74). 2) A tall structure at either side of a gate, bridge, or avenue, marking an approach or entrance.

QUATREFOIL. An ornamental element composed of four lobes radiating from a common center (figs. 474, 492).

RADIATING CHAPELS. Term for CHAPELS arranged around the AMBULATORY (and sometimes the TRANSEPT) of a medieval church (figs. 380, 424, 444).

REFECTORY. 1) A room for refreshment. 2) The dining hall of a monastery, college, or other large institution.

RELIEF 1) The projection of a figure or part of a design from the background or plane on which it is CARVED or MODELED. Sculpture done in this manner is described as "high relief" or "low relief" depending on the height of the projection (figs. 53, 273). 2) The apparent projection of forms represented in a painting or drawing.

RESPOND. 1) A half-PIER, PILASTER, or similar element projecting from a wall to support a LINTEL, or an ARCH whose other side is supported by a freestanding COLUMN or PIER, as at the end of an ARCADE (fig. 302). 2) One of several pilasters on a wall behind a COLONNADE (fig. 257) which echoes or "responds to" the columns, but is largely decorative. 3) One of the slender shafts of a COMPOUND PIER in a medieval church which seems to carry the weight of the VAULT (figs. 392, 438).

RHYTON. An ancient drinking horn made from pottery or metal, and frequently having a base formed by a human or animal head (fig. 113).

RIB. A slender, projecting archlike member which supports a VAULT either transversely (fig. 383), or at the GROINS, thus dividing the surface into sections (fig. 392). In Late Gothic architecture, its purpose is often primarily ornamental (fig. 451).

RIBBED VAULT. See **VAULT.**

ROSE WINDOW. A large, circular window with stained glass and stone TRACERY, frequently used on FACADES and at the ends of TRANSEPTS of Gothic churches (figs. 430, 433).

ROSTRUM. 1) A beaklike projection from the prow of an ancient warship, used for ramming the enemy. 2) In the Roman FORUM, the raised platform decorated with the beaks of captured ships, from which speeches were delivered. 3) A platform, stage, or the like used for public speaking.

SACRISTY. A room near the main altar of a church, or a small building attached to a church, where the vessels and vestments required for the service are kept. Also called a vestry.

SANCTUARY. 1) A sacred or holy place or building. 2) An especially holy place within a building, such as the CELLA of a temple, or the part of a church around the altar.

SARCOPHAGUS (pl. **SARCOPHAGI**). A large stone coffin usually decorated with sculpture and/or inscriptions (figs. 225, 312). The term is derived from two Greek words meaning flesh and eating, which were applied to a kind of limestone in ancient Greece, since the stone was said to turn flesh to dust.

SATYR. One of a class of woodland gods thought to be the lascivious companions of Dionysus, the Greek god of wine (or of Bacchus, his Roman counterpart). They are represented as having the legs and tail of a goat, the body of a man, and a head with horns and pointed ears. A youthful satyr is also called a faun.

SCRIPTORIUM (pl. **SCRIPTORIA**). A workroom in a monastery reserved for copying and illustrating MANUSCRIPTS.

SCROLL. 1) An architectural ornament with the form of a partially unrolled spiral, as on the CAPITALS of the Ionic and Corinthian ORDERS (figs. 162, 177). 2) A form of written text.

SECTION. An architectural drawing presenting a building as if cut across the vertical plane, at right angles to the horizontal plane. Cross section: a cut along the transverse axis. Longitudinal section: a cut along the longitudinal axis.

SEXPARTITE VAULT. See **VAULT.**

SHAFT. In architecture, the part of a COLUMN between the BASE and the CAPITAL (fig. 162).

SIDE AISLE. A passageway running parallel to the NAVE of a Roman BASILICA or Christian church, separated from it by an ARCADE or COLONNADE (figs. 254, 298). There may be one on either side of the NAVE, or two, an inner and outer.

SILENI. A class of minor woodland gods in the entourage of the wine god, Dionysus (or Bacchus). Like Silenus, the wine god's tutor and drinking companion, they are thick-lipped and snub-nosed, and fond of wine. Similar to SATYRS, they are basically human in form except for having horses' tails and ears (fig. 289).

SILVER LEAF. See **GOLD LEAF.**

SINOPIA (pl. **SINOPIE**). Italian word taken from Sinope, the ancient city in Asia Minor which was famous for its brick-red pigment. In FRESCO paintings, a full-sized, preliminary sketch done in this color on the first rough coat of plaster or "arriccio" (fig. 514).

SPANDREL. The area between the exterior curves of two adjoining ARCHES, or, in the case of a single arch, the area around its outside curve from its springing to its keystone (figs. 284, 403).

SPHINX. 1) In ancient Egypt, a creature having the head of a man, animal, or bird, and the body of a lion; frequently sculpted in monumental form (fig. 62). 2) In Greek mythology, a creature usually represented as having the head and breasts of a woman, the body of a lion, and the wings of an eagle. It appears in classical, Renaissance, and Neoclassical art.

STELE. From the Greek word for standing block. An upright stone slab or pillar with a CARVED commemorative design or inscription (figs. 95, 197).

STEREOBATE. The substructure of a classical building, especially a Greek temple (fig. 162).

STILTS. Term for pillars or posts supporting a superstructure; in 20th-century architecture, these are usually of ferroconcrete. Stilted, as in stilted arches, refers to tall supports beneath an architectural member.

STOA. In Greek architecture, a covered COLONNADE, sometimes detached and of considerable length, used as a meeting place or promenade.

STOIC. A school of philosophy founded by Zeno about 300 B.C., and named after the STOA in Athens where he taught. Its main thesis is that man should be free of all passions.

STUCCO. 1) A CONCRETE or cement used to coat the walls of a building. 2) A kind of plaster used for architectural decorations such as CORNICES, MOLDINGS, or for sculptured RELIEFS (fig. 229).

STYLOBATE. A platform or masonry floor above the STEREOBATE forming the foundation for the COLUMNS of a classical temple (fig. 162).

STYLUS. From the Latin word *stilus*, a pointed instrument used in ancient times for writing on tablets of a soft material such as clay.

SUPERIMPOSED ORDERS. Two or more rows of COLUMNS, PIERS, or PILASTERS placed above each other on the wall of a building (fig. 245).

TABERNACLE. 1) A place or house of worship. 2) A CANOPIED niche or recess built for an image. 3) The portable shrine used by the ancient Jews to house the Ark of the Covenant (fig. 295).

TABLINUM. From the Latin word meaning writing tablet, or written record. In a Roman house, a small room at the far end of the ATRIUM, or between it and the second courtyard. It was used for keeping family records.

TEMPERA PAINTING. 1) A painting made with pigments mixed with egg yolk and water. In the 14th and 15th centuries, it was applied to PANELS which had been prepared with a coating of GESSO; the application of GOLD

LEAF and of underpainting in green or brown preceded the actual tempera painting (figs. 508, 525). 2) The technique of executing such a painting.

TERRACOTTA. Italian word for baked earth. 1) Earthenware, naturally reddish-brown but often GLAZED in various colors and fired. Used for pottery, sculpture, or as a building material or decoration. 2) An object made of this material. 3) Color of the natural material.

TESSERA (pl. **TESSERAE**). A small piece of colored stone, marble, glass, or gold-backed glass used in a MOSAIC (fig. 338).

THEATER. In-ancient Greece, an outdoor place for dramatic performances, usually semicircular in plan and provided with tiers of seats, the ORCHESTRA, and a support for scenery (fig. 180). See also AMPHITHEATER.

THERMAE. A public bathing establishment of the ancient Romans which consisted of various types of baths and social and gymnastic facilities.

THOLOS. In classical architecture, a circular building ultimately derived from early tombs (fig. 179).

THRUST. The lateral pressure exerted by an ARCH, VAULT, or DOME, which must be counteracted at its point of greatest concentration either by the thickness of the wall or by some form of BUTTRESS.

TRACERY. 1) Ornamental stonework in Gothic windows. In the earlier or "plate tracery" the windows appear to have been cut through the solid stone (fig. 403). In "bar tracery" the glass predominates, the slender pieces of stone having been added within the windows (fig. 444). 2) Similar ornamentation using various materials and applied to walls, shrines, facades, etc. (fig. 509).

TRANSEPT. A cross arm in a BASILICAN church, placed at right angles to the NAVE, and usually separating it from the CHOIR or APSE (fig.298).

TREE OF KNOWLEDGE. The tree in the Garden of Eden from which Adam and Eve ate the forbidden fruit which destroyed their innocence.

TREE OF LIFE. A tree in the Garden of Eden whose fruit was reputed to give everlasting life; in medieval art it was frequently used as a symbol of Christ.

TRIFORIUM. The section of a NAVE wall above the ARCADE and below the CLERESTORY (fig. 437). It frequently consists of a BLIND ARCADE with three openings in each bay. When the GALLERY is also present, a four-story ELEVATION results, the triforium being between the gallery and clerestory. It may also occur in the TRANSEPT and the CHOIR walls.

TRIGLYPH. The element of a Doric FRIEZE separating two consecutive METOPES, and being divided by channels (or glyphs) into three sections. Probably an imitation in stone of wooden ceiling beam ends (figs. 162, 169).

TRIPTYCH. An ALTARPIECE or devotional picture, either CARVED or painted, with one central panel and two hinged wings (fig. 345).

TRIUMPHAL ARCH. 1) A monumental ARCH, sometimes a combination of three arches, erected by a Roman emperor in commemoration of his military exploits, and usually decorated with scenes of these deeds in RELIEF sculpture (fig. 284). 2) The great transverse arch at the eastern end of a church which frames ALTAR and APSE and separates them from the main body of the church. It is frequently decorated with MOSAICS or MURAL paintings (figs. 299, 302).

TROPHY. 1) In ancient Rome, arms or other spoils taken from a defeated enemy and publicly displayed on a tree, PILLAR, etc. 2) A representation of these objects, and others symbolic of victory, as a commemoration or decoration.

TRUMEAU. A central post supporting the LINTEL of a large doorway, as in a Romanesque or Gothic PORTAL, where it was frequently decorated with sculpture (figs. 401, 480).

TRUSS. A triangular wooden or metal support for a roof which may be left exposed in the interior (figs. 299, 457), or be covered by a ceiling (figs. 374, 398).

TURRET 1) A small tower, part of a larger structure. 2) A small tower at an angle of a building, frequently beginning some distance from the ground.

TYMPANUM. 1) In classical architecture, the recessed, usually triangular area, also called a PEDIMENT, often decorated with sculpture (fig. 164). 2) In medieval architecture, an arched area between an ARCH and the LINTEL of a door or window, frequently carved with RELIEF sculpture (figs. 406, 470).

UNDERPAINTING. See **TEMPERA PAINTING.**

VAULT. An arched roof or ceiling usually made of stone, brick, or CONCRETE. Several distinct varieties have been developed; all need BUTTRESSING at the point where the lateral THRUST is concentrated. 1) A barrel vault is a semicylindrical structure made up of successive ARCHES (fig. 235). It may be straight or ANNULAR in plan (fig. 303). 2) A groin vault is the result of the intersection of two barrel vaults of equal size which produces a BAY of four compartments with sharp edges, or "groins," where the two meet (fig. 235). 3) A ribbed groin vault is one in which RIBS are added to the groins for structural strength and for decoration (fig. 391). When the diagonal ribs are constructed as half-circles, the resulting form is a domical ribbed vault (fig. 394). 4) A sexpartite vault is a ribbed groin vault in which each bay is divided into six compartments by the addition of a transverse rib across the center (figs. 391, 392). 5) The normal Gothic vault is quadripartite with all the arches pointed to some degree (fig. 438). 6) A fan vault is an elaboration of a ribbed groin vault, with elements of TRACERY using conelike forms. It was developed by the English in the 15th century, and was employed for decorative purposes (figs. 452, 453).

VELLUM. See **PARCHMENT.**

VESTRY. See **SACRISTY.**

VICES. Often represented allegorically in conjunction with the seven VIRTUES, they include Pride, Avarice, Wrath, Gluttony, Unchastity (Luxury), Folly, and Inconstancy, though others such as Injustice are sometimes substituted.

VICTORY. See **NIKE.**

VILLA. Originally a large country house. See DOMUS.

VIRTUES. The three theological virtues, Faith, Hope, and Charity, and the four cardinal ones, Prudence, Justice, Fortitude, and Temperance, were frequently represented allegorically, particularly in medieval manuscripts and sculpture.

VOLUTE. A spiral architectural element found notably on Ionic and Composite CAPITALS (figs. 162, 177, 236), but also used decoratively on building FACADES and interiors.

VOUSSOIR. See **ARCH.**

WATERCOLOR PAINTING. Painting, usually on paper, in pigments suspended in water.

WESTWORK. From the German word *Westwerk*. In Carolingian, Ottonian, and German Romanesque architecture, a monumental western front of a church, treated as a tower or combination of towers, and containing an entrance and vestibule below, and a CHAPEL and GALLERIES above. Later examples often added a TRANSEPT and a CROSSING tower (fig. 371).

WING. The side panel of an ALTARPIECE which is frequently decorated on both sides, and also hinged, so that it may be shown either open or closed.

ZIGGURAT. From the Assyrian word *ziqquratu,* meaning mountaintop or height. In ancient Assyria and Babylonia, a pyramidal tower built of mud brick and forming the BASE of a temple; it was either stepped or had a broad ascent winding around it, which gave it the appearance of being stepped (figs. 84, 87).

ZODIAC. An imaginary belt circling the heavens, including the paths of the sun, moon, and major planets, and containing 12 constellations and thus 12 divisions called signs, which have been associated with the months. The signs are: Aries, the ram; Taurus, the bull; Gemini, the twins; Cancer, the crab; Leo, the lion; Virgo, the virgin; Libra, the balance; Scorpio, the scorpion; Sagittarius, the archer; Capricorn, the goat; Aquarius, the water-bearer; and Pisces, the fish. They are frequently represented around the PORTALS of Romanesque and Gothic churches in conjunction with the LABORS OF THE MONTHS (figs. 406, 474).

ART AND ARCHITECTURE
WEB SITE GAZETTEER

The directory below is comprised mainly of the significant museum collections and monuments illustrated in this book. A few additional non-illustrated art sites are also listed. All efforts have been made to gather up-to-date addresses, phone numbers, and Web sites. Contact information is current as of time of printing.

UNITED STATES

ARIZONA

The Heard Museum, 22 E. Monte Vista Rd., Phoenix 85004. (602)252–8840. hanksville.phast.umass.edu/defs/independent/Heard/Heard.html

Phoenix Art Museum, 1625 N. Central Ave., Phoenix 85004. (602)257–1880. aztec.asu.edu/AandE/phoenix.art

Center for Creative Photography, University of Arizona, 843 E. University Blvd., Tuscon 85721. (520)621–7968. www.library.arizona.edu/branches/ccp/ccphome.html

CALIFORNIA

University Art Museum and Pacific Film Archive, University of California, 2626 Bancroft Way, Berkeley 94704. (510)642–0808. www.uampfa.berkeley.edu

Los Angeles County Museum of Art, 5905 Wilshire Blvd., Los Angeles 90036. (213)857–6111. www.lacma.org

The Museum of Contemporary Art, Los Angeles, 250 S. Grand Ave. at California Plaza, Los Angeles 90012. (213)382–6622, 621–2766. www.MOCA-LA.org

University of California, Los Angeles, Frederick S. Wright Art Gallery, 405 Hilgard Ave., Los Angeles 90024. (213)825–1461

The J. Paul Getty Museum, 17985 Pacific Coast Hwy., Malibu 90265. (310)458–2003. ca.living.net/trav/museums/carjpgm.htm

Stanford University Museum and Art Gallery, Lomita Dr. & Museum Way, Palo Alto 94305. (415)725–4177. www.leland.stanford.edu/dept/SUMA/

Norton Simon Museum, 411 W. Colorado Blvd., Pasadena 91105. (818)449–6840; 449–3730. www.citycet.com/CCC/Pasadena/nsmuseum.htm

Crocker Museum of Art, 216 O St., Sacramento 95814. (916)264–5423

Museum of Contemporary Art, San Diego, 1001 Kettner Blvd., San Diego 92101, 700 Prospect St., La Jolla 92037. (619)454–3541

San Diego Museum of Art, Balboa Park, 1450 El Prado, San Diego 92101. (619)232–7931. www.sddt.com/sdma.html

The Fine Arts Museums of San Francisco, www.famsf.org: **California Palace of the Legion of Honor,** Lincoln Park, near 34th Ave. and Clement St., San Francisco 94121. (415)863–3330; **M. H. de Young Memorial Museum,** Golden Gate Park, San Francisco 94118. (415)221–4811

San Francisco Museum of Modern Art, 151 3rd St., San Francisco 94103. (415)357–4000. www.sfmoma.org/

San Jose Museum of Art, 110 S. Market St., San Jose 95113. (408)294–2787. www.sjliving.com/sja

Huntington Library, Art Collections, and Botanical Gardens, 1151 Oxford Rd., San Marino 91108. (818)405–2141

Santa Barbara Museum of Art, 1130 State St., Santa Barbara 93101. (805)963–4364. www.artdirect.com/sbma/

COLORADO

The Denver Art Museum, 100 W. 14th Ave. Pkwy., Denver 80204. (303)640–2793

Colorado Springs Fine Arts Center, 30 W. Dale St., Colorado Springs 80903. (719)634–5581

CONNECTICUT

Wadsworth Atheneum, 600 Main St., Hartford 06103. (203)278–2670

Yale Center for British Art, 1080 Chapel St., New Haven 06520. (203)432–2800

Yale University Art Gallery, 1111 Chapel St. at York, New Haven 06520. (203)432–0600

DELAWARE

Delaware Art Museum, 2301 Kentmere Pkwy., Wilmington 19806. (302)571–9590. www.udel.edu/delart

DISTRICT OF COLUMBIA

The Corcoran Gallery of Art, 500 17th St. NW, 20006. (202)638–1903. www.corcoran.org

Freer Gallery of Art, Smithsonian Institution, Jefferson Dr. at 12th St. SW, 20560. (202)357–4880. www.si.edu/

Hirshhorn Museum and Sculpture Garden, Smithsonian Institution, Independence Ave. at 7th St. SW, 20560. (202)357–2700. www.si.edu/

National Gallery of Art, 4th St. at Constitution Ave. NW, 20565. (202)737–4215; (202)842–6176 (TDD). www.nga.gov

National Museum of American Art, 8th and G Sts., 20560 (202)357–2700. www.nmaa.si.edu

National Museum of American Art, Renwick Gallery, Pennsylvania Ave. at 17th St. NW, 20006. (202)357–2700

National Museum of Women in the Arts, 1250 New York Ave. NW, 20005, (202) 783–5000. www.nmwa.org

National Portrait Gallery, 8th and F Sts. NW, 20560. (202)357–2700. www.npg.si.edu

The Phillips Collection, 1600 21st St. NW, 20009. (202)387–0961

Vietnam Veterans Memorial, The Mall

FLORIDA

Lowe Art Museum, University of Miami, 1301 Stanford Dr., Coral Gables 33124. (305)284–3535

John and Mable Ringing Museum of Art, 5401 Bay Shore Rd., Sarasota 34243. (813)359–5700. www.sarasota online.com/ringling/welcome.html

Museum of Fine Arts, Saint Petersburg, Florida, 255 Beach Dr. NE, Saint Petersburg 33701. (813)896–2667

GEORGIA

Georgia Museum of Art, University of Georgia, Jackson St., North Campus, Athens 30602. (706)542–GMOA or 4662

High Museum of Art, 1280 Peachtree St. NE, Atlanta 30309. (404)733–HIGH or 4444. www.high.org

HAWAII

Honolulu Academy of Arts, 900 S. Beretania St., Honolulu 96814. (808)532–8700; 532–8701

ILLINOIS

Krannert Art Museum, University of Illinois, 500 E. Peabody Dr., Champaign 61820. (217)333–1861. www.art.uiuc.edu/kam/

The Art Institute of Chicago, 111 S. Michigan Ave. at Adams St., Chicago 60603. (312)443–3600; 443–3500. www.artic.edu/aic/firstpage.html

Museum of Contemporary Art, 220 E. Chicago Ave., Chicago 60611. (312)280–2660; 280–5161. www.web core/chicago/thingsplaces/museums/mca/mca-home.html

Oriental Institute Museum, The University of Chicago, 1155 E. 58th St., Chicago 60637. (773)702–9520

Terra Museum of American Art, 666 N. Michigan Ave., Chicago 60611. (312)664–3939

INDIANA

Indianapolis Museum of Art, 1200 W. 38th St., Indianapolis 46208. (317)923–1331. web.ima-art.org/ima

IOWA

Des Moines Art Center, 4700 Grand Ave., Des Moines 50312. (515)277–4405

University of Iowa Museum of Art, 150 N. Riverside Dr., Iowa City 52242. (319)335–1727

KANSAS

Spencer Museum of Art, University of Kansas, 1301 Mississippi St., Lawrence 66045. (913)864–4710

Wichita Art Museum, 619 Stackman Dr., Wichita, 67203. (316)268–4921

KENTUCKY

J. B. Speed Art Museum, 2035 S. 3rd St., Louisville 40208. (502)636–2920. www.gatech.edu/CARLOS/AAMDO/Speedext.htm

LOUISIANA

New Orleans Museum of Art, 1 Collins Diboll Circle, City Park, New Orleans 70124. (504)488–2631

MAINE

Bowdoin College Museum of Art, Walker Art Building, Brunswick 04011. (207)725–3275

Portland Museum of Art, 7 Congress Sq., Portland 04101. (207)775–6148

MARYLAND

The Baltimore Museum of Art, Art Museum Dr. at North Charles and 31st Sts., Baltimore 21218. (410)396–7100. www.world-arts-resources.com/cgi-bin/access?mu269

Walters Art Gallery, 600 N. Charles St., Baltimore 21201. (410)547–9000; 547–ARTS

MASSACHUSETTS

Mead Art Museum, Amherst College, Amherst 01002. (413)542–2335

Addison Gallery of American Art, Phillips Academy, Andover 01810. (508)749–4015. www.andover.edu/addison/home.html

Isabella Stewart Gardner Museum, 280 The Fenway, Boston 02115. (617)566–1401. www.boston.com/gardner

Museum of Fine Arts, Boston, 465 Huntington Ave., Boston 02115. (617)267–9300. www.mfa.org

Harvard University Art Museums, Cambridge 02138. (617)495–9400 www.fas.harvard.edu/˜artmuseums/: **Busch-Reisinger Museum**, 32 Quincy St.; **Fogg Art Museum**, 32 Quincy St.; **The Arthur M. Sackler Museum**, 485 Broadway

Smith College Museum of Art, Elm St. at Bedford Terrace, Northampton 01063. (413)585–2760

Peabody Essex Museum, East India Sq., Salem 01970. (508)745–1876. www.pem.org

Mount Holyoke College Art Museum, South Hadley 01075. (413)538–2245

Rose Art Museum, Brandeis University, 415 South St., Waltham 02254. (617)736–3434

Davis Museum and Cultural Center, Wellesley College, 106 Central St., Wellesley 02181. (617)283–2051

Sterling and Francine Clark Art Institute, 225 South St., Williamstown 01267. (413)458–9545

Williams College Museum of Art, Main St., Williamstown 01267. (413)597–2429

Worcester Art Museum, 55 Salisbury St., Worcester 01609. (508)799–4406

MICHIGAN

The University of Michigan Museum of Art, 525 S. State St., Ann Arbor 48109. (313)764–0395

The Detroit Institute of Arts, 5200 Woodward Ave., Detroit 48202. (313)833–7900. www.dia.org

Grand Rapids Art Museum, 155 Division North, Grand Rapids 49503. (616)459–4677

MINNESOTA

The Minneapolis Institute of Arts, 2400 3rd Ave. S., Minneapolis 55404. (612)870–3131; 870–3200. www.artsMIA.org

Walker Art Center, Vineland Pl., Minneapolis 55403. (612)375–7622. www.walkerart.org

MISSOURRI

The Nelson-Atkins Museum of Art, 4525 Oak St., Kansas City 64111. (816)561–4000

The Saint Louis Art Museum, 1 Fine Arts Dr., Forest Park, St. Louis 63110. (314)721–0072. www.slam.org

NEBRASKA

University of Nebraska-Lincoln/Sheldon Memorial Art Gallery and Sculpture Garden, 12th and R Sts., Lincoln 68588. (402)472–2461

Joslyn Art Museum, 2200 Dodge St., Omaha 68102. (402)342–3300. www.gatech.edu/CARLOS/AAMDO.cenreg.htm

NEW HAMPSHIRE

Hood Museum of Art, Dartmouth College, Wheelock St., Hanover 03755. (603)646–2808

NEW JERSEY

The Montclair Art Museum, 3 S. Mountain Ave. at Bloomfield Ave., Montclair 07042. (201)746–5555. www.interactive.net/˜upper/mam.html

The Newark Museum, 49 Washington St., Newark 07101. (201)596–6500

Jane Zimmerli Art Museum, Rutgers The State University of New Jersey, Hamilton and George Sts., New Brunswick 08903 (201)932–7237

The Art Museum, Princeton University, Princeton 08544. (609)258–3788

NEW MEXICO

Millicent Rogers Museum, 1504 Millicent Rogers Rd., Taos 87571. (505)758–2462

NEW YORK

The Brooklyn Museum, 200 Eastern Pkwy., Brooklyn 11238. (718)638–5000. wwar.com/brooklyn_museum/index.html

Albright-Knox Art Gallery , 1285 Elmwood Ave., Buffalo 14222. (716)882–8700

Herbert F. Johnson Museum of Art, Cornell University, Ithaca 14853. (607)255–6464

Storm King Art Center, Old Pleasant Hill Rd., Mountainville 10953. (914)534–3115

American Craft Museum, 40 W. 53rd St., New York 10019. (212)956–3535

The Cloisters, Fort Tryon Park, New York 10040. (212)923–3700

Cooper-Hewitt National Museum of Design, Smithsonian Institution, 2 E. 91st St., New York 10128. (212) 860–6868

The Frick Collection, 1 E. 70th St., New York 10021. (212)288–0700

The Grey Art Gallery and Study Center, New York University Art Collection, 33 Washington Pl., New York 10003. (212)998–6780

Guggenheim Museum SoHo, 575 Broadway, New York 10012. (212)423–3500

International Center of Photography, 1130 5th Ave., New York 10028. (212)860–1777

International Center of Photography Midtown, 1133 6th Ave., New York 10036. (212)860–1783

The Jewish Museum, 1109 5th Ave., New York, 10128. (212)423–3200

The Metropolitan Museum of Art, 5th Ave. at 82nd St., New York 10028. (212)879–5500. www.metmuseum.org

The Museum of Modern Art, 11 W. 53rd St., New York 10019. (212)708–9400. www.moma.org

The New Museum of Contemporary Art, 583 Broadway, New York 10012. (212)219–1222. www.newmuseum.org

The Pierpont Morgan Library, 29 E. 36th St., New York 10016. (212)685–0008

Solomon R. Guggenheim Museum, 1071 5th Ave., New York 10128. (212)423–3500.www.mediabridge.com/nyc/museums/guggenheim.html

The Studio Museum in Harlem, 144 W. 125th St., New York 10027. (212)864–4500

Whitney Museum of American Art, 945 Madison Ave., New York 10021. (212)570–3676. www.echonyc.com/˜whitney

Neuberger Museum of Art, Purchase College, State University of New York at Purchase, 735 Anderson Hill Rd., Purchase 10577. (914)251–6133

George Eastman House/International Museum of Photography and Film, 900 E. Ave., Rochester 14607. (716)271–3361

Memorial Art Gallery of the University of Rochester, 500 University Ave., Rochester, NY 14607. (716)473–7720

Everson Museum of Art of Syracuse and Onondaga County, 401 Harrison St., Syracuse 13202. (315)474–6064

Munson-Williams-Proctor Institute Museum of Art, 310 Genesee St., Utica 13502. (315)797–0000

The Hudson River Museum of Westchester, 511 Warburton Ave., Yonkers 10701. (914)963–4550

NORTH CAROLINA

The Ackland Art Museum, University of North Carolina, Chapel Hill, Columbia and Franklin Sts., Chapel Hill 27599. (919)966–5736

Duke Univerisity Museum of Art, Buchanan Blvd. at Trinity, East Campus, Durham 27708. (919)684–5135. www.duke.edu/duma

Weatherspoon Art Gallery, University of North Carolina, Greensboro, Spring Garden and Tate Sts., Greensboro 27412. (910)334–5770

North Carolina Museum of Art, 2110 Blue Ridge Rd., Raleigh 27607. (919)833–1935

OHIO

Great Serpent Mound, Adams County

Cincinnati Art Museum, Eden Park, Cincinnati 45202. (513)721–5204

The Taft Museum, 316 Pike St., Cincinnati 45202. (513)241–0343

The Cleveland Museum of Art, 11150 E. Blvd., Cleveland 44106. (216)421–7340. www.clemusart.com

The Columbus Museum of Art, 480 E. Broad St., Columbus 43215. (614)221–6801

Wexner Center for the Arts, The Ohio State University, North High St. at 15th Ave., Columbus 43210. (614)292–3535

Dayton Art Institute, 456 Belmonte Park North, Dayton 45405. (513)223–5277. www.gatech.edu/CARLOS/AAMDO/Daytext.htm

Allen Memorial Art Museum, Oberlin College, 87 N. Main St., Oberlin 44074. (216)775–8665. www.oberlin.edu/wwwmap/allen_art.html

The Toledo Museum of Art, 2445 Monroe St., Toledo 43620. (419)255–8000; (800)644–6862

The Butler Institute of America, 524 Wick Ave., Youngstown 44502. (216)743–1711. www.butlerart.com

OKLAHOMA

Gilcrease Museum, 1400 Gilcrease Museum Rd., Tulsa 74127. (918)596–2700

The Philbrook Museum of Art, 2727 S. Rockford Rd., Tulsa 74114. (918)749–7941

OREGON

Portland Art Museum, 1219 SW Park Ave, Portland 97205. (503)226–2811. www.pam.org/~pam/index.html

PENNSYLVANIA

Brandywine River Museum, Brandywine Conservancy, Rt. 1 at PA Rt. 100, Chadds Ford 19317. (610)388–2700

Barnes Foundation, 300 North Natch's Ln., Merion Station 19066. (610)667–0290

Institute of Contemporary Art, University of Pennsylvania, 118 S. 36th St., Philadelphia 19104. (215)898–7108

Museum of American Art of the Pennsylvania Academy of the Fine Arts, 118 N. Broad St., Philadelphia 19102. (215)972–7600. www.pond.com/~pafa

Philadelphia Museum of Art, 26th St. and Benjamin Franklin Pkwy., Philadelphia 19130. (215)763–8100. libertynet.org/~pma/pmahome.html

University of Pennsylvania Museum, 33rd and Spruce Sts., Philadelphia 19104. (215)895–4000

The Andy Warhol Museum, 117 Sandunsky St., Pittsburgh 15212. (412)237–8300. www.clpgh.org/warhol

The Carnegie Museum of Art, 4400 Forbes Ave., Pittsburgh 15213. (412)622–3131. www.clpgh.org/moa

The Frick Art Museum, 7227 Reynolds St., Pittsburgh 15208. (412)371–0600

RHODE ISLAND

Museum of Art, Rhode Island School of Design, 224 Benefit St., Providence 02903. (401)454–6500. www/gatech.edu/CARLOS?AAMDO/RISDext.htm

SOUTH CAROLINA

Greenville County Museum of Art, 420 College St., Greenville 29601. (803)271–7570

TENNESSEE

Knoxville Museum of Art, 410 10th Ave., World's Fair Park, Knoxville 37916. (615)525–6101. www.esper.com/kma/index.html

Memphis Brooks Museum of Art, Overton Park, 1934 Poplar, Memphis 38104. (901)722–3500

TEXAS

Dallas Museum of Art, 1717 N. Harwood, Dallas 75201. (214)922–1200. www.unt.edu/dfw/dma/www/dma.htm

Amon Carter Museum, 3501 Camp Bowie Blvd., Fort Worth 76107. (817)738–1933. cartermuseum.org

Kimbell Art Museum, 3333 Camp Bowie Blvd., Fort Worth 76107. (817)332–8451. www.corbis.com/features/secure/kimbell

Modern Art Museum of Fort Worth, 1309 Montgomery St. at Camp Bowie Blvd., Fort Worth 76107. (817)738–9215

Contemporary Arts Museum, 5216 Montrose Blvd., Houston 77006. (713)526–0773. riceinfo.rice.edu/projects/cam

The Menil Collection, 1515 Sul Ross, Houston 77006. www.menil.org/~menil

The Museum of Fine Arts, Houston, 1001 Bissonnet St., Houston 77005. (713)639–7300. www.mfah.org

Rothko Chapel, 1409 Sul Ross, Houston 77006. (713)524–9839

Marion Koogler McNay Art Museum, 6000 N. New Braunfels Ave., San Antonio 78209. (210)824–5368

San Antonio Museum of Art, 200 W. Jones St., San Antonio 78215. (210)978–8100. www.samuseum.org

VIRGINIA

Monticello, Charlottesville. www.monticello.org/

Hampton University Museum, Hampton 23668. (804)727–5308

The Chrysler Museum, 245 W. Olney Rd., Norfolk 23510. (804)664–6200. www.whro.org/cl/cmhh

Virginia Museum of Fine Arts, 2800 Grove Ave., Richmond 23221. (804)367–0844

WASHINGTON

Seattle Art Museum, 100 University St., Seattle 98101. (206)625–8900; 654–3100. www.pan.ci.seattle.wa.us/sam

Tacoma Art Museum, 12th and Pacific Ave., Tacoma 98402. (206)272–4258

WISCONSIN

Milwaukee Art Museum, 750 N. Lincoln Memorial Dr., Milwaukee 53202. (414)224–3200. www.mam.org

OUTSIDE
THE UNITED STATES

AUSTRIA

Graphische Sammlung Albertina, Augustinerstr. 1, Vienna 1010. (0222)534830

Kunsthistoriches Museum, Burgring 5, Vienna 1010. (0222)525240

Church of St. Wolfgang, Vienna

Österreichische Galerie Belvedere, Prinz. Eugen. Str. 27, Vienna 1037. (01)79557

BELGIUM

Antwerp Cathedral

Musées Royaux des Beaux-Arts de Belgique: Musée d'Art Ancien, 3 Rue de la Régence, Brussels 1000. (32)25083211; Musées d'Art Moderne, 1-2, Place Royale, Brussels 1000. (32)25083211

Musée Royaux d'Art et d'Histoire, Parc du Cinquantenaire 10, Brussels 1040. (02)7417211

Church of St. Bavo, Ghent

CANADA

Edmonton Art Gallery, 2 Sir Winston Churchhill Sq., Edmonton, Alberta T5J 2C1. (403)422–6223

Glenbow, 130 9th Ave., Southeast, Calgary, Alberta T2G 0P3. (403)268–4100. www.glenbow.org

Vancouver Art Gallery, 750 Hornby St., Vancouver, British Columbia V6Z 2H7. (604)682–4668. www.vanartgallery.bc.ca

National Gallery of Canada, 380 Sussex Dr., Ottawa, Ontario K1N 9N4. (800)319–ARTS; (613)990–1985. national.gallery.ca

Art Gallery of Ontario, 317 Dundas St. W., Toronto, Ontario M5T 1G4. (416)977–6648. www.ago.on.ca

Royal Ontario Museum, 100 Queen's Park, Toronto, Ontario M5S 2C6. (416)586–5551. www.rom.on.ca/

Canadian Center for Archicteture, 1920, rue Baile, Montréal, Quebec H3H 2S6. (514)939–7000; 939–7026

Montréal Museum of Fine Arts, 1379-80 Sherbrook St. W., Montréal, Quebec H36 2T9. (514)285–1600; 285–2000. www.mmfa.qc.ca

CZECH REPUBLIC

National Gallery in Prague. (42)2 53 08 95. (43)5132782

Sternberg Palace, Hradcanske namesti 15, Prague 1-Hradcany. (42)23524413

DENMARK

Ny Carlsberg Glyptotek, Dantes Plads 7, Copenhagen 1556. (45)33418141. www.europe-today.com/denmark/museum2.html#carlsberg2

Louisiana Museum of Modern Art, Gl. Strandvej 13, Humlebaek 3050 (nr. Copenhagen). (45)42190719. www.europe-today.com/denmark/museum2.html#Louisiana

EGYPT

Tomb of Khnum-hotep, Beni Hasan

Egyptian Museum, Cairo University. Midan el Tahrir, Cairo. (2) 760390

Funerary Temple of Queen Hatshepsut, Deir el-Bahari

The Great Sphinx, Giza

Pyramids of Menkaure, Khafre, Khufu, Giza

Temple complex of Amun-Mut-Khonsu, Luxor

Funerary district of King Djoser, Saqqara

Tomb of Ti, Saqqara

Tomb of Ramose, Thebes

ENGLAND

Birmingham Museum and Art Gallery, Chamberlain Sq., Birmingham B3 3DH. (0121)2352834

Durham Cathedral, Durham

Banqueting House, Whitehall Palace, London

British Library Exhibition Galleries, Great Russell St., London WC1B 3DG. (0171)4127595

British Museum, Great Russell St., London WC1B 3DG. (0171)6361555

Westminster Abbey, London

Courtauld Institute Galleries, Somerset House, Strand, London WC2R ORN. (0181)8732538

The Houses of Parliament, London

The National Gallery, Trafalgar Sq., London WC2N 5DN. (0171)8393321

Royal Academy of Arts, Burlington House, Piccadilly, London WIV ODS. (0171) 439-7438

St. Paul's Cathedral, London

Sir John Soane's Museum, 13 Lincoln's Inn, London WC2A 3BP. (0171)4052107

Tate Gallery, Millbank, London SWIP 4RG. (0171)8878000

Victoria and Albert Museum, Cromwell Rd., South Kensington, London SW7 2RL. (0171)9388500. www.vam.ac.uk

Wellington Museum, Apsley House, 149 Piccadilly, Hyde Park Corner, London N1V 9FA. (0171)4995676

Ashmolean Museum of Art and Archaeology, Beaumont St., Oxford 0X1 2PH. (01865)278000. www.ashmol.ox.ac.uk

Salisbury Cathedral, Salisbury

Stonehenge, Salisbury Plain (Wiltshire)

Blenheim Palace, Woodstock 0X7 1PX. (01993)811325

FRANCE

Chauvet cave, Vallon-pont-d'Arc

Amiens Cathedral, Amiens

Autun Cathedral, Autun

Chartres Cathedral, Chartres

Musée Unterlinden, 1 rue des Unterlinden, Colmar 68000. 89201550

Lascaux cave, Montignac, Dordogne

Château de Fontainebleau, Fontainebleau. (1)60715070

Musée Claude Monet, rue Claude Monet, Giverny 27620. 32512821. giverny.org/monet/welcome.htm

Musée des Beaux-Arts de Lyon, Palais St. Pierre, 20 place des Terreaux, 69001 Lyon. 78280766

Pont du Gard, Nîmes·

Abbey Church of St.-Denis, Paris

Bibliothèque Nationale de France, 25 rue de Richelieu, Paris 75002. (1)47038126

Bibliothèque Ste. Geneviève, Paris

The Eiffel Tower, Paris

Galeries Nationales du Grand Palais, 3 avenue du Général Eisenhower, Paris 75008. (1)42895410

Musée Auguste Rodin, 77 rue de Varenne, Paris 75007. (1)47050134

Musée du Louvre, rue de Rivoli, 75001 Paris. (1)40205009. www.Louvre.fr

Musée National d'Art Moderne—Centre National d'Art et de Culture Georges Pompidou, Centre Beaubourg, Paris 75191. (1)781233. www.paris.org/Musees/Beaubourg

Musée d'Orsay, 1 rue de Bellechasse, Paris 75007. (1)40494814. www.paris.org.:80/Musees/Orsay/

Musée Picasso, Hôtel Salé, 5 rue de Varenne, Paris 75003. (1)42712521

Notre-Dame, Paris

The Opéra, Paris

Rodin Museum, Paris

Riems Cathedral, Reims

Notre-Dame-du-Haut, Ronchamp

Musée des Antiquités Nationales, Château de Saint-Germaine-en-Laye, Saint-Germain-en-Laye 78100

Château de Versailles, Versailles. (1)30847400

GERMANY
Palace Chapel of Charlemagne, Aachen

Brücke-Museum, Bussardsteig 9, Berlin 14195. (030)8312029. www/dhm.de/museen/bruecke/

Ägyptisches Museum und Papyrus-sammlung, Staatliche Museeun zu Berlin-Preussischer Kulturbesitz, Schlossstr. 70, Berlin 14059. (030)32091261. fub46.zedat.fu-berlin.de:8080/¯kurtwagn/gendir/aegy-pap/aegychar.html

Schloss Charlottenburg, Berlin. peri.pericont.in-berlin.de/cgi-bin/cg/museummuseumshow.pl?80; land=Berlin

Staatliche Museen zu Berlin, Gemälde-galerie. peri.pericont.in-berlin.de/cgi-bin/cg/museummuseumshow.pl?80; land=Berlin

Staatliche Museen zu Berlin, Preussisch-er Kulturbesitz, Stauffenbergstr. 41, Berlin 10785. (030)2666. peri.pericont.in-berlin.de/cgi-bin/cg/museummuseumshow.pl?80; land=Berlin

Museum Ludwig, Bischofsgartenstr. 1, Cologne 50667. (0221)2212379. www.blackbox.de/kunst/museen/mlu.htm

St. Pantaleon, Cologne

Städelsches Kunstinstitut und Städtis-che Galerie, Schaumainkai 63, Frankfurt 60596. (069)6050980. peri.pericont.in berlin.de/cgi-bin/cg/museumcity search.pl?city=Frank furt_am_Main

Hamburger Kunsthalle, Glockengiesser-wall, 20095 Hamburg. (040)24862612. www.hamburg.de/Behoerden/Museen/kh/

Hildesheim Cathedral, Hildesheim Staatliche Kunsthalle, Hans-Thoma-Str. 2, Karlsruhe 76133. 1353370. www.rz.uni- karlsruhe.de/Nick/Karlsruhe/

Alte Pinakothek, Barer Str. 27, Munich 80333. (089)238050. server.StMUK WK.bayern.de/kunst/museen/pinalt.html

Bayerische Staatsgemäldesammlungen, Barrer Str. 29, Munich 80799. (089)238050

Staatliche Graphische Sammlung, Meis-erstr. 10, Munich 80333. (089)5591490

Staatliche Antikensammlungen und Glyptothek, Konigspl 1–3, Munich 80333. (089)1598359

Staatsbibliothek, Munich

Staatsgalerie Stuttgart, Konrad-Ade-nauer Str. 30, Stuttgart 70173. (0711) 212 4050. macserver.zedat.fu-berlin.de:1080/index.html

The Episcopal Palace, Würzburg

GREECE
Acropolis, Athens

Acropolis Museum, Athens. www.culture.gr

National Archaeological Museum, Od Tosita 1, Athens 10682. (01)8217717. www.culture.gr

Archaeological Museum, Corfu. www.culture.gr

Archaeological Museum, Heraklion, Crete. www.culture.gr

Palace of Minos, Knossos, Crete

Archaeological Museum, Delphi 33054. (0265)82313. www.culture.gr

Archaeological Museum, Eleusis. www.culture.gr

Monastery of Hosius Loukas (St. Luke of Stiris)

HUNGARY
National Gallery, Budapest

IRAN
Archaeological Museum, Teheran

IRAQ
Iraq Museum, Karkh Museum Sq., Baghdad. 361215

Ziggurat of King Urnammu, Ur (El Muqeiyar)

"White Temple", Uruk (Warka)

IRELAND
National Gallery of Ireland, Merrion Sq. W., Dublin 2. (01)6615133

ITALY
Museo Civico Archeologico, Via del-l'Archiginnasio 2, Bologna 40124. (051)233849. www.dsnet.it/Bologna/engl_musei.html

Museo Civico Cristiana, Via Musei, 81, Brescia 25100. (030)44327

Museo Etrusco, Piazza della Cattedrale, Chiusi 53043

Florence Cathedral and Baptistery of S. Giovanni, Florence

Galleria dell'Academia, Via Ricasoli 60, Florence 50122. (055)214375

Galleria degli Uffizi, Piazza degli Uffizi 6, Florence 50122. (055)2388651. www.televisual.it/uffizi/

Museo Archeologico Nazionale du Firenze, Via della Colonna 38, Florence 50121. (055)23575

Museo Nazionale del Bargello, Via del Proconsolo 4, Florence 50122. 055210801

S. Lorenzo, Florence

Sta. Maria delle Grazie, Milan

Museo Archeologico Nazionale, Via Museo 19, Naples 80135. (081) 440166

Museo e Gallerie Nazionale di Capodi-monte, Palazzo di Capodimonte, Naples 80136. (081)7410801

"Basilica" and "Temple of Poseidon", Paestum

Parma Cathedral

House of the Vettii, Pompeii

Villa of the Mysteries, Pompeii

S. Apollinare in Classe, Ravenna

S. Vitale, Ravenna

Arch of Constantine, Rome

Arch of Titus, Rome

Casino Rospogliosi, Rome

The Colosseum, Rome

Column of Trajan, Rome

Galleria Borghese, Piazzale Scipione Borghese 5, Rome 00197. (06)858577

Galleria Nazionale d'Arte Antica, Via delle Quattro Fontane 13, Rome 00184. (06)4824184

Il Gesù, Rome

Musei Capitolini, Piazza del Campidog-lo, Rome 00186. (06)67102475

Museo dei Conservatori, Piazza del Campidoglio, Rome 00186. (06)67102475

Museo di Antichità Etrusche e Italiche, Piazza Aldo Moro, Rome 00185

Museo delle Terme, Rome

Museo Nazionale di Villa Giulia, Piazza di Villa Giulia 9, Rome 00195. (06)350719

Museum of the Ara Pacis, Rome

Palazzo Barberini, Rome

Palazzo Farnese, Rome

The Pantheon, Rome

S. Carlo alle Quattro Fontane, Rome

S. Luigi dei Francesi, Rome

St. Peter's, Rome

Sta. Maria Maggiore, Rome

Sta. Maria della Vittoria, Rome

Vatican Museums, Viale Vaticano, Città del Vaticano 00120, Rome. (06)69883333

Villa Medici, Rome

Cave of Addaura, Monte Pellegrino (Palermo), Sicily

Tombs, Tarquinia

Peggy Guggenheim Collection, Palazzo Venier dei Leoni, 701 Dorsoduro, 30123 Venice. (041)5206288

Galleria dell'Academia, Campo della Carità, Venice 30121. (041)22247

S. Giorgio Maggiore, Venice

St. Marks, Venice

Villa Rotonda, Vicenza

JORDAN
Jordan Archaeological Museum, Amman. 638795

THE NETHERLANDS
Rijksmuseum, Stadhouderskade 42, Amsterdam 1070. (020)6732121. www.nbt.nl/holland/museums/home.htm

Rijksmuseum Vincent van Gogh, Paulus Potterstr. 7, Amsterdam 1070. (020)5705200. www.nbt.nl/holland/museums/home.htm

Stedelijk Museum of Modern Art, Paulus Potterstraat 13, Amsterdam 1070. (020)5732911. art.cwi.nl

Frans Halsmuseum, Groot Heiligland 62, Haarlem 2001. (023)164200. www.nbt.nl/holland/museums/home.htm

Kröller-Müller Museum, Otterlo 6730. 08382. www.nbt.nl/holland/museums/home.htm

Museum Boymans-van Beuningen, Museumpark 18-20, Rotterdam 3015. 010441400. www.nbt.nl/holland/museums/home.htm

Centraal Museum Utrecht, Agnietenst. 1, Utrecht 3500. (030)362362. www.nbt.nl/holland/museums/home.htm

NORWAY

Nasjonalgalleriet, Universitestsgaten 13, Oslo 0033. 22200404

ROMANIA

National Museum, Str. Stirbei Vida, nr. 1–3, Bucharest 70733. (01)6155193

RUSSIA

Cathedal of St. Basil, Moscow

Pushkin Museum of Fine Arts, Ul. Volkhonka 12, Moscow. (095)2037412. www.rosprint.ru/art/museum/pushkin

Hermitage Museum, 36 Dvortsovaya Naberezhnaya, Saint Petersburg, (812)3113420

SCOTLAND

National Gallery of Scotland, The Mound, Edinburgh EH2 2EL. (0131)5568921

SPAIN

Altamira cave

Church of the Sagrada Familia, Barcelona

Museo Nacional del Prado, Paseo del Prado, Madrid 28014. (91)4680950

Museo Nacional Centro de Arte Reina Sofía, Santa Isabel 52, Madrid 28012. (1)4675062

Toledo Cathedral, Toledo

SWEDEN

Moderna Museet, Spårvagnshallarna, Box 16382, Stokholm 10327. (08)6664250

Nationalmuseum, S. Blasieholmshamnen, Stockholm 10324. (08)6664250

University Art Gallery, Uppsala University

SWITZERLAND

Öffentliche Kunstsammlung Basel, Kunstmuseum, St. Alban-Graben 16, Basel 4010. (41)612710828. www.access.ch/bsweb/museum/e/kusa_ku/index.htm

Musée des Beaux-Arts de Berne, Bern

Musée d'Art et d'Histoire, 2 Rue Charles Gallard, Geneva 1211. (022)3114340

TURKEY

Archaeological Museum, Ankara

Archaeological Museum of Istanbul, Gülhane Sultanahmet, Istanbul 34400. (520)7742

Hagia Sophia, Istanbul

Kariye Camii (Church of the Saviour in Chora), Istanbul

INDEX

PHOTOGRAPH CREDITS and COPYRIGHTS

The author and publisher wish to thank the libraries, museums, galleries, and private collections for permitting the reproduction of works of art in their collections and for supplying the necessary photographs. Photographs from other sources are gratefully acknowledged below. All numbers refer to figure numbers.

PHOTOGRAPH CREDITS and COPYRIGHTS

ACL, Brussels: 396, 411; Adros Studio, Rome: 416; Alison Frantz Collection, American School of Classical Studies, Athens: 169, 172, 177, 332; Archivi Alinari, Florence: 111, 228, 238, 271, 272, 274, 279, 280, 344, 393, 409, 461, 463, 484, 490, 491; Ronald Sheridan's Art & Architecture Collection, Pinner, England: 343, 405; Cameraphoto-Arte, Venice/Art Resource, New York: 465; Erich Lessing/Art Resource, New York: 342; Foto Marburg/Art Resource, New York: 176, 357, 387, 392, 407, 430, 431, 435, 445, 472, 473, 477; The Pierpont Morgan Library/Art Resource, New York: 369; Scala/Art Resource, New York: 504, 505; Foto Barsotti, Florence: 486, 487; Bayerische Staatsbibliothek, Munich: 377, 378, 422; M. Beazley, *Atlas of World Architecture*: 259, 382; Jean Bernard, Aix-en-Provence: 433, 437; Constantin Beyer, Weimar, Germany: 478; Bildarchiv Preussischer Kulturbesitz, Berlin: 78, 79, 105, 211, 213, 257; Erwin Böhm, Mainz: 87; Lee Boltin Photo Library, Croton-on-Hudson: 108; W. Braunfels, *Mittelalterliche . . . Toskana*: 419; Brisighelli-Undine, Cividale, Italy: 356; The British Museum, London: 202; Jutta Brüdern, Braunschweig: 374, 375, 412; Photographie Bulloz, Paris: 426; Studio C.N.B. & C., Bologna, Italy: 81; Caisse Nationale des Monuments Historiques et des Sites/© Arch.Phot.Paris: 45, 384, 385, 401, 402, 438, 444, 447, 466, 480, 481; Canali Photobank, Capriolo: page 316, 10, 12, 116, 164, 165, 183, 189, 223, 231, 232, 236, 238, 250, 255, 263, 266, 267, 270, 277, 278, 285, 287–92, 302, 303, 306, 308, 310, 317, 320–22, 329, 394, 398, 399, 417, 457, 482, 483, 485, 489, 492, 500, 503, 506, 509–13; Canali Photobank/ Bertoni, Capriolo: 261, 515, 525; Canali Photobank/Codato: 336; Canali Photobank/Rapuzzi, Capriolo: 143; Editions Citadelles & Mazenod, Paris: 68; Peter Clayton: 62, 65, 71, 83; Collection Colonel Norman Colville: 97; Colorphoto Hans Hinz, Alschwill-Basel: 30; K. J. Conant, *Carolingian and Romanesque Architecture, 850–1200*: 381, 389; Costa and Lockhart, *Persia*: 115; The Conway Library/Courtauld Institute of Art, University of London: 364, 469; Photo Daspet, Villeneuve-des-Avignon: 517; Deutsches Archäologisches Institut, Baghdad: 84, 86; Deutsches Archäologisches Institut, Rome: 6, 253, 262, 275, 276, 284; Jean Dieuzade [YAN], Toulouse: 380, 400; Dom-und Diözesanmuseum, Hildesheim: 376; Dumbarton Oaks, Washington, D.C. © Byzantine Visual Resources: 338, 340; Editoriale Museum/Pedicini, Rome: 249; Nikos Kontos, Courtesy of Ekdotike Athenon, Athens: 331; English Heritage Photograph Library, London: 47; B. Fletcher, *A History of Architecture*: 168; Fototeca Unione, American Academy, Rome: 166, 240, 242, 258,

269; G. De Francovich, Rome: 410; H. Frankfort, *The Art and Architecture of the Ancient Orient*: 85; Henry Gaud, Molsenay: 441; G.E.K.S., New York: 21, 22, 245, 273; Photographie Giraudon, Paris: 406, 446, 467, 522; Edward V. Gorn, New York: 337; Foto Grassi, Siena: 483, 485; The Green Studio, Limited, Dublin: 353; Dr. Reha Günay, Istanbul: 348, 349; Hirmer Fotoarchiv, Munich: 35, 53, 130, 149, 154, 158, 160, 161, 170, 175, 179, 184, 185, 187, 190–92, 218–22, 224, 225, 229, 268, 283, 307, 312, 313, 327; Foto Karl Hoffmann, Speyer: 395; Walter Horn: 363; Instituto di Etruscologia e Antichità Italiche, University of Rome: 33; H. W. Janson: 455; S. W. Kenyon, Wellington, U.K.: 37, 38; A. F. Kersting, London: 388, 452; © Studio Kontos, Athens: 1, 19, 120, 121, 126, 127, 129, 133–35, 137, 140, 148, 152, 153, 173, 174, 178, 182, 186, 188, 198, 207, 216; S. N. Kramer, Studio Koppermann, Gauting, Germany: 142, 200, 212; *History Begins at Sumer*: 94; R. Krautheimer: *Early Christian and Byzantine Architecture*: 297, 298; Kurt Lange, Oberstdorf, Allgäu, Germany: 51, 52; A. W. Lawrence: *Greek Architecture*: 171; Ralph Liberman: 464; Lichtbildwerkstätte Alpenland, Vienna: 311, 316, 385; Tony Linck, Fort Lee, N.J.: 47; Barbara Maltern, Rome: 210; Alexander Marshak, New York: 34, 43, 44; Arlette and James Mellaart, London: 39–41, 42; H. Millon, *Key Monuments in the History of Art*: 456; Ministry of Culture/Archeological Receipts Fund (Service T.A.P.), Athens: 122, 123, 125, 132, 196, 197; Ministry of Public Buildings and Works, London: 46, 47; Monumenti, Musei, e Gallerie Pontificie, Vatican City, Rome: 206, 234, 265; Ann Münchow, Domkapitel Aachen: 358; National Buildings Record, London: 450, 451; Nippon Television Network Corporation, Tokyo: 9; © Takashi Okamura, Shizuoka City, Japan: 494, 525, 526; The Oriental Institute of the University of Chicago: 89, 100, 101, 110, 112; G. Picard, *The Roman Empire,* © Benedikt Taschen Verlag, Cologne, Germany: 241; Josephine Powell, Rome: 341; Pubbli Aer Foto, Milan: 237, 335; Mario Quattrone Fotostudio, Florence: 499, 507; Studio Rémy, Dijon, France: 519; © Réunion des Musées Nationaux, Paris: 4, 36, 66, 95, 96, 98, 106, 111, 141, 144, 145, 146, 150, 151, 214, 330, 345, 508, 520; Rheinisches Bildarchiv, Cologne: 370, 371; Ekkehard Ritter, Vienna: 420, 421; Jean Roubier, Paris: 243, 383, 427, 468, 470, 471, 474; Sächsische Landesbibliothek, Deutsche Fotothek, Dresden: 477; Société Archéologique et Historique, Avesnes-sur-Helpe: 418; Soprintendenza alle Antichità, Palermo: 33; Soprintendenza Archaeologica, Ministero per i Beni Culturali Ambientali, Rome: 233; Soprintendenza Archaeologica all'Etruria Meridionale, Tarquinia: 226, 227; Soprintendenza dei Monumenti, Pisa: 514; Stiftsbibliothek, St. Gallen, Switzerland: 362; Wim Swaan: 3, 56, 58, 59, 63, 69, 72, 74, 75, 77, 82, 99, 114, 386, 397, 423, 428, 429, 439, 448, 454, 462, 488; © Jean Clottes, SYGMA, New York: 28; J. W. Thomas, Oxford: 475; Marvin Trachtenberg, New York: 180, 328, 334, 459; © University Museum of National Antiquities, Oslo: 351; Jean Vertut, Issy-les-Moulineaux: 29, 31; Foto Vitullo, Rome: 297; Leonard von Matt, Buochs, Switzerland: 128, 366, 408; © Elke Walford, Hamburg: 524; Clarence Ward: 426; © CORBIS/Roger Wood, Bellevue, Washington: 119; Woodfin Camp & Associates, New York: 432; (former) Yugoslav State Tourist Office, New York: 260.